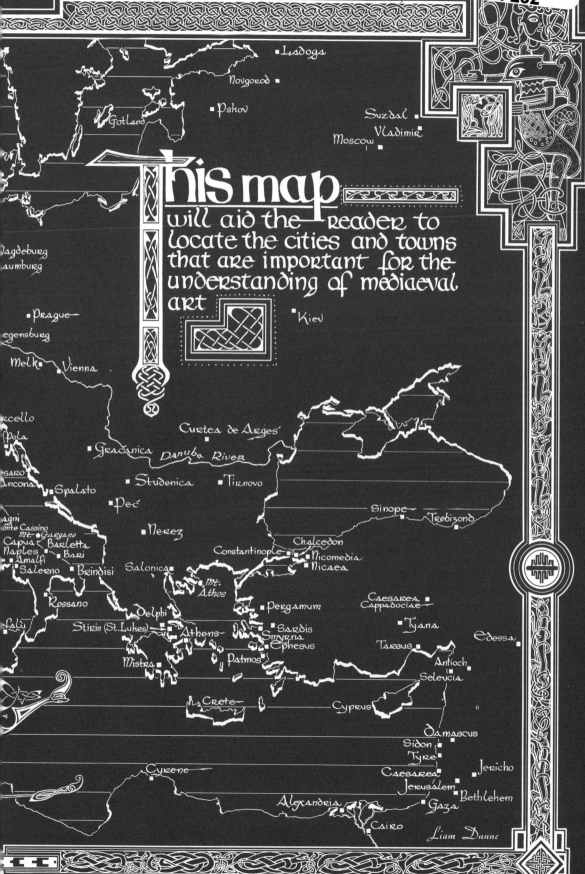

Mediaeval Art

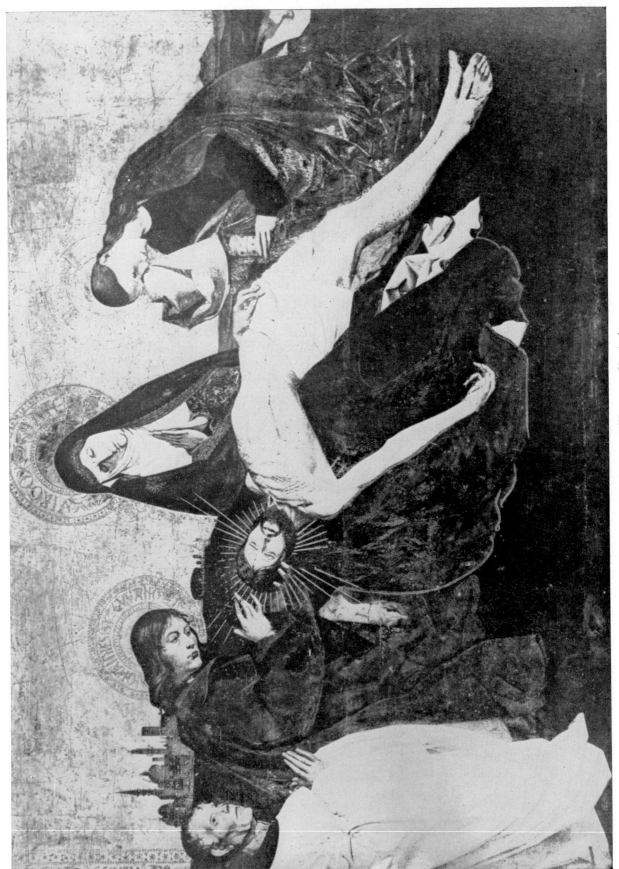

PARIS, LOUVRE: *Pietà* from Villeneuve-lès-Avignon

Mediaeval Art

CHARLES RUFUS MOREY

Marquand Professor of Art and Archaeology

PRINCETON UNIVERSITY

W. W. Norton & Company, Inc. PUBLISHERS NEW YORK

SBN 393 04170 0

PRINTED IN THE UNITED STATES OF AMERICA
FOR THE PUBLISHERS BY THE VAIL-BALLOU PRESS

Contents

[v]

CONTENTS

Illustrations

[vii]

ILLUSTRATIONS

ILLUSTRATIONS

[ix]

[x]

ILLUSTRATIONS

[xi]

ILLUSTRATIONS

[xii]

ILLUSTRATIONS

[xiii]

ILLUSTRATIONS

[xiv]

ILLUSTRATIONS

ACKNOWLEDGMENTS

Photographs of many illustrations furnished by The University Prints, Newton, Massachusetts

I

Introduction

FACTORS AND PHASES OF MEDIAEVAL ART

ONE WHO UNDERTAKES to write on mediaeval art is confronted at once with the problem of boundaries both of space and time. What geographical area does the concept of the Middle Ages imply, and when do the Middle Ages begin and end? The answering of these questions immediately produces another: what phenomenon is inherent in this section of the world's history characteristic enough to be synonymous with "mediaeval," and informing us by its presence or absence whether we are within or outside the limits of geography and history which the word connotes?

If we accept this criterion as adequate, the determination of our frontiers is simplified. For the characteristic mediaeval phenomenon, in any place or time, is the Christian religion—not in its later character of convention or custom, but as the determinant of thought and expression, controlling the general habit of mind to an extent unseen before the Middle Ages or thereafter, transcending boundaries of race and language, and so permeating the processes of life that even trivial acts were somehow suffused with Christian significance. This state of things did not begin to be apparent until the new religion had forced its recognition from the Roman state in the fourth century and had become the pervasive leaven of Mediterranean civilization. It began to disappear

[3]

with the rise of the Renaissance in the fifteenth century, when, so to speak, men began to look upon themselves and their surroundings as more interesting than God. Our limits of time can then be loosely fixed about 300 A. D. for a beginning and about 1450 for an end.

Our limits of place include Europe, and the regions of Asia and Africa comprised within our notion of the Nearer East. For the Christian world of the Middle Ages was not confined to Europe but extended, until the Arab and Turkish conquests, throughout the shores of the Mediterranean, the African and Asiatic as well as the European. We shall see in fact that one highly important aspect of mediaeval art was the imprint on its style imposed by a point of view that was not European but oriental—using that term to designate the Nearer East, the *Oriens* of the later Roman Empire: Egypt, Palestine, Syria, Mesopotamia, and Persia. Christianity itself, the force that mainly made the Middle Ages, was not a mediaeval product, but a final creation of antiquity, proceeding out of a religious evolution that spread from the East westward through the Empire. This was a growth which had its genesis in the decay of tribal and racial cults, and the necessity, as life grew more difficult and complex in the economic and social stress at the end of antiquity, of religious solutions that could no longer be obtained through public and communal worship but must be reached by the piety of the individual soul. Christianity's beginnings lay in the twofold legacy of Jesus, a moral code and a mystery, and conformed in these two elements to the customary pattern of the mystery religions of the later Empire. But none of the pagan cults made the claim to world-wide acceptance which was advanced for Christianity by Paul, nor did they have the powerful leaven of *Charitas* (the "Charity" of I Corinthians) —the love of God and of one's neighbor that looked toward a universal brotherhood of man. Another distinction lay in the greater depth of the Christian implications, the profound and cosmic meanings that could be read into the terms of the early faith, "the Word," the "Son of God," "Salvation," and the like. It is in the development of these implications that a third factor in Christianity revealed itself, namely, the philosophic habit of the Greco-Roman mind, not content as was the oriental with mystery as such, but insisting on definition, and finally evolving in consequence the dogmatic foundations of mediaeval theology. We shall meet this Hellenistic mentality again, as a conservative factor in the mediaeval art of eastern Christianity.

The genesis of anything notably and distinctively mediaeval lies then in the Christian faith, without which the very notion of the Middle Ages is empty of significance. It was a faith born and reared in a world that was still ancient, and had perforce to express its novel concepts in the locutions and art of an-

tiquity. This was the medium of communication with which the Christian mission commenced, and its Hellenistic origin must not be forgotten as we see, in following the course of mediaeval art, how Christian content was able at last to revise to its use the Greco-Roman forms and tell the Christian story in an idiom of its own. The mediaeval mode of expression was at first in both art and literature the style that had been invented by the Greeks and spread by them and their Roman conquerors throughout the ancient world.

So cosmopolitan had this ancient world become, in spite of the manifold races comprised within the *pax Romana*, and so uniform its outward cultural manifestations, that it is difficult to find within it the germs of that extraordinary dichotomy of style which separated mediaeval art in the east of our area from that in the west, by the time the Middle Ages had run their course. It is true that people wrote and spoke Greek in the eastern lands of the Roman Empire, and Latin in the west, but they used both languages to say very much the same things. Never before, and never since, has the coast of the Mediterranean been so unified in culture. Yet the eastern lands at the end of the Middle Ages were employing in their art the Byzantine style—grave, reflective, conveying the deep emotion that is stirred by the contemplation of mystery, reticent in expression, fastidious in its decorative vocabulary, as Greek as the Parthenon in the intellectual clarity of its broad idealism, but utterly un-Greek in its suppression of plastic form and in the rhythmic composition that gives unity to its ensembles. The Latin West had meantime evolved the Romanesque and Gothic styles, at once ecstatic and specific, striving to grasp the infinite while rooted in the concrete, not content as was the Byzantine with contemplation of the idea of God, but bent upon a personal union with the Divine. How is the wide divergence of these two streams of style to be explained, arising as they do from a common Christian source of content, and the common fountainhead of Hellenistic art?

The answer lies in the two racial influences that played upon the Hellenistic tradition as it developed into mediaeval art: the oriental in the East, the "barbarian" in the West. These are hard to isolate and define as artistic styles, emerging rather as points of view. The one represents the habit of mind of the peoples along and beyond the eastern frontiers of the Empire—Egyptians, Syrians, Jews, the races of Mesopotamia and Persia—a habit of mind that lay dormant during the long centuries of Greek and Roman ascendancy, and began to revive and rival the classic tradition only with the loosening in late antiquity of the grip of Greco-Roman culture on the Mediterranean world. It is a habit distrustful of reason and of its power to compel nature, more abstract than the Greek view in its conception of deity, deeply impressed with the

[5]

unendingness of things, and the eternal rhythm of recurrent experience. Con·
trasting with this attitude, the disillusioned detachment of ancient civilizations,
was the vigorous and primitive genius of Celtic-Teutonic culture in the West,
mingling fresh blood with Latin stock to make new nations out of Roman
Europe, and gradually transforming Latin art into the mediaeval western
forms of Romanesque and Gothic. The "barbarian" instinct was even more
irrational than the oriental, because more unsophisticated, and even more, per-
haps, impressed with the mystery of existence. But one feels, at first contact
with the earliest expression of this "barbarian" genius in mediaeval art, the
positive force of its reactions and the eagerness and confidence with which it
strives to render in terms of personal experience the Christian mysteries which
the oriental artist was satisfied to contemplate.

❖　　　　❖　　　　❖　　　　❖　　　　❖

We have named three factors, components of mediaeval art—the Greco-
Roman tradition that was the original medium of Christianity's expression, the
oriental attitude of esoteric contemplation, and the positive and poignant mys-
ticism of the barbarian races that entered the Empire in the fifth century. The
terms employed, however, are lamentably general, and the reader may well de-
mand some concrete illustration of these factors in their actual operation. This
is not easy to provide, for they are nearly always found in fusion, and prone
to mutual borrowing. The problem is somewhat like that of the critic of paint-
ing who endeavors to discover among the various influences playing upon the
author of a picture some sure indication or authentic hallmark of style that will
determine his identity. In such case the critic is likely to follow the method
suggested in the eighties and nineties of the last century by the Russian Ivan
Lermolieff, who wrote his keen criticisms of Italian painting under the pseu-
donym "Giovanni Morelli." Morelli insisted that the obvious aspects of a work
of art—color, composition, figures, drapery, and the like—were not the best
evidence for authorship, which can be better detected in the drawing of minor
features such as hands and ears, because in these subordinate passages the art-
ist's creative tension is relaxed, and he follows instead an unconscious habit,
which by its very unconsciousness is personal enough to sign his work.

An art historian, in search of "Morellian" characteristics wherewith to illus-
trate the nature and distinction of our three factors of mediaeval art, would
probably have recourse to ornament. For ornament is the most "Morellian"
feature in style in that it reflects the naïve racial or regional preference of the
artist using it. Like Morelli's hands and ears, it plays a subordinate role in ar-
tistic creation, imposing no conscious attitude on the painter or sculptor such

[6]

as he must assume toward the natural forms he undertakes to reproduce, nor on the architect as he struggles with his problem of the organization of space. It is without specific content, having nothing specific to say. Ornament, in fact, is style reduced to its barest terms, an intuitive revelation, when it is indigenous and unborrowed, of what the artist and his race and fatherland considered normal and satisfactory in pure design.

It is true that ornament is also the international currency of art, a medium of exchange in style that commonly ignores all boundaries of region, race, or time. A motif may originate in China, like the cloud pattern, and later on become a characteristic feature of Persian painting. Wood construction in archaic Greece developed the dentil, which in the Middle Ages reappears as the billet molding of Lombard architecture. If ornament is to be our guide to characteristic racial and regional expression, we must choose the ornamental motifs with care, that they be really indigenous to the arts they are selected to represent, and that the arts themselves be really native, and free of foreign contamination.

With this in mind we may find the first of our three factors best exemplified in Greek art, as the fountainhead of style in antiquity; and for the oriental and Celtic-Teutonic factors we shall turn to the fringes of the Empire, and to cultures that were least affected by the prestige of the antique. Of oriental attitudes and preference no purer representative can be found than Islamic art; and of the "barbarian" habit of mind in the Latin West, in a state of primitive innocence, we have a signal example in the Celtic art of the British Isles, untouched by Latin sophistication. In the ornament of these three styles, Greek, Islamic, and Celtic, we shall find, perhaps, the "Morellian" features that will make clear what is meant by the antique, oriental, and "barbarian" factors in mediaeval art.

❖　　　❖　　　❖　　　❖　　　❖

As characteristic motifs of ornament, typical of these styles, the reader is invited to consider the palmette, the allover pattern, and the spiral. The reason that these three familiar forms are typical is that each represents a determinant of style, namely, a mode of composition, and in each case the mode is different, peculiar to the style concerned, and revealing in final analysis not only an artistic preference, but also a fundamental racial attitude.

The palmette, to begin with, is a characteristic Greek creation in its finished form, whatever Egyptian or Asiatic models may have influenced its inception. It differs from the other two motifs we have selected in its derivation from nature; it is in fact the tuft of leaves at the top of a palm tree, revised and stylized under the imperative of a very strong, however unconscious, preference in

[7]

design. The preference is one for axial symmetry, the ordering of subordinate and lateral units about a central dominating stem, so that the resultant figure is self-sufficient and needs no suggested continuation to complete it. We might call such composition "architectonic," since it is the sort of stable arrangement we look for in architecture; or "triangular," since the importance given the central feature results in diminishing accents on either side, and the contour of a triangle; but the determinant being always the central axis, the most appropriate term and the one which we shall use for this type of composition is "axial."

This word in fact most sharply differentiates the palmette from the allover pattern, which has no axis at all. It has instead the feature which is cardinal for composition in Islamic ornament—indefinite extension. The determined limits of the palmette are absent here; the Greek form could be, and was, repeated in alternation with the lotus in a horizontal band, but an allover pattern is extension in all directions *ad infinitum,* depending on pervasive continuity for its perfection, as did the palmette on its self-sufficient silhouette. Such composition introduces a factor which Greek ornament, and Greek art in general, instinctively banned—the factor of infinity, or (to give this mathematical term a warmer humanistic color) of infinitude. It is saved from the mere vagueness which lack of limitation might produce by an integration quite different from the axial effect of the palmette, but equally productive of unity and beauty, namely, by rhythm, wherewith the

Types of Ornament and Composition as Illustrated by the Palmette, Spiral, and Allover Pattern

accents are spaced as in music at measured intervals. We react to the design with the same conviction of artistic propriety with which we hear the beat of a drum.

Our Celtic spiral achieves its own effect with equal success by a third means quite distinct from the other two. It has no axis and lacks the built-up symmetry of the palmette. It is more like the allover design in its freedom from any limit to extension, and shares with it the suggestion of indefinite continuity. But whereas the allover ornament has no more beginning than end, the spiral has specific origin in its center, so that its expansion has a positive direction which an allover pattern, repeating itself on all four quarters, has not. The factor of infinitude imposes rhythm on both designs, but the unity and beauty of the spiral stems less from this than from the illusion it induces of vitality, of a living organism. Such design, with a point instead of a line for center, is not "axial," nor "rhythmic" in the sense in which the word is more truly used of allover ornament, since its rhythm ends, as well as begins, at its core. Its governing principle and its beauty rest in its aliveness, and the only word that fits it is "dynamic."

❖ ❖ ❖ ❖ ❖

Composition in art is clearly the effort to achieve unity, to reduce the nature or experience that is to be reproduced or interpreted to consistent order. The unconscious preference which our "Morellian" motifs of ornament have in each case revealed is thus the choice of mode in which such consistency could be conceived and reduced to its simplest terms, by Greek, Oriental, and "barbarian" according to the peculiar attitude of each. But to achieve consistency is the most fundamental of human aspirations. To understand the purpose and meaning of life, to reconcile its contradictions, to realize existence in a pattern through which the mind or instinct can recognize the integrating thread of some harmonizing principle is the goal of all speculation and faith. The imaginative reaching of this goal by the intuition of art in composition is but a swifter version of the more profound procedure of philosophy and religion; the objective is the same. The three modes we have illustrated are therefore competent indices not only of the compositional preferences that accompany the antique, oriental, and "barbarian" attitudes but of the attitudes themselves.

The self-sufficient unity of the palmette, and the axial organization it displays, are basic in Hellenic art and eloquent of the Hellenic ideal of clarity. If one compares Greek civilization with the cultures that preceded it in the eastern basin of the Mediterranean, the difference that emerges is the *understanding* that was added by the Greek to observation. In Egyptian and

[9]

Assyrian art, for all the careful recording of individual natural forms that they exhibit—as for example in the fine rendering of animals which Assyrian reliefs can show—one seeks in vain an organization of the facts and details of nature into consistency. The Assyrian sculptor gave five legs to the human-headed bulls that guarded his doorways, since he saw the hybrid animal in front and again from the side, recording both impressions. The human-headed bull itself is inconsistent, as an association of two disparate facts. The Egyptian "conventions"—the torso frontal with face and legs in profile, the limbs so separately described that a figure may have two right or two left hands—are part of this pre-Hellenic primitivism, brought to high finish and sophistication but lacking the power to relate things seen to one another in simultaneous unity. "Relation" is, in fact, a word comprising all the Greek achievements and innovations in philosophy, science, and mathematics, as well as art: all are functions of the Hellenic power to organize fact into universal and typical truth.

The palmette is a form taken from nature, but revised into a concept, shorn of natural eccentricity, and reduced to type. This treatment of nature was instinctive in the Greek, who brought his world under control by transforming its varied phenomena into ideas. Nature was thus subordinated to intelligence and lost thereby the fearful mystery which haunted the oriental mind. Translated thus into human terms, landscape in Greek art becomes personification; instead of unlimited variety and unlimited space, we have dryads and oreads, fountain nymphs and river gods.

The world thus revised and clarified was complete and self-contained, undisturbed by infinitude, like the composition of the palmette. It was bounded by the bourn of experience, excluding what could not be understood. The gods, for purposes of mythology, could transcend these limitations, but the immortality of Greek gods was not so much the preoccupation of Greek belief as their humanity. They were subject to human frailty—one remembers the peccadilloes of Zeus and the howling Ares of the Iliad running wounded from the fray at Troy—and the Greeks were the first to render them by preference in human form, discarding the hybrids of Egypt and Asia. A Victory (*Fig. 2*) on the balustrade of the Nike temple on the Acropolis could stoop, like any woman, to tie her sandal.

Time and space, to us the synonyms of infinity, were barred by true classic style, sometimes by means of subtle niceties of composition, more often by obvious arrangement. In classic relief the terminal figures ordinarily turn inward toward the center, avoiding suggestion of continuity to right and left; extension in depth is likewise canceled by a neutral background. The attitude which most distinguishes the Greek point of view from those we have yet to consider is

[10]

just this classic insistence on the finite. Parmenides's principle, *to me on anoe-ton*,[1] "what is not, is unthinkable," might be said in Greek concepts to be inverted into "what is unthinkable, is not," reducing the cosmos to the bounds of intelligence, and surrounding the noble idealism of Greek art with a barrier of materialism. "For evil is a form of the unlimited," said Aristotle, "and good of the limited." [2]

The rhythmic composition of allover patterns reflects an opposite ideal. Harmony and order here depend upon the very element that was taboo to Greek materialism—the factor of infinitude. The attitude toward the infinite is, moreover, not positive but one of negative acceptance and contemplation—the common denominator of oriental final concepts, well summarized in the Hebrew "fear" of God, and the very name of the Mohammedan religion, Islam, "submission." The indefinite extension of this kind of ornament is counterpart to the strong impression of enduring time which is imparted by the monuments of ancient Egypt, and the rhythm of alternating accents is parallel to the chiaroscuro of warring good and evil that is the unending theme of the Mazdean religion of Persia.

The very inability of Near Eastern peoples to achieve an organization of the facts of experience left them with no explanation of their world except a transcendental one. Too near to nature, they could not see it, like the Greeks, in intelligent perspective, and were forced to imagine their ultimate realities not in finite but in spiritual terms. The gods of Egypt, Mesopotamia, and Persia were never reduced to the familiar human level of the Olympians, and where the oriental concept of deity assumed its purest form, in races more closely connected by circumstance or time with mediaeval culture, it became an accentuated and highly abstract monotheism. The Hebrew Jehovah was so far removed from material reality as to be an ineffable name; no one could represent in human form the Arab Allah; and the taunt most often flung at Christianity by Moslem critics was that Christ was *born*. The Hebraic prohibition of idolatry and the similar veto of the Koran were only a religious crystallization of a racial attitude that could not tolerate the materializing of its ideals.

As the civilization of the later Roman empire drew to its close, and age-old eastern prejudice began to crack the Greco-Roman veneer of Mediterranean culture, the rhythmic composition connoting infinitude slowly overcame the idealized naturalism of Greek art. If one compares a capital of the second century with one of the sixth, the process is plain. In the one, despite symmetry

1 Οὔτε γὰρ ἂν γνοίης τό γε μὴ ἐόν (H. Diels, *Die Fragmente der Vorsokratiker I*, Berlin 1903, p. 120).

2 *Nicomachean Ethics*, ed. H. Rackham (Loeb Classical Library 73), II, vi, 14: τὸ γὰρ κακὸν τοῦ ἀπείρου . . . τὸ ἀγαθὸν τοῦ πεπαρασμένου.

and convention, the acanthus leaves have foliate form and outline, with modeled surfaces and visible veins, spreading outward and bending their tips in convincing imitation of nature. But when the oriental influence has done its work the natural effect is gone: in its place is a flat pattern in whose abstraction the leaf is but a reminiscence, and a decorative effect achieved not by a revision of nature but by a lacelike rhythmic alternation of light and shade. This was the sea change, qualified by later revivals of Hellenistic taste, that was to transform the antique tradition in the east of our mediaeval area into its final expression of Christianity, the Byzantine style.

Christianity was, of course, the leaven that wrought this orientalizing of the antique. Its content was one with the transcendentalism of the East, and the progress of irreality in Christian art is easily followed by the gradual transformation in this direction of Christian iconography—the mode of rendering the subjects of the new faith. While Hellenistic flavor still possessed the nascent Christian art, the Ascension of Christ was depicted as a material event, the Saviour being lifted up to Heaven by the Hand of God. This appears in our first example of the Ascension, an ivory relief of the fifth century in Munich, representative of a school of Latin art which had not yet succumbed to the negation of physical reality that was spreading westward from the oriental focus of the faith. In the latter region, when its picture of the Ascension reached a final form, Christ was shown rising supernaturally in a glory supported by angels.

The transcendental is never completely apprehended by the reason; when the infinite or sublime is realized by the mind, it has become a formula in mathematics or a dogma. In language such concepts inevitably emerge in metaphor, being incapable of direct and literal expression. The actual experience of the supernatural is emotional; the content thereof is translated into feeling rather than thought, and to be embodied in art must find an emotional mode. The vehicles in art proper to emotion are color and movement, and both were used by the oriental factor of mediaeval art as it wrought the change in antique style. The color scheme of Hellenistic painting, as we see it on the walls of Pompeii, was extrovert and lively, delighting in strong contrasts, and even sometimes garish in its tones; as the emotion generated by Christian transcendental content deepens, the tones also deepen, until in Byzantine art the observer is conscious of an appropriate color accompaniment to the sacred theme, a sonorous and thoughtful harmony of blue, green, purple, and gold, with lesser lighter notes of violet and white.

The outlet of movement for the emotional expression required by transcendental content is provided in rhythmic composition, and can be experienced even in so humble an example of this as an allover design. The movement here

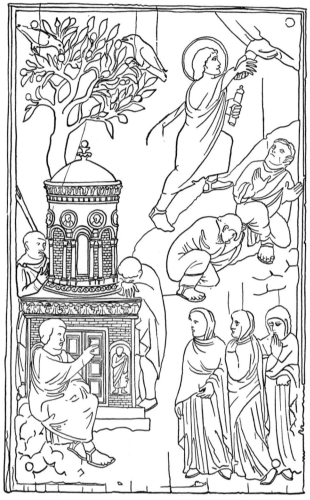

MUNICH, IVORY RELIEF OF FIFTH CENTURY: *Ascension; The Holy Women at the Sepulcher*

is in the eye of the observer as it travels over the pattern, and from the pattern's deliberate rhythm a quieting and negative effect results. The movement of the spiral is on the other hand a direct communication and empathic, arising from the illusion of organic life. This is the type of dynamic composition, resulting in positive stimulation, and given definite direction as the design unrolls from its focal point.

Herein we meet the "barbarian" element in mediaeval art. Its germination was long: we first meet dynamic composition in clear development in the Celtic art of Ireland and England, where it is as yet confined to abstract design. It attacks the antique tradition in Christian art on the Continent in the ninth century, in the Carolingian school of Reims. It is there applied to figured scenes and issues in a burst of barbaric exuberance, twisting human forms into impossible postures, within landscapes that heave and roll as if in the throes of an earthquake, in episodes of scattered arrangement innocent of any principle of composition save reality. The feeling pervading these pen drawings of Reims is in polar contrast to the deep contemplative quietism of Byzantine art, though the mystic Christian content is the same. It is an outpouring of undisciplined emotion, stirred by the religious theme whose depth it has not sounded, and depicting the Christian stories as illustrations of a native ideal of effective force. The same attitude finds later monumental expression in the tortured writhings of

the figures carved on the Romanesque portals in the south of France, or in the brutal masks and massive forms of Romanesque sculpture in Italy.

As Romanesque passes into Gothic, the deeper implications of the Christian content revise and refine the style. The transcendental concept dimly grasped by the Romanesque gradually finds issue in the vertical axis of the Gothic cathedral, in its shadowy interior, its mystical lighting by the colored windows, its towering spires and pointed arches, dissolving the mass of the building into space. In this infinitude, the realism of western style finds its complement. One cannot conceive the specific, or imagine any object or action at a given place or moment, without imagining as well the boundless extension of space and time this point connotes. These infinities, synonyms of the divine, might be contemplated by the Byzantine world with reverent detachment, and result in a sense of harmony expressed by measured rhythm. But the Gothic faith was ecstatic, striving not to contemplate but to compass the divine, grasping the concrete, and realizing in immediate experience the implication of an endless sequence, linking finite with infinite and man with God.

Throughout High Gothic art of the thirteenth century one sees the opposition of its two factors: a native realism acutely conscious of the charm of things in particular, and an insistent faith in their ultimate significance within the comprehensive Christian scheme. The tension between the specific and the universal, which exercised without end the dialectic of Gothic philosophy, was also what gave poignancy to Gothic style. Simple things were viewed by Gothic eyes *sub specie aeternitatis*. Out of the infinite variety of familiar existence, the Gothic in its ideal period elicited an ultimate harmony, an orchestration, so to speak, of the cosmic theme. The two most perfect expressions of High Gothic were attained in architecture and in scholastic philosophy, both intricate and bewildering when examined in detail, both exhibiting as ensembles a marvelously logical articulation. A French cathedral of the thirteenth century, pursuing with its thousands of statues and reliefs a concrete illustration of scholastic synthesis, embodying in architectural terms the ultimate generalizations of scholastic faith, was the *Summa* of Thomas Aquinas in stone. The all-embracing completeness of this Gothic *Welt-*

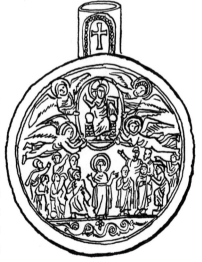

PILGRIM'S OIL FLASK FROM PALESTINE: *Ascension*

anschauung is astonishing. This was the age of encyclopedias, when men could write books like Vincent of Beauvais's *Speculum Maius,* comprising all of human knowledge, since all riddles of existence, all problems of natural and moral philosophy, were felt to be finally solved. A sense of possible perfection informs for its brief duration the whole of the High Gothic scene, enlivening its world with optimism; the Romanesque ideal of patriarchal age is replaced by the same apotheosis of youth that gave virility to classic art.

It was the insistent Gothic quest of the concrete that led it into the most surprising phenomenon of mediaeval art—the shift to natural ornament. In this minor aspect of style we find again the index to its inner inspiration. The imitation of nature in ornament was no more to be expected in the earlier phases of the Middle Ages than its imitation elsewhere, in view of the negative attitude of Christianity toward nature. The frank enjoyment of the physical world and the idealization of natural beauty were a part of paganism, frowned upon by ecclesiastical teaching. Christian art as well was gradually diverted from the classic habit of observation of nature toward the repetition of natural forms by rote and formula, employing them as symbols for the expression of transcendental truth. So also, the vocabulary of antique ornament grew poor in the mediaeval centuries, the ancient motifs losing what relation they once had to nature, and becoming more and more abstract until they degenerated into geometric and linear patterns. The Romanesque revived the Roman forms, but Gothic forsook them, inserting in their stead the flora observed by the artist round about him in his native environment. Thus in Gothic manuscripts begins the border of natural leafage, and in Gothic sculpture the leaf capitals and friezes, crisp and curling in the early period as if in their first vernal appearance, opening broadly as the style matures, and even suggesting in the final stage of Gothic the sere and brittle foliage of autumn. No phenomenon of mediaeval art is more revealing of stylistic instinct than this remarkable shift in ornament at the end of the twelfth century, from a conventional vocabulary to the fresh vernacular of nature.

Gothic naturalism flowered in the final phase of western Christian art, the realistic movement which, as it lost its Christian inspiration, led on inevitably to the apotheosis of the individual in the Renaissance. Even in this end of mediaeval art, its beginning can be seen; for the religious realism of Gothic is but an eventual function of that revolution of thought which was accomplished by the fourth century in the Christianizing of the ancient world. Christianity introduced the expression of transcendental ideas, and these in turn demanded emotional expression in art as well as intellectual embodiment in dogma. Such expression transformed the style inherited from antiquity into Byzantine

[16]

rhythm and color in the East, into Romanesque energy and Gothic realism in the West. But all these styles and mediaeval art *in toto* derive their character in the last analysis from the factor of infinitude which came with Christianity into the ancient world, and opened spiritual vistas through the crumbling walls of Greek materialism.

This brief introduction will suffice to sketch the broad outlines of a survey of mediaeval art, and may have at least suggested the contribution which it added to the antique inheritance, and passed on to modern times. It was a contribution of profound importance, since through it our own culture was greatly enriched and direction given to our modern art. The contribution was threefold, consisting of three values that were obscure enough in the consciousness of antiquity to find no habitual expression in the classic, but so vital to the mediaeval evolution that each is characteristic of a separate phase of mediaeval art. These values were the recognition of transcendental concepts, the acceptance of emotion as a valid element in content, and the establishment of the realistic point of view. They are named in the sequence in which they became determinant of the periods of mediaeval art, for the early Christian period is the time when transcendental concepts struggled to find expression through a materialistic Greco-Roman style; the Romanesque in the West, and Byzantine in the East, are products of the emotional reworking of the Christian theme; while Gothic gave this emotion the concrete focus that caused it to outlive its Christian inspiration, to become the vital element in the humanism of the Renaissance, and to emerge eventually in modern guise as the romantic movement of the eighteenth and the nineteenth centuries.

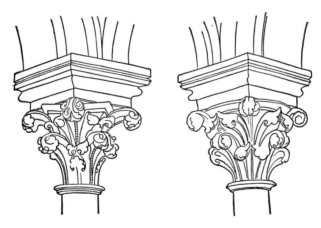

GOTHIC CAPITALS

II

Early Christian Art

THE TRANSCENDENTAL FACTOR

THE DISSOLUTION OF CLASSIC STYLE

VERY GROWTH PROCEEDS from a decay, and early Christian art arose from the rich soil left by the dissolution of classic style, whose transformation into the Hellenistic, and the division of this into the styles of late antiquity, must be the first concern of this chapter. The point of view which informed the classic has been sketched in the Introduction; it reached its full expression in the fifth century B. C. in Attica, and notably in the work of two Attic sculptors, Phidias and Polyclitus.

In the art of both is manifest the classic equilibrium; their figures embody the Attic ideal of the superman, untroubled by a world with which he feels no lack of harmony. Polyclitus's men and women, descended artistically from the Argive school and its quest of physical perfection, are more mundane than those of Phidias; the head follows the motion of the body, thereby diminishing the figure's mentality. He used by preference a walking pose, even in his standing figures; the easy movement thus given to his famous *Spear Bearer* enhances its sovereign serenity, untouched by the wear and tear of circumstance.

Phidias is much more Attic; the nobility of his statues depends not on physical beauty alone, but also on the subtle quality of intellectual perfection. The head of his *Athena,* bowed in thought, is possibly the most perfect presentation

[21]

of the competent and confident Attic mind. The "Theseus" of the Parthenon, so called, more probably personifies Mount Olympus (*Fig. 1*), over whom play the rays of the rising sun, heralding the birth of Athena which was represented in the center of the pediment. This is the first of those reclining mountain gods which will continue in Mediterranean art for over a thousand years, maintaining always the same unweary posture, and the same divine indifference to physical surroundings.

What the two sculptors have in common is common as well to all classic art: the ideal distinction imparted to humanity. The most obvious element in this is the sheer beauty of the classic figures themselves; the less apparent but perhaps more powerful factor in the effect is the elimination of specific time, place, or circumstance which might condition personality, the absence in short of any sense of environment.

This element is added to the second phase of classic style, in the fourth century B. C. Here too we meet two sculptors who fully represent the spirit of fourth-century art, Praxiteles and Scopas, and in the works of both we note reaction to surroundings. Praxiteles, like Phidias, has more Attic subtlety than Scopas; his figures manifest a negative attitude, a recoil so to speak, that gives an effect of brown study. His *Hermes*, resting on his journey to the Nymphs to whom he is carrying the infant Dionysus, looks not at the playful child upon his arm, but dreamily into the distance; the relaxation of reverie is skillfully expressed in parted lips, the softening of the profile of the lower eyelid, and more obviously in the hipshot pose which necessitates support for the elbow. In Scopas's statues the attitude is positive: the gaze is centered on an object; desire and passion knit the brows and tense the muscles. The dionysiac ecstasy possessing his *Bacchante* throws her head far back upon her shoulders and distorts her posture.

But these masters of the later age adhere with faithfulness to a norm of classic style—the third dimension is fully rendered in the modeling of the figure, but not in its movement. A single plane determines the meditative pose of Praxiteles's men and women, and limits even the vio-

PHIDIAS: *Athena*

lent action of those of Scopas. The figures react to surroundings that are not themselves expressed; they are not free in space. Freedom of movement came into Greek art along with the widening horizons introduced into Greek life by Alexander's conquests at the end of the fourth century, and the first sculptor who conceived the figure as moving in more than two dimensions was Alexander's own court sculptor and the modeler of his portrait, Lysippus.

The last of the classic sculptors, Lysippus is also the progenitor, so to speak, of the Hellenistic style expressive of the new international culture of the age which followed the conquests of his royal patron. His own style, despite his Sicyonian origin, pays full respect to Attic tradition; his Hellenistic tendencies are more developed and visible in the work of his school. In the contemporary copy of one of his bronzes that has come down to us, the *Agias*, the head has still the tousled hair, lifted chin, and shadowed eyes of Scopas, but in the torso is a slight twist that marks departure from the single plane. In the *Apoxyomenus* we have a Hellenistic replica of the original bronze which underlines effects, especially the torso's twist, that Lysippus himself seems only to have suggested: one cannot be content, as with preceding classic works, to view this figure from the front alone; the observer wants to walk around it. The freer movement demanded a lither body; the old canon of Polyclitus of a height seven times the length of the head was changed by Lysippus to a proportion of eight to one. Movement in space in turn imposed the suggestion of space itself, as in the great *Victory* of Samothrace (*Fig. 3*) that fittingly closes the classic style. She stands on a ship's prow, and the sea wind whips her drapery; striding magnificently, her body nevertheless retains the classic equilibrium by accentuating a Lysippean movement of the torso, generating thereby an upward spiral that holds the figure to its place.

The sense of environment which was absent from the fifth-century style of Phidias and Polyclitus, and realized in the awareness of surroundings which one senses in the statues of Praxiteles and Scopas, became in the school of Lysippus a major element in sculptural effect. Eutychides, Lysippus's pupil, when commissioned by Seleucus Nicator to make a personification of his new capital of Antioch in Syria, placed the figure on her own Mount Silpius, and introduced the swimming river god Orontes at her feet. This statue belongs in every way to the new Hellenistic era: the city it represents is one of the new foundations that sprang up in the wake of the Conquest. After Alexander's death in 323 B. C., and the two generations of personal wars between his generals and their successors which ensued, the Hellenistic Mediterranean world took form: in Egypt the Ptolemies established themselves at Alexandria in the Delta, controlling and exploiting the valley of the Nile; in eastern Asia Minor, Syria, and the

ancient Persian empire, the kingdom of the Seleucids, with capital at Antioch, commenced its long and losing fight to retain a too vast dominion; in the west of Asia Minor the realm of Pergamum was flourishing; Macedon imposed its sovereignty over Greece, which nevertheless retained a semblance of independence in the Achaean and Aetolian leagues, and in the respect paid by the Macedonian monarchs and all the other Hellenistic dynasts to Athens, as the focus and wellspring of Greek culture.

The world of the Greek no longer was bounded by the seacoast and mountains that limited the little classic city-states; his horizons had been vastly broadened by the internationalizing of the eastern Mediterranean. The oases of Greek culture established by the foundation of new Greek cities in oriental lands, such as Alexandria in Egypt and Antioch in Syria, not only spread a Hellenic veneer over the Orient, but served to orientalize the colonizing Greeks as well. The Hellenistic age was one of free exchange of ideas as well as commodities; international trade brought with it a cosmopolitan attitude. Greek became the common language of the East, but literature, lacking local roots, took on an academic character. The age was one of criticism and retrospection; its characteristic products were anthologies, editions, and lexicons. The oriental gods, more mysterious and possibly more potent than the familiar denizens of Olympus, impressed the Greek imagination. The Asiatic cults of Adonis and Attis, of the Magna Mater of Phrygia and the Sun-Baal of Syria, competed with the ancient mysteries of Dionysus and Demeter. Syncretisms were frequent, such as that combination of Zeus with the Egyptian Osiris who became as Serapis the most popular divinity of the Delta.

With the widening of Hellenic horizons came a change in moral attitude. The greater complexity of experience, the loss of political participation, the economic stresses consequent on international trade made more difficult the individual adjustment to environment. One can trace a shift of thought by the change of focus in Greek philosophy: after the classic concentration on metaphysics come the scientific activities of the Peripatetic school at the end of the fourth century, when the Conquest had opened up the East and multiplied the material of knowledge. With the third century a prevalence of Stoic and Epicurean thinking marks that significant concentration on ethics and the necessity of a moral code wherewith to make one's peace with the world, which was to dominate Hellenistic philosophy until supplanted by more transcendental solutions.

The trend leaves its imprint on Hellenistic style. The outstanding school of sculpture in the third and second centuries B. C. was that of Pergamum under the Attalid dynasty. Its products are scattered, in the form of later copies, through the museums of Europe, the best known being the replicas of works

THE TYCHE OF ANTIOCH

commissioned by Attalus I to celebrate his victory over the Gallic invaders of Asia Minor in the third century. The statues are familiar in copies preserved from Roman times: the fallen Gauls, Persians, Amazons, and giants by which the triumph was allegorically rendered in the monument Attalus set up in Athens, and the dying Gauls from that commemorating the victory at Pergamum itself. Significant is the survival of the victims alone; the Hellenistic taste of copyists preferred the suffering of the vanquished. The *Dying Gaul* of the Capitoline Museum at Rome is an excellent reflection of the age, not only in its idealized rendering of agony, but in the new interest in ethnology; the distinctive hair and mustache, and the torque around the neck, are recorded as racial peculiarities.

These sculptures, even through the Roman replicas, show a hard and leathery surface, and a loosely jointed figure; the Hellenistic eye saw something tougher in humanity than did the graceful Praxiteles. But most of all, they are witness to a new phenomenon in ancient art, the lifting of *pain* to the level of a major artistic motif. The same theme inspires the *Flaying of Marsyas,* loser of a presumptuous musical contest with Apollo, a group in which the satyr hangs upon a tree, and the slave who is to skin him sharpens his knife, with calculating gaze upon his victim. The same insistence on struggle and defeat, reflective of moral strain, animates the greatest Pergamene work of the second century, the frieze of the Altar of Zeus, now in Berlin, which represents the Battle of Gods and Giants. Here the sense of pain has become current enough to lend itself to decoration; the coiling serpent legs of the monsters, as they go down to annihilation under the onset of the Olympians above them, form a buoyant cushion that helps to lighten the otherwise heavy effect of the colonnade the frieze supports. Every figure in the frieze, despite a violence of effort, resolves its contortions none the less into a balanced and beautiful silhouette.

[25]

The summation of Pergamene art, and the final effort of Greek style to deal in classic terms with Hellenistic content, is displayed in the product of a Rhodian branch of the school of Pergamum, the *Laocoön* (*Fig. 4*). Despite the exaggerations wherewith the sculptor forces his painful content through the stone —the straining muscles of the torso, the mouth opened in a shriek, the contorted face and brow—the head is taken from a traditional type of Zeus, the body is a noble physique, the priest dies in agony, but like a god. The classic ideal of the superman is still with this artist, however much it is overborne by the stress and strain of Hellenistic feeling.

THE TWO HELLENISTIC STYLES

The *Laocoön* dates, according to prevalent opinion, about 100 B. C. In the century succeeding, there becomes apparent a dichotomy of Hellenistic style which is determinant of Mediterranean art from this time on to the end of antiquity. The first century B. C. witnessed the final integration of the Mediterranean world under Roman domination, and the extension of Hellenistic culture through the Latin West. It also saw the division of Hellenistic art into two trends: one of these, issuing from Athens and the older centers of Hellenic tradition, is an academic style, uncreative, reviving for their decorative beauty the forms and formulae of classic art; the other is a phenomenon native to the newer cities of Hellenistic date, such as Antioch in Syria and Alexandria in Egypt, and expressive therefore of the Hellenistic point of view, developing the implications of unlimited space and local setting, free movement, and dramatic episode which were initiated by the school of Lysippus. The evidence available on the origin and focus of this second trend indicates Alexandria as its most likely source and point of distribution.

The first of these two currents of Hellenistic style represents a termination of invention in Greek statuary; new themes thereafter were mostly confined to relief. Even in relief (*Fig. 6*) the art reverts to classic models, imitating the creations of its great past, adapting to new subjects the formulae of Phidias and Polyclitus, Praxiteles, Scopas, and Lysippus. The sculptors who worked in this mode almost always sign themselves as Athenians, and copy by preference well-known monuments of Athens, to such an extent that the whole school is quite properly known as the Neo-Attic. Their public comprised the wealthy amateurs of the age, particularly in Italy, and was very much the same sort of public that supports the art dealers of the present day—possessed of some taste, and at any rate the means of satisfying it, and having the same penchant for the earlier and quainter stages of style which animates our contemporary seekers after primitives. For such buyers, the Neo-Attic sculptors made copies of classic works, and

also invented pasticcios combining different styles, like the *Orestes and Electra* of the Museum at Naples, in which the youth imitates a typical athlete statue of the early fifth century, while the female figure, set on a mound so that her arm may encircle her brother, is copied from another statue of the end of the fifth, as shown by her transparent and clinging drapery. To complete this eclectic conglomeration, her figure is given a head which is even earlier in type, with its stylized hair and eyes, than that of the youth. A head of the same sort contrasts with a Praxitelean body in the *Venus* from the Esquiline in the Conservatori Museum at Rome.

The Neo-Attic quality of conservatism comes forth more clearly in reliefs and paintings, for here is present the problem of environment and setting, which these artists treat in strictly classic style. The relief of *Perseus rescuing Andromeda* from the sea monster is a case in point: Andromeda is a common Attic type of dancing girl; the Perseus repeats an equally familiar formula for Hermes. But especially noteworthy is the classic limitation of background; the landscape is reduced to a roughening of the field by way of indicating the rock

on which Andromeda was bound, while the figure of Perseus is relieved against a neutral wall. There is no illusion of free space, and no suggested extension to left and right; movement and posture are not only determined by a single plane, but are also turned inward, in harmony with the axial unity of classic style.

Neo-Attic painting, known to us mainly by the copies of classic pictures which adorned the walls of Pompeii and Herculaneum, shows the same conservatism. An excellent example is the *Sacrifice of Iphigeneia* from the House of the Tragic Poet, in which we find the same single plane of action and pose, and the

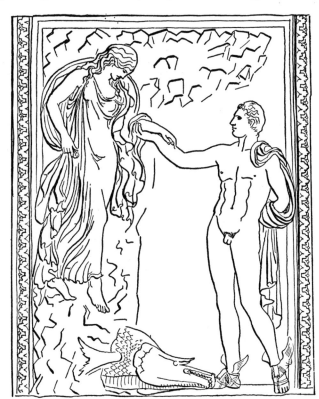

NEO-ATTIC RELIEF: *Perseus rescuing Andromeda*

same neutrality of background; the fresco seems to be a replica of a famous com-position by Timanthes of the early fourth century B. C. The frescoes of the bur-ied cities of Campania have been prolific of such imitations, some of them even reproducing the frames of the easel pictures from which they were copied.

But also from the walls of Pompeii and Herculaneum have come some of our best examples of the second Hellenistic style, which is known as the Alexan-drian. This is a natural product of the newer Hellenistic point of view in its em-phasis on setting and the realization of environment as the important element of experience. Hence its love of unlimited effects of space, and landscape—a land-scape, however, that rarely attempts the realistic, but seems rather the poetic imagining of oversophisticated city dwellers, and an idyllic avenue of escape. One of these vistas was romantically labeled by an ancient observer who left his impression in a scratched inscription: χθὼν ἐκπιπτόντων, "land of exiles." The pictures set mythological scenes in wild and sylvan surroundings, or within the walled precinct of a garden, or vary the genre scenes of country life with shrines, streams, and seacoasts lined with villas. The mode is occasionally found in relief as well as painting, though the latter is its natural medium; the tiny piece representing a peasant on his way to market with a cow, in the Glyptothek at Munich (*Fig. 5*), translates a painted landscape into sculpture, retaining the spatial background represented by a precinct with a pillar surmounted by some decorative object which here takes the form of a *baetylion*, or sacred meteoric stone. This feature of a pillar or stele set as a central focus to the composition is so constant in these Alexandrian landscapes as to be almost a signature of the style.

Another favorite genre of Alexandrian painting is the mountain landscape, peopled by the mountain gods who carry on, for the hundreds of years through which this style persists, the easy reclining pose of the "Theseus" of the Parthe-non. Most famous of these pictures is the series of landscapes preserved in the Vatican Library, depicting episodes from the Odyssey of Homer. "Series" is not a completely proper word, for while the episodes were separated by simulated pilasters on the walls of the room they once decorated (in a house on the Es-quiline at Rome, excavated in 1848), the landscape is continuous behind them, a mountainous panorama varied with seascapes, a view of the interior court of Circe's palace, and vistas of the underworld. The figures throughout are sub-ordinated to the landscape, and sketched with the impressionistic contrast of light and shade which was part of the Alexandrian style, and a natural result of the introduction of space and atmosphere into its pictures. Through all the episodes of Odysseus's adventures in the land of the Laestrygones, his meeting with Circe, and his descent into the nether world, runs the thread of Alexan-

drian allegory, personifying natural phenomena with fountain nymphs, nymphs that mark the promontories overlooking the sea, gods of the winds, and the ever present reclining mountain deities.

This style, domesticated in Italy in the first century B. C., gradually supplanted in Roman art the academic Neo-Attic manner. Its greater appeal to less sophisticated taste can be seen in the fact that scenes of contemporary life when portrayed in the frescoes of Pompeii adopt this free and spacious impressionism, painting rather than drawing the figures and objects, and scaling the human beings down to the dimensions of their surroundings. Such frescoes are the *Fight in the Amphitheater* between the Pompeians and their neighbors of Nocera, and the scene of *Evening Worship at the Temple of Isis*. The history of the style in Italian painting subsequent to the destruction of Pompeii and Herculaneum in 79 A. D. is difficult to follow by reason of the scarcity of examples, but one can pursue its evolution in the characteristic Latin category of Roman historical relief.

Almost contemporary with the eruption of Vesuvius that destroyed the cities of Campania is the Arch of Titus in Rome, erected to commemorate the

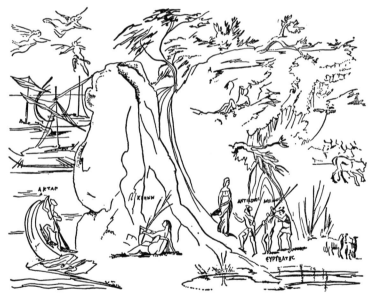

ODYSSEY LANDSCAPE: *The Messengers of Odysseus land on the Coast of the Laestrygones*

capture of Jerusalem that ended the revolt against Roman rule in Palestine. The reliefs of this arch (*Fig. 7*) translate the Alexandrian impressionism into monumental relief with a skill that excites the admiration of modern sculptors (the reliefs were imitated by our own Saint-Gaudens in the Shaw Monument in Boston). One panel shows the emperor Titus in his triumphal chariot, preceded by his lictors and followed by senators, accompanied as well by the inevitable Alexandrian personifications—the goddess Roma leading the horses, the Genius of the Roman People (a half nude youth) beside the chariot, and a Victory within it, crowning the triumphant emperor. In the other relief are porters carrying the trophies of the campaign, the sacred table of the shewbread from the Temple, and the seven-branched candlestick, symbol throughout the Hellenistic world of Jewish faith. The two reliefs are like two sudden views of the triumphal procession seen from a window as it passed; the arrangement of the figures is casual as in real life, and they range from forms almost in the round to a projection so low as to cast no shadow on the background, which thus assumes the illusion of open space and atmosphere.

But one detail betrays an element of decay in this Alexandrian illusionism, converted to Latin use. In the rendering of the emperor's quadriga, the sculptor has placed the chariot as if moving forward toward the spectator, at right angles to the general axis of the procession's movement, and then deployed the horses on the turn, apparently in order to make visible the forequarters of all four animals. This is a slight symptom, but one of importance, since it marks the entrance into Latin art of the tendency to describe and narrate the subject after the manner of writing, instead of the simultaneous representation of an event that is proper to classic art. A narrative mode is similarly used in the Odyssey landscapes, in the scene in Circe's palace, where she welcomes Odysseus at the portal and again appears in the center of the courtyard, kneeling before the hero when her magic potion fails. Narration and description are characteristic of primitive art, and in this detail of the reliefs of the Arch of Titus we may see a step backward toward that absorption in facts at the expense of their relation, from which ancient art was rescued by the classic unities of time and place.

A generation later, in Trajan's reign, a pair of curious reliefs was carved on the balustrades that flanked the speakers' platform in the Roman Forum, the *Rostra* of Roman antiquity. In these a local setting was employed, namely, the southwest side of the Forum, representing its buildings and the opening of the streets that gave upon it in a background continued from one relief to the other. The setting is thus a single one, but each relief represents a different event and time in Trajan's reign, one the enactment of a measure against race

suicide, in thankfulness for which a personification of Italy presents a child to the emperor, the other a remission of imperial taxes, with men burning the tax accounts in Trajan's presence. The mode employed is frankly narrative, preserving as a story might the unity of place, but ignoring any unity of time.

The monument that exhibits above all others the triumph of the literary method of continuous narration is Trajan's famous Column, focal point of his Forum in Rome. Here there is no compromise with classic unities: the story of the emperor's two campaigns in Dacia is told in terms so historical that the reliefs are often cited to piece out our scanty sources for this epoch in Roman annals. The sculptures wind spirally up the column, and the cartoons from which the sculptors worked must have been drawn on parchment rolls. There is no diminution of technique or finish in the almost invisible reliefs at the top; the intention was to *record* rather than to represent. The same literary rather than artistic motivation may be seen in the sketching in of local color as an historian might do, in the reliefs at the base, where we see the Danube, with barbarian huts along its banks, the native population, and the Roman outposts on the frontier—details that serve to introduce the main narrative. The figure of the emperor recurs (over twenty times) wherever the story needs it, as it might demand his name in a written account. Cities, camps, and other indications of locality become also mere symbols like words, and are consequently diminished out of scale with the figures. Spatial relation is sacrificed for clear description; where the army is represented, the rear ranks overtop the front, developing an artificial bird's-eye perspective.

The age of Hadrian and the Antonines, the most phil-Hellenic in Roman history, checked to some extent this Latin reversion to primitive technique. The Column of Marcus Aurelius imitates that of Trajan, but gives the figures larger scale, and more differentiation, reviving the Hellenic respect for any rendering of humanity. In the curious episode of the *Miracle of the Rain* (*Fig. 8*), where a providential cloudburst dispersed the enemy and saved the Roman troops, we have a singular mingling of Latin description and Hellenistic allegory—Jupiter Pluvius represents the storm, with his beard dissolving into the rain itself. But perspective is still of the bird's-eye variety, and the bodies of dead barbarians and ranks of Roman troops are items isolated one from another in the interest of descriptive clarity. The sarcophagi of the period can furnish some of the finest of Roman reliefs, notably the Orestes sarcophagus in the Lateran on which the tragic story of the hero is rendered in continuous fashion, with the hero thrice represented; but toward the end of the second century and in the early third arrives an instability of scale, the figures alternating between squatness and overlength. The mythological scenes that

[31]

formed the repertory of the sarcophagus sculptors become in the third century so much a matter of routine that the heads of the protagonists are replaced at times with portraits of the deceased. The casual composition introduced by Alexandrian impressionism becomes crowded, and the spatial background is rendered by an undercut shadow alone.

After the Hellenic revival of the second, the third century resumes the descriptive trend. In the reliefs of the sarcophagi comes the "ladder type" of composition, whereby the smaller and less important figures are placed in the foreground so as not to obscure the more essential ones that loom up behind them. By isolation and equating of the forms, composition tends to depart from the Hellenistic axial triangle and to become the rectangular scheme that is normal from this time forward. In the badly damaged reliefs of the Arch of Septimius Severus in the Roman Forum, set up in 203 A. D., the figures are turning toward frontality and emphasize their flattened lighted surfaces in contrast to the undercut shadows. The reliefs are in narrative style, evidently taken from a rotulus-cartoon like those which must have been used for the Column of Trajan, but cut into strips to accommodate them to the attic of the arch. In these reliefs and on the sarcophagi of the third century that follow them, the features of fourth-century Latin style are announced—the undercutting that retains the old illusionistic effect of space, the isolation of figures from each other, the reduction of scale as if the action were seen from a distance, and the flatness of the planes. In the better works a chiaroscuro of flat planes and broad shadows compensates to some extent for the unpleasant contrast of a descriptive isolation of the composition's parts that is possible only at near view, with a summary and conventional rendering of detail, possible only when seen from afar.

The integration of this Latin revision of Hellenistic style is accomplished in the fourth-century reliefs on the attic of the Arch of Constantine in Rome (*Fig. 9*), erected after his victory over Maxentius in 312 A. D. The technical poverty of the Roman ateliers at this time is evident in the pillaging of earlier monuments to decorate the arch: eight of its ten medallions were taken from some building of Hadrian, and eight of its reliefs from one of Marcus Aurelius. The six friezes contemporary with the arch itself represent triumphs of Constantine, his appearance before the people, the siege of Verona which opened the Maxentius campaign, and the battle at the Milvian Bridge that closed it. The figures are small and crude, mere mannequins repeating conventional types, with isolation carried so far as to separate from one another not only the figures but their parts. The besiegers of Verona stride with legs profiled in one direction, their heads impossibly turned in the opposite one. Depth is obtained

by an extra row of heads above those in the forward plane. Through narrative and description, both unity of form and of composition have been lost; the artist depicts what he knows rather than what he sees, and confuses the eye with spatial detail brought to the forward plane.

The evolution in Latin painting which paralleled the change in sculptural style during the first four centuries of our era is difficult to follow, as said before, for lack of examples that have escaped destruction. It can best be illustrated by the paintings of the Christian catacombs of Rome, which will be considered when we come to deal with the beginnings of Christian art. But the crystallization of descriptive style which we have seen in sculpture, in the reliefs of the Arch of Constantine, is well reflected in the miniatures of two of the earliest of our manuscripts of Vergil, both in the Vatican Library, and both dating in the fifth century. A miniature in the finer of the two (*Fig. 10*) illustrating one of the Georgics, represents the old gardener described by Vergil instructing his two servants in Vergil's presence. The landscape slopes upward in descriptive fashion to the cottage or barn in the background; the usual imperative of clarity isolates figure from figure, flower from flower, and tree from tree. From the other Vergil, the Codex Romanus, we may take an example in *Dido and Aeneas in the Storm* (*Fig. 11*). The elements of antique style are apparent here, becoming painfully visible as the style disintegrates. The costume of the two lovers, sheltered in their cave, is correct, with tunic, chlamys, and Aeneas's Phrygian cap, and the trees and rocky mount that compose a landscape are all present, one tree protecting a soldier attendant of the Trojan hero, while another follower uses his shield for an umbrella. But isolation has turned the background vertically upward, so that each object may be separately recorded with no overlapping. Not only is spatial relation gone, but also the relation of component parts of figures and objects. Nowhere in late antique art can better illustration be found of what is meant when such composition is described as "crystalline."

A similar fate overtook the Neo-Attic style during these centuries of Hellenistic decline. But the Neo-Attic, dedicated from the beginning to decorative rather than representational verity, was saved from eventual ugliness by this, and by one other distinction from the Alexandrian style. When descriptive isolation overtook the Neo-Attic, as it did every aspect of art in late antiquity, it was not encumbered with the details of spatial setting which, brought to the forward plane in the decadent illusionistic style, made composition so confused. The statuesque Neo-Attic figures, adhering to the self-sufficient classic types, arranged in two-dimensional extension against a neutral plane, could adapt themselves readily and decoratively to crystalline composition. The

process of this adaptation can be followed in sculpture by the series of Asiatic sarcophagi, and in painting by the recently discovered mosaics of Antioch.

The Asiatic sarcophagi, produced from the second century to the fourth in western Asia Minor, are characteristic products of the Neo-Attic wing of Hellenistic style, and exhibit in their earliest examples many affinities with Attic art, and specifically with Attic sarcophagi. But they introduced into the neutral background of Neo-Attic relief their own device for limiting space —an architectural façade which often took the form of a colonnade (*Fig. 12*) crowned with alternating arches and gables, borrowed from the decoration of the back stage wall of the theaters in Asia Minor. In the intercolumniations of this colonnade were placed the usual copies or adaptations of Attic sculpture, as for example in the case of the earliest and most beautiful item in the series, dating *c.* 170 A.D., a sarcophagus in the court of the town hall at Melfi in South Italy. Following a peculiarity of the stage façade, the entablature curves back in the central niche; as the series progresses this curve flattens out in conformity to the simplifying of planes which we have noted as a symptom of decline in Latin work. The entablature consists of an egg-and-dart molding above and a leaf-and-dart below; the evolution of this ornament is significant as one traces it through the series; the moldings first lose their traditional profiles (the parabola for the egg-and-dart; the S-curve for the leaf-and-dart), then the outline of their component parts. Later the profiles merge into a continuous outward flare, and finally in the latest member of the series, a fragment of the fourth century in Berlin, the profile becomes a symmetrical arc (*Fig. 17a*). Throughout the evolution figures grow at the expense of the architecture until any semblance of proportioned scale or spatial relation is lost, and their heads are relieved inconsequentially against the cornice. The capitals, at first cut in Asiatic fashion with serrated acanthus leaves, gradually lose their naturalism and become a field for the sculptor's drill, submerging the original naturalism of the Corinthian capital in a confused foliation. The effect of this progressive disintegration of Hellenic forms is not, however, the trend toward artistic confusion that repels the observer of late Latin art; these sculptors are relinquishing the Hellenistic form without regret, seeking instead, with their alternation of flat lighted surface and broad shadow, a rhythmic chiaroscuro that assumes a definite beauty as it frees itself from antique tradition and becomes more conscious of decorative purpose. The final example of the series is also its first with Christian subject; it is the fragment at Berlin mentioned above, discovered in Constantinople, and bearing the figures of Christ and two disciples. Here the disintegration of ornament into lacelike design has reached an ultimate, and the denaturalizing of the fig-

ures has reduced them to exaggerated stiffness. Nevertheless, the dignified tradition of Neo-Attic style is not betrayed by this trio, and the closest replica of the figure of Christ will be found in a classic portrait of Sophocles in the Lateran Museum. No monument of early Christian art so signally reveals its antique ancestry.

The mosaic pavements of Antioch [1] have a longer range than the Asiatic sarcophagi, dating from *c.* 100 A. D. to the sixth century. They show a consistent evolution, but one that spans the distance from opposite poles, for the earliest compositions are in Alexandrian style, the intermediate ones revert to Neo-Attic, while the last have absorbed to a remarkable extent an oriental rhythm of composition, and an un-Hellenic choice of subjects, that seem to stem from the art of Persia.

The earliest floor so far discovered at Antioch is the pavement of a dining room dating in the end of the first century of our era, whose most striking panel, now in the Louvre, represents the *Judgment of Paris.* The landscape in which the scene is set is the familiar mountain background of Alexandrian style, and contains the usual focal point of stele with its associated tree. Paris sits in the foreground, counseled by Hermes standing behind him, while the three competing goddesses face him at the right: Athena recognizable by her helmet, Hera seated according to her rank as consort of Zeus, Aphrodite standing at her left. A Psyche is seen on the mountain to the left, an Eros to the right. In the right foreground, quite out of scale, is the flock of Paris which he pastured for his father Priam on Mount Ida.

The Alexandrian mode, natural in the initial phase of the art of a new Hellenistic city, had a remarkably short existence at Antioch. A panel which decorated the vestibule of the dining room above mentioned was devoted to a symposium of Heracles and Dionysus, in which the wine god, easy victor, holds up his inverted cup to show the last drop drained, while the swaying Heracles lifts a cup to his lips with unsteady hands. This panel, like the *Judgment of Paris,* has an open spatial background; but a hundred years later the same scene was used in a floor of a villa on the slopes of Musa Dagh, above Seleucia (the port of Antioch), and change of taste has here inserted the limiting wall which belongs to that Asiatic version of Neo-Attic style which we have seen in the Asiatic sarcophagi. The wall is bisected by a pilaster at its center, from which curtains are draped on either side—a motif destined to long life in eastern early Christian art.

As we pass into the third century, the symptoms of the shift to Neo-Attic style become more evident. A pavement of a bath contains the subject immor-

[1] C. R. Morey, *The Mosaics of Antioch,* New York 1938, Longmans.

talized by the *Hermes* of Praxiteles, representing again the god carrying the infant Dionysus to the nymphs who are to rear him. The mosaic, now in the Worcester Art Museum, is later than a coin of the mid-third century found beneath it, and its style would indicate a dating near to the fourth. The baby god, as the important personage of the episode, has his head encircled with a nimbus. All Alexandrian depth of background has disappeared; against a neutral field the figure of Hermes strides to the right, with one leg completely frontal like the torso, the other quite impossibly in profile. The head is almost *en face,* and the eyes have already acquired what will later be a signature of eastern early Christian style—the wide-open, frontal stare.

A mingling of the two Hellenistic traditions may be found in the most magnificent of Antiochene pavements, a floor now in the Louvre, coming from a villa in Antioch's suburb Daphne and dated by coins in the time of Constantine. This mosaic surrounded an octagonal pool, with trapezoidal compartments spreading to the corners and sides, and a border made up of rectangular panels. At the corners are the winged figures of the Four Seasons, with Spring, Summer, and Autumn holding flowers and fruit, and Winter hooded and wrapped against the cold. The other trapezoids contain hunting scenes, in one of which Artemis has slain a boar and advances with a male companion (possibly Meleager) against a rearing lion. In the oblongs of the border are rural scenes, pairs of birds, and charming groups of putti dancing, feasting, and gathering flowers.

The hunting scenes are evidently adapted from earlier models in Alexandrian style; in the Artemis panel we see the telltale stele with its accompanying tree, and the grouping, postures, and movement belong to composition in three-dimensional space. But the copyist was evidently not native to the style he copied, betraying his Neo-Attic limitations and his period in lack of atmosphere, stiff movement, and the characteristic squat proportions of the age of Constantine. Contemporary taste is evident in the rectangular panels: the putti have the summary nudes and restricted movement of the late antique, the background has succumbed to Neo-Attic neutrality, with landscapes symbolically indicated by a building and a tree or two, and pairs of birds already moving into symmetrical balance. In the pastoral scenes of these panels are figures and settings that call to mind the miniatures of the first of the Vatican Vergils, and those of an early Christian manuscript to be considered later, the Genesis of Vienna.

With the fifth century the Hellenistic tradition in composition disappears. The geometric designs become reciprocal patterns of indefinite extension, often enclosing in the center of the floor a medallion with a female head personify-

ing, after the manner of late antiquity, some abstract concept. One such panel (at Worcester) is framed with a border of oleander sprays taken from the common flower of the Orontes valley, interspersed with waterfowl, the whole design reminding one of a border in an early Christian gospel book to be considered later, the Codex of Rossano. Another motif of this Gospel Book of Rossano is popular in the Antiochene pavements of the fifth century: the rows of falcons with ribbons banded about their necks. Through such experiments with rhythmic composition we pass to the favorite design of the century's end, which is the simple repetition of the oleander blossom, each floret forming the center of a scale made up of concentric semicircles of tesserae. In the center of one such floor, now installed in the Louvre, the phoenix stands on its mythical pyre, its head surrounded by a rayed nimbus. The border of this mosaic consists of recurrent pairs of rams' heads,

MOSAIC FROM ANTIOCH: *The Phoenix*

descriptively rendered with their horns in two-dimensional lateral extension. This peculiar motif is characteristic of seals made under the Sassanian dynasty, which reigned in neighboring Persia from the third century to the Arab conquest of the seventh.

The Persian influence thus indicated is confirmed by the resemblance of Sassanian textiles to another type of Antiochene pavements of the fifth century, in which the intersecting diagonals composing the pattern are constructed of rows of flowers. The lozenges of the pattern enclose birds and fish, with careful recording of species and complete indifference to the incongruity of their setting and juxtaposition. This Persian principle of the excellent rendering of animals without regard to natural setting is found again in the rinceaux borders of the fifth century, where birds and beasts succeed each other in the unnatural habitat of the convolutions of a vine. In one of these a fine detail (*Fig. 13*) is furnished by a pair of confronted peacocks, a popular motif with Antiochene artists, and one which we shall find again on the early Christian sarcophagi of

[37]

Ravenna in Italy, as evidence for the penetration thither of oriental style. The prominence given to animals in preference to human figures is another indication of intruding Persian taste, and well illustrated by the great hunting floor at Worcester, where the edges of the pavement are occupied by hunters, mounted and afoot, pursuing or spearing wild animals in utter disregard of rational composition, and the center filled with beasts and hounds, surrounding a single standing huntsman, quite oblivious of the activity on the borders. To complete the unnatural arrangement, the corners of the floor are filled each with a single tree, with yellow fruit descriptively relieved in the forward plane, against blue-green foliage much resembling that employed by the painters of miniatures in the Genesis of Vienna, mentioned above. This is the sort of decoration which was used sometimes in Christian churches of the fifth century, since it is criticized as such in a letter of St. Nilus of Sinai, and we have a description of similar decoration in the early cathedral of Ravenna.

The prosperity of Antioch terminated in the first half of the sixth century, with the terrible earthquake of 526 and the Persian raid that followed it. Nothing of artistic significance which postdates these two events has been discovered during the excavations conducted from 1932 to 1939. But from the second century to c. 500, the mosaics provide illustration of a consistent evolution in style that has filled a gap in our knowledge of late antique painting within this period. Commencing with Alexandrian composition in depth and picturesque landscape, the Antiochene ateliers gradually fell under the spell of the two-dimensional Neo-Attic manner which invaded the East from Asia Minor, and then exchanged its teachings, as the Greek element in Syrian culture waned, for the influence of Persian art and taste, revived and vigorous under Sassanian rule. As everywhere in the Mediterranean world of late antiquity, descriptive interest undermined naturalism, and Antiochene style finally relapsed into the same pre-Hellenic primitivism which we have noted in late Latin art, isolating objects and details from one another, and relapsing into frontality. But its Neo-Attic inheritance and the adoption of oriental rhythm of composition saved this art from the ugliness of Latin confusion; for the beauty and intellectual interest of Hellenistic naturalism that it could not retain, it substituted a new esthetic, finding satisfaction in decorative design, and allover patterns of composition which were better suited to a temperament that, by the end of Antioch's greatness, was far more oriental than Greek.

THE BEGINNING OF CHRISTIAN ART

The evolution of style so briefly sketched in the preceding pages reaches from the fifth century b. c. to the fifth a. d., from an ancient world divided into sep-

arate realms and city-states to an international polity united under the *pax Romana*. The ten centuries thus traversed witnessed the dissolution of classic style, and of the classic self-sufficiency which it expressed; the rise of the troubled morale of the Hellenistic period, conscious of the claims of circumstance and ultimately at odds with the world, revealing its new attitude first in the admission of setting and surroundings into its artistic renderings, and later expressing a friction with environment by a preference for the rendering of pain. Hellenic invention finally reached a minimum in the Neo-Attic style, foregoing creation and reverting to imitation of classic models. A parallel attempt was meanwhile made by Alexandrian art to meet the needs of Hellenistic culture with a sort of pseudorealism, placing the figure in unlimited, albeit idyllic space, specifying its surroundings, and freeing it for lively and dramatic action. To this point style had come at the opening of our era. What ensued was the remarkable transformation described in the preceding pages. Both Neo-Attic and Alexandrian styles gradually forswore their inherited naturalism and returned to a primitive disintegration of composition, isolating objects and figures, and even the parts thereof, for a descriptive recording that reveals a secondhand approach to nature. The noble beauty of the human form which the Neo-Attic sought to preserve in its classic imitations, and the verity and picturesqueness of the Alexandrian style, were both disintegrating by the end of the fourth century. The immediate vision of nature had begun to succumb to decorative pattern in the Greek East, and in the Latin West was relapsing into confused and unrelated detail. Only in Alexandria, as we shall later see, was a vigorous Hellenistic naturalism retained. A screen had arisen between the artist and the physical world, which he reproduces no longer *con amore,* but by rote and formula.

To ascribe this denaturalizing of style to mere loss of skill is quite to misunderstand the culture of late antiquity. The later phases of Hellenism may have been academic and uncreative, but were certainly not without sophistication and techniques. The cause is rather to be sought in a shift in point of view, from a materialism which took a positive joy in nature to one that could find no peace in physical experience and sought beatitude in a world to be, or escape by withdrawal from the world that is. Every close observer of the late antique is familiar with the settled seriousness and even melancholy that pervades the rendering of humanity in this epoch. The ideal is no longer man in positive aspects, as warrior or civic dignitary; on the tombs of late antiquity the deceased is pictured by preference with a book or scroll, in the meditative guise of philosopher or scholar. The quest of mind was *gnosis,* the knowledge of ultimate reality, of which the physical world could only be a symbolic

expression and had, therefore, no intrinsic value in art. In short, the transcendental attitude had entered into Mediterranean life and thought.

The sense of pain, the realization of a new poignancy in experience, which issued in the motifs of suffering favored by the school of Pergamum, had by the end of the pre-Christian era become the sense of sin, as men began to feel within themselves the cause of maladjustment to their world. The outward symptom of this change is the rapid rise and spread of the mystery religions in the first centuries A. D. To the ancient rites of Demeter at Eleusis, and the Dionysiac and Orphic cults already practiced in antiquity, were added the mystic rituals of Asia and Africa, of Adonis and Attis, of the Magna Mater of Phrygia, of Sabazius, of the Dea Caelestis of Carthage, and the Hellenistic form of Isis worship, popular cult of Pompeii at the time of its destruction. Last of all, late enough to be a serious contender with Christianity for religious dominance in the Roman world, arose and spread the cult of Mithras, a popularization of the Mazdean faith of Persia, wherein Mithras plays a role analogous to that of Christ as savior of the world. The routines of these mysteries might vary, but their dual objective was always the same: purification from sin, and immortality by identification with the god. Many of them had sacramental meals and some of them baptisms, like the *taurobolium* of the Mithraic cult, in which the initiate was drenched with the blood of a bull. Not infrequent also was the concept of the god that died and by his death insured salvation. In the soil thus prepared and fertilized by the transcendental trend of pagan mysteries was planted the seed of the greater mystery of Christianity, elevating the pagan sacramental feast to the cosmic significance of the Eucharist, and purifying the ritual bath with moral catharsis, a remission of sin by repentance and the grace of God.

Offshoot of Judaism, Christianity spread at first through the Jewish colonies of the Empire. It was in fact an urban religion for the most part; "paganism" by derivation indicates the rural rather than the city people as more tenacious of ancient cults. The new faith appealed to the poor and distressed of metropolitan populations, more subject to the oppressions, social and economic, of the time. By the third century the religion was firmly established as far west as Gaul, and recent excavations at Dura-Europos,[2] on the banks of the Euphrates, have unearthed a Christian chapel dated in the same century at that outpost of the Empire in the East. The paintings of this chapel of the mid-third century, which has been reconstructed in the art museum of Yale University, are of the low artistic level common to all primitive Christian art, but interesting for their subjects: the Good Shepherd and his flock; the Healing of the

2 M. I. Rostovtzeff, *Dura-Europos and its Art,* Oxford 1938.

Paralytic; Christ saving Peter on the sea; David and Goliath; Adam and **Eve** beside the Tree, with the Serpent crawling on the ground; and two uncertain scenes that have been interpreted as the Saviour's conversation with the Samaritan Woman, and the Holy Women coming to the Sepulcher on Easter Morn.

Although it is doubtful if the great complex of Christian cemeteries at Rome known as the catacombs can offer paintings of earlier date than *c.* 200, the frescoes in these underground galleries are so numerous that they constitute our principal material of primitive Christian art, since in the East where the faith first expanded, Mohammedan iconoclasm has done its work so thoroughly that only by accident have Christian works of painting and sculpture survived, and these seldom antedate the fifth century.

The subterranean cemeteries of Rome, estimated to extend over five hundred miles in the total extent of their galleries, were excavated in the hills of soft tufa that line the roads leading out of the city. While their earliest portions show by plan a conformity to private burial plots, they became in the course of the third century so extensive and complex that they were taken over by the church as communal property and administered by the bishop. They are laid out in narrow galleries, occasionally illumined by light shafts, and hardly high enough to permit one to walk upright; from these passages open the rooms called *cubicula,* to which the burials were confined until numbers compelled the cutting of the *loci* or grave-niches in the walls, and even the floors, of the galleries themselves. The walls of the cubicula received the frescoes,[3] the earliest of which are those of the cemeteries of Domitilla and Priscilla, and the area of Lucina in the catacomb of Callixtus. To these some writers have assigned a date in the early second century, and even in some cases the end of the first. Recent opinion is inclined to date none of the frescoes earlier than the end of the second century and to place the bulk of the paintings in the third and fourth, with which dating their style is quite consistent. Little work was done in the cemeteries after the Gothic sack of Rome in 410, save by later popes who commissioned commemorative paintings at the graves of martyrs.

The subjects of the early frescoes (*Fig. 14*) are drawn for the most part from the Old Testament, as might be expected both from the dominant Jewish element in the earliest church, and the newness of the themes of the nascent faith, crystallizing with difficulty into visual concepts. Daniel standing between the lions first appears, closely followed by Noah in the ark, who is pictured standing with hands uplifted in prayer like Daniel, in an ark which is a mere box. Other types from the Old Testament are Abraham, stayed in the act of sacrificing

[3] The frescoes are reproduced in J. Wilpert's corpus, *Roma Sotterranea: le pitture delle catacombe romane,* Rome 1903, 267 plates.

[41]

Isaac, the three young Hebrews saved from the fiery furnace of Babylon, Moses striking the rock to make the miraculous spring for the host of thirsty Israelites, and Jonah's story. The last, an obvious symbol of resurrection, is the most popular theme in catacomb painting, and is usually portrayed in Latin narrative form: he is thrown overboard to the sea monster, spewed up by it, and rests under the gourd vine which the Lord caused to grow and wither as a sign to the prophet. The sea monster is not the "great fish" of King James's Version, but the *ketos* or monster of the Greek text of the Old Testament, and takes in consequence the Hellenistic form of a sea serpent.

In the earliest frescoes, themes of the New Testament are few: the Incarnation is recalled by the Annunciation, and inferred in scenes of the Adoration of the Magi, which vary the number of the Wise Men from two to four, since the Gospels speak of three gifts they brought—gold, frankincense, and myrrh—but not of three men. Slowly the miracles of Christ appear, of which the favorite is the Healing of the Paralytic. From this the figure of the Saviour is absent, and it is only in later painting that Christ is consistently represented, changing the water into wine at the marriage in Cana, multiplying the Loaves and Fishes, seated as Teacher amid his disciples. The Miracle of Loaves and Fishes, like that of the Paralytic, omits the miracle worker in its earlier form, wherein the multitude is always seven in number, seated on the ground around a semicircular bolster flanked by the baskets of superfluous loaves.

The omission of Christ's figure in such scenes gives the key to their interpretation. They are not conceived historically, but as symbols of salvation. The Paralytic, obeying Jesus's command to "take up thy bed and walk," and depicted as a single figure carrying a couch upon his back, was guarantee of Christ's power to save the person buried in the tomb the fresco decorated. The Miracle of Loaves and Fishes was an allegory of the Lord's Supper, the partaking of which was to primitive Christian belief an assurance of life eternal. "Elixir of immortality" was the phrase for the Eucharist used by St. Ignatius, famous martyr of Antioch in the second century. Deliverance is the theme of catacomb art—deliverance from sin, and from death. This explains the brevity of the representations, and their unhistorical character; Moses striking the rock is the only figure represented in the scene, and in one rendering of Abraham's Sacrifice the patriarch and his son desert the episode to face the spectator with hands raised in a prayer of thanksgiving for God's mercy on them both. The actual selection of subjects may with good reason be assigned to their mention in the early prayers of the church, such as those assigned to St. Cyprian of Antioch, or the ancient *Commendatio Animae* or prayer for the dying still in use by the church, in which God is implored to "free the soul as Thou didst free Noah

from the Flood, Isaac from the hand of his father Abraham, Daniel from the den of lions, the three youths from the furnace of burning fire," etc.

Summing up this simple symbolism of primitive Christian art is the attitude of prayer always given to the figures of the dead when portrayed upon the walls of the cubicula, and also to Old Testament figures such as Noah, Daniel, and the Three Hebrews in the furnace. The abstract idea of thanksgiving for the assurance of deliverance is personified in Hellenistic fashion by the *Orans,* a praying female who often alternates with the Good Shepherd in the decoration of the corner trapezoids of ceilings. The central compartment of the ceilings is commonly occupied also by the Good Shepherd, but occasionally by Orpheus, playing the harp among the beasts his music has charmed. This figure, sometimes employed as a metaphor for Christ in early Christian literature, shows the influence of the pagan mysteries on early Christianity, and also the inevitable use which the new faith had perforce to make of the Hellenistic vocabulary of paganism. The Good Shepherd himself is another instance of this, for the artists have had recourse for the illustration of their Christian text to a time-honored type of Hellenic art, the Hermes Criophorus of archaic Greek sculpture, bearing a ram upon his shoulders, or a similar Hellenistic rendering of the shepherd-hero Aristaeus. Noah's ark repeats a representation on the coins of Apamea in Phrygia, where the ark by one tradition was supposed to have grounded. The Multiplication of Loaves and Fishes depicts the banquet after the manner of a Greco-Roman funeral feast, and the pagan formula is used again in the curious "celestial banquets" of fourth-century frescoes, where the blest are seated at a table and served by personifications of Peace and Love.

The single article of food upon the table in these representations is the fish, which in primitive Christian symbolism stood for Christ. It doubtless received this meaning by the eucharistic association of the Miracle of Loaves and Fishes, whereby the food became synonymous with the Bread and Wine, and thereby with the Saviour himself. But the symbol crystallized under the influence of the acrostic-word ἰχθύς = "fish," formed from the initials of Christ's title in Greek, Ἰησοῦς Χριστὸς Θεοῦ Υἱὸς Σωτήρ, "Jesus Christ, of God the Son, Saviour," which became current in the third century. Such symbolic concealment of the Founder's personality corresponds to his tardy portraiture in Christian art.

In the catacombs he is first seen in later paintings as a short-haired beardless youth like Hermes, a type also used, as we shall see, in Egypt, and contrasting with the long-haired youthful type which represents Christ on the last of the Asiatic sarcophagi, the Berlin fragment discovered in Constantinople (*Fig. 17a*). This seems to have been the conception of the Saviour incorporated in the Neo-Attic style in Greece, Constantinople, and Asia Minor, and is used in a type of

Good Shepherd statuette that originated in these regions, possibly the same type as the bronze Shepherd between two sheep which decorated one of Constantine's fountains in Constantinople. An example of this Good Shepherd is the well-known statuette in the Lateran Museum at Rome. This beardless head with long shoulder locks was adapted either from the feminine aspect of Apollo as the god of music and the arts, and "leader of the Muses," or more probably from the current concept of the youthful Dionysus, familiar to the Roman world from the second century on as the embodiment of Hadrian's deified favorite, Antinoüs. What the original Christ type was in the more oriental East we have no means of knowing, since his figure in the Dura fresco is too blurred to be informative, but in later Syrian and Palestinian art we find the bearded head which became eventually the mediaeval norm. No authentic tradition exists of the Saviour's actual portrait; the earliest and most significant allusion is a phrase of the African writer Tertullian in the third century: *ne aspectu quidem honestus*, "not even respectable in appearance."

The frescoes of the catacombs, crude as most of them are, provide nevertheless our principal means of bridging the gap in Italian painting between the wall decorations of Pompeii and Herculaneum and the appearance of the Christian church mosaics in the fourth century. Finest of the frescoes, and one of the few in which can be detected the inspiration of more subtle theological thinking than the simple faith embodied in the deliverance types, is an early painting in the catacomb of Priscilla representing the seated Virgin with the Child upon her lap (our first Madonna) confronted by the figure of Isaiah who stands and points to a star above Mary's head, marking the fulfillment of his prophecy: "Behold, a virgin shall conceive, and bear a son, and shall call his name Immanuel." [4] The group of mother and infant is well executed in the impressionistic Alexandrian manner, with bold modeling and high lights and a natural rendering of the frightened Child who squirms toward his Mother at sight of the prophet. A century and a half later, another group of mother and son affords comparison; it is a fresco of the fourth century representing the deceased, on a tomb in the cemetery called the Ostrianum. Here the Alexandrian rendering of form by contrasting light and shade has been replaced by heavy lining of the contours; the brows are arched and the eyes opened in an ugly stare; the Hellenistic three-quarters pose has succumbed to complete frontality.

Such frescoes show the Christian art of Italy in the fourth century at its lowest level, since these paintings were executed by poor workmen in poor conditions for working, but they are nevertheless witness of a style quite consonant

4 Isaiah vii:14.

[44]

with what we have already learned of the fate of the Alexandrian manner in Latin hands as the Western Empire drew to its close. The catacomb paintings, however, reveal little of the momentous change that had come over the status of Christianity within the Empire. Constantine's recognition of the legality of the new religion, and the imperial favor it found with his successors, not only "brought Christian art above ground" but multiplied the building of churches, many of them imperial foundations, and introduced wealth and social distinction into the congregations. The Christian theme could now command in church decoration the best available skill and invention, and the most notable works of art of the fourth century, aside from the best mosaics of Antioch of this period and an interesting pavement of the imperial palace at Constantinople recently laid bare, are the mosaics decorating two churches at Rome, and this in spite of extensive destruction and restoration. One of these "churches," S. Costanza, was not originally a church at all, but the mausoleum of Constantine's daughter Constantia (or Constantina), and probably had no Christian character until converted into a baptistery in the fifth century. At this time its lateral apses were added, and decorated with mosaics which despite unhappy restorations still retain their old compositions of the Lord seated on a globe giving the Law to Moses, and Christ in similar guise presenting their missions to Peter and Paul. The ring vault of the original structure is covered with mosaics in compartments: vintage scenes and vine scrolls alternate with geometric patterns, and in two of the panels are busts which may be portraits of Constantia and her husband Gallus. The mosaics of the dome are destroyed and known only from drawings of the sixteenth century, which show that they employed the same motif of female figures rising from acanthus clumps which was used at Antioch in the "Seasons" mosaic of the time of Constantine; at the base of the dome was a river with putti fishing, and at its top, between the acanthus candelabra, were scenes of indeterminate subject.

The introduction of mosaic for wall and ceiling decoration is not only evidence of the luxurious taste of late antiquity; it is interesting evidence as well of the control of technique by style. As the screen of transcendentalism between the artist and nature grew more effective, and natural forms became in consequence a conventional vocabulary, simplification set in and drawing was stylized, so that effect in painting became less and less a function of line and modeling, and more and more dependent on massed flat color. So much is this the case at Antioch that from the end of the third century there is scarcely any differentiation in the size of tesserae to match the impressionism of easel painting, but all are standardized to a cube about a centimeter square. Nevertheless, in

the great mosaic which closes the history of fourth-century painting in Rome, this antinatural technique has left us an authentic example, though it be the last, of the spatial compositions traditional in Latin Alexandrian style.

This is the apsidal mosaic of the old church of S. Pudenziana (*Fig. 16*), which must indeed be judged for its composition rather than detail, for of the figures, Christ, Paul, and Peter are the only ones that are even approximately original, and parts of the background have been restored. But the general arrangement is not impaired, and preserves a theme seen in catacomb art, of Christ as Teacher, enthroned amid the apostolic college—a theme which was also known, as we shall see, to the Christian art of Alexandria. Above, in an atmospheric sky, are the four beasts of Ezekiel's vision: man, lion, calf, and eagle, which the early Christian writers identified as the four Evangelists, and St. Jerome further specified as representing Matthew by the man, Mark by the lion, Luke by the calf, and John by the eagle. Below them in a curve is deployed one of those arcades which in Roman times lined the principal street of cities in the East; the buildings behind it have been identified by some with those erected by Constantine and his successors in Jerusalem, and the jeweled cross that looms in front of it with the votive cross set up on Golgotha. At any rate the architectural perspective is at once a survival of the Alexandrian tradition of three-dimensional space, and symbolically a rendering of the Holy City as a type of the Heavenly Jerusalem. A curious piece of imagery which does not survive the early Christian period in mediaeval art is furnished by the two female personifications placing wreaths on the heads of Peter and Paul. They are the two Churches, the sources from which the primitive congregations were recruited, one the *Ecclesia ex circumcisione,* the Jewish element, crowning Peter as the recognized head and symbol thereof; the other the *Ecclesia ex gentibus,* the Church of the Gentiles, crowning Paul.

The Christian sarcophagi of Latin style begin to appear in the fourth century, as the membership of the church filled up with a higher social class, able to afford more circumstantial burial than the poor loci of the catacombs. They continue the catacomb tradition in one respect, however, inheriting from it the abbreviation of Biblical episodes which was imposed by the early symbolism. The earlier examples employ central and terminal figured panels, filling the intermediate space with an ornament of S-curves derived from the antique athlete's strigil with which he scraped the oil and sand from his body after exercise. But the common type from the fourth century into the early fifth is decorated with a frieze like the pagan coffins that preceded them (*Fig. 15*), and in a style which rarely rises above that of the sculptures of the Arch of Constantine. Instead of a single subject spread across the sarcophagus, the abbreviated

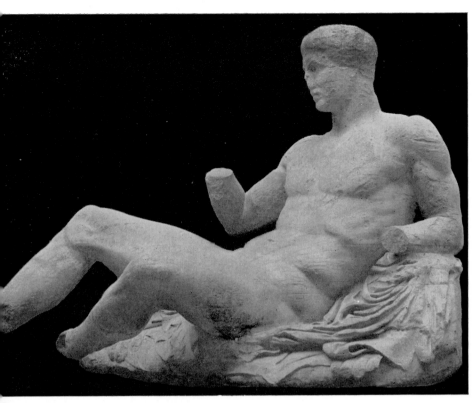

1. LONDON, BRITISH MUSEUM: "Thesus" from the Parthenon

2. ATHENS, ACROPOLIS MUSEUM: Victory fastening Sandal

3. PARIS, LOUVRE: Victory of Samothrace

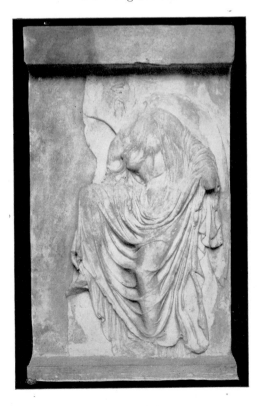

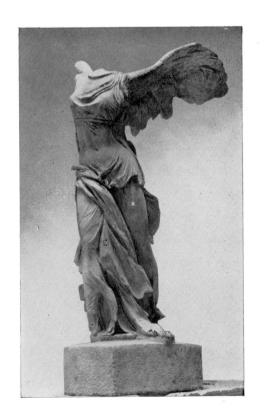

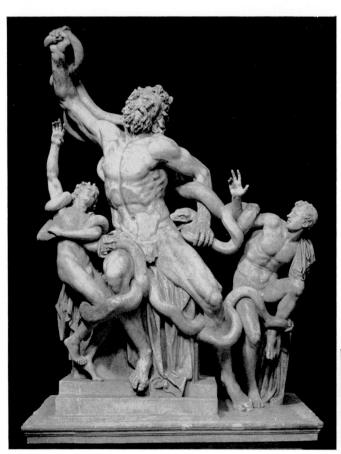

4. ROME, VATICAN: The Laocoön

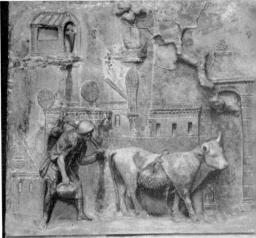

5. MUNICH, GLYPTOTHEK: Peasant going to Market

6. NAPLES, MUSEUM: Dionysus visiting the Poet

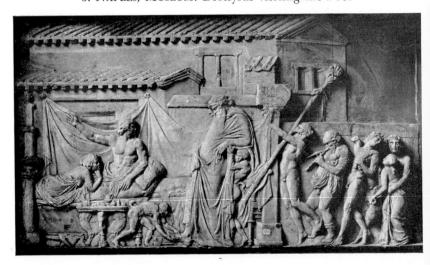

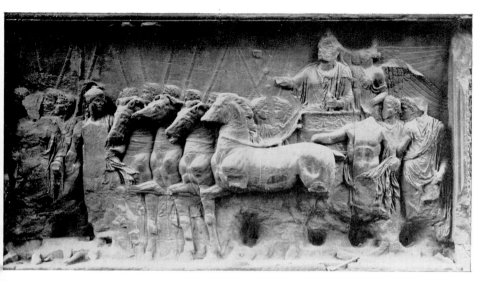

7. ROME, ARCH OF TITUS: Triumph of Titus

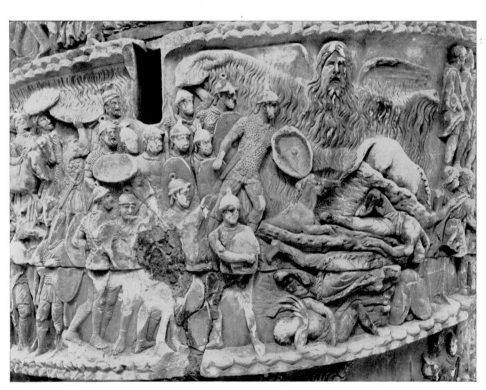

8. ROME, COLUMN OF MARCUS AURELIUS: The Miracle of the Rain

9. ROME, ARCH OF CONSTANTINE: The Emperor addresses the People

10. ROME, VATICAN LIBRARY:
Illustration of a Vergil Manu-
script; the Gardener instructs
his Workmen

11. ROME, VATICAN LIBRARY:
Illustration of a Vergil Manu-
script: Dido and Aeneas take
refuge from the Storm

12. CONSTANTINOPLE, MUSEUM: The Sarcophagus from Sidamara

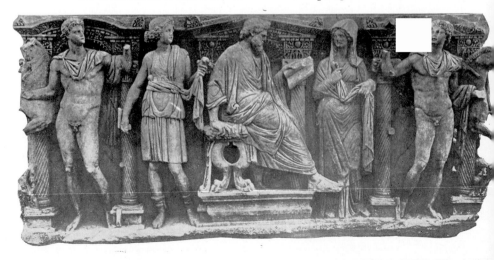

13. WORCESTER, MUSEUM: Border of Mosaic from Antioch

14. ROME: Details from Paintings in the Catacombs

15. ROME, LATERAN: Frieze sarcophagus; Creation and
Fall of Man; Miracles of Christ

16. ROME, S. PUDENZIANA: Mosaic in the Apse; Christ, the Apostles, the Symbols of the Evangelists

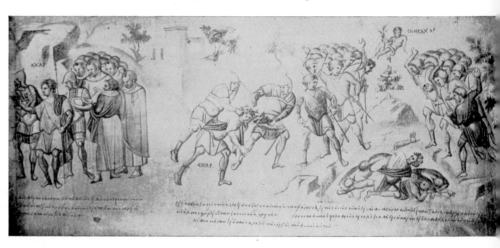

17. ROME, VATICAN LIBRARY: The Joshua Roll; Stoning of Achan

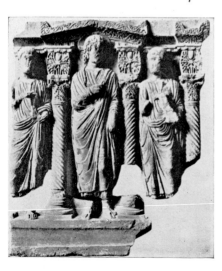

17a. BERLIN, KAISER FRIEDRICH MUSEUM: Fragment of Sarcophagus from Constantinople; Christ and Apostles

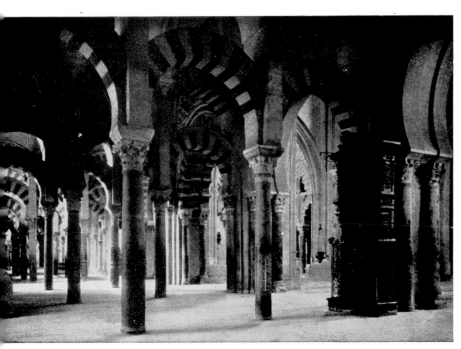

28. The Mosque of Cordova

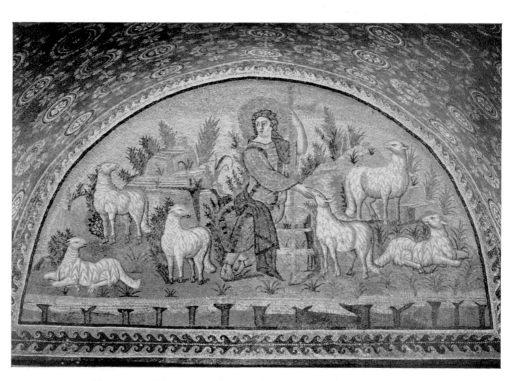

29. RAVENNA, TOMB OF GALLA PLACIDIA: The Good Shepherd

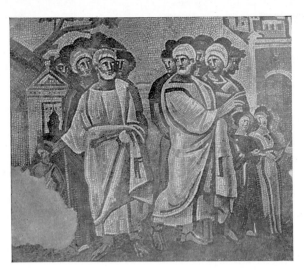

30. ROME, S. MARIA MAGGIORE:
Mosaic; the Parting of Lot and
Abraham

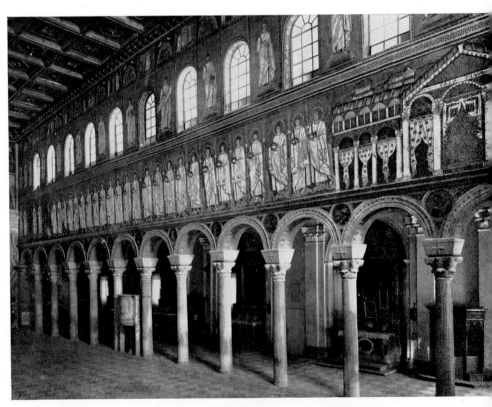

31. RAVENNA, S. APOLLINARE NUOVO. Interior, showing the Mosaics

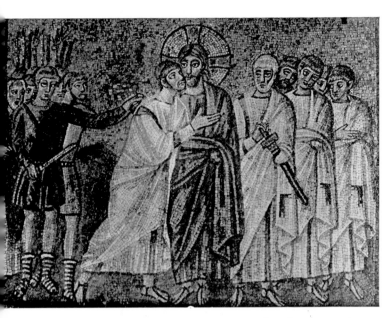

32. RAVENNA, S. APOLLINARE NUOVO: Mosaic; the Betrayal

33. RAVENNA, S. VITALE: Mosaic; Theodora's Offering

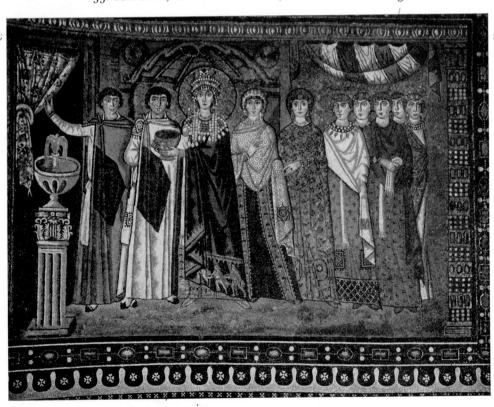

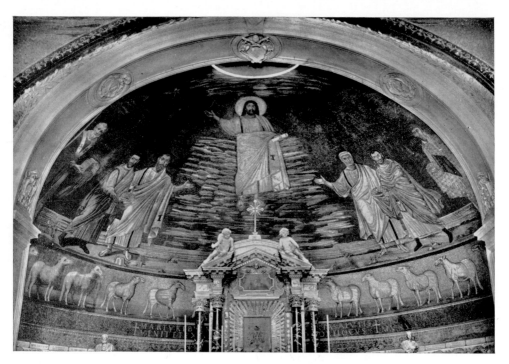

34. ROME, SS. COSMA E DAMIANO: Mosaic of the Apse; Christ and Saints

36. ROME, S. MARIA ANTIQUA: Fresco: The Crucifixion, with Mary, John, Longinus, and Stephaton

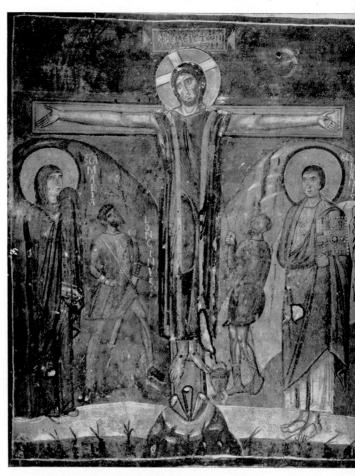

35. ROME, S. MARIA ANTIQUA: Fresco; Salomona, Mother of the Maccabean Martyrs

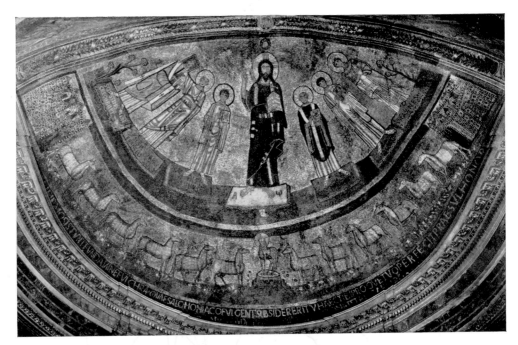

37. **Rome**, S. **Marco**: Mosaic in the Apse

38. **Rome**, **Vatican Library**: Menologium of Basil II; St. Ambrose of Milan

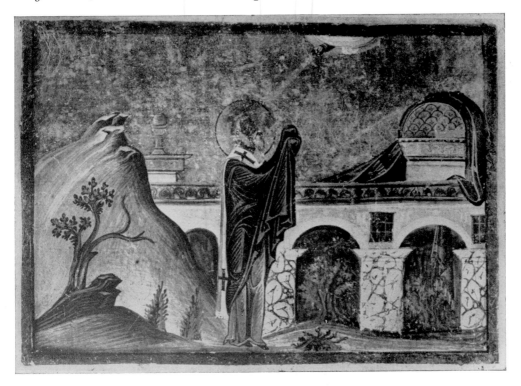

39. PARIS, BIBLIOTHÈQUE NATIONALE: The Paris Psalter: David
anointed by Samuel (after Buchthal, *The Miniatures of the Paris
Psalter*, London, Warburg Institute)

40. PARIS, BIBLIOTHÈQUE NATIONALE: The Homilies of Gregory
Nazianzenus; David anointed by Samuel

Christian scenes are crowded together without division. From the catacomb cycle the sculptors take the miracles of Christ and a number of the Old Testament episodes, adding the figure of the Saviour in the miracles, and increasing the Old Testament repertory with new subjects such as Ezekiel's vision of the resurrection of the bones, while that of the New Testament is varied with late catacomb subjects such as the Prophecy of Peter's Denial, and some curious episodes drawn from a lost story of Peter's ministry in Rome, wherein he like Moses smites a rock, to obtain water wherewith to baptize his erstwhile jailors.

The style of most of these Latin frieze sarcophagi is at the lowest level of Roman sculpture, retaining only the souvenir of the parent Alexandrian impressionism. The Hellenistic three-quarters view of the head is reduced to a sidewise glance indicated by a drill hole in the corner of the eye; the drapery is a loose array of grooves; the atmospheric background survives only in an undercut shadow and the suggestion of space given by accessory figures in a rearward plane. The figures are merely badly proportioned puppets. Invention is suppressed by symbolism, posture and movement reduced to formula, and variation obtained only by attributes and gesture. The wealthier Christians commissioned a better type of frieze sarcophagus, of which a few examples have survived. These arrange the scenes in two registers; in the center of the upper register a conch shell appears, enclosing the portraits of the deceased. On these sarcophagi the extra space invited an expansion of the cycle of subjects, and new themes appear: the story of Susanna; other episodes besides that of the furnace in the history of Shadrach, Meshach, and Abednego; the Lord giving their tasks to Adam and Eve; and the Creation of Man. Some of the additions are taken from the illustrative cycles of texts of the Old Testament and of the Gospels which will be considered later, such as Moses removing his sandal before the burning bush, the Miracle of the Quail, the Crossing of the Red Sea, and scenes from Christ's Passion such as the Entry into Jerusalem and his arraignment before Pilate. The style of the best of these sarcophagi is distinctly above the average of Latin relief in the fourth century; the figures have a classic dignity and inventiveness of movement and pose, sometimes even forsaking the current frontal trend to turn the back to the spectator; the drapery is of clean-cut design and functional. But the new scenes they add to the Latin cycle come from east Christian art, as does also the iconography of another even finer class of Christian tombs used in Italy and Gaul from the end of the fourth century, the columnar coffins that continue the architectural decoration of the sarcophagi of Asia Minor. With such intrusions, Latin Christian art enters a new phase so strongly impregnated with Greek style and subject matter that we

[47]

must postpone its treatment until we have examined the east Christian schools from which this influence came.

EARLY CHRISTIAN ART IN EGYPT

The early Christian art of Egypt presents us with a dualism, the two elements of which exhibit an extreme of contrast in style; the common factor is a distinctive iconography that marks Egypt off from the rest of the early Christian world. Christ, for example, is usually represented as a beardless youth with short curly hair, and often carries a short cross like a scepter; Lazarus stands swaddled in graveclothes in a tomb that takes the form of a mummy case, and his head is left bare while elsewhere it is always covered by the winding sheet. Saints are occasionally depicted as horsemen. The river god Jordan intervenes in the Baptism of the Lord, and at his Nativity we see the figure of Salome, the midwife whose doubting of the virginity of Mary is related in apocryphal gospels, and who paid for her incredulity by a withered hand. In the Entry into Jerusalem a rug instead of a mantle is spread in the pathway of the Lord.

The opposition in style is consequent on the deep-seated antipathy which existed from the time of the Ptolemies between Alexandria and the Delta on the one hand, center of persistent and uncompromising Hellenism, and the country of Upper Egypt, continually exploited by its Greek and Roman conquerors, and habitually resistant to Greco-Roman culture. With the advent of Christianity this division took on doctrinal complexion, especially after the Council of Chalcedon of 451, whose insistence on the duality of Christ's divine and human nature was too Greek and too materialistic for native Egyptian theology. As a result, the native Christians of Upper Egypt and their compatriots of the Delta as well allied themselves with the Monophysites of Syria and Palestine, following the age-old oriental theism that could tolerate no carnality in God. The church in Egypt divided in two, with a diminishing orthodox communion in Alexandria, and the monophysite confession electing its own patriarch in opposition to it, initiating the Coptic branch of Christianity which still survives in Egypt and Ethiopia. The split was accentuated by the foundation of monasticism in the fourth century; it was in the valley of the Nile that this mediaeval phenomenon took its rise, first in the form of hermitages, and later in the cenobite organization of monastic life on which were based the Basilian rule for monks in the eastern Church, and the Benedictine in the West. The monasteries of Egypt became the Mecca of pious escapists from the whole of the Mediterranean world, but were recruited especially from Syria and Palestine, which accounts, along with the common monophysite creed, for the strong influence of those lands on Egyptian Christian art in its final phase, of

which we shall see evidence later. The schism between the Delta and Upper Egypt, between orthodoxy and the monophysite belief, between the Greeks and the Copts, as the Christians of Upper Egypt came to be called, was never healed. To the Monophysites of Egypt, as to those of Syria and Palestine, the Moslem invasion came as a liberation from imperial orthodoxy and persecution, thus explaining the rapidity with which the old oriental prefecture of the Empire fell prey to Islam. When after Amru's conquest of Egypt a Byzantine expedition attempted to recover the province, the Copts helped the Arabs repel the "invaders."

We have to deal then, in Egypt, with a Christian style of pronounced Hellenistic character in Alexandria and the Delta, and another style, the Coptic, centering mostly in the monasteries of the upper Nile and the deserts that flanked the valley—a style which by its iconography shows a filiation from the Alexandrian, but rapidly loses any Hellenistic character by reason of its own reaction toward native oriental tradition and also because of the influence upon it of the Asiatic art of Syria and Palestine.

If we were to chronicle the Christian art of the Delta solely on the basis of existing works, we should commence at a date long after the traditional founding of the church in Alexandria (by St. Mark), and begin not earlier than the fifth century. But one early phase of Alexandrian style has been preserved to us by virtue of its faithful copying in the illustration of manuscripts; and through analysis and comparison of these illustrations we can reconstruct the art of the city, in a general way, at a period as early as the second century A. D. The manuscripts on which we base this reconstruction are those which contain the Greek version of books of the Old Testament.

The Old Testament, or at least its first five books, were translated into Greek from Hebrew for the benefit of the great Jewish population of Alexandria— one third of the city—by order of Ptolemy Philadelphus in the third century B. C. The necessity of such translation reveals the extent to which Hebrew had become a classic and dead tongue among the Jews of the *diaspora* (the Jewish colonies outside of Palestine), like the literary Arabic among Arabs of the present day. Tradition tells of Ptolemy's invitation to six scholars from each of the twelve tribes, to come to Alexandria from Jerusalem for the labor of the translation, and of the whole work done individually by each of the seventy-two, with miraculous lack of discrepancy in the resulting texts. The legend at any rate has bestowed its name upon the Greek version, which was thereafter known as the translation of the Seventy, or the Septuagint. The original work was probably confined to the Pentateuch, the first five books of the Bible known to Jews as the Law; the following sections of History, Prophecy, and Poetry

[49]

were translated later, and the whole text was probably not completed before the second century A. D.

The illustration of the Septuagint seems to have commenced about this time, since we can discern in later copies some unmistakable signs of that period. The two most important copies are the miniatures of a Book of Psalms in the Bibliothèque Nationale at Paris, known as the Paris Psalter (gr. 139), and a parchment scroll in the Vatican Library, now separated into its fifteen membranes which originally were sewed together into a roll about thirty-five feet in length. This roll is filled with drawings which illustrate the Book of Joshua, whose text, excerpted to explain the pictures, is inserted below the frieze of drawings, sometimes intruding into the empty spaces between them. The script of the Greek text is of the tenth century, but it was evidently a later addition, and the drawings themselves may be dated, in the writer's opinion, about 700 A. D.

The story of Joshua's invasion of Canaan is depicted in a perfect application of the narrative mode; the Joshua Roll gives us an excellent image of what the cartoons used by the sculptors of Trajan's Column looked like. We see Joshua leading the Israelites across the Jordan, the setting up in Gilgal of the twelve stones picked up from the bed of Jordan as its waters parted for the passage of the host; Joshua meets and prostrates himself before the angel impersonating the "Captain of the host of the Lord," whom he met outside of Jericho (*Fig. 43*); Jericho falls, and the Tyche, or personification of the city, throws aside her cornucopia in despair; the Israelites are repulsed before Ai and their defeat expiated by the stoning of Achan and his sons (*Fig. 17*); Ai is taken, its king executed, and an altar of thanksgiving built by Joshua in Ebal; the Gibeonites are aided by Israel to vanquish the Amorites; Joshua commands the sun to stand still in Gibeon, and the moon in the Valley of Aijalon; the five kings flee into the cave of Makkedah, but are brought to Joshua and hung like the king of Ai on forked stakes. The beginning and end of the story are not on the present Roll, but can be supplied from much later copies stemming from the same original Septuagint illustration, the Byzantine Octateuchs of the twelfth century which contain and illustrate the first eight books of the Old Testament.

We do not know through how many intermediate copies the drawings of the Joshua Roll are descended from its source, but the tradition has been amazingly well preserved. Our draftsman shows the difficulties which the less facile technique of his period involved; he has trouble with anatomical articulation as in kneecaps and rounds out his bodies into inflated contours instead of modeling the surface. He misunderstands details of landscape, and his movement is a mechanical formula; groups become masses of superimposed heads. But the

heads themselves are often good replicas of a beautiful Alexandrian type, domed in the cranium and tapering to the chin, with a characteristic exaggeration of the turn upon the neck, on which a curly lock of hair has fallen. The background continues the idyllic landscapes of Pompeii, with mountains on which the mountain gods recline as they did in the Odyssey landscapes, and structures thrusting their profiles above the shoulders of descending hills. The Alexandrian personifications extend to the cities, beside which sit the same Tyches, each holding a cornucopia and crowned with a diadem made of a city wall, whose type was invented by Eutychides to represent Seleucus Nicator's Antioch a thousand years before. The hallmark of Alexandrian landscape appears, the stele with its attendant tree. The hosts of the Israelites and their enemies are arranged in superposed rows like the soldiers on Trajan's Column, and their dress is the Roman uniform of the second century. There can be no question that we have in the Joshua Roll a fairly faithful replica, reserve being made for the awkwardness of later and alien technique, of the general style of Alexandrian drawing in the early centuries of our era.

The Paris Psalter,[5] possibly a little later in the date of its miniatures, adds color to our reconstruction of Alexandrian art. It, too, has a tenth-century text, but its miniatures are full-page insertions, on parchment of different quality from that of the rest of the book, using a different gold in their palette, and in their borders exhibiting an earlier type of ornament than that used in the text initials and chapter headings. The miniatures are fourteen in number and done by a group of artists of ability that varies from the masterly execution of *David as Musician, David slaying the Lion,* the *Crossing of the Red Sea, Moses on Sinai,* the *Prayer of Isaiah,* and the *Prayer of Hezekiah,* all by the hand of the head master of the atelier, to the very poor renditions of the *Women of Israel glorifying David,* and his *Coronation.* The head master understood very well the style he was copying; his figures have a firm and muscular anatomy and are well constructed by impressionistic chiaroscuro, with male flesh darkened in contrast to the white of females, in good Hellenistic fashion. He opens up his background with architectural perspectives or foliage, or like the draftsman of the Roll suggests depth with a distant city or a mountain landscape. One of his figures, the personification of Melody who sits beside the music-making David (*Fig. 18*), is an actual replica of a figure of Io in a fresco of Pompeii. The mountain god labeled *Bethlehem* in the lower corner of this picture repeats in his somewhat cramped position the reclining gods of the Odyssey landscapes as well as those of the Joshua Roll. The miniatures are filled with personifications: in the *Combat of David and Goliath,* done by the best of the head master's helpers,

[5] H. Buchthal, *The Miniatures of the Paris Psalter,* London 1938; C. R. Morey, "The Byzantine 'Renaissance'," *Speculum,* XIV (1939), pp. 139 ff.

the young hero is encouraged by a female figure inscribed as *Dynamis*, or "power," while Goliath is deserted by another labeled *Alazoneia*, "vainglory." This composition, minus the personifications, is repeated on a beautiful silver plate of the sixth century, found in Cyprus whither it was probably exported from Alexandria. It is now in the Morgan wing of the Metropolitan Museum in New York (*Fig. 19*).

The *Crossing of the Red Sea,* in the Paris Psalter, has been cut in two in the copying and the left portion inserted below the right; the original composition is preserved for us in the Octateuchs. Here too the personifications are rife: *Bythos,* "abyss," pulls down the hapless Pharaoh into the depths of the sea; "Night" with a flying veil above her head, and the seated "Desert," give time

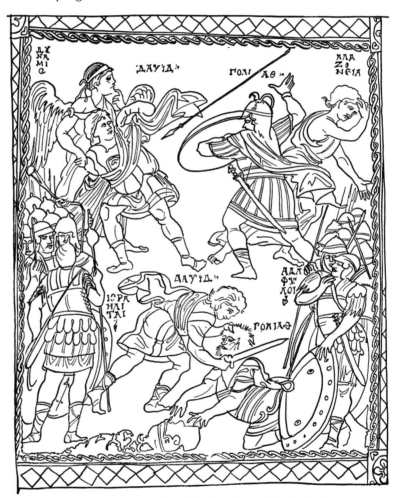

PARIS PSALTER: *David's Combat with Goliath*

and locality in Alexandrian fashion; to the right below is a nymph with rudder in hand personifying the Red Sea. The syncopation of the composition shows that it has been reduced to page form from the frieze arrangement of a roll, and the same adjustment can be detected in others of the miniatures. In the *Prayer of Hezekiah,* for example, the king and his attendant personification of "Prayer" look toward a Hand of God that has been amputated in the process of cutting the narrative frieze of a roll into pictures, to fit a bound book or codex. In the *Penitence of David,* the kneeling king needs a repeated figure of Nathan, who denounces him at the left, to receive his vow of repentance and complete the composition.

Like the Roll, the Psalter's miniatures reflect the essentials of the Alexandrian style, and arrive, in the miniature of *David as Musician,* at an extraordinary affinity with that style as represented in the frescoes of Pompeii and Herculaneum. The persistence of the Alexandrian landscape, thus preserved by centuries of patient copying of the text and pictures of illustrated Greek Septuagints, is one of the marvels of mediaeval art. Throughout early Christian art Old Testament subjects are normally relieved against a mountain range or a landscape enlivened with architecture, and the setting makes its way in Byzantine painting into the Life of Christ as well. The landscape is stylized until in the Octateuchs of the twelfth century the mountains become a mere scalloped silhouette, and details are diminished out of scale, but it is an almost indispensable accessory to any narrative scene within the artificial repertory of Byzantine style. From Byzantine art it passed to Russian—whose use of it is a strange anomaly in view of the unmountainous aspect of the actual Russian terrain—and to the beginnings of Italian painting, where it provides the landscape for the compositions of Duccio.

The early character of the originals of both the Roll and the Psalter is reinforced by the absence from them of any specifically Christian allusion; they may well have been devised for Jewish use alone. The adaptation of the Septuagint cycle to Christian purpose is seen in a manuscript earlier in date (sixth century) than the two above described, but deriving its pictures from a later stage of Alexandrian Bible illustration. This is the book of Genesis whose remnants are now in the British Museum, known as the Cotton Genesis. It was almost completely destroyed by a fire in 1731; but its previous owner, Sir Robert Cotton, had loaned the manuscript to the French antiquarian Peiresc in 1618, and the latter copied two of its miniatures in drawings that are now preserved in the Bibliothèque Nationale at Paris. One of these represents the *Third Day of Creation,* with the Lord indicating by outstretched hand the newly created plants, while the time is specified in Hellenistic fashion by three winged

beings personifying the Days. The Lord is given the Alexandrian attributes of Christ—the cross in his nimbus, and crossed scepter, as well as the local type of boyish head with curly hair. This is reflective of an Alexandrian theology even antedating Christian dogma, for Christ in this Old Testament scene assumes the role of *Logos,* the Word of God antecedent to the Incarnation, the emanation from the Godhead that embodied the active participation of the Deity in mundane affairs. The doctrine of the Logos was already present in the Jewish mystic theology of Philo of Alexandria, and appears in Christian literature in the first verse of the Gospel of John.

To the fifth century probably belongs the earliest Christian ivory of Alexandrian style. It is a pyxis, a circular box, now in the Kaiser Friedrich Museum at Berlin, on which is carved the same rendering of Christ seated in the midst of the disciples which we have found in catacomb painting, allied in this and other respects with Alexandrian art, and in the apsidal mosaic of S. Pudenziana. The Christ is the curly-haired youth of Egyptian iconography, and his figure and those of the disciples are boldly modeled and free of movement, showing a remarkable persistence of Hellenism, and contrasting with the wreck of illusionism in contemporary Latin style. The group is interrupted by a *Sacrifice of Abraham,* in which the patriarch, clad in tunic and mantle, holds the nude Isaac by the hair of the head, about to slay him on an altar which stands

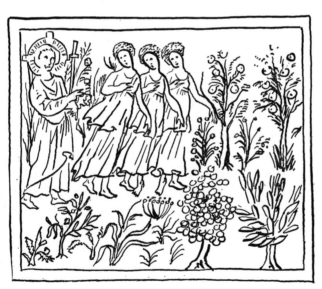

COTTON GENESIS: *The Third Day of Creation*

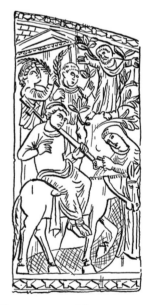

CATHEDRA OF MAXIMIANUS: *Entry into Jerusalem*

[54]

at the top of a flight of steps. The top of this altar has a peculiar scalloped profile which recurs in the same scene in a fresco at Bagawat in Upper Egypt, and the group is repeated on a bone carving found in Alexandria, now in Berlin.

About 500 A. D. was made the most famous of the ivory works in this style, the bishop's throne in the archbishop's palace at Ravenna, known as the Cathedra of Maximianus (*Fig. 20*). The monogram of Maximianus, archbishop of Ravenna who died in 556, appears on the front of the throne, but seems to have been added later, and while it is lettered in Latin, the assembly marks on the ivory panels that veneer the wooden chair are in Greek, showing that the throne was imported from some Greek center of manufacture. This center has been considered by recent opinion to be Constantinople, because of the similarity of style between the Cathedra's reliefs and the ivory diptychs issued by the consuls proclaimed at Constantinople in the early sixth century, as souvenirs of their elevation to office. However this may be, the subjects on the Cathedra are conceived in unmistakable Alexandrian iconography, and if made in Constantinople, the work must have come from the hands of Egyptian craftsmen. Christ throughout is the curly-haired youth, and sometimes carries the scepter-cross; Salome appears in the Nativity, imploring the reclining Virgin to heal her withered hand; the river god Jordan is added to the Baptism; in Christ's entry into Jerusalem, the rug is spread in his pathway, as on the wooden lintel of an ancient Coptic church in Cairo. These panels of Christ's life and ministry decorate the anterior and posterior faces of the Cathedra's back; they were twenty-four originally, of which twelve are lost. On the sides the story of Joseph, hero alike of Egyptian Jew and Christian, is told with a prolixity which is itself evidence of the Alexandrian origin. We see the bloody coat of many colors brought by Joseph's brothers to Jacob, the brothers lowering Joseph into the well, his sale to the Ishmaelites who sell him to Potiphar, the episode with Potiphar's wife and his imprisonment, the dream of the fat and lean kine and its interpretation to Pharaoh, Joseph's reception of his brethren in Egypt and the meeting with Jacob. In the New Testament scenes one is struck with the Hellenic dignity of the figures and the souvenir of Alexandrian impressionism that persists in the unusual realism of their grouping considering the narrowness of the panels, and in the blocky sketching of the eye and the natural pose of the head, in noteworthy contrast to the frontality that by this time was overtaking style elsewhere in the Mediterranean. The same tradition lingers in the oblique canting of the architecture that forms the background of some of the Joseph scenes. On the front, between borders that already betray the infiltration of Syrian ornament into Egypt in their vine rinceaux interspersed with birds, beasts, and paired peacocks, is the chef-

d'oeuvre of the atelier—five panels filled with truly impressive standing figures of the Baptist and the four Evangelists. The nobility of these forms is witness to the indestructibility, in Alexandrian art at least, of Hellenic humanism.

The style of the Cathedra's ivories is matched by a number of pieces in the same material scattered through the museums of Europe, notably a fine plaque in the Louvre of a type known as composite, made up of a central panel surrounded by four oblongs, and carved with a representation of a mounted emperor receiving tribute, with a bust of the youthful Alexandrian Christ in the center of the upper panel in a wreath supported by two flying angels. A famous member of the group is the Archangel Michael which decorates a panel in the British Museum and equals in its beautiful modeling and sensitive design of drapery the Evangelists of the Cathedra. The architectural frame in which this figure stands is that used on the front of the Cathedra and displays the same characteristic Alexandrian motif of detaching, in isolated relief, the conch shell that ordinarily fills the lunette of an arch in late antique ornament. Other pieces that show by subject their origin in Egyptian ateliers are a pyxis at Wiesbaden on which are carved the figures of Egypt personified and Father Nile, and another in the British Museum, with reliefs devoted to the trial and martyrdom of St. Menas, famous saint of the Delta whose shrine outside of Alexandria was a great focus of pilgrimage. In the Vatican Library's Christian Museum is the lid of a small physician's case, evidently once the property of an oculist, for on it we see the youthful Christ healing the Blind Man, while beside the Saviour stands a bearded Evangelist holding a book, in attestation of the miracle. These witnesses to the miracles of Christ are constant in the Alexandrian ivories: if holding a book, they seem to be Evangelists; if a roll, as the more archaic form, they are probably prophets whose prophecy is deemed to be fulfilled in the New Testament scene.

LID OF IVORY PHYSICIAN'S CASE:
Christ Healing the Blind

During the sixth century the style decays,

FRESCO AT BAWIT

lapsing into a scratchy linearity that loses the Hellenistic modeling of the
Cathedra group. This phase, represented by numerous ivories not only in Euro-
pean but American collections, and notably by a pyxis of the Dumbarton Oaks
collection at Washington, crystallizes *c.* 600 in a style that integrates the
decadence into consistency, with elongated figures rounded into undifferenti-
ated form. The curly impressionistic hair of Alexandrian style becomes in
this Coptic carving a stylized wig. In such later works we meet the signs of Syrian
influence in some details of iconography, such as the occasional use of the
bearded type of Christ, and especially in the sharp frontality which the figures
finally assume, with staring eyes in which the iris is indicated by a drill hole.
The key piece of this final phase of Egyptian Christian ivory carving, un-
doubtedly originating in the monastic ateliers of the upper Nile, is a composite
book cover from Murano in the National Museum at Ravenna (*Fig. 21*). De-
spite its complete divergence in style as compared with the ivories of the
Cathedra group, the iconography of this book cover continues the Alexandrian
tradition: Christ is still the curly-haired youth and carries the scepter-cross.
Jonah is nude in the story of his adventures which decorates the lower panel,
as he is also in the Roman catacombs and in Coptic art, in contrast to the robe
he wears throughout his vicissitudes in the Jonah scenes met with in Asiatic
iconography, at least in such examples thereof as have been preserved.

The style of these unmodeled, frontal, staring figures on the Murano book

[57]

cover is a plastic translation of the manner employed in the frescoes on the walls of the monastic churches and mortuary chapels of Bawit and Saqqara in the valley of the Nile. Wall painting in Christian Egypt had its Alexandrian phase: we know by water-color copies that a lost fresco of a catacomb in Alexandria itself represented the Miracle of Loaves and Fishes in the picturesque extension of a landscape, and the characteristic mountain background with buildings projecting their silhouettes above its ridges was used in the frescoes of an underground church at Antinoë. These paintings, possibly of the fifth century, depict scenes from the life of the parents of the Baptist, the infancy of Christ, and episodes from the Gospel of John. But in the sixth century the frescoes of Bawit and Saqqara have become entirely Coptic, denaturalizing and flattening the figure to an extent that removes their art from the stylistic milieu of Alexandria, except for occasional reminiscence of its impressionistic drawing and a number of its mythological types and personifications. The mounted saints peculiar to Egyptian iconography are frequent, and a type much used at both Bawit and Saqqara is the Vision of Ezekiel, transformed into an Ascension of Christ, in which the Lord appears in a circular glory sustained by angels, with the four beasts and their wheels and the eyes in their wings continuing the details of the vision. The scene is converted into an Ascension by the group below, consisting of the Apostles with the Virgin seated or standing in their midst. As the type disintegrates, she is placed between archangels or saints, and becomes a seated Madonna, holding the Christ child in her arms and sometimes exhibiting her Son as a symbolic figure surrounded by an aureole.

This type of Madonna, with the Child thus distinguished by a glory, is peculiar to Coptic art in the early Christian period, and also another type in which the Virgin suckles the infant. A symptom of monophysite prejudice is the invariable Coptic label given to Mary: ἡ ἁγία Μαρία, "the holy Mary," excluding the human origin of divinity implied by the epithet θεοτόκος, "mother of God," which orthodox doctrine bestowed upon the Virgin in the east Christian world.

Syrian influence is much to the fore in these frescoes; though the Christ type used for the Lord in the Ezekiel visions is of the short-haired, beardless variety, the bearded head also appears. The ornamental motifs of the Antiochene mosaics are frequent: the twisted ribbon, the rinceaux enclosing animals, the paired peacocks. The Asiatic influence is most obvious in the stark frontality of the figures and their utter lack not only of depth of setting but of physical thickness; they seem completely flat and undifferentiated save by

[58]

cut of beard or special gestures. Their expression is always the round-eyed oriental stare.

Coptic art is the most primitive phase of the early Christian; its inspiration, when one can penetrate its content, is more superstition than faith. The obsession with sex which transpires from the detailed account of temptation in the lives of Egyptian monastic saints is apparently present also in the treatment of the mythological motifs which are much used in Coptic stone carving; a favorite theme is Leda and the swan, rendered with a sensual fatness in the nudes and an obvious interest in the implications of the story. The same prepossession is responsible for the introduction of the doubting midwife in the Nativity. The relapse into primitive style which Coptic art illustrates is confirmed by its better performance in ornament, a genre in which a primitive esthetic can always be best expressed. For Coptic ornament at its best can be very beautiful, fully repaying its loss of naturalism with an agreeable lacelike chiaroscuro of lighted flat surface and shadow, often obtained by a perforated design. To such decorative ends it denaturalizes the Hellenistic ornamental vocabulary, tending toward a stringy linearity that makes the acanthus into a fern and the split palmette into a leaf like the fingers of a hand. The Greek motifs lose their curves in a curious cult of staccato angularity, as when the bead and reel becomes a succession of cubes and lozenges—a rectilinear fashion which has much to do with the angular pattern of Egyptian wood carving under Islamic rule. The greatest wealth of material for examining Coptic ornament, and to some extent its figure style, is provided by the thousands of

COPTIC RELIEF

[59]

textiles that have come out of Nilotic burial grounds, preserved by the dry air in sometimes faultless state. In these one may trace the evolution of the art from pieces of almost pure Hellenistic inspiration like the Hestia textile of Dumbarton Oaks to the weavings of the sixth and later centuries in which the skillful ornament disintegrates and the flat frontality of figures and infantile drawing of the wide-eyed heads marks a dead end of antique style.

EARLY CHRISTIAN ART IN CONSTANTINOPLE AND THE ASIATIC EAST

In contrast to the marked dichotomy of early Christian style in Egypt, clinging with extraordinary pertinacity in Alexandria to Hellenistic tradition, and degenerating with the Coptic into an infantile primitivism so far as figured representations were concerned, the Christian art of Greece, Constantinople, Asia Minor, and Syria with its dependent regions of Mesopotamia and Palestine presents a more consistent picture. Here too there is the tension between Hellenistic heritage and the reviving oriental point of view, but the Greek factor in this case was the Neo-Attic style, by nature more adapted to oriental abstraction and decorative rhythm. The western end of this artistic polity was of course the more Hellenic, its eastern area, as we have seen by our brief examination of the mosaics of Antioch, more receptive of eastern influence.

We have very little left, it is true, of the early Christian art of Greece and Constantinople, or of the western regions of Asia Minor which constituted the real hinterland of the capital, despite its European site. The sarcophagus end at Berlin with the figures of Christ and two apostles (*Fig. 17a*) of the late fourth century, is about as early as any example of Constantinopolitan Christian art available. To this may be added a few fragments of sculpture in Berlin or the Ottoman Museum of Istanbul: a column drum decorated with the foliage of a vine, into which is inserted a Baptism of Christ; a relief of Christ's entry into Jerusalem; a sculptured slab with a figure of Peter carrying a cross. But few as these fragments are, they clarify our concept of the capital's style: the forms have a weight and mass completely absent from the doll-like saints of Coptic frescoes; gesture and movement are conceived with Neo-Attic reticence; backgrounds are neutral and composition in two dimensions; the drapery is clean-cut and sharp in its folds with none of the slovenly grooving of the Latin frieze sarcophagi. The outstanding feature of the figure style is the treatment of the head, on which the hair is rolled to a sort of pompadour above the brow, and the pupil of the eye, which Latin sculptors placed in the corner of the eyeball, is rendered with a drill hole in its center. The remaining works are too few to

tell us much of the iconography of this art, but the Christ of the Berlin sar-
cophagus fragment and of the Entry in
the Ottoman Museum reveal its current
type of the Saviour in the fourth and
fifth centuries—a beardless head with
shoulder locks, used also on the Good
Shepherd statuettes which seem also to
belong to this area of early Christian
art. A recent find in Constantinople it-
self has made a notable addition to our
material: a child's sarcophagus deco-
rated on the ends with pairs of apostles,
and on the front and back with two fly-
ing angels of fine style, supporting a me-
dallion which encloses a peculiar form
of the monogram of Christ ✳, made
up of the I and X that are the initials
of his name in Greek, Ἰησοῦς Χριστός.

RELIEF: *St. Peter*

The abbreviation of Jesus's name
and title into a monogram arose early in
Christian writing as a piece of conven-
ient stenography, but did not become a
separate symbol of the Saviour, like
the fish, until the reign of Constantine.
Whatever the historicity of the dream and vision which Constantine experi-
enced just before the battle of the Milvian Bridge, the sign which he is said to
have seen in the sky, and put upon the standard of his bodyguard, was certainly
the ligature that has come to be known as the Constantinian monogram, the
☧, made up of the first two letters of *Christos* in Greek. In the Greek part
of the Christian world, and those Latin lands where eastern influence was
strong, the loop of the *rho* was usually left open, ☧ ; in Latin usage it was
always closed. But the monogram carved on the sarcophagus of Constantinople
is very limited in currency; it was employed, with an additional horizontal bar,
✳ , in the sixth-century mosaic decoration of the narthex of Hagia Sophia,
and had a sporadic distribution elsewhere, but it seems to have been especially
popular in Ravenna. Here it is found not only on the imported sarcophagi (p.
62), but also among the symbolic motifs employed by the mosaic makers, as for
example in the ceiling of the chapel in the palace of the archbishop. In the
mosaic, the allusion to Christ is emphasized by surrounding the monogram with

[61]

the four Beasts that represent the Evangelists, and four caryatid angels.

This is one of many indications of the close relation of Ravennate art from the second half of the fourth century with that of Constantinople, a relation so intimate that we may supplement the meager remains of the Christian art of the capital with monuments of the Italian city, particularly when the latter bear the aspect of imports. This last is the case with a series of sarcophagi existing in Ravenna, dating from the fourth century into the sixth, and of a type found nowhere else, though certain figures of the earliest example of the group are very similar in structure, pose, and gesture to a pair of apostles on the end of the sarcophagus at Constantinople mentioned above. The Ravennate sarcophagus is decorated with an arcade after the manner of one variety of the Asiatic sarcophagi, and shows a similar technique in the carving of the capitals. In the arcade are placed the figures of the apostles and Christ, the latter with the same coiffure he wears on the fragment at Berlin. In the first half of the fifth century these sarcophagi, which by reason of their utter dissimilarity from Latin examples must be imports, take on a semicylindrical lid, suppress the arcade, and frequently decorate the front with the single scene of Christ bestowing their missions on Peter and Paul. On the back, and sometimes on the front as well, we see the paired peacocks (*Fig. 22*) so popular in the mosaic floors of Antioch, but the home of this sarcophagus type is indicated as Constantinople by the occasional use of the "star" monogram, ✱, which appeared on the sarcophagus of Istanbul. A beautiful variety of the leaf-and-dart molding decorates the lower edge of the lid and the top of the trough. Both the arcaded type and the later one with vaulted lid were imitated by Latin workmen at Ravenna, and these supplied the market as well in the less prosperous years of Ravenna in the second half of the fifth century. The imported sarcophagi, however, reappear in the sixth century, with style transformed: the figures are smaller, stiffer, in marked frontality, and out of scale with the large-sized vases, conches, and crosses that divide the decoration with them.

Another very probable product of Constantinopolitan sculpture of the fifth century is the reliefs of the forward pair of the four alabaster colonnettes supporting the ciborium over the high altar of St. Mark's in Venice. Since there is good evidence that the ciborium took this form in the thirteenth century, and the two posterior columns, with the inscriptions labeling the reliefs, were added at that time, it is a natural conclusion that the forward shafts were part of the loot brought by the Venetian contingent from the sack of the churches of Constantinople in the Latin occupation of 1204, and employed with the added pair to make the present canopy. The style of the reliefs on the rearward colonnettes is transitional between a belated Romanesque and incipient Gothic, and

[62]

the scenes selected (the apocryphal history of the Virgin and unusual episodes of the ministry of Christ) are evident supplements of the Life of Christ portrayed on the forward pair.

This Life of Christ is highly important in the history of early Christian art, being the earliest cycle we possess. It reaches from the Annunciation to the Descent into Hell and the Ascension, in scenes ensconced in an arcade of technique identical with that of the early imported Ravennate sarcophagi. Two sculptors were employed, of whom one carved the four lowest bands of the reliefs, the other the upper five. The artist of the lower zones is the most gifted of our early Christian sculptors, setting his figures into free and dramatic movement, with truly functional drapery, and capable of expressive modeling, action, and gesture—in short, recalling in style the Alexandrian carving of Christ and the apostles on the ivory pyxis of Berlin. His compeer is more Neo-Attic, concerned more with decorative effect than drama, and given to formula and static composition. The juxtaposition of the two styles is symptomatic of the eclectic character of the art of a newly founded capital, to which craftsmen from all sections of the Mediterranean world were gravitating, and the stylistic mixture is borne out by a similar mingling of iconography in the scenes. The Virgin of the Annunciation, for example, is placed at the left as in Alexandrian art, but she stands in conformity with Asiatic usage. The midwife Salome intervenes in the Nativity, as in Egypt; the scene of Christ's agony in Gethsemane is on the other hand closely related to the rendering of the epi-

VENICE, S. MARCO, COLONNETTE OF ALTAR CANOPY: *Raising of Lazarus*

sode in the Gospel Book of Rossano which, as we shall see, was probably executed in Antioch. A peculiar feature of Peter's Denial of the Lord, which is carried on by Latin Christian art in its later, orientalized phase, is the placing of the cock upon a pillar.

Antioch was the eastern pole of Greco-Asiatic Christian art, as Constantinople was the western, and it is here that we can probably locate our earliest existing illustrated gospel books—the Codex of Rossano, and a fragment of Matthew found at Sinope in Asia Minor, now in the Bibliothèque Nationale at Paris

and known as the Sinopensis.[6] The first of the two is a manuscript in the cathedral of Rossano, in southern Italy, containing the text of Matthew and part of Mark, and illustrated by twelve pictures of Christ's miracles, parables, and Passion, with two decorative pages for the title and preface to the Canons (the nature of which will be explained below). The original order of the miniatures followed the readings of a liturgy for Holy Week which can with some reason be attributed to Antioch: the Healing of the Blind commences the series, with the scene of the Good Samaritan on the reverse of the leaf, succeeded in order by the Raising of Lazarus, the Entry into Jerusalem, the Cleansing of the Temple, the parable of Wise and Foolish Virgins, the Last Supper and Christ washing the disciples' feet; the Communion with bread and the Communion with wine, in which Christ is the officiating priest and the apostles the congregation; Gethsemane; Christ before Pilate and Judas returning the blood money and hanging himself; and the Choice between Christ and Barabbas before the judgment seat of Pilate. Following these miniatures come the title pages to the Canons, the text of Matthew, and then a portrait of the Evangelist Mark.

The scenes are set above a row of four Old Testament authors, who hold, unrolled before them, scrolls on which are inscribed the prophecies fulfilled by the episodes above. The concept is the same as that which introduced the figures of prophets or Evangelists into the New Testament scenes on the Alexandrian ivories, but here the witnesses are set symbolically apart. The significance of the episode is becoming the artist's theme rather than the episode itself; in the parable of the Good Samaritan, the latter is envisaged as Christ, wearing a nimbus with a cross enclosed within it. The rendering of nature, already idealized in the Neo-Attic tradition basic to this style, has succumbed to a dogmatic unreality announcing Byzantine abstraction; some of the episodes, such as the Raising of Lazarus, the Communions of Bread and Wine, the Last Supper, and the Washing of Feet, are already cast in arrangements that will persist for centuries in east Christian art. The background is neutral; even in the out-of-doors in which the Agony in Gethsemane is enacted, the landscape is reduced to a conventional rendering of rocky terrain. In the *Cleansing of the Temple* the style's two-dimensional quality is curiously evident in the double drawing of the Temple, at one end as a frontal façade, at the other as a colonnade in profile. In *Judas's Repentance,* a column is distorted to afford a clear view of the seated priest. The figures are flat and isolated where possible; when grouping is unavoidable it is done *en masse* with superposed heads. The characters have not however the doll-like triviality with which

[6] The best reproduction of the miniatures of these manuscripts (with the miniatures of the Rossanensis in color) is A. Muñoz, *Il codice purpureo di Rossano e il frammento sinopense*, Rome 1907.

Coptic painting caricatured this style; in posture and movement, as for example of Christ in the Raising of Lazarus, they retain the Neo-Attic reticence and dignity, save where the story requires some action outside the limited Neo-Attic formulary. The central Hellenistic composition is dissolving into a rhythmic frieze with no axial center; the mode is the narrative of the oriental storyteller, acquiring a certain dramatic force not by gesture or movement as in Alexandrian work, but by a curious peering glance of the eye. Noteworthy is the deepening of the color scheme: the parchment, stained purple, makes the background; against this is relieved a charming harmony of silver letters in the text, white garments on the figures with shadows in blue, and details ranging from deep red through rose to violet.

The Neo-Attic ancestry of the style emerges most clearly in the portrait of Mark, first instance in existing Christian art of the Evangelist-author picture (*Fig. 24*). He sits in a wicker chair, writing his Gospel on an unrolled scroll. Before him stands a female figure of uncertain iconographic meaning, but clear enough in artistic significance, for the group of Mark and his strange Egeria are only the continuation of the poet-and-muse combination popular on third-century Asiatic sarcophagi. The architecture in the background is also a mere misunderstanding of the alternating gables and arches of these sarcophagi. But the cubical central motif with curtains draped on either side is a favorite passage in the Antiochene mosaics, appearing *c.* 200 in the *Symposium of Heracles and Dionysus* found in a villa at Seleucia and again in a similar scene of a banquet of personifications of Fruit and Field served by a satyrlike figure representing Wine, which decorated the floor of a villa in Daphne, Antioch's suburb, of the third century. The Mark portrait in the Rossanensis is thus truly representative of the two elements in Asiatic Christian style—the Neo-Attic tradition emanating from the Greek centers at the West, and the more oriental version thereof that was current in the metropolis of the East.

But the detail of the curtained pilaster is not the only indication of a provenance from Antioch for the Rossanensis. It is true that the reasons hitherto advanced for this attribution have not been impressive, save perhaps the liturgical connection of which mention has been made; but the mosaics unearthed at Antioch have provided some further ornamental parallels to its miniatures that point in this direction. On the drapery of the face of the couch on which Christ and his disciples recline in the *Last Supper* are painted three birds with ribbons floating from their necks. This adorning of the necks of birds and animals with bands and ribbons is a Persian motif occurring again and again in the pavements of Antioch, and the actual appearance of these birds of the miniature is duplicated by several examples in the mosaics. The same

may be said of the pairs of ducks and doves, the fruit baskets, and the oleander flowers of the title page of the Canons. These parallels of the Rossanensis miniatures would tend to limit the date of the manuscript, for the motifs cited from the mosaics are most frequent in the fifth century, and it is unlikely that a work as luxurious as this *codex purpureus* would have been produced in a city prostrate, after the early sixth century, from its epochal earthquake and Persian raid. The date must lie in the neighborhood of 500 A. D.

The Sinopensis was purchased by a French officer at Sinope in Paphlagonia, who sold it to the Bibliothèque Nationale. It has only five miniatures left, all illustrating its fragment of the Gospel of Matthew. The technique of silver script on purple vellum, and its style, align it in the same school as the Rossanensis, but it is inferior in execution and probably somewhat later. The Old Testament witnesses here are two in number, flanking each picture (*Fig. 23*); their connection with the episode is well illustrated by the passage from Psalms on David's scroll beside the martyrdom of John the Baptist: "Blessed in the sight of the Lord is the death of his Saints." This picture is our earliest rendering of Herod's Feast, at which Salome presents the head of the decapitated Baptist to Herodias. The style differs from that of the Gospel Book of Rossano in a lessened Hellenism; the ground line is gone and the silhouettes are outlined on the flesh parts with heavy contours.

A third example of this school of book illustration is the famous codex of Genesis in the National Library of Vienna.[7] It consists of twenty-four leaves of purple vellum, with the pages divided between an excerpted text of Genesis and the miniature that illustrates it. The forty-eight pictures (*Fig. 25*) carry the story from the Fall of Man to the Death and Burial of Jacob, and show a somewhat more Hellenistic technique than the Rossanensis, which has suggested the prevalent dating in the fifth century. The earlier appearance of the miniatures is however mostly the result of an evident copying of an illustrated Septuagint roll, which accounts for the double register of most of the pictures, the frieze composition of the roll having been cut and its parts superposed, as in the case of the Crossing of the Red Sea in the Paris Psalter (p. 52). In one such instance, depicting Jacob's caravan as it crosses the ford of Jabbok, the composition is actually continuous, turning to the left after the crossing, and pursuing that direction in the following scenes of the patriarch's encounter with the angel. The communities of style and iconography with the manuscripts of Rossano and Sinope are numerous and clear enough to place the Genesis in the same school; not only is the same technique of silver script on purple vellum followed, but Joseph's prison where he is con-

7 Color facsimile by H. Gerstinger, *Die Wiener Genesis*, Vienna 1931.

fined with Pharaoh's butler and baker repeats that of John the Baptist in the Sinopensis, doors are rendered in the same fashion as in the Rossanensis, and the ciborium sheltering Melchizedek's altar in the Genesis, in the scene where he offers bread and wine to Abraham, has the same form as that which appears in the Repentance of Judas. The squinting eye in heads of three-quarters pose, the stocky little accessory figures in short tunics and leggings, the bullet heads, are features shared by the Genesis with the other manuscripts of the school, and the appearance of these little mannequins is so similar to some in the pastoral scenes that border the Constantinian "Seasons" mosaic as to add this item also to the evidence for Antiochene origin of all three codices.

The Genesis pictures are by several artists of distinctive styles, though some of their difference may be ascribed to the varying degree to which these Greco-Asiatic painters were able to assimilate the Alexandrian manner of their model. Here and there impressionism is retained, as in the blue or violet shadows and the unusual effect of sunrise in the miniature of the *Blessing of Jacob*. The mountain background that accompanies Septuagint illustration is prevalent, and in the miniature of Joseph sent to join his brethren, and in that of *Pharaoh's Feast,* we even find the characteristic stele. In the first of these two compositions, the angel conducting Joseph was probably in the original roll a personification; another figure of the sort, doubtless representing Repentance, accompanies Adam and Eve in the *Expulsion from Eden. Pharaoh's Feast* is an excellent example of the difficulty the Asiatic school encountered in copying the perspective depth of the other style: the banquet couch and table are tilted vertically up, and the buildings, stele, tree, and other elements of a landscape are inserted where space allowed without much reference to unity. The miniatures throughout give an impression of a two-dimensional technique struggling with the imitation of a three-dimensional style, alien to the Neo-Attic tradition of the Greco-Asiatic school.

❖ ❖ ❖ ❖ ❖

The three manuscripts described above, if attributed to Antioch, would constitute our only evidence for the early Christian art of the Syrian capital, but reflection of their style and iconography can be traced in works produced in Mesopotamia and Palestine, whose culture in late antiquity was always dependent on that of the great metropolis of the Near East. Of the scenes that once adorned the church of S. Sergius at Gaza we have only the highly rhetorical description of a writer of that city in the sixth century, Choricius, from which we gather that the pictures constituted a full cycle of the Life of Christ from the Annunciation to the Ascension. We may discern, in Choricius's account,

certain peculiarities of Asiatic Christian iconography. For example, no mention is made of the shed that covers the manger in Latin renditions of the Nativity; the wedding feast is added to the Miracle of Cana, and the two crucified thieves to the Crucifixion; the description of *Christ saving Peter on the Sea* sounds remarkably like the fresco of that subject in the Christian Chapel of Dura-Europos. Twelve of the twenty scenes described by Choricius and some not mentioned by him are portrayed in the full-page and marginal miniatures of a Syriac gospel book preserved in the Laurentian Library at Florence, signed and dated by a certain monk named Rabula of a monastery at Zagba in northern Mesopotamia, in 586 A. D.

Most of Rabula's pictures are set in the margins of the *canon tables* of his gospel book, which is the earliest existing example, at least of certain date, of this peculiar method of concordance. When the four Gospels were made into a single book in the first half of the second century, the problem arose of obtaining a unified life of the Saviour from these four sources, solved at first by the composite narrative in Greek of Tatian, called the *Diatessaron*, which was written in the second half of the second century and used by the Syrian church for three centuries thereafter. In the third century, Ammonius of Alexandria produced another harmony of the Gospels by taking Matthew as the norm, and ranging the other accounts beside his, in parallel columns. This however left out much of Mark, Luke, and John, and in the fourth century, Eusebius, bishop of Caesarea in Palestine and famous historian of the early church, invented his canon tables, wherein the verses of the four Gospels, indicated by numbers, are arranged to correspond with each other in columns. The first table contained the passages common to all four, the next three the corresponding verses in three, the following five those in two, and the last canon the passages unique in each. In accordance with Asiatic practice the frame surrounding the tables took on the architectural form of an arcade, and thus disposed, the canons became an indispensable element in every mediaeval gospel book, usually retaining the architectural frame, but modifying its form in accordance with the variations of taste and style.

In Rabula's book, the dilution of Antiochene art may be seen in the misunderstanding of the architecture of the canon pages, whereby the colonnettes become mere flat bands enclosing a variety of ornamental motifs. The same Persian influence which transformed the style of Antiochene mosaics in the fifth century is present in this Mesopotamian work of the sixth: rinceaux of plants and flowers flourish illogically at the top of the arch embracing the arcade, enclosing birds in their scrolls, and animals are introduced on the lower margins. The figured scenes show an evident filiation from some illustrated

[68]

gospel book on the order of the Rossanensis, and the bearded type of Christ varies from what is apparently a local portrait, with a head of triangular contour made by a pointed beard and a lateral bushing-out of the hair, to one that closely resembles the Christ of the Gospel Book of Rossano. This is especially true of the rendering of the Saviour in the scene of Easter Morn in one of the full-page miniatures, where we see the Holy Sepulcher as a colonnaded round shrine with a conical roof, the guards fallen in fright at the rays of light proceeding from it, and the angel announcing the Resurrection to the two Holy Women. The risen Saviour appears to the right, meeting the two Marys. Above this scene is our earliest Asiatic rendering of the Crucifixion, with the Crucified dressed in a long tunic, the *colobium* characteristic of this type. The two thieves **are** present as in the Crucifixion at Gaza; the lancer and sponge bearer; the soldiers gambling for the garments of Christ; John, Mary, and the Holy Women; and the mount of Golgotha in the background. The Greek model from which the picture was copied has left its trace in the misspelled label for Longinus who pierces Christ's side with his lance: ΛΟΓΙΝΟC. Beside the tables of Canons VII and VIII, the Evangelists are depicted in peculiar guise, John and Matthew seated, Luke and Mark standing. The seated posture, as we have seen by the portrait of Mark of the Rossanensis, was the Greco-Asiatic form, and the standing evangelists have already been observed in Alexandrian art in the portraits of the Four on the front of the Cathedra of Maximianus; the mixture of types here corresponds to the conflation of the Asiatic and Alexandrian texts of the Gospels which is generally ascribed to Lucian's edition at Antioch, *c.* 300 A. D.

MINIATURE IN RABULA'S GOSPEL BOOK: *Crucifixion and Resurrection*

Palestine, and especially Jerusalem, was once, as one might expect, covered with monuments that contained a wealth of early Christian art. The churches built in the Holy City and its vicinity by Constantine and his successors must have been adorned with mosaics, and we know that the church of the

Nativity at Bethlehem had upon its façade a representation of the Adoration of the Magi, since it was spared by Chosroes the Persian, when he raided Jerusalem in 614, because the Phrygian caps and oriental pantaloons of the Wise Men (their regular costume in early Christian art) were recognized by the king as Persian dress. Some of the mosaics of these Palestinian churches may be imitated in the paintings on the lid of a wooden pilgrim's souvenir box which came out of a collection of reliquaries found under the altar of the chapel of the Sancta Sanctorum at the Lateran in Rome when it was opened four decades ago. The Crucifixion on this panel, much resembling that of Rabula's codex, may well have been the principal scene decorating the church of the Martyrion, marking the site of Christ's death at Golgotha; the Ascension must have been a subject portrayed in the church on the Mount of Olives; the Nativity may recall a mosaic in the church of that name at Bethlehem; the Baptism, one in the shrine described by pilgrims on the bank of the Jordan. At any rate the first picture on the panel is probably the most correct representation we have of the Holy Sepulcher as it looked before it was destroyed in the Persian raid above mentioned and restored later by Modestus, bishop of Jerusalem. The scene is the Visit of the Holy Women to the Sepulcher, showing Mary the mother of Jesus and the Magdalen greeted by the angel in front of the monument, which is represented in descriptive fashion by poising the dome of the Anastasis, the church Constantine founded at the site, over the conical rotunda that enshrined the Tomb.

Another sort of pilgrim souvenir is represented by the little leaden phials, mostly preserved in the treasury of the cathedral of Monza near Milan, and in the old church of S. Colombano at Bobbio; one example exists in this country in the Institute of Art at Detroit. These were bought by pilgrims to hold oil taken from the lamps that burned before the holy places in Jerusalem, Bethlehem, and at the Jordan, and are decorated with tiny reliefs which in the opinion of many are crude replicas of the mosaic compositions in the churches at those sites. The scenes are certainly reminiscent of the pilgrimage shrines, the favorites being the same ones painted on the box lid from the Sancta Sanctorum, and using the same types. The Crucifixion however, which sometimes takes the Rabula form with Christ in the colobium, is usually rendered in a type peculiar to

PILGRIM'S OIL FLASK: *The Crucifixion*

[70]

Palestine, in which the Crucified appears merely as a bearded head surmounting the Cross.

These phials (or *ampullae*, to give them their ancient name), the painted cover described above, and occasional floor mosaics found in the excavation of the ancient churches of the Holy Land are the poor remains of early Christian Palestinian art, interesting for their iconography, and by their small number enormously eloquent of the thoroughgoing destruction of Christian monuments under Islamic rule. They tell us little of style, less in fact than the first examples of Mohammedan art at Jerusalem and Damascus, of the end of the seventh and the early eighth century. The most important of these examples are the mosaics of the Dome of the Rock at Jerusalem and those that were executed for the Ommayad mosque at Damascus. The floral ornament of the Jerusalem mosque is a baroque complication of Antiochene decoration transformed by Persian style, and features the Persian version of the lotus pattern known as the "Sassanian palmette" (p. 113). In the mosaics on the walls of the mosque at Damascus may be seen a stylization of Alexandrian landscape with figures replaced in the foreground by monumental trees, following Islamic prejudice against the rendering of the human figure. Such works were no doubt produced by native and probably Christian artists under Moslem direction, and certainly no Arab hand can be predicated in the extraordinary achievements in painting and sculpture that decorated the Ommayad hunting lodges or castles on the edge of the desert at Kuseir-Amra and Mschatta. The walls of the former are frescoed in a lively style bearing the imprint of Alexandrian vivacity, and something of that sensuality, in the treatment of the female nude, which marks late antique art in Egypt. On a still standing dome is seen a pseudoscientific map of the heavens, with constellations personified in Hellenistic fashion, reminiscent of Alexandrian astronomical lore. The remains of the enclosing wall of the castle at Mschatta are now in Berlin (*Fig. 27*); the façade is covered with a long frieze of ornament in which the lacelike chiaroscuro of carved surface and undercut shadow, whose initial stage we saw in the later Asiatic sarcophagi, has reached a climax. The human figure occurs but once; the theme of the frieze is a vine so cut up in small details that its structure is submerged in a coloristic pattern dominated by huge rosettes. These are separated one from another by the diagonals of a zigzag that carries the eye along the frieze in a perfect application of rhythmic design. The underlying tendency of Greco-Asiatic art toward the oriental allover pattern is here unhindered by any Hellenistic inhibitions, and fully expressed in conformity with the purely oriental taste of Islam. The façade of Mschatta is an

[71]

ornamental version of the same Moslem translation of the antique which we find produced in architecture by another Ommayad dynasty two centuries later in Spain. In the mosque at Cordova (*Fig. 28*) the Hellenistic colonnade loses its specific alignment and erstwhile logic in a forest of shafts, extending in all directions in rhythmic repeat, and expressing by its elimination of focal point or axis the negative contemplative attitude of the oriental mind.

EARLY CHRISTIAN ART IN THE LATIN WEST

The destruction of early Christian monuments in the Asiatic East is the more to be regretted since it is clear that from that section of the Christian world were issuing important determinants of iconography and style. The evidence thereof is manifold; we have already seen two instances in the Palestinian invention of the canon tables and the establishment in Syria and Palestine alike of the bearded type of Christ. It is also true that while the Alexandrian illustration of the Septuagint determined the schemes in which the stories of the Old Testament were cast in the Christian East and even in Italy throughout the Middle Ages, the Asiatic school was no less formative for the illustrative cycle of the Gospels. The Septuagint tradition preserved the three-dimensional Hellenistic manner of Alexandria; Gospel illustration, by reason of the Neo-Attic ancestry of the Asiatic art in which its dominant habit was formed, adhered to two-dimensional composition, restricted action for the figures, and a neutral background. Book illustration is thus a fundamental factor in the formation of early Christian art, whose later aspect shows little inheritance from the primitive renderings of the Christian theme in the frescoes of Dura and the catacombs of Rome. It was the integration of the book cycles, in Alexandria for the Old Testament, in the Asiatic East for the New, that determined the course of later Christian iconography, and also, to a large extent, the course of style. It is not too much to say that the real evolution of Christian art commences with the stabilizing of these illustrative cycles, which probably was fairly complete by the fourth century. In the middle

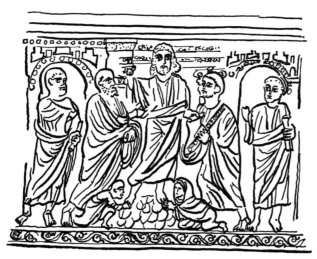

DETAIL OF A "CITY-GATE" SARCOPHAGUS

of the fifth century, at any rate, Pulcheria, the pious sister of Theodosius II, was able to decorate the Virgin's church in the Blachernae quarter of Constantinople with a mosaic cycle of the Life of Christ as extensive as that in the Sergius-church at Gaza. The same century produced the sculptured Life on the ciborium columns of St. Mark's.

Only the termination of early Christian art is for the most part illustrated in Syria, Palestine, and Egypt, where works of the fifth century or earlier are rare. We have seen that some idea of the earliest Christian art of Constantinople can be derived from the imported sarcophagi of Ravenna, the columns of St. Mark's ciborium, and a few sculptured fragments from the capital or its vicinity in Istanbul and Berlin. The sarcophagus recently discovered at Constantinople (p. 61) is isolated evidence for the fourth century, and can be

SARCOPHAGUS OF JUNIUS BASSUS: *Raising of Lazarus*

supplemented in secular work by the stiffly ceremonial reliefs on the base of the obelisk in the Hippodrome, set up under Theodosius I in 390 A. D. But the development of Christian art from the fourth to the seventh century can best be traced in Italy and Gaul, partly because there only can one find a sufficient number of existing works to illustrate all its phases, and partly because the art of the Latin West during these centuries was so increasingly impregnated with Asiatic style that it can almost serve as substitute for what we have lost by Islamic iconoclasm in the East. The process of this orientalizing of Latin art can be followed in three stages, best reflected in the Christian columnar sarcophagi, the Latin ivories of the fifth century, and the mosaics of the fifth, sixth, and seventh centuries at Rome and Ravenna.

The columnar sarcophagi begin to appear in the West at the same time as the imported sarcophagi at Ravenna, in the second half of the fourth century.[8] They continue into the early fifth. They preserve the habit of the pagan Asiatic sarcophagi, decorating all four sides in the purer types (the Latin frieze sarcophagi left the rear face uncut), and using the Asiatic architectural motifs of alternating gables and arches on a colonnade, or an arcuated colonnade, or level entablature; in later phases one finds the arcade transformed into a series of city gates with crenelated tops, or a row of palms or other trees whose

[8] Marion Lawrence, "Columnar Sarcophagi of the Latin West," *Art Bulletin*, XIV (1932), pp. 103 ff.

interlacing foliage makes a substitute for arches, or a mixture of all the architectural vocabulary into a medley of level entablatures, city gates, arches, and trees. The more Asiatic types seem due to Greek workmen domiciled in Italy and are characterized by closer adherence to the tradition of the pagan sarcophagi: there is unity of composition, marked by the use of a single scene instead of the jumbled series of episodes in the Latin friezes; occasional head types of the apostles resemble closely those of the philosophers and poets of the older works, and heads are often relieved against the cornice as in the Asiatic sarcophagi of the third century. The favorite subject is Christ giving their missions to Peter and Paul, with whom are ranged the other disciples. Christ usually stands upon Mount Zion, from which flow the Four Rivers of Paradise representing in Christian symbolism the four Gospels. Peter carries a cross as on the Berlin relief mentioned above (p. 60).

Latin ateliers took up the style, and it is often difficult to distinguish between the Greek and Latin traditions, especially since the iconography of the two becomes inextricably mixed. The Greek ateliers introduced into Latin art the cycle of Christ's Passion that was elaborated in Gospel illustration, and it is on the columnar sarcophagi that these scenes first appear in the West: the *Entry into Jerusalem* (in which by reason of the earlier date Christ rides in Hellenistic fashion astride the ass instead of sidesaddle as in the oriental rendering of the Rossanensis); the *Washing of Feet; Christ before Pilate.* The Crucifixion, as a disgraceful death, was still avoided in any realistic rendering, but one type of columnar sarcophagus uses the Cross as its central motif on the front, topped with a wreath containing the monogram of Christ. Doves perch upon the arms, and two sleeping soldiers sit below; the content seems to be a contamination of the Crucifixion as a symbol of triumph (the wreath of victory) and the Resurrection (the sleeping soldiers). But with these scenes that are evidence of the penetration westward of book cycles invented in the Greek East, are mingled survivals of the old subject cycle of the catacombs and the frieze sarcophagi: Daniel in the den of lions, the Fall of Man, Abraham's Sacrifice, the Denial of Peter with the cock at Peter's feet, the Miracles of Wine and the Bread and Fishes, etc. A classic example of the

IVORY IN THE BRITISH MUSEUM: *Suicide of Judas; Crucifixion*

[74]

fusion of Latin and Greek style and iconography in the fourth century is the sarcophagus of Junius Bassus in the crypt of St. Peter's at Rome (*Fig. 26*). This individual was prefect of the city of Rome and "went to God as a neophyte," the inscription tells us, in 359, evidence enough of the rapidity with which the new religion extended its conquest of the upper brackets of Roman society after recognition by the state. The Bassus sarcophagus retains the two registers of the better frieze types, but decorates both upper and lower with the Asiatic architectural frames for its ten scenes. The new subjects of Job and his wife, the Entry into Jerusalem, and Christ before Pilate are juxtaposed with traditional Latin subjects such as those listed above. In the central niche of the upper row Christ sits enthroned above the veiled head of *Caelus*, the sky, showing the persistence of Hellenistic personification, and bestows, as on the columnar sarcophagi, their missions on Peter and Paul. In the spandrels of the lower arcade are little scenes that show the versatile invention of this period when iconography was not yet fixed. The Three Youths in the Furnace, Moses smiting the Rock and receiving the Law, and Christ receiving baptism, multiplying the Loaves and Fishes, and raising Lazarus are enacted by lambs that impersonate the characters throughout with the exception of the mummified Lazarus in his tomb.

The Latin ivories of the fifth century are the most handsome products of Latin early Christian art. They commence with the Ascension plaque in Munich, whose material rendering of the Ascension of Christ, in contrast to the oriental supernatural levitation in a glory upheld by angels, was mentioned in the Introduction (p. 13). Below this is the scene of Easter Morn, with a two-storied Sepulcher modeled on a familiar type of Latin tomb, and the angel greeting three women instead of the two of Matthew, in accordance with the account of Mark, which was preferred by Latin liturgy. This subject is repeated in a plaque in the Trivulzio Collection at Milan,[9] with the Greek two women instead of three, and the upper rotunda of the Sepulcher, together with the sloping roof of the lower story, enclosed in a bordered panel above. The soldiers here sleep on the sloping roof. The episode thus divided is not due so much to misunderstanding as to the predilection of these ivory carvers for square panels, often bordered by an egg-and-dart that violates Hellenistic tradition by pointing outward from the relief it encloses. The angel in both ivories is wingless, showing a date no later than the early fifth century.

Four ivory panels that once adorned a small wooden casket are in the British Museum: they represent the Bearing of the Cross, the Crucifixion (the earliest example in mediaeval art), the Marys at the Sepulcher (of the character-

9 C. R. Morey, *Early Christian Art,* Princeton 1942, University Press, fig. 145.

[75]

istic Latin two-storied type), and the Incredulity of Thomas. Noteworthy are peculiarities of both iconography and style: the lancer who pierces the side of the Crucified stands at the spectator's right, against the universal rule which puts him at the left, and Thomas in consequence approaches the Saviour's left side to interrogate the wound. The forms are squat and heavy, with more robust projection than in the Munich and Trivulzio ivories, whose beautifully flattened relief and delicate modeling seem to differentiate the north Italian branch of this school of ivory carvers from the Gallic wing represented by the London plaques; "north Italian" because of many indications that point to North Italy as the focus of this re-Hellenized style. The heavier Gallic manner is further represented by two lateral panels from a composite book cover in Berlin and the Louvre, on which are carved scenes from the Life of Christ.[10] Here too an iconographic peculiarity appears, in that the children in the Massacre of the Innocents directed by Herod are not stabbed by the soldiers, but dashed to the ground. The same motif appears in this episode as represented on a pair of ivory book covers in the treasury of Milan cathedral, which offers another Latin characteristic in the enthronement of Christ on a globe in two of its scenes.

A north Adriatic location is indicated for the ivory panels veneering a wooden casket in the museum of Pola, some of whose scenes contain a rendering of an altar canopy that seems to be peculiar in location and form to churches of Istria and Dalmatia. In these reliefs also can be traced a strong resemblance to the style of the most Greek of the columnar sarcophagi, especially in the roll of hair around the forehead, the drilled eye, and the tight, sharply carved drapery which we have seen to be characteristic of Constantinopolitan work of this period. The use of palms to separate the figures, and Peter carrying his cross, are also features of the sarcophagi, and can be therefore employed to date the Pola ivories no earlier than the end of the fourth century when these sarcophagi began to be made, and no later for the same reason than the early fifth.

The most elaborate product of these ateliers is the reliquary of the Civic Museum at Brescia, a wooden box decorated with ivory reliefs representing a whole cycle of New Testament scenes and an equally large number of subjects from the Old.[11] These are executed in the flat and smooth relief of the Munich and Trivulzio ivories, and show much ingenious invention by an art not yet confined to a fixed iconography. Among the fifteen medallion portraits of apostles and other worthies that form a border for the scenes is one of

10 Morey, *op. cit.,* fig. 143.
11 *Ibid.,* fig. 146.

[76]

the youthful Christ, wearing the long shoulder locks that mark his portrait in the Constantinopolitan western wing of Asiatic style, and we may probably ascribe to the same source, in view of its occurrence on the ciborium columns of St. Mark's, the placing on a column of the cock symbolic of Peter's Denial.

The same north Italian school has left us a monumental work, attesting the durability of their cypress material, in the carved doors of the church of S. Sabina at Rome, undoubtedly contemporary with the building of the church which was dedicated in 432.[12] The combination of New with Old Testament scenes which occurred on the reliquary of Brescia is met with here again, but adapted to the early Christian notion of a *dittochaeum,* in which the Old Testament episodes are selected by reason of some symbolic parallel with those of the New. Such a parallel of subjects is recommended by St. Nilus of Sinai of the fifth century, in his letter to Olympiodorus, prefect of Constantinople, who had asked his advice on the decoration of a church the prefect was planning to build. It was the inspiration as well of a literary work which appeared a generation before the carving of the doors of S. Sabina—the *Dittochaeum* of Prudentius, a series of versified labels for twenty-four scenes each from the Old and New Testaments. An excellent example of such analogies is furnished by two of the long panels of the doors; on one are the miracles of Moses—the Quails, the Manna, and the Water from the rock; on the other the miracles of the Loaves and Fishes and the Marriage at Cana, whose jars of wine are equated in number, in spite of their specific description as six in the Gospel of John, to the seven baskets of bread in the companion episode. The reliefs are full of stylistic and iconographic parallels to the fifth-century ivories and the columnar sarcophagi, among them the use of palm trees to separate figures, the peculiar placing of Thomas, and the perching of the cock on a pillar in Peter's Denial.

❖ ❖ ❖ ❖ ❖

At about the same time that the doors of S. Sabina were carved, Pope Sixtus III (432–440) finished the mosaic decoration of the nave and sanctuary arch in Greater St. Mary's in Rome, S. Maria Maggiore. The structure was an old one, a pagan basilica whose level entablature in the nave was retained with its conversion to Christian use, making a broad clerestory wall on which, so high up as to be almost invisible to the observer, were located the forty-two panels of mosaic depicting the stories of Abraham, Moses, Jacob, and Joshua. Later openings of chapels into the nave have destroyed all but twenty-seven of the panels, and the remaining ones have suffered much from

[12] Morey, *op. cit.,* fig. 149.

restoration. The dependence of the compositions on Septuagint illustration is evident from their correspondence to the Joshua Roll in the scenes of the *Crossing of Jordan* and the *Staying of the Sun and Moon,* and to the Octateuchs in the *Defeat of the Amalekites* (see p. 50). An early model can in any case be assumed from the wingless angels, as for example the "Captain of the host of the Lord" whom Joshua meets before Jericho, and the three angels welcomed by Abraham in the plain of Mamre. That the model was an illustrated book or roll may be deduced from the two registers in which the pictures are composed, like the double-strip miniatures of the Genesis of Vienna. The resemblance of female costume and the dress and appearance of priests to the same features in the mosaics of the arch are sufficient to date the nave mosaics in their period, which is fixed by the dedicatory inscription of Pope Sixtus at the summit of the arch: *Xystus episcopus plebi Dei.*

From the Septuagint tradition are derived the pastoral setting and mountain background prevalent throughout most of the scenes, and the mosaicists have been at pains to reproduce, not always with success, the nuances of the paintings they imitated. The graded atmospheric background is retained, though it tends to become striped; impressionism lingers in the streak of light color contrasted with shadow to render the contour of a figure on the lighted side. The gold used for high lights in miniatures such as those of the Vatican Vergil is reproduced as yellow. In spite of the evident employment of an illustrated Septuagint text (more probably in codex than in rotulus form), the artists or the cleric who directed them has modified the narrative in several places in a symbolic sense, introducing into the Abraham, Moses, and Jacob series the half figure of the Logos in the sky, in the semblance of Christ, instead of the traditional Hand of God. In the *Meeting of Abraham and Melchizedek* the bread and wine offered by the king to the patriarch are given eucharistic meaning not only by the Christ figure who blesses the scene from the heavens, but by the very large size of the chalice. The central one of the three angels entertained by Abraham at Mamre is surrounded by a glory to identify him as the Lord. The most obvious symbolic revision is found in the *Parting of Lot and Abraham (Fig. 30),* in which Lot and his daughter turn away to Sodom and destruction, while Abraham's family is led toward a structure that stands for the church, by Isaac, symbol of the crucified Christ, although Abraham's son was in actuality born after this event. It is in such compositions, as one might expect, that the contemporary orientalized Latin style transcends its model; in the *Parting of Lot and Abraham* the figures have the same broad flattening of plastic relief which gives undue but not

unpleasant width to the forms on the ivories of the Brescia casket and other north Italian ivories of the fifth century.

The same style is evident in the mosaics of the arch,[13] which are devoted to the Infancy of Christ, probably with the purpose of honoring his Mother, recently vindicated as the Mother of God by the triumph of orthodoxy at the Council of Ephesus in 431. The fluid and inventive state of iconography at this period is nowhere better illustrated; not a single scene on the arch can be paralleled elsewhere in Christian art. The stories seem to be taken from the apocryphal gospel known as the Pseudo-Matthew, whose Latin text began to circulate in the West in the fifth century, or from some very similar text; a feature showing this derivation is the four doves instead of two offered by Joseph in the *Presentation of the Child in the Temple.* The winged angels who surround the Virgin as she receives the message of the flying Gabriel in the *Annunciation,* and attend the Holy Family in the *Presentation,* are also part of apocryphal tradition. The *Adoration of the Magi* is unique in Christian art: the Child is elaborately enthroned with a female figure seated at either side; the one at his right, by the jeweled costume which she wears here as in the *Annunciation* (closely resembling that of Pharaoh's daughter in a panel of the nave representing the childhood of Moses), is undoubtedly the Virgin; conjecture still is baffled by the somberly clad woman at the infant's left. In the *Massacre of the Innocents,* the mothers are an immobile group, seemingly offering their babes for sacrifice. A feature borrowed from the columnar sarcophagi and the ivories decorates the lower corners of the arch—the lambs coming forth from Jerusalem and Bethlehem. Here they are grouped for lack of room at the gate of each city. They represent, like the personifications crowning Peter and Paul in the apsidal mosaic of S. Pudenziana, the two Churches, Jewish (Jerusalem) and Gentile (Bethlehem), which made up the congregations of early Christianity.

The background of these mosaics of the arch, in accordance with the Neo-Attic tradition basic to New Testament illustration, is without depth, relieving the scenes against a neutral gold field or an architectural setting as in the *Presentation.* This scene tops the arch on its right side and is followed in the same zone by the *Angel warning Joseph to flee to Egypt,* mutilated in the narrowing of the apse by a baroque reconstruction. Below comes the story narrated in the Pseudo-Matthew of the welcome given to the Holy Family in Egypt by the prince Affrodosius, in whose city the idols had fallen at the

[13] Illustrations of this and other mosaics cited in this chapter may be found in the writer's *Early Christian Art.*

[79]

approach of the Child. Next below is Herod, surrounded by his priests, receiving the Wise Men; Hellenistic tradition still lingers in the nimbus given Herod as a mark of worldly distinction, not yet limited at this early date to its Christian significance of sanctity. The series on the right closes with the city of Bethlehem and its lambs, mentioned above.

At the crown of the arch there appears for the first time in mediaeval imagery the curious symbol of the *Etimasia*, the "throne prepared in heaven" of the Book of Revelation, foretelling the Second Coming—a Latin type in early Christian art, since the final book of the New Testament was not recognized as canonical by the eastern Church until late in the Middle Ages. The type is here rendered by a draped throne bearing a gemmed cross within a wreath, with the Book (a roll) of the Seven Seals on its footstool (Rev. v:1). Beside the throne stand Peter and Paul, whose heads also appear in the medallions terminating the arms, and above are the four beasts of Revelation, man, lion, calf, and eagle, representing the four Evangelists.

The subsequent history of early Christian monumental painting in Italy is better traced in Ravenna. This city, capital of Italy from the Visigothic invasion and sack of Rome in 410, was as we have seen from its importation of Greek sarcophagi, intimately related to Constantinople and the East, economically as the main Adriatic seaport of the peninsula for the reception of eastern trade, and culturally as the capital of an Italy dependent on the eastern Empire for political survival in the midst of barbarian invasions. Its importance lapsed with the Frankish intervention in Italian affairs in the second half of the eighth century, and its existing monuments date mostly from the fifth to the seventh, of which period it is the outstanding illustration—the early mediaeval city *par excellence*. Political changes divide this brief epoch of Ravenna's florescence into three periods: the fifth century when it was the center of a still-existing Latin empire; the interlude of Ostrogothic domination of the peninsula from 493 to the Byzantine reconquest in 539; and the rule of Italy by the Eastern Empire through an exarch residing in Ravenna, down to the donation of the exarchate to the See of St. Peter by Pippin the Frank.

Two monuments are outstanding as exponents of the first period: the Orthodox Baptistery decorated by the bishop Neon in the middle of the fifth century, and the lovely little building called the Mausoleum of Galla Placidia, sister of the emperor Honorius, wife of a Visigothic king, and again by a second marriage mother of Honorius's successor Valentinian III. The dome of the Baptistery has as its central feature a much-restored medallion containing the Baptism of Christ; the scene was imitated in a later baptistery built under Theodoric the Ostrogoth for the heretical Arian cult of the Gothic Chris-

tians, and from this we may gather its appearance before restoration. Christ was beardless, with the long hair of the Constantinopolitan type, and the Baptist carried a shepherd's crook, as regularly in Latin art of the fifth century. In both mosaics an Alexandrian motif recurs in the figure of the river god Jordan. The zone surrounding the Baptism represents the procession of apos-tles so often found on the columnar sarcophagi, and the lowest register has a peculiar alternation of altars and thrones of a symbolic content similar to that of the Etimasia of S. Maria Maggiore. The filling of the base of a dome with such an architectural border reflects an Asiatic taste in contrast to the river scene of the cupola of S. Costanza (p. 45); the solution by means of landscape is a characteristic survival of Alexandrian preference in this respect.

The Mausoleum of Galla Placidia, dating c. 450, was probably not the tomb of this celebrated woman alone (if indeed she was ever buried there at all), but an imperial burial place for the rest of her family as well. It is a cru-ciform structure, initiating the eastern cross plan in Italy, and bears tunnel vaults in the arms of the cross, rising in the crossing to a dome borne on a pendentive vault. In this interior one is able to judge the effect of a completely preserved and relatively unrestored decoration; a recent insertion of translu-cent alabaster windows of the ancient type has modified the light to a limpid illumination in which the mosaics gain their full value, filling the interior with a jeweled atmosphere like that attained later by the colored glass of Gothic cathedrals. The blue vaults are carpeted with rosettes and stars and acanthus scrolls, with the four symbolic beasts surrounding a cross in the dome, whose windows are flanked by pairs of white-robed apostles. In the apsidal lunette is St. Lawrence, carrying a cross and book and marching to his martyrdom, expressed materially by the flaming gridiron on which he was roasted to death, and with reference to the martyr's inspiration by the bookcase containing the volumes of the Gospels. Narrative and reality are forgotten here, in the inter-est of a transcendental rendering of the spiritual content of the event. The same abandonment of the natural for ulterior significance is seen in the sin-gular rendering of the Good Shepherd in the beautiful lunette above the doorway (*Fig. 29*). The Shepherd sits in a rocky landscape amid his flock, but here the natural aspect of the allegory ends, for he is clad imperially in tunic and mantle and holds aloft a jeweled cross.

The church of S. Apollinare Nuovo, built by Theodoric, is our example of the second period in Ravenna's artistic history (*Fig. 31*). It was dedicated in 504 to the great Gallic saint, Martin, and received its present name only in 856, when the relics of Apollinaris, apostle of Ravenna, were brought from his church in Classis, Ravenna's seaport, and deposited here. Its apse is

modernized, but on the walls of the nave are three zones of mosaic decoration of which the upper two date from the time of Theodoric, the lowest zone (excepting the representations at its ends) from the conversion of the church to the orthodox cult about 560 A. D. The topmost band is divided into thirteen panels on each side of the church, containing a Life of Christ made up of scenes whose singular selection may be due to their illustration of the readings used in the church at Ravenna from the first Sunday in Lent to Easter Eve. The encroachment of oriental usage begins to be more evident here: although on the left side of the nave the Christ is beardless with long shoulder locks after the Constantinopolitan manner, on the other side, where the scenes represent the events of Passion Week, he is rendered with the Syrian beard. The iconography shows a similar mixture: Latin is the retention of the symbolic two fishes, remnant of the old catacomb type of the Multiplication, on the platter of the *Last Supper*, but the composition of the reclining Saviour and his disciples exactly parallels the corresponding miniature of the Gospel Book of Rossano. *Peter's Denial* includes the cock upon a column as on the ciborium columns of St. Mark's and the Latin ivories, but the scene of Easter Morn shows the eastern two Marys instead of the Latin three. Most evident, however, is the growing transcendental content; throughout the scenes, and even in the tragedies of the Passion, Christ dominates the episode, not only by the larger scale of his figure, but by the outward turning of his face, indifferent to surroundings and expressive of esoteric meaning (*Fig. 32*). Indications of locality, intrusions in these solemn scenes, are reduced to a minimum, and throughout the series the Neo-Attic neutral background is the rule.

Between the windows are conches of yellow edged with white, terminating in a bird's head as they do sometimes on the columnar sarcophagi; below each conch is a small white cross flanked by two doves. The thirty-two figures between the windows in the second zone were originally thirty-four, two having been lost by an earthquake which destroyed the apse and the eastern termination of the nave. They are clad in bluish-white garments like the apostles of Galla Placidia's Mausoleum, and probably represent worthies of the Old Testament. The lowest zone like the uppermost must once have been divided into panels but was redecorated, when the church was dedicated to orthodox cult, with the famous processions of saints. There are twenty-six male saints on the right side, led by St. Martin to a bearded Christ enthroned between two pairs of angels at the east end of the nave. The twenty-two female saints on the other side are all undifferentiated like their male compeers, except for their labels and the lamb (*agnus*) which stands at Agnes's feet in punning allusion to her name. Dark garments are given to St. Martin (restored)

and St. Lawrence among the white-clad male saints of the north frieze. Between the figures are the palm trees which separated the characters on some of the Latin sarcophagi and ivories; the faces look outward in a pose close to frontality, but the bodies sway slightly forward and carry the eye in gentle rhythm toward the apse. Facing the enthroned Christ, and receiving the file of saintly women, the Madonna sits in frontal pose with the same two pairs of attendant angels; Mariolatry has not yet progressed to the point of representing her as a separate object of adoration, and the Magi are introduced at the head of the procession of female saints, by way of justifying the enthronement of the Virgin.

These processions issue (in a wholly conventional sense, since the figures are taller than the portals) from the gate of Ravenna on the right side, from that of Classis on the other. The representations of the cities belong to the original decoration of the zone; that of Ravenna is made up of the façade of Theodoric's palace with the tops of structures within the city rising above it, and on the columns of this façade may still be seen a hand or arm here and there, remains of figures, presumably Theodoric and his family, which once stood in the intercolumniations that are now draped with curtains. The picture of Classis on the other wall includes the port, with three ships in the harbor, descriptively placed one above the other, and an amphitheater and the church of S. Apollinare in Classe discernible within the walls.

The introduction of these processions, instead of the probably paneled composition of the zone as originally designed, is significant of the orientalizing of Latin taste. Hellenistic composition forced an artist to divide a long frieze into rectangles, unless he had an unusually extended subject at his disposal, for only thus could he obtain the layout for an axial arrangement. But these arrays of saints depend for unity on rhythmic repeat, enhanced on the one hand by lack of differentiation in the accents offered by the figures, and made slow and solemn by the outward turning of the faces that catch and arrest the eye. To the introduction of the transcendental oriental content, impressive in the Life of Christ, must be added as well the capitulation of Latin art to the oriental rhythmic composition.

The Life of Christ in S. Apollinare Nuovo represents the best of Ravennate work in the period of Ostrogothic rule; the outstanding work of the exarchate is the church of S. Vitale, and the jewellike mosaic decoration of its choir. The church was founded by the archbishop Ecclesius and is itself an instance of the penetration into Italy of Asiatic forms, for it follows the plan and possibly the elevation of the *Domus Aurea,* the famous octagon which Constantine built at Antioch. S. Vitale was finished by Ecclesius's successor

Maximianus and decorated at least in part with direct subvention on the part of Justinian, whose particular favor Maximianus enjoyed. The decoration of the main octagon has been lost in subsequent remodeling, and the mosaics that concern us are confined to the choir.

The groined vault of the ceiling at once introduces an Asiatic note—the rich acanthus scrolls filled with the same birds with occasional beribboned necks, which animate the rinceaux of late mosaics at Antioch. The oriental impression deepens with the decoration of the groins—four angels standing on globes and supporting the central garland enclosing the Lamb of God, repeating thus an old Syrian motif of caryatid Victories, like those which hold up the medallion portraits of the deceased in a tomb at Palmyra of the third century. In the semidome of the apse on the other hand, the composition is conceived in a Latin sense: Christ, beardless and short-haired in Alexandrian and early Latin fashion, attended by two angels, sits on a globe (another Latin attribute) above the Mount from which the Four Rivers flow. He receives from Ecclesius a model of the church and bestows the wreath of martyrdom on the patron saint Vitalis.

The sides of the choir open by colonnaded arches into the two-storied surrounding aisle of the octagon. In the lunettes of the lower of these arches are Old Testament symbols of the Lord's Supper: on one side Abraham entertaining the three angels under the oak of Mamre, and his sacrifice of Isaac; on the other Melchizedek offering at an altar his bread and wine to the Hand of God, with Abel opposite him lifting up a lamb. On the altar two loaves of bread and a chalice make the symbolism clear—Abel's offering of the lamb is a type of the Crucified Lamb of God, and Melchizedek's bread and wine are the elements of the Eucharist that commemorates the Crucifixion. The same symbolic content inspires the unrealistic juxtaposition, within one setting, of the Supper spread by Abraham before the three angels, and the sacrifice of his son, from the earliest times the church's readiest allegory of the Atonement. In spite of their obvious reshuffling for better rendering of an esoteric content, these scenes betray their Septuagint ancestry as do all early Christian pictures of the Old Testament; trees and an atmospheric clouded sky are still reminiscent of landscape, and the buildings at the sides of the compositions retreat in three-dimensional foreshortening. Toward the entrance to the choir are prophets: Isaiah on one side, foretelling the Incarnation; Jeremiah on the other as the prophet of the Passion. The Septuagint tradition is resumed in the Moses scenes on the wall toward the apse, for the mountain landscapes and the types employed in these pictures of the *Burning Bush* and the *Receiving of the Law* are familiar in the tradition of the Old Testament illustration. The walls

[84]

of the upper story are decorated with the figures of the four Evangelists and their symbols, in a presentation unique in early Christian art, for the lion and the ox have no wings, and the Evangelists sit in a rocky open landscape —a motif which along with the wingless beasts we shall see imitated in Carolingian painting.

Despite such evidence of local and Latin practice, to which may be added the Latin elements in the iconography of the apse, and despite the dependence on Septuagint illustration of the settings given the eucharistic types and the episodes of Moses's life, the Asiatic influence is unmistakable in these mosaics, especially in the marked frontality and solemn stare of the apsidal figures. The wholly symbolic selection and combination of the scenes that symbolize the Eucharist are part of the oriental transcendentalizing of Hellenistic style, the force of which can be better estimated when it attacks the rendering of an actual event, as in the final pair of mosaics of S. Vitale which interrupt the marble dado in the lowest zone of the apse. These are the famous groups showing Justinian and Theodora making their offerings to the church. The archbishop Maximianus, a remarkable portrait considering the impersonal trend of the style, is figured with two chanting deacons in the emperor's panel, and dates the mosaic, since he became patriarch of Ravenna in 546. Justinian is accompanied by a bodyguard and three court officials. The latter wear the badge of their rank, the dark *tablion* or patch embroidered on their capes, which first appears on the chlamys of the young Moses in S. Maria Maggiore, in the scene of his reception by Pharaoh's daughter. Theodora enters the atrium of the church, marked by a fountain, with a suite of seven ladies and two officials, and carries a jeweled chalice as her offering (*Fig. 33*). She is very richly attired, wearing a diadem hung with pearls and a heavy pearled neckpiece; her purple mantle is embroidered with an *Adoration of the Magi*. The luxury and majesty surrounding the imperial status in the sixth century, reflecting the orientalizing of manners in the eastern capital, may be gauged by comparing this empress with the simply garbed ladies of the Julian house at the beginning of the Empire. But more eloquent of oriental quality is the denaturalized rendering of this contemporary happening: spatial relation is gone to the extent that the figures step on one another's feet, and the dangling feet themselves show an entire lack of plastic weight. The slightly swaying posture of these groups is allied with the rhythm of the saintly processions in S. Apollinare Nuovo, but the movement thus suggested is contradicted as in these by the staring frontality of the faces that fix and fascinate the gaze of an observer.

The style of Ravenna dominates the art of Italy in the sixth and seventh centuries, not only in the vicinity of the capital of the exarchate, but throughout

the rest of the peninsula. At Rome the composition of the apse of the Ravennate church is already in evidence in the mosaic of SS. Cosmas and Damian in the Roman Forum (*Fig. 34*), built by Felix IV (d. 530). The arch that surrounds this apse has lost most of its lateral areas by later reconstruction: in original state the arch portrayed the full Vision of the Book of the Revelation, centering in the Lamb upon his throne, with the roll of seven seals below, the four Beasts and the angels who stood at the corners of the world, the seven candles that represent the "seven lamps of fire," symbols of the seven churches of Asia Minor, and in the spandrels the four-and-twenty Elders offering their crowns on veiled hands, of which portion only the veiled hands and crowns of the inner row remain. In the apse itself Christ stands on a pathway of illumined clouds, and above his head a Hand of God, now replaced by a window, once held a wreath. The Alexandrian-Latin notion of a river at the bottom of an apse or cupola persists in the blue streak below labeled *Jordanes,* and an Antiochene motif is present on the other hand in the phoenix with rayed head which perches on a branch of one of the two palms enclosing the composition and localizing it symbolically in Paradise. This side of "Jordan" are the recipients of Christ's grace: a modern figure of the donor Pope Felix, balanced by the Greek saint Theodore, a newcomer from the East into the Roman Christian pantheon, and Peter and Paul introducing the titular saints of the church, Cosmas and Damian. These were twin physicians, martyred under Diocletian, and one of them carries beneath his mantle the little red medicine case indicating his profession. In the lowest zone an old motif of the columnar sarcophagi persists—the lambs issuing from Jerusalem and Bethlehem and converging toward the Agnus Dei on his Mount. The mosaic represents the domestication of oriental style at Rome, and is even more proto-Byzantine than the apse of S. Vitale in the concentration of its accents and decorative spacing of the group. The same transcendental content emerges here, in the wholly symbolic locality, and the strong frontality of the figures.

The recrudescence of that fluctuating and inventive iconography which makes the mosaics of S. Maria Maggiore so hard to parallel in Christian art is evident in a mosaic of S. Apollinare in Classe, principal church of Ravenna's Adriatic port, whose apse and arch were decorated about the same time as those of S. Vitale. The bearded Syrian type of Christ is introduced at the top of the arch between the much-restored symbols of the Evangelists, and the lambs marching from the two cities fill the middle zone with the palms of Paradise in the spandrels. Interest centers in the curious composition of the apse: a Transfiguration symbolically depicted with a Cross for Christ, made clear in its significance by the Alpha and Omega beside it, the bust of the Saviour in its cen-

ter, and the inscriptions ΙΧΘΥΣ and *Salus Mundi*. On either side of the Cross are the figures of Moses and Elias who appeared with the Saviour in the Transfiguration, while the three disciples who witnessed the vision, Peter, James, and John, are the three lambs in the field below. The bottom of the apse has the usual procession of lambs from the cities, but the central Lamb of God is here replaced by the figure of St. Apollinaris.

In the cathedral of Parenzo in Istria, within the immediate artistic domain of Ravenna, it is not surprising to find an apsidal mosaic which repeats even more closely than SS. Cosmas and Damian the composition of S. Vitale. But it shows as well a weakening of iconographic standards: the two angels here attend the enthroned figure of the Madonna, elevated for the first time to a position at the liturgical focus of the church, and the three saints on the Virgin's right are balanced at her left not only by the donor of the mosaic, the bishop Eufrasius (*c.* 540), but his archdeacon Claudius and this ecclesiastic's son. The beardless Christ on the globe of S. Vitale is also present here, but transferred to a secondary post at the top of the arch, receiving advancing files of wreath-bearing apostles.

The same Latin enthronement on the globe is used for the Christ who is the center of the mosaic on the arch of S. Lorenzo *fuori le mura* at Rome, dating at the end of the sixth century, where the Saviour's attendants are Peter, Paul, and a trio of favorite Roman saints—Lawrence, Stephen, and Hippolytus. The Latin early Christian iconography is dissolving here; the cities of Bethlehem and Jerusalem in the spandrels of the arch are represented without the processions of lambs, and a sign of late date is the jeweling of the city's walls. Christ at S. Lorenzo holds a staff-cross, and this motif continues in the seventh-century apse of the little rotunda of St. Theodore below the Palatine at Rome, where again the Ravennate globe is the Saviour's throne. About the middle of the seventh century, the church of St. Agnes outside the walls received its apsidal mosaic, which illustrates the growing cult of the saints by giving the central place of honor to St. Agnes herself, standing in imperial Byzantine dress above the flames and sword of her martyrdom, and attended by the two popes Honorius and Symmachus, who were donors of the mosaic and the church. The frontal style is moving toward the Byzantine: the golden background which became the norm in Ravennate mosaics is here the more effective as a spiritual *locus* by reason of the wide spacing of the fewer figures. These have almost the Byzantine stance with weight on one leg, but still retain, in the too wide placing of the feet, the unsteady posture of late antiquity.

Two mosaics of Rome are witness of the extent to which the art of the decadent erstwhile capital had capitulated to the East in this period of the

seventh and early eighth century, when nearly half of the reigning popes were of oriental origin. In the chapel of S. Venanzio at the Lateran, the long files of Dalmatian martyrs who flank the orant Virgin and Peter and Paul make up a composition evidently based on an Asiatic Ascension like that of the Gospel Book of Rabula; although the ascending Christ has been changed to a bearded bust, the two supporting angels remain as half figures on either side. A direct importation of Palestinian iconography is the bust of Christ surmounting the Cross (as on the oil flasks used by pilgrims in the Holy Land) which forms the central feature of the mosaic in the apse of S. Stefano Rotondo, commissioned in the forties of the seventh century by Pope Theodore, himself of Palestinian origin.

THE END OF EARLY CHRISTIAN ART

The practically universal acceptance of this two-dimensional, frontal, flat, and unreal presentation of Christian themes throughout Italian painting of the sixth and seventh century, and as we have seen, in Coptic frescoes as well, shows how completely Asiatic style, and the Asiatic transcendental attitude it expressed, had subjugated Mediterranean art by the time of the Islamic conquest. That its diffusion in Italy was indirect for the most part, coming through the intermediary of Constantinople, can be surmised not only from the dependence of Ravennate style on that of the eastern capital, but from examples within the sphere of influence of Constantinople itself, which reveal the same manner that is used in the Italian mosaics, although with the better design that always distinguishes authentic Greek style, in mediaeval as in ancient art, from its Latin version.

At Constantinople itself nothing survives of the age of Justinian or of the seventh century, save the ornamental borders and fields of the mosaics in the narthex of Hagia Sophia, uncovered lately under the patient and skillful direction of Whittemore, who ascribes this decoration to the sixth century. But in Salonica, western outpost of Constantinopolitan art, recent research has given to the cupola mosaics of St. George a dating in the sixth century more credible than that in the fourth or fifth hitherto generally accepted. The mosaic of this dome is a sort of Christian calendar, presenting a row of orant saints, each with his name and feast month inscribed beside him, who stand in rigid frontality reminiscent of Ravennate sarcophagi and mosaics of the sixth century, in front of a bewildering façade of fantastic architecture, piled up in the illogical construction of the architectural backgrounds of Pompeian wall painting in its final stage. The use of architectural forms as the base motif for the decoration of a vault, in contrast to the Alexandrian river landscape, we

[88]

have seen before in the dome of the Orthodox Baptistery in Ravenna, and can recognize as another expression of the Greco-Asiatic preference for limited space, and a development of the old architectural background of the Asiatic sarcophagi. A highly interesting series of Salonican mosaics is that which decorated the aisles of the great church of St. Demetrius, but were unfortunately destroyed in a fire of 1917. Demetrius was patron of the city, and credited with staving off the seventh-century attacks of Avars and Slavs. The mosaic panels seem to have been individual ex-votos set up in honor of the saint in gratitude for some miracle of healing, and intended also to restore the decoration of the church after a fire in the seventh century. They cannot have been far apart in date, so uniform was their style, which corresponded in every way, save for the better preservation of Hellenistic form, to contemporary mosaic art in Italy. The figures usually compose a group of Demetrius and the donors, frontally and symmetrically posed in observance of strict Greco-Asiatic rules, but here and there appears a strange divergence from this hieratic manner, in landscapes opening into depth of background with mountains, trees, and the traditional stele that marks the Alexandrian style.

The same phenomenon is found in a mosaic of the apse of the church of Hosios David at Salonica, of which a mediaeval tale relates that it was made first to represent the Virgin, was miraculously transformed into a Christ, and later, after being walled up, was uncovered by an Egyptian monk. Whatever historical connection with Egypt may be concealed within the fantasy of the story, the artistic relation is clear, for the scene depicts the Vision of Ezekiel in close imitation, with its short-haired Christ figure impersonating the Logos, its round glory and four Beasts, of the frescoes of that subject at Bawit and Saqqara. Beside the Vision the prophets Ezekiel and Habbakuk are figured in the foreground of a landscape with the mountains, trees, and half-concealed silhouettes of buildings, which are the hallmarks of Alexandrian style. The resemblance to late Coptic frescoes, and the arc of heaven that forms the throne of the Lord (first seen in Christian iconography on a leaden pilgrim ampulla of the end of the sixth century) indicate a date in the seventh century for this mosaic as well as for the exceptional landscapes in S. Demetrius.

Such sporadic appearance of the Alexandrian manner in the midst of the prevalent Asiatic style, and at the time of the Islamic conquest of the Delta, suggests that Alexandrian artists, seeking refuge and employment in other seaports of the Mediterranean, were responsible for these intrusions of an exotic manner into the dominating art of the Christian world. We probably also owe to the Moslem conquest our finest collection of early Christian silver—the silver plates with repoussé reliefs of the life of David, most of which are

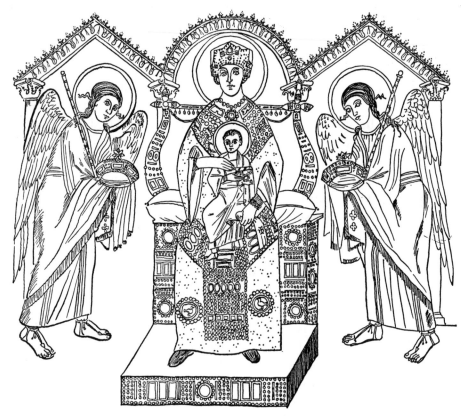

ROME, S. MARIA ANTIQUA: *The Crowned Madonna*

in the Metropolitan Museum at New York. These were found buried on the island of Cyprus, and since the coins found with them date as late as the mid-sixth century, it is a plausible conjecture that they were concealed in the seventh, in anticipation of an Arab raid. On these the style of the Joshua Roll and the Paris Psalter is seen in an earlier phase, and consequently more retentive of its Hellenism. The *Combat of David and Goliath* on the largest of the plates (*Fig. 19*) repeats in all essentials the corresponding miniature of the Paris Psalter, revealing thus a similar derivation from the illustration of the Septuagint.

The migration of artistic exiles from Alexandria was not confined to Salonica. In the middle of the seventh century the style of the Egyptian city interrupts, as it did at S. Demetrius, the Asiatic mode till then employed in the frescoes decorating the church of S. Maria Antiqua in the Roman Forum. The earliest fresco of this church is a sixth-century composition in the apse depicting the Madonna enthroned with an angel at either side, against a back-

ground which repeats the arch-and-gable alternation of the Asiatic sarcophagi. She wears a crown, an attribute never found on early east Christian Madonnas, but otherwise her stark frontality and the symmetrical convention of arrangement align the painting readily enough within the Ravennate version of Asiatic style. But in the seventh century a number of paintings were executed in the church in a manner wholly alien to this Italo-oriental art, showing casual grouping, depth of composition, and occasional lively movement, which combines with a markedly superior plastic realization of the mass of the human figure to assure us of the intrusion here, as well as at Salonica, of a troop of Egyptian painters. With this came also certain features of Nilotic iconography, such as the "Holy Mary" title peculiar to Egypt, the Virgin seated in the Annunciation, and the Christ child enclosed in an aureole which the Virgin holds.

This Greek style lasts through two generations and is accompanied by Greek inscriptions; but in the eighth century the paintings of the church begin to return to the Asiatic manner and to Latin labels. An excellent example of this change, with somewhat of the Alexandrian plasticity still lingering in the modeling, can be seen in the *Crucifixion* of a lateral chapel in S. Maria Antiqua (*Fig. 36*). The fresco of purest Greek style is the *Annunciation* of the seventh century on a pillar of the nave, with a Gabriel whose windy drapery and lithe form is a not too distant reminder of the *Victory* of Samothrace. Another is the group of the Maccabean martyrs of Antioch, Salomona (*Fig. 35*) and her sons, with the scribe Eleazar. In these and somewhat later paintings such as the *Adoration of the Magi* and *Christ carrying his Cross,* the resemblance is so close, of profiles, rounded backs, and hair treatment, to the drawings of the Joshua Roll and the miniatures of the Paris Psalter, as to afford our best evidence for the dating of these illustrations about the time of the second generation of Alexandrian artists at S. Maria Antiqua, in the period from the end of the seventh century to the early eighth.

The Moslem conquest did more than scatter the seeds of Alexandrian style. By lopping off the oriental lands of Syria, Palestine, and Egypt, it closed to Christian art these wellsprings of eastern influence which had succeeded in denaturalizing the Hellenistic tradition from Antioch in the east to Italy in the west. Mediterranean art, in the period succeeding the Conquest, became on the whole more Hellenistic than before, as if because thenceforward it was confined to lands more Greek by history and tradition. This probably is the reason for the stronger Hellenism in Byzantine style as it commences its integration in the eighth and the following centuries, even more than the Iconoclastic Controversy that racked the eastern Church for a hundred years from the

middle of that century to the middle of the ninth, and is thought by some, because of the retarding of religious painting which resulted, to have turned the artists back to pagan Hellenistic models. But some credit for the Hellenic revival is doubtless to be given to the dispersion of the Alexandrian schools that followed the Islamic wave, and the consequent implanting of their style in centers less impregnated with antique tradition. We know that the libraries of Constantinople were the hunting ground of artists in search of models, not only for the illustration of books but for sculpture as well, as we shall see in a later examination of Byzantine ivories. The Joshua Roll must have been one of the chief treasures of such a library, and the Genesis of Vienna too, for their miniatures were copied by Byzantine ivory carvers in the tenth and eleventh centuries. The Roll was the model for a series of pictures in an Octateuch now in a monastery of Mount Athos, dating in the twelfth century. Miniatures of the Paris Psalter were copied in the Bristol Psalter of the eleventh century, and in two other books of Psalms of the twelfth, in the Vatican Library and in Leningrad.

The importance of these book illustrations and their constant and careful copying, in the formation and direction of Byzantine style, may be qualified by remembering that they constitute our only existing examples for certain periods of the art of the eastern Church. The early frescoes and mosaics have disappeared. But the book miniature remains as the chief determinant of Byzantine iconography at least in the case of its narrative cycles, and consequently a principal avenue as well for the transmission of style. From the gradual monumentalizing of the miniatures into larger scale, and the infusion of broader and deeper dogmatic content under ecclesiastical direction, came the impressive and stately themes of the mosaics and frescoes decorating the Byzantine churches of the eleventh and twelfth centuries.

III

Byzantine Art

CONTEMPLATIVE MYSTICISM

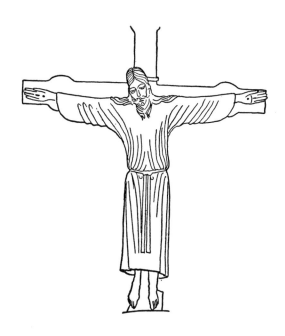

THE FORMATION OF BYZANTINE STYLE

THE TRANSFORMATION OF early Christian art into Byzantine was a process in which the city of Constantinople held the leadership throughout. Here was focused the reviving Hellenism which resulted from the loss of the eastern provinces to the Moslems, the consequent lessening of the pressure of oriental notions on east Christian art, and the infusion of the Alexandrian tradition, exiled from its native land and taking refuge, as we have seen at Rome and Salonica, within the Greco-Roman bounds of the diminished Empire. Every phase and change of Byzantine style, from the time its distinctive features began to appear in the eighth century, to its full development in the eleventh and twelfth, was shaped and conditioned by the fashion of the capital, as was the art of Europe and America by the taste of Paris in the latter half of the nineteenth century. The role of Constantinople becomes the more apparent as we note the lag in style and iconography on the Empire's frontiers—in Italy at the west and the Asiatic provinces to the east. Throughout the evolution of the art of Byzantium this contrast between the metropolitan and provincial manners can be observed, the latter clinging to early Christian habits and oriental or Latin prepossessions, the former achieving a new synthesis of oriental color and pattern with Hellenic form, steadily deepening its content,

[95]

clothing its concepts with the splendor of the Byzantine court, and arriving at a distinction of style that made Byzantine design the norm of elegance not only within its own domain, but in the Latin West and Moslem Orient.

The account of early Christian art outlined in the preceding chapter has brought us to the eighth century, which is the period least represented by existing examples of Constantinopolitan art. But it is not without products of provincial archaism. At S. Maria Antiqua in Rome, as we have seen, the Alexandrian infusion of the seventh century was by *c.* 700 giving way to a resumption of the Ravennate version of Greco-Asiatic style which had been domesticated in Italy since the sixth. A good example of this reversion of manner at the Roman church was furnished by the *Crucifixion* in the lateral chapel of S. Maria Antiqua, where Asiatic iconography has determined the form of the Crucifixion, retaining the colobium on the Crucified which he wore in the Syrian Gospel book of Rabula, and the lancer and sponge bearer (*Fig. 36*). The reminiscence of the waning Alexandrian influence may be seen in St. John's firmly planted feet and some semblance of depth of composition and background. But even this is absent from the succeeding frescoes of the church, where flatness of form, frontality of posture, and rhythmic rather than natural composition are the rule.

Rome indeed provides a curious illustration of provincial style in both Italy and Palestine, in the eighth century, by virtue of the preservation of the frescoes of the lower and original church of S. Saba on the Aventine. This church was founded *c.* 600 by Basilian monks who had migrated, perhaps under the threat of a Persian raid, from their monastery near Jerusalem, and the use of Greek labels on its frescoes until the ninth century shows that the monastery retained till then, and doubtless till its occupation by the Benedictines in the tenth, an oriental character. One of the frescoes is a rendering of the Healing of the Paralytic at Capernaum, in which the sick man's bed is let down through the roof, according to the east Christian scheme employed in the corresponding scene at S. Apollinare Nuovo in Ravenna; and another picture, of Christ saving Peter from the sea, is with one exception the first occurrence of this subject in the West, though we have found it already in Asiatic usage at the Christian chapel of Dura, and among the lost scenes of the Life of Christ in S. Sergius at Gaza. The figure of Christ in these frescoes is typical of the period— larger in scale than in the miniatures of the early Christian gospel books, bearded as regularly hereafter in east Christian art, wearing a nimbus in which the cross has lost the flaring arms typical of the earlier period and assumes the rectilinear form that will be the Byzantine norm for this and the following century. The Saviour is solemnly erect and majestic, the other figures seem

[96]

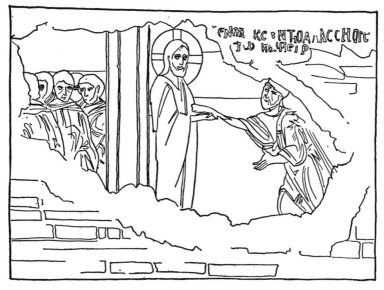

Rome, S. Saba: *Christ Saving Peter*

suffused with consciousness of a deeper significance in the episode than was present in the minds of the storytelling illustrators of the gospel books of Rossano and Sinope. The backgrounds are neutral, the figures flat and linear in design.

Another phase of this provincial style is presented by the miniatures on the fifteen leaves of a Greek lectionary in the Public Library of Leningrad (No. 21).[1] These folios are bound in with a text of the Gospels of the tenth or eleventh century, in a codex that came originally from Trebizond; and for this reason as well as the style of the miniatures, the provenance of the folios is considered to be eastern Asia Minor. Their date is disputed; no set of miniatures has received so many datings (eighth, ninth, tenth, eleventh centuries), but the text remaining upon the leaves is a large early uncial, the iconography of the scenes is archaic, and the borders of the pictures use a foliate design like the teasel plant, or rows of jewels, and the "rainbow" band, or the device like a carpenter's square that carries a garland around the corner of a frame (*Fig. 39*)—all of them motifs to be found in the borders of the Paris Psalter (p. 51). It seems impossible therefore to date the miniatures later than the eighth century, and they are more readily understood in point of style and iconography as the continuation of the sort of illustration found in the gospel books of Rossano and Sinope.

[1] These miniatures are reproduced in the author's article "Notes on East Christian Miniatures," *Art Bulletin*, XI (1929), pp. 53 ff.

They employ for instance the same semifrontal, semioblique position of the head, a similar treatment of hair and eye, and the curious angle formed by the familiar Asiatic "pompadour" across the forehead when it meets the vertical contour of the side of the face. The figures appear as enlarged versions of those of the Rossanensis and Sinopensis, and their drapery bears another indication of early date—the "letters," or "musical notes," so called from their peculiar and angular shape, which represent ornamental patches sewn or woven on the garments. The compositions of the Last Supper and the Washing of Feet are essentially the same as in the Rossanensis. But one can divine in the art of these miniatures even more of that deepening of content which was observed in the frescoes of S. Saba: the faces show intent and sensitive reaction; the ulterior meaning of the episode beneath its narrative surface is not rendered by the obvious introduction of the prophets as in the early Christian illustration, but expressed in the scene itself. If one wishes to gauge the Byzantine mystic attitude thus appearing, let him compare the Leningrad miniatures with the allegories of the Paris Psalter, where the implications of the scene are intellectually rendered by the female personifications, but not visible in the faces.

The dependence of this Asiatic style on Constantinople is nevertheless certain, for the Leningrad artist used as models for his portraits of John and Mark the Evangelists pictured in some early gospel book, which were copied also by the Constantinopolitan painter of the evangelist portraits in a tenth-century manuscript of Mount Athos (Stavroniketa 43). This artist, a finished manipulator of metropolitan style, handled with ease the perspective Alexandrian backgrounds of his model (p. 114), but the Asiatic miniaturist of the lectionary made hopeless confusion of their architectures and landscapes, as something alien to his two-dimensional tradition. He also knew Constantinopolitan fashion in the matter of borders, since his vocabulary in this respect is that of the Paris Psalter's miniatures, which must be dated along with their stylistic parallels in the drawings of the Joshua Roll and the "Greek" frescoes of S. Maria Antiqua, no later than c. 700, and credited to a Constantinopolitan atelier.

The robust Hellenism of the Psalter's pictures, the competent handling of Alexandrian landscape in the best of them, their objective naturalism in the rendering of episode, with esoteric content relegated to the personifications, present a striking contrast to the spiritual primitivism of the provincial works just described. They also bring a fresh vitality into the Greco-Asiatic art inherited by Byzantium from early Christian times. Lively and free movement contrasts with Neo-Attic immobility, depth of space with neutral background,

and robust modeling with flattened forms, made flatter by the unmodeled color preferred by Asiatic taste. This was the element, conveyed by the expatriate Alexandrian style, which was ultimately to re-Hellenize the art of Constantinople, to oppose its naturalism to the oriental trend toward pattern, and give some illusion of form to the dogmatic abstractions of Byzantine art. Its effectiveness in this respect was enhanced by the Moslem conquest, which cut off the oriental provinces of the Empire and isolated from these wellsprings of eastern style the ancient Hellenic core, in Greece and Asia Minor, of the Byzantine polity. But the creative process whereby the Alexandrian infusion could be absorbed in Byzantium's native Neo-Attic–Asiatic tradition was checked by the outbreak of the Iconoclastic Controversy.

❖ ❖ ❖ ❖ ❖

The Controversy lasted with varying intensity from the edict of the emperor Leo the Isaurian in 726, prohibiting the use and worship of sacred images, to the restoration of the images in 843 by the regent Theodora, an event still celebrated in the Greek church on the first Sunday in Lent, as the feast of Orthodoxy. The ban was not complete throughout this period; in 787, at the second Council of Nicaea, the church restored the images to veneration, but the general attitude of the Isaurian and Phrygian dynasties was iconoclastic. In this they were supported by the army, by a portion of the clergy, and by the more eastern Asiatic populations of the Empire, from which the Isaurian dynasty itself was sprung. The opposition came from women in every section of the Byzantine domain; from the monks, whose great spokesmen were John of Damascus in the eighth century, and, in the ninth, Theodore, the leader of the violently iconodule monks of the Studion monastery in Constantinople; from most of the peoples of the European provinces, still Greek enough to find no fault with the materializing of divinity; and finally from the Latin branch of the church, whose steady refusal to follow the iconoclastic decrees finally led to the complete separation of the eastern and western confessions, and ended the lingering concept of a pan-Mediterranean Roman empire. In 781 Pope Hadrian ceased to use the regnal year of the eastern emperor in dating his documents, and in A. D. 800 Charlemagne was crowned emperor of the West.

It is not difficult to see that the Controversy was the culmination of the old dogmatic opposition of Oriental and Greek, of the monophysite and eastern insistence on the completely supernatural concept of deity, against the Greek and orthodox perception of both human and divine in the person of Christ. Almost every theological dispute in the church had hinged upon this disagreement.

The extraordinary aspect of the contest in its ultimate phase was the political complexion which it quickly assumed: when the decree of Leo III was promulgated in 726, Greece and the islands of the Aegean proclaimed a rival emperor and almost the whole of the exarchate of Italy rose in revolt. The revolt of Artavasdus against Leo's son Constantine V was engineered and supported by the orthodox iconodules in 741; it was suppressed, and followed in 753 by the Council of Hieria condemning image worship, which in turn initiated the most violent attack of the iconoclasts upon ecclesiastical art and the monks as the chief purveyors of icons. Constantine V destroyed the mosaic Life of Christ in the Blachernae church, replacing the scenes with "trees, birds of all sorts and animals, framed in the rinceaux of a vine." "All beauty," writes a contemporary observer, "disappeared from the churches." The brief restoration of the images under Irene, who assumed the Byzantine imperial title despite her sex, was effectuated at the second Council of Nicaea in 787, at the behest of a woman who was devoted like most Greek women to the cult of images, but scheming to use the orthodox interest in furtherance of her own ambition. In the ninth century the conflict had assumed the wider outlook of a struggle between church and state, and while another severe persecution took place under Theophilus (829–842), in which we hear of the torturing of icon painters, and the branding of the foreheads of iconodule leaders, the underlying issue was whether the emperor or the patriarch was the head of the church. The dogmatic controversy ended with the restoration of the images by Theophilus's widow Theodora, regent for the infant Michael III, but the triumph of orthodoxy was won at the expense of ecclesiastical liberty; thenceforward the constitution of the eastern Church was Caesaropapism, a definite subordination of ecclesiastical organization to imperial authority.

The effect of the Controversy on the artistic life of Byzantium has doubtless been exaggerated, but it must have been considerable. We have no monument of religious architecture, sculpture, or painting surviving or recorded in the capital during this period. Italy alone, as if to underline her defense of images, produced a florescence of ecclesiastic art in the time of Paschal I (817–824) and Gregory IV (827–844), represented by the mosaics which these popes installed in the Roman churches of SS. Nereo ed Achilleo, S. Maria in Domnica, S. Cecilia, S. Prassede, and S. Marco (*Fig. 37*). The mosaics of the last-named three are copies of the composition on the apse and arch of SS. Cosmas and Damian, and the ceiling of the chapel of S. Zeno at S. Prassede repeats the caryatid angels, supporting here a bust of Christ, which adorned the vault of the choir of S. Vitale in Ravenna. The cult of the Virgin, an especial prepossession of Paschal, and valiantly defended by the iconodule crusaders, is vindicated in the

apsidal mosaic of S. Maria in Domnica, where she is enthroned amid a throng of angels, with Paschal kneeling at her feet. The veneration of Mary is also curiously apparent in metalworks commissioned by this pope, namely, two silver reliquaries found in the same treasure of the Sancta Sanctorum at the Lateran which preserved the pilgrim's souvenir box (p. 70). One of these is decorated with repoussé reliefs of the Theophanies, the appearances of Christ after the Resurrection, and the Virgin is introduced into some of these scenes to which she does not, textually, belong. The most important item among such survivals of ninth-century metalwork at Rome is a gold cruciform reliquary for a fragment of the True Cross (now in the Museo Sacro of the Vatican Library). The enamels which decorate this piece include an inscription stating that it was commissioned by Paschal as an offering to the Virgin, and illustrate, on the one face of the cross which remains, the scenes of Christ's Infancy. They are executed in cloisonné enamel—the first datable example of the introduction of this Persian technique into what may be called, despite its provincial character, a phase of Byzantine art within the iconoclastic period.

The influence of the East, suggested by the introduction of cloisonné, is apparent also in the descriptions which have come down to us of the palace which the emperor Theophilus built at Constantinople, in which one can divine an imitation of Arab palace planning. The Triconchos or throne room followed as its name implies the trefoil plan of early Islamic design. Its west side opened on the Sigma terrace (the name connoting the semicircular form of the later Greek sigma), brilliant with polychrome marbles and gilded ceiling. Beyond this terrace was a colonnaded court descending to the open area of the Phiale, whose central feature was a bronze fountain edged with silver with waterspout in the form of a golden pine cone. Around this central portion extended collateral rooms whose names connote the luxury of their decoration—the Hall of Love, the Triclinium of the Pearl—and pavilions in the midst of gardens, incrusted with marble, and with ceilings of gold mosaic, adorned with a subtle elegance that suggests names such as those of Musikos and Harmonia, given to the sleeping chamber of the empress. The oriental luxury of such installations was supplemented by ingenious displays of mechanism; in the hall of the Magnaura the imperial throne was shaded by a golden plane tree with its foliage interspersed with birds; the throne was flanked by golden lions and griffins, and faced organs ornamented with enamels and jewels. On the occasion of receptions of state, the moment of obeisance to the emperor was marked by operation of the mechanisms; music came from the organs, the birds raised their wings and sang, the griffins rose, the lions lashed with their tails and roared.

Results of the Iconoclastic Controversy emerge in odd but sometimes important aspects. One was the migration, by thousands, of persecuted monks to the south of Italy, the most Greek, save Venice, of the regions of the peninsula, and even more faithful than Venice to its Byzantine allegiance. There they founded new monastic centers of the Basilian type and decorated their curious underground grotto-churches with frescoes which only now are receiving adequate study, as reflections, however wanting in sophistication, of periods in Byzantine style otherwise undocumented. Another consequence of the struggle of the orthodox party to sustain by tradition the propriety of Christ's portraiture was the appearance in literature and art at this time of his legendary likeness. In this category is the detailed description of the Saviour written by John of Damascus, wherein we can read a translation into words of the traditional type of John's own country of Syria: a stately figure with meeting brows, large nose, and curling hair, black beard, broad hands with long fingers, and a complexion of palish yellow "like his Mother's." The portrait of Christ painted by St. Luke is first heard of in the protest which Pope Gregory II sent to Leo III after the edict against the images of 726, and appears again in a

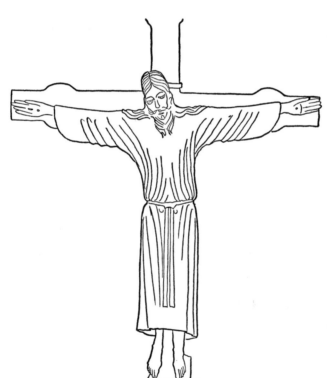

LUCCA: *The Volto Santo*

ninth-century life of Theodore of the Studion. The portrait, miraculously created, which Christ was believed to have sent to King Abgar of Edessa is cited by both the Pope and John of Damascus; four examples of this now claim originality—those at S. Silvestro in Rome, at the Sainte-Chapelle in Paris, in Genoa, and at Nazareth. Many of these miraculous icons in Latin churches have a history traceable to the iconoclastic period, in stories relating their supernatural translation from the East, and probably were exported during the Controversy for preservation from destruction. One such is the famous

Volto Santo of Lucca, which arrived according to local tradition in 782, a wooden crucifix with Christ clad in the Syrian colobium, attributed to Nicodemus, all except the face, which was carved by angels while Nicodemus slept. A third result of the struggle was the introduction into church decoration, by the iconoclasts themselves, of the Cross as substitute for human images. The cross discernible under the later Madonna in the apse of Hagia Sophia at Salonica has been attributed to this period, and that which still decorates the apse of Hagia Irene in Constantinople dates from a restoration by the iconoclast Constantine V.

❖ ❖ ❖ ❖ ❖

It was during the iconoclastic period that the last recorded imperial statue was erected in Constantinople—that of Constantine VI (780–787). This is worth noting, as showing the gradual elimination of sculpture in the round from an art that was less and less interested in the third dimension. Already in the Greco-Asiatic style the early Christian art had reduced its concepts to length and breadth alone, not only under the pressure of the oriental taste for pattern, but because its transcendental content could not brook the material reality connoted by plastic form. We have seen the infancy of this attitude in the paintings of the catacombs, striving to express their naïve symbols in the untoward vocabulary of Hellenistic naturalism. It becomes more positive and self-conscious in the reliefs of the sarcophagi and ivories and the mosaics of the fifth and sixth centuries, in which a triumphant church constructed out of the Old and New Testaments a Christian epos, recording the history of the faith. Through this historical phase of early Christian art one can trace the growth of dogmatic content—in the introduction of the *dittochaeum,* the parallel of Old and New Testaments which Paulinus of Nola employed to decorate his churches, which inspired the poetry of Prudentius, and selected the subjects on the doors of S. Sabina.

This concept of the old dispensation as prophetic of the new finally invests the narrative art of illustration with fresh significance; in the gospel books of Rossano and Sinope the prophets are witness to the fulfillment of their words in the Life of Christ, and even the New Testament parable of the Good Samaritan becomes didactic with the Saviour in the role of its protagonist. The character of Byzantine art lies in the consistency with which it pursued this sublimation of the Christian theme, seeking ever the expression of mystic truth in the intelligible form of dogma, dwelling on that which does not change but is, excluding the specific details of naturalism that might impair the timelessness of its ideal. In such an art, sculpture must needs divest itself of

material mass, and what Byzantine sculpture we have is actually in flat relief, tending less and less to concern itself with figures, and more and more with abstract geometrical design. The major arts of Byzantium were architecture and painting. When Irene, restorer of the image cult in 787, replaced the statue of Christ which Constantine had set up over the entrance to the imperial palace and Leo the Isaurian destroyed, she substituted an image in mosaic.[2]

The mysticism that Byzantine art expressed was contemplative; the emotion it inspired, profound and introvert, expressed itself not in dramatic action by the figures in its sacred themes, but rather in the absence thereof. The protagonists seem to be above and beyond what they portray, demanding, with gaze fixed often not on the episode but on the spectator, his recognition of ulterior significance. The clearest evidence of this contemplative Byzantine detachment is the feature that most distinguishes the liturgy of the eastern from that of the western Church—the iconostasis which screens the mystery of the Mass from the congregation. It had already appeared in primitive form at Hagia Sophia in Constantinople in the time of Justinian, when an elaborate chancel was erected in the church, of which we have a poetic description by Paulus Silentiarius. It was a colonnade, with the intercolumniations half closed by panels, and the entablature adorned with figures of Christ, a group of angels, the Virgin, prophets, and apostles. The *Heavenly Hierarchy,* composed by a writer who assumed the name of Paul's disciple Dionysius the Areopagite (Acts xvii:34), had begun its circulation in the eastern Church shortly before. In this the heavenly hosts are grouped about their King in the nine gradations of seraphim, cherubim, thrones, virtues, dominations, powers, principalities, archangels, and angels—in a descending scale which parallels the elaborate officialdom of the Byzantine court. Such compositions as that of Justinian's iconostasis show the same assimilation to the imperial hierarchy; the enthroned Lord is the *basileus,* the Virgin his empress; the angels, prophets, and apostles his imperial entourage.

In the *Ecclesiastical History* attributed to Germanos, patriarch of Constantinople (715–730), we read that the "church is heaven on earth, in which lives and moves the heavenly God; it is a symbol of the Crucifixion, the Entombment and Resurrection of Christ, glorified above Moses's tabernacle of the Covenant, prefigured in the persons of the patriarchs, announced by the prophets, founded in the apostles, adorned in the hierarchy, consummated in the martyrs, and enthroned upon their relics." The symbolism permeating the art and cult invested the architecture of the church as well, and the central plan

[2] A passage in a letter of St. Germanos, patriarch of Constantinople in the eighth century, seems to imply that painting is "more holy" than sculpture (Epist. IV, *Patrologia Graeca* 98, col. 188).

that dominated Byzantine church building from the fifth century was so intimately adapted to the significant distribution of the decoration that one might believe the plan was a function of iconography. Of the prothesis and diaconicum, rooms or alcoves flanking the apse, the former takes on a special meaning. The diaconicum corresponds to the Latin vestry or sacristy, but the prothesis was the scene of the elaborate ceremony of the cutting of the wafer and blessing of the wine, with which the Greek Church began the divine service. This preparation of the elements of the Eucharist before the Great Entrance symbolized the Crucifixion, and the Great Entrance itself that opens the visible ceremony became a funeral procession whose goal was the altar conceived as the Holy Sepulcher. The prothesis was thus Golgotha and the altar the tomb of Christ, whose Resurrection was connoted by the Communion.

The rest of the church assumed a hieratic scale of sanctity; after the sanctuary, the nave and aisles were the sensible world, the upper parts of the church the intelligible cosmos, the vaults the mystical heaven. Holiness increased with nearness to the bema: the saints depicted on the walls were classified, with the monastic saints near the entrance, the ecclesiastics and martyrs further toward the eastern end, and the soldier martyrs in the places of honor on the soffits of the arches supporting the dome. The dome itself was reserved for the Christ Pantocrator, the Almighty, a bust of the Saviour in the aspect of Lord and Master of the Universe. Around him, on the base of the dome or on its drum, were ranged his satellites, the angelic hosts or prophets, and in the pendentives were the four Evangelists, revealing the Pantocrator to the world. The Second Coming was symbolized by the Etimasia (p. 80) on the ceiling of the apse, and the link between heaven and earth, between God and man, was furnished by the Virgin, regularly the occupant of the apsidal semidome. Below her, ordinarily, Byzantine usage prescribed a rendering of the Communion of the Apostles, first seen in the Gospel Book of Rossano, but gradually transformed into the Divine Liturgy, where Christ is the officiant, served by angels clad as deacons and carrying the instruments of the eucharistic celebration.

This symbolic system was only gradually developed, and can be found in consistency and approximate completeness only in churches of the eleventh century. But the core of it is already evident in the sparse details of the mosaics of the "New" church, the Nea erected by Basil I (867–886), as described in a sermon of the patriarch Photius. Here the main dome contained the bust of the Pantocrator, and the apse displayed the orant Virgin, "praying," says Photius, "for the safety and triumph of the Emperor over his enemies." The Pantocrator appeared again in the central cupola of the cruciform, five-domed church of the Holy Apostles, reconstructed by Justinian. This circumstance,

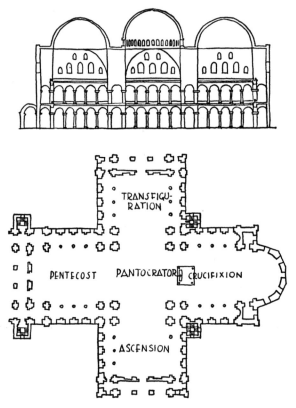

together with certain developed bits of iconography, gives color to the supposition that its mosaics dated not from Justinian's time but from a restoration by Basil I. The mosaics are lost with the church, like those of the *Nea,* but we have descriptions of them by Constantine the Rhodian in the early tenth century, and by Mesarites, *c.* 1200. Around the Pantocrator were arrayed the Virgin and the apostles. The rest of the subjects followed an historical arrangement and made up a cycle of the Gospels and Acts, retaining thus the tradition of early Christian art. But they were distributed into four chapters: the scenes of Christ's ministry were in the north arm, and crowned by the Transfiguration in its dome; the Passion in the east arm ended similarly with

PLAN OF THE CHURCH OF THE HOLY APOSTLES, CONSTANTINOPLE

the Crucifixion; the Theophanies after the Resurrection, terminated by the Ascension, occupied the south arm and cupola; on the west were the missions of the Apostles and the Pentecost. The disposition of the subjects shows a dogmatic as well as historical intention, and in the four compositions of the cupolas we see the nucleus of the later cycle of the Twelve Feasts, of which more hereafter. Another feature more Byzantine than early Christian is the inclusion of the four Evangelists among the apostolic Twelve. In the mosaic picture of the Holy Women at the Sepulcher, the artist Eulalios included his own figure standing by the Tomb, "like a sleepless watcher," in the words of Mesarites's description.

Of Basil I's buildings there is nothing left, nor of the mosaics that adorned them. One possible exception might be the lunette over the south entrance to the narthex of Hagia Sophia, recently brought to light by removal of the plaster with which it was covered under Moslem rule. It is executed in a style of sturdy forms and strong modeling that seems to indicate the ninth century,

and represents Constantine and Justinian making each his offering to an enthroned Madonna, Constantine presenting a model of the city of Constantinople, Justinian one of Hagia Sophia. The mosaic may belong to Basil's restoration of the church, occasioned by the threatened collapse of the great western semidome supporting the central cupola. On the soffit of its arch, when it was reconstructed, Basil placed a medallion of the Madonna flanked by Peter and Paul. Basil or his son Leo VI the Wise (886–911) may be the donor of another lunette in the narthex of Hagia Sophia, represented as a prostrate figure at the foot of Christ's throne; the Saviour's figure is flanked by symbols of his Incarnation—medallions containing busts of the Virgin and the archangel Gabriel of the Annunciation. The rest of the decoration of the great church is being slowly brought to light by Whittemore's painstaking removal of the plaster covering and his restoration of the mosaics.[3] Among the most recent of the works thus revealed is the huge Madonna of the eastern apse, possibly of Basil's time; otherwise a replica of one of that period. The great central dome, remade after an earthquake in the late tenth century, held the Pantocrator; on its pendentives are the four seraphim that can still be dimly seen beneath the Turkish plaster. The symbolic hierarchy was continued with the sixteen prophets on the north and south walls of the nave, and an array of bishops

[3] T. Whittemore, *The Mosaics of St. Sophia at Istanbul. Preliminary Reports,* Oxford 1933–47.

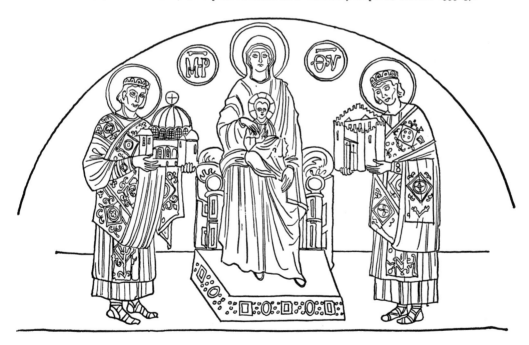

HAGIA SOPHIA: *Mosaic of the Vestibule*

[107]

below them. In the south gallery Whittemore has uncovered an arresting series of imperial portraits of the eleventh and twelfth centuries, and the fragments of a Deesis (Christ with Mary and the Baptist) of uncertain date. The group has fortunately retained the faces of the three figures, in which the profound significance of this thoroughly Byzantine theme may be read. It is the *Deesis,* or "Supplication," of Mary as guarantee of Christ's humanity, and of the Baptist as type of the old dispensation completed and justified in the new, for the salvation of mankind. The head of Christ is the finest presentation of the Saviour in Byzantine art, a finer rendering of the archetype followed by the Pantocrators in Sicilian domes and apses of the twelfth century.

Basil's mosaics were not limited to churches nor to sacred themes. In the Cenourgion, the magnificent addition he made to the imperial palace, the throne room was adorned with a composition representing the emperor seated amid his generals who offered him the cities they had conquered. On the ceiling were depicted his feats of arms and beneficial civic works. The ceiling of his bedchamber showed Basil and his family adoring the Cross, set in the midst of a starry heaven, and on the walls the same assemblage appeared, with the enthroned emperor as its central feature. It is in Basil's time that descriptions begin to emphasize the magnificence of the Byzantine court, its luxury, and the awe-inspiring sanctity surrounding the person of the basileus. The pages which his grandson Constantine Porphyrogenitus devotes to Basil's construction in his *Vita Basilii* abound in references to their costliness, of which an ex-

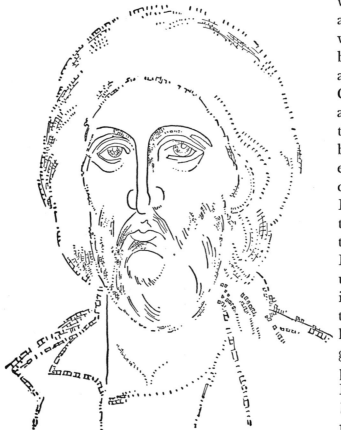

HAGIA SOPHIA, MOSAIC: *Head of Christ*

[108]

ample is the oratory of the Saviour built within the palace, paved and wainscoted with silver and further enriched with gold, pearls, and precious stones. Its iconostasis had columns and a stylobate of silver, with an entablature of gold in which were enameled images of Christ.

The splendor of the Sacred Palace—not to be thought of as a single building, but as a series of peristyles, courts, separate pavilions, baths, reception halls, churches, and chapels, in the midst of an enormous garden—was matched by the extraordinary luxury of the court ceremonial as described by Constantine Porphyrogenitus in the tenth century, designed to impress the populace and foreign observers with the power and majesty of the imperial authority. Brocades and silken tapestries were hung on the walls of the great Magnaura hall of audience when an ambassador was to be received; the pavement was covered with oriental carpets or rose leaves; the assemblage added its gorgeous color to the scene with the silver corselets and gilded shields of the guard, and the purple and gold mantles and embroidered tunics of the court officials. To augment the accent of inexhaustible wealth, the jewels and precious vestments of the imperial treasury were displayed, culminating in the golden throne set in the terminal apse for the emperor, and the gold chairs for the members of the imperial family. The plane tree and its birds, the lions, griffins, and the golden organ which were made for Theophilus in the ninth century added their mechanical wonders to the majesty of the sacred person of the basileus, who took his place upon the throne in the midst of organ notes and the chanting of choirs, and then was suddenly raised by an ingenious mechanism high above the audience, becoming thus a superhuman focus of adoration.

Of all this glory, so far as Basil's reign is concerned, there remains but one of the emperor's commissioned works—a modest one compared with the magnificence of his churches, palace, and mosaics, but precious to the art historian as almost his sole source for the style and iconography of Byzantine art at Constantinople in the second half of the ninth century. This is a richly illustrated manuscript written for the emperor between the years 880 and 886, containing the Sermons of Gregory of Nazianzus. The manuscript is now in the Bibliothèque Nationale at Paris (gr. 510). Its forty-six miniatures vary in style, apparently because they are adapted from illustrations which the miniaturist found in older manuscripts in the libraries of Constantinople. We know these were very large and rich: from the time of Constantine, the accumulation of books was an imperial interest, and one of the areas in Theophilus's Triconchos was reserved for a library. The extent of the imperial collection may be gathered from the loss of 150,000 manuscripts in a fire of the fifth century. In such stores of early illustrated codices the artist (or artists) of the Gregory

found their models, executed in both of the early Christian styles, the Greco-Asiatic and the Alexandrian; and the resulting series of illustrations in the Paris manuscript reflects the disparity of its sources. As might be expected, the scenes drawn from the Old Testament to exemplify the allusions in Gregory's homilies retain the traditional landscapes of the Septuagint and to a large extent the forms they assumed in early Christian art: such are *Joshua staying the Sun and Moon*, and *Moses smiting the Rock*, or *Receiving the Law*.

But one finds the same picturesque setting in new subjects drawn from Christian legend, such as the sequence relating the unhappy end of Julian the Apostate's expedition against the Persians, wherein the hated emperor meets his death not at the hands of the Persians as recorded by a too prosaic history, but from the lance of St. Mercurius, whose representation as a mounted warrior indicates an Alexandrian origin for the pictured story. The life and martyrdom of St. Cyprian are couched in similar Hellenistic terms: we see him clad in pallium, surrounded by the symbols of his unregenerate pre-Christian state as philosopher-magician, sending forth a demon to tempt the pious maiden Justina. The demon is repulsed by Justina's sign of the Cross and a Vision of Christ, and Cyprian's conversion in consequence is indicated by the two little idols which he plunges in water at his feet. Below, as a martyr, he is tortured in a caldron of boiling pitch, and beheaded. The backgrounds of these episodes are filled with foreshortened architectural perspectives and trees in Alexandrian fashion, but the miniaturist could not always cope with the compositional depth of his model, and was forced to diminish, completely out of scale, the extensive portico barring the demon's flight from Justina.

The same inability to compass or assimilate the Alexandrian third dimension, on the part of these disciples of Asiatic style at Constantinople, is even more evident in some of the miniatures which seem to be actual imitations of the Paris Psalter. In the *Penitence of David*, the figure of Bathsheba behind the throne, erased by a pious mediaeval hand from the Psalter's miniature as *fons et origo mali,* is here retained, but the continuous narrative of the earlier picture which repeated the figure of the king, enthroned and denounced by Nathan, and again kneeling, is condensed; the king has left his throne and kneels before the minatory Nathan, and the pagan personification of Repentance of the Alexandrian type is replaced with Byzantine piety by an angel.[4] Of particular interest is the comic reduction of architectural setting to the tiny structure at Nathan's feet. In similar fashion, the replica which the artist of the Gregory made of the Anointing of David has brought the pavilion which deepens the background in the Psalter's miniature down to the fore-

4 Buchthal, *The Miniatures of the Paris Psalter*, figs. 7 and 63.

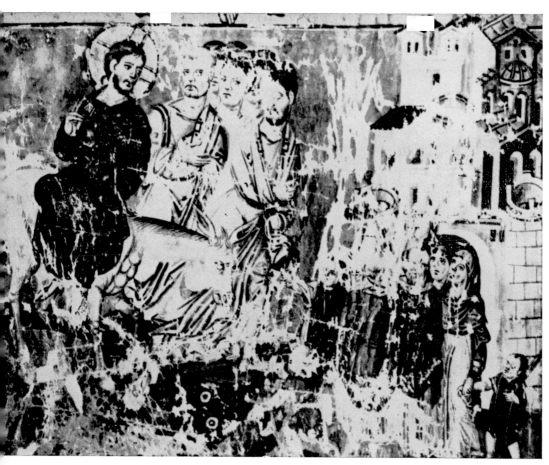

41. PARIS, BIBLIOTHÈQUE NATIONALE: The Homilies of Gregory Nazianzenus;
the Entry into Jerusalem

42. PALERMO, CAPPELLA PALATINA: Mosaic; the Entry into Jerusalem

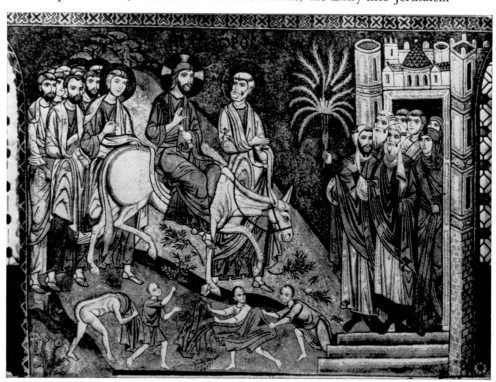

43. ROME, VATICAN LIBRARY:
The Joshua Roll; Joshua meets the
"Captain of the Host of the Lord"

44. ROME, VATICAN LIBRARY: Menologium of
Basil II; Joshua meets the "Captain of the Host
of the Lord"

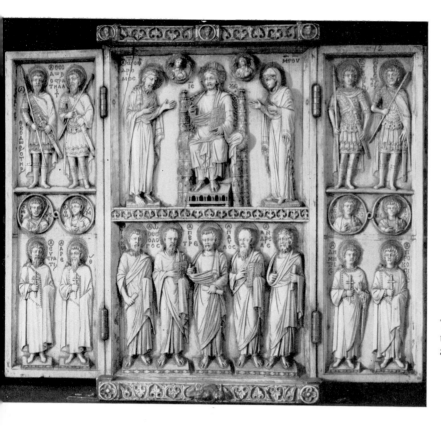

45. PARIS, LOUVRE: Ivory Triptych; the *Deesis* (Christ, the Virgin, John the Baptist), and Saints

46. VENICE, LIBRARY OF ST. MARK'S: Initial Page of a Byzantine gospel book

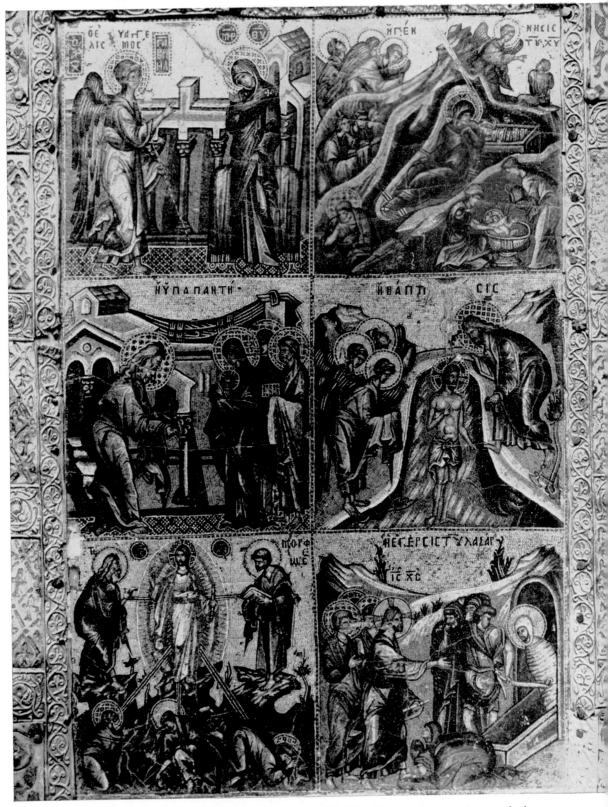

47. FLORENCE, CATHEDRAL MUSEUM: Portable Mosaic; the Feasts (Annunciation,
Nativity, Presentation, Baptism, Transfiguration, Raising of Lazarus)

ground in a scale so small that it is no higher than Samuel (*Figs. 39, 40*). This was done in the interest of his native preference for a two-dimensional composition, further evident in the alignment of the characters in a single row against a neutral ground. The personification of Meekness which the Psalter's miniature contained is omitted in accordance with the usual Byzantine practice of eliminating such heathen survivals from sacred themes.

In the New Testament episodes which Gregory cited in his sermons, the illustrator was more at home, these being, as we have seen, traditionally conceived in the Greco-Asiatic two-dimensional style which was Constantinople's inheritance from the early Christian period. The Asiatic iconography is faithfully followed: the Virgin stands in the *Annunciation,* and the *Entry into Jerusalem (Fig. 41)* and *Raising of Lazarus* are replicas of the compositions in the Rossanensis, though with an abridgment by elimination of detail which marks, as did the miniatures of the lectionary of Leningrad, the growing Byzantine quest for abstract and spiritual effect. The stature of the figures has not wholly emerged from the miniature proportions current in the early Greco-Asiatic cycles, and reminiscence of the facial types of the *codices purpurei* can still be traced in the Gregory pictures. The compositions are two-dimensional, with no development of space in the backgrounds, which are mostly blue. But there is stirring in these quaint illustrations the genius of authentic Byzantine style; in the unconscious effort toward symmetry and centralization instead of the earlier strung-out narrative, and in the attempt to eliminate environment evident in the bringing down of background architecture into the forward plane—naïve testimony to the Byzantine desire for symbolic rather than actual *ambiente.*

A similar conservatism of Greco-Asiatic style is shown by contemporary miniature painting in Asia Minor. This is represented by a class of manuscripts known as the "marginal" psalters, being texts of Psalms with illustrations painted on the margins of the page. They contain much evidence of Anatolian origin, and also enough of anti-iconoclastic propaganda to convince us that their cycle of illustrations cannot postdate the great controversy by many years. The earliest examples remaining date in the late ninth or early tenth century. While these examples and the formation of the illustrative cycle may be assigned an Asiatic and provincial provenance, the later ones cannot so be limited, and the most noted of these, the "Theodore" psalter in the British Museum (Add. 19352), was executed in 1066 by the monk Theodore of Caesarea at the Studion monastery in Constantinople. The tradition of this peculiar psalter illustration was so persistent that it can be followed in Russian religious art to the seventeenth century.

The inspiration of these miniatures is clearly monastic, and the manuscripts

MINIATURE OF A "MONASTIC" PSALTER:
Peter's Denial

are often called "monastic psalters" to distinguish them from the so-called "aristocratic" type represented by the Paris Psalter, which employs full-page instead of marginal illustration. The difference is much greater than a mere variation in the mode of illustration; for while the psalters of the "aristocratic" class represent their Biblical scenes with extrovert interest in the episode and humanistic personifications, the monastic illustrations are typological, like the prophets and the Christ-Samaritan of the Rossanensis.

When Moses smites the Rock, for instance, the Rock from which the salutary water flows is Christ, and is so indicated by the figure of the Saviour on its summit. The Asiatic roots of this art are evident in iconography: Christ wears the colobium in the Crucifixion, which itself conforms to the Syrian type illustrated in the Gospel Book of Rabula, and he distributes the Bread and Wine as in the Rossanensis. In contrast to Alexandrian practice, backgrounds are nil and personifications rare, while the colors used correspond to a degree with early Christian Asiatic miniatures. In one of the earlier of the group, for instance, the Chludoff Psalter in the Historical Museum at Moscow (cod. 129), the palette is dull rose, yellow, reddish brown, and purple, and Christ's drapery has gold hatching, like the golden mantle given him in the Rossanensis and the Sinope fragment. A further feature common to these manuscripts of probable Antiochene origin, and to the psalters, is light blue employed to render white hair. The figures are loosely drawn and modeled, but with a lively and expressive movement (in the early psalters) that seems to cling to monastic work in Byzantine art, and while the scale is small and the scenes conceived in the narrative vein of the early Asiatic miniatures, they are of surprising dramatic effect, often approaching the comic. Mediaeval legends find in them an early illustration, in the story of St. Eustace and the stag, and of the unicorn seeking the virgin. The monastic bias, and the atmosphere in which the cycle was first composed, are evident in occasional pictures showing iconoclastic persecution by way of illustrating the "wicked" in psalter texts—e. g., an emperor and bishop, enthroned and inspired by demons, superintending the painting out of an image of Christ.

MID-BYZANTINE MINOR ARTS. THE TWELVE FEASTS

The integration of Byzantine style was accomplished in the tenth century, through the amalgamation of its Greco-Asiatic tradition with the Hellenistic infusion stemming from Alexandria—a synthesis spurred by the instinct of Byzantine genius toward a loftier and more ideal expression of its themes, which tend to acquire in increasing degree as time goes on the serene authority of a classic style. Our monumental evidence is no more at hand than in the ninth century, and the evolution must be traced for lack of this in the ornament and miniatures of manuscripts.[5] In these the dominating role of the capital becomes more evident, and the metropolitan style can be detected in a fondness for gold and the blue that gives the gold its most splendid accent, and in an almost impeccable taste as it refines and modifies into more Hellenic form the motifs borrowed from oriental sources. Among these are Syrian canon tables with arches surmounted by plants and flowers and birds, after the manner of those in Rabula's Gospel Book, with their looseness corrected into the more precise Byzantine delineation. A feature that seems to show Islamic influence is the curious type of "jigsaw" ornament, in which rinceaux and foliate designs undergo a thickening of stems and leaves to make an equal alternating rhythm of solid and void in the pattern, after the manner of Byzantine silks of the time. Such ornament seems to have been influenced by early Islamic Cufic lettering, and such lettering is actually used for a border of a relief of the tenth century in the Byzantine Museum at Athens, which also displays the oriental composition of two lions flanking a tree. Other definitely Persian motifs are found: the birds with bands about their necks, and especially that luxuriant form of the palmette that first appears on Persian capitals in the late Sassanian period. This "Sassanian palmette," first used in manuscripts at the end of the ninth century, becomes in the tenth a stock motif of Byzantine illumination.

ATHENS: *Byzantine Relief*

The Alexandrian standing Evangelists appear in some gospel books, along

5 K. Weitzmann, *Die byzantinische Buchmalerei des 9. und 10. Jahrhunderts*, Berlin 1935.

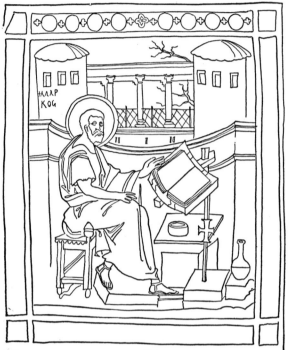

MINIATURE OF A GOSPEL BOOK OF MOUNT ATHOS
(STAVRONIKETA 43): *St. Mark*

with the Asiatic seated types which are the norm, and sometimes have brought with them their native background of garden wall and trees or an architectural perspective. They are thus represented standing in front of an architectural landscape in a manuscript of the National Library at Vienna (Theol. gr. 240). But it is noteworthy that the miniaturist, addicted by his native tradition to a Neo-Attic neutral ground, has eliminated the spatial depth such a setting might give, by *tooling* it into the gold background, and leaving the figure, despite its full and re-Hellenized modeling, in no space at all. Only once among these author portraits of the tenth century is the Alexandrian background fully expressed, namely in the quartet of Evangelists in the gospel book of Mount Athos which has been cited before (No. 43 in the library of the Stavroniketa monastery), where it is used with seated figures. It is in these pictures that tenth-century style most nearly approaches the miniatures of the Paris Psalter and the Joshua Roll: the space is rendered in foreshortened buildings with landscape indicated behind them, and the Hellenistic quality of these settings is matched by an excellent rendering of the figures in faces, pose, and drapery. The later date is betrayed by the tight precision which here replaces the impressionism of the earlier miniatures.

The same stiffening of the more fluent line of Hellenistic drawing is visible in the miniatures illustrating a copy in Florence of the *Treatment of Dislocations* by Apollonius of Citium, a Cypriote physician of the first century B. C. These afford a unique opportunity to judge Byzantine modeling, for in the pictures of operations the patient, the assistants, and even the surgeon himself are sexless nudes, with muscles organically marked off by streaks of high lights. The effect is too precise and metallic, and unreal to the extent that the figures stand on nothing and in no space, being painted directly on the vellum. Mid-

Byzantine features that are already apparent here are the overexpansion of the cranium in the heads, the exaggeration of high lights, and the curious immobilized effect of limbs and bodies in movement. The vellum ground also neutralizes any spatial effect in most of the pictures of a tenth-century manuscript of Oppian's *Cynegetica,* in the Marciana library at Venice, though some of the mythological scenes have backgrounds in rose and blue. Such subjects as Achilles in his chariot, Alexander pursuing Darius, Bellerophon slaying the Chimera correspond to those described as decorating the palace of the hero of the great Byzantine epic on the deeds of Digenis Akritas, which began its literary history in the tenth century. The most convincing revival of antique form and quality to be found in Byzantine manuscripts of this period is furnished by the medallion portraits of the prophets in a codex of Turin, wherein the artist has been able to preserve in no small degree the Hellenistic modeling of an early archetype.

At the end of the century the synthesis of Alexandrian humanism with the abstract transcendental manner contributed by the Greco-Asiatic tradition can be seen in the Menologium of Basil II (976–1025), in the Vatican Library, dating roughly a century later than the Homilies of Gregory executed for the first Basil, and showing by comparison the change that this lapse of time had wrought in Byzantine style. The Menologium is a synaxary, or collection of lives of saints or Gospel episodes commemorated in the months from September to February, arranged in the order of the feast days. The iambic verses of the preface hail the emperor Basil as "nursling of the purple"—a phrase applicable only to the second of the name, since the origin of Basil I was anything but imperial. The book contains 430 miniatures, of which over 300 represent the fate of Christian martyrs with the amount of monotonous repetition which the limited means of martyrdom entailed. These may be in part invented on the basis of literary texts, or copied from earlier synaxaries; the singular phenomenon presented by the miniatures of the codex is the uniformity of style, despite their varied sources and the fact that they are the work of eight painters of whom each signed his name to his miniatures. Such variation as occurs does not coincide with change of hand, but seems to be due to the model copied.

The Menologium's pictures, unlike the copies of the antique in the medical manuscripts and the Prophets of Turin, are of really Byzantine style; whatever models were used lost their character in the consistency of this art of the century's end. Its measure can be taken by comparing the drawing of Joshua's meeting with the Angel at Jericho, in the Joshua Roll of the Vatican, with the replica with which one of the artists of the Menologium illustrated the feast

of St. Michael (*Figs. 43, 44*); the sketchy impressionism of the Alexandrian style is stiffened to convention, with rhythm of pose and movement eliminated. The standing figures of the saints have increased their stature over the lower proportions of the ninth century (*Fig. 38*), and have acquired more volume in the body and more modeling of the face, which testify to a returning Hellenic sense of physical distinction. The mingling of the two late antique styles has here progressed to integration. The Alexandrian mountain slopes are present, interrupted at times by the protruding profiles of half-hidden structures; the favorite formula for the mountainous setting is a conical peak at one side contrasting with a hill sloping upward at the other—an arrangement which Byzantine art transmitted to the landscapes of Duccio. The buildings in the foreground (among them occasional renderings of actual churches such as the Holy Apostles and the Studion) retreat on the Hellenistic diagonal. But the favorite background is still the Asiatic wall, relieved with the draped hangings which were introduced by the Antiochene mosaicists of the third century. The landscape itself provides no natural setting; the atmosphere of these pictures is spiritual, not physical; real space and air are banished by what has become a Byzantine norm—the gold background. Against this gold ground there rises on a mountain top in one of the miniatures, as a far-off reminiscence of Alexandrian picturesqueness, the stele which was always the hallmark of Hellenistic landscape, recurring wherever this was used by Christian copyists, in the Genesis of Vienna, the Joshua Roll and the Paris Psalter, the Alexandrian mosaics of S. Demetrius at Salonica, the Homilies of Gregory, and here finally in pictures painted a thousand years after the motif was first employed in the wall paintings of Pompeii.

❖ ❖ ❖ ❖ ❖

The inference that one can draw from the descriptions of the churches, palaces, and ceremonies of Constantinople in the tenth century is that of a period of luxury, delighting in precious materials and complicated techniques. This century witnessed the full flowering of the Byzantine art of woven silks and cloisonné enamel, and the beginning of characteristic production in the ivory ateliers of Constantinople, whose beautifully executed pieces, together with the enamels and silks, were articles of export to the West.[6] On these was largely built the Latin concept, persistent through the Middle Ages, of Byzantine culture as a superior type of civilization.

[6] The Byzantine ivories are collected and reproduced in the corpus of A. Goldschmidt and K. Weitzmann, *Die byzantinischen Elfenbeinskulpturen des X.–XIII. Jahrhunderts,* Berlin 1930–34. On their chronology, see A. S. Keck and C. R. Morey, *Art Bulletin,* XVII (1935), pp. 397 ff.

The characteristic Byzantine ivory of the tenth century is a triptych with a projecting edge at the bottom of its central panel, into which the lateral wings are hinged by dowels. In the figures of these triptychs one can divine a growth of proportion toward monumental scale, and a trend toward abstraction in the composition, though far as yet from the elongated verticality of the forms, and the combination in composition of equilibrium and rhythm, which was attained in the eleventh century. These ivories are products of craft rather than creative talent, and in them the mid-Byzantine style is undeveloped; the personages have still a reminiscence of the unstable stance of the late early Christian works. A characteristic feature

RELIEF ON A "PICTORIAL" IVORY IN THE VATICAN: *Nativity*

is the outward flare of the drapery about the ankles. The nimbus of Christ in this "triptych" group contains a cross of early Christian type, with splayed arms. The subjects are few and repeated in a monotony of type: half and full figures of the Madonna, or Christ, the Deesis, Crucifixion, and the Dormition of the Virgin, flanked by busts of saints upon the wings. A dating no later than the tenth century is assured by the extensive use of such plaques on Romanesque book covers in the West at the end of the tenth or the early eleventh century.

At the end of the tenth century appears a type of ivory which is so clearly based on the miniatures of manuscripts, that Goldschmidt and Weitzmann have properly entitled the examples of it the "pictorial" group. The painted models which the carvers followed provide a variety of subject to the "pictorial" plaques which is a welcome change from the monotonous frontal groups of the triptychs; landscape is attempted, and the isolation of figures from the background which was suggested in the paintings copied is rendered in relief by a sharp undercutting. Drapery details are indicated by grooved lines. The ivory workers even imitate the inscriptions found in the miniatures, at times retaining the accents of the script, and one plaque in Berlin, representing the *Presentation of the Virgin in the Temple,* and (in an upper corner) the *Virgin fed by an Angel,* seems to be adapted from a miniature in the Menologium of Basil II, since the inscription τὰ ἅγια τῶν ἁγίων, "holy of holies," which is

incised on the ivory to designate the Temple, is a phrase appearing in the text of the *Menologium* immediately above the picture. The relation with the Menologium is confirmed by identities of ornamental motifs (notably a peculiar form of wind-swept acanthus leaf) with those employed in the manuscript.

This is the only indication we have of a *terminus a quo* for the dating of the "pictorial" plaques, but it is important as fixing also a date in the end of the tenth or early eleventh century for the first production of the well-known Byzantine "rosette" caskets, since the curious curly hair and knobby limbs of the figures in their reliefs are identical in style with those of the "pictorial" group. The lower date of the caskets is undetermined save as earlier than the Latin conquest of Constantinople in 1204, when a bronze statue of Heracles by Lysippus was destroyed, this being copied in a casket at Xanten. Another example, in Pesaro, exhibits an *Expulsion of Adam and Eve from Eden* which was copied on the bronze doors of Pisa cathedral in 1186.

The caskets are of wood veneered with ivory plaques, and mainly of two types—a flat oblong box with sliding lid, and one with a hinged lid in the shape of a truncated pyramid. The latter type has a late antique ancestry in the boxes with bone inlay incised with figured ornaments which have been found in Egypt and were continued by the painted ivory caskets with similar lids produced by Arab workmen in Sicily in the twelfth century. The Byzantine carvers sought their subjects for the panels into which the ivory veneer is

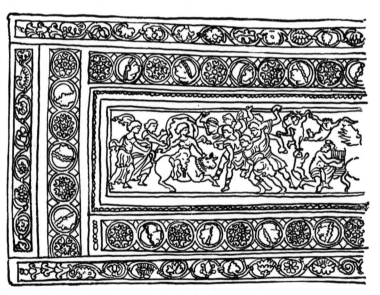

BYZANTINE IVORY CASKET: *Europa; The Stoning of Achan*

[118]

divided, in antique reliefs or paintings and in Christian miniatures. The apparent extent of their repertory is diminished by countless repetitions and dismemberment of groups into single figures, whose attitude or action is thus deprived of meaning. A characteristic example of such unintelligent copying is a casket in the Victoria and Albert Museum on which we find the throng of Israelites stoning Achan, copied from the Joshua Roll (*Fig. 17*), but Achan himself, victim and focus of the melee, is replaced by Europa on the bull, taken from some antique relief or picture.

Besides the Joshua Roll, these craftsmen in their rummaging in the libraries of Constantinople must have seen the Genesis of Vienna, since one of their panels reproduces the charming duet in one of its miniatures, of Joseph taking leave of his little brother Benjamin. The Christian subjects employed are in fact taken almost entirely from Genesis; a single scene of Moses's life is depicted (the priestly ordination of Aaron and his sons), and a few David scenes. The profane themes include the games and entertainments of the Hippodrome, scenes of battle and hunting, and a quantity of mythological themes (Mars and Venus, Heracles and the Nemean Lion, the seated Heracles of Lysippus mentioned above, Europa on the bull, etc.). The stock decoration of the borders surrounding the panels is a row of medallions, filled with rosettes in the early and middle period of production, though occasionally the roundels contain heads that seem copied from coins. In later examples the medallions are sometimes replaced by rinceaux, or an interlace, or a frieze of palmettes; but such variation is usually accompanied by departure from authentic Byzantine style.

The "triptych" group of the tenth century, and the "pictorial" ivories and the caskets of similar style of the end of the tenth century and early eleventh, are followed by the finest of Byzantine ivories, a class named the "Romanus" group by Goldschmidt and Weitzmann, from a plaque in the Bibliothèque Nationale at Paris representing Christ crowning the emperor Romanus IV and his empress Eudocia. This ivory has been dated by some in the tenth century, and the emperor identified as Romanus II (959–963), because it was imitated in a plaque of the Cluny Museum supposed to be of the end of that century. But such early dating of the Cluny plaque is based on a garbled incised Latin inscription which names the imperial couple Otto II, emperor of the Holy Roman Empire, and his wife, the Greek princess Theophano. Since the piece exhibits another and original inscription in Greek, which discloses the donor of the plaque, represented prostrate at Christ's feet, as a monk named John who dedicates it to the Saviour, the Latin label must be taken as a later addition,

and the Cluny imitation dated on its style as of period *c.* 1100. By the same criterion of style the ivory of the Bibliothèque Nationale must then be given a dating in the eleventh century.

The Romanus plaque bears in fact the authentic imprint of the developed Byzantine manner of this century, as we see it in the mosaics of the second half thereof, and the motif of Christ crowning emperor and empress cannot be documented in Byzantine art before that time. It is in the eleventh century that we encounter the elongated, sharply vertical figures, the flat drapery converging at the ankles, with folds that make the characteristic Byzantine compromise between functional and decorative, and forms that likewise reduce the Hellenistic volume infused by Alexandrian style to a relief that is low enough to be incorporeal. The early Christian frontality is tempered by oblique gestures and a slight turning of the head in reminiscence of the Hellenistic three-quarters pose. But the essentially Hellenic element in this style is Neo-Attic, visible in the neutral background and the statuesque nobility of the figures; an oriental factor is present only in the subtle rhythm of the decorative pattern they compose.

The other chefs-d'oeuvre of this "Romanus" school of ivory carvers are recognizable not only by style, but by an iconographic peculiarity—the cross in Christ's nimbus has assumed the rectangular outline of the proto-Byzantine period, but added a pearled border to both cross and nimbus. The best-known of the group is the Harbaville triptych in the Louvre (*Fig. 45*), exhibiting a *Deesis,* Christ enthroned between the Baptist and the Virgin, with roundels at either side of his head containing the busts of archangels, and the rest of the surface filled with an array of apostles and sainted soldiers and ecclesiastics. The conservative clinging of Byzantine style to established types is evident in this ivory's relation to others. Its scheme of decoration is taken from a triptych in the Palazzo Venezia at Rome, whose heavier forms, simple borders, and more Hellenic modeling of features and hair indicate a date in the late tenth or early eleventh century. Both triptychs are in turn imitated in a third, preserved in the Museo Sacro of the Vatican Library, which with its more elongated figures and developed scheme of ornament can hardly be earlier than 1100. The "Romanus" style in the extreme of its refinement and beauty is seen in the apostle figures on the wings of a dismembered triptych in the Münz and Antiken Cabinet at Vienna and the ducal palace of Venice, inscribed with iambic verses that mention an emperor Constantine who may be Constantine Monomachus (1042–1058) or Constantine Ducas (1059–1067). In these the drapery arrangement is perhaps the most beautiful that Byzantine art can show. It follows the classic method of sharp edges and shallow hollows,

thus revealing such form as the sculptor allows the saintly personages, but weaves a subtle pattern of light and shade from ridges and plane surfaces, developing a rhythm that is physically embodied in the slight sway of the apostles' posture.[7]

The technique loses its fluency to some extent in the next class, named the "Nicephorus" group by Goldschmidt and Weitzmann, whose examples date from the end of the eleventh century into the twelfth. Characteristic of these ivories is the central band of pearls that bisects the arms of the cross in Christ's nimbus, and a carving of the hair in lobes with rounded ends. "Nicephorus" style extends into the twelfth century in a large group of ivories apparently executed in Venice, whose examples are scattered through museums and collections in the north of Italy and particularly Ravenna. In these the technique develops a peculiar undercutting of the faces in three-quarters pose, and an unpleasant reduction of posture, movement, and drapery pattern to straight lines, which reveals the same provincial stiffening of the fine mid-Byzantine rhythm one finds in the mosaics of St. Mark's of the thirteenth century.

The Italian school represents the last phase of any considerable vogue of ivory carving in Byzantine art; in the twelfth century taste seems to have turned to plaques of steatite with sacred subjects carved on the soft surface, to replace the triptychs and plaques of ivory that hitherto had furnished icons for private devotion. The steatites were sometimes gilded, as were the ivories, but the loss of their gold has not diminished their charm, which arises from the combination of sculptural solidity afforded by the stone, with a delicacy of carving that rivals that of ivory. Their late date is evinced by the rigidity of the figures, their marked frontality, and the repetition of restricted formulae of drapery and pose. A feature characteristic of the steatites is the rendering of hair as a wig of knobby curls, much like the coiffure employed by the carvers of the "rosette" caskets. The finest examples are icons of saints in which the figure stands in the frame of an arch—often supported by colonnettes whose shaft is knotted in curious fashion in its middle—and plaques with representations of the Twelve Feasts of the Byzantine Church (p. 125), such as that preserved in the cathedral of Toledo in Spain. The end of the steatite style is well represented by a paten in the monastery of S. Panteleimon on Mount Athos, on which is carved a Madonna surrounded by the figures of the prophets, dating probably c. 1200.

Evident throughout these examples of the minor sculpture of Byzantine is their unplastic character. Relief is almost as subject to the norms of painting as it was in ancient Egypt. The Byzantine attitude toward plastic expression,

[7] G. Schlumberger, *Mélanges d'archéologie byzantine I,* Paris 1895, pp. 337 ff.

as contrasted with that of the Latin West, is well illustrated by the treatment of bronze doors: the Saxon bronzeworkers of the eleventh and twelfth centuries (p. 215) adorned their doors with reliefs that aim so strongly toward sculptural form that many details protrude into the round; their Byzantine contemporaries contented themselves with incised designs in imitation of fresco or mosaic.

The earliest of the Byzantine bronze doors that have been preserved are those of Hagia Sophia. The fine borders of rinceaux and meanders which surround their panels are in part at least of earlier date, but the panels themselves are inscribed with the names of the emperors Theophilus and Michael and the date of 840. This places them within the iconoclastic period, and explains the restriction of their decoration to incised designs of crosses, monograms, and abstract motifs; but the technique of incision rather than relief continues in the bronze doors made in Constantinople for Italian churches in the eleventh century. These were provided mainly through the good offices of a noble family of Amalfi in South Italy, whose familiar relations with the eastern capital, where it maintained a domicile, are evidence of the Byzantine character of the south Italian cities down to, and even after, the Norman conquest. The first pair of doors was made at the instance of Pantaleon I of this family for the cathedral of Amalfi. Their only reliefs were six lions' heads on one of the horizontal bands; crosses, *appliqués*, filled sixteen panels; four were incised with the figures of Christ, the Virgin, St. Peter, and St. Andrew, the last being the apostle especially honored, after Peter and Paul, by the Ortho-

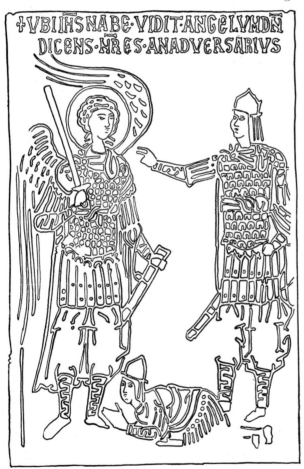

PANEL OF BRONZE DOOR: *Joshua Meets the Angel at Jericho*

[122]

dox Church. Doors of similar decoration, but without figures, were given to the abbey church of Monte Cassino by Pantaleon's son Mauro; in 1076 Pantaleon II presented a pair to the church of St. Michael at Monte Gargano, on the Adriatic coast, with scenes related to the cult of the archangel. One of these reproduces the meeting of Joshua and the archangel at Jericho, following the formula of the Joshua Roll and the Menologium (*Figs. 43, 44*). Pantaleon III in 1087 had a copy of the doors of Amalfi executed for the cathedral of Atrani. About the same time the cathedral of Salerno received its doors, comprising eight panels filled with figures and ornament. The finest pair was that which was commissioned in 1070 by the monk who was afterward Pope Gregory VII, for the portal of St. Paul's outside-the-walls at Rome, signed by the caster Stauracius, with fifty-four panels containing in addition to the usual repertory of crosses, inscriptions, and ornament, a long series of figures of saints and prophets, a Life of Christ from the Nativity to the Harrowing of Hell, and scenes of the life and death of the apostles. It is in this pair of bronze doors that the technique of the Constantinopolitan bronzeworkers can best be analyzed: the figures are incised as to contours and drapery, and the incisions filled with silver strips hammered in, or with green or red enamel, but faces, hands, and feet are done on separate plaques of silver on which the incised details are brought out by the black enamel known as niello.

The employment of enamel on these bronze doors of the eleventh century brings us to the most elaborate technique developed by Byzantine art—that of cloisonné. Of probable Persian origin, it was already practiced in the Christian East by the beginning of the ninth century, for the enameled cross from the Sancta Sanctorum (p. 101), signed by Pope Paschal I (817–824), displays in its crudely executed scenes of Christ's Infancy more than one indication of dependence on eastern style and iconography. The technique was in fact a means of luxurious decoration which would naturally be sought by the splendor-loving monarchs of the Macedonian dynasty, and even their iconoclastic predecessors such as Theophilus; we first hear praise of enamel decoration in the descriptions of the works of Basil I. The earliest existing example of Byzantine cloisonné that can be attributed to the ateliers of the capital and bears a certain date is the reliquary of the Cross in Limburg, executed for the emperors Constantine VII and Romanus II (948–959). This is an oblong box veneered with gold, and set with enamels on the lid and in the interior, where they surround the golden cruciform receptacle for the relic. The border of the cover is partitioned into cloisonné panels and jewel settings; in the center the principal group of the Deesis (Christ enthroned, attended by the Baptist, the Virgin, and two archangels, as on the Harbaville triptych) is bordered above and below

by the figures of the Twelve Apostles. The intricate technique is here at its best. The figures were incised in outline and details; the flat gold *cloisons* whose edges make the design were soldered into the incisions; the colored enamel of lead, borax, and metallic oxides was poured into the compartments thus formed; finally the flat surface was polished to enhance the colors and bring out the details of drawing furnished by the edges of the gold partitions.

Technically perfect, the figure style [8] of the Limburg reliquary reveals its date in the lower height of the figures as compared with the elongated proportions of the eleventh century, in their relative frontality, not yet modified by Hellenistic obliquity, and in the lack of equilibrium in their posture. The developed figure style is reached, as everywhere in Byzantine art, in enamels of the late tenth or eleventh century, such as those of some of the small medallions on that magnificent conglomeration of cloisonnés of various periods which constitutes the high altar, the Pala d'Oro, of St. Mark's in Venice.[9] It began to assume its present appearance in 1105, at the instance of the Doge Falier, and its earliest parts are the small panels and medallions above mentioned, products without question of Byzantine ateliers. The Latin conquest and sack of Constantinople in 1204, and the discriminating looting which the Doge Dandolo and his Venetians performed on that occasion, were probably responsible for the six Feasts of the Church flanking the figure of St. Michael in the upper part of the altar. In these the style is of the twelfth century, reduced to a simplified and geometric formulary that makes the restricted technique almost its natural expression; the forms are flat and abstract, the compositions reduced to rigid symmetry. The lower part of the altar frontal sums up the symbolic iconography of a mid-Byzantine church: the Pantocrator of the central dome of the church is here also the center of the composition; around him are the four Evangelists that in mosaics are often depicted on the dome's pendentives. Above, the choirs of angels are arrayed on either side of the Throne, the Etimasia, and beside the Almighty extend the rows of prophets, apostles, and saints. Below the central compartment, three panels display the figures of the Virgin orant, an empress Irene, and an emperor who must be one of the two Comneni whose empress bore that name, Alexius I (1081–1118) or John (1118–1143). A Latin inscription has altered him into the donor Falier. The images of the four Evangelists and those of the prophets are of late date, probably of the thirteenth or fourteenth century, and of Venetian workmanship, as are also the

8 W. Burger, *Abendländische Schmelzarbeiten*, Berlin 1930, figs. 11, 12; O. M. Dalton, *Byzantine Art and Archaeology*, London 1911, fig. 311.

9 Ongania, *La basilica di S. Marco in Venezia*, VIII, 1, *Il Tesoro*, Venice 1885, pls. XV–XX.

scenes of the Life of Christ and of St. Mark in the small rectangular panels on three sides of the lower portion. The earliest work seems to be the fine enamels of the small medallions of the upper and lower borders, to be attributed to the tenth or the early eleventh century, in which the oriental taste of the time is revealed by Persian subjects, such as the mounted king with a falcon in hand, and a tree flanked by griffins, peacocks, or serpents.

❖ ❖ ❖ ❖ ❖

The six scenes of the Life of Christ represented in the enamels of the upper portion of the Pala d'Oro were part of a frieze twice as long, no doubt once adorning the iconostasis of some church in Constantinople, and including all of the twelve subjects that made up the cycle known in Byzantine art as the Twelve Feasts. These are the holy episodes commemorated in the great festivals of the eastern Church, constituting a series which is first mentioned as a sacred cycle by writers of the eleventh and twelfth centuries, in which period the Feasts take their place, though not always in the canonical number or with the same subjects, in the decoration of the churches. The selection of these twelve scenes out of the rich narrative of the New Testament is evidence of the concentration of Byzantine art and iconography on the fundamental concepts of the faith and their illustration. To the same dogmatic interest may be ascribed the rare appearance of the Old Testament in developed Byzantine iconography, as offering few types that were readily symbolic of doctrine. Two of the Twelve Feasts were usually given locations of special prominence in the church. These were the Crucifixion and Resurrection, embodying the dogmas of Atonement and the divinity of the Saviour. The Resurrection was no longer represented by the early Christian historical theme of the Holy Women at the Sepulcher, but by the Harrowing of Hell, more important theologically as insuring the salvation of the Just who preceded the Incarnation. To the Twelve Feasts were often added, in the mosaics of the churches, the apocryphal stories of the Virgin's life that include the narrative of her parents, Joachim and Anna, her birth, her life in the Temple as a maiden, her marriage, and the episodes preceding the Nativity. On the west wall the customary subject was the vast complex of the Byzantine Last Judgment, with Christ enthroned as Judge in a glory amid the heavenly choirs and apostles, the angels trumpeting the commencement of the Last Day, the tortures of the Damned, and the beatitude of the Elect, symbolized by a harvest of little souls gathered in Abraham's bosom, and by the repentant thief Dismas of the Crucifixion, carrying his cross. This is a feature distinguishing Greek from Latin Last Judgments,

as also the introduction of the apostles as Christ's assessors, and of John the Baptist instead of the Evangelist, to be the companion of Mary in her intercession for erring humanity.

The Twelve Feasts are the *Annunciation, Nativity, Presentation, Baptism, Transfiguration,* the *Raising of Lazarus,* the *Entry into Jerusalem, Crucifixion,* the *Harrowing of Hell, Ascension, Pentecost,* and a new subject, appearing commonly for the first time in developed Byzantine art, the *Dormition of the Virgin,* or her death, represented in a composition which inspired the deathbed scenes of early Italian painting. The Virgin lies on her couch, behind which stands Christ in a glory, holding her soul as a small child in his arms, attended by angels ready to lift his burden to heaven, and by the apostles, miraculously transported from the various parts of the world where they were preaching the Gospel, to witness the passing of Mary. The composition, as an invention of developed Byzantine style, is important testimony to its esthetic proclivity: the figure of the Virgin and her bed give a solid horizontal pedestal to the scene, which is focused by the verticality of the standing Christ, while this accent is diminished and spread into rhythm by the varied and arresting heads of the apostle groups, and by a constant feature of mid-Byzantine arrangements—the two pavilions at either side, framing the gold background behind the scene.

The other scenes of the Twelve Feasts reveal the persistence of the Asiatic types of early Christian art, but also show, in their iconographic transformations, the increased spiritual significance imparted by Byzantine style to the early narratives (*Fig. 47*). The *Annunciation* maintains the Syrian placing of the Virgin to the right, and represents her standing, with the basket of purple wool at her feet with which she weaves the Veil of the Temple. The *Nativity* is a scene in the open, without the shed that shelters the manger in Latin renderings, and places the episode in a grotto, in conformity with the appearance of the shrine of the Nativity at Bethlehem as described by pilgrims, the *spelunca ubi natus est Dominus.* But the Adoration of the Magi, still separately depicted in the Menologium of Basil II, *c.* 1000, is now often combined with the Birth, as is also the *Annunciation to the Shepherds,* which in turn introduces a choir of attendant angels. The Bathing of the Child by two midwives in front of the reclining Virgin, and the seated meditative Joseph, become fixtures in the type. The *Presentation* of the Christ child in the Temple, represented in early Christian art by the highly original composition of S. Maria Maggiore and Choricius's description of the scene as depicted in the Sergius-church at Gaza, follows the latter at least in the rendering of Simeon, the priest who receives the Child, as "bent with age."

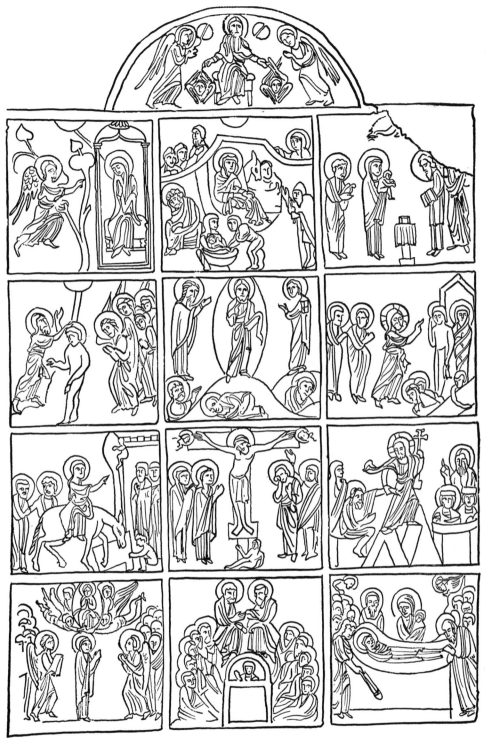

TOLEDO, STEATITE PLAQUE: *The Twelve Feasts of the Church*

[127]

Among these twelve types the *Baptism,* with the possible exception of the *Crucifixion,* is perhaps the most revealing of the new spirit in Byzantine iconography and style. It was an important feast in Byzantine liturgy, for the eastern Church regarded this event as the true Epiphany, the revealing of Christ to the world, rather than the Adoration of the Magi, which accounts for the frequent Byzantine relegation of the latter to the status of an accessory to the Nativity, in contrast to its elaborate development in the West. In early Christian Baptisms, the Christ is commonly a boy; in proto-Byzantine renderings the Saviour stands in the Jordan with apparent shame of his nakedness, covering himself with his hands, as on the painted cover of the pilgrim's souvenir box from the Sancta Sanctorum (p. 70). But the fresh Hellenic inspiration of mid-Byzantine ennobles his figure, which becomes a dignified nude with weight resting on one leg in classic *contrapposto,* and a gesture which is both graceful and significant of the solemnity of his recognition as the Son of God.

The *Transfiguration* occurs in early art in the symbolic complex of the apse of S. Apollinare in Classe at Ravenna, where Christ is a cross and the three disciples lambs, and in a mosaic in the monastery church of St. Catherine on Mount Sinai (if this be really of the sixth-century date commonly assigned it). The Sinai mosaic is already conceived in mid-Byzantine form: Christ standing in a glory flanked by the prophets Moses and Elias, with the three frightened disciples below—Peter looking up and speaking, James half-rising, John prostrate. The *Raising of Lazarus* follows closely the Asiatic type of the Gospel Book of Rossano, retaining the cavern-tomb in distinction to the gabled aedicula or sarcophagus of Latin art and the mummy case of Egypt, and the motif of the man who unwraps the winding sheet and holds his garment before his nose. But the composition has solidified and narrowed the strung-out narrative frieze of the Rossanensis and introduced the Alexandrian mountain background used in mid-Byzantine art for scenes of the New as well as the Old Testament, making such strange contrast with the airless gold field. The same consolidation overtakes the *Entry into Jerusalem,* in which Christ rides sidesaddle in eastern fashion, as indeed was the case in oriental early Christian art, though the Latin sarcophagi rendered him astride, maintaining in this a Hellenistic trait. The scheme is that of the Rossanensis, but the narrowing of the scene has given the appearance of a hill at the left, down which Christ rides, with disciples walking behind, to the gates of Jerusalem, from which issues a throng of welcoming men and women and boys strewing palm branches in his path.

The *Crucifixion* reduces the episode to almost purely esoteric expression. Gone are the group of Holy Women, the lancer and sponge bearer, the two

[128]

thieves, and the soldiers gambling for the garments of the Crucified. These details of the early narrative succumb to a direct rendering of the dogma involved. The location of the scene, and its doctrinal meaning of Atonement of original sin, are both symbolically conveyed by inserting the skull of Adam (traditionally interred on Golgotha, "place of the skull") at the foot of the Cross. The witnesses are only two: the figures of Christ's Mother and the beloved disciple John, whom he joined together with his dying words. The body is ennobled by a conventional but classic modeling of the torso, and draped with a loincloth whose symmetrical hanging and central knot are characteristic of Byzantine Crucifixions. The feet are separately fastened, a Byzantine trait contrasting with the Latin Gothic practice of representing the feet of the Crucified as transfixed by a single nail. The scene is reduced to its barest physical terms, that no material detail may impair its transcendental force.

The *Harrowing of Hell* is an uncanonical event, described in the apocryphal gospel of Nicodemus. It first appears on the ciborium columns of St. Mark's in the fifth century, but in its proto-Byzantine form three centuries later, in frescoes of S. Maria Antiqua of the early eighth century, and in a contemporary mosaic of the lost chapel of John VII in Old St. Peter's. It entered the Creed as a necessary provision for the universal salvation of mankind, that should include those who lived before Christ's coming as well as later generations. In Byzantine art it was the regular type of the Resurrection, preferred, because of its profounder implication, to the scene of Easter Morn which appealed to the early Christian taste for narrative. Late Byzantine art gave it the Alexandrian mountain slopes on either side, flanking the pit of Hell over whose gates the Saviour strides, grasping by his hand the resurrected Adam with Eve beside him. Opposite these two is a group headed by, and sometimes confined to, the crowned figures of David and Solomon. To one or the other of these groups is often added John the Baptist, the final figure in the old dispensation.

The *Ascension* shows the least change of all from its early Asiatic iconography; as on the pilgrim's box from the Sancta Sanctorum and the leaden ampullae from Palestine, the Saviour sits enthroned in an aureole borne upward by angels, with the apostles gathered around the orant Virgin below, while two angels direct their gaze to the ascending Christ. On the other hand, the Byzantine type for the *Pentecost* is more elaborate than the horizontal group of Apostles and the Virgin which represents the scene in the Gospel Book of Rabula, and seems to have originated in posticonoclastic times from a formula of Hellenistic art used for the rendering of groups of famous seers or poets, arranged on a hillside in a semicircle. This scheme is developed in the Homilies of Gregory of Basil I (p. 109) to represent a general council of the church, with

[129]

the discomfited heretics condemned by the council crouching below. The council type was borrowed for the semicircular array of apostles in the Byzantine *Pentecost*, with the Virgin sometimes included in their number, and rays descending on their heads from the Dove of the Holy Spirit. Instead of the defeated heretics, there appears in the circular space below, a personification of the world and its various "tongues," in which the apostles were to preach the Word. The frequent location of the scene among the church mosaics in a cupola of course transformed the type into a circle of apostles at the base of the dome, with the rays of inspiration radiating from the Dove in the center.

MID-BYZANTINE MONUMENTAL ART.
MOSAICS AND FRESCOES

This highly selective iconography first appears in existing Byzantine churches in the eleventh century, and we cannot know, for dearth of monuments, how widely or completely it was used before that time. Were the New Church of Basil I still standing, and the mosaics preserved, we should doubtless find in them the nucleus of the iconographic system, but this and most of the other churches antedating A. D. 1000 have been destroyed or have lost their original mosaic decoration. At Hagia Sophia in Salonica [10] the central dome is occupied by an Ascension, in which the enthroned Christ in the center may well be of the seventh century to which it has been ascribed, having the squat proportions and the rounded contour of the head, enhanced by bushy hair, which belong to early style. The Virgin, angels, and apostles who complete the compositions at the base of the dome are of the eleventh century. The Madonna [11] in the apse of this church dates in the time of the temporary restoration of the image cult at the second Council of Nicaea in 787, and exhibits the too large head and abbreviated stature of the Christ in the cupola. Our first example of the developed decoration of a church is the mosaic cycle of St. Luke of Stiris, remotely located in the ancient land of Phocis north of the Corinthian gulf, and dating in the early years of the eleventh century.[12]

The decorative and symbolic cycle is here fairly well developed. The Pantocrator occupied the central cupola, surrounded by a choir of archangels to whom the Virgin and the Baptist are added. The Baptist is winged, a late Byzantine feature, and all of this decoration, together with the figures of prophets between the windows of the drum of the cupola, is done in fresco dating from the sixteenth century. In the apse the original mosaic remains: a Ma-

[10] Ch. Diehl et al., *Les monuments chrétiens de Salonique*, Paris 1918, atlas, pls. XLV–XLIX.
[11] Diehl et al., *op. cit.*, pl. XLIV.
[12] R. W. Schultz and S. H. Barnesley, *The Monastery of Saint Luke of Stiris*, London 1901.

[130]

donna holding a gold-clad Child, while the Pentecost is figured in the small cupola covering the sanctuary. The numerous saints that line the walls follow a gradation of importance, with the monks more numerous toward the entrance. The Feasts are not complete, nor is the series yet in its integrated form: four are inserted in the squinches of the central dome: the *Annunciation* (restored in fresco), *Nativity, Presentation,* and the *Baptism* in which appears the cross marking the pilgrimage site of Christ's immersion in Jordan. The rest are found in the narthex and include only the *Crucifixion* and the *Harrowing of Hell* (Fig. 48), with two scenes extraneous to the normal cycle, the *Washing of Feet* and the *Incredulity of Thomas.* The execution of these mosaics is archaic and provincial; there is a constant trend toward frontality, and the accents of the drapery and movement are harsh and staccato. The better work is in the narthex, and here one is most impressed by the half figure of Christ above the principal portal, whose introvert gaze and breadth of style reach a considerably higher level than that of the mosaics of the sanctuary, especially archaic in the squat figures of the apostles in the *Pentecost.*

S. Sophia at Kiev,[13] next in point of time, is another example of provincial rather than metropolitan style. It is the monument of Russia's conversion to Christianity. The Scandinavian German tribes that began to filter down the waterways of western Russia in the ninth century were settled in Kiev by the early tenth, and under Vladimir accepted Christianity as their state religion, and with it the dominance in South Russia of Byzantine culture and art. The cathedral of S. Sophia was vowed by Vladimir's son Jaroslav the Wise on the field of battle, and begun in 1037. The mosaics here, owing to the close connection of this incipient Christianity with the Byzantine capital, conform more closely than those of St. Luke's to the metropolitan norm, but only so far as iconography is concerned. The Pantocrator of the dome is surrounded by four archangels (three restored) and the apostles (almost entirely restored), with the four Evangelists (two only surviving) in the pendentives. A huge Madonna evidently reproducing the original of Hagia Sophia at Constantinople, and known locally as the "indestructible Wall," fills the apse, with the *Deesis* on the apsidal arch. Below the Virgin is the *Communion of the Apostles,* with Christ twice represented and aided by angels in the distribution of the bread and wine, a eucharistic symbolism continued by figures of Aaron and Melchizedek, and bishops and deacons. Flanking the sanctuary arch appears a disposition of the Annunciation which later becomes a norm in Italian art—the archangel Gabriel on the left pier, the Virgin to the right. The rest of the decoration is mainly done in fresco, with scenes of Christ's Passion in the north and south

13 P. Schweinfurth, *Geschichte der russischen Malerei im Mittelalter,* The Hague 1930, figs. 15-24.

tunnel vaults, and the usual array of saints on walls and piers, conforming to the Byzantine principle of allover ornamentation of an interior. Noteworthy are the Peter cycle and the Life of Mary in the prothesis and diaconicum, and especially the frescoes adorning the walls of the staircases leading to the galleries. Here we find some reflection of the secular art of Byzantium, in scenes of the hippodrome, a representation of the strange "Gothic" play that was performed at Christmas in the imperial palace, and acrobatic feats like those described by Luitprand of Cremona when he was ambassador at the Byzantine court in 968.

The great Madonna of the apse, over seventeen feet in height, may owe her misproportion to an attempt to counteract the optical effect of the curving apsidal vault, but this cannot explain the similar high-waisted Christ of the *Communion of the Apostles,* the most interesting of the mosaics. To this symptom of provincial style may be added, as at St. Luke's, the archaic tendency to frontalize the figures, which becomes effective only in the impressive portraits of the bishops in the apse, especially striking in the case of the Doctors of the Church, St. John Chrysostom, Gregory the Miracle Maker, and Basil the Great. The apostles of the *Communion* are relieved against a gold field, and move on no ground line, while the altar from which Christ distributes the eucharistic elements hovers in mid-air. The Christ of the cupola sums up this expatriate art in heavily accented facial features and the coarse drawing of unfunctional drapery, underlining and exaggerating the subtle Byzantine undertones.

A singular opportunity to gauge the difference between authentic Byzantine and its provincial modification is afforded by the frescoes of the south Italian church of S. Angelo in Formis, north of Capua,[14] built by the abbot Desiderius of Monte Cassino (1056–1086). We know that Desiderius employed Greek painters for the decoration of the church, and their work stands out conspicuously amid the bulk of the frescoes executed by their local Benedictine pupils. The Byzantine artists have left us the orant Virgin (crowned in deference to Latin taste) and the archangel Michael in the atrium, delineated with a delicacy of technique and a subtle balance between reality and decorative detachment which reduces the Latin frescoes by comparison to a somewhat naïve primitivism. The selection of subjects in S. Angelo is itself a compromise: the west wall received a Last Judgment conceived in general after the Byzantine norm, but the apse retains the early Latin type of Christ amid the four evangelistic beasts, with the added figures below of St. Benedict and Desiderius, presenting a model of the church, and three archangels. The rest of the decoration of the church entirely deserts the Byzantine symbolic distribution,

[14] F. X. Kraus, *Die Wandgemälde von S. Angelo in Formis,* Berlin 1893.

adhering instead to the old Latin historical scheme which in this case can probably be traced in its essential features back to the cycle of Old and New Testament stories painted on the naves of St. Peter's and St. Paul's in Rome under the direction of Pope Leo I (440–461); the influence of this early archetype can be detected in the decoration of many Italian churches down to the thirteenth century. Between the windows of the nave are the figures of prophets, including, for the first time in mediaeval art, one of the Sibyls in their number, and above these an extended cycle of the Life of Christ (*Fig. 49*). The parallel Old Testament cycle was frescoed on the walls of the aisles. The style of these Benedictine creations is an honest appropriation of the externals of Byzantine —its two-dimensional composition, decorative distribution of accents, attenuation of physique, solemnity of gesture and pose—but the Latin elements emerge despite Greek schooling, in heavily outlined silhouettes, large spots on cheeks instead of modeling, and in general a narrative rather than symbolic content in the scenes.

From these provincial imitations of Byzantine style in the eleventh century it is a long step to the authentic Greek work at Daphni of the century's end.[15] This monastery church on the ancient Sacred Way from Athens to Eleusis, deriving its name from a laurel grove which once surrounded a temple of Apollo on its site, has retained a mosaic decoration which is in no way false to the Hellenic tradition clinging to its situation. In it we see the developed mid-Byzantine iconographic scheme: the Virgin in the apse, the Etimasia on its vault, Gabriel and Michael in the lateral niches, with the Pantocrator in the dome, surrounded by the prophets. The Feasts are supplemented with extra scenes from the lives of Christ and the Virgin; in the squinches under the dome are the *Annunciation, Nativity, Baptism,* and *Transfiguration;* in the north arm of the cross plan appear the *Nativity of the Virgin* and the *Raising of Lazarus* (fragmentary); in the south the *Adoration of the Magi,* here a separate subject, and the *Presentation* (destroyed). In the gallery above, the north arm of the cross exhibits the *Crucifixion* and the *Entry,* as Passion subjects deserving loftier location, and the south arm the *Harrowing of Hell* and the *Incredulity of Thomas.* Over the door is the *Dormition of the Virgin,* in which for the first time the figures of two bishops are added to the group of apostles. The rest of the cycle is depicted in the narthex: the *Washing of Feet,* the *Last Supper* (fragmentary), the *Betrayal;* the *Presentation of the Virgin in the Temple,* her *Benediction* by the priests, the *Prayer of Joachim and Anna* that was answered in her birth. The symbolism extends to the significance of prothesis and diaconicum; in the one, whence the prefatory service issues, the apse

[15] G. Millet, *Le monastère de Daphni,* Paris 1899.

depicts the Precursor John the Baptist; in the other, the place of liturgical preparation, appears the figure of St. Nicholas, bishop-saint *par excellence* in the eastern Church.

The mosaics of Daphni are our best surviving illustration of mid-Byzantine style. They are curiously Neo-Attic in quality—the pervasive gold background has the neutrality of ancient reliefs, though its brilliance connotes a trans-figured *ambiente;* the gestures and attitudes retain for the most part the stat-uesque reticence of antiquity. Even the proportions, with height seven to eight times the head, conform to a classic norm. But the ideal naturalism of classic style is revised into a transcendental physique. The nude for example is lighted according to a predetermined formula regardless of its placing. When the torso is exposed, as in the case of the crucified Christ (*Fig. 50*), the ana-tomical division becomes a conventional six-part drawing, and the lines of the chest are made into symmetrical arcs that destroy the articulation of the shoul-ders. The blood that spouts from the Saviour's side assumes a decorative curve. The rendering of this scene is typical in its suppression of specific detail and in the subtlety with which the Greek artist achieves his expression. The hu-man pathos of the event, reticently expressed by the gestures of John and Mary, is dominated by the strong white accent of the figure on the cross, whose uplifted arms are more a gesture of embracing benediction than of suffering. The frontality of Christ's figure and of John make characteristic Byzantine "spots," arresting the eye and joining with the sway of all three figures to carry the composition, despite its classic axis, into a quieting rhythm.

The bed for these mosaics was made of two layers of lime and marble dust, the lower coarser and sometimes reinforced with nails, the upper surfaced with a fine plaster to hold the tesserae. The tesserae are usually from five to eight millimeters square, becoming smaller for facial details, and are made of glass and local marble, the white Pentelic, the gray-blue from Hymettus, and the black of Eleusis. The color scheme is mainly carried by the drapery, in which the mantle is regularly lighter than the tunic, the customary contrast being a white himation with brown-violet shadows over a deep-blue under-garment. The general lightish tone of early Christian mosaics is deepened into far richer colors, which contribute largely to esoteric effect, especially in the ex-ceptional purple-violet of Christ's tunic, made more somber by an equally dark mantle. Flesh tones have greenish shadows on the face and blue on the body; hair is lilac or brown for youth and white or bluish-white for age. The nimbi vary from red or blue to green, and the wings of angels are brilliant in color, with gold alternated by green or lilac and the white feathers turning to red,

blue, or green at the edges. Where the Alexandrian landscape appears, the mountains are usually red, contrasting with the green foreground.

In the mosaics of Daphni we obtain as it were a glimpse of what the art of Constantinople must have been in the eleventh century, and can analyze its quality. These works of the great Byzantine century date, however, at its very end (the monastery is first mentioned in a text of *c.* 1100), and in them, despite perfection of style and execution, a symptom of decay can be detected. This is the slight but evident emphasis on decorative effect over the expression of content; the schemes are becoming somewhat *arrangés,* and the rhythmical accents somewhat too apparent. The decadence of the twelfth and thirteenth centuries is at least suggested by the mosaics of Daphni, but one must add that in the pathos that accompanies the dogmatic rendering of the Crucifixion, there is announced as well the dramatic style of Neo-Hellenism which will parallel this decadence as the second and more vital phenomenon of late Byzantine style.

❖ ❖ ❖ ❖ ❖

Byzantine painting *in partibus* during the tenth and eleventh centuries, and the continuation of the mid-Byzantine style in later centuries, translated into the artistic argot of the furthest provinces, east and west, of the Empire, are represented by the strange frescoes of the underground churches in Cappadocia and South Italy. West and south of Caesarea in Cappadocia, in the southeast of Asia Minor, is a volcanic desert whose rocky valleys and dolomites exercised the same attraction for the monastic-minded as did the deserts flanking the valley of the Nile. Here one may find, carved in the rock walls, an extraordinary number of subterranean churches and chapels, decorated from top to bottom with frescoes in a style that for the most part betrays the artistic inexperience of monastic hands, employing an iconography which reveals an ultimate Syrian and early Christian basis, modified in the later frescoes by attempts to assimilate the liturgical schemes of the mid-Byzantine mosaics.[16]

The earliest frescoes, painted directly on the rock without plaster, are mostly confined to pure ornament, and figured decoration does not become common until the tenth century. The principal examples of this period are the cycle that decorates the old church at Toqale-Kilisse, and the paintings of the church of Qeledjlar. In studying these, one feels still within the atmosphere of early Christian art; the arrangement is narrative and the stories told with the naïve

[16] G. de Jerphanion, *Une nouvelle province de l'art byzantin; les églises rupestres de Cappadoce,* Paris 1925–36.

detail of the early miniatures. In the Miracle of Cana at Toqale, for example, the episode develops in two scenes as in the Lectionary of Leningrad (p. 97) with the Saviour warned by his Mother of the lack of wine at the wedding feast, and performing the miracle in another scene with circumstantial detail. Early Christian types never seen in the Byzantine church mosaics are here preserved, such as the Testing of the Virgin with Water, a favorite Cappadocian theme, and the Escape of Elizabeth and the infant Baptist, according to the account in the apocryphal Protoevangelium of James, telling of the mountain which opened and enclosed the pair in response to Elizabeth's supplication. Usually in the Cappadocian frescoes the Crucifixion retains the archaic details of the crucified thieves, and the spear and sponge bearers; in the Harrowing of Hell, the Baptist is regularly omitted, and along with this Byzantine scene the early Christian Resurrection type recurs—the Holy Women at the Sepulcher.

In the eleventh century, the influence of Constantinopolitan style begins to be manifest. The mid-Byzantine types of the Pantocrator, the Deesis, and the Communion of the Apostles appear, but seldom in the location prescribed by Byzantine custom. It is only in the cruciform chapels at Göremé that the orthodox arrangement is finally integrated, with the Pantocrator in the central dome, the Evangelists on the pendentives, and the prophets on the great arches supporting the cupola. The Deesis, with the Communion of Apostles sometimes below it, occupies the apse in these chapels, in place of the Virgin, who is relegated with the archangel Michael to the prothesis and diaconicum. The Gospel scenes on the walls hesitate in arrangement between the historical and liturgical motive, but one can see an attempt to emphasize the Feasts. The frescoes of the cruciform chapels are decidedly the best among those of Cappadocia; in them, despite the archaic tendency to multiply details, one can discern a growing ability to concentrate the accents, and to achieve a stiff approximation of Byzantine rhythm.

The frescoes of the subterranean chapels and some parish churches in the south of Italy [17] furnish a similar picture of expatriate style, expressing a monkish content in untutored technique. South Italy was as essentially Greek, down to the fourteenth century, as it was in antiquity under its ancient appellation of Magna Graecia. The monastic population was immensely increased by thousands of immigrant refugees during the iconoclastic period, and the Greek rite continued in the south Italian church even under the Norman and Angevine dominations. Throughout the "heel, instep, and toe" of the peninsula were founded monasteries of Basilian monks, in Apulia, the Basilicata, and Calabria,

17 Ch. Diehl, *L'art byzantin dans l'Italie méridionale*, Paris 1894; E. Bertaux, *L'art dans l'Italie méridionale*, Paris 1904.

and in connection with these foundations there grew up a fringe of hermits' cells cut into mountain sides, on which, as also sometimes in the parish churches of the Greek cult, were painted frescoes of provincial Byzantine style. The iconography of these paintings has a content of personal devotion which makes the influence of the Byzantine church cycles even less effective here than in Cappadocia. St. Michael, patron of the pilgrimage shrine on Monte Gargano, is a favorite subject, and the frescoes abound with images of pious donors. Dates are not infrequent; two portraits of Christ at Carpignano are inscribed with the years 959 and 1020, both signed by Greek painters, the earlier by *Basilios*, the later by *Eustathios*. But few if any of the frescoes antedate the tenth century, and the twelfth is the most prolific period of their production. Their style, with a curious assimilation of Gothic quality, continues through the thirteenth and fourteenth centuries. Only occasionally does one encounter reminiscence of the Byzantine mosaic cycles: in the crypt of S. Biagio near Brindisi (1197), a medallion of the Lord in the aged guise of the "Ancient of Days" occupies the center of the ceiling, and is surrounded by the Annunciation, Presentation, Flight into Egypt, and Entry into Jerusalem, with the Nativity and Adoration of the Magi mingled with figures of saints on the walls below. The Deesis sometimes decorates an apse, and in the later frescoes one may even find a Last Judgment and the Dormition of the Virgin. The south Italian style crystallizes in the eleventh and twelfth centuries into a reduced Byzantinism: the primitive technique and conventional content result in frontality, an undue emphasis on line, and a difficulty in maintaining proportion and scale. The colors are dull to the point of a monotonous and uniform tonality, contrasting with the much gayer palette employed by the painters of the thirteenth and fourteenth centuries. In the latest frescoes in fact one can detect along with Gothic fluency a stirring of the new life in Byzantine which flowered in Neo-Hellenism, and throughout the last phase of this obscure monastic art there can be traced a rustic counterpart, so to speak, of the more distinguished evolution of transplanted Byzantine style which is visible in the mosaics of St. Mark's at Venice.

❖ ❖ ❖ ❖ ❖

St. Mark's was completed toward the end of the eleventh century.[18] It was based on the cruciform plan of the five-domed church of the Holy Apostles at Constantinople, but its scale and the system of decoration as first planned owe more to the ninth-century basilical church which it replaced. Even in the developed mosaic cycle there are many discrepancies in location of subject as

[18] O. Demus, *Die Mosaiken von San Marco in Venedig*, Vienna 1935.

compared with that described by Mesarites (p. 106) in the church of Con-
stantinople: the only scene that occupies a corresponding place in St. Mark's
is the Pentecost of the west cupola; the Christ of the Holy Apostles' central
dome is at St. Mark's in the cupola of the sanctuary, which in the Constan-
tinopolitan church was decorated with the Crucifixion. The Transfiguration
of the north cupola in the Apostles' church is replaced at Venice with the Life
of St. John. The Ascension which decorates the central dome of St. Mark's
was in the right transept of the Holy Apostles. Even if the mosaics of the par-
ent church be ascribed to Basil's restoration, the iconography of corresponding
scenes at St. Mark's seems too developed to be imitative thereof. The earliest
discernible plan of decoration in the Venetian cathedral is in fact basilical
and Latin, since the theme of the apse is not the Virgin but Christ (a sixteenth-
century restoration) with SS. Peter, Mark, Hermagoras, and Nicholas.

The relics of St. Nicholas were brought to Venice c. 1100, which affords a
dating a quo for the apsidal mosaic, and for the first program of decoration.
To this program also belong the Virgin and apostles represented in the niches of
the main portal. These earlier mosaics have some affinity with the Daphni style
in their softer drawing, less attenuated forms, and less confusing drapery lines as

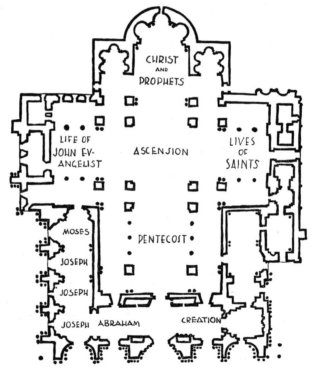

PLAN OF ST. MARK'S, VENICE

compared with later work, and in their fusion with the gold ground against which the later figures seem so isolated. The first undertakings were interrupted by a fire in 1145, in consequence of which a new scheme was commenced, initiated by the marble veneering of the lower walls. Numerous gifts are recorded in the archives of the cathedral in the seventies of the twelfth century, indicating a resumption at that time of a second phase of mosaicwork. To the first stage of this may be ascribed the *Pentecost* of the west cupola with the angels in its pendentives, the *Life of St. John* in the north dome, and the *Temptation of Christ*, his *Entry into Jerusalem*, the *Washing of Feet*, and the *Last Supper* on the south arch of the central dome. The softer line of the earlier period is lost in these compositions; the poses are becoming stiff and the drapery assuming those mechanical conventions which give so artificial an effect to the thirteenth-century mosaics. Characteristic are the unarticulated compositions, tending to crystallize into isolated groups. The iconography is Byzantine, but yielding to Latin intrusions; Greek custom is followed in including the four Evangelists with their books among the twelve apostles of the Pentecost but in the Last Supper the Hellenistic semicircular couch is replaced by a rectangular table. This scene has deepened its content, since Christ's gesture is one of blessing the elements of the sacrament instead of the historical one of indicating Judas as the destined traitor.

The manneristic modeling of forms and draperies continues in the Christ, Virgin, prophets, and evangelist symbols of the sanctuary vaulting (partly of the thirteenth century), the Ascension of the central dome, the Passion scenes of its west arch (*Fig. 52*), and the apostle martyrdoms on the south arch of the west cupola, with the style's full development to be best observed in the Ascension and the martyrdoms of the apostles. These last are an innovation in church iconography and did not appear in the apostle histories of the Holy Apostles, where the episodes were confined to the apostles' preaching. We note other variations: four angels carry the aureole of Christ in the Ascension instead of two as in the Holy Apostles and the dome of Hagia Sophia at Salonica, and Latin personifications of the Virtues and Beatitudes are introduced between the windows in this central dome. In its spandrels are the Evangelists (Luke restored) writing at lecterns between the characteristic Byzantine pavilions that flank the composition, but with them also is the old Latin symbol of the Four Rivers of Paradise, one assigned to each of the scribes. Another Latin feature, though possibly due to restoration, is the three women (instead of two) in the scene at the Sepulcher.

These mosaics belong to the end of the twelfth century and the early thirteenth, their chronology fixed to some extent by the resemblance of details in

the Christ scenes to the fragments of mosaics once decorating the apse of St. Paul's at Rome, which were done by Venetian workmen summoned by Pope Honorius III in 1218. A slightly later atelier is responsible for nearly all the decoration of the choir chapels and transepts (an exception is the Life of John of the north transept dome, above mentioned). The Byzantine tradition in these mosaics is thin indeed, the style descending to a flat linearism which makes the figures seem like thin appliqués upon the gold ground, and a reduction of landscape features to papery two dimensions. Examples of this stage in style are the mosaics of the Lives of Peter and Mark in the choir chapels, the miracles of Christ in the transepts, and the saints of the south transept cupola. An indication of date for this series seems to be given by the inclusion of Marina among the saints represented, since her relics were brought to Venice in 1230.

Two other ateliers, one of the first half, the other of the second half of the thirteenth century, worked on the domes that cover the bays of the narthex. The departure from Byzantine practice is evident here in the choice of Old Testament subjects, rare in pure Byzantine cycles. The most interesting of the domes is one which recites the story of Genesis, for it has been demonstrated that the thirteenth-century mosaicist copied his scenes from the Cotton Genesis of the sixth century (p. 53), or from an illustrated Genesis of like date and identical iconography. The Days of Creation, for instance, are depicted here with their winged personifications of the Days from one to seven, and the composition of the Third Day reproduces detail for detail the picture which Peiresc copied from Sir Robert Cotton's manuscript (p. 54). The style, however, is reduced to the Venetian dialect of Byzantine, with a stiffening of action and drapery, a compression of groups, and a verticalizing of figures, that rob the early Christian subjects of their Hellenistic spontaneity, while on the other hand the Venetian manner gains new interest by imitation of its storytelling model. The series continues in the other narthex domes and arches with the history of Abraham, Joseph, and Moses, using very probably an illustrated Pentateuch or Octateuch of quasi-contemporary date. In the last cupola of the Moses sequence the style changes to a frank adoption of the landscape settings of Neo-Hellenism, though the figures continue the Veneto-Byzantine style of the other domes. The mosaics of the narthex were in construction over a long period, from c. 1215 to the end of the thirteenth century.

The names of the artists found in Venetian documents during the period of the decoration of St. Mark's are frequently Greek. It is evident that the basis of this Venetian school was the Byzantine art of Constantinople and that whatever local variation thereof was produced at Venice was kept within the norm of that style. But the Latin intrusions into the iconography and to a lesser extent into

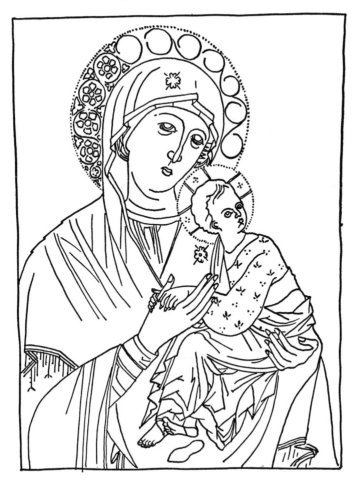

ANDREA RICO: *Madonna*

style show that the school was after all for the most part local, and had domesti-
cated the art and artists it imported. A Venetian edict of 1258 required two ap-
prentices to each mosaicist. From this local application and translation of an
exotic manner come its transformation and decadence—a decadence caused by
the fact that the borrowings from contemporary Latin art were superficial and
confined for the most part to iconography, without any real infusion of the re-
newal of Italian painting which was going on elsewhere in the peninsula in the
thirteenth and fourteenth centuries. The mosaics of the Baptistery, c. 1350, re-
cite the history of the Baptist in the manner of the Neo-Hellenism of this date
prevalent in Byzantine, tempering its pseudorealism with somewhat of Latin
Gothic grace and picturesque detail, but in this only continuing the characteris-

tic Veneto-Byzantine practice. The influence of contemporary Italian style is only rarely evident in the mosaics of the chapel of S. Isidoro of *c.* 1355.

The Italo-Byzantine style was continued at Venice even into the Renaissance, by the art of the "Madonneri," [19] mostly natives of Crete, which became Venetian officially in 1204 and by the fourteenth century was so well assimilated to the half Byzantine culture of Venice that Venetian families became Cretan (e. g., the Polentani) and Cretan families Venetian. The best-known of these craftsmen, who painted mainly icons of the Virgin for private devotion, was Andrea Rico of Candia in Crete, whose Madonnas have sometimes the peculiarity of a sandal dangling from the foot of the Child. His art is worthily representative of the "Cretan" school (p. 170), in late Byzantine painting, by fineness of execution, a sensitive but reticent expression and the peculiar Byzantine conception of the sacred subject as an *icon,* a worshipful image, in this contrasting with the Neo-Hellenism of the opposing "Macedonian" school, which strives to animate the hieratic formulae with specific action and feeling. The Greek tradition at Venice left its mark on Venetian painting of the early Renaissance, in the preference for color over form, which it indicated by the Byzantine high lights instead of the Tuscan method of darkening the contours.

The Venetian school extended its activity, as we have seen, to Rome in the papacy of Honorius III, and some fragments of mosaic preserved in the Archiepiscopal Museum at Ravenna are testimony to the work of Venetian craftsmen in the cathedral of that city. Other works of the school have been more fortunate in preservation, and can be found in churches of the islands of the lagoons and on the Adriatic shores; the style of Venetian workmen can even be detected in the mosaic decoration of the Florentine baptistery of S. Giovanni. The principal apse of the cathedral of Torcello contains a figure of the standing Madonna, whose isolation in the midst of the gold exedra is a Venetian exaggeration of the Byzantine cult of empty space and concentrated accent. She is attributed to the second half of the twelfth century, but the row of apostles below her seems to be by the same atelier which executed the early apostle group in the entrance portal of St. Mark's, and another group of mosaics of the first half of the twelfth century adorns the diaconicum with a composition of early Christian and Ravennate character: a Christ amid archangels and saints, with four angels in the vault supporting the Lamb in a medallion. Contemporary with the striking Madonna of the apse are the Annunciation on the triumphal arch, disposed as at S. Sophia at Kiev (p. 131), and the great Last Judgment of the entrance wall—the best example of this Byzantine ensemble that we possess (*Fig. 55*).

The panorama includes at its summit the concluding act of the Atonement,

[19] S. Bettini, *La pittura di icone cretese, veneziana e i madonneri,* Padua 1933.

the *Anastasis* as the Byzantines called it, or the Harrowing of Hell, wherein Christ carries his Cross as he resurrects Adam and Eve, while David and Solomon on one side, and the Baptist with a throng of Old Testament personages on the other, greet the act of salvation. Two colossal archangels frame the scene. Below, the Last Judgment deploys its complicated detail; Christ sits on the arc of heaven in a glory upheld by cherubim, attended by the seated apostles, behind whom is ranged a throng of saints and angels, headed by the intercessors for humanity, the Virgin and the Baptist. Below him is the symbol of his Second Coming, the Etimasia, guarded by two archangels and completing the cycle whose commencement in original sin is embodied by the kneeling figures of Adam and Eve. To right and left, at the summons of trumpeting angels, the Earth and Sea give up their dead. The separation of the Elect and the Damned ensues in the zone below, the Elect arranged in groups according to saintly distinction, the Damned already gathered in the embrace of a white-haired personification of Hades, and engulfed in a stream of fire descending from the Throne. In the final register the sufferings of the Damned on one side contrast with the beatitude of the Elect, symbolized by Abraham's bosom full of little souls, the Virgin, the Good Thief, and the portal of Paradise attended by a cherub, an angel, and St. Peter.

<div align="center">❖ ❖ ❖ ❖ ❖</div>

The illustration here given of one of the thirteenth-century panels in St. Mark's (*Fig. 52*) from the sequence of the Life of Christ, will serve to show the decadence of the style, since Daphni. The dogmatic content is lost in the episode, which must still, however, employ the conventions which were meant to submerge the episode in the content. The emphasis is on the unessential superficialities of Byzantine renderings: the multiplication of drapery folds into a mere pattern of lines; the stylizing of anatomy where the drapery reveals it into high-lighted spirals and circles, the jerky movement like that of figures galvanized by an electric current. Of this last, the right leg of Adam in the *Anastasis* is a signal example. In the scene of *Christ's Appearance to the Holy Women,* the landscape is out of scale, and the figures of the kneeling women as well. In the *Incredulity of Thomas* the Saviour's feet have no relation to the steps on which he stands, and the drapery high light on Thomas's thigh has become a perfect circle.

Such staccato accents, destructive of the even Byzantine rhythm, will be found sometimes again, though less obviously, in the later stages of another transplanted Byzantine style, visible in the mosaics executed for the Norman kings of Sicily. This island, melting pot of cultures, was Byzantine in language and reli-

gion from the end of antiquity to the Arab occupation of the ninth century, and mingled this tradition with a highly developed Moslem polity in the two centuries that followed, the Arab element being especially to the fore in the center and west of Sicily. The Norman conquest of the second half of the eleventh century could therefore do little more than reinstate Latin as the official and liturgical tongue, and Sicily at the end of the eleventh century was "more than half Arab, and Byzantine for most of the rest."

King Roger, second of the name in the line of Norman kings, made a vow when his ship off the north of Sicily was almost wrecked by storm, to found a cathedral wherever he made port. The port was Cefalù, and there the cathedral was commenced, following the Romanesque basilical and longitudinal plan, in 1131.[20] An inscription in the apse records its completion in 1148, but some of the mosaics of the choir were still being made in the thirteenth century. The Latin basilical plan involved a rearrangement of the iconographic scheme: the Pantocrator here reigns in the vault of the apse, with the Virgin and four archangels below, followed in the two lowest registers by the apostolic Twelve *à la Byzantine,* including the Evangelists. On the ceiling, in accordance with the concept of the upper spaces in the church as a celestial location, are angels, seraphs, and cherubim. The apsidal figures have Greek inscriptions and are of fairly pure Byzantine style, dating before the completion of the structure in 1148, but the ceiling displays the same decadence that overtook the style in St. Mark's of the thirteenth century, in the first third of which it is probably to be placed. The walls of the choir are covered with prophets, patriarchs, and saints, all with Latin inscriptions except the quartet of great fathers of the Orthodox Church:

[20] V. Lasareff, "The Mosaics of Cefalù," *Art Bulletin,* XVII (1935), pp. 184 ff.

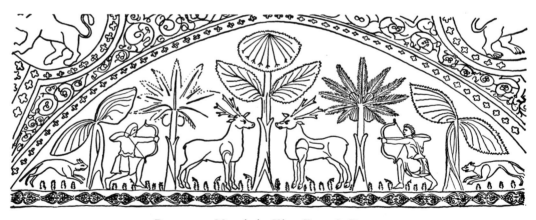

PALERMO: *Mosaic in King Roger's Room*

PALERMO, MARTORANA: *Christ crowning Roger II*

Nicholas, Basil, John Chrysostom, and Gregory of Nazianzus, who are inscribed in Greek. The change to Latin indicates a change from the original Byzantine atelier to local craftsmen, and a date in the fifties or sixties for the lower zones of the wall mosaics, while the even more provincial style of the upper two zones must be placed with the ceiling a generation or two later.

The choir of Cefalù is not the earliest field of activity for Byzantine mosaicists in Norman Sicily; the Martorana at Palermo was built and decorated by the admiral George of Antioch in 1143, conforming in both architectural layout and disposition of its mosaic subjects to the Byzantine norm. The church is a Greek cross in plan and retains Greek throughout its inscriptions. In its central dome is the Pantocrator with four archangels, the hierarchical arrangement descending through the prophets on the drum to the four Evangelists of the squinches.

Warrior-saints and bishops, and the apostles, decorate the arches supporting the dome and the north and south transepts. The apse retains from its original decoration only the figures of Michael and Gabriel flanking the central space which once must have contained the figure of Mary, and of the Feasts we have only the *Annunciation, Presentation, Nativity,* and the *Dormition of the Virgin.* Most curious are two mosaic panels in the western arm of the cross; in one Christ crowns King Roger II; in the other the donor George of Antioch is prostrate at the Virgin's feet. Notwithstanding its earlier date, the mosaics of the Martorana, in their stronger linearity and a charming narrative sense that counterbalances the decorative rhythm, exhibit a somewhat less pure Byzantinism than the apsidal mosaics of Cefalù, and more affinity with the first atelier which worked on the decoration of the royal chapel of the palace at Palermo, the Cappella Palatina.

The royal chapel is of singular effect upon the observer, since it affords as does no other monument the full jeweled ensemble of a Byzantine interior entirely covered with mosaic. And yet not entirely Byzantine, for the basilical plan introduces the Latin longitudinal axis focusing upon the apse rather than the dome. The extraordinary rich inlay of the marble dado, and the painted stalactite ceiling, remind one of the presence of Arab craftsmen, such as those who decorated with mosaic the room in the palace known as King Roger's room, with hunting scenes, centaurs, peacocks and wild animals heraldically grouped amid

MONREALE, CATHEDRAL: *Creation of Eve*

[146]

trees of geometric design. Such translation into wall decoration of oriental textile style can evoke a notion of the secular art which adorned with similar subjects the imperial palaces of Constantinople.

The Byzantine element emerges, however, in the iconographic scheme governing the choice of subjects of the apse and choir of the Cappella Palatina, and the dome which qualifies in a Byzantine sense the basilical aspect of the interior. The bust of the Pantocrator occupies this dome, with his usual entourage of archangels, the four Evangelists in the squinches, alternating with the figures of David, Solomon, Zechariah, and the Baptist, with the rest of the prophets as busts in the spandrels above. The Pantocrator appears again, as a colossal bust, in the apse, above the Madonna and attendant saints who fill the semicircle below, while Gabriel and Michael, at the summit of the sanctuary arch, stand in reverence beside the Etimasia. The New Testament story is deployed upon the walls of the transept, from the Annunciation to the Ascension and Pentecost which occupy the vaults of the north and south arms of the transept, and reaches its extreme of expressive power in the *Entry into Jerusalem,* here reproduced (*Fig. 42*).

This scene ranks with the *Crucifixion* of Daphni as the purest example of Byzantine expressionism which the writer knows, and indeed surpasses the Daphni mosaic in its fidelity to content. For at Daphni one is conscious of the decorative accents, which here are submerged in a rendering ostensibly narrative, but deeply significant. The very enthronement of the Saviour on a donkey, and the position of the beast in mid-air, reveal the ease with which this art transcends reality; the specific details such as this and the boy stripping off his garment to cast it in the Saviour's path are subtly out of focus, and the path itself is symbolically portrayed by a broadly lighted tone. What most deprives the scene of actuality and makes it seem rather a solemn act of liturgy is the semifrontal faces, fixing the eye of the spectator in mutual comprehension. To these in addition is due, even more than to the balanced color scheme, the distribution of accents which resolves the composition, despite the dominating central figure, into a rhythm less obvious than at Daphni, but quite as satisfying in effect.

The mosaics at the east end of the Cappella Palatina were done under Roger II in the forties of the twelfth century, but the nave, with its Old Testament history, was decorated under his son and successor William I, *c.* 1155. The Latin inscriptions which replace the Greek ones of the sanctuary have usually been taken as evidence that western pupils had also here replaced the Byzantine craftsmen of Roger II, but if this be so, the Latin artists well absorbed their schooling, for this narrative cycle of the Old Testament retains the essential of Byzantine distinction, exhibiting in the figures a Hellenic dignity, and in the

compositions a measured rhythm, that seem more Greek than the Old Testament scenes at St. Mark's. The mosaics of the nave, carrying the story from *Creation* to *Jacob's wrestling with the Angel,* were followed by the histories of SS. Peter and Paul adorning the walls of the side aisles, executed by another atelier a few years later, and focusing upon the figures of the two Princes of the Apostles which occupy the lateral apses at the east end of the church. These remain within the *cadre* of Byzantine style, whether they be by Greek or Latin workmen, but exhibit also a sense of drama in the episodes, and a growing realization of space in setting, and of occasional volume in the silhouette of the figures, that reveal a touch of Neo-Hellenism.

Byzantine art in Sicily reaches its final phase with the mosaic decoration of the cathedral of Monreale near Palermo,[21] the most vast and magnificent of all the Norman efforts, covering an area of wall space of over 6000 square meters, but marking nevertheless the decline of Sicilian Byzantine style. The church was built by King William II (d. 1189), but only the mosaics of the apse, the choir, and the sanctuary arch are probably to be ascribed to his reign, while the Old and New Testament scenes of the transept, nave, and aisles seem to have been finished under the emperor Frederick II. As compared with the previous Sicilian cycles, the mosaics of Monreale are of inferior style, and the work of a school of local craftsmen whose Latin predilections are at least indicated by one iconographic variant: in the Creation scenes of the nave the Lord is seated on a globe in accordance with western tradition, whereas in the first picture of this sequence in the Cappella Palatina, its more Byzantine artist depicted the Creator in the arc of heaven.

The disposition of the subjects is a combination of Cefalù and the Cappella Palatina. The Byzantine hierarchy of sanctity is still observed in the mosaics of the apse: the bust of the Pantocrator, huge in scale, is in its vault (*Fig. 51*), a less tranquil rendering than its archetype at Cefalù, and disturbing somewhat by its dramatic gesture and expression the quietism of the Virgin, archangels, apostles, and saints, whose flat figures, descending in hieratic importance, line the hemicycle of the apse below. This apsidal decoration, however, is our best existing revelation of the Byzantine notion of the architectural function of mosaic; it is conceived as a tapestry enfolding, not accentuating, the architectural forms. A classic or Gothic architect would have insisted on some framing of the forward walls of the apse to show the functional division of his superstructure; not so the Byzantine, who carries the mosaic around the corners without a separating border. The flat figures may be, and in fidelity to their supernatural content should be, devoid of natural existence, but they are also free from any suggestion of a

21 D. B. Gravina, *Il duomo di Monreale,* Palermo 1859.

third dimension that would seem to penetrate and contradict the curving surface. To the other qualities of this style must be added its impeccable propriety as wall decoration.

The Byzantine symbolic complex is carried out by the Etimasia in the sanctuary vault, the seraphs that surround the medallions of Christ in the lateral presbytery vaults, the archangels and cherubs on the sanctuary arch, and the angelic choirs lining the walls of the nave. The New Testament is treated with the same compromise between a narrative cycle and that of the Twelve Feasts which can be observed in the Cappella Palatina: the Annunciation is placed as in the Cappella and the Martorana, and also at S. Sophia at Kiev, upon the face of the apsidal arch, the Infancy scenes (with the Cana Wedding and Baptism) in the crossing of the transept, and the Ministry and Passion in its arms. The Miracles are relegated to the side aisles. Peter and Paul, as in the royal chapel, occupy the lateral apses, with their acts and martyrdoms on the walls of the lateral chapels. The Greek inscriptions of the apse are replaced by Latin in the nave, where is unrolled a panorama of Old Testament history obviously in imitation of that of the Cappella Palatina so far as general conception goes, but revealing in such motifs as the Creator on his globe the traces of the Latin cycle that seems to stem ultimately from the ancient decoration of the naves of St. Paul's and St. Peter's at Rome, devised by Pope Leo in the fifth century.

Christ and the Virgin appear here as at the Martorana in votive panels: in one Christ crowns King William II; in the other, with a portraiture of so oriental physiognomy as to suggest a Moslem hand, William offers a model of his church to the seated Virgin. He produced as magnificent an interior as did his predecessor in the royal chapel and on a huger scale, but his workmen merely imitate and exaggerate the mannerisms of the earlier school, galvanizing formulae of movement into a mechanical activity in curious contrast with the underlying static composition. A superficial enrichment of setting in the New Testament scenes, perhaps borrowed from the budding Neo-Hellenistic style, cannot conceal an emptiness of content, which in the mosaics of the nave reduces the stories to a mere outline of narrative composed of trite conventions.

At the other, eastern, end of the cultural world of Byzantium, in Christ's birthplace of Bethlehem, the church founded by Constantine in the fourth century received in 1169 a new mosaic decoration of its nave, transepts, and apse.[22] It had had an earlier one about 700 A. D., when the nave was given its still-existing frieze of the first six ecumenical councils of the church, and six provincial councils to match them. The councils are rendered symbolically, as altars and arcades enclosing inscriptions that sum up their decisions, resembling in this

22 R. W. Schultz et al., *The Church of the Nativity at Bethlehem*, London 1910.

MELISSENDA'S PSALTER: *The Harrowing of Hell*

respect the architectural friezes that decorate the domes of the Orthodox Baptistery in Ravenna and of the church of St. George at Salonica. The six general councils were redone in the twelfth century when the second Council of Nicaea of 787 was added to the series. The provincial councils, however, are original productions of c. 700, which date may explain the discreet and aniconic mode of rendering these assemblages as due either to respect for the prejudice of the Moslem rulers of Palestine against figured representations or to an iconoclastic attitude on the part of the Palestinian church itself. In any case, the Moslem influence is also felt in the decorative motifs that separate the symbols of the provincial councils, these being foliate designs midway in character between the mosaics of the Ommayad mosque at Damascus and those of the Dome of the Rock at Jerusalem (p. 71).

The rest of the mosaics of the church belong to the renovation of the twelfth century recorded in 1169 by a Greek inscription in the choir. Between the windows were figures of angels of which a few are preserved, forming a procession toward the sanctuary, and below the council frieze was a row of busts representing the ancestors of Christ—a motif more Latin than Byzantine. We are thus reminded that the date of the execution of these mosaics falls not only within the reign of the emperor Manuel Comnenus of Byzantium, but also in that of Amaury I, king of the Latin crusading kingdom of Jerusalem, and

husband of Manuel's grandniece. This was a period and a political situation which produced many such mixtures of Greek and Latin taste, as for example the Psalter in the British Museum which was written and illustrated in the twelfth century for a queen of this Latin realm of the Holy Land, Melissenda (d. 1161), wife of Fulk of Anjou. In this book the miniatures of the Life of Christ are wholly Byzantine in style, but once at least Latin in iconography, where three instead of two Marys are depicted at the Holy Sepulcher, and the calendar illustrations and initials are distinctly western in character.

One of the Melissenda miniatures is signed (in Latin) by *Basilios*. The same Greek name appears in a Latin signature near one of the angels in the nave at Bethlehem, and the dedicatory inscription of the choir gives the mosaicist the Syrian name of Ephraim, still more suggestive of the eclectic inspiration of this outpost of Byzantine style. In the mosaics of the choir and transept whose two apses complete the trefoil plan of the eastern end of the church, the style and scene selection are quite Greek, so far as the scanty remains can tell us. The remaining figure of the evangelist John at one angle of the transept crossing shows that the Four were represented here in their usual location. The *Nativity, Christ and the Samaritan Woman,* and *Gethsemane,* once in the south transept, are now destroyed, but there remains a fragment of a *Transfiguration* (the kneeling James) and the *Entry into Jerusalem.* In the north transept the *Harrowing of Hell* is lost and also the upper half of the *Ascension;* the *Incredulity of Thomas* is left, reminding one of the Syrian implication of Ephraim's name in its oriental ornament and the horseshoe arches of its background. We know that the Madonna once occupied the apse, in the orant type with the Child enclosed in an aureole upon her breast.

This is the Madonna type known in Byzantine art as the *Blacherniotissa,* from an icon at the Virgin's church in the Blachernae quarter of Constantinople, where on each Friday the image miraculously displayed the Child in the symbolic enframement of the aureole. The motif is first found in the Coptic frescoes of Egypt (p. 58). A variant, without the aureole surrounding the Child, who is held by the Virgin frontally before her, was called the *Kyriotissa.* The oldest and commonest type of the Mother of God was the Madonna with the Child on her left arm, supposed to have been first painted by St. Luke at Jerusalem and sent to Antioch, where the empress Eudocia, pilgrim to the Holy Land in the fifth century, obtained the picture and brought it to Constantinople. Thence its fame and imitation spread as the *Hodegetria,* the Virgin "who points the way." With the dramatic and sentimental trend of Byzantine iconography ushered in by the Neo-Hellenistic movement, this Madonna took on its "tender" aspects, with the Mother pressing her cheek against

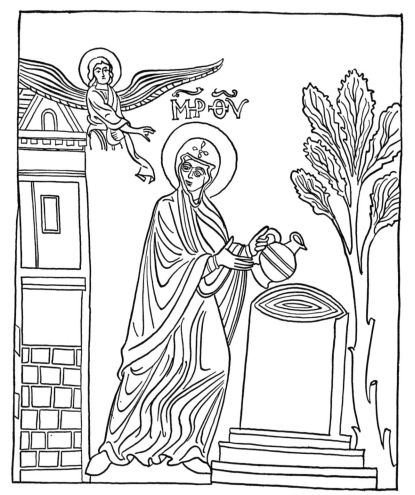

VENICE, S. MARCO, MOSAIC: *The Annunciation at the Well*

that of the Babe, or nursing him (another motif invented by Coptic art), or merely expressive of maternal melancholy. These modifications of the Hodegetria were individually named in later Byzantine nomenclature, as the *Glykophilousa, Galaktrophousa,* or comprehensively as *Eleousa.*

❖ ❖ ❖ ❖ ❖

Parallel to the evolution of Byzantine style thus far traced, and continually affected by its spell, was the development of early mediaeval painting in Italy.[23] We have already noticed the "renaissance" of Paschal I and Gregory IV (*Fig. 37*), a renewal of mosaicwork in Rome which did not pass beyond the imita-

[23] R. van Marle, *The Development of the Italian Schools of Painting*, I, The Hague 1923.

tion of the Greco-Asiatic, early Christian apse of SS. Cosmas and Damian, and reduced even this stylized composition to new extremes of linear flatness and of colored surfaces juxtaposed without shadows. These mosaics of the ninth century are the ancestors of a continual effort on the part of Italian painters throughout succeeding centuries to achieve a Byzantine effect, an effort usually frustrated, on the one hand by their lack of comprehension of the long Hellenic tradition which informs the Byzantine style, and on the other hand, happily, by the insistence of their native Latin genius on its own expression, and the infiltration south of the Alps of Romanesque and nascent Gothic. Taken as a whole, Italian mediaeval painting can be divided into the "Italo-Byzantine" manner of the mosaics of St. Mark's and Sicily, initiated and schooled by Greeks, which kept whatever Latin proclivities it felt (such as the picturesque sequence of the Life of Mary at St. Mark's) within the Byzantine proprieties; and the *maniera greca* in which Latin content and expression strove to clothe its native genius in Byzantine form. In this mode the permanent Byzantine contribution was less stylistic than iconographic, bringing in the compositions of the Nativity, of the Raising of Lazarus, the Crucifixion, Deposition, Last Judgment, the Life and Death of Mary, and innumerable other types, together with the Septuagint landscape backgrounds which maintained themselves in Italian painting to the fifteenth century.

At times the *maniera greca* is no more than a barbarizing of Byzantine style, an accentuation of its stiffness, flatness, and frontality; at others the Byzantine forms are overborne by a Latin revolt from rectilinear and vertical design, as in the lively figures of the ninth and tenth century frescoes in the old church of S. Clemente at Rome, or the almost complete detachment from Byzantine rules in the paintings of S. Urbano alla Caffarella near Rome, of the eleventh century. The unconscious clinging to Latin usage we have already noted in the Benedictine frescoes of S. Angelo in Formis (*Fig. 49*), where Byzantine schooling did not prevent the painters from strong accents in modeling action and expression, nor from any number of un-Byzantine motifs in iconography. Christ sits on the globe in his conversation with the Samaritan Woman and in the episode of the Adulteress, and the latter is not among the readings of Byzantine lectionaries. The scene of Dives and the beggar Lazarus is one that we shall meet elsewhere in the Romanesque art of France (p. 235). At the end of the eleventh century certain frescoes of the lower church of S. Clemente at Rome, especially those of the saint's history, show such style in a mood demure and restrained, but less because of Byzantine assimilations than the general stabilizing of Romanesque design which was becoming evident all over Italy at this period. If one compares these frescoes with the mosaic of the Pentecost

of 1025 in the Greek monastery of Grottaferrata near Rome, the distinction between the "Byzantinizing" and "Byzantine" styles of Italy is plain. In the stories of S. Clemente one is listening to a Benedictine storyteller, careful to enrich his tale with Byzantine ceremonial and static dignity, schooled in the superficials of conventional setting and decorative rather than functional drapery, but nevertheless enthralling the observer with the numerous enlivening details of fluent narrative. The static apostles of Grottaferrata on the other hand are as Greek as the inscriptions that label them, and in them the style

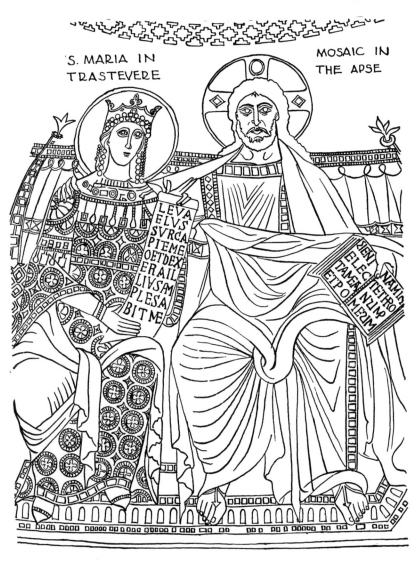

S. MARIA IN TRASTEVERE

MOSAIC IN THE APSE

[154]

has crystallized into fixed formality, corresponding to the notion often held of Byzantine as a *main morte* laid on artistic creation.

The manipulation of such static style by Latin hands explains the curious contradiction one feels in the apsidal mosaic of S. Maria in Trastevere in Rome (1145), where the figures of Christ enthroned with the Virgin are built up by heavy planes of drapery masking the anatomy, and topped with faces conventionally modeled and almost expressionless. But the sharing of his throne with his Mother by a Saviour who places his arm around her shoulders, and the crown the Virgin wears, make this group the nucleus of a wholly western concept in iconography—the Coronation of Mary which a century later becomes the central feature of Gothic Virgin portals. The same mixture of conventional Byzantine drawing with Latin invention or tradition may be seen in the frescoes of the church of S. Pietro at Ferentillo near Terni (*Fig. 50a*), decorated in a scheme very close to that followed by Pope Leo's artists at St. Paul's, with prophets between the windows and three tiers of Old and New Testament scenes on the walls of the nave. These frescoes of the second half of the twelfth century, with their unarticulated nudes, conventional trees in airless landscapes, Byzantinizing drapery, nevertheless show a native Latin element not only in the beardless Lord of the creation scenes and his enthronement on the globe, but also in the same genius for naïve narrative which rescues the frescoes of S. Clemente from monotony. A similiar quality infuses the atmosphere of a story into the mosaic sequence of the Life of Mary in St. Mark's, though the scenes are reduced to a minimum of representation in the details of figure drawing and setting.

By the middle of the thirteenth century the Byzantine factor in Italian painting takes on the new trend of Neo-Hellenism, visible first in the school of Pisa, whose founder Giunta Pisano betrays his Byzantine models in details of iconography such as the change to the dead Christ in Crucifixions which appeared in Byzantine art at this time, and in the heightened dramatic sense which he borrows from late Byzantine style. The same trend toward a realistic quickening in traditional schemes may be followed through the century in the Pisan crucifixes and icons, and is even evident in the preliminary stages of Franciscan art and iconography. The Moses sequence of the last of the domes of the narthex at St. Mark's to be decorated is executed in a Neo-Hellenistic manner, with a revival of a detailed Alexandrian landscape silhouetted against the gold background, with depth and eccentricity of composition, and some stress upon the dramatic content of the incident portrayed. The force and restless quality of this new phase of Byzantine inspires the frescoes of the Baptistery at Parma, especially in the sharply accented scenes

set in rocky landscapes that tell so vividly the story of the Baptist. It has even been recognized, tempered with Gothic grace and fluency, in the *fin de siècle* frescoes of S. Maria in Vescovio, close in style to the art of Cavallini, and to the Isaac sequence of the upper church of S. Francesco at Assisi where some have sought to find the genesis of Giotto's art. Whatever other elements entered into the revival of painting in Italy, this later version of Byzantine must now be credited with some contribution thereto of style, as well as its long-recognized loan of iconography.

COMNENIAN AND PALAEOLOGAN STYLE.
NEO-HELLENISM

One cannot follow, for lack of monuments, the evolution of church decoration at Constantinople that must have conditioned the course of mid-Byzantine style, described above, in the peninsula of Italy and in Sicily. But the process of stylization, the denaturalizing of forms, in the interest on the one hand of spiritual expression, and on the other of rhythmic accent in composition, can be pursued in the illumination of the manuscripts produced by the ateliers of the capital.[24] In them also can be traced, though not to so great an extent, the overemphasis on superficial conventions, and the exaggeration of the decorative interest, which gradually deprive the art of the twelfth and thirteenth centuries, in so far as it clung to mid-Byzantine tradition, of the deep expressiveness of Daphni.

Our illustration of a chapter heading in a gospel book of the twelfth century is a typical example of Byzantine ornament in the period of the Comneni. The larger scale and simpler motifs employed by the proto-Byzantine decorators and their successors of the ninth and tenth centuries have developed, as is almost always the case in the evolution of ornamental style, into greater complexity with smaller elements (*Fig. 46*). The "Sassanian palmette," stock motif throughout the period, has become an intricate design dissolving the foliate forms into a rhythm of contrasting lights and darks, with a rippling movement arising from the reversed and serrated edges of the acanthuslike lobes in which the petals terminate. Every motif in this square of ornament can be traced back to early Christian times and thence into antiquity; what is Byzantine is the rhythmic rather than axial arrangement; what is Comnenian is the multiplication of accents and the minuter scale. A feature of the period is the development of the leaf acroteria which rise from the horizontal base into treelike enlargements of the "Sassanian palmette."

The period of the Comneni (1057–1185) produced the most extensive illus-

[24] J. Ebersolt, *La miniature byzantine*, Paris 1926.

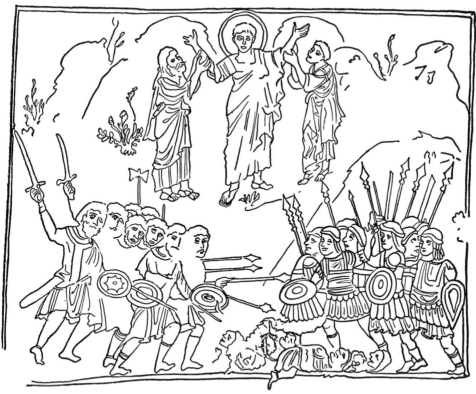

VATICAN LIBRARY, MINIATURE OF AN OCTATEUCH: *The Battle with the Amalekites*

tration of books, and the existing illustrated Octateuchs (p. 50), whose filiation from the Alexandrian Septuagint illustration has been explained in Chapter II, are dated in the twelfth century. Five of them have survived; two in the Vatican (gr. 746, 747), one in the Vatopedi Library on Mount Athos, one in the library of the Serai at Constantinople, another in the Laurentian Library at Florence; of a sixth, once in the Evangelical School at Smyrna, the miniatures exist only in photographic reproductions, for the manuscript itself was destroyed in the burning of the city during the Greco-Turkish war. They are all descended from an archetypal illustration of the Old Testament, but one that was undoubtedly increased by later copyists to the extraordinary sequence of over 350 miniatures exhibited by the example in Constantinople, and they show, like the pictures of the Joshua Roll and the Paris Psalter, their derivation from a roll. A monkish revision of the tradition has diminished and deformed the personifications and other pagan survivals, and the landscape background of the archetype either disappears entirely or is reduced to convention.

[157]

The Old and New Testament themes of Gregory's sermons, most popular of Greek patristic texts, which were so varied and picturesque in the manuscript of Basil I (p. 109), are less in evidence in the Comnenian edition, where the mythological and pagan themes to which Gregory makes scornful allusion are curiously singled out for an illustration that exhibits a remarkable mid-Byzantine deformation of antique forms and subjects. Aphrodite, rising from the sea, is fully clothed, and Zeus appears in the elaborate costume of a Byzantine *basileus*. The prolix illustration of the Octateuchs is matched by the numerous pictures of certain gospel books of the eleventh century, of which two, a codex in the Laurentiana (Vi, 23), and another in the Bibliothèque Nationale (gr. 74), have been selected by Millet in an elaborate but somewhat tenuous demonstration, as representing very early forms of Gospel cycles, the one descending from a primitive archetype formed at Alexandria, the other from one at Antioch.[25] The miniatures have the delicate attenuation of figure style in the eleventh century, but their monotonous sequences, full of repetitions and unessential detail recording the minutiae of the narrative, have the air of mid-Byzantine monasticism rather than that of Christian antiquity. Monastic also by virtue of its authorship is the long series of miniatures decorating the two existing copies of the Homilies of the monk Jacobus in honor of the Virgin, one a codex in the Vatican (gr. 1162), the other copied from it, in the Bibliothèque Nationale (gr. 1208).[26] The illustration is often very literal; Solomon's guard of "sixty of the bravest of Israel," for instance, is duly expressed by six superposed tiers of ten warriors each behind the sleeping king, and the style is anything but brilliant, revealing its date in the twelfth century by a characteristic broadening of silhouette and looser treatment of features, contrasting with the fastidious sharp precision and slim figures of eleventh-century drawing. The mystic Mariolatry of the text and many of the miniatures seem to be connected with the dramatic dialogues of mid-Byzantine liturgy. The Annunciation is distributed over no less than eight scenes to illustrate the long dialogues between Gabriel and Mary, and the colloquy of Gabriel and God which precedes the Annunciation must be of liturgical origin since it is not drawn from any canonical or apocryphal text. Such dramatizing of the Christian theme is akin to the emotional content of the new trend of Byzantine art which began in the middle of the twelfth century.

This vital transformation of Byzantine style is not, however, to be found in

[25] G. Millet, *Recherches sur l'iconographie de l'évangile*, Paris 1916. This work is a mine of information on Byzantine iconography.

[26] C. Stornajolo, *Miniature delle omilie di Giacomo Monaco* (Cod. vatic. gr. 1162), Rome 1910; H. Omont, *Miniatures des homélies sur la Vierge du moine Jacques*, Paris 1927.

such monastic works as the Octateuchs, the Gospel illustrations, and the Homilies of Jacobus. We have no evidence wherewith to attribute its genesis to Constantinople; to judge by its earliest existing examples the new style would seem to be of provincial origin. The name by which it was formerly known, "Macedonian," is indicative of this; its later appellation of "Neo-Hellenism" is descriptive of its character, as a fresh infusion of the naturalism inherent in the Hellenistic fountainhead of Byzantine, whose echo can be noted in some of the mosaics of Venice and Sicily, and in Italian painting of the thirteenth century.

Its first appearance in existing painting is in the frescoes of the monastery church of S. Panteleimon at Nerez near Skoplje in Serbia. The church was built by a member of the Comnenian house, Alexius, in 1164, and its decoration must be of nearly the same date. Much of this work of the last third of the twelfth century has been freed from its modern coating of frescoes by Okunev,[27] revealing one of the earliest examples of a realistic movement in European art. The style is manifest in the Christ-and-Mary scenes of the upper zone of frescoes, and especially visible in the dramatic *Descent from the Cross* (*Fig. 53*), in which the Virgin's kiss upon the cheek of the dead Christ antedates by more than a century this motif in Duccio's Maestà at Siena (p. 330). The *Lamentation* of Mary and John over the body of Christ announces the composition of the group of Giotto in the Arena at Padua, surpassing the latter in the violence of expressive feature and movement.

This sudden injection of disturbing drama into the stylized mid-Byzantine schemes is controlled to more monumental purpose in the Serbian frescoes of the end of the twelfth century and the early thirteenth, in the church of the Virgin at Studenica, built *c.* 1190, and that of the Apostles at Peć, where the forms become more solid, and expression more reticent, though expression is still the major purpose of the art. Two features become apparent in Serbian painting of this time, the one characteristic of its realistic trend, the other of the Byzantine irreality which kept it from full realistic effect. The first is the introduction of that series of remarkable portraits of Serbian royalty which are interspersed in the frescoes among the sacred themes, and leave so strong an impression of the individual despite their iconic frontality. The second is the billowing out of drapery to make a decorative ellipse from the small head to the contraction of the mantle and tunic around the ankles, expanding in the middle to an inflated curve which ignores anatomy. The

[27] Most of Okunev's writing is in Russian, and has appeared in numerous articles and a work in four volumes, *Monumenta Artis Serbicae*, Prague 1928–32. A convenient corpus of Serbian painting is V. Petković, *La peinture serbe du moyen-âge*, Belgrade 1930–32.

curious effect of this can be seen in later Balkan frescoes where the nude is employed, and assumes not the form of nature but the elliptical silhouette suggested by this artifice of drapery.

The dramatic trend is resumed in Serbian painting of the middle of the thirteenth century. At Mileševo it reaches fine expression in a *Betrayal;* its figure of Judas is repeated in the scene in the upper church of S. Francesco at Assisi, which by comparison lacks some of the tragic atmosphere imparted to the scene by the Serbian artist. At Sopoćani, *c.* 1265, the royal portraiture is at its best, culminating in a fine fresco of the death of Queen Anna (mother of the founder Uros I), whose prostrate form upon her deathbed, her soul carried to Christ and Mary in heaven by an angel, and her royal son and his family in a mourning group surrounding her, compose an arrangement obviously based on the scheme of the *Dormition of the Virgin.* In the fresco of the *Dormition* itself, the expressiveness of Nerez is in full return, with the added resurrection of a Hellenistic background, in which the lateral Byzantine pavilions are transformed into buildings that have volume and attempted foreshortening. The hieratic tradition of this composition is broken by loosely constructed and casual groups, and figures whose novel attitudes and action distort the conventions of Byzantine drapery. A new feature in this cycle of Sopoćani is the

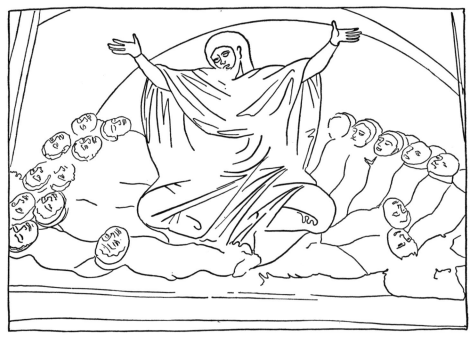

Markov Manastir, Serbia: *The Massacre of the Innocents*

[160]

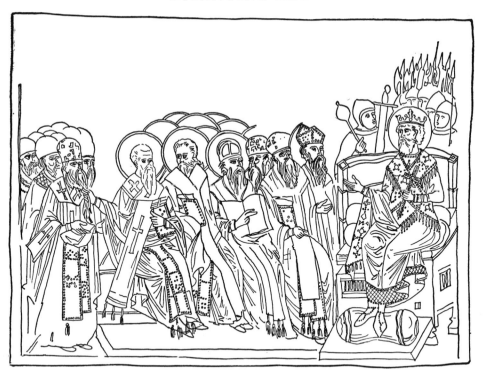

TIRNOVO, BULGARIA: *The Council of Chalcedon*

reintroduction of a Joseph sequence in one scene of which he halts the caravan of his Ishmaelite masters to make obeisance at the tomb of his mother Rachel.

Weaknesses of this effort toward realism which make it eventually only pseudorealistic in effect become evident at the end of the thirteenth century. One is the yielding to the temptation to narrate instead of represent the stories, as in the panoramic cycle of the Nativity and Flight into Egypt at Gradac (*c.* 1276), and the frescoes of the Virgin's Infancy in the little church built by King Milutin at Studenica (1314), very close to the mosaics of Kahrie-Djami (p. 174). In the Studenica paintings a second inhibition is also coming to the fore—the Byzantine refusal to realize real space and constructed form, whereby architecture, depth, action, scale, and anatomy seem conditioned by an atmosphere of unreality. At Staro Nagoričino (1318), the narrative detail reduces the drama of the Life of Christ to confusion, and the walls of Jerusalem back of the Crucifixion undulate not by unevenness of terrain, but only that their crenelations may avoid the heads of the groups which stand before them. Most attractive of the frescoes of this church, signed by two painters named Mikhail and Eutychios, is that representing St. George triumphant over the dragon, which is led in comical tameness by the rescued princess to the gates of

a city thronged with joyful people. The city is an enlargement of the crenelated enclosures of the Vienna Genesis or the early Christian mosaics; to the left is a conventional version of the ancient Alexandrian mountain landscape.

The narrative trend reaches its height in the church of the Annunciation at Gračanica, built before 1321. The Dormition of the Virgin, the Sacrifice of Abraham, the Easter scene, the Raising of Lazarus become continuous stories instead of single scenes, and the mountain landscapes are manipulated to provide boundaries for the episodes of the narrative sequence. A noteworthy fresco, resembling Giotto's Navicella in St. Peter's, is that of Christ stilling the storm, in which also a fourteenth-century feature of the style appears in the sharply pointed zigzag fold of the mantle as it falls over the back of Christ's figure. The frescoes at Peć of the first half of the fourteenth century elongate the figures, and impart to the scenes a certain hieratic quality, enhanced in the Virgin-church by a strongly vertical axis in the compositions, and an obvious use of motifs borrowed from liturgical hymns. A Greek signature, of an artist named John, testifies at Peć (in S. Demetrius) as at Staro Nagoričino, to the nationality of the style. Western influence is beginning to be felt; it is altogether likely that Italy is the source of such motifs as the Madonna "of the Poor" and the Virgin suckling the Child, in the church of the Virgin. In the middle and second half of the century, at Dečani, Lesnovo, Markov Manastir, the decoration becomes encyclopedic in variety, illustrating not only the traditional themes, but saints' lives, hymns, Old Testament themes hitherto untouched, and the apocryphal gospels. The finest Balkan example of the Byzantine Eleousa is found at Dečani, a half-length Madonna pressing her cheek against that of the Child, who grasps a fold of her mantle. The multiplication of subjects and their complicated narrative treatment dissolve, however, the dramatic force and feeling present in the earlier phases of Neo-Hellenism. A singular exception is furnished by the frescoes of the church of St. Andrew on the Treska, in which one finds a *détente* of the prevalent multiplicity of themes and detail, in scenes set in measured depth (though still a nonenclosing back drop), and figures that have Hellenic bulk and dignity. But this church was founded in 1389, the year of the fall of Serbian power on the field of Kossovo, the beginning of Turkish domination, and of a rapid decline in the Christian art of this section of the Balkans.

The evolution of Neo-Hellenism can be better followed in the frescoes of Serbian churches than in the other Balkan countries, not only because of the systematic research of Okunev, but also because the style in Serbia took indigenous root and flourished as a national school, while its appearance elsewhere in the peninsula is more sporadic and more indicative of importation.

[162]

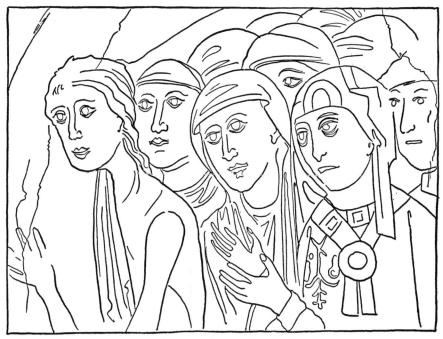

VLADIMIR, S. DEMETRIUS: *The Holy Women*

The frescoes in Bulgaria [28] of the twelfth and thirteenth centuries repeat for the most part the normal Byzantine manner of the period, and their inscriptions are in Greek; the new style shows itself timidly in rocky landscapes and architectural settings of some depth, but the principal feature allying them with Serbian art is the taste and genius for the contemporary portrait, and the usual decoration of the lower walls of the church with iconic figures of saints. Bulgaria was Christian from the ninth century, but its Byzantine art, so far as it has survived, dates mostly from the thirteenth century and the replacement of the earlier basilical churches with the Byzantine type of cruciform plan and dome. The best examples are the frescoes of Boiana (1259), and those of SS. Peter and Paul in the old capital of Tirnovo (fourteenth century), where in the interesting rendering of the Councils in the narthex, dramatic interest is amusingly registered in the figure of an archbishop (at the Council of Chalcedon) who pulls a colleague's beard. Byzantine art in Rumania has left a remarkable monument in the frescoes of the church of St. Nicholas at Curtéa de Arges, not only in their style, but in their rich but orderly iconography. They have been dated by Tafrali [29] in the second half of the thirteenth cen-

28 A. Grabar, *La peinture religieuse en Bulgarie*, Paris 1928.
29 O. Tafrali, *Monuments byzantins de Curtéa de Arges*, Paris 1931.

NEREDITSA: *The Blacherniotissa*

tury; by others, chiefly because of the close association of the style with that of Kahrie-Djami, in the fourteenth. Greek inscriptions accompany the scenes, and the quality of content is a happy synthesis of "Cretan" and "Macedonian," of traditional solemnity and Neo-Hellenistic narrative. The subject matter is extensive, including compositions such as the "Tent of the Covenant," Joseph and Mary before the Roman legate "to be taxed" (recurring at Kahrie-Djami) and a striking fresco (in the prothesis) of the Blacherniotissa above the dead Christ on his sepulchral slab, surrounded by reverent angels. The narthex contains a cycle of the story of St. Nicholas that is perhaps the most complete in mediaeval art.

To follow the purer Byzantine development of Neo-Hellenism, one must have recourse to its transplantation to Central Russia in the twelfth century, when the importation of artists from Byzantium is historically recorded.[30] The principality of Kiev, the first Russian polity to be organized under rulers of Scandinavian race, lost its sovereignty in the twelfth century and about 1200 became incorporated in the new states of Volhynia and Galicia. In its stead arose the realm of Vladimir-Suzdal in the center of European Russia, and the commercial centers of Novgorod and Pskov, situated on Russia's western waterway connecting the Baltic with the Black Sea, purveyors of raw materials to the Hanseatic cities to the west, and prosperous in consequence. The central state survived the terrible Tartar conquest of the thirteenth and fourteenth centuries, and from its new capital of Moscow began in the fifteenth a gradual absorption of the rest of Russia (hastened by the fall of Novgorod in 1478) which

30 P. P. Muratoff, *L'ancienne peinture russe*, Rome 1925; P. Schweinfurth, *Geschichte der russischen Malerei im Mittelalter*, The Hague 1930.

terminated in the integration of the empire under Peter the Great in the beginning of the eighteenth.

The remnant of early Russian painting which most clearly allies itself with Neo-Hellenism is the fresco of the Last Judgment in the church of S. Demetrius at Vladimir of the end of the twelfth century, and especially in this, the group of St. Peter leading to Paradise a group of holy women, among whom St. Mary the Egyptian stands forth as an extraordinary rendering of ascetic personality. Among the churches and monasteries that ringed the environs of Novgorod, the small domed structure of the Saviour-church at Nereditsa has preserved its frescoes of the twelfth century, a decoration which is essentially Byzantine in iconographic arrangement. The Ascension occupies the cupola, with prophets in the drum and the four Evangelists in the pendentives. A new motif appears on the faces of the four arches supporting the dome—the two miraculous portraits of Christ: the *mandilion* or Veronica kerchief, and the *keramidion* or Abgar portrait (p. 102). The orant Blacherniotissa is in her accustomed place in the apse, whose vault displays the Etimasia. The "Ancient of Days," with Michael and Gabriel, occupies the ceiling of the sanctuary. Below the Virgin the semicircle of the apse is divided into four zones, the Divine Liturgy occupying the topmost, saints the second and third, while the fourth contains the Deesis, remarkable for its placing of the Baptist, instead of the Virgin, on Christ's right hand, and the tonsure given the Saviour—a motif found also at Nerez.

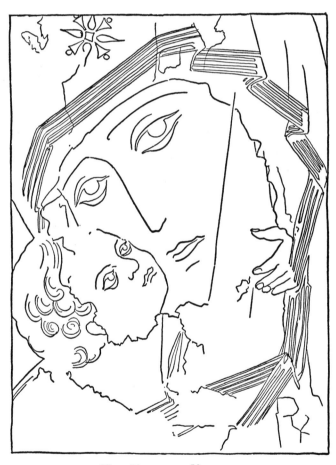

THE VIRGIN OF VLADIMIR

[165]

Another novelty is the scene of *Elijah fed by the Ravens,* introduced beside the Deesis as a eucharistic type. The rest of the church is covered with the Lives of Christ, Mary, and John the Baptist, interspersed with Old Testament scenes and figures of saints, and the west wall with an elaborate Last Judgment following essentially the disposition at Torcello. The style while certainly Byzantine at core, and Neo-Hellenistic in its narrative and expressive interest, reveals a provincial hand in most of the frescoes, unused to the complexities of movement and setting which the new trend involved. The most Greek of the paintings are those figuring the saints.

A similar organization of the subjects prevails in the frescoes of the church of St. George at Old Ladoga, built *c.* 1180, in which the diaconicum contains a rendering of St. George conquering the dragon, of a type that is evidently an earlier and simpler phase of the more developed composition at Staro Nagoričino. Despite the interest of church frescoes of the twelfth century, recently rescued in many cases from modern restoration and plaster, the finest and purest Byzantine art in Russia is to be found in the icons of the period.[31] Most famous of these is the Madonna of Vladimir, brought according to Russian chronicles to Suzdal "by ship from Constantinople," and thence installed in the mid-twelfth century in the church of the Assumption in Vladimir. In 1395, this image was transferred to Moscow to turn back the hordes of Tamerlane, after which it remained in the new capital, and is now preserved, freed of six or seven layers of repainting, in the Historical Museum of that city. Archetype of the Eleousa of Dečani, it controls the emotional content with exquisite Byzantine refinement, and reveals the extent of our loss in the disappearance of the Comnenian painting of Constantinople. Other icons of the twelfth century display this balanced and reticent expressionism, notably in the heads of the saints, and of angels, as for example the beautiful Greek head of Gabriel in the *Annunciation* of Ustjúg, a panel in the cathedral of Moscow. More fully realizing the realistic bent of Neo-Hellenism is the extraordinary portrayal of personality in the icon of the Twelve Apostles, of the Historical Museum at Moscow.

The thirteenth century, period of the Tartar invasions, has left us no fresco cycles, even in the region of Novgorod, defended from the fearful raids by its swamps and lakes. In the fourteenth century, the Byzantine infusion recommences, in the person of the most unique individuality in Byzantine art, the Greek Theophanes, active in Novgorod and Moscow in the end of the fourteenth and the early years of the fifteenth century. Of his documented work there remain only fragments of his frescoes in the Novgorod church of the Transfiguration (1378)—strange conceptions in which the impressionism de-

[31] N. P. Kondakoff, *The Russian Icon,* trans. by E. H. Minns, Oxford 1927.

veloped by the realistic movement is turned to esoteric effect after the manner of another Greek two centuries his junior, El Greco. On the linear pattern of traditional Byzantine drawing this master imposes a strange chiaroscuro which gives an appearance like that of a photographic negative. He disdains any but the most symbolic setting, and distorts physique, features, and functional drapery into unearthly forms. The same sweeping style, by some ascribed to him, is in the frescoes of the Assumption-church of Volotovo near Novgorod, and the church of S. Theodore Stratelates in Novgorod itself.

Trained by Theophanes was the greatest of Russian painters, Andréi Rublióv, who with his assistant Daniíl Tschorny decorated the Assumption-church in Vladimir in 1408 with frescoes which were partly recovered by a Soviet commission, headed by Grabar, in 1918. In these paintings Rublióv shows himself the pupil of his master in the elongation of his figures and the artificial chiaroscuro of drapery, but reveals as well his native taste in the curious transformation which begins with him in the treatment of the Hellenistic background, whose unfamiliar rocky mountain heights become a wholly conventional piling up of cubical facets, lighted by stripes and dots, or white rectangles which have no relation to natural illumination—as the mountains have none to actual landscape, and especially none to the flat steppes of Russia. In Rublióv's masterpiece, the *Trinity (Fig. 58)* formerly in the monastery of SS. Sergius and the Trinity near Moscow (*c.* 1425; now in the Tretyakoff Gallery, Moscow), the expressive chiaroscuro of Theophanes is replaced by a precise line, a reticent and mystic sentiment, and a hieratic immobility of figures that yet lend their accents to a decorative rhythm, which one associates rather with the conservative "Cretan" wing of Palaeologan art, than with Neo-Hellenism. The Trinity is expressed in the fashion of the eastern Church by the three angels met by Abraham at Mamre, whose tree and a bit of architecture are the only remainders of physical reality. Abraham and Sarah, unnecessary to the dogma contemplated, are absent. Typical of Russian art is the exaggeration of the elliptical contour by which the drawing of the figures betrays its date, and also the Slavic melancholy that broods over the trio. The contemplative Byzantine mysticism and the undertone of emotion it engenders are perhaps more clearly here expressed than in any of its more indigenous productions. The icon is a Greek hymn upon a Slavonic tongue.

The fifteenth century domesticated Byzantine style in Russia. The formulae of the Neo-Hellenistic settings became transformed into local vernacular, and in the second half of the century the faces sometimes assume Slavonic features. Native subjects and saints compete with the traditional themes of Byzantine painting. The outstanding artist who embodies this Russianizing of

[167]

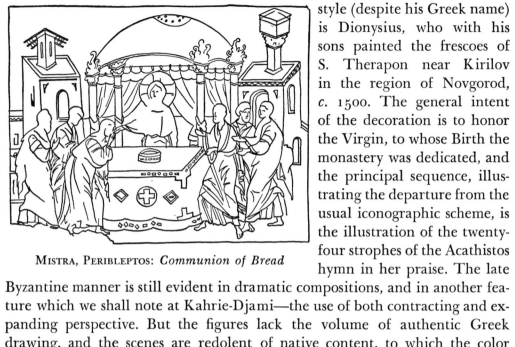

MISTRA, PERIBLEPTOS: *Communion of Bread*

style (despite his Greek name) is Dionysius, who with his sons painted the frescoes of S. Therapon near Kirilov in the region of Novgorod, *c.* 1500. The general intent of the decoration is to honor the Virgin, to whose Birth the monastery was dedicated, and the principal sequence, illustrating the departure from the usual iconographic scheme, is the illustration of the twenty-four strophes of the Acathistos hymn in her praise. The late Byzantine manner is still evident in dramatic compositions, and in another feature which we shall note at Kahrie-Djami—the use of both contracting and expanding perspective. But the figures lack the volume of authentic Greek drawing, and the scenes are redolent of native content, to which the color scheme contributes its share, with a prevalent blue background contrasting with rose and yellow accents, and colorful costume such as the gold, purple, violet, and light-blue garments of the Virgin, and Christ's bright mantle over a tunic of purple or blue.

❖　　　❖　　　❖　　　❖　　　❖

The icons of the Orthodox Church in Russia carry on the Byzantine tradition down to our own times, and so also do the countless frescoes of the Greek monasteries on Mount Athos, which almost all lie beyond the chronological limit of the mid-fifteenth century observed in this book, though furnishing by far our best material for Greek painting of the sixteenth, when the art of the Mount deserts its earlier "Macedonian" style for nearly complete adherence to the "Cretan" manner. It was this century, and the practice of the artists of Mount Athos, that crystallized church decoration into a formulary that could be embodied in a handbook—the *Painter's Guide*.[32] This book, still a manual for religious painting in the Orthodox Church, is the work of Dionysius of Fourna, who wrote from sixteenth-century sources but probably no earlier than the eighteenth, and codified the principles of the distribution of subjects, and of their composition in detail, following, he says, the example of the cele-

[32] A. N. Didron (Dionysius of Fourna), *Manuel d'iconographie chrétienne grecque et latine*, 1845.

brated Panselinos of Mount Athos, whom he describes as "above all painters, ancient and modern." In the Athonite frescoes ascribed to Panselinos, however, some have detected borrowings from Italian art, and in the *Massacre of the Innocents* in the Lavra monastery, Theophanes the Cretan made use of a print by the Italian Marcantonio. Other frescoes are obviously based on German woodcuts of the Renaissance. The general aspect of the art of Mount Athos is nevertheless faithfully Byzantine, and a late reflection of the two modes of Palaeologan style whose finest Greek monuments are the frescoes of Mistra in the Peloponnese,[33] and the mosaics of Kahrie-Djami in Constantinople.

Mistra, capital of the Peloponnese when it was recovered from its Latin invaders in the thirteenth century, and once a princely residence rivaling Constantinople in splendor, was also in the time of the Palaeologi a focus of Greek culture, and a religious center whose importance can still be read in the great ruins of its monasteries. Of its churches, three have retained to a great extent their frescoed decoration, the Metropolis of the early fourteenth century, the Peribleptos of its second half, and the Pantanassa of the beginning of the fifteenth. In the first of these a half of the frescoes, in the nave, the north aisle, and five panels of the Life of the Virgin in the aisle to the south, show a style little more developed than the conservative painting of the twelfth-century miniatures; faint shadows, simple settings, traditional formulae of movement, and a subdued scheme of color reveal a school little touched by the new pseudorealism. It approaches nearest to it in the best of the scenes of the Life of Christ in the nave, the fragmentary *Betrayal*. Another atelier, which decorated the rest of the south aisle and the narthex, is on the other hand fully engaged, especially in the narthex, in the "modern" movement. The difference is most marked in color, which seeks strong contrasts, usually of complementary tones, but producing a lively chiaroscuro which has much to do with an emphatic dramatic effect, enhanced by fantastic architectural settings and free movement of the figures. This is the manner of Neo-Hellen-

MISTRA, PERIBLEPTOS: *Communion of Wine*

[33] G. Millet, *Monuments byzantins de Mistra,* Paris 1910.

ism, the "Macedonian" style as it is called in the *Painter's Guide,* represented by Panselinos in contrast with whom is placed Theophanes, the great exponent of the "Cretan" school.

The "Macedonian" use of the narrative frieze and large compositions, complicated in motifs and action and by an architectural background in pseudo-perspective, is avoided by the "Cretan" artists of the Peribleptos, who conceive their subjects after the manner of icon painters, less as episodes for narration than as objects of devotion. Their drawing is more precise, their color harmonizing and warm, their composition the traditional static rhythm of Byzantine Hellenism. The distribution of subjects reveals conservatism as well: a ruined fresco of the Pantocrator, with cherubim, seraphim, prophets, and Etimasia, still decorates the central dome, and the sanctuary vault contains the Ascension. But the more complicated symbolism of Palaeologan times intrudes itself; below the Madonna of the apse the Lamb of God lies on an altar, adored by angels and the Doctors of the Church; in the conch of the diaconicum the boyish Christ-Immanuel is asleep, with angels attending; the apse and walls of the prothesis are filled by the Divine Liturgy, with Christ officiating as priest at the altar in the center, while a rhythmic file of angels on either side advances with the elements and implements of the Eucharist. The "Cretan" quality is most observable in these frescoes of the two lateral apses, though the diaco-

MISTRA, PANTANASSA: *The Raising of Lazarus*

[170]

nicum contains a *Christ Mounting the Cross* (by means of a ladder) that reveals the new narrative interest of Neo-Hellenism. The Feasts are represented in the nave and transept, but the prolix late Byzantine iconography appears in the aisles—in a sequence of scenes at the south, depicting the burial of Christ, and in the north aisle a long cycle of the Virgin's life. This art is not untouched by the quest of human interest and variety of setting that dominates the "Macedonian" style, and employs with discretion its mountain landscapes and their cheeselike rocks, but it absorbs this realism within a hieratic purpose, retaining along with occasional picturesque detail and more numerous figures the imprint of Byzantine gravity, most evident perhaps in the traditional outward gaze of the faces wherever the action will permit.

The Pantanassa was decorated *c.* 1430, with frescoes which are in strong opposition to those of the Peribleptos, vocal in color, and losing equilibrium in occasional excessive movement of the figures. The scenes impress one by their complication and the variety of accents which convey a certain momentum to the effect, and the artists have caught some of that marked verticality in composition (visible also in the "Feasts" of the Peribleptos) which gave to the frescoes in the Virgin-church at Peć so much of mystic meaning. Characteristic of this handling of episode is the *Raising of Lazarus,* in which the ancient Alexandrian landscape lays the scene in a solemn and unreal topography, wherein the walls of Bethany, emerging above the bleak and rocky profile of the mountains, provide an only semireal location. The narrative effect of the descending throng, and the multitude accompanying Christ, is reduced to lesser emphasis by the dominating figure of the Saviour and by the broad and simple spacing which isolates and dignifies the central episode. The resemblance of the scene to the famous rendering of the subject in the lower church at Assisi is noteworthy, and one must admit that the fresco of Mistra conveys no less than the Italian painting the powerful effect of Christ's command, *foras veni Lazare,* which the Greek artist found it unnecessary to inscribe upon his picture. Such parallels raise the question again of possible Italian influence upon this Palaeologan art, but bring one in the last analysis to conclude that the Trecento in Italy, and the Neo-Hellenism of Byzantine, are but parallel phenomena (with mutual interaction no doubt) of the realistic movement stirring throughout the mediaeval art of Europe from the middle of the twelfth century. The closer cultural and economic relations which linked the East and West from the time of the Crusades and the Latin conquest of Constantinople will suffice to explain the contacts one can discover between the revival of painting in Italy and the art of Mistra, and a similar explanation may be found for the parallels in style and iconography

VATICAN, SILK TEXTILE: *The Annunciation*

which Balkan frescoes exhibit with contemporary Latin work. It was precisely the lack of such contacts until the sixteenth century that maintained a more conservative and purer Byzantinism in the art of Russia.

Perhaps the most remarkable of the aspects of Palaeologan art is the perfection which was achieved at this time by textile technique in silk. The manufacture of decorative textiles was from the sixth century, after the introduction of silk culture in the Empire, one of the principal luxury trades of the capital. We have a description of the curtains that draped the altar of Hagia Sophia which shows the high development of figure art in this medium: Christ, between Peter and Paul, occupied the center of one of these curtains, a figure in purple and gold beneath a golden cupola, contrasting with the white forms of the apostles; miracles of Christ adorned the borders, and representations of the buildings erected by Justinian and Theodora. The Greek weavers in such productions showed themselves ready pupils of the makers of Sassanian textiles, much in vogue, with their medallions enclosing animals, horsemen, and hunting scenes, often grouped about the age-old Asiatic symbol of

the *hom,* the sacred tree. These imported pieces were highly prized in Byzantium in the preiconoclastic period, and made their way westward, some of the best extant pieces being preserved as vestments in the treasuries of Latin churches. The artists soon employed the Persian patterns for enclosing Christian subjects, as in the case of the two superb pieces of the sixth century in the Museo Sacro of the Vatican, found in the reliquary chest of the Sancta Sanctorum (p. 70), on which are figured the Nativity and the Annunciation. By the tenth century the industry was regulated with careful legislation, and the finest pieces executed in imperial ateliers, where were made the magnificent fabrics which played so colorful a part in the court ceremonials. The oriental influence continued to exert itself in the ornamental subjects and patterns, which remind one of the "jigsaw" effect in the decoration of contemporary manuscripts, but with a slower rhythm in design and a respect for empty space that marks the integration of Byzantine taste. The church profited as well by the encouragement of the art, though some of the pieces that ultimately found ecclesiastical use in the West were not made originally with such intention. The fine fabric found in Charlemagne's tomb and preserved in Aachen minster is of completely oriental design with its roundels enclosing yellow elephants on a purple ground, and marked with an inscription naming the officials of the imperial atelier which produced it. Another inscribed piece, dated in the twelfth century, is an altar frontal with the figures of archangels, in the treasury of St. Mark's. But the application of the art to liturgical use reached its height in the magnificent ecclesiastical textiles of the Palaeologan period.

The most elaborate of these is the so-called "dalmatic of Charlemagne," preserved in the sacristy of St. Peter's at Rome, but dating, despite its legendary name, no earlier than *c.* 1400. It is a Greek *sakkos,* corresponding to the dalmatic of Latin liturgical vestments, of deep blue silk, embroidered in silver and gold. On the back is the *Transfiguration,* and on the shoulders the *Communion of the Apostles,* while the front displays a *Last Judgment* reduced to its symbolic essentials, with Christ enthroned on the arc of heaven in the center, surrounded by angels and saints, and the interceding figures of the Virgin and Baptist. The Cross surmounts the scene, which is completed below by Abraham with a symbolic soul in his lap, and the Good Thief carrying his cross. The altar cloths of the period have usually a decoration symbolic of the Eucharist, as for example the *Communion of the Apostles,* or more often the image of the dead Christ for which the cloth could symbolize the winding sheet. Such coverings were called for this reason *epitaphioi* and begin to appear

at the end of the thirteenth century. The finest existing example is the *epitaphios* of Salonica,[34] on which angels with liturgical fans make obeisance to the body of the Saviour, and two angels, weeping, soar above. A late motif here is the introduction of the Latin theme of the four evangelistic symbols at the corners. The *Communion of the Apostles* is divided into two compartments, one at each end of the altar cloth. The piece dates in the mid-fourteenth century, and evinces the quality of naturalism in composition and movement which belongs to the period (the apostles of the *Communion*, for example, are no longer in hieratic file, but casually grouped), combined with an extraordinary fluency of design in view of the difficult technique. The colors are a harmony of green, red, silver, and gold.

This brief survey of Byzantine art may find a fitting termination in the mosaics of Kahrie-Djami at Constantinople,[35] the single example of Palaeologan art that the capital has preserved, and also the only surviving church decoration of considerable extent in that city that has survived Islamic iconoclasm. This structure was once the church of a suburban monastery, called from its location "in the Chora," or "country," and was built in the first half of the twelfth century. It has preserved the mosaics of the narthex and exonarthex, and these are dated by the lunette over the portal of the inner narthex, representing Theodore Metochites (councilor of the emperor Andronicus II) who restored the church and commissioned these mosaics between 1310 and 1320. The inner narthex has two domes, in one of which Christ is surrounded by the patriarchs from Adam to Methuselah, and figures representing the Twelve Tribes; in the other the Virgin is attended by the sixteen kings of Israel and eleven prophets. A Deesis decorates the wall of this narthex, whose principal interest is however provided by the narrative cycle of the Life of the Virgin, followed in the outer narthex with the Infancy and Miracles of Christ.

The apocryphal history of Mary here depicted (*Fig. 54*), based on the Protoevangelium of James, had already entered Byzantine iconography as early as the first half of the eleventh century in the frescoes of S. Sophia at Kiev (p. 131), but its narrative interest and the opportunities it offered for picturesque setting and emotional expression made it a favorite of the Neo-Hellenistic painters. Nowhere else has the style reached such perfection, save possibly at Curtéa de Arges, as in these mosaics, testimony to the status of Constantinople in this as well as other periods of Byzantine painting as *arbitrix elegantiarum*. The revival of Alexandrian background is here realized in a fuller sense, in that the

[34] Ch. Diehl, *Les monuments chrétiens de Salonique*, Paris 1918, pl. LXVIII.

[35] F. I. Shmït, *Kahrie-Djami*, Sofia 1906. A few of the mosaics are reproduced in P. P. Muratoff, *La peinture byzantine*, Paris 1928, pls. CCXXXI–CCXXXVII, and Ch. Diehl, *La peinture byzantine*, Paris 1933, pls. XL–XLIII.

figures are less "down stage" and more enclosed in their settings, and the stories are told with a wealth of human interest, exhibited not alone in mere narrative detail, but in convincing gesture and facial expression. Most Hellenistic of all is the lively color that pervades the compositions, quite different from the deep and contemplative gamut of mid-Byzantine, and resembling more the palette of Pintoricchio.

Nevertheless, the bounds of Byzantine idealism are not transcended. Architectural perspectives are sometimes real in their foreshortening, but are quite as likely to expand as they retreat into depth. The Hellenistic solid stance is not observed, but rather the tiptoe dangling of feet that deprives the body of weight. The late Byzantine formulae are still in evidence: the ultraelongation of the figures and their billowing elliptical silhouettes of drapery, with the characteristic zigzag drawing of a free-hanging fold; the exaggerated high lights; the airless background. What most keeps these lovely pictures still within the Byzantine norm is the subtle rhythm running through them all, skillfully promoted, despite the specific requirements of episodic action and detail, by a gesture here, a turn of the head there, or by the fluent pattern of the architectural landscape, maintaining thus the traditional Byzantine decorative unity, even while delighting eye and mind with an absorbing narrative.

❖ ❖ ❖ ❖ ❖

This autumnal flowering of the Byzantine genius closes the history of Greek art at Constantinople, and illuminates the end of Byzantine art in the city which was its focus. The perspective over the evolution of this art from the standpoint of the fourteenth century is immensely shortened by the conservatism it displays. Many a theme is still conceived essentially in the form it assumed at the close of the Iconoclastic Controversy or even earlier, and in this persistence of iconography Byzantine style reveals the most Hellenic of its component factors—the intellectual apprehension of the faith. Its spirit was Greek enough to reduce mystery to theology, and theology to types, which once arrived at defied the process of essential change by their very perfection. No Christian art has ever so completely and so grandly portrayed the dogmas of Christianity.

Byzantine art drew the expression of this Hellenic quality from the two antique sources from which its style was formed, the Neo-Attic with its classic forms and ideal ignoring of the specific, and the Alexandrian with its fuller and more facile modeling, retaining the volume of the figures that was lost by Neo-Attic flatness. The two traditions live on, with a tenacity characteristic of this timeless art, to reappear in late Byzantine, in the opposition of the

"Macedonian" and "Cretan" schools, the one reviving the picturesque humanism of Alexandria, the other clinging to Neo-Attic abstraction.

The oriental element, the factor that transformed such Hellenism into Byzantine, is not obvious in style, where superficial observation can only see the eastern influence in subordinate accents or ornament. It is there nevertheless in the fundamental change in composition, frankly evident in the final Asiatic phase of early Christian art, subtly masked in Byzantine by the revival of Hellenic form. This is the achievement of unity by rhythm, and this in turn by the equalizing of accents, which was accomplished by the best of Byzantine decorators without loss of the static equilibrium inherited from their Greek ancestry. This is why one's gaze moves so slowly over a Byzantine composition, in comparison with its rapid exhaustion of an early Christian sequence such as the processions of saints in S. Apollinare Nuovo. The eye is engaged and retarded by the noble solemnity of each figure, and fixed by its semifrontal glance; it is assured of compositional stability by symmetry of placing, or by an accent on some central feature which recalls the classic axis. But the eye moves nevertheless, and in a fine Byzantine work with infinite pleasure, over a subject that can finally be resolved into rhythmic pattern.

Such stylistic expression fits the content of Byzantine art, a content mystic and contemplative, viewing its Christian theme as something sublime and physically intangible, like its liturgy that was enacted behind the wall of the iconostasis, and like its concept of supreme worldly authority embodied in the sacred and unapproachable person of the emperor. Hence the grandeur and magnificence, in unconscious imitation of imperial splendor, with which it invested the vision of celestial things, and the unreality with which it clothed its version of Christian history, even in the last phase of Neo-Hellenism when it made its own peculiar effort toward realism in response to the general realistic movement in European art. The apparent failure of this effort is in fact rather the triumph of the Byzantine genius, refusing to sacrifice a decorative principle of rhythm to the eccentric demands of drama, or to materialize its transcendental content. Byzantine art, to quote an arresting phrase of Muratoff, "held to the reality of myth, in distinction from other arts, including that of our own day, which pursues in vain the myth of reality."

IV

Romanesque Art

POSITIVE MYSTICISM

"BARBARIAN" STYLE.
THE CHRISTIAN ART OF IRELAND

THE NAMES OF TOWNS in Europe reveal a great deal of history. In Italy and Spain, and in the south of France, they still preserve the ancient city names— Arles is Arelate, Marseilles ancient Massilia, Narbonne the original Narbo. But further north, in France for instance, the names become tribal, condensed from the appellations of ancient Gallic peoples, whereby we arrive at Soissons from the Suessiones, Reims from the Remi, and Paris itself from the Parisii. This means that the southern towns have continued an unbroken existence through the mediaeval centuries as towns, while in the north where Roman settlements were scarcer, the cities that we know today had their beginnings as mere meeting and trading places of un-Latinized tribes. Once across the frontier the town names seldom show any Latin roots at all: if Cologne on this side of the Rhine still preserves its old name of Colonia Agrippinensis, Frankfurt, Karlsruhe, Freiburg, Darmstadt are Germanic from the beginning.

As antiquity drew to a close and the Middle Ages began, we find throughout the European world this threefold geographic and cultural division—the Mediterranean zone where Latin city civilization persisted with astonishing pertinacity, a twilight zone of recent conquest where barbarian and Latin modes of life met and mingled in equal measure, and the zone beyond the

Roman military pale where the Latin *modus vivendi*, if visible at all, was an article of importation. In this last zone dwelt the tribes whom the Romans, with some measure of snobbery, called the barbarians—the Celts of the British Isles, the Germans who fringed the Rhine and the upper Danube, and the Sarmatian and Scythian peoples who lay beyond the lower Danube and extended through the south of Russia to the Black Sea. Each of these nations had an art of its own, expressive of its native genius, and varying greatly from tribe to tribe. But all their arts had in common a goal or purpose quite the opposite from that toward which the art of Rome and Greece was oriented. Greco-Roman art was an anthropocentric naturalism, bent on expressing what it had to say through the medium of man and the human figure. Barbarian art seldom employed the human figure, preferred animals to the plants which gave the Greeks and Romans most of their motives for ornament, and cared more for decorative effect, even when depicting its beloved animals, than for accurate representation. It was in fact a nonrepresentational art; even when it adopts a natural form, this form will change in the course of a few generations of barbarian use to pattern. The barbarian trend was always toward abstract design.

Such was the quality of barbarian style. As for its forms, these were for the most part borrowed from the southern cultures with which the migrations of the barbarian tribes brought them into contact, and primarily that of the Scytho-Sarmatian peoples inhabiting the south of Russia. These races themselves had borrowed to a large extent the motifs which they developed into a beautifully decorative style, and borrowed them from Persia. From the Persian use of animals in ornamental design the peoples of the Black Sea region elaborated their peculiar animal style: beasts in relief on gold brooches, horse trappings, sword hilts and the like, studded unnaturally with gems and amber, and modeled with an exaggerated fluency which expresses the quest of Scytho-Sarmatian art for movement in design. From Persia, too, the Scytho-Sarmatians borrowed the technique of cloisonné, which they modified into a "cold" cloisonné where imitation gems are set, without fusing by heat, into the cloisons of gold plaques. This was the technique that most appealed to the German Goths who wandered from the Baltic to the Black Sea in the second century, and carried thence this pseudocloisonné in the course of their later migrations to the west. Their characteristic application of it was the Gothic fibula or brooch (*Fig. 57*), imitated in one form or another by almost all the barbarian tribes that invaded the Empire.

Barbarian art, as arts go, was short lived on the continent of Europe, save in Scandinavia. It lasted, in fact, not much beyond the date when the barbarians

adopted orthodox Christianity. The barbarians embraced the new faith at first in its heretical form of Arianism, which qualified the divinity of Christ. The heathen Franks became orthodox Christians in the sixth century. Burgundians, Visigoths, Lombards followed suit in the sixth and seventh; the Germans beyond the Rhine were converted by the sword of Charlemagne about 800. Denmark became Christian in the ninth century, Norway in the eleventh, and Sweden not until the twelfth. It was the advent among these tribes of the missionaries of the orthodox Latin church that destroyed their native art; with the missionaries came the pictured gospel books and carved reliquaries, made in Mediterranean lands, and even builders to build the new churches, and painters to decorate them. Against this influx of Christian art in Greco-Roman garb the less sophisticated ornamental and non-representative style of the barbarians rapidly lost its headway. The first effect of the collision was to neutralize the good points of both; the classic naturalism became grotesque; the barbarian ornament coarse. The ultimate effect, visible throughout continental Europe by the ninth century, was the submergence of barbarian style in what was left of classic tradition. By the ninth century the Carolingian artists when they represent their emperor are doing their best to make him look like a Roman Augustus; the geometric and abstract designs in ornament are yielding place to the acanthus, the vine, and all the other foliate motives handed on from antiquity.

Only in the remote recesses of the barbarian population of Europe was the influx of Greco-Roman fashion resisted, in the Scandinavian peninsula and Ireland. In both places the barbarian style retained its sway, and in both it collapsed in the twelfth century and gave way to the art of the human figure—an art by this time transformed from its Roman aspect into the new forms of the Romanesque. There is however this difference between the capitulations of Scandinavia and Ireland: in Scandinavia the barbarian art persisted because the peninsula had not yet been Christianized; in Ireland, converted in the fifth century, it was Christianity that surrendered to barbarian style. Irish art, already full grown by the fifth century in an island that was never Romanized, translated the Christian theme completely into its own vocabulary, and never surrendered its barbarian preference for non-representative and abstract pattern. It did more: whereas on the Continent the collision between the two cultures, barbarian and Latin, neutralized the beauty of both, in Ireland the barbarian style was carried on to high sophistication, and to a perfection of technique and taste that makes the best of Irish works stand out as historic masterpieces of ornamental design.

The art of Ireland is purely Celtic—the only branch in fact of Celtic art that

managed to maintain its purity. The Celtic race, domiciled at first not only in Gaul but on both sides of the Rhine and in Central Europe, began in the fifth century B. C. a great migration which history first hears of in the sack of Rome by the Gauls in 390 B. C. After the repulse of this raid we find the Celts descending upon Greece, and attacking Delphi, from whose shrine they are said to have been frightened away by Apollo himself. In 278 they entered Asia Minor and made themselves a nuisance for centuries thereafter, particularly to the Pergamene kings, until they settled down in Galatia to become the peaceful people to whom in the first century of our era Paul wrote his Epistle. From such contacts the Celts seem to have learned the use of perforated ornament, the spiral, and the Greco-Roman leaf designs, all of which they combined into a characteristic mode of their own whose obvious features are a leaf motif known as the "fish bladder," and an S-shaped doubling of the spiral. But with the expansion of Roman power on the Continent and in Britain the Celtic style was submerged beneath the tide of Latin art; so that it was only in Ireland that Celtic art survived and flourished, with a trend toward more linear design and a development of the spiral into a peculiar and characteristic element.

The Celts brought the Age of Iron to Ireland. As early as 400 B. C. the aboriginal inhabitants, a swarthy, squat, and short-haired people, began to be disturbed by the infiltration into the gold-bearing regions of the southeast of the isle, in County Wicklow, of the taller, blond, and long-haired race of Celts, migrating in a westward expansion parallel to the great eastern trek above described. They came to Ireland from previous settlements in Britain, and partly from the coasts of Belgium and Holland. The newcomers multiplied, drawn by the lure of gold, and easily subdued by their iron weapons the natives who were still living in the Age of Bronze. They were undisturbed, unlike their relatives in Britain, by any Roman conquest, and began to be literally on the map of Europe in the second century of our era, when the geographer Ptolemy noted the names of some of their tribes in his description of the world. The mists of legend lift from Irish history in the third century with the reign of Cormac, who developed the ancient kingship of Tara from a Druidical theocracy into a political unity, founded an army, and left his monument in the assembly hall of Tara, the foundations of which can still be seen. His descendant Niall was strong enough to raid Britain and the coasts of Gaul; in one of these raids a part of the loot was a youth of sixteen named Patricius, brought to Ireland as a captive by Niall. Escaping afterward, he returned in 432 to convert Ireland to Christianity and live in history as St. Patrick.

The new faith had already taken root before Patrick's arrival. A year before

he came, there had been a mission headed by Palladius, and directed, so a contemporary chronicle tells us, *ad Scotos in Christo credentes,* which shows that there were Christians already in Ireland. Both Palladius and Patrick received their priestly training in Gaul, and the Gallic Church had much influence on the beginning of the Irish Church and of its art, which will explain some peculiarities thereof to which we will have later occasion to refer.

The progress of the new faith was rapid; its measure can be determined by the antiquity of the Irish monastic foundations, many of them on the sites of Druidical shrines, and the decadence of the national shrine and meeting place of Tara, where the last assembly was held in 552. A decade later St. Columba began his missions with an expedition to Scotland which founded Iona, in turn the mother abbey of Lindisfarne in Northumbria. Through the sixth and seventh centuries this missionary activity, commenced by Columba, developed an extraordinary range, and some of the oldest monastic foundations on the Continent are of Irish origin; for example, Bobbio in North Italy, Saint-Denis in France, and Saint Gall in Switzerland. The missionaries to whom these foundations are due were some of them graduates of the schools of Latinity which flourished within the pale of the Irish Church, at Iona and Lindisfarne, and in Ireland itself at Armagh and Clonmacnois, founded in 548.

At the end of the eighth century, the peaceful though sporadic intercourse that had up to that time existed between Ireland and Scandinavia developed into the terrible raids which ravaged the coasts of Scotland, Northumbria, and Ireland throughout the ninth century. To these raids we may trace the better representation of Irish metalwork in Norway and Denmark than in Ireland itself. The worst of the Norse leaders whose names have come down to us was Thorgestr who sacked Armagh in 840, and whose wife enthroned herself as an exponent of heathen oracles on the high altar of the cathedral of Clonmacnois. The final defeat of the foreigners was accomplished in 1014, after which their stock was gradually and with no further notable dissension assimilated into the native population. The Norman conquest of the end of the twelfth century terminated the Celtic art of Ireland in a most decisive manner.

The two characteristic motifs of early Celtic ornament are the "fish bladder" and the spiral. The former played no important part in Irish art, but the latter was destined to a remarkable development. In continental Celtic works the spiral had already doubled itself into an S or a volute like an Ionic capital, and had begun to broaden its stem into a shape like a trumpet. These forms are seen on one of the earliest examples we have of Celtic style in Ireland, a stone of the first century B. C. in Turoe, County Galway. Here already is the

Irish quality of waywardness in design; resolving however in final effect into rhythm and unity. The Celtic love for the unexpected led to the divergent spiral, with the thickened trumpet ends continuing to form a focal point from which the spirals can spring in radiating directions. The object was to dynamize the design, interjecting a catchpoint that would halt the eye and interrupt any effect of monotonous uniformity.

The spiral-and-trumpet pattern is pure Celtic; the other motifs of Irish ornament were borrowed. The interlace, for example, seems to have no more remote ancestry than the interlaces on the Roman mosaic pavements in Britain, but Celtic use of this motif differs from that of the barbarian races on the Continent, for the latter regularly employ a third central ridge in the band besides the two ridges marking the edges, while in Ireland the band is plain or at most shows only the two ridges of the border. What most distinguishes the Irish interlace is however its excessive complication: there are no loose ends and no plain loops; always another band is present for the loop to curve around. Often the whole interlace will consist of a single strand which the patient observer may follow (sometimes having to do so with a magnifying glass) until after innumerable crossings it returns to its starting point. The apparently limitless meanderings of these Irish interlaces remind one of the Irish sagas with their effect of nonarrival; the hero forgets the purpose with which his wanderings commenced, and the poem ends on a theme, plot, and destination quite foreign to that with which it started.

The diagonal fret, or "key pattern," is obviously the meander, picked up from Latin art by Celtic artists of the Continent and by them transmitted to their insular cousins. Here too the Celtic genius for dynamic design asserted itself, in changing the rectangular verticals and horizontals of the Greco-Roman ornament to diagonals. The fourth of the Irish ornamental motifs, the "lacertines" of interlacing animals, is something which Celtic art, like Scandinavian, derived from Scytho-Sarmatian sources. The Irish artists used the motif discreetly in the earlier works; when it becomes the principal part of any decoration and rectilinear in design, it is a mark of decadence and late date.

All four of these motifs—spirals, interlaces, key pattern, and lacertines— were employed in Irish metalwork. The islanders showed their originality in the unique forms they gave to metal objects; the brooch for example takes no shape that parallels the barbarian fibulae of the Continent, but assumes instead the "penannular" form—a ring with a movable pin whose point could be manipulated through an opening in the circle. The earliest ones have flat terminations of the opening of the ring, and since the ornament exhibits spirals and no interlaces, they can be dated in the seventh century. With the eighth

century the interlace comes into the ornament, the ring closes, so as to become merely the top of a pin, and the circular section is abandoned in favor of a flat band. Later the whole brooch becomes larger, running to five or six inches in diameter, and the ornament delicate and complicated, with fine filigree work, complicated designs in relief, and settings of enamel and amber. The finest example is the Tara brooch [1] found on the seashore near Drogheda in County Meath, whereon the beading is so minute that a lens must be used to follow the detail. In the tenth century divided rings appear again, with bosses on the terminals, and silver brooches are used, with bulbs instead of flat ends. Some of these are enormous, reaching to ten inches in the diameter of the rings and with extra long pins, reminding one of the old Irish law that "men are guilt- less of pins on their shoulders or breasts, *provided* that they do not project too far beyond." Such exaggeration, both of size and intricacy of design, is in keep- ing with Irish love of hyperbole; one thinks of the hero Cuchulain who called for three caldrons of cold water wherein to cool his battle heat at the Battle of the Ford: into the first he jumped, and the water disappeared in steam; into the second, and it was too hot to touch; only the third became tepid enough for the hero's final bath.

Some notion of the intricacy of this Irish goldsmithery may be gained from the Ardagh chalice,[2] made of 354 separate pieces. It has been dated from the eighth century to about 1000 A. D. and is a marvelous gold, silver, and bronze creation of microscopic filigreework, cloisonné enamel, amber and glass set- tings. All the four motifs are used, and the honesty of the work is revealed by the location of the most beautiful portion out of sight inside the foot: this is a crystal set in a circular amber frame, surrounded by lacertines enclosed in another circle of amber, then a band of trumpet spirals, and a final frame of interlace. Around the lip of the bowl are incised the names of the twelve apostles.

The Irish "shrines" or reliquaries were favorite loot for the Norse raiders, and existing examples are more numerous in Norwegian and Danish collections than in Ireland itself. The Irish ones, by the same token, date from the period after the raids, in the tenth to the twelfth century, when new donations to mon- asteries and churches were repairing the ravages of the Scandinavian pirates. The earliest example, however, is the reliquary of wood covered with bronze plates which was pulled out of Loch Erne by fishermen in 1891, decorated with the trumpet spirals and interlaces only, and dating probably in the eighth cen- tury. These reliquaries were often in the hereditary possession of a family, such

1 Françoise Henry, *Irish Art in the Early Christian Period,* London 1940, pl. 46, a.
2 Henry, *op. cit.,* pl. 47.

as the O'Mellans who owned the shrine enclosing St. Patrick's Bell. They kept it till 1441, when it passed to the Mulhollands, and the Royal Irish Academy bought it from the estate of Henry Mulholland in 1758. The bell itself is an ordinary cowbell, and is said by tradition to be the one used by St. Patrick and removed from his tomb by St. Columba in 552, but the shrine enclosing it is dated by its inscription between 1091 and 1105. Other shrines, known as *cumdachs*, were made for gospel books, always in the early Middle Ages the object of superstitious reverence. Such is the Soiscel Molaise, made to enshrine a gospel book believed to have belonged to St. Molaise who died in 563—a bronze box with silver veneer which was done, according to its inscription, by Cennfaelad, abbot of Devenish on Loch Erne, about 1000 A. D.

Figured representations are rare on Irish metalwork until a late date, and the earliest example is probably the Crucifixion represented on a bronze ajouré plaque found at Athlone, dating about 800 (*Fig. 59*). Here we see the influence on Irish art of the south of France, for the lancer who pierces the side of Christ is on the spectator's right. It is the rule of mediaeval iconography that he should stand on the other side, the spectator's left. But as early as the fifth century, the Christian artists of the south of Gaul and North Italy fell into the habit of placing the lancer as here (p. 76), and from the early connection of the Irish Church with these regions came this peculiar inversion of the subordinate actors in the Crucifixion.

Irish crosses, like everything else in Irish Christian art, take a form of their own, whose peculiar feature is the circle surrounding the intersection. This appears in the ninth century; in the tenth, on the tombstones of the old cemetery of Clonmacnois, the form is further developed by terminating the arms with semicircular expansions, and finally in the eleventh by the addition of loops at the corners of these terminals. An example of the typical Irish cross of the ninth or early tenth century is the great high cross of Monasterboice. On this there is a plethora of figured scenes, from Adam and Eve in the Fall of Man to the Crucifixion with the lancer on the "wrong" side, and

THE CROSS OF MONASTERBOICE

[186]

a number of groups whose meaning still remains a secret of Irish imagination. The same form of cross is used for the famous high crosses of Bewcastle and Ruthwell on the Scottish border, and since this form is not known before the ninth century in Ireland, it is difficult to see how these Border examples can be given their customary dating in the seventh, particularly as some of the ornament on the crosses is Romanesque in a mature stage and the figure style of the Ruthwell cross gives the same impression.

One must not forget, however, the reason for the appearance of these Irish crosses on the Border. They are products of the Celtic art disseminated by the great monastery founded in c. 563 by St. Columba on the island of Iona off the west coast of Scotland. From its foundation to its destruction in a Norse raid c. 800, Iona spread its missionary influence over Scotland and especially the Anglo-Saxon kingdom of Northumbria, off whose east coast was founded a daughter abbey on the island of Lindisfarne. From this in turn sprang the foundations of Jarrow and Wearmouth, and a school of Irish art in Anglo-Saxon hands that had a brilliant existence in the eighth and ninth centuries.

The finest work of this school is the illumination of the Gospel Book of Lindisfarne in the British Museum, known also as the Durham Book from its long residence in the Durham Cathedral Library.[3] We have precise information on the making of the codex in the entry at its end: "Eadfrith, bishop of Lindisfarne, wrote this book to the glory of God, of St. Cuthbert, and of all the brotherhood of saints upon this island; and Ethelwald, bishop of Lindisfarne, made outside the binding, and decorated it with his utmost skill; and Billfrith the hermit forged the outer metalwork and set the gold and gems within it; and Aldred, the unworthy humble priest, wrote with the help of God and St. Cuthbert the glosses in English."

Aldred, who put in the explanatory glosses in Northumbrian dialect, "with the help of God and St. Cuthbert," may be the bishop of Durham of that name who occupied the see from 946 to 968, but the tradition he records in the tenth century seems worthy of belief, and since the Ethelwald he mentions was bishop of Lindisfarne from 724 to 740, we can safely place the manuscript in the early decades of the eighth century. The decoration of the book consists of portraits of the Evangelists, the canon pages, the pages of pure ornament usually disposed in the form of a cross and peculiar to Celtic manuscripts, and the initial pages. These and the cross pages are executed in the best Irish tradition, with a reticence and economy that bear witness to the superior taste of this Anglo-Saxon version of Celtic style. One of the cross pages is testimony also to the close relation between Celtic illumination and Celtic metalwork; the best parallel

3 E. G. Millar, *The Lindisfarne Gospels,* London 1923.

for it is found in the silver lacertines on the back cover of the Lindau Gospels in the Morgan Library,[4] an early ninth-century product of some Celtic atelier, perhaps the Irish monastery of Saint-Gall in Switzerland, possibly one of the Anglo-Celtic centers of the south of England which developed from Augustine's evangelization of Kent in the sixth century.

About the same time as the Durham Book, in Ireland itself, was produced the earliest of the extant Irish illuminated manuscripts, the Book of Durrow, now in Trinity College Library at Dublin.[5] The contrast is sharp. Instead of the delicate minutiae of the Lindisfarne craftsman, the painter of the Book of Durrow designs in patterns of rustic simplicity and heavy scale, colored in primary tones of dark green and yellow with secondary use of red. His order of illumination is the traditional Irish one for gospel books: first for each Gospel the evangelist page—in the Durrow Book occupied by the symbol instead of the Evangelist himself—next the ornamental page, and finally the initial page beginning the text of the Gospel. The symbols have no wings, which indicates that they are descended from an early Latin tradition, and they are drawn with true barbarian preference for abstraction.

In the Durrow Book we have what was evidently the indigenous native art of Ireland; in the Durham Book a sophistication thereof, stemming from the more brilliant center of Iona. This is probably the explanation of the even more striking contrast between the rusticity of the Durrow illumination and the elaborateness of the masterpiece of Irish art, the Book of Kells.[6] Friend [7] has shown that the Book of Kells was executed about a century later than the Durrow Book, but this magnificent affair can hardly be considered a product of the same school. It seems rather to have been done in Iona, and brought to Ireland, after the destruction of that monastery, by the monks who refounded the monastery of Kells in 802. Thus one can understand its isolation among the cruder works of local Irish inspiration, and the affinity which its style displays with that of the Gospels of Lindisfarne, an earlier product of the same Iona tradition and produced in Iona's daughter foundation. The Durham Book is the only Celtic illuminated manuscript which approaches Kells in grandeur, unity, and precision of ornament, but even it cannot compare with Kells in the microscopic complication of ornament. The contrast with the Book of Durrow is striking. The script is highly decorated instead of being left plain, and the initials become compositional fields, at times pervading the whole page

[4] Pierpont Morgan Library, *Exhibition of Illuminated Manuscripts* (at N. Y. Public Library), *Catalogue,* New York 1934, pl. 6.

[5] E. H. Zimmermann, *Vorkarolingische Miniaturen,* Berlin 1916–18, III, pls. 160–165.

[6] Sir E. Sullivan, *The Book of Kells* (with 24 plates in color), London 1927.

[7] A. M. Friend, "The Canon Tables of the Book of Kells," *Studies in Memory of A. Kingsley Porter,* Cambridge, Mass. 1939, I, pp. 611 ff.

BOOK OF KELLS: *St. Matthew*

(*Fig. 60*). The plain parchment which is so prominent an effect in the Durrow Book here disappears under an avalanche of ornament which, with all its involution and a minuteness that sometimes requires a lens to follow, nevertheless seldom fails to give an ultimate effect of unity and grace. The buxom coarseness of Durrow is replaced by swift, fine, serpentine lines. Naturalism of man or beast would be an obvious intrusion in this revel of abstraction; here one sees the genius of barbarian art extending itself with no inhibitions or sense of inferiority; the drawing is confident and knowing, the ultimate sophistication of Celtic design.

Animate life is frankly reduced to pattern, whereby men and animals alike are integrated into the decorative system, and derive their undeniable vitality not from their own existence but from the dynamic scheme. The Evange-

[189]

lists are so stylized, so closely hemmed in by their borders, that though ulti-
mately derived from the seated frontal author portrait of late Latin
manuscripts, the sitting posture has disappeared under the imperative of flat-
ness. The ornamental vocabulary which in the Durrow Book was limited to
the four basic Irish motifs is here enriched with many additions: rinceaux
and rosettes and other foliate and floral forms ordinarily taboo in the geometric
Irish repertory, as well as a profusion of human and animal forms outside the
category of lacertines. The colors too are more numerous and less primary, the
yellow paler and often paired with blue. The one respect in which the Book of
Kells restricts its color in accordance with Irish practice is the absence of gold.
So too, the meager illustration customary in Irish books is enlarged to include
a picture of the Virgin and Child and the Temptation and Arrest of Christ.

Such pictures show the extraordinary power of the Celtic genius, strong
enough to overcome the pious desire that must have existed, to copy faithfully
the sacred images in the Latin books which were undoubtedly the ultimate
models of these strange transfigurations. The naturalism of the antique was
simply abhorrent to these true exponents of abstraction. The beauty of the
style, inhibited by the struggle with the human figure, is fully revealed in the
full-page initials. Here we have the quintessence of Celtic art, and the full im-
pression of its originality, visible not only in bewildering but fascinating invo-
lution, but also in a novel composition. Novel for its period, but not for us, for
here we see for the first time in European art a type of composition that is still
with us today. It is not the arrangement with balanced equilibrium that was
the ideal of classic style, nor yet the musical repetition of accents wherewith the
oriental peoples achieved unity in pattern, but a composition that depends for
beauty solely on its impulsive movement and vitality. It is neither symmetri-
cal nor rhythmic. We may call it dynamic, since it satisfies by the illusion it
gives of something that is vividly alive, and the suggestion of the eccentric, unex-
pected aspect which is always presented by nature in the concrete. This realistic
way of seeing things, lost in the decay of Irish style in the centuries succeed-
ing the Book of Kells, was destined to new life in Carolingian art, and to fresh
revival in the Romanesque and Gothic, whence it passed on to us in modern
times—a distant legacy from a brilliant art that, but for the happy preserva-
tion of a few masterpieces of metalwork and manuscript illumination, would
be today forgotten.

The indigenous Celtic style of the Book of Kells decays in the ninth, tenth,
and eleventh centuries. The "playing-card" aspect of the Evangelists is pre-
served in their renderings of the Gospels of Macdurnan, in the library of the
Archbishop of Canterbury at Lambeth, dating in the second half of the ninth

century, and another gospel book in the distant Irish monastery of Saint-Gall in Switzerland, also of this century, approaches in some degree the style of the Book of Kells, but with no such full decoration of the text pages, and with much coarsening of the microscopic patterns.[8] Its Crucifixion is a curious calligraphic translation of the Syrian colobium type (p. 69), with the lancer, as usual, on the "wrong" side. In the tenth century, a Psalter in the library of St. John's College at Cambridge contains the comical result of an Irish artist's attempt at narrative; the overthrow of Goliath by David is literally rendered (with Goliath standing on his head) in figures that struggle to be real through their abstract pattern. The process of decadence in such manuscripts is marked by a domination of the interlace and lacertines over the other Celtic motifs, and a relapse into coarse and angular design for the major initials, and into plain black for the minor ones. The gradual pressure of the Saxon invasions in England forced the Celtic population westward, so that some of the latest manuscripts of Celtic style come from monasteries in Wales. A further refuge was found by the displaced Celtic population across the channel in Brittany, whose modern name is derived from the filling up of this peninsula in the fifth and sixth centuries by refugee Britons from England. Here in a monastery which bore the purely Celtic name of Landevennec was written and decorated the only example of Celtic illumination in this country—a gospel book of the second half of the ninth century in the New York Public Library. This has a frontispiece of Christ surrounded by the four Evangelists, but the Evangelists have the heads of their symbols—a motif picked up from the practice of the south of France and Spain. The figures are still imprisoned within the abstract Celtic design, but the initials and other fields of ornament have absorbed the manner of the barbarized illumination of continental manuscripts which preceded the Carolingian "renaissance" and is known as Merovingian style.

❖ ❖ ❖ ❖ ❖

This is the style that best illustrates the ruin of antique culture in Europe. It arose in the north of France and the north of Italy and Spain, where Latin civilization was less firmly rooted or more easily impaired by the barbarian invasions and infiltrations, prolonged through the sixth century after the first destructive wave of the fifth, and continued in the ninth by the terrible Viking raids which introduced into Latin litanies the prayer *Libera nos a furore Normannorum.* It is a style that initiates, in the seventh and eighth centuries, the mediaeval attitude toward the book as an object of reverence, to be decorated, *illuminated,* rather than illustrated as were the books of late antiquity. The

[8] Henry, *op. cit.,* pls. 54, 55.

earliest example of such Merovingian illumination that bears a certain date is a codex in the Morgan Library of New York of the year 669, containing a single illuminated initial M. The date of this example and of the rise of the barbaric style it illustrates is not much later than that of the latest existing early Christian illustrated books: the Cambridge Gospels, the Codex Purpureus of Munich, and the Ashburnham Pentateuch.

By tradition, the Cambridge Gospels (No. 286 in the library of Corpus Christi College in Cambridge) [9] is supposed to be one of the books sent by Gregory the Great (590–604) to implement St. Augustine's mission in Kent, and may well date from this time. The frontispiece is a full-page miniature showing St. Luke sitting frontally within an arched border—an excellent example of the Latin Evangelist portrait which was reduced to pattern by the Irish illuminators. In the sides of the frame are little compartments containing illustrations of Luke's Gospel, of an iconography provincial and sometimes unique, including for example a Peter (in the Washing of Feet) who has no beard. The codex contains one other page of illustrations, again arranged in small compartments, which depict the episodes of the Passion with much dependence on John's Gospel, and the same detachment from traditional Latin types that can be observed in the frontispiece. The same beardless Peter is found in the miniatures occupying four pages of two leaves bound into a ninth-century gospel book

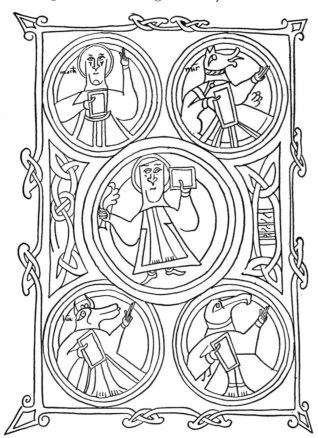

New York Public Library, Miniature in the Landevennec Gospels: *Christ and the Symbols of the Four Evangelists*

[9] R. van Marle, *La peinture romaine du moyen-âge*, Strasbourg 1921, pl. IV.

[192]

in the National Library at Munich,[10] written on the purple vellum which accounts for its name of Codex Purpureus. The miniatures belonged once to an earlier gospel book, possibly of the sixth but more probably of the early seventh century, written and illustrated in the same general region as that of Cambridge, with the south of Gaul the most likely location. This last is indicated by the *Massacre of the Innocents* in one of its miniatures, in which soldiers dash the babes to the ground in the fashion of the Italo-Gallic ivories (p. 76), and by Thomas in his *Incredulity*, approaching the wound in the Saviour's side from the observer's right (p.76). The other scenes relate to the history of Mary (drawn from the Protoevangelium of James), the Theophanies after the Resurrection, and the Last Supper which has lost its antique form of the reclining banquet and become a liturgical act, like the Communion of the Apostles, with Christ standing between two disciples at an altar on which is a loaf and a chalice.

The Ashburnham Pentateuch[11] (given this name from a former owner, the Earl of Ashburnham; now in the Bibliothèque Nationale at Paris), the latest of this trio of late antique books, is of more certain date in the seventh century, and a fairly assured provenance from Spain. Its miniatures, of a style and arrangement unique in Christian art, illustrate the stories of Genesis and Exodus in nineteen full-page pictures with the episodes strewn irregularly over a background which isolates them only by a change of color from scene to scene. The domed architecture and the

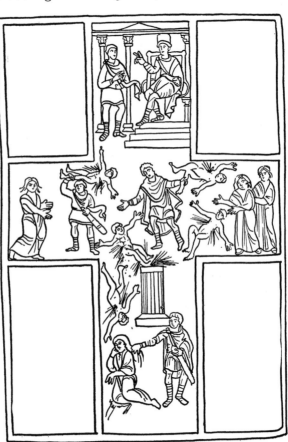

MUNICH, CODEX PURPUREUS: *The Massacre of the Innocents*

[10] A. Boinet, *La miniature carolingienne*, Paris 1913, pls. I, II.
[11] O. L. von Gebhardt, *The Miniatures of the Ashburnham Pentateuch*, London 1883.

[193]

obvious familiarity with oriental fauna and flora, and with eastern manners, suggest an Egyptian prototype, but the copyist shows his Latin quality in the arched frame of a frontispiece that resembles the one in the Cambridge Gospels, and a fluttering inflated drapery which is like that of St. Lawrence in the mosaic of the Mausoleum of Galla Placidia, and of the figures in stucco relief that adorn the Orthodox Baptistery at Ravenna. His Spanish proclivities are evident in such peculiarities as the spiral drawing of the tops of angels' wings and the parti-colored backgrounds. Both features are characteristic of the illustrations in a type of book with which the Romanesque painting of Spain commences—the *Commentary on the Book of Revelation* by Beatus of Liebana (p. 229), of which the earliest example, dating *c.* 900, is in the Morgan Library.

The contrast between these lingering examples of antique literacy and the Merovingian manuscripts that were produced between 650 and 750 in the new Celtic foundations on the Continent such as Luxueil and Bobbio is startling evidence of the submergence of Latin culture. The ornament in these truly "barbarian" books is limited to initials, and these in turn to fish and bird forms twisted into the shapes of letters (*Fig. 56*)—a type of initial found in the ninth and tenth century in Greek manuscripts of Asia Minor, whose archetypes may well have been the source of these illuminated Merovingian initials, especially since the latter seem to have no relation to the ornament the invading tribes brought with them. The one Teutonic element in this type of illumination is the growth in the eighth century of a "plaid" ornament made up of sharply contrasting juxtaposed areas of color, which reproduce the effect of the inlaid colored-glass "jewels" in the pseudocloisonné one finds on barbarian fibulae and other objects. In the latter half of the eighth century the human figure, absent from the earlier manuscripts, begins again to be attempted, and the illuminators begin to imitate the more sophisticated Celtic designs found in such imported Irish manuscripts as the Gospel Book of Saint-Gall (p. 191). At Echternach near Trier, for example, in the abbey founded in 698 by the Anglo-Saxon missionary Willibrord, the library contained in the eighth century a Celtic gospel book with the evangelistic symbols drawn in the manner of the Durrow Book. This served as model for a local illuminator who assimilated very well the Irish decorative pages and initials, while his assistant scribe still used the Merovingian birds and fishes. The continental artists of a later generation improved upon such Celtic models by simplifying the bewildering insular ornament and combining it with a free use of gold and silver. Such style is known as Franco-Saxon, and is native to northern France and Belgium, whence it spread into Germany and in later periods along the west of France even into

Spain. It is a purely ornamental style, borrowing its figured illustration else-where, and characterized by a Celtic paneling of the interlace into neat com-partments, and the termination of initials and border corners in volutes and animal heads.

For tracing the earlier stages of Romanesque style, the illumination of manuscripts is our only guide. Monumental painting and sculpture in the Latin West suffered almost complete eclipse, save in Italy, in the two centuries follow-ing the establishment of the barbarian kingdoms in the sixth, and are sparsely represented from the ninth to the eleventh century. Even thereafter the book art continued to be the source of style. Art, like other humanistic activities, was in the service of the church, and within the ecclesiastical polity its practi-tioners or directors were mainly monks. No religious service could proceed without three books, a psalter, gospel book, and the sacramentary that was the handbook of the Mass, and these, as literacy faded, became objects of devotion rather than enlightenment, achieving the status of sacred relics which accounts for the pious elaboration of the jeweled *cumdachs* in which such books were preserved in Ireland, and the care with which their reverend texts were dec-orated. The early Christian books brought from Italy to Gaul, Germany, Spain, and the British Isles constituted the slender life line of civilization, and the monastery libraries the centers thereof. Art, in these circumstances, was transmitted by the illumination of manuscripts, and there are many cases where a single codex is responsible for the generation of a style throughout the region of which the abbey that possessed it was the center. The miscellane-ous threads of the antique inheritance, thus transmitted through the incessant copying of books, were gathered together and given organization and focus by the schools and literary centers founded or promoted by Charlemagne.

THE CAROLINGIAN "RENAISSANCE"

The revival under Charlemagne and his immediate successors known as the Carolingian Renaissance, extending from Charlemagne's accession in 768 to the death of Charles the Bald in 877, was an effort which began as a reform of cler-ical literacy and of liturgical practice, but broadened as it developed into a con-scious attempt to reconstruct both politically and culturally the Latin Empire which the ancestors of the Carolingian house had so effectively helped to de-stroy. The "renaissance" was thus an attempt not of innovation but of reno-vation. The ecclesiastical literature of the period is typified in its characteristic form of the Commentary on the earlier Christian writings, in which no criti-cism was intended, but only an interpretation which would make them intel-ligible to the lesser Latinity of the age. The chapel which Charlemagne built

for his palace at Aachen epitomizes the Carolingian attitude; with painful re-learning of forgotten methods of Roman vaulting, and substitution of contemporary practice when the antique was found beyond their art and means, the builders of the Aachen octagon did their best to reproduce the aspect of S. Vitale at Ravenna, and it was not their fault if the Carolingian church is more naïvely expressive of A. D. 800 than of 550.

The ancient empire which the Carolingian age admired and imitated was not however the realm of Augustus, Trajan, and Marcus Aurelius, nor were its literary models in the first instance Cicero and Vergil. The Latin writers studied and aped by Carolingian churchmen were first of all the patristic authors of late antiquity—Augustine, Ambrose, Jerome, and Gregory the Great—whose works were of necessity the source of their own content. It was the Empire their forefathers knew that Charlemagne and his successors strove so piously to reconstruct—the Empire whose western capital was not Rome but Ravenna, and whose habit of thought was not the materialism of pagan antiquity but the Christian mode of the fifth and sixth centuries. The antique, as H. O. Taylor has observed,[12] passed on into the Middle Ages through Christian avenues of transmission. In art as well the source from which the Carolingian schools immediately drew was the Christian art of the end of the ancient world, orientalized even in the Latin West by the prevalence of Greco-Asiatic style, and represented in Frankish eyes by the fifth and sixth century buildings, mosaics, and manuscripts of Italy.

From Italy came the psalters, gospel books, and sacramentaries on which the Carolingian church based its reform of liturgy, and the monastic scriptoria their reform of style. The sophisticated Greco-Asiatic manner of such works diverted Carolingian illuminators from imitation of Celtic design—content with an abstract outline of the human figure to be filled with any sort of imagined pattern—toward what could be gleaned from Greek and Latin models found in Italy, of antique modeling, impressionism, and light and shade. The change can be observed in the earliest of the Carolingian schools, named from Ada, a supposed sister of Charlemagne for whom one of its manuscripts was made, and initiated by a gospel book in the Bibliothèque Nationale known from the name of its scribe as the Gospels of Godescalc, and dating in the end of the eighth century.[13]

Godescalc dated his gospel book with verses which celebrate an imperial visit to Italy, and he himself must have seen the choir of S. Vitale in Ravenna, for in his pictures of Evangelists he repeats the unwinged ox and lion that are

[12] H. O. Taylor, *The Mediaeval Mind*, London 1911, I, ch. I.
[13] Boinet, *op. cit.*, pls. III, IV.

the unusual renderings of these symbols in the Ravenna church. His illustration extends beyond the usual evangelist portraits to a miniature of Christ enthroned in which we recognize the Constantinopolitan type of beardless long-haired Saviour used on the Italo-Gallic ivories of the fifth century and the mosaics and sarcophagi of Ravenna, but with a Carolingian revision of the shoulder curls into stringy locks. Another page is filled with a representation of a colonnaded rotunda surmounted by a conical cupola, beside and above which is a miscellaneous assortment of birds, and a stag, arranged in the inconsequential fashion wherewith they decorate the canon tables of the Syrian Gospel Book of Rabula (p. 68). The tempietto itself is an oriental feature, added to the canon tables by their Palestinian inventors (p. 68) in probable allusion to the Holy Sepulcher, and transmitted thence to the Italian imitations of Asiatic gospel books which doubtless furnished his models to Godescalc.

The text of this book is written in gold on purple vellum with silver headings for the chapters, in accordance with the luxury usual in manuscripts of the Ada group, all destined for Charlemagne or members of his family or court. The Evangelists have profited by their Italian models (and will profit more in later manuscripts of the group) to become more natural in posture, modeling, and drapery, in contrast to Celtic stylization (*Fig. 63*). In their faces the lights and shadows on one side are in red, and brown or black; on the other in a green varying toward gray or blue—a constant feature of this school. The backgrounds are neutral, save for a colored band on which the symbols perch, but behind Godescalc's portrait of John is an attempt at architecture recalling the buildings within the walls of Classis in the mosaic of S. Apollinare Nuovo (p. 83). Celtic influence is not wanting, discernible in the paneling of the borders, the frequent interlace, and the major initials. But the ornament that fills most of the panels reveals a heterogeneous vocabulary, drawn from Roman pavements and eastern manuscript illumination. To the former belongs the perspective meander, and the double-ax motif, whose use can be traced in antique pavements from the first century to the sixth, and from the Ada manuscripts to Romanesque sculpture of the twelfth. To the latter may be ascribed the "rainbow" design, of facets ranging through the spectral colors, which was used in Antiochene pavements as early as the fourth century, and is characteristic as well of the borders of proto-Byzantine miniatures. The general aspect of Ada decoration is one of more magnificence than taste, and of an ornamental repertory of indiscriminate accumulation from any source available.

About a dozen manuscripts can be assigned to the group, and a limit of time not beyond the reign of Charlemagne (768–814). The finest of the list is one

now in the Bibliothèque Nationale, once in the abbey of S. Médard at Soissons,[14] which received it together with other objects belonging to Charlemagne, from his son Louis the Pious in 827. It contains six miniatures of which four represent the Evangelists within borders which square up the usual arches enclosing the figures. In the spandrels of these frames (and also in the initial pages) tiny Gospel scenes are inserted, such as the *Annunciation to Zacharias* of the coming birth of the Baptist, and the *Miracle of Cana* and the *Last Supper* adorning the picture of John. An Ada feature of this manuscript is the use of imitations of antique gems in the borders. Of the other two miniatures, one is an obvious attempt to reproduce the arch mosaic of an Italian church, with the apse indicated by a curve in the structure: the Lamb of God stands in a gold medallion; the Four-and-Twenty Elders in vermilion, buff, and pink, are relieved at either side against a blue ground above which a sky is indicated in mauve and white. One may compare with this the mosaics of the apse and arch of SS. Cosmas and Damian at Rome (p. 86). Below the Elders

[14] Boinet, *op. cit.*, pls. XVIII–XXIII.

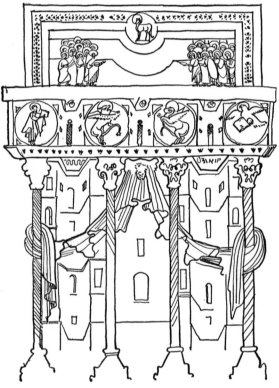

Soissons Gospels: *The Adoration of the Lamb*

is a green river filled descriptively by regimented fishes and with birds on its bank or flying over the waters. The architecture under this is of the confusing sort characteristic of the school, consisting of angular windowed exedras behind a colonnade on which is an entablature containing the silver-nimbed Symbols, in blue medallions that contrast sharply with the yellow, white, blue, purple, green, vermilion, and gold variegation of the rest of the structure.

The center that produced these Ada manuscripts is undetermined. It must have been a scriptorium peculiarly in touch with Charlemagne's court, but the location of this varied greatly during his reign. Aachen, Trier, Fulda in Hesse, Metz, and Lorsch have all been suggested, but these attribu-

[198]

tions only reflect a general probability that the school was located in the Rhenish portion of the Carolingian empire. The only school of Charlemagne's own time that can be definitely located and traced in its development throughout the duration of the "renaissance" is that which grew up in the monasteries of Tours, St. Martin's and Marmoutier, under the stimulus of the great abbot of St. Martin, called from Northumbria by Charlemagne to preside over his cultural effort, Alcuin of York.

Alcuin's interest was not so much in the decoration of texts as their proper form; his lifework was the revision of the Vulgate or Latin text of the Bible, established by St. Jerome at the end of the fourth century but corrupted in successive copying. He also reformed the Latin script, become unreadable in the illiterate centuries preceding, and the beautiful Carolingian minuscule which originated in his time at Tours became standard throughout those portions of Europe reached by the Carolingian revival, and ultimately the basis of our own writing and of our printing types. The early manuscripts produced at St. Martin's show the insular connection which one would expect from the origin of its abbot, employing animals and birds after the manner of south English illuminators of the eighth century, but with admixture of Merovingian motifs. The characteristic Tours illumination, most expert of all the Carolingian types, evolved under Alcuin's successors, particularly in the ornamentation of the great Bibles with his new text, in demand throughout the Empire. The initials adopt the Franco-Saxon form with terminations in volutes, but develop the interlace filling of the initial into a continuous articulation which imparts vitality to the letter, and solidity also as the artists learn to line the interlacing pattern with gold, and thus give the design more weight and slower rhythm.

The style reaches its height during the abbacy of Count Vivian (844–851), a secular head of St. Martin's in the time of the emperor Charles the Bald. Vivian celebrated an imperial visit to the monastery by presenting to his master the great Bible which is No. 1 of the Latin codices of the Bibliothèque Nationale.[15] In the dedication page of this we see the emperor enthroned, flanked by four attendants of whom two carry his sword and shield, receiving the Bible from four dignitaries of St. Martin's, while to the right stand the monks with their lay abbot in court array at their head. The same artist who was head of the atelier that worked on the Vivian Bible probably also did the illustrations of the Gospel Book of Lothair, likewise in the Bibliothèque Nationale, described by Koehler as the finest manuscript of the period. In both of these masterpieces the characteristic features of Tours style are prominent: the

[15] Boinet, *op. cit.,* pls. XLVII–LV.

BERCE

N ERATIONISIHU

ΧΡΙ ΓΙLJI ΟΛΟΙΟ

ΓΙLJI

ΛBRΛbΛ

AN INITIAL OF TOURS

arcaded canon table with a square frame enclosing it, and lamps hanging from its arches; the fondness for gold titles relieved against a purple ground; the medallions that are scattered through the canon pages of the Gospels, imitating antique coins.

The imitation of the antique is more discriminating, and seeks earlier models than did the Ada school. In the scenes of Genesis on the page illustrating that book of Vivian's Bible, one can discern the influence of some fifth-century Latin archetype which must have resembled the Vatican Vergil. The atmospheric graduated sky of antique impressionism is reproduced by the Carolingian artist in a series of stripes, and he puts an antique temple behind the group which illustrates Moses delivering the Law to the Israelites, in the miniature preceding the Book of Exodus. The banded borders which surround the pictures of the Vergil are repeated in the Carolingian imitation, and the leaf finials at their corners. The curious eclecticism of this Turonian art, seeking to revive antique artistic forms as Alcuin labored to restore Latinity, is to be seen in the frontispiece of the Gospels in the Bible of Vivian, where Christ sits on the globe as in the Italo-Gallic ivories or mosaics, but is surrounded by the oriental mandorla, which takes the form of a figure 8.

The steady tendency of these Carolingian artists to reach back to purer sources of antique style is best exemplified in the so-called school of Reims, by far the most important of the Carolingian schools in view of its far-reaching influence. It has received the name of "Reims" because the only one of its

manuscripts whose early provenance is known, the Gospel Book of Ebbo, archbishop of Reims, came to its present location in the town library of Épernay from the monastery of Hautvillers near Reims. But the style of the Ebbo manuscript is a later phase of what we find in three other gospel books which come from Aachen and Xanten on the lower Rhine and seem to be works executed for the imperial court. One of them, in fact, is the Coronation Book still preserved in Vienna as the book on which the mediaeval German kings took their oath, and is said to have been found on the knees of the dead Charlemagne when Otto III opened his sepulcher.[16]

A Canon Page of Tours

This Coronation Book is singular among illustrated Latin Gospels in that the Evangelists depicted in its four miniatures are not accompanied by their symbols, which is a trait characteristic of Greek gospel books, while Latin Evangelists were regularly associated with the four beasts of Revelation from the time St. Jerome identified the man with Matthew, the lion with Mark, the calf with Luke, and the eagle with John. The Matthew of the Vienna book is evidently copied from another Evangelist painted on an early leaf sewed into the Xanten Gospels, and this figure shows resemblance to Greek miniatures of late antiquity, such as the pictures in the Gospel Book of Rossano, or the figures in the illustrations of the Lectionary of Leningrad (p. 97). From this and other indications it seems that the artist of the Coronation Book reproduced in his Evangelists the corresponding portraits in a Greek book, or an earlier Latin Gospel which had thus borrowed from a Greek source. Such an

16 Boinet, *op. cit.*, pls. LVIII–LIX.

archetype probably came from Ravenna, since we have the further peculiarity in the Vienna Evangelists that they sit in an open landscape, and the only previous example of such setting for these scribes is to be found in the choir mosaics of S. Vitale, where the Four are strangely placed in the foreground of a rocky landscape, on a ledge of which the symbol stands.

However this Hellenistic vein entered into the school, it is manifest in the impressionism of these figures, sitting on authentic faldstools of antique type, or before an exedral wall above which protrude the shrubs of a garden, or curiously placed, in the Gospel Book of Aachen, on red cushions within the clefts of a blue-green mountain landscape. They are painted with swift strokes of the brush, in a technique that not only imitates but understands the method of Hellenistic painting. The faces and costumes, particularly in the case of Matthew, have a Greek quality equal to that of the figures of the Paris Psalter, and far surpassing in their approximation of antique effect anything that can be found in the manuscripts of the Ada group or Tours.

The Evangelists of the Coronation Book were copied in another gospel book from Blois (Bibl. Nat. lat. 265), and again in one from Cleves in Berlin (National Library lat. theol. fol. 260; though only two are imitated in the latter case), and finally in the Gospels of Archbishop Ebbo mentioned above.[17] Ebbo,

[17] Boinet, *op. cit.*, pls. LXVI–LXIX.

CANON PAGES OF THE EBBO GOSPELS

before he became primate of Reims, was head of Charlemagne's library and the school connected with it at Aachen, and it is probably owing to him that the style was thus transported to the neighborhood of Reims. But with the transfer came also the emergence of this style's exuberant invention: in Ebbo's Gospels the impressionism of the brush has turned to expressive line. The canon tables assume the antique gabled form that differentiates them from the arched ones of the Ada school and the squared-up frames enclosing the arcades of Tours, but are topped with plants, birds, and lively men and beasts engaged for the most part in violent activity (in one case the figures are hammering the gable of the canon table to its uprights), and even the ornament of the colonnettes partakes of movement and life, the spiral fluting becoming ribbons, and windows opening in the shafts through which leafy branches sprout. In the borders the acanthus is drawn diagonally as if bent by the wind. The figures are still painted, but with short brush strokes that virtually draw the figure, and the silhouette of the Coronation Book's Evangelists has become a quivering outline. The mountain landscape behind them is topped with trees and once with bits of architecture, and into its horizon the Latin Symbols are timidly intruded. But the Evangelist now looks up at his symbol, which is no longer isolated as an abstract token, but placed in personal communication with the scribe, as if a source of inspiration.

Based, as we have seen, on antique sources of impressionistic technique, the style develops more and more a Teutonic emotional content, transforming the dignity of the Hellenistic figures into expressive attitudes and gestures that upset their equilibrium, and breaking into jagged outlines the even silhouettes, just as at a later period the Gothic architects broke up with crockets the solid contours of buildings, and Gothic scribes dissolved the integrity of their alphabet into the sharp points and eccentric forms of black letter. The restraint of color was gradually thrown off as the style moved steadily toward its natural medium of outline drawing which would give free play to a windy and expressive line. The ornamental forms of birds and beasts, and the human figures as well, lose the objective isolation they enjoyed of old, to become active participants in lively genre episodes. A significant innovation of the school is the new communion established between the Evangelist and his symbol. This is a symptom of the beginning of Romanesque, in that it shows the trend toward concrete embodiment of the abstractions of Christian faith.

The masterpiece of the "Reims" school is the Utrecht Psalter (*Fig. 61*).[18] Now in the library of the University of Utrecht, it nevertheless spent most of its life in England; it was copied in Anglo-Saxon style about the year 1000 in

18 E. T. DeWald, *The Illustrations of the Utrecht Psalter,* Princeton 1932, University Press.

PARSCALICISFORUM
QMIUSTUSONSIUSTITI
XI INFIUEM

ASDILIXII
AIQUITATIMUIDIT
PROOCTACIA

UTRECHT PSALTER: *"Nunc Exsurgam"*

a psalter of the British Museum (Harl. 603), and again about 1150 at Canterbury by the monk Eadwine. At the time of the dissolution of the monasteries it passed into the hands of the Talbot family and thence *c.* 1621 to the library of Sir Robert Cotton. A certain De Ridder had come into possession of it in the early eighteenth century and presented it in 1718 to the University of Utrecht. The volume contains 108 vellum leaves, with the text (in rustic capitals) not only of the 150 psalms, but also the canticles (the Old Testament songs used in the liturgy), the Te Deum, Gloria in Excelsis, Pater Noster, Apostles' Creed, Fides Catholica, and the Apocryphal Psalm, with a miniature for each and every one. Even this statistic does not measure the illustration of the manuscript, for each drawing comprises a number of scenes or types interpreting the several verses or concepts in the relative psalm that lend themselves to pictorial rendering. To such rendering is added an enormous amount of picturesque detail, comprising a veritable repertory of animals, birds, implements, occupations of farming and trade, architecture and landscape—if the forms reproduced were truly contemporary for the ninth century, one could reconstruct the life and manners of the Carolingian epoch on the basis of the Utrecht Psalter alone.

But the illustrations are copied, however much this must be qualified by the wealth of originality that has entered into the adaptation of the original. The evidence of the copy is everywhere: in the use of the antique rustic capitals in the text, despite the Franco-Saxon initial; the evident adhering in the drawings to the limitation of an original border, eliminated in the copy; and the use of the Greek two-part division of the Psalms, instead of the Roman eight-part, or the Celtic three-part arrangement. This last indicates a Greek model as the ultimate archetype for the illustrations, though through a Latin intermediary, and explains the multitude of parallels which the Psalter's drawings exhibit with Greek miniatures, notably in the forms of trees, the half-hidden structures emerging above the sloping shoulders of hills (as in the Joshua Roll, the Paris Psalter, and the Menologium of Basil II), the drawing of animals and groups of animals, and the posture and gesture of figures.

The formulae employed by the Psalter's draftsmen may be basically Greek;

[204]

their use was new and Frankish. All of the antique reserve disappears in a wave of expressionism; for the first time in European art the artist *feels* as well as *sees* his subject. The imagery of the psalms is turned into lyric verse as their text was so transformed in the plain song; no figure can merely stand, or lift a modulated gesture; it must twist, gesticulate, unbalance itself in the interest of concrete action and excitement. The illustration is intensely literal: "Awake, why sleepest Thou, O Lord?" is rendered by the Lord in bed, while angels vainly strive to rouse Him. "When my father and mother forsake me, the Lord will take me up" becomes a real scene of a rejected child, and a genuine hauling up by the Lord in contrast. The story of David, Bathsheba, and Nathan's condemnation of the king is pictured in the most poignant illustration that it ever received in Christian art. The breakthrough to realism which these artists can accomplish, from their antique inheritance of allegory and

their early Christian tradition of symbolism, is best shown in the drawing which pictures the phrase *Nunc exsurgam dicit Dominus*, "Now will I arise, saith the Lord." Throughout the Psalter, the Lord is expressed by the figure seated on a globe within an elliptical glory, as in the school of Tours, but here, in response to the literal invitation of the text, He arises indeed, steps forth from his symbolic globe and glory, and goes forth to rid the psalmist from him "that puffeth at him."

This is the translation into figured illustration of the dynamic impulse of Celtic ornament, and indeed the composition of the Psalter's drawings partakes of the same principle of unity through vitality alone. Ut-

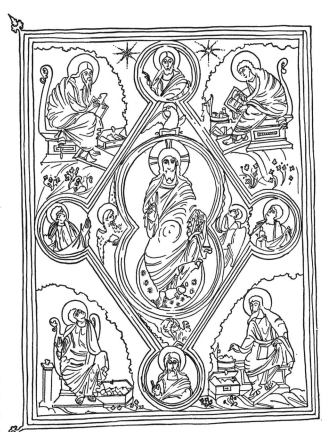

MINIATURE OF VIVIAN'S BIBLE: *Christ, the Evangelists, and the Four Major Prophets*

[205]

terly without symmetry or rhythm, they are strewn about the page, spreading beyond the bounds that limited the archetypal illustration, and held together solely by an intense animation, underlined in the mountainous background descending from Alexandrian landscape, which is made to heave and roll in unison with the excited tempo of the drawing. The style is also the beginning of European realism: for the first time the Christian theme is couched in really concrete terms, and the illustrator feels himself one with the infinitudes that it implies. Such powerful expression of the barbarian genius could not fail to supplant the earlier Carolingian passive assimilation of the antique, and we find the Reims style penetrating in the middle of the ninth century into other schools, furnishing its nervous drawing to the Franco-Saxon ateliers and the scriptoria of Tours, and leaving its imprint especially in the new intimacy of the upward-gazing Evangelist and his symbol. The most obvious inheritance of its style is to be found in the new manner of illumination that grew up in the second half of the century, which has been connected by Friend [19] with the abbey of Saint-Denis near Paris.

This school developed under the personal patronage of the emperor Charles the Bald, for whom most of its manuscripts were executed, and dates from the year 867 when the emperor assumed the function of abbot of Saint-Denis, which was his favorite residence, and the location of his very considerable library. This library contained the Bible which Count Vivian presented to him at Tours, and must have included as well some specimens of the Ada group, inherited from his grandfather Charlemagne, and examples also of other Carolingian schools. For the scriptorium at Saint-Denis makes an eclectic synthesis of all the Carolingian styles, employing the Franco-Saxon initials, which it develops into forms rivaling the fine initials of Tours; borrowing the lively and nervous figure drawing of Reims and its windy acanthus borders, but toning down the exaggerations of this school into more sober, but still vivacious, expression. In the finest of its manuscripts, the Codex Aureus of Munich, written by the scribe Liuthard for Charles the Bald, the canon tables imitate those of the Gospel Book of Soissons, of the Ada school; and the Bible in the monastery of St. Paul's at Rome, also made for the emperor, reproduces page after page of the Turonian Vivian Bible. The school is however no mere atelier of imitation; it transforms what it borrows, adding crockets to the rinceaux it takes from Tours, and a curious white-dotted scintillation to the Reims acanthus and its other ornament. Its salient characteristic is *horror vacui;* the surface of the vellum is completely covered, especially in initial pages, with ornament in which Ada geometric patterns mingle with crocketed rinceaux,

[19] A. M. Friend, "Carolingian Art in the Abbey of Saint-Denis," *Art Studies,* I (1923), pp. 67 ff.

surrounding initials of Franco-Saxon design carried to excessive complication.

Saint-Denis was also noted for its goldsmith's work, of which the finest example exists in this country, in the gold cover of the Ashburnham (Lindau) Gospels in the Morgan Library (*Fig. 67*). The Crucifixion of this cover shows the transformation of Reims style in the workshops of Saint-Denis: the distorted figures of the angels, their hunched shoulders and fluttering drapery, as well as the crouching attitudes given John and Mary, direct comparison at once to the drawings of the Utrecht Psalter, but there is more volume in the forms and less reduction to line, and with all the attenuation of the fingers of the Crucified, and his sharpened features, his figure is far more plastic and stable than those of Reims. In the leaf settings of the jewels, the Reims acanthus has found new application, in a perfection of technique unrivaled by mediaeval jewelers until the Gothic period. Other surviving works are the gold cover of Charles the Bald's Golden Gospels and the portable altar of Arnulf of Carinthia (850–899), presented to this east Frankish king by Odo, count of Paris, who took it from the treasury of Saint-Denis. The reliefs on Arnulf's altar are much closer to Reims style than those of the Morgan book cover, whose greater sobriety and equilibrium are more representative of the Saint-Denis revision of Reims vivacity. The Christ in Majesty surrounded by the Evangelists which decorates the cover of the Golden Gospels repeats the composition of the gold frontal which once was the anterior face of the high altar of Saint-Denis; this antependium is lost, but a careful reproduction of it can be seen in a Franco-Flemish painting of the fifteenth century, in the National Gallery in London.

The Carolingian "renaissance" had no popular basis, but was the product of the individual effort of Charlemagne and his successors, the churchmen of the imperial entourage, and the abbeys over which these churchmen ruled. Its duration was brief, partly by reason of the havoc caused in the few Frankish seats of learning by the Norse raids of the latter half of the ninth century. Tours for example was so devastated in 853, two years after Vivian's death, and again in 856, 862, 872, 886, and finally in 903. Nor was the geographical extension great: if its effect is visible in the Irish and Anglo-Saxon monastic foundations beyond the Rhine, there is no trace of it beyond the Alps, the Pyrenees, or the Channel. It was a movement confined to monasteries, and its art was for the most part limited to book illumination and goldsmithery such as that which issued from Saint-Denis. We know that the imperial palaces were frescoed with subjects both religious and profane, but the only considerable remains of Carolingian frescoes are the wall-paintings of Swiss churches at Münster and Mals, and those of St. Germain d'Auxerre. These last depict sainted

bishops, and stories of St. Stephen, differ only in scale from the illustrations in the books of Saint-Denis, revealing however a greater influence of Tours in the figure drawing than do the miniatures. Of other monumental painting of the period there remain only fragments of the frescoes of Charlemagne's chapel at Aachen, one mosaic, in the apse of Germigny-des-Prés in the valley of the Loire, and a few descriptions in mediaeval chronicles and verse.

What was transpiring in Italian art of the ninth century can be judged by the mosaics of Paschal I and Gregory IV at Rome (*Fig. 37*), flat copies of early Christian models, with an orientation entirely toward the Byzantine, and by the stone carving known as "Lombard," decorating the chancel balustrades, pulpits, and altar canopies of Italy and the Adriatic coast in the ninth and tenth centuries with reliefs in a single plane which rarely attempt the figure, content with an ornamental repertory of interlace, lozenges, and cruciform designs that enlarge the scale and coarsen the technique of the late antique patterns they imitate. When the figure does appear (*Fig. 64*) it is a translation into stone of the flat, stiff, frontal, and angular rendering of the mosaics and frescoes of Italy that preceded the renovation of style in the eleventh century under Byzantine influence and Benedictine leadership. In Spain the Latin style reached its lowest capacity of representation, well illustrated by the primitive drawing and raw colors of the miniatures of the Beatus manuscripts (p. 229). In England, the Norse raids of the ninth century effectively stopped the Anglo-Celtic schools of illumination in Northumbria and the south, and Celtic art retreated to Ireland, into the British monasteries of Wales and the west, and across the Channel to Brittany. "I saw," writes King Alfred (871–901), "before all were spoiled and burnt, how the churches throughout Britain were filled with treasures and books." But even the humanism of Alfred could not revive the illuminative art in England, which awaited the submission of the Danelaw in the second half of the tenth century, and the Danish kingdom of the eleventh, for the relative order and quiet which could nourish a revival of monastic art.

The end of the ninth century and the first half of the tenth constitute a period of mediaeval art nearly as barren as the seventh. Nevertheless, the vital strain of style may still be followed in Frankish lands—in painting, for instance, by the persistence of a modified and invigorated version of Saint-Denis style in the monastery of Saint-Gall in Switzerland, which develops a vigorous drawing of expressive power and evolves from the Saint-Denis rinceaux a crocketed and plaited initial that becomes characteristic for German Romanesque illumination. In the ivories produced in France and Rhenish districts

during the ninth and early tenth centuries,[20] one can follow not only the sculptural replicas of the manuscript styles during their florescence, but their continuation in plastic form even after the schools of illumination had fallen into decadence.

The earliest Carolingian ivories, dating *c.* 800, adhere as one could expect to the meticulous and somewhat timid copying of Italo-Gallic models that characterizes the first essays of the Ada illuminators. A prime example of such copying is the book cover in the Bodleian Library at Oxford (*Fig. 62*), whose central panel portrays the Christ of the ninety-first Psalm, trampling "the lion and the dragon, the young lion and the adder," surrounded by smaller scenes of his infancy and miracles. Of these scenes six were copied from actually existing Italo-Gallic ivories of the fifth century (in the Kaiser Friedrich Museum in Berlin, and the Louvre; p. 76), and are elo-quent of the change from an-

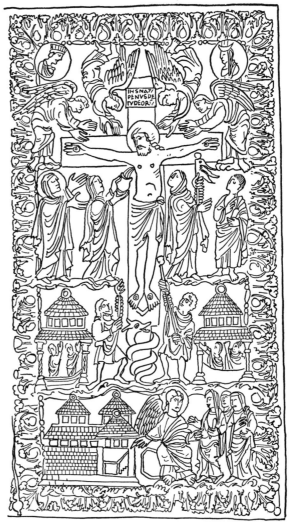

Ivory of the Metz School: *The Crucifixion*

tique to mediaeval style in the loss of weight in the figures and the emphasis on line at the expense of plastic form. Certain miniatures of the Utrecht Psalter are imitated in ivories that strive to reproduce the effect of drawing with utter disregard of sculptural quality, ignoring borders, undercutting relief to obtain the shadows of the miniature, and reproducing the billowy ground line of the Psalter in a series of perforated spirals. These ivories belong

[20] A. Goldschmidt, *Die Elfenbeinskulpturen aus der Zeit der karolingischen und sächsischen Kaiser*, I, Berlin 1914.

however not to the school of Reims that produced the Psalter, but to the later ateliers of Saint-Denis that inherited its style, and several of its products served as book covers for the manuscripts of Charles the Bald. Out of the later phase of this ivory carving of Saint-Denis issues the manner which Goldschmidt assigns to Metz and traces to the middle of the tenth century. Its favorite theme is the Crucifixion, developed into a highly symbolic type that includes the Sun and Moon, the resurrection of the Dead, a serpent twining about the base of the Cross, and the Church opposing the Synagogue, beside it. The acanthus border which Saint-Denis borrowed from Reims continues on the Metz ivories, in the form of luxuriant rinceaux or upright leaves enclosed by the fan-shaped lobes of leaves on either side. But the lively drawing of Reims and Saint-Denis acquires in these ivories a reticence and solidity that is the ancestor of the figure style met with later in the manuscripts of Reichenau at the end of the tenth century. The school of Metz was apparently more prolific than the earlier ateliers, to judge from the numerous products of it still surviving, and more varied in the types of object executed, including not only plaques and book covers but combs, pyxides, and caskets. One such casket, in the museum at Braunschweig (*Fig. 66*), presents upon its principal face a *Baptism of Christ;* this relief is repeated in a miniature of a manuscript which marks the revival of English illumination at the end of the tenth century—the Benedictional of Aethelwold (*Fig. 65*).

ANGLO-SAXON AND OTTONIAN STYLE. ITALIAN ROMANESQUE

The new style of Anglo-Saxon illumination [21] which supplanted the Celtic tradition in the second half of the tenth century in England developed in the wake of a spread of Benedictine monasticism and the introduction, in writing, of the Carolingian minuscule. We can trace its beginnings to Winchester, where Bishop Aethelwold (963–984) replaced the secular canons of the Old and New Minsters with Benedictines. For him, *c.* 980, the Benedictional above mentioned was made, the masterpiece of Winchester illumination and the work of a scribe named Godeman of Newminster, who represents the best of Winchester taste in his soft coloring of violet, blue, light green, yellow, and pink. He drew from the Reims style his acanthus borders (*Fig. 65*), confined in the Winchester manner by broad bands of gold, and sprouting rosettelike bursts of foliage at the corners and lateral centers of the picture's frame. We have seen the resemblance of one of his miniatures to the *Baptism* on the Braunschweig casket, which shows that he drew his figure style from the later Saint-Denis and Metz

[21] O. E. Saunders. *English Illumination*, Florence 1928.

revision of Reims drawing. The iconography employed in the Christ scenes is mixed, using sometimes the oriental bearded type of the Saviour, and sometimes the Latin beardless one. In the Entry into Jerusalem, we see a composition of fully developed Byzantine type, but Christ is beardless and rides astride in Latin fashion, and in the Ascension climbs to the Hand of God as in Italo-Gallic works (p. 13), though encircled by the eastern glory.

The Winchester school had nearly a monopoly of color illumination in England, and the Anglo-Saxon style in general is best represented by the outline drawings of English manuscripts, a vogue which appeared so coincidentally with the date at which we can determine the presence in England of the Utrecht Psalter (p. 204) as to indicate that this manuscript had much to do with the preference for line over color. Early in the eleventh century two such drawings illustrated the Register of Newminster, one of which, here reproduced (*Fig. 69*), presents the *Last Judgment* with characteristic English originality in its rendering. Heaven is depicted as a walled city within which the Blest adore Christ in glory, and outside of its door St. Peter (beardless) holds an enormous key and summons the saved. He is active again below, thrusting his key into the face of a demon who is trying to hold a soul. An angel beside Peter holds the record book of good; the demon brandishes his book of sins. To the right an angel herds a couple toward the Hell in which a devil tortures the damned before the gaping mouth of a monster, while another angel locks the infernal portal.

This drawing sums up the striking style, its distorted postures, its insistence on a diagonal axis for movement, its drapery fluttering about the ankles, its hunched-up shoulders, its curious drawing of the head that obliterates the division of neck and jaw. The Reims style has here come into its own again, but these artists give it a more positive accent, reducing its eccentric drawing to formulae, and achieving a certain rhythm through what have been called "the cunning convolutions of Anglo-Saxon line." [22] The art may have found its inspiration in Reims, and specifically in the Utrecht Psalter, but it is no mere imitation, and indeed originates motifs that were later adopted by continental painting, notably the literal rendering of the Ascension which replaced the older types —a scene in which Christ is depicted disappearing in clouds, with only his body and feet visible to the wondering disciples below (*Fig. 70*). The influence of the style on continental art was extensive, since English drawing of the tenth and the first half of the eleventh century distinctly surpassed the capacities of continental ateliers. We hear of an English book passed from hand to hand in a church council at Limoges in the eleventh century, eliciting great admiration, and of presents of English illustrated codices to the abbey of Fleury on the

[22] J. A. Herbert, *Illuminated Manuscripts*, New York 1911, p. 119.

Loire. The best examples of Winchester drawing in this country, two gospel books from the Earl of Leicester's collection at Holkham Hall, now in the Morgan Library, were transferred to Weingarten in Germany and there imitated. Robert of Jumièges, bishop of London (1044–1050), commissioned a Winchester missal which he sent as a gift to the Norman abbey of Jumièges over which he once presided. Anglo-Saxon style inspired the art of Abbot Odbert, who decorated a psalter now in the Public Library of Boulogne for his abbey of Saint-Bertin. The school of illumination which was active in the French monastery of Mont-Saint-Michel, on the Channel coast, was based on Winchester painting, reducing its exuberance, and changing its strong drapery accents to a sort of quivering pattern of undulating lines, but owing what strength it has to the vigorous draftsmanship across the Channel. The continuation of the Reims manner which we can see in Belgian work of the eleventh century may owe much to English influence. Even as far south in France as Poitiers, a *Life of St. Radegonde* of the eleventh century has a portrait of its author Fortunatus drawn with typically Anglo-Saxon angularity, and the typical Winchester luxuriant leaf bursts adorn the corners of its border. The manuscripts of Burgundy, about 1100, show a similar dependence on English style. The importance of this diffusion of the Anglo-Saxon manner will be apparent when we come to discuss the beginnings of French Romanesque sculpture.

The Norman conquest brought an end to Anglo-Saxon style, no less in manuscript decoration than in architecture, imposing, as it were, the Norman discipline on art as on all other aspects of English life, and transforming Anglo-Saxon exuberance into the slower rhythm of the Romanesque. The transition from pre-Norman style to that which followed the Conquest is to be seen in the embroidery known as the tapestry of Bayeux, undoubtedly of English workmanship although it celebrates the victory of William the Conqueror. In this the difficult technique has emphasized the decadence of drawing, in which the old distortions have lost their rhythm and the dynamic effect of diagonal action; the pattern becomes a mere confusion of slanting lines. The chinless faces, long necks and bodies, and comic attitudes of the dismayed English who gaze at Halley's comet in our illustration from the Tapestry (*Fig. 68*), or the toppling attitude of King Harold as he receives news of the portent, as well as the unarticulated architecture, are evidence enough that even aside from the effect of the Conquest the vitality of Anglo-Saxon art had passed.

❖ ❖ ❖ ❖ ❖

Eastward, into the more Teutonic regions of the Rhine valley and the south of Germany, the Carolingian tradition took another direction, emphasizing

rather the sober aspects of the "renaissance," and encouraged therein by the relation of the German kingdom with Byzantium—a relation politically expressed by the marriage of Otto II (973–983) to the Greek princess Theophano and artistically by the numerous Byzantine ivories (p. 117) to be found on the bindings of German manuscripts of the late tenth and the eleventh centuries. As western style in these centuries was dominated by Anglo-Saxon drawing and the school of Winchester, so in the east the principal influence was that of south German illumination as practiced in the island monastery of Reichenau in the Lake of Constance, and the branches of the school which were located in Trier and Echternach. These scriptoria brought into a generally consistent line of German style the other centers of illumination. Cologne, with its initial preference for the impressionism of the early Reims manner as seen in the Coronation Gospels of Vienna; Regensburg, which commenced with an imitation of Saint-Denis; Hildesheim, whose eclectic taste retained survivals from Franco-Saxon, Ada, and Saint-Denis, all succumbed in greater or less degree to the more developed and self-assured manner of the south German school. The "Ottonian renaissance," so called because evolved during the reigns of the three Ottos of the Saxon royal house, was carried on in the main by Reichenau and its branches. Its style represented as did the imperial ideal of the Saxon monarchy a revival of antiquity, but with the more distant perspective that two centuries had brought, and the employment of models that included not only Latin imitations of east Christian art, but Greek works as well.

The most famous of Reichenau manuscripts, the gospel lectionary (*Fig. 72*) illustrated for Archbishop Egbert of Trier (977–993),[23] shows in the thick legs of the minor figures, the simple bead-and-reel borders, the assignment of half the text page to the miniature, and above all in the sharply peering glance of the eyes, so close an affinity with the miniatures of the Rossanensis and Sinopensis (p. 63), or those of the Greek lectionary of Leningrad, as to make it clear that the island monastery possessed in its library one or more early Byzantine illustrated gospel books, such as that we know existed in the ninth century within the library of Saint-Gall. It is to such models that the school owes certain features of its iconography, as for instance the colobium worn in east Christian fashion by Christ in the Crucifixion, which scene itself reveals a proto-Byzantine type in the inclusion of the crucified thieves. It is in the narrative cycle that the eastern element comes most clearly forth; but in the portraits of the Evangelists and symbolic compositions such as the Majestas (Christ in Glory), the Reichenau artists turn to Carolingian models of the Ada and Tours schools, and in their ornament adhere to the rich repertory of Saint-Denis. Initials

23 F. X. Kraus, *Die Miniaturen des Codex Egberti*, Freiburg im Breisgau 1884.

[213]

especially are based on the Saint-Denis rinceaux, or rather on the development thereof which Saint-Gall had already made in the ninth and tenth centuries (p. 208), evolving the plaited design with crockets which became the norm for German illumination from the end of the tenth through the eleventh century.

From the fastidious style of Byzantium, the Reichenau manner, especially in the version of Trier (where actual Greek inscriptions sometimes accompany the scenes), acquires at first a Hellenic equilibrium and a solidity of composition and drawing, contrasting strikingly with the contemporary linear liveliness of Anglo-Saxon art. It is indeed an introvert style, tending toward closed contours in the figure's silhouette, and an elimination of space by decorating the background with patterns. As time went on, however, the same Teutonic expressionism which dynamizes the illustrations of the Utrecht Psalter began to animate the Reichenau creations with a curious potential energy, displayed not in the contorted postures and convolutions of the western style, but in fiercely staring eyes, harshly angular folds of drapery, and sharply contrasting tones. The drawing is firm throughout, but in the eleventh century becomes metallic, so that even flying folds of garments seem solid, with none of the evaporation of silhouette one sees in Anglo-Saxon design. Through the inhibitions laid on German style by Byzantine tutelage one feels the Teutonic ideal of effective force expressed, in heads thrust truculently forward, intensity of gaze, and a heavy rhythm in the compositions from which is absent entirely the English cult of the slanting axis. Most characteristic of the introvert direction of this German energy is the strange development of a complicated and sometimes almost unintelligible symbolism, especially in the school of Regensburg, whereby the field of the miniature divides into compartments containing numerous symbols and symbolic figures (prophets, personifications, angels, Evangelists), that are woven into esoteric significance by metaphorical inscriptions.

❖ ❖ ❖ ❖ ❖

The essence of this Ottonian style is present in the *Transfiguration (Fig. 71)*, from a miniature in a gospel book of Otto III in the National Library at Munich. The artist still employs the early Carolingian head of the Christ in Ada manuscripts, beardless and with the curly lengthy locks of the Constantinople Christ type changed to stringy tresses. On the other hand the Byzantine scheme of the scene is adopted in the symmetrical placing of the transfigured Saviour between the two prophets, and the rising and speaking posture and gesture of Peter among the three disciples. But the symbolic glory that encircled Christ or all three of the principal figures in Byzantine Transfigurations is gone, and instead of the abstract Greek conception we are here aware of the artist's own

[214]

inhabitation of the episode, visible in the frightened faces and disturbed drapery of James and John, the solemn stare of the Saviour, and the intent gaze of the prophets. This is the Teutonic element in the picture; its symmetrical equilibrium and what it can achieve of Greek drapery arrangement and form may be ascribed to Byzantium.

The Romanesque quality of German art of the Ottonian period is more to the fore in sculpture, less open to exotic models than the illumination of manuscripts. The outstanding German contribution in this field was bronze casting, of which the German school had if not a monopoly at least the leadership, throughout the eleventh and twelfth centuries. Chief center in the eleventh century was Hildesheim in Saxony, where Bishop Bernward (d. 1022) assembled an atelier whose production continued even to the thirteenth century. He was the tutor of the young Otto III, and lived for a time (in 1001) in his palace on the Aventine in Rome, where the doors of S. Sabina (p. 77) seem to have inspired him to emulation. For on his return to Hildesheim he commissioned a pair of bronze doors for the church of St. Michael (they were later removed to the cathedral) on which were portrayed scenes from the Old and New Testaments as in the case of the doors of S. Sabina; on the left door scenes from Genesis, on the right Christ's Infancy and Passion. Bernward was a pious visitor to Tours and Saint-Denis, and must have procured at the latter spot an illustrated Bible like that of St. Paul's (p. 206), for the story of Adam and Eve on the left door follows the iconography of the Saint-Denis Bible, and the style of the doors is obviously based on the Reims manner from which that of Saint-Denis was derived. Hence the slim vigor of the bodies in the Hildesheim reliefs, the draperies that seem blown back against the forms, the unexpected twists of body, head, and legs. Nowhere in Christian art is the Judgment on Adam and Eve presented with such naïve drama as here, where the accusation

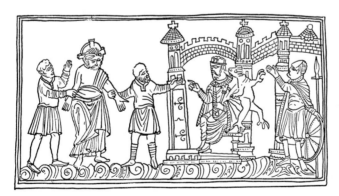

BERNWARD'S DOORS AT HILDESHEIM: *Christ before Pilate*

[215]

of the threatening head and pointing finger of the Lord is promptly transferred by Adam to Eve, and by her with a gesture to the Serpent. There is no more touching instance of the literal quality of this Teutonic art than the cheerful pride with which Mary exhibits the Child to the Magi. The technique is virtuosity itself; the head of Mary in the *Adoration of the Magi* protrudes into the round, and it is interesting to see that the master technique of such artists is that of painting, whose effects they go out of sculpture's way to obtain. Thus the compositions expand loosely as in the Utrecht Psalter over a space that is too big for them; the plants and buildings of landscape, of complicated and wide-flung design, are freely introduced. Expression here is undimmed by Byzantine restraint, and at times arrives at real characterization: in the *Expulsion from Eden* Adam bows his head and submissively seeks the Gate of Paradise; Eve turns toward the threatening angel with a last gesture of protesting entreaty.

These doors were the first historiated bronze doors of the Middle Ages to be solidly cast, instead of being a construction of flat panels affixed to wood. An even more ambitious undertaking than the doors was the bronze column, also destined for St. Michael's (removed to the cathedral in the seventeenth century), whose spiral frieze is obviously an imitation of the imperial columns in Rome (*Fig. 73*). The frieze depicts the Life of Christ, but begins with the Baptism and ends with the Entry into Jerusalem, thus singling out the episodes not rendered on the doors, which shows that the column postdates the completion of the doors in 1015. The detail here reproduced is the *Transfiguration,* affording comparison with the scene as depicted in the Gospels of Otto III. The bronzework is far more reminiscent of Carolingian style, even retaining the spirally rolling ground line of Saint-Denis ivories (p. 209), and certainly in its rude masks of faces and exaggerated accents revealing a purer Teutonic strain. But in the column reliefs the pictorial freedom of the doors is subjected to a sense of plastic form; for one thing, there is no projection of heads and shoulders from the mass of the monument. The figures are in larger scale in proportion to the space they occupy, and they are progressing toward a realization of sculptural rather than pictorial effect.

This Saxon art reached its height of sculptural expression in the end of the eleventh century, with the Crucifix in the abbey church of Werden in Westphalia, whither it came in the sixteenth century from the Saxon monastery of Helmstedt near Braunschweig (*Fig. 74*). In such works one senses the emotional vein in Romanesque; possessed by the essence and force of his theme, the artist does not hesitate to distort material form in order to deliver more directly the feeling thus engendered. The affinity with ultramodern sculpture is astonishing. The bulging eyeball, the beaklike nose and brow, the convention-

ally striated hair, the elimination of unexpressive features of the face, the abstract curve that marks the juncture of the eyelids, the simplification of the chest—these are traits of expressionism, given full play and geometric emphasis as in modern art.

Bronze casting was still the Saxon art *par excellence* in the first half of the thirteenth century, assuming the fluent lines of Gothic in its patterns, but still Romanesque in an occasional flying fold, unbalanced postures, and the discounting of form and equilibrium for expression. A singular example of the survival of the Romanesque attitude in German art into a period when French Gothic was at its height is the baptismal font in Hildesheim cathedral (*Fig. 76*). Even the Ottonian miniatures of the eleventh century cannot show much more involution of symbolism. The font rests on the figures of the Four Rivers of Paradise, holding each his jar from which the water gushes, but assimilated also to the Four Cardinal Virtues (Courage, Temperance, Justice, and Wisdom), since one is clothed in the coat of mail of Courage. The personification of the Virtue appears above each one of these kneeling caryatids, in a medallion which supports a colonnette surmounted by another medallion containing the bust of an Evangelist, with his symbol above him. The scenes of basin and lid are from the Old and New Testaments, selected with elaborate reference to the rite of baptism, and the whole catena of symbols is explained by four hexameters of inscription on the upper molding of the font. The compositions have undergone the transformation toward solidity and symmetry which Romanesque accomplished in the twelfth century, and the lettering is already Gothic, but the clinging drapery, absence of ground line, and dangling feet are still within the earlier style.

❖ ❖ ❖ ❖ ❖

This work is the last that came from the Saxon bronze-casting ateliers. They had had a prolific history in the twelfth century, executing the doors of S. Sophia at Novgorod in Russia and those of Gnesen in Poland, an altar at Goslar, the famous lion of Braunschweig, and numerous sepulchral plaques and other works. Perhaps through their smaller and exportable works such as crucifixes, and more generally through the carved ivories and the miniatures of later Ottonian style, one can explain the emergence of this German Romanesque manner in the revival of architectural sculpture which took place in the north of Italy at the beginning of the twelfth century, and is known as Lombard style. Its only title to the name is its appearance first in Lombardy, but its importance in the history of sculpture is great, since it marks the recovery of plastic volume in the art of an Italy which since early Christian times

had been under the two-dimensional limitations imposed by Byzantine painting.

A relief in the façade of Modena cathedral represents Enoch and Elijah, quaint symbols of immortality, holding a tablet on which is a metrical inscription giving the date of the foundation of the church, 1099, and praising the genius of the author of its sculptured decoration, "Wiligelmus"—a name connoting German origin, translated in the art history of Italy into Guglielmo. His principal work on the façade is the frieze at either side of the portal, recounting the story of Genesis down to Noah, of which the earlier scenes are reproduced in our illustration (*Fig. 75*). The Creator first appears, a half figure supported in a glory by two angels, with that effect of painful effort which distinguishes the caryatid figures of Romanesque. The Lord holds a book inscribed: *ego sum lux mundi via verax vita perennis*. Next is the *Creation of Adam*, and that of *Eve* who rises from the sleeping form of Adam, couched uncomfortably upon a rock which is washed by a stream. The water is indicated with the double-ax motif that was borrowed by the Ada illuminators (p. 197) from antique pavements and passed by them on to the school of Reichenau. The absence of any physical relation of Adam's body to the rock on which he reclines is curious evidence of the descriptive isolation of forms one from another that is always found in a primitive style. The rising of Eve from Adam's body is a Byzantine rendering that will become the norm in Italy, differing from the more textual version represented by the Carolingian Bibles, the doors of Hildesheim, and the Genesis mosaics of St. Mark's, where the Lord removes a rib from Adam's side. To the right the Fall is accomplished, with our first parents already covering themselves with leaves, though Eve is still receiving the fruit from the Serpent, which has not yet acquired the woman's head that Gothic art will give it.

Guglielmo's heavy forms, flapper feet, spadelike beards on retreating chins are plastic replicas of these characteristic features of Ottonian painting, and can be compared with our illustration from the Gospels of Otto III (*Fig. 71*). The affinity of this sculpture with German Romanesque is not surprising when it is viewed as counterpart of the "axis" uniting Italy to Germany under the Rome-conscious rule of the Ottos and the Salian and Hohenstaufen emperors, down to the revolt of the Lombard cities which issued in the defeat of Frederick Barbarossa at Legnano in 1176. Pupils of Guglielmo, a younger sculptor of the same name and Nicola, carry the style throughout North Italy, collaborating on the portal sculptures of S. Zeno Maggiore at Verona with its scenes of Genesis and of the Life of Christ, varied with knightly themes. Nicola alone signs the portals of Verona and Ferrara cathedrals and must be credited as well with the decoration of the south portal of the façade of the cathedral of Pia-

PORTAL, CATHEDRAL OF PIACENZA

cenza. Characteristic of the school is the centering of the composition of the lunette above the portal in a single large figure: at S. Zeno the patron saint stands on a dragon and presents standards to the town's militia (as we learn from an inscription); at Ferrara St. George occupies the tympanum, triumphant over his dragon; at Verona, in the cathedral portal, the Virgin is enthroned between an Annunciation to the Shepherds and the Magi. An especial feature is the "Lombard porch" which projects from the portal and is carried on two colonnettes resting on the back of lions.

This first Lombard school, whose works date in the first third of the twelfth century, restored the antique form in Italian sculpture which had been lost through the centuries of ascendancy of Byzantine painting. The singular quality of this art is that it is true sculpture, not seeking as did the Saxon bronze

[219]

founders, and the French Romanesque carvers whose acquaintance we have yet to make, to translate drawing and painting into relief. The figures bulk, and protrude their modeling from the mass, giving the ensemble an effect of powerful momentum that remains with the observer after he is done smiling at their crudities. These primitive aspects are refined out of the style in later stages, with some loss of power, and some evidence of French influence as the refining factor; on the campanile of the cathedral at Modena we find Roland and Oliver represented, and heroes of the Arthurian legend, including the king himself, appear in the reliefs of the Porta della Pescheria.

The connection with France is, however, much more evident in the later Lombard school, active in the last quarter of the twelfth century and the first of the thirteenth, and taking its name from Benedetto Antelami, whose first dated work (1178) was the pulpit of Parma cathedral, decorated with reliefs of the Passion of Christ. The pulpit was dismantled in 1566, and the relief here illustrated, all that remains of it, is now in a side chapel. The subject is the *Descent from the Cross* (*Fig. 78*), enacted by immobile figures that retain the reticent power of Guglielmo, but reduced in scale and refined in features and design of drapery. Profuse inscriptions explain the scene: the row of women at the left are labeled *Salome, Maria Jacobi, Maria Magdalene, Sancta Maria*. Behind the Virgin is *Sanctus Johannes*. Above the group is the Sun in a wreath, balanced by the Moon at the further extremity of the frieze. An angel descends, extending protecting hands to the Church, a small figure with chalice and banner, explained by the inscription: *Ecclesia exaltetur*. Joseph of Arimathaea lifts the body of Christ from the Cross, while Mary lays her Son's hand to her cheek, and Nicodemus climbs a ladder to unfasten a nail from the left hand. The Synagogue (*Synagoga deponitur*) is discomfited, her banner broken, and an angel pushes the crown from her bowed head. The centurion, labeled by a circular inscription on his shield, bears his witness: *vere is filius Dei erat*. Five spectators make a group to the right, besides the soldiers dividing the garments of the Crucified.

The introduction of Church and Synagogue into the scene is a French motif dating back to the ivories of Metz (p. 210). The curious "accordion pleating" of the sleeves above the elbow is a mannerism that, so far as dated examples can show, first appeared in the sculptures of Saint-Denis about 1140 and was used as well in the contemporary French school of Provence (p. 241). The fine lines of the drapery and the slim verticality of the figures are features again that we shall meet in the proto-Gothic art of Île-de-France. The weedy acanthus scrolls that form the incised border to the relief, filled with a black amalgam like niello enamel, are of a design resembling that employed by Benedetto's

French contemporary Brunus at Saint-Gilles in Provence, and the affinity of Antelami work with the Provençal Romanesque is even more obvious when one compares with it the massive figures of David and Ezekiel standing in niches on the façade of the cathedral of Borgo S. Donnino, near Modena, while the reliefs of this façade, recounting the history of the patron St. Domninus, contain many a parallel to the early sculptures on the Sainte-Anne portal at Notre-Dame in Paris.

These sculptures of S. Donnino date about 1200, a few years after the greatest "Antellami" work which was the Baptistery of Parma, designed and decorated with its sculpture by this Lombard school (1196). Three of the portals are so adorned; one with the allegory of the sinner in a tree, enjoying its fruit, while its roots are gnawed by rats, with a dragon waiting to devour the erring one when the tree succumbs. Another tympanum holds the *Adoration of the Magi,* with a Tree of Jesse arranged in rinceaux on the jambs and archivolt, and the story of the Baptist on the lintel. The third contains a Last Judgment, with Christ baring his wounds in the manner of French renderings, and angels holding up the lance, sponge, crown of thorns, and the Cross, as symbols of the Passion. The rest of the scene—the resurrection of the dead on the lintel at the sound of angels' trumpets, and the apostles in the archivolt—adheres to the Byzantine scheme for this type. The stylistic qualities of the *Descent from the Cross* are present here with increased refinement, but with no loss of the essential plasticity of the school; the halting movement and reticent gestures still recall the stolidity of Guglielmo, and an echo of ultimate derivation is the roughhewn wood of the Cross, a popular iconographic detail of German Romanesque. The epitome of Antelami style is present in a beautiful font of the Parma Baptistery, where a Lombard lion supports on his back the basin carved with the weedy acanthus current in the school, unfolding its leaves and tendrils with the slow and heavy rhythm which imparts a monumental force to all creations of Lombard sculpture (*Fig. 77*).

The name Antelami has been dubiously derived from that of a valley near Lago Maggiore; at any rate Milan and its nearby Alpine lakes was apparently the homeland of these renewers of architectural sculpture, since we hear of them in documents as *Comacini,* indicating Como as their provenance. *Comacino* was a synonym even for a local stone carver in South Italy in the thirteenth century, and *Lom-*

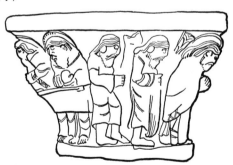

ÎLE-BOUCHARD: *Capital*

bardo for stonemason in Catalonia. The style of Guglielmo and his school turns up in faraway places beyond the Alps, notably in capitals of churches in Burgundy and the valley of the Loire (e. g., at Île-Bouchard), and the Lombard splayed portal with its radiating orders of the archivolt became the norm in the west, north, and east of France, with sporadic imitation in England, Germany, and Spain. The first extension of the style in Italy itself was in Tuscany, where Pistoja is a veritable museum of Romanesque sculpture, with dated and signed examples ranging from the middle of the twelfth century to the mid-thirteenth. Tuscan Romanesque was initiated by a Pisan artist also named Guglielmo, who combined the mode of his Lombard namesake with borrowings from south French style, and carved the Lombard-looking reliefs of the pulpit (1161) which once stood in the cathedral of Pisa and was presented to Cagliari in Sardinia when Giovanni Pisano's new pulpit replaced the old one in 1310. His pupils and followers Gruamons and Adeodatus, Henricus and Rodolfinus, develop at Pistoja the characteristic Tuscan tendency to groove the drapery and carve the features too deeply, destroying the Lombard solidity with which the style commenced. They initiate as well the childish, storytelling quaintness of Tuscan relief that takes it far from the heavy seriousness of Lombard work. This trend eventuates in the curious air of sophisticated infancy which pervades the work of the last of the Romanesque sculptors of Tuscany, Guido da Como, whose natal city is all that connects him with the Lombard school except perhaps the use of lions for his column pedestals. Recent criticism has so divested him of works that only one with figured decoration remains—the pulpit of S. Bartolommeo in Pantano at Pistoja, of which a detail is here reproduced (*Fig. 80*). From this one can note the virtuosity of Guido as a marbleworker; in pure ornament he is hard to equal, and the one certain attribution that can be made to him, other than this pulpit, is the beautiful font in the Baptistery at Pisa, where his handling of antique motifs of ornament, seen here in the rosettes that separate the figured panels, reaches a maximum of skillful technique and taste. But the Life of Christ depicted on the Pistoja pulpit is enacted by dolls, whose infantile quality is enhanced in the childish stare produced with a dot of black stone in the pupil. This pulpit, dated 1250, precedes by but ten years the pulpit of Nicola Pisano in Pisa's Baptistery, with which Italian Gothic sculpture commenced.

As one descends southward in the Italian peninsula, the Romanesque factor in style diminishes, and antique survivals, direct or in their Byzantine revision, are more evident. At Rome indeed there was no break in early Christian tradition; the city never had a church of Romanesque style or construction, and

its only Gothic example is S. Maria sopra Minerva. Church decoration during the twelfth and early thirteenth centuries was almost devoid of figure sculpture, and specialized in the marble inlay which from one of its chief practitioners, Giovanni Cosmati, is known as Cosmatesque. This style of ornament, developed around the discs of porphyry and serpentine sawed from the colossal columns of Roman ruins, continued as did the Tuscan the repertory of antique motifs in its carved moldings and borders, but its polychromy was far more brilliant than the simple alternation of white and dark-green marble that is characteristic of Romanesque architecture in Tuscany. The designs of ancient pavements were resurrected to ornament episcopal thrones, altars, tombs, fonts, and pulpits, and the main motifs of the pattern inlaid with colored glass, which also enlivens the spiral flutings of the twisted colonnettes that are the principal feature of Cosmatesque. The cathedra of S. Lorenzo *fuori le mura,* here illustrated (*Fig. 79*), is a developed example of the style, executed at a time when the Roman marbleworkers were timidly beginning the use of figure sculpture, as on the Easter candlestick at St. Paul's, whereon Vassalletto carved scenes of the Passion which seem to resurrect the late antique formulae of early Christian sarcophagi.

The polychrome Cosmatesque work was employed as well in Campania, adding another element to the motley aspect of south Italian Romanesque. The painting of the period in this Greek section of Italy was steeped in Byzantine tradition (p. 136), and the sculptured ornament of the churches of Campania and Apulia, during the twelfth century, is a plastic translation of the arabesques, peopled with oriental animal forms, which one encounters in the ornament of mid-Byzantine manuscripts, textiles, and ivories. Lombard influence introduced the porch, and the animal pedestal, but modified both motifs in picturesque local fashion, employing sometimes a brute seated on his haunches instead of the lion *passant* or *couchant.* Elsewhere the pedestals are elephants in imitation of the Saracen taste of nearby Sicily, such

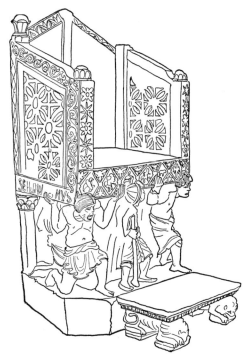

BARI: *Episcopal Throne*

[223]

CATHEDRAL OF BENEVENTO: *Panels of the Bronze Doors*

as those that support the episcopal throne at Canosa, or serve as base to the colonnettes that frame the beautiful window opened *c.* 1190 in the apse of Bari cathedral (*Fig. 81*). The half nude Saracen (?) captives beneath the cathedra of this church, dating in 1098, are probably our earliest example in sculpture of the Romanesque concept of the caryatid, crushed beneath the weight of the burden carried. The Romanesque trend is perhaps best shown in the transformation of technique in the bronze doors that succeeded in the twelfth century the portals imported from Constantinople (p. 122). The pair that was made by Roger of Amalfi for the tomb of the Norman Bohemund at Canosa (d. 1111) still uses the Byzantine incised design and silver inlay, but replaces the sacred themes with contemporary figures, and adopts for the ornament in relief the motifs of Arab metalwork. The doors of Troja, on the other hand, executed in 1119–1127 by Oderisius of Benevento, while still employing the Greek incised drawings for the figures, introduce lions' heads and winged dragons in high relief for the door grips and knockers. By the second half of the century relief had supplanted the earlier method, but the Byzantine influence is no less evident; Barisanus of Trani, author of the doors for the cathedral of his own city, and of those for Ravello and Monreale (1170–1185), seems to have found the models of his reliefs in Byzantine ivories and repeats them from one set of doors to another. A real appropriation of the north Italian style in relief is found on the doors of the cathedral of Benevento, on which an unknown bronze founder has rendered the Life of Christ with ponderous Lombard rhythm and full plasticity. The stylistic distinction of this artist is lacking in the doors Bonannus of Pisa made for the principal portal of Monreale, to match

the lateral portal of Barisanus. In these, as in the pair which Bonannus executed for the cathedral of Pisa, the models are Byzantine ivories (p. 118) and other objects of minor art, but the summary modeling and descriptive isolation of the figures reflect the Tuscan's inability to absorb either Lombard force or Byzantine refinement.

The encumbered caryatids of the Bari bishop's throne were employed on occasion by the sculptors who had learned the ancient technique of carving porphyry, and made of this material the fine coffins of the Norman kings at Palermo. The chief works of this Sicilian school are the Paschal candlestick of the Cappella Palatina, resting on an animal pedestal, but with a capital supported by antique half nude ephebes, and the shaft carved with foliate ornament enclosing birds and dogs; and the beautiful cloister of Monreale, whose figured capitals and paired colonnettes betray the infiltration of the Romanesque of Provence or Languedoc. But most of these colonnettes are incrusted with glass mosaic after the manner of the marbleworkers of Rome and Campania, and the abacus of one capital actually bears the signature of a *Romanus filius Constantinus marmurarius*. Another capital depicts William II offering the church of Monreale to the Virgin; others have Biblical subjects, scenes of war and the chase, allegorical figures, saints, prophets, Evangelists, and real and fantastic animals. A few of the colonnettes are carved with vine rinceaux interspersed with birds and putti, like the central pair on the sarcophagus of Junius Bassus (p. 75), and would be taken for antique pieces were it not for the heavy design of their spirals and their schematic nudes. The figured scenes are occasionally sheltered by canopies like those used by the proto-Gothic sculptors of this time in Île-de-France; the broken drapery, fluttering about the feet, and the large heads on slender bodies, remind one of Romanesque style in France.

The final phase of "Romanesque" art in Sicily and South Italy can hardly be called Romanesque at all, being rather a protorenaissance, due almost entirely to the personal initiative of the Hohenstaufen emperor Frederick II (1212–1250), who inherited the kingdom of the Two Sicilies from his mother Constance, daughter of Roger II. Frederick was far more of an Italian than a German. Born at Iesi in the march of Ancona and brought up in Palermo, he spent but eight years of his reign in Germany and sojourned for nearly the whole of the rest in South Italy. An enlightened ruler whose unfeudal and

MONREALE: *Capitals of the Cloister*

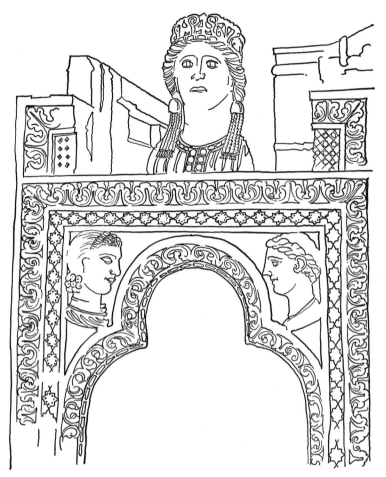

PULPIT AT RAVELLO

unmediaeval ideal was peace for his dominions, his linguistic attainments reflect the *mélange* of races and cultures over which he was called to govern; besides his native German and traditional Latin, he knew Arabic, Greek, and French, and was a contributor himself to the vernacular Italian poetry that flourished long before Dante at the court of Palermo. Nowhere in the whole history of art can so confusing a mixture of styles be found as that which was exhibited by the art of South Italy and Sicily during his reign. On an underlying stratum of Latinity was overlaid the Byzantine influence in a land for centuries part of the eastern Empire; the Lombard stone carvers have left everywhere the traces of their passage; the exiled French supporters of Frederick's attempt to oust the Lusignan family from its sovereignty of Cyprus brought to South Italy a taste for French Gothic architecture and ornament, visible in the crocketed capitals that appear in Frederick's constructions; the Arabic element in

Sicilian art passed over the straits and found provincial expression in the peninsula. A fine synthesis of all these seemingly disparate elements may be seen in the apsidal window of Bari cathedral (*Fig. 81*).

Interspersed with all these factors, the antique tradition always latent in South Italy shows itself in details of ornament and the handling of figure and drapery. But the direct revival of antique forms, corresponding to the emperor's effort toward a more than superficial imitation politically of the ancient Empire, was undoubtedly due to the taste and inspiration of Frederick himself. A ruler who coined his money on the model of Roman issues of the fourth century and gave the name of *augustalia* to his gold pieces might be expected to enact more than the role of Maecenas in the works of art he commissioned. The most important of these was the bridgehead constructed north of the Volturno to protect Capua against possible pontifical invasion, consisting of two round towers flanking a marble arch, modeled on Roman triumphal arches, and making a picturesque contrast with the mediaeval aspect of the Romanesque towers beside it. The characteristic decorations of the arch were the statue of Capua, a seated figure of the emperor, and two laureate busts of his councilors Taddeo da Sessa and Piero delle Vigne. The local museum contains these two busts, and the head that is all that is left of "Capua," together with the decapitated figure of Frederick. In all of these the effort to recapture antique style is visible; the head of "Capua" reproduces in tight modeling the type of Juno, the emperor wears the toga, and the heads of his councilors, with laurel wreath, Olympian beard, and knotted chlamys, miss the classic effect only by the too meager modeling of surface, and oversimplification of planes.

The imitation of classic models initiated by the commissions of Frederick II did not cease with his death in 1250. The pulpit of the cathedral of Sessa Aurunca, with its figured capitals and reliefs of prophets (including the Erythraean Sibyl in classic drapery), was finished after 1259. Its sculptor Peregrino also signed the Paschal candlestick and did the huge fish that spews up a well-modeled Jonah on the parapet of the pulpit stair, as well as the Life of St. Peter which decorates the cathedral's porch. His style recurs in the reliefs, executed with the fineness of ivory carving, which depict the stories of Joseph, Samson, and St. Januarius on the marble parapets that once enclosed the pulpits of S. Restituta at Naples. The portraits of Nicola Rufolo and his wife Sigilgaita, carved like Roman cameos in the spandrels of the Cosmatesque pulpit at Ravello, and the pseudoclassic bust of the Church above them, were done by the son of Frederick's *protomagister*, Nicola di Bartolommeo di Foggia, in 1272. It is now generally admitted that the art of Nicola Pisano (son of Pietro of Apulia) derived its power to assimilate the antique not wholly from

his own invention, but largely from this "renaissance" which was under way during his south Italian youth and apprenticeship. The Junoesque head of "Capua" is continued in the Madonna of the *Epiphany* and *Presentation* of Nicola's pulpit in the Baptistery of Pisa, which initiated the Gothic period of Italian sculpture (*Fig. 135*).

THE ROMANESQUE IN SPAIN AND FRANCE

The preceding sketch of Italian sculpture of the twelfth and thirteenth centuries illustrates a truism of the history of art in Italy, that whatever stimulus be applied to the Italian genius will eventuate in classic expression and form. The recovery of plastic volume initiated by the Lombard school early in the twelfth century found issue in the "renaissance" of Frederick II of the thirteenth. The Latin instinct of the peninsula sought clarity rather than a mystic involution of its themes, and was therefore predisposed to the less esoteric vocabulary of the antique. Hence the conversion of Lombard style in Tuscany into the infantile simplicity of Guido da Como's narrative, and the submergence of it in the south by a conscious effort toward a classic revival. It is also true that the positive mysticism which animates the truly Romanesque phenomenon, the emotional inhabitation of his subject by the artist, never grew where it had no Carolingian roots; the absence of a Carolingian "renaissance" south of the Alps is another reason for the failure of the German style of the North to dominate the evolution of pre-Gothic art in Italy. Even when the Gothic movement arrived, in the art of Nicola Pisano, its initial feature was an obvious imitation of the antique.

In Spain also, there was no Carolingian "renaissance." The same may be said for the south of France as well, and in fact the early mediaeval history of this part of Gaul is culturally and politically associated with Spain. The Visigothic kingdom of the fifth century had its capital at Toulouse, and Languedoc along with Spain suffered the Moslem conquest of the eighth; during the periods of the ninth and tenth centuries, when Moslems and Christians lived in a state of more or less tolerant peace, the southwest of France was hardly more a part of the Frankish kingdom than the little Christian states which had taken refuge from the Islamic conquest in the mountains of northern Spain. The art of both regions until the eleventh century is a steady degeneration of early Christian Latin style, reducing Roman ornament to geometric simplification, and losing its *a priori* organization in wandering design and coarsened scale, of which last the revision of the antique guilloche into a heavy rope border is a good example. The extent to which the Latin tradition had lost its naturalism is illustrated by the attempt of the sculptor who decorated the portal of

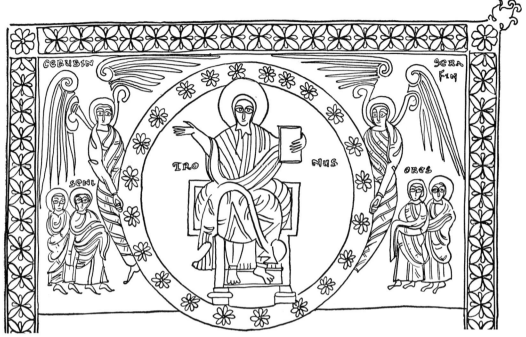

BEATUS MANUSCRIPT: *"The Throne Set in Heaven"*

San Miguel de Lino, near Oviedo, to reproduce a consular diptych (p. 55) which had come into his notice. The seated consul and his attendant personifications of Rome and Constantinople, and the acrobats of the circus games in the lower panel, have become amorphous make-ups of isolated heads, drapery, and feet, with grooves for folds and incised lines for features.

This extreme of primitive design appears in the major effort of Spanish art of the tenth and early eleventh centuries—the illustration of the *Commentary on the Book of Revelation*. This is a crystallized hieroglyphic, without pretensions to naturalism, conveying with extraordinary power, by virtue of raw stylization and strident color, a content equally barbaric. The *Commentary* was written in the second half of the eighth century by Beatus of Liebana, a monk of the monastery of Valcavado in León, but the illustrated exemplars of the work do not antedate 900, the earliest being a codex in the Morgan Library executed shortly after that date, while the iconographic tradition and much of the primitive style that expressed it will be found in another Morgan example as late as the thirteenth century. The parti-colored backgrounds of the early miniatures recall those of the Ashburnham Pentateuch (p. 193). The frontal, staring, flat figures, in drapery as conventional as that of Irish Evangelists without the latters' calligraphic sophistication, are nevertheless strangely in tune

[229]

with the apocalyptic content of Revelation, whose terrifying details are literally recorded and unreservedly believed.

But in the second half of the eleventh century, in both Spain and the southwest of France, the Romanesque movement intrudes itself into this barbaric style, transforming even the traditional formulae of the Beatus illustration. The Beatus which was made for the Abbot Gregory (1028–1072) of the monastery of Saint-Sever in Gascony (Bibl. Nat. lat. 8878) shows in its facial drawing, fluttering drapery, and swaying postures the same remote influence of Anglo-Saxon drawing that had percolated about this time into the miniatures of the *Life of St. Radegonde* at Poitiers (p. 212). The lively northern design, and its angular pattern of the human figure, appear on the ivory crucifix (Madrid, Museo Arqueologico) presented in 1063 to the church of S. Isidoro at León by King Ferdinand I and Sancha his queen. The reliefs representing the Beatitudes on an ivory casket in Madrid from S. Isidoro (Museo Arqueologico), which seems to date from the same consecration of the church in 1063 that occasioned the gift of the crucifix, betray similar symptoms of the entrance of Romanesque intensity and disturbed equilibrium, besides the introduction of the double lines marking folds of drapery which will persist throughout this southwestern style. The most marked approximation of English drawing, though retarded still by primitive survivals, is to be discovered in the thinly clothed skeletons enacting the scenes of Genesis on the silver *arca* of S. Isidoro, which seems to have been the original repository of St. Isidore's relics when they were deposited in the church at its consecration.

These Leonesque works are selected as examples of the transformation of style visible in other parts of Christian Spain in the later eleventh century, for which earlier examples such as the Beatus miniatures prepare us not at all. The revolution is as abrupt as that which substituted Carolingian for Anglo-Celtic style in England, and the reason is the same, namely, the introduction of a new Benedictine monastic rule, of new books in Carolingian script and Carolingian tradition in their decoration, and in addition the substitution of the *ordo Romanus* for the old Mozarabic rite that had been the liturgy of Spain since early Christian times. The Benedictine reform in this case was the more effective because it came from Cluny, center of an international monastic polity which extended its influence wherever its daughter priories (numbering three hundred in the twelfth century) happened to be located. The Cluniac invasion was initiated by Sancho the Great of Castile with several foundations of the first third of the eleventh century. In Languedoc, the monastery of St. Peter at Moissac became a Cluniac priory in 1047 and the order spread widely in Languedoc in the last third of the century. Such foundations involved the

immigration of French monks and monastic culture; by 1100 the secular clergy in Spain was largely French, and the bishops often former monks of Cluny.

But the most effective avenue of northern influence in southern France and Spain was the organization, again by Cluny, of the pilgrimage route to the shrine of St. James at Compostela in the northwest corner of the peninsula, known indeed in Spain as the "French road." Over the four routes so carefully mapped and provided with hostels for the pilgrims, artists and artistic ideas made their way as well as other travelers, and to this pious linking of France with Spain is attributed the identity of architectural style found in churches on the "road," such as Sainte-Foy at Conques, S. Martial at Limoges, S. Sernin at Toulouse, and the pilgrimage church itself, Santiago de Compostela.

Through this exotic planting, the Romanesque movement which had left the Southwest untouched in Carolingian times took root in the second half of the eleventh century. Its development can be followed best in sculpture,[24] and in two phases, the earlier of which in the end of the eleventh and the early years of the twelfth, is usually known as the school of Toulouse, though the French city cannot claim the origin of a style that so far as dated monuments can show, was coeval in Languedoc and Spain alike. In fact the earliest dated example of this Romanesque is the Panteón de los Reyes (c. 1065) at S. Isidoro of León, tomb chapel of the kings of León, whose capitals present an interesting documentation of the emergence of the style from its Mozarabic infancy. Thence it passes to the cathedral of Jaca, and other Aragonese churches, where it betrays at times so strong an affinity to the style of Guglielmo of Modena as to suggest the intervention of *Comacini*. The new church of S. Isidoro at León (between 1072 and 1124) produced another phase of this sculpture, in which the Spanish style begins to approximate more closely its Toulousan relative, in heavy caplike coiffures, boldly modeled faces, and the standing figures decorating the spandrels of arched portals.

The *locus classicus* of Spanish Romanesque sculpture is the great pilgrimage church of St. James at Compostela, of whose construction and decoration we are abundantly informed by the *Historia Compostelana*, and by the pilgrims' Guide, the *Codex Calixtinus*, which not only contained information as to routes, hostels, and shrines along the "Way of St. James" that led to the shrine from across the Pyrenees, but described the church that was the goal of pilgrimage. It was begun in 1078 and finished in the third decade of the twelfth century, except for the elaborate western porch, the Pórtico de la Gloria, added in its last third. Through the period of building our style develops more

[24] G. Gaillard, *Les débuts de la sculpture romane espagnole,* Paris 1938.

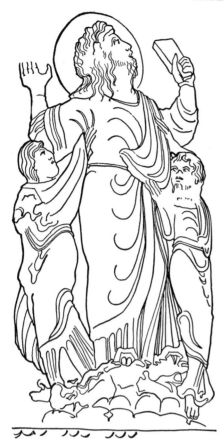

SAINT-SERNIN, TOULOUSE: *Christ's Ascension*

and more in the direction of Toulouse, as one may see by following it from the ambulatory capitals to those of the transept, and reaches an aspect closely resembling its Languedocian parallel in the reliefs of the Puerta de las Platerias, the portal of the south transept.[25] This was finished early in the twelfth century, but the present conglomeration of figures incased in its façade contains later additions, some of them from the original decoration of the west front and the portal of the north transept.

In these reliefs the characteristics of the style are well crystallized: the elongated, sharply vertical figures with high cheek bones in the faces and heavy caplike hair, drapery falling in concentric arcs on the body with pleats marked by double lines, and the flying fold of northern drawing confined to a flare at the ankles. Only occasionally does a later motif appear—the crossed legs of a standing or sitting figure. The pier relief from the lower cloister of S. Domingo de Silos, which we reproduce in our illustration (*Fig. 84*), is a variant of the Puerta's sculpture; it is from the hand of too individual a master, and reveals too much a fresh infusion of northern Romanesque, to be wholly typical. Yet this group of the end of the eleventh century, representing Christ and the two disciples of the *Journey to Emmaus* (with Christ wearing the scrip adorned with a cockleshell that denotes a pilgrim to Compostela) presents the essentials of the style in meticulous refinement: the double lines of drapery are reduced to minute drawing, the folds are ironed to an extreme of flatness, and the heavy hair only incised upon the cranium. The crossed legs of Christ are Toulousan, his oblong face and high-placed drilled eyes are features we shall find in Burgundian Romanesque, and the tiptoe stance of the elongated figures reminds one of English work in the period following the Conquest.

At Toulouse, the revival of monumental sculpture begins with a group of reliefs in the ambulatory of Saint-Sernin, removed from some portal, whose cen-

[25] A. K. Porter, *Spanish Romanesque Sculpture*, Florence 1928, I, pls. 60–62.

tral feature was a beardless Christ in Majesty, in a mandorla surrounded by the Four Symbols. The other pieces are carved with a cherub, a seraph, two angels, and two figures that may be apostles or prophets (*Fig. 83*). These heavily modeled, immobile figures owe their essential monumentality to no influence of northern Romanesque; they are rather based on a local sculptural tradition lingering from late antiquity, but they share with the new manner the superficial features of heavy hair and double-lined drapery. They are succeeded by the capitals of the church, and the style finally emerges in an aspect closely resembling the sculptures of the Puerta de las Platerias, in the Porte Miègeville of Saint-Sernin, roughly contemporaneous with the Santiago portal. The figures of the *Ascension of Christ* in the tympanum borrow something of their plasticity from the ambulatory figures, but we have already the marked verticality maintained despite movement, the dangling feet, and the exaggerated wig of curly hair that show affinity with their Spanish counterparts. The lunette is flanked by the characteristic spandrel figures which the sculptor Nicola (p. 218) borrowed from this source in his Lombard portals. These figures represent St. James and St. Peter, the latter continuing in his beardless face a south Gallic tradition reaching back to the Codex Purpureus of Munich (p. 193).

CLOISTER OF MOISSAC: *The Abbot Durandus*

A shrewd observation on the part of D. M. Robb has pointed out the contrast between the bold modeling and monumental sense of the sculpture at Saint-Sernin, and the flat relief and more minute detail of the reliefs of Silos, and accounted for it by the greater opportunity open to the sculptors of urban centers (such as Toulouse) for imitation of the relics of antique art, whereas monastic ateliers such as that of Silos would be prone to follow the two-dimensional style of miniatures and ivories. The latter seems certainly to be the case with reference to the sculpture of the cloister of St. Peter's monastery at Moissac, constructed (*c.* 1100) by Ansquitil, third of the Cluniac abbots. For Mâle [26]

[26] E Mâle, *L'art religieux du XIIᵉ siècle en France*, Paris 1922, pp. 10 ff.

has pointed out the derivation from Beatus miniatures of some motifs in the seventy-six cloister capitals and the close resemblance of the pier reliefs, representing the abbot Durandus and nine of the apostles, to the Evangelists in an eleventh-century gospel book of Limoges (Bibl. Nat. lat. 254). These pier figures, flat and cramped, have much in common with those of Silos, but are less affected by exotic northern style, clinging to the heavy wigs, sharp verticality, doubled drapery lines, and ankle flare of the skirt, which belong to the Toulousan manner.

In the portal of the church at Moissac, however, a new impulse is visible in the tradition of the Southwest. For one thing, the scale is enlarged to truly monumental dimensions—almost three times the size of the Porte Miège-ville at Toulouse (*Fig. 82*). The subject is still in the apocalyptic vein popularized by the Beatus illustrations: the Christ of the Second Coming, crowned as was usual in south French portals, surrounded by the Four Symbols and a pair of hulking angels, and adored by the Four-and-twenty Elders of Revelation, holding their vases and viols, and twisting their heads painfully to keep the Lord in view. Filling the lateral edges of the lower portion of the lunette is a twisted ribbon issuing from an animal's mouth and illustrating in its papery flatness the peculiar ironed effect of surface which is visible also in the draperies of the Christ. The lintel is minutely carved with a series of bossed rosettes that seem to be copied from some late antique model. On the *trumeau* (the pillar supporting the lintel at its center) is a strange medley of motifs: the front has three pairs of lions in crossed arrangement; on one side a cross-legged prophet holds a scroll, balanced by St. Paul with a book on the other face. On one jamb of the portal is Peter, clutching his keys; on the other Isaiah. The excited movement of these figures and the tension of the tympanum composition are enhanced by the sharp cusping of the interior edges of the jambs, wherein one may detect an accent borrowed from the Moorish art of Spain.

This portal postdates the Moissac cloister, but not by many years; its strange accentuation of the style is not due to time but to a new infusion of northern energy, issuing from the Burgundian art of Cluny. This is responsible for the purer features of northern Romanesque that now appear: the vigorous thrust of the head from the shoulders, the flying double fold of Christ's tunic, the skeletonlike attenuation of physique. The portal dates in the second decade of the twelfth century, in the period that witnessed the building of the great portal of the abbey church at Cluny. In fact the Apocalyptic vision of Moissac, based on the fourth chapter of the Book of Revelation, seems to follow closely the composition of the Cluny portal, destroyed in the early nineteenth century

but known by some drawings and descriptions of the eighteenth. It too displayed the Lord in Majesty, with the Symbols and angels about him, and the Elders on the lintel beneath.

The Cluniac style, modified in the tympanum by Languedocian features such as the "plate" folds of drapery instead of the fine ridges which cover such surfaces in Burgundian work, is even more evident in the somewhat later sculptures of the side walls supporting the tunnel vault that serves as vestibule to the portal. Here are scenes from the Infancy of Christ (to the right), and at the left, allegories of the two vices chiefly attacked by monastic morality, Unchastity and Avarice. In the frieze above one sees the rich man feasting and the beggar dying at his door, his sores licked very literally by dogs, and an angel hovering above to carry his soul to Abraham's bosom. Abraham in person sits to the left, with the soul in his lap, and a prophet at the end of the frieze points to the prophecy thus fulfilled, inscribed upon his scroll. In the mutilated reliefs below, enclosed in an arcade of two arches, the rich man dies, with a devil taking his moneybag and his weeping wife kneeling beside his bed, while an angel and a demon dispute possession of his soul. The rest of the panels carry out in repulsive figures a rendering both symbolic and literal of the two deadly sins. The Infancy scenes on the other side are more cheerfully envisaged, with a circumstantial relief at the top showing the idols falling in an Egyptian city at the approach of the Holy Family, a scene followed by the Presentation of the Christ child in the Temple. Below, we see the adoring Magi advancing in haste toward a Madonna who sits in bed and eagerly thrusts the Christ child toward them. In the bottom panels are the Annunciation, and the meeting of Mary and Elizabeth, the two pregnant mothers of Jesus and the Baptist (the Visitation), expressing their emotion in Romanesque exaggeration with uplifted and turned-back hands, bent heads, and shaking knees.

The grotesque imaginings of this monastic art, filled with visions of ruthless power and impending doom, infuse a note of cruelty into the animal ornament which mingles with the figured themes. At the abbey church of Souillac, some years subsequent to the Moissac portal, the *trumeau* exhibits a pell-mell of birds and animals, clawing and biting one another and their human victims. A calmer spirit pervades a relief (*c.* 1140) from a former portal, now on the interior wall of the west façade, relating the story of the churchman Theophilus, who sold his soul to the devil for ecclesiastical preferment, and was rescued from the ultimate penalty, with hardly even-handed justice, by the Virgin. Here the Toulousan style persists in the sharply vertical seated figures of an abbot and an Evangelist who flank the scene. The same survival is visible in the prophet Isaiah at Souillac, epitome of the Cluniac phase of

Languedocian Romanesque (*Fig. 87*). His enormous stringy beard and hair, the double lines marking the drapery folds, and the crossed legs of his posture are all within the southern tradition, but one needs merely to compare this figure with that of the angel who locks the gate of Hell in the *Liber Vitae* of Newminster to perceive the affinity with northern style (*Fig. 69*). The pains this sculptor took to reproduce the master monastic art of drawing are incredible. The stone is tortured into undercutting to develop pictorial shadows, and its mass ignored in the careful relief of ridges that merely counterfeit the details of a pen design.

❖ ❖ ❖ ❖ ❖

The Burgundian style, which thus animated the later epoch of Southwestern Romanesque, appears first in the capitals of the ambulatory of the abbey church of Cluny, mother abbey of the Cluniac order. It was Burgundy too whence issued the principal contemporary commentary on the decoration of Romanesque churches, wholly unfavorable. St. Bernard, founder of Clairvaux and apostle of the Cistercian reform that was meant to purify the Cluniac rule, inveighs in his *Apologia* (*c.* 1130) against "this formless decoration and decorative deformity. These dragons, monkeys, centaurs, tigers, and lions affronted or in combat, these soldiers fighting, these hunting scenes, and many-headed monsters, or two of them with one head, are of no use except to distract the eye, trouble attention, and disturb contemplation—Proh Deo! If we are not ashamed of such foolishness do we not even regret its expense?" But however much the puritanism of Bernard may have affected Cistercian practice later, it certainly had not hindered the continuation of monastic art in the early monasteries of this persuasion. In 1109, Stephen Harding the Englishman, third abbot of Cîteaux and the promulgator of the constitution of the order, finished his four-volume Bible, now in the library at Dijon (No. 12–15), which was richly decorated with ornament that includes many of the objects of Bernard's tirade. But what is principally remarkable in the miniatures of this Bible is the strong influence upon them of English drawing.

The English style thus introduced to Burgundy was doubtless of indirect derivation, coming rather from the ateliers of the Low Countries and northern France, and analogies for the style of the Cluny capitals have been noticed in miniatures and ivories of Liége, Stavelot, and Saint-Omer, or the famous baptismal font of S. Barthélemy at Liége, dated in 1107–1108. Hézelon, one of the architects of Cluny, had been a canon of Saint-Lambert at Liége. The capitals of the ambulatory at Cluny must have been finished when the choir of the abbey church was consecrated in 1095. Of these the ones display-

ing personifications of the tones of the plain song are the most striking, both as indicative of the cult of music so active at Cluny, and as illustrating the genesis of the Burgundian sculptural style. The figures have the slender bodies with too large heads of northern Romanesque, postures deliberately off balance, and clinging draperies already beginning to show the multiplication of ridged folds that become later the Burgundian characteristic. The heads are rectangular and oblong, with a high-placed, drilled eye.

The style is at its best in the portal sculpture of the narthex of Vézelay, the great abbey dedicated to the Magdalen, whose relics made it a focus of pilgrimage (*Fig. 85*). The huge Christ, enthroned amid the clouds of Heaven and dominating this tympanum, is the radiating center of the Holy Ghost, which emanates from his hands in rays descending upon the Apostles of the Pentecost. The scene is aquiver with emotion, as if swept by the Pentecostal wind recorded in Acts; each figure and even that of the Lord himself is distorted by the blast of inspiration, literally evident in the swirling folds and ridges of drapery. Through one of the outer archivolts runs a calendar of monthly occupations and the Signs of the Zodiac, but the strange scenes of the inner archivolt are of difficult interpretation, as also the frieze of the lintel. The eight compartments of the archivolt may be meant to represent the peoples among whom the inspired apostles preach and perform miracles, and the dog-headed persons in the upper left compartment may be the *cynocephali* of India, known to mediaeval fable. The curious procession of the lintel, enigmatic in spite of its arresting detail (such as the man mounting a horse on a ladder!), is at least evidence for the irrationality of an art that could so obscure its themes. Mâle [27] has interpreted the frieze as containing the catalogue of distant peoples; the creatures with huge ears would be the Panotii of South Russia; the procession at the left, received by a priest, the pagans who had not yet heard the Gospel. Symbolic of the apostolic preachers are the figures, in larger scale, of Peter and Paul, embracing one another in the right center of the frieze. On the lintel pillar is the Baptist holding an aureole that once enclosed the Lamb, now destroyed; the lateral faces of the *trumeau* have figures of apostles, pairs of whom also, in an ardor of disputation, occupy the jambs.

The portal of Vézelay dates in the first third of the twelfth century. It was followed by the famous *Last Judgment* of S. Lazare at Autun, covered over with bricks and plaster in the middle of the eighteenth century and thus saved from the iconoclasm of the Revolution. This is a scene that deserves comparison with the Last Judgments of Byzantine art, in its immediate vision of

[27] Mâle, *op. cit.*, pp. 330 ff.

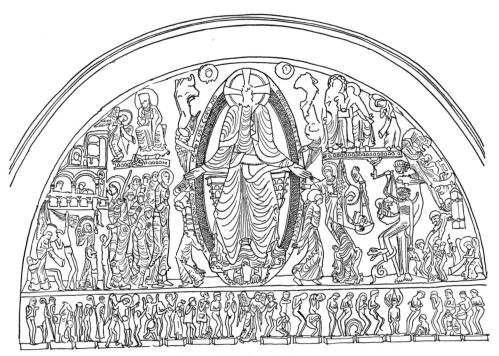

AUTUN: *The Last Judgment*

Doomsday, so different from the dogmatic abstraction which the subject maintained in the frescoes and mosaics of the eastern Church. The sculptor Gislebertus who signed the work left no doubt of its purpose in his inscription: *terreat hic terror quos terreus alligat error,* "let this horror appall those bound by earthly sin." The great Christ of the center spreads his hands to show his wounds, but does not yet bare his side as in Gothic Last Judgments. Mary and John, the intercessors, are a timid pair in the upper register, seeming to shrink from the trumpeting angel beside them. St. Peter below, with a huge key, marshals the little souls toward the Heavenly City, through whose battlements an angel "boosts" one of the Blest, while another clings to him, frightened by the trumpet blast. To the right St. Michael weighs the soul, with a devil striving to pull down his side of the balance, while another demon, grimacing with delight, thrusts the Damned into the flaming mouth of Hell. A devil reaches forth from a monster's mouth and grasps a group of shuddering sinners; infernal hands even grope for the dead that rise from their tombs on the lintel below. Thus was the *Dies Irae* translated into physical experience.

The capitals of Vézelay and Autun adapt the vigorous style to the difficult capital block with extraordinary skill. Beginning at Vézelay with a type that

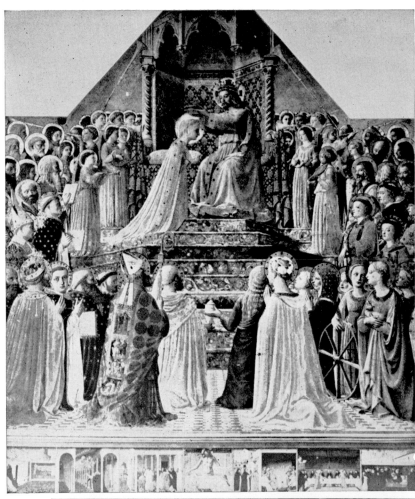

152. PARIS, LOUVRE: *Coronation of the Virgin* by Fra Angelico

153. FLORENCE, ACADEMY: *Coronation of the Virgin* by Fra Filippo Lippi

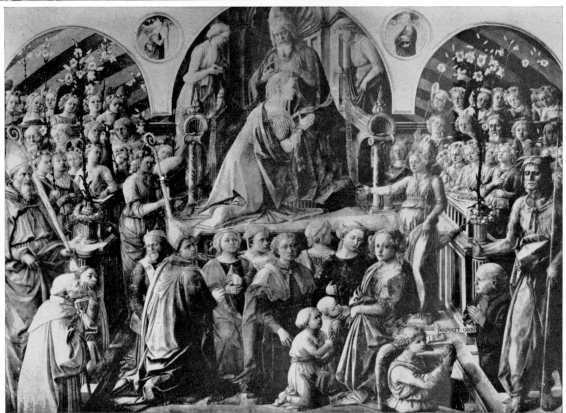

149. FLORENCE, S. MARIA NOVELLA, THE GREEN CLOISTER: Uccello's fresco of the *Deluge;* detail

151. FLORENCE, CARMINE, BRANCACCI CHAPEL: Fresco by Masaccio; *Expulsion from Eden*

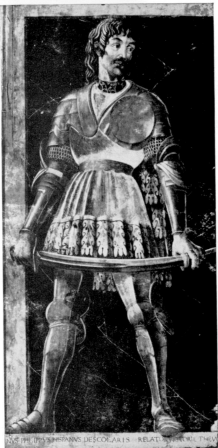

150. FLORENCE, S. APOLLONIA, FRESCO: Portrait of Pippo Spano by Andrea del Castagno

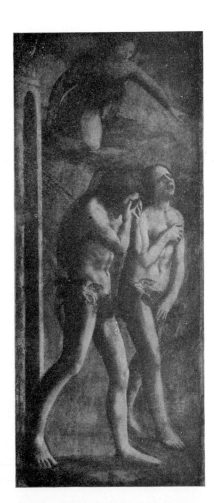

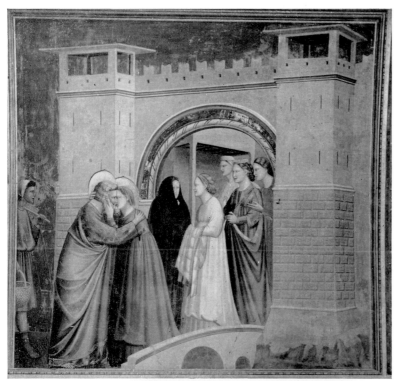

146. PADUA, ARENA CHAPEL: Fresco by Giotto; Joachim and Anna meet at the Golden Gate.

148. FLORENCE, S. MARIA NOVELLA, STROZZI CHAPEL: Orcagna's fresco of the *Last Judgment;* the Virgin Mary

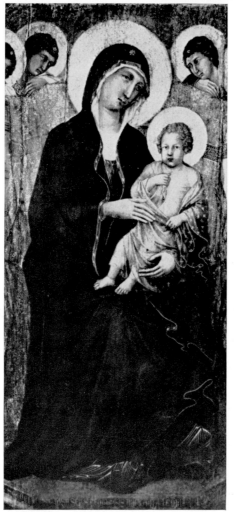

147. SIENA, CATHEDRAL MUSEUM: The Madonna; detail of Duccio's altarpiece

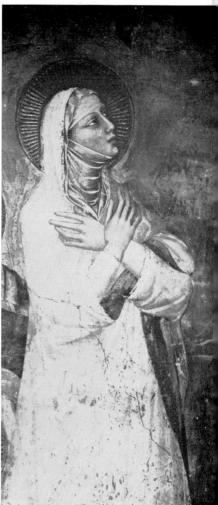

144. ORVIETO, CATHEDRAL: Detail of the Genesis pier; the *Creation of Woman*

145. FLORENCE, UFFIZI GALLERY: *Annunciation* by Simone Martini

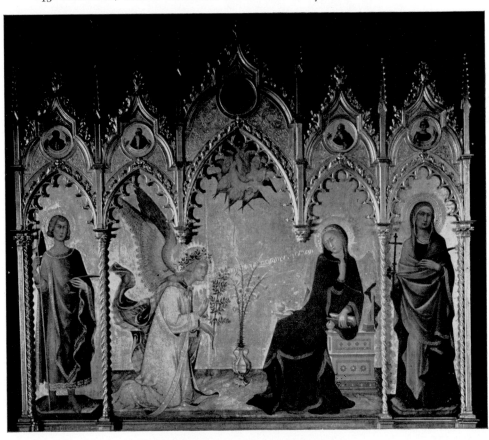

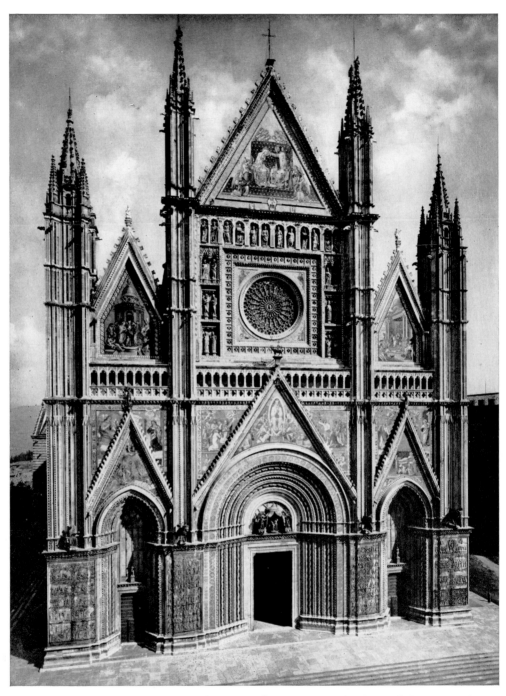

143. ORVIETO, CATHEDRAL: The four piers are carved with reliefs illustrating Genesis, the Prophets, the Life of Christ, and the Last Judgment. A detail of Genesis is reproduced in Fig. 144.

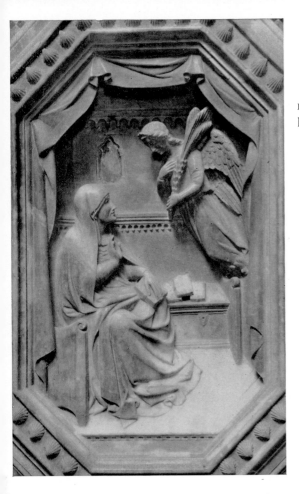

141. FLORENCE, OR SAN MICHELE, TAB-
ERNACLE: The Angel announces her ap-
proaching death to the Virgin

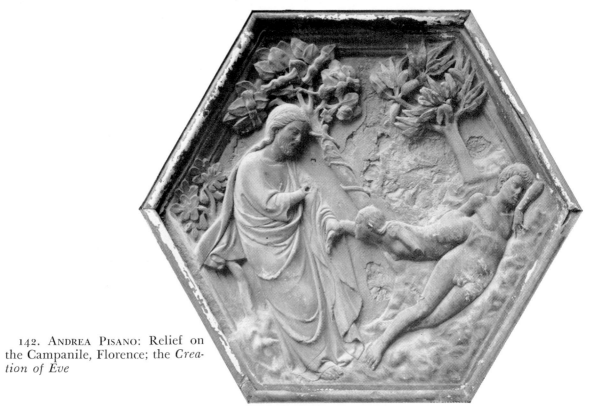

142. ANDREA PISANO: Relief on
the Campanile, Florence; the *Crea-
tion of Eve*

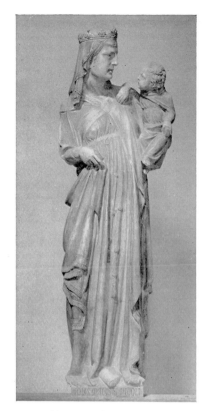

138. PISTOJA, S. ANDREA, PULPIT
OF GIOVANNI PISANO: A Sibyl

139. PADUA, ARENA CHAPEL:
Madonna of Giovanni Pisano

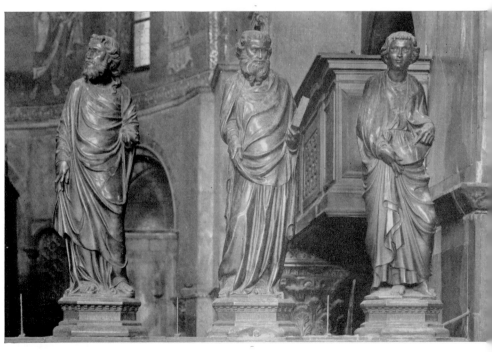

140. JACOBELLO AND PIER PAOLO DELLE MASSEGNE: Apostles on the Choir screen of
St. Mark's, Venice

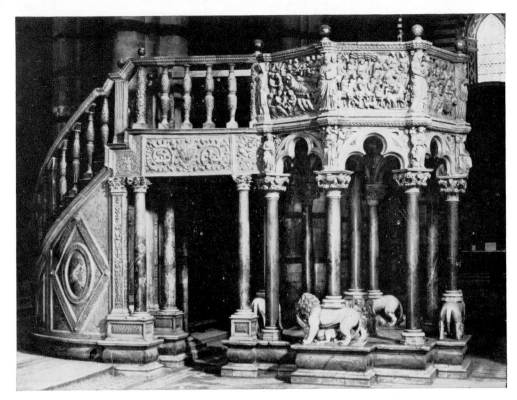

136. SIENA, CATHEDRAL: Pulpit of Nicola Pisano

37. PISTOJA, S. ANDREA, PULPIT OF GIOVANNI PISANO: *Annunciation and Nativity*

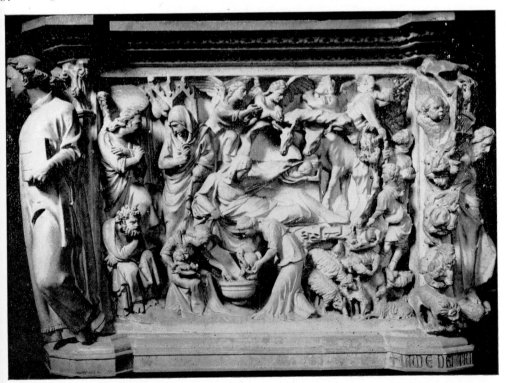

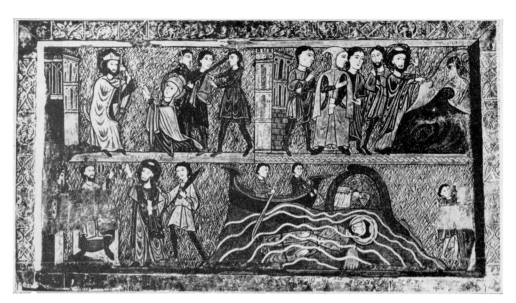

134. BARCELONA, PLANDIURA COLLECTION, ALTAR FRONTAL: The *Story of St. Clement*

135. PISA, BAPTISTERY, PULPIT OF NICOLA PISANO: The *Presentation of the Christ Child in the Temple*

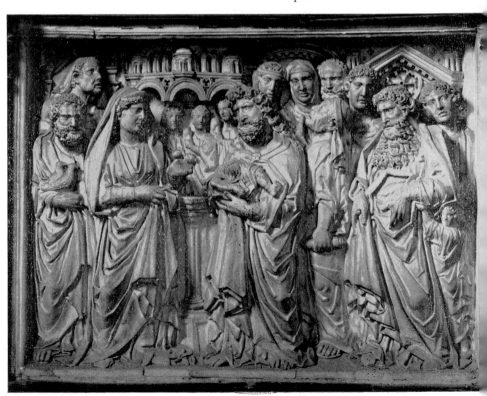

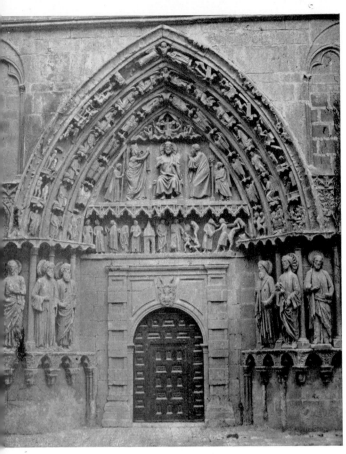

132. BURGOS, CATHEDRAL, NORTH TRAN-
SEPT: Last Judgment

133. BURGOS, CATHEDRAL: Pillar relief
in the Cloister; the *Adoration of the
Magi*

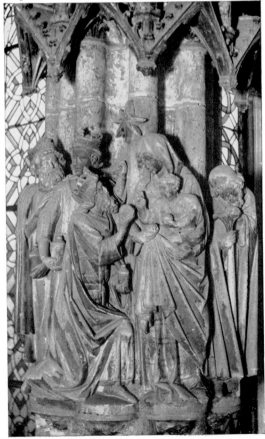

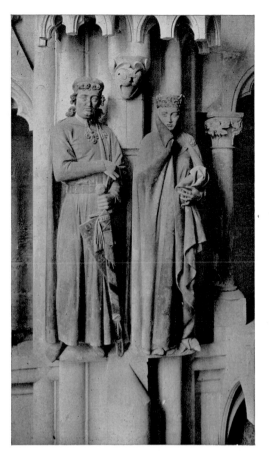

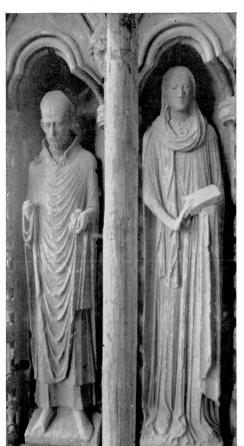

130. WELLS
THEDRAL: S
on a North Bu

129. NAUMBURG, CATHEDRAL: The Mar-
grave Ekkehard and the Margravine Uta

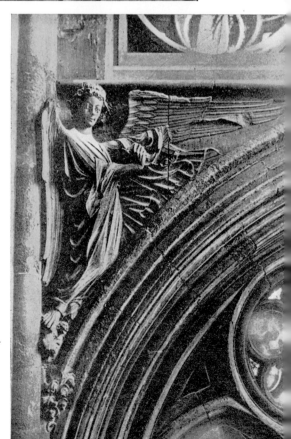

131. LONDON, WESTMINSTER ABBEY: An-
gel on the Triforium Gallery

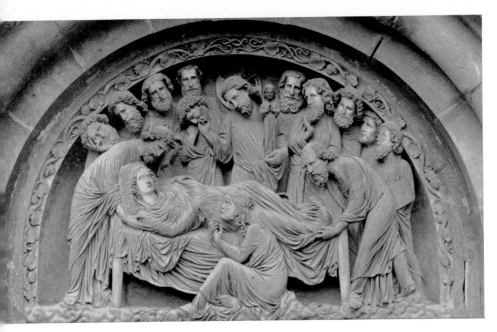

127. STRASSBURG, CATHEDRAL, SOUTH TRANSEPT: The *Death of the Virgin*

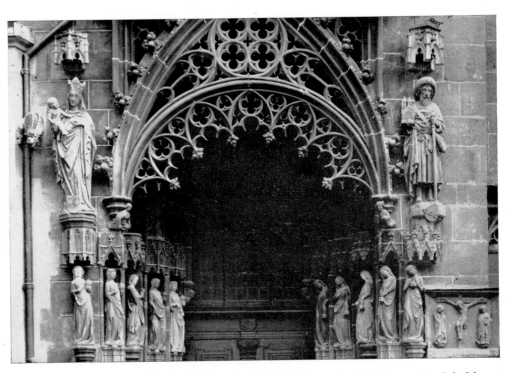

128. NÜRNBERG, SEBALDUS-CHURCH: the Bride's Door; the Madonna, St. Sebald, the Wise and Foolish Virgins

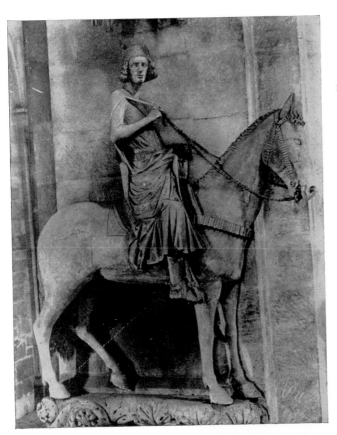

124. BAMBERG, CATHEDRAL, EAST CHOIR:
The Royal Knight

125. STRASSBURG, CA-
THEDRAL, SOUTH TRAN-
SEPT: The Synagogue

126. STRASSBURG, CATHE-
DRAL, WEST FRONT: a Foolis
Virgin

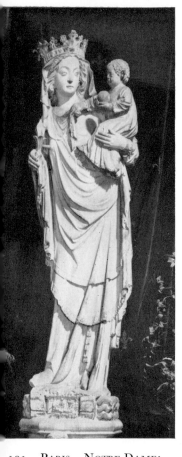

121. Paris, Notre-Dame:
The Madonna in the Choir

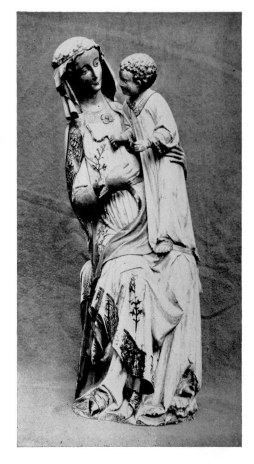

122. Paris, Louvre: Ivory
statuette of the Madonna

123. Bamberg, Cathedral: The
Adam portal; St. Stephen, Kunigunde,
Henry II, St. Peter, Adam and Eve

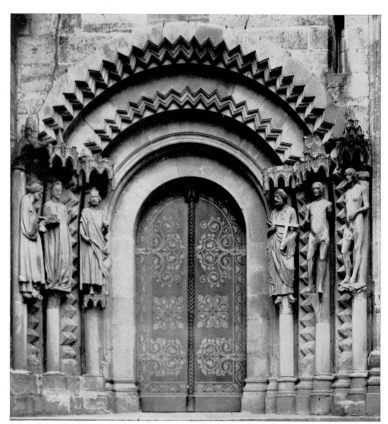

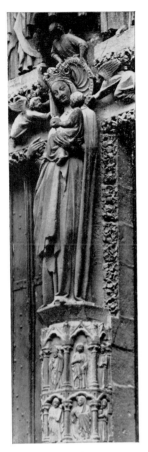

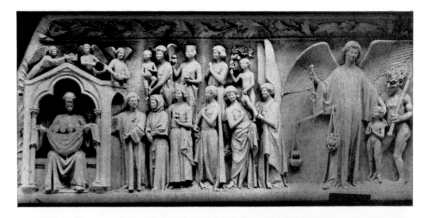

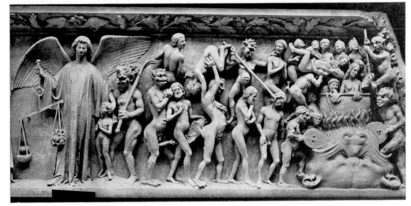

118. BOURGES, CATHEDRAL, WEST FRONT: Details of the Judgment Portal

117. AMIENS, CATHEDRAL, SOUTH TRANSEPT: the "Golden Virgin"

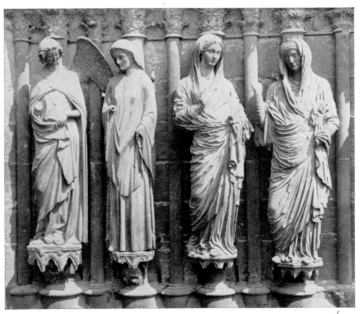

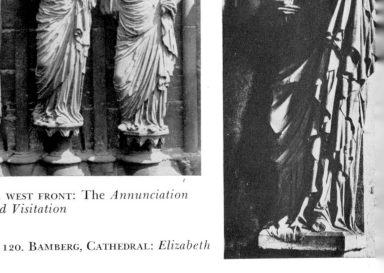

119. REIMS, CATHEDRAL, WEST FRONT: The *Annunciation and Visitation*

120. BAMBERG, CATHEDRAL: *Elizabeth*

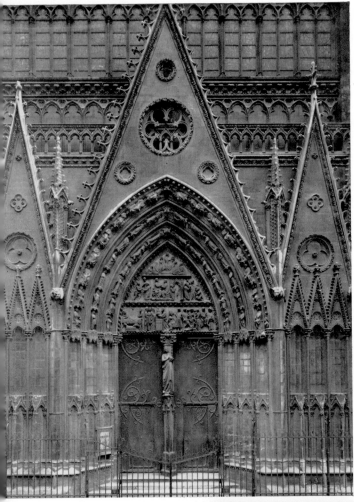

116. PARIS, NOTRE-DAME: Madonna of the North Transept Portal

114. AMIENS, CATHEDRAL, WEST FRONT: The Zodiac Sign of the twins, and the Month of May

combines figure sculpture with a luxuriant foliate ornament reminiscent of Winchester leaf work, they develop extraordinary virtuosity in scenes from the Old Testament and the lives of the saints at Vézelay, and the Life of Christ at Autun. The figured capital is indeed a principal product of Romanesque art, having its prototype in the introduction of human and animal forms on capitals of late antiquity, which never however developed the motif to the Romanesque extent. The school best represented by its capitals is that of Auvergne in the center of France, a region singularly conservative of antique tradition, and inventive in Romanesque forms of architecture, but timid in sculpture on a large scale, examples of which in Auvergne are usually of late date in the twelfth century or derivative from the style of Languedoc. The capital here illustrated from Notre-Dame du Port at Clermont, dating in the mid-twelfth century, is a good example of the ability of these Auvergnat carvers to retain the solidity and volume of antique style, as well as a measure of classic regularity in the features, contrasting with the racial physiognomy which was exaggerated into the brutal masks of Moissac and Souillac. This capital from Clermont (*Fig. 86*) represents the angel's reassurance of Joseph as to the virginity of Mary—a reassurance underlined by a vigorous grasp of Joseph's beard. To the right is the angel who announces to Zacharias the coming birth of the Baptist. The scrolls contain the texts of Matthew and Luke that identify the scenes, and on the one to the left is added the signature of the sculptor.

Auvergne portals of pure type can usually be identified by a restricted use of sculpture and by a "pentagonal" lintel, the pentagon being a frame surrounding the lintel, with two short vertical sides supporting a gabled top. Another local peculiarity serves to classify the Romanesque sculpture of the west of France, in Saintonge and Poitou, where the tympanum is habitually omitted, leaving the charge of sculptured decoration to the archivolt alone. This is in harmony with a prevailing tendency in the West to keep the sculpture at the service of the architectural surface and silhouette. In Saintonge for example the voussoirs of an arch are separately carved with a motif limited to the block (*Fig. 88*). In such a system iconographic schemes were difficult to compose, and there is a dearth of Biblical subjects, while decorative patterns and animal and floral motifs fill the gap left by the infrequency of figured scenes. The façades are screens, with a characteristic arcading in two or three stories, modified (in the Poitevin type especially) by engaged columns, single or in clusters, rising to the cornice. In the transept portal of Aulnay here reproduced, the first order of the archivolt contains a rich rinceau enclosing human-headed lions and griffins, the second a series of figures whose cross-legged pose, "plate" drapery, and verticality are diminutions of Toulousan

style. The voussoirs of the third order being thirty-one, the Elders of the Apocalypse that occupy them are consequently of that number instead of four-and-twenty. The final order contains the richest assemblage of fantastic animal and human forms that mediaeval art can show—the sort of decoration abhorred by St. Bernard: birds and animals with human heads, from which on occasion another bird's head may emerge, centaurs, griffins and the like—all erect on two legs to fit the narrow surface of the voussoir on which each is carved. The west portal of the church contains a scheme of iconography typical of Saintonge-Poitou: a choir of angels supporting a medallion containing the Lamb; the Virtues trampling the Vices in illustration of Prudentius's poem (the *Psychomachia* or Battle of the Soul) and the Labors of the Months with the zodiacal signs. The portal dates in the middle of the twelfth century, and later than that of the transept, showing its period by introducing the long slender Languedocian figures, which forced abandonment of the voussoir motif normal to the arch, and spread the forms over several blocks.

❖ ❖ ❖ ❖ ❖

The schools of Burgundy and Languedoc were the creative centers of the French Romanesque, as is evident from the abundant borrowing from them in the ateliers of Auvergne and the West. The last of the French schools, that of Provence, is indebted not only to Languedoc, but to the Lombard sculpture of Italy, and even to the proto-Gothic art of Île-de-France. The earlier work in Provence manifests a curious contrast between the intelligent assimilation of the antique in architectural features and ornament, and a very primitive style of figure relief. The two great ensembles of Provençal Romanesque, the church of Saint-Gilles near the mouth of the Rhone, and Saint-Trophime at Arles (*Fig. 89*), belong in the latter half of the twelfth century, and resume, as it were, the accomplishment of Romanesque style to that date, besides showing in their orderly organization of the architecture and sculpture of the façade a spirit of *a priori* design that is foreign to the eccentric genius of Romanesque.

The architectural forms are Roman—engaged columns with correct Corinthian capitals, entablatures *en ressaut*, moldings of classic design. The Roman frieze is even imitated in the Life of Christ that runs across the entablature at Saint-Gilles, centering in the Last Supper over the main portal. Roman too is the luxuriant acanthus border below it, but the scrolls are of the weedy type employed by Lombard sculpture, from which these sculptors of Provence borrowed also their lion pedestals. On the other hand the twelve apostles whose figures flank the principal portal, classic enough in their fluted folds of dra-

pery, and Lombard in their heavy forms, occasionally display the cross-legged posture of Languedoc. One of them, St. Bartholomew, is signed by the sculptor: *Brunus.* The tympanum of the main portal is modern; in those of the lateral doors are an Adoration of the Magi and a Crucifixion with many affinities to the Antelami style. The frieze is continued on the lintels of these portals with the Entry into Jerusalem and the Holy Women at the Sepulcher, the latter including a motif characteristic of the school—the women purchasing their perfumes with which to anoint the dead body of Christ.

A general terminus for this style at Saint-Gilles and Saint-Trophime is given by the inscription on a pillar of the cloister attached to the latter church—1180. This pillar is carved with reliefs of the Resurrection and the Holy Women at the Sepulcher, and the three figures of SS. Peter, John, and Trophimus, the last being the finest creation of Provençal Romanesque, and the most typical as well, both in the local character evinced in the strong modeling of the face and the fluted drapery with its "lamp-shade" skirt falling to the knee, and in the motifs borrowed from Languedoc and Lombardy. To the former is due the device of carving the figure out of the angle of the pillar; to the latter (or Île-de-France) the "accordion pleating" (p. 220) of St. Trophimus's sleeve. The portal of the church (*Fig. 89*) is a pseudoclassic conception, combining its Lombard arch with a Roman gable on modillions, and arranging its sculpture in the same scheme of a Latin frieze above figures in niches defined by engaged columns, as at Saint-Gilles. These figures have the stolid monumentality of Antelami work at Borgo S. Donnino, and the columns rest on animal pedestals. The frieze displays on one side a procession of the Blest, and on the other the Damned led by a devil to perdition like a chain gang. But the central lintel is occupied by the seated apostles as on the portals of Île-de-France, and the influence of the proto-Gothic school is further evident in the theme of the tympanum: Christ amid the four Evangelistic beasts, adored by a throng of angels in half figure on the archivolt. The one local feature retained in this composition is the crown the Saviour wears.

A similarly eclectic sculpture supplanted the early Romanesque of Spain during the later years of the twelfth century. The façade of S. María la Real at Sangüesa in Navarre (*Fig. 90*) repeats the arcaded screen of the churches in the

SAINT-TROPHIME: *Relief in the Cloister*

west of France and fills the spandrels of its portal with a miscellaneous decoration that is local in its *horror vacui,* but has already adopted the pointed arch of Gothic and its heavily carved archivolt, while the colonnette figures in the jambs are borrowings from the west front of Chartres. Even at Santiago de Compostela the main portal of the church, constructed and signed by "Master Matthew" in 1183,[28] betrays its debt to French proto-Gothic, though with flashes of poetic originality which ranks its creator Matheus among the foremost of mediaeval artists (p. 306). Instead of Christ, St. James is on the *trumeau,* and the figures that occupy the colonnettes of the three portals in the manner of Île-de-France have nevertheless a vigorous movement and lively expression that is absent from the reticent statues of the French portals. In the tympanum of the central door Christ is enthroned in the Judgment, whose details are spread over the lateral arches.

In England, the Norman conquest brought in the real beginning of English mediaeval architecture, but no more impulse toward a native sculptural style than can be found on the meagerly decorated Romanesque churches of Normandy itself. The sculptured ornament of early Norman buildings in England has more in common with the Viking art of Scandinavia than with Romanesque, as one might expect from a race representing the final Teutonic intrusion into Latin culture. The favorite subject of St. Michael conquering his dragon is an obvious Christian translation of the Norse sagas of dragon killers. According to Prior and Gardner [29] the beasts in the tympanum of Dinton church (Buckinghamshire; early twelfth century) (*Fig. 92*) are "the souls of the righteous vigorously battening upon the Tree of Life (the world-ash of the Sagas)," and at any rate are belated survivals from the "Viking" period of Norse ornament. Northern mythology is Christianized on the lintel by confronting the Scandinavian dragon with a diminutive St. Michael. The two panels representing the story of the Raising of Lazarus that are walled into the south aisle of the choir of Chichester cathedral have been dated by English mediaevalists *c.* 1000, but their style is too developed to be ascribed to a Saxon school otherwise undocumented, and too much indebted to Hispano-French work of the late eleventh or twelfth century to be of native invention. The insular quality of these ill-proportioned, inhibited figures is their expressiveness, attained simply enough by drilling the pupil and tilting the eyebrow, but nevertheless effective. The analogy that comes to mind is the much more sophisticated but essentially similar conception of the reliefs in the cloister of S. Domingo de Silos.

28 E. H. Buschbeck, *Der Pórtico de la Gloria von Santiago de Compostela,* Berlin 1919.

29 E. S. Prior and A. Gardner, *An Account of Mediaeval Figure-Sculpture in England,* Cambridge, England 1912, p. 154.

Monumental Romanesque in England really begins with the Plantagenet accession and English domination of the south and west of France. The west door of Rochester (*Fig. 91*) shows the same mingling of styles as the later twelfth-century portals of Spain; its arcaded façade and the separate carving of the voussoirs of the arch are features of Saintonge and Poitou, while the influence of Chartres is visible in the two colonnette-figures of the jambs, probably later than the south French composition of the tympanum, which exhibits Christ in a mandorla flanked by angels (as at Moissac) and the Four Beasts. The portal is fairly typical of English sculpture in the twelfth century, whose best examples followed the style imported from the French possessions of Henry II and Eleanor of Aquitaine.

❖ ❖ ❖ ❖ ❖

Monumental painting outside of Italy does not afford the documentation of the Romanesque evolution which is furnished by miniatures of manuscripts and sculpture in ivory and stone. Wall painting was too readily renewed, and most of our Romanesque frescoes in France, Spain, and Germany do not antedate the great activity in church decoration which characterized the twelfth century. In Spain a primitive Romanesque style informs the Wise and Foolish Virgins on the apse wall of San Quirce de Pedret near Barcelona, a series of identical heads on unarticulated bodies, with drapery folds marked by double lines and clinging tightly to the legs. They are dated by Kuhn [30] in the eleventh century. On the cheeks of these maidens is the characteristic spot of Latin mediaeval painting, seen in the frescoes of S. Angelo in Formis (p. 132) and indicating, along with the personification of the Church (labeled ECREXIA and seated on a basilica) a south Italian influence on these frescoes, this concept of *Ecclesia* being frequent in the iconography of lower Italy. But in the churches of Tahull in Catalonia, S. Clemente and S. Maria, the apsidal compositions seem already determined by the sculptured portals of Île-de-France, and the solemn frontal Virgin in the sanctuary of the latter church repeats the formula of the Madonna on the west front of Chartres. The consecration date for both churches is 1123. The sculptural style of Spain and Languedoc is more obvious in the apses of S. Miguel at Seo de Urgel, now removed to the Barcelona Museum, where "plate" folds in concentric curves, and the curious flying fold of Christ's tunic at Moissac, are duly reproduced in fresco. These Catalan painters became soon aware of the expressive possibilities that painting could add to the linear and plastic vocabulary of sculpture, and in their frescoes and altar frontals and canopies one begins for the first time to become conscious

[30] C. L. Kuhn, *Romanesque Mural Painting of Catalonia*, Cambridge, Mass. 1930.

of the Spanish mediaeval spirit—a fierce and belligerent piety born of a faith that throughout the Middle Ages, by reason of its proximity to Moorish Mohammedanism, was a crusade. To this one may ascribe the piercing stare of emaciated faces, the minatory effect of gestures, the harsh contrasts of parti-colored backgrounds, and the powerful accentuation which the very *gaucherie* of the figures contributed to their expression. Superficially the mode is Byzantine, in hieratic arrangement, vertical isolation of the personages, fixation of attention by frontal stare; but the content here is a positive, not contemplative mysticism, poignantly experienced. In the best example of Catalan painting in this country, the apse of S. Maria de Mur in the Museum of Fine Arts at Boston, an obvious imitation so far as composition is concerned of the central west portal of Chartres, something of the urbanity of proto-Gothic has modified the style, adding an equilibrium that does not impair its force.

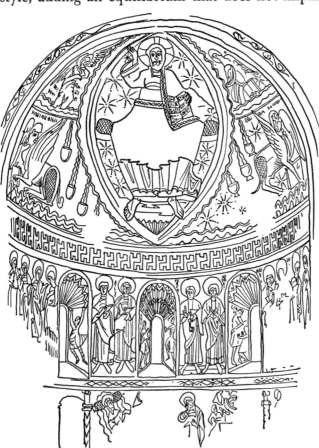

S. Maria de Mur, Fresco: *Christ in Glory and the Apostles*

North of the Pyrenees, remains of mural painting are less plentiful. Save for the Swiss murals of Münster and Mals, and the frescoes of Auxerre and Aachen (p. 207), the Carolingian wall paintings have disappeared, leaving only the descriptions of what once were the decorations of the ninth-century abbeys of St. Martin at Tours, Saint-Riquier, Saint-Wandrille, the cathedrals of Reims and Auxerre, and Louis the Pious's palace at Ingelheim. The Ottonian style known to us from the miniatures and ivories of Reichenau is continued in frescoes whose remains, of the tenth and eleventh centuries, are still on the walls of churches at Oberzell and Niederzell on the isle of Reichenau itself,

at Burgfelden, and at Goldbach, exhibiting the characteristic mingling in Reichenau art of Byzantine influence with the Carolingian inheritance from Reims. In France the Romanesque murals are only now becoming well known and adequately studied.[31] The best-preserved examples are found in the west of France, and the earliest of these is the cycle of frescoes decorating the Poitevin church of S. Savin-sur-Gartempe, of doubtful date, but probably executed in the first half of the twelfth century. The frescoes here are in four groups, lo-

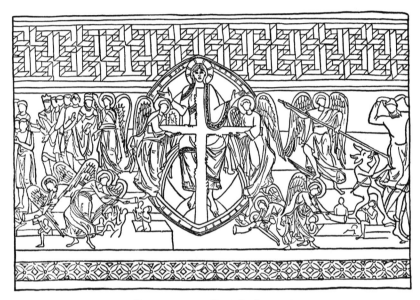

BURGFELDEN: *Last Judgment*

cated respectively in the nave, the porch, the gallery above it, and in the crypt. The paintings on the barrel-vaulted ceiling of the nave are probably the oldest, depicting in four zones the Old Testament history from Creation through Exodus. The painters of this series have absorbed far more than the sculptors of their school the emotional force of south French Romanesque, whose formulae became in their hands tremendously expressive—crossed legs, and tight drapery in overlapping folds, binding the knees and fanning out to enliven movement, or swirling in curves that somehow justify in an artistic sense the exaggerated gestures. The Apocalyptic scenes of the porch are alive with a rolling pattern of action both decorative and dramatic, yet the same artist or the same atelier was capable of the monumental dignity of the saints and apostles of the gallery.

The frescoes of Vic-sur-Saint-Chartier (Indre) embody Languedocian style in a balder aspect, accentuating its heavy overlapping "plate" folds in the

31 H. Focillon, *Peintures romanes des églises de France*, Paris 1938.

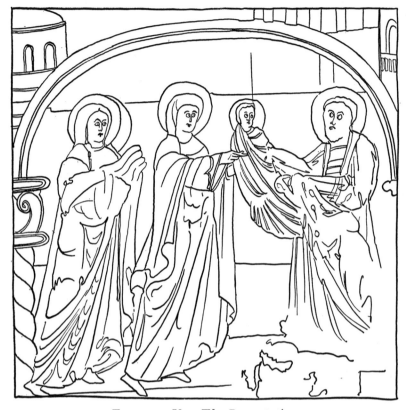

FRESCO AT VIC: *The Presentation*

drapery, and hardening the drawing. The prominent spots on the cheeks and the
rotundity of the faces, together with the exotic design of the birds and animals
in the ornamental borders, suggest a connection with Spain. The fluency of
Saint-Savin is absent here; the frescoes of Vic are no less expressive, but un-
sophisticated and brusque; Mary in the Presentation all but throws the Child
at the high priest Simeon. The same is true of the lively figures animating the
groin vaults and east wall of the crypt of St. Nicholas at Tavant (Indre-et-
Loire), once a priory of the abbey of Marmoutier at Tours. Here the painters
use a favorite motif of Romanesque sculptors in the west of France (p. 240)—
the Psychomachia or Battle of the Soul—in its early form with the Virtues as
armed knights victorious over the Vices. The faces owe their eerie effect to
the superficial technique of these southern frescoes, which were painted on
a thin bed; the pupils of the eyes, added after the quick drying of the plaster,
dropped off in time, leaving a blank and blinded facial effect that is a preva-
lent feature of Romanesque paintings in the southwest of France.

The colors of these frescoes are mat, and convey a general tone of reddish

brown. Blue is rare; the usual Romanesque preference for a gamut of yellow, green, and red is very generally observed. It is interesting to note that this palette coincides to a degree with the prescriptions for fresco painting contained in the *Schedula Diversarum Artium* of Theophilus, a guide to mediaeval technique variously dated from the tenth to twelfth century. Theophilus candidly confesses his debt to "Greece," and his recipe for shadow enjoins a green tone that might be said to be a favorite practice of Byzantine painting. The influence of the latter is actually evident in the few surviving frescoes of Burgundy and the center of France which were inspired by the art of Cluny. The best example thereof is preserved in the decoration of the upper chapel of Berzé-la-Ville, a priory of Cluny. This Cluniac painting is of quite different technique and style from that of Poitou, Touraine, and Berry, showing its Byzantine schooling in more careful preparation (up to six layers) of the plaster to be painted, a richer palette with tones obtained by superposition, real modeling of forms, and especially a gamut of bright color contrasting markedly with the duller hues of the Southwest. The Christ in glory, and apostles and saints at Berzé-la-Ville are curious translations of Byzantine heads and figures, and even show some knowledge of Greek formulae of drapery, but where action is depicted as in the martyrdoms of SS. Lawrence and Blasius, the garments cling in true Romanesque fashion and the movement is no less sharp and angular than in the reliefs of Vézelay and Autun.

The dependence on Byzantine tutelage acknowledged by Theophilus and

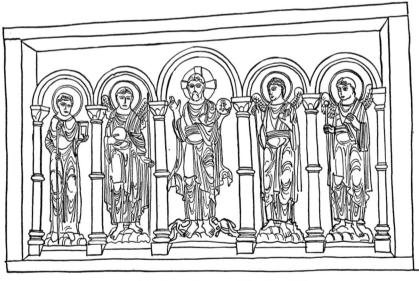

PARIS, MUSÉE DE CLUNY: *The Basel Altar*

[247]

evinced by the Cluniac school of Romanesque painting is, of course, more evident in the difficult techniques of Romanesque metalwork. Indeed the most splendid example thereof we have, the golden altar frontal in the Cluny Museum at Paris that once adorned the high altar of the cathedral of Basel in Switzerland, actually uses a Greek word in its inscription entitling the figure of Christ: *Prospice terrigenas clemens mediator usias* (οὐσίας—"of the divine substance"), and its ornament is largely the arabesque of "Sassanian palmettes" (here enclosing beasts and birds), which was the customary filling of the chapter headings in mid-Byzantine manuscripts. So too the repoussé figures of Christ, three archangels, and St. Benedict, standing within an arcade on this antependium, have the hieratic rigidity of Byzantine work. But they betray their Romanesque conception by clinging and fluttering drapery and the convolutions of the mountain tops on which they stand, designed in the rolling pattern which was the Ottonian convention for the calligraphic landscapes of the Carolingian school of Reims. The tiny kneeling figures at Christ's feet are the emperor Henry II (1002–1024) and his queen Kunigunde, and the altar seems to be an ex-voto of Henry's made in gratitude for his recovery from an illness at St. Benedict's monastery of Monte Cassino, thus accounting for the saint's presence among the five holy figures represented on its front.

The most obvious imitation of Byzantine technique is found in the Romanesque translation of the Byzantine enamelwork in cloisonné. The western enamelers at first attempted the difficult process of cloisonné, but toward the end of the eleventh century the leading schools, located on the banks of the Rhine and Meuse and in the south of France at Limoges, began the development of the characteristic Romanesque enamelwork in *champlevé*, whereby the hollows into which the enamel was to enter are cut out of the metal ground instead of being built up by the flat wire inserted edgewise into the incised design (p. 123). The most prolific of these schools was that of Limoges, whose earliest important dated work is the tomb plaque in S. Julien at Le Mans, of Geoffrey Plantagenet, count of Anjou and Maine, who died in 1151. The count is represented on this slab in the full panoply of a knight, and his head is done in flat enamel, instead of being separately cast in relief and riveted on, as in later works of Limoges. In the late twelfth and early thirteenth century this characteristic feature was extended to whole figures, as on the book cover here reproduced (*Fig. 93*). The date of it may be surmised from its imitation of the Île-de-France proto-Gothic *Majestas,* with the Christ enthroned on the arc of Heaven and surrounded by the Four Beasts (*Fig. 104*); its south French provenance from the symbolic Alpha and Omega, favorite accompaniments of Christ in the Romanesque art of Aquitaine and Spain, and from the crown

the Saviour wears. The iconography of Limoges enamels is not however local for the most part. Articles of export, they reveal their international market by the subjects chosen, and by their widespread imitation; a whole class of Limoges caskets displays the assassination of St. Thomas of Canterbury as the principal theme, and one of the largest enameled plaques in existence is an Italo-Byzantine imitation of Limoges work in S. Nicola at Bari, representing the Saint crowning King Roger of Sicily.

❖ ❖ ❖ ❖ ❖

The Romanesque presents a varied aspect, ranging from the almost pure barbarian art of Norman portals to the approximation of the antique in the "renaissance" of Frederick II. But between these extremes of lingering Teutonism in the north and Italian nostalgia for the classic, the essential genius of the style is clearly visible, descending from the Carolingian school of Reims. There first the barbarian spirit was expressed in figured scenes, after its ornamental embodiment in Celtic illumination. The illustrations of the Utrecht Psalter apply the principle of eccentric and dynamic composition to the rendering of human action, and thereby initiate the realistic mode in European art. To its draftsmen the themes of Psalms were no mere narratives to be objectively retailed with allegorical accompaniment as in the Alexandrian miniatures of the Paris Psalter, nor profoundly typical of dogma as they were regarded by the painters of the marginal miniatures in the "monastic" psalters of Byzantine art. They were dramatic incidents, fraught with a feeling shared by the artist himself.

The style of Reims, disciplined by the eclectic taste of the craftsmen of Saint-Denis, passed on to North France and Belgium, and across the Channel to England, to supplant in the last case the Anglo-Celtic tradition of insular art and evolve a revival of Reims vivacity in the outline drawings of Anglo-Saxon manuscripts. From these and their counterparts produced by French and Flemish ateliers, the spirit of Reims was transferred to the revival of monumental sculpture in Burgundy under the leadership of Cluny, and through the infiltration of this northern style into the south arose the parallel impulse toward plastic expression in southwestern France and Spain. From the extension of Cluny's influence to the south, and the part played by the pilgrimage road to Compostela, came the powerful union of Burgundian and Languedocian styles in the sculpture of Moissac and Souillac.

Eastward the Carolingian realism encountered the restraining influence of Byzantine models cherished by the Ottonian renaissance and its leading school of Reichenau. It found a native continuation in the Saxon art of bronze

casting, but in Ottonian miniatures, frescoes, and ivories, its exuberance was disciplined by Byzantine decorum, its expression transferred from twisted bodies and wide-flung arms to facial emphasis, its fluttering drapery confined to a closed contour or a metallic rigidity of folds. Within these limits, the Romanesque quest for emotional expression took on more plastic weight and gained in momentum what it lost in liveliness, emerging finally in the heavy rhythm and powerful volume of the Lombard style which revived in Italy the tradition of monumental sculpture. This style, Teutonic in the extreme in its Lombard phase, was eventually to succumb in other parts of the peninsula to the latent Italian taste for antique form and expression, so that the final

WERDEN: *Detail of Crucifix*

aspect of Italian Romanesque is Roman enough to justify the traditional name of the style.

"Romanesque" is otherwise a misnomer for this phase of mediaeval art, for it represents no mere modification of antique Latinity, but a fruition of barbarian, Teutonic genius. The sculptures of Vézelay and Moissac, the drawings of Winchester and the miniatures of Reichenau, are counterparts in art of the feudal system, which also achieved its typical form in the eleventh and early twelfth centuries and was itself a political phenomenon wholly un-Roman, wherein a traditional tribal instinct had finally overborne the imperial machinery which Charlemagne labored so long to construct. The antique Roman tradition in Christian art succumbed in similar fashion to the Teutonic preference for emotional rather than intellectual apprehension of the creed, reducing its dogmas to personal terms, and its hieratic images to forms suffused and even distorted by ecstatic feeling. It was the Romanesque age that produced the irrational explosion of the first crusades, that made religious poetry lyric with assonance and rhyme, and laid the foundation of the modern stage by originating the mystery and miracle plays, turning thereby the Christian story into visible and concrete experience.

V

High Gothic

THE SCHOLASTIC SYNTHESIS

GOTHIC DUALISM AND GOTHIC SPACE

The ROMANESQUE MOVEMENT described in the preceding chapter continued into the thirteenth century (and even later in isolated cases) in a lingering aftermath represented by work produced in regions remote from its fountainheads in France and Rhenish Germany. But in France itself the style had reached its climax by *c.* 1150, and begun its transformation into Gothic, a transformation which took place in the second half of the twelfth century and was initiated in northern France, traditional breeding ground of mediaeval change. This metamorphosis of art was the expression of a revolution in European thought and manners which is known to historians of the present time, since Haskins's keen analysis of the period, as the "renaissance of the twelfth century"; the style that expressed it, though rooted in the Romanesque, is so prophetic of the art to come as to merit the name of "proto-Gothic."

Inherent in it are the two factors which give Gothic art its quality, disparate enough to provide the sensitive tension which is its loveliest element, but so mutually complementary that the art of the thirteenth century could achieve an optimistic synthesis, constructed by intricate adjustment of concrete experience to a highly subjective *Weltanschauung*, based on the revelation of Scripture and on experience not at all. In every art there is a conflict between the

[253]

universal and the specific, between the real and the ideal, but commonly one or the other determines style, while only in High Gothic are the two equally potent and productive of poignant beauty by their very opposition. One of these factors is the popular and plebeian element in European culture, becoming articulate in the twelfth century, and reducing as it were the poetry of Romanesque emotion to prose. The other is the church and the new learning of the universities, whose schoolmen by their logic made out of Christian theology an all-embracing Christian philosophy, offering confident solution to all the problems of existence. From the variety and confusion of experiential fact, the scholastic philosophy of the thirteenth century could elicit a synthetic harmony, whose volume and grandeur is the greater for the endless number of its component notes.

The rise of the Third Estate in the twelfth century is most evident in politics, in new forms which are functions on the one hand of the decline of feudalism, and on the other of the expansion of commerce, begun in the eleventh. Commerce and industry destroyed the localism on which feudalism rested, and produced a bourgeoisie of merchants and the craftsmen's guilds. The interests of crafts and trade were extralocal, tending to support a central government that provided safer roads and juster taxes than could be expected of the feudal lord. Where such government was weak, as in the Holy Roman Empire, the guilds and bourgeoisie that ruled the towns could make them independent as "free" cities, and powerful enough to defend the liberty thus acquired, as when the league of Lombard towns defeated Frederick Barbarossa at the battle of Legnano in 1176.

Where central government was strong, as in France and England, the bourgeoisie and guilds made common cause with it against the pretensions of feudalism, and as a result the decentralized polities of Romanesque times were gradually amalgamated into national states. Henry II (1154–1189), first king to unite in his blood the English and Norman royal lines, commenced the reorganization of England as a nation, sanctified by Magna Charta in 1215. In France as well, though somewhat later, the kingdom was consolidated by Philip II Augustus (1180–1223), under whom the English domains of the south and west were detached from insular control, and the feudal lords of Flanders brought to heel at the battle of Bouvines in 1214, with the significant assistance of the militia of the cities.

The economy of Europe, agricultural in the early Middle Ages, and focused on the self-supporting manor operated by serfs, began even in the eleventh century to feel the effects of trade and industry. International commerce recommenced with the fleets and colonies of Venice, Genoa, and Pisa, reviving

intercourse with Byzantium and Islam. Raw materials from the British Isles, North Germany, and Scandinavia, fed the factories of the Low Countries and the north of Italy, especially in the textile trade. The fairs of Champagne, clearinghouse for the routes of commerce, east-and-west and north-and-south, were well established by the twelfth century, which also witnessed the rise of mercantile codes and the reduction to writing of maritime law. Far-flung enterprise developed banking, first in the hands of Jews and later dominated by the "Lombards," capitalists of the commercial towns of Italy. Commerce and industry increased the demand for agricultural products, leading to the clearing of land for cultivation as on the American frontier in the nineteenth century, with the new Cistercian order foremost in this pioneering. New land and new trades meant new openings for free labor, and spelled the end of serfdom, first of feudal institutions (save in Central and Eastern Europe) to decline. Capitalism had come to stay, but not as yet revealing its eventual result of concentrated wealth and poverty; its symptoms rather than its essence alarmed the moralists of the church, who denounced usury as the Romanesque monks had inveighed in art and speech against the deadly sin of avarice.

"Stadtluft macht frei": the air of the growing cities bred plebeian criticism of traditional shibboleths both feudal and ecclesiastic. The monastic orders reacted to a discontent with the luxurious paresis that had overtaken Cluniac rule, reviving anchorite life, as in the Carthusian system of semi-isolated cells. The final reform of Benedictine monasticism came in the Cistercian order founded in 1098, made famous in the next generation by its greatest exponent, the abbot of Clairvaux, St. Bernard. The church was in need of such reformers and defenders, for the wave of heresies that swept Europe in the twelfth century was only stemmed by his preaching and the skill with which a succession of able popes canalized such revolts into the ecclesiastic organization. This was the easier because the popular support of such departures from orthodoxy was given less to their dogmas than to their violent denunciations of the wealth, laxity, and temporal pretensions of the clergy. Against these were directed the most ingenious and the most scurrilous verses of the "Goliardic" Latin poets of the twelfth century. Churchmen themselves could even hold their holy office in contempt, meriting the censure of Dante for preaching "with jests and buffoonery," or the condemnation of a council of 1227 for introducing profane and flippant wording into hymns and plain song.

The most serious of the rebellions against established religion was the Albigensian heresy of southern France, which inherited the ancient Mazdean dualism of Persia, translated into Christian terms by the Manichaeans of early mediaeval times, lingering on in the Byzantine East, filtering westward in the

tenth and eleventh centuries, and given a powerful impulse in the twelfth by popular discontent, which could easily identify the errant clergy as servants of the Evil God, the "Synagogue of Satan." The sect was suppressed in the bloody Albigensian Crusade of the early thirteenth century, but these very years saw the rise of religious revolt again in mendicant orders of Franciscan friars and Dominican preachers, both converted by the end of that century into papal instruments, but both in their inception inspired by the same naïve and popular desire for a realistic piety, that would reduce to everyday practice the precepts of the faith. St. Francis, when he followed the injunction to preach to "every living creature" with his sermon to the birds, was voicing that quest of the concrete which is the evolutionary factor in all Gothic phenomena. His life, itself a work of art, was as literal an application of religion as were the illustrations of the Utrecht Psalter, wherewith the underlying mediaeval realism had come to its first expression four centuries before.

❖　　❖　　❖　　❖　　❖

With the disintegrating force of popular unrest was matched the trend toward synthesis, of the intellectual movement. The most obvious symptom of this was the transfer of the foci of scholarship and education from the many monasteries to the few great cathedral or other schools which eventually became the universities. Five universities at least—Bologna, Montpellier, Oxford, Paris, and Salerno—were in operation by the twelfth century. Here was gathered the new material which had come from the Latin translations, made mostly in the second quarter of the century, of Greek philosophy and science from the Arabic versions discovered in the libraries of Moslem Spain. In the twelfth century, to quote Haskins,[1] "the great adventure of the European scholar lay in Spain." There he could make the Latin versions from Arabic texts of Galen's medical treatises of the second century, of the natural philosophy and logical writings of Aristotle, of the *Almagest* of the astronomer Ptolemy. This was the time when Europe acquired a wealth of Arab words—algebra, zero, cipher, almanac, alcohol, tariff, admiral, arsenal—and learned the use of zero in mathematics, the processes of algebra, and Arabic numerals. The sources were not all Greek, and not always reached through Arabic; the writings of Arab physicians such as Avicenna were as eagerly sought as those of Galen, and at Frederick II's court in Sicily there was sufficient scholarship to make translations directly from the Greek. With the monastic schools, in decline from the middle of the century, was lost the old interest in classical literature and history; and indeed any other scholarly pursuit was checked in the

[1] C. H. Haskins, *The Renaissance of the Twelfth Century*, Cambridge, Mass. 1933.

monasteries by the mystic and puritan prepossessions of recent orders such as the Cistercian. By the thirteenth century the Latin classics had no place in the university curriculum. The learning inspired by the new translations turned to medicine, mathematics, philosophy, and theology, and in these, as time went on, the tendency became dominant to formalize the material acquired from ancient sources, and to cite Aristotle, Galen, Ptolemy, Euclid as authorities, rather than as points of departure for research. The new logic was employed less for new speculation in philosophy than for the rationalizing of faith. The *Sic et Non* of Abelard (1079–1142), which contrasted the opinions of the fathers on questions of the faith, and opened the gates wide for skeptical discussion, was revised by Peter Lombard (d. 1160) into a reconciliation of the contradictions in which Abelard delighted, and the *Sentences* of Peter became the textbook of orthodox theology.

The revival of Roman jurisprudence which was one of the phenomena of the "renaissance" led to the codification of ecclesiastical practice in canon law, which was finally cleared of its contradictions and set up as a powerful instrument of papal control by Gratian's *Decretum* of the mid-twelfth century. The period indeed was one of growing centralization in the church, when monasteries exchanged autonomy for direct dependence on Rome, bishops were limited even in their own jurisdictions, and the appeal to the See of St. Peter was the rule in cases of dispute. The power of the papacy reached a towering height in this epoch of synthesis; Innocent III (1198–1216) was able to intervene in the election of a Holy Roman Emperor, to carry through the Albigensian Crusade in defiance of Philip Augustus of France, and to compel John of England to accept his crown as vassal of the Chair of St. Peter.

Christian philosophy, inseparable from theology, seized upon the Aristotelian system to elaborate its reconciliation of faith with experience, of "realism" in its scholastic sense, the insistence on the reality of universals, with a nominalism which limited reality to the individual object. It is not difficult to see in this, the principal concern of High Gothic thinking, the opposition between the synthetic idealism of Gothic ensembles, in politics, manners, and art, and the persistent cult of the specific which any Gothic phenomenon evinces in detail. The attitude of the scholastic philosophy of the period was enunciated by Anselm of Bec (d. 1109), archbishop of Canterbury in the time of William Rufus, as *fides quaerens intellectum*, "faith seeking understanding," with faith the initial and inevitable prerequisite. Hugh of St. Victor (1096–1141) saw the material universe as a symbol, and even Scripture as an allegory. The scholastic ideal of intelligible order was realized in the spiritual, not in the material domain; the modern confidence in physical causes

for all of life's phenomena is in complete contrast to scholastic distrust of sensory experience. Such an attitude involved an *a priori* and deductive method in philosophic thought, and even the stimulation of recovered Greek learning failed to encourage experiment, save in exceptional minds like Albertus Magnus, Frederick II of Sicily, and Roger Bacon. "Mediaeval philosophy was less interested in the foundations of knowledge than in its processes."

In the logical process, indeed, the scholastic mind was supreme. Its monument is the great *Summa Theologiae* of Thomas Aquinas (d. 1274), which replaced in the thirteenth century the *Sentences* of Peter Lombard, and became the final statement of Latin Christian doctrine. His method is an elaboration of Abelard's *Sic et Non,* setting up the doctrinal questions, and answering them with citation of authority, but fortifying authority with a dialectic manipulated with unequaled mastery, leading to conclusions of eventual harmony. "As other sciences do not argue in support of their principles," said Aquinas, "but from these principles go on to prove other things, so this doctrine does not argue in support of its principles, which are articles of faith, but from these goes on to prove something else." To illumine faith by the findings of the reason, and make clear the logical operation in the physical world of God's providence as revealed in Scripture—such was the purpose of the *Summa,* and such the measure of its purview, extending with its 631 answered questions through all of the problems that have troubled the human soul.

The comprehensiveness of the *Summa* is characteristically High Gothic. The writers and thinkers of the thirteenth century were no specialists; their vista was encyclopedic. Typical of their confident and all-embracing approach was Vincent of Beauvais's *Speculum Maius,* in which the whole lore of the Middle Ages, its theology and ethics, its accumulation of historical legend and fact, its miscellaneous science compounded of tradition and the new Greek and Arab learning are summed up in a huge encyclopedia amounting to fifty or sixty octavos of modern printing, but organized *sub specie aeternitatis* as a demonstration of the workings of God's will with the material world and man. This was an age that could feel, like classic Greece, that it had solved the riddle of the universe and knew all that was necessary for salvation. One of its polymaths, Burgundio the Pisan, could write upon his tombstone:

Omne quod est natum terris sub sole locatum
Hic plene scivit scibile quicquid erat.

From the scholastic synthesis, and its confident understanding of existence, comes the optimism that one feels throughout the range of High Gothic art, allied to the serenity of Greek classic style. Yet the one is a harmony of intri-

[258]

cate complication, the other a simple theme. In Gothic one is conscious, however powerful the synthesis, of the variety of notes and fundamental discords which the synthesis resolves. When Gothic artists conceived the opposition of Vice and Virtue, the latter might be a personification enthroned in lofty and serene abstraction, but the corresponding Vice was a chapter of real existence, a noblewoman kicking her servant for Anger, a man and wife pulling each other's hair for Discord, or a monk doffing his habit and leaving the monastery door, for Inconstancy (*Fig. 112*). Throughout this art a deeply rooted sense of the concrete contends with the ideal order of the churchmen and the schoolmen, and the evolution of the style is the growth of its underlying realism, which in the fourteenth century so impairs the ideal content that a superficial mannerism ensues, and in the fifteenth breaks forth in the pervasive naturalism of the early Renaissance. Of these two factors in the Gothic duality, the ideal one is visible only in its ensembles; the other is revealed in innumerable details of which these ensembles are composed. To illustrate the one we shall consider the Gothic cathedral; the other we can follow in the evolution of the art that most truly reflects individual imagination and taste—the illumination of Gothic manuscripts.

❖　　　❖　　　❖　　　❖　　　❖

The Gothic cathedral is the termination of a series of steps in architectural design, toward a conception of space composition which is wholly mediaeval and western. We are apt, in considering architecture, to be more absorbed by its solids than its voids, though the latter can have the greater effect upon us. For space in architecture is its least determinable element and hence its most suggestive, furnishing the wings so to speak for whatever imaginative flight the building may inspire. Space in architecture satisfies the same desire which seeks the panorama of a view, the craving for submergence of self in real or suggested infinitude, and release from limitations of personality and circumstance.

Being thus in architecture the factor of infinity, it had no major role in ancient styles. Egyptian architecture is especially negative in this respect, since its most peculiar form, the pyramid, had no interior space beyond the tomb chambers, carefully screened and guarded from entrance, whose location, even, was a secret that died with the builder. The rock-cut temples have sizable interiors, it is true, but their builders did not hesitate to dwarf the space enclosed by colossi which line the walls. The only great interiors of Egyptian constructions are their uncovered forecourts, wherein, so to speak, the space is raw material with no esthetic working; once one enters the roofed portion

of a temple like that of Edfu, the rooms are small and circulation cramped. Especially is this true in the grandest creation of Egyptian architecture, the hypostyle hall at Karnak (*Fig. 94*), where in spite of vast area and height the space is actually oppressive, owing to the huge scale of the columns that seem to crowd rather than to line the aisles. In Egypt it was obviously the solids of his building, not its voids, that mainly constituted for the architect his *parti.*

Mesopotamia and the rest of the Nearer East show for the most part the same abhorrence or neglect of space composition in their architectures, enclosures being small in proportion to the scale of the plan. Even in Crete, where Minoan art exhibits so many and so peculiar departures from the pre-Hellenic norm in Mediterranean culture, the same inhibition holds, witness the cut-up plan of the Minoan palace at Cnossos. It is only as the Greek genius realizes its classic sense of the relation of form to the space defining it that void begins to be considered in architectural design.

The attitude of the Greek toward the problem was in keeping with his rational approach to everything. In search of clarity, he found its expression in form, and instinctively controlled, in the interest of clearer definition, the spatial factor which suggests unlimited extent. The same passion for tangibility that made sculpture rather than painting the favored medium in Greek art made also of space, to use Phillipps's expressive phrase, an adjective to form.[2] The composition of a Greek temple depends on its silhouette and the proportions of its façade and porch. In this proportion space plays its part, but only to justify the dimensions of the solid units, and to furnish a background of shadow against which the colonnade may reach a fuller and more beautiful isolation. None but an archeologist is interested in the interior of the Parthenon, and this interior, spacious though it was, was deprived of possible effect like the rock-cut interiors of Egypt, by the colossal size of the cult statue of Athena, forty feet high from the pavement. Greek structures were built as exteriors, not as organized space, and the aim of the Attic architect was to isolate his forms *from* space, which therefore played a wholly subsidiary role.

The architecture of Roman times produced the fundamental change in composition, whereby for the first time a building was composed as an interior. We have seen enough of the relation of art to shifting points of view to realize that such a change reflects a new conception of experience. It is the more significant as being a change in architectural style, since this art is one of collective inspiration and expressive always, if only by virtue of its plural utility, of social content. The first great structure that displays the change is the Ha-

[2] L. M. Phillipps, *Form and Colour,* London 1915.

[260]

drianic Pantheon at Rome (*Fig. 95*), built at a time when the transcendental element was fast transforming Mediterranean belief—the period of popularity of the mystery cults soon to be supplanted by a nascent Christianity, vehicles of that sense of infinitude which is precisely satisfied by architectural space. So in this curious temple at Rome, so ugly outside, and so singularly beautiful in its interior, we have a design which uses the space enclosed as its point of departure, a half sphere on a cylinder, lighted by an oculus at the summit of its impressive cupola.

In the composition of the Pantheon's space, however, infinitude is recognized, but not exploited. The space enclosed is commensurable, composed of geometric forms, so clearly defined as to partake somewhat of the rational actuality of solids. The single circular window at the top is no more suggestive or connective with the unlimited extent of space outside than if it were an artificial source of the light it furnishes. The architect of the Pantheon was not yet free of classic inhibitions; he models his dome into cofferings and his cylindrical supporting wall into subordinate units of distinctive composition, emphasizing in Hellenic fashion the importance of the solids of his structure.

Space composition in the third century followed the dispersive trend, away from axial arrangement, that we have seen in late antique painting and relief. The units of space were multiplied, as in the great baths of Caracalla and Diocletian or the basilica of Constantine (to speak only of edifices in Rome) where the space is decentralized by three equal bays, and geometric definition lessened by interrupting accents of engaged orders and the groining of vaults. In the last building of antiquity in which the Greco-Roman imperative of space defined is still operative, Hagia Sophia at Constantinople,[3] the accents are still further multiplied, but integrated by the central dominance of the dome (*Fig. 96*). This interior, the finest ever composed, is conditioned by an element that had not bothered earlier architects, but was to shape the forms of mediaeval building thereafter—the necessities of the Christian cult. These demanded the horizontal axis terminating in the eastern apse, which was the Christian variation on the Hellenistic basilica, with the difference that while the pagan basilica, as in the case of the Basilica Ulpia in Trajan's Forum at Rome, might carry its interior colonnade around all four sides of its rectangle, and make the plan symmetrical by an apse at either end, the Christian variation had to suppress one apse and eliminate the colonnades on the short sides, to provide convenience of entrance at the west, and space in the east for the sanctuary. To underline this longitudinal plan at Hagia Sophia the great square on which rise the arches supporting the dome was increased by

[3] E. H. Swift, *Hagia Sophia*, New York 1940.

bays to east and west, and the vertical axis had to be adjusted to a horizontal one culminating in the altar at the eastern end.

The solution was magnificent. From the central cupola descend two half domes covering the adjoining bays, and these in turn are buttressed by smaller semidomes to east and west, so that wherever one may stand in the main aisle of the church, the eye rises without interruption of the gaze, from vault to vault and upward to the dome, ringed with its circle of windows, which seems to hang above the interior like a chandelier. The soaring effect of this hemisphere is enhanced by the evasive treatment of the supporting piers; the preoccupation of the Pantheon's artist with his solids is not in evidence here, where effort seems to be directed toward masking, rather than accentuating, the units of support. The lighting is decorative, provided by the relatively small windows in the base of the dome and others of restricted size, spotted in rhythmic arrangement on the lateral lunettes of the central square. Over all this interior there once was laid a tapestry of colored marble veneer and mosaic, to further obscure its architectonic articulation, and further emphasize the oriental preference for color over form that had transfigured Hellenistic style.

Even so, the interior of Hagia Sophia is still antique, bounded by surfaces that are geometrically and rationally conceived, however intricate and subtle their composition. The full acceptance of unlimited space is not yet discovered here, nor for that matter in the subsequent development of Byzantine architecture. The evolution of this was rather in the direction of rhythmic repeat, by multiplying domes and vaults over longitudinal or cruciform plans, and a fair measure of the loss of Hellenic inspiration that resulted may be observed by comparing Hagia Sophia's plan with that of St. Mark's at Venice. The linking of infinitude with the church's interior was accomplished not by the contemplative genius of the Byzantine, but the more ecstatic piety of the Latin West.

In the West, church architecture commenced with the basilical form and kept it far into the Middle Ages, with modification only by the addition of a bell tower, or towers, to its façade, enlargement of the sanctuary into a choir with crypt below, and the addition of space for chapels around the east end or in transepts. The basilical type (*Fig. 31*) was, like all the mediaeval phenomena of the West, charged with possibilities of growth, in contrast to the conservatism with which Byzantine architecture clung to the central plan so perfectly applied at Hagia Sophia. For one thing, the Latin basilica was roofed with wood, an impermanent solution and a fire hazard that invited vaulting. Since the clerestory supported no masonry, its wall could be weakened at will with

windows, and the interior was lighted too profusely for its devotional character. But most pregnant of all the basilica's potentialities was the instability of its horizontal axis, carrying the eye forward by the rapid succession of the closely spaced columns of the nave arcade, arriving too abruptly at the apse and altar of the eastern end. The space of this interior was thus in movement, too freely united by the clerestory lighting with space *in genere,* and lacking significant composition.

The implications of this unsatisfactory interior began to be realized with the vaulting of the church, and the schools of Romanesque architecture can almost be classified by their solutions of the consequent problem of construction. The evolution that ensued can best be followed in the Romanesque churches of France, which fall broadly into the two general types indigenous to north and south. In the north, where sunlight was a prime *desideratum,* every effort was made to keep the clerestory of the nave projecting above the side-aisle roofing, to provide a space for windows wherewith to light the nave. In the sunnier south, where light was at a discount, the side aisles served to buttress the nave vaulting, eliminating the clerestory altogether. All the Roman modes of vaulting were employed (save the expert technique of concrete vaults which was lost with the collapse of Latin imperial civilization)— the dome, the tunnel vault, the cross or groined vault resulting from the intersection of two tunnels, and the domed-up groined bay. In southeastern France the nave was tunnel-vaulted, in heavy masonry supported by tunnel vaults or half tunnels over the aisles. In the Southwest, the buttressing side aisles were covered with groined bays and raised high so that their windows might light the windowless nave. The "pilgrimage" group of churches in the diocese of Toulouse, whose style conforms to that of Santiago de Compostela (p. 231), brace the nave vaulting with a vaulted gallery surmounting the side aisles (*Fig. 97*). In Périgord the Byzantine dome was used, and occasionally even on a Byzantine cross plan (S. Front at Périgueux), but usually in the basilica form with narrow aisles and a nave divided into domed bays.

As one moves north, the clerestory and its windows become more and more the rule. In Île-de-France, singularly hesitant in its Romanesque construction until the sudden appearance there of early Gothic architecture, one even finds the early Christian wooden roof (Vignory). But in Burgundy, by dint of fine construction, the Romanesque builders raised their clerestories high above the aisles, vaulting them with tunnel vaults or groins, and producing the most imposing interiors to be found in France before the advent of Gothic.

The atmosphere of this Romanesque space is in keeping with the style. The objective simplicity of the early Christian basilica, and its unimaginative lighting,

was gradually transformed into a truly mediaeval interior, by changed methods of construction it is true, but methods that were as much inspired by new content as by new means of building. Heavy piers, more widely spaced, replaced the rapid succession of units in the basilical colonnade, and the transverse arches, supported by engaged pilasters or columns rising from the pavement, divided the nave into measured bays, introducing a vertical accent to counteract the horizontal movement of the plan, and charging the slower approach to the altar with reverential meaning.

The Gothic revolution began in North Italy and Normandy, in the timid introduction, probably only to support centering for the easier construction of groin-vaulted bays, of the diagonal rib, which, added to the wall rib and the transverse arch already used in Romanesque, produced the characteristic Gothic ribbed vault. With rib construction, a bay becomes an independent armature, with vaults built up and bearing on the ribs alone, so that the side walls of the church, including the all important clerestory, become unnecessary as bearing members of the vaulting. The implications of this invention were worked out in Normandy and Île-de-France in the first half of the twelfth century, and by its second half had transformed Romanesque architecture into Gothic. The church was thereafter a skeleton of piers and ribs, filled at sides with walls that could be windowed to whatever extent the builder wished,

SAINT-LEU D'ESSERENT

and covered with stone vaults that concentrated weight upon the ribs, whence it passed to the piers, the special portion of the building which must then be securely buttressed against the outward thrust. This last problem was solved by the most peculiar architectural form of Gothic—the flying buttress—and also by weighting a secondary weak point, the haunch of the vaulting cone, where transverse, longitudinal, and diagonal ribs converge.

Gothic builders, like the Romans with their concrete floors and ceilings, did not at first realize either the structural or esthetic possibilities of their innovation. The early Gothic churches of the north of France, such as Saint-Leu d'Esserent, reveal a relatively timid opening up of the clerestory wall for larger windows, and an experi-

mental treatment of the flying buttress. But by the thirteenth century the whole clerestory beneath the longitudinal arches had exchanged its stone for glass; the pointed arches, introduced at first to level the crown of vaults, had discovered an esthetic as well as a useful purpose, the vertical axis had overcome the horizontal, and the Gothic interior had begun to soar. The quest for greater and greater height reached its limit when the choir of Beauvais, 157 feet high from the pavement, collapsed in 1282. The Gothic naves of lesser altitude were nevertheless high enough to satisfy the Gothic effect of soaring space—space no longer rational, commensurable, and geometric as in antique and Byzantine interiors, but irregular in volume and expansion, linked with the infinitude of out-of-doors in a union made mystic by the jeweled light of the clerestory, losing the eye of the observer in the shadowy severies of the vaulting—in short, a space in movement, with the same dynamic inspiration and effect that vitalized Celtic ornament, the drawings of the Utrecht Psalter, and the writhing sculptured figures of Romanesque.

Thus was the transcendental content of Christianity, and the emotion it engendered, brought to final and complete expression (*Fig. 98*). But one is conscious as well, in a perfect Gothic interior such as Amiens, of the *rationale* controlling both construction and design. The heavy piers of Romanesque have become more slender as their burden is transferred to the system of ribs, and these are adjusted in size to the task each must assume. The shafts that bear the transverse arches of the nave run down the face of the pier to the pavement, and surpass in size the ones which support the diagonal ribs and rise from the pier capitals of the nave. Still smaller are the shafts with the lesser duty of bearing the longitudinal or wall ribs which enclose the windows and rise from the stringcourse running beneath the triforium gallery. At each place where these units of support begin there is a burst of natural ornament, the leaf capitals at the summit of the piers, and the leafy border that marks the opening of the gallery, providing an accent of vitality at points of strain. The ordered perspective of the nave arcade, the fine proportion of gallery to nave arcade and window space, the regular succession of bays and severies in the ceiling bring the ensemble into harmony, with an intricate but inevitable logic like that of Aquinas's *Summa*.

The Gothic cathedral is indeed the architectural counterpart of scholastic synthesis; as the latter resolved by dialectic the problems imposed by faith, so the architects of the thirteenth century achieved an integrated unity out of endless detail, despite their courting of indeterminate space. It is Gothic space nevertheless, in Gothic architecture, that finally determines its effect. The movement and subtle communication with outer space that links the observer

with infinity are potent factors in the spiritual levitation a Gothic interior can give; but give in full measure only when reinforced with its panopoly of painted glass. The Gothic window turned the light of day to Christian use and significance, stirring the devout soul with jeweled color, and the devout mind with a panorama of the Christian epos, recorded in the illumined figures and symbols which took the place in Gothic churches of Byzantine mosaics.

GOTHIC WINDOWS AND GOTHIC MANUSCRIPTS

The history of mediaeval stained glass [4] can be traced in literary accounts from the end of the tenth century, but documented with existing works only from the twelfth, when the art took on a sudden popularity and expansion that seem, like the rapid rise of Gothic architecture, to be in no small measure due to Abbot Suger of Saint-Denis. This churchman of humble origin rose to be not only abbot of the great royal monastery near Paris, but prime minister of the kingdom, which he managed so well while Louis VII pursued the second Crusade as to be titled *pater patriae* by his royal master on his return. Suger's importance for mediaeval art is enormously enhanced by the account he has left us, in his *De rebus in sua administratione gestis,* of his activities as abbot and especially of his reconstruction of Saint-Denis, whose west façade he dedicated in 1140 and choir in 1144. Suger's contribution to Gothic lay in the assembling by his invitation of craftsmen "from all lands" (meaning probably from all parts of France rather than from foreign countries), at a time when the Romanesque was fully developed and ready for new ways; the motley atelier of Saint-Denis was thus a natural crucible for innovations. For the windows of his abbey church the artists used cartoons of his devising, and though most of his glass is gone, the few fragments that remain are sufficient to show by comparison that the influence of his atelier spread far and wide. A Tree of Jesse of which some pieces remain is imitated in one of the three windows which were made soon after those of Saint-Denis for the west front Chartres Cathedral (*Fig. 99*). This theme, known to Byzantine painters, was developed from the prophecy of Isaiah (xi:1, "there shall come forth a rod out of the stem of Jesse") into a fabled ancestry of the Virgin and Christ, wherein the "rod" becomes a genealogical tree rooted in Jesse's prostrate body, with David, Mary, and Christ (surrounded by seven doves representing the Gifts of the Holy Spirit), sitting in its branches.

[4] L. B. Saint and H. Arnold, *Stained Glass of the Middle Ages in England and France,* London 1913; L. F. Day, *Windows,* London 1897. A convenient set of color reproductions of French windows of the twelfth and thirteenth centuries is contained in M. Aubert, *French Cathedral Windows of the Twelfth and Thirteenth Centuries,* New York 1939.

In the arcs of the inner border stand the prophets who foretold the Incarnation or other acts of the new dispensation. The window of Chartres is both characteristic of the Saint-Denis school of glass painting and of the windows of the twelfth century in general: the borders are wide and of rich and varied designs; the armature of iron bars traverses the window with rectangles that have little regard for the figures; the bands of lead which carry the design are many and the segments of glass minute. By this last feature the effect of the window was enhanced, for multiplied leading and small panes meant more refraction of light, and greater vibration of the colors. These in the twelfth century were dominated by the lovely blue that almost always constitutes the field of the window; accessory to it was a red whose tone was kept in check by thickness and irregular surface, and has been often improved, in the windows that have survived to our own day, by weathering and incrustation. Yellow, green, white, and violet were also in the repertory, but toned by black overpainting, with which such modeling was done as the superior taste of these early Gothic artists would allow, to figures intended mainly as vehicles of vibrant color.

The three west lancets of Chartres—the Jesse window, the Infancy of Christ, and the window of the Passion—are the first essays of the Saint-Denis school outside of Paris. The influence of the school was destined to extend much further; to Vendôme, Le Mans, and possibly Poitiers, Angers, and even York in England. Another school worked in the east of France, apparently continuing a tradition of glassmaking which stemmed from Reims, where Archbishop Adalberon is recorded, *c.* 980 A. D., as adorning his cathedral with windows "containing histories." By the beginning of the thirteenth century, however, French glassmaking in the north and center of France was dominated by the style of Chartres, itself a development of the manner and technique initiated by Suger's glaziers at Saint-Denis. A Clement of Chartres signed the Joseph window in Rouen cathedral, and the Chartres style crossed the Channel into England, where it is represented by glass at Canterbury and Lincoln. The school was active also at Sens, Laon, Bourges, Tours, and Le Mans, and left its influence on the local atelier that made the windows of Lyon cathedral, mingling the teaching of Chartres with notions of iconography that show the influence of Byzantine.

The art of Gothic glazing followed the trend of French ecclesiastic art in general during the latter half of the thirteenth century by establishing its focal point at Paris. There, in the middle of the century, the complex of space, light, and color that makes the Gothic interior was carried to extremity in the Sainte-Chapelle, built by Saint Louis as his palace chapel, and to house

the relics most treasured by that pious monarch (portions of the Crown of Thorns, a piece and a nail of the Cross), and demonstrating in its single aisle and fifteen huge windows the necessity of stained glass to control the abundant lighting and opening up of this interior, which otherwise would have little more composition than a greenhouse. As it is, the chapel is bathed in color and given its principal artistic meaning by the windows alone. The same Parisian school did the glass of S. Germain-des-Prés and the great rose windows of the transepts of Notre-Dame. Its work or workmen traveled afar in France, and the style is traceable in the choir windows of Tours, Le Mans, and Angers. Only the south of France, less sensitive to the problem and possibilities of fenestration, remained outside the field of influence of the schools of Chartres and Paris; stained glass was not installed in the churches of the Midi until the fourteenth century.

The composition of the window changed in the thirteenth century: the grid frame of verticals and horizontals in the iron armature was curved to enclose the figures and scenes, into circles, half circles, lozenges, and squares. The subjects are whole histories of saints, or symbolic *dittochaea* wherein the incidents and persons of the Old Testament are made to typify the New. In a window of Le Mans (*Fig. 100*) the Passion is summed up in three medallions of Christ carrying his Cross, the Crucifixion, and the Resurrection, with a Last Judgment at the window's summit. In the arcs beside the quatrefoils are the Old Testament antitypes: for the Cross the crossing of Jacob's arms as he blesses the sons of Joseph; Elisha and the Widow of Zarephath, who holds her "two sticks" in such fashion as to form with them a cross; and the T marked on the houses of the Israelites in Egypt that the angel of death might pass them by. For the Crucifixion we have the Murder of Abel; Moses striking the Rock, from which the water gushes as it did from the wounded side of the Crucified, to typify baptism; and Moses again, showing his people the Brazen Serpent (John iii:14, "And as Moses lifted up the serpent in the wilderness, even so must the Son of man be lifted up"). For the Resurrected Christ, risen from the dead three days after his Crucifixion, the legendary zoology of the time presents us with the lion roaring over its still-born cubs, three days after birth, to bring them to life, and the same symbolic view of nature inspires the pendant composition of the pelican piercing her breast to feed her young, even as Christ bled upon the Cross for humanity. The Old Testament furnishes also its parallels for the Resurrection: Jonah emerging from the jaws of the sea monster, and Elisha raising the son of the Shunammite Woman.

The broken color that vibrated from the minute partitions of the design

[268]

in windows of the twelfth century is somewhat missed in thirteenth-century glass, where the figure drawing was clearer, and done with larger panes. The beautiful leaf work of the earlier broad borders and unfigured areas was replaced by a conventional mosaic of red and white bands on blue, while red was more and more, as the century advanced, preferred to blue as background. The mosaic character of the earlier work is impaired by the simpler design of the leaden contours, and its medley of hues transformed into a prevalent violet from the insistent red-on-blue. But the windows are more readable, and their stories sprinkled with the homely detail with which Gothic art was wont to enliven its elaboration of sacred themes—partly perhaps because of the popular appeal of this particular art. Stained glass was *par excellence* the lay contribution to the adornment of the church, and the donor panels at the bottom of the windows are more likely to contain the figures of the craftsmen and tradesmen of the guilds which gave the windows than those of ecclesiastics or noble patrons.

In the second half of the twelfth century, the Cistercians spurned the luxury of colored glass for windows of plain greenish-white panes enclosed in leaden frames which are often of exquisite design. The austere beauty of these grisaille windows was softened in the thirteenth century by arabesques painted upon the glass, and toward the century's end, one finds a taste developing for a contrast of medallions or large figures upon a field of grisaille. Another innovation of this epoch was the reversion to the horizontal bars of the iron framework, leaving the figured panels with only painted, instead of metal borders. Still another was the Gothic canopy designed above the heads of the single figures which sometimes replace the customary series of medallions. All these symptoms of changing taste were developed in the fourteenth century, and had their part in the complete transformation of the Gothic window that ensued.

In technique, the great invention of the fourteenth century was silver stain —the painting of glass with an oxide or chloride of silver that turned the glass yellow when heated. This, and the greater use of "flashed" glass whereby one color was fused on a pane of another hue, which could be brought to view by abrading the covering layer, immensely increased the craftsman's decorative repertory. He also now knew how to make large panes, and since he needed no longer the detailed armature imposed by small pieces, the medallion windows became in consequence a thing of the past. More light was demanded, and also the contrast of grisaille and color, both of which *desiderata* were achieved by the typical composition of the fourteenth century, in which the window is dominated by a single figure or group, set in the middle of a long lancet of

grisaille, and standing within a niche which developed a bewildering architectural complication from the canopy of the thirteenth century. Toward 1400, perspective begins to intrude itself into these architectural settings, ushering in the window composition of the fifteenth century, when more dexterous technique and a lessened sense of artistic propriety began to imitate the naturalism, space, and plastic form of easel painting—and to divorce the window from its architecture. The greater prominence of yellow in these late windows gives them a coloring that matches in autumnal effect the mature and almost brittle rendering of leaves in the natural ornament of the last stage of Gothic architecture, and of Gothic illumination.

❖　　❖　　❖　　❖　　❖

The "renaissance of the twelfth century" reveals its universal and international aspect nowhere so well as in the decoration of manuscripts. The illumination and illustration of books in the eleventh century was so local that attribution of a manuscript to its proper school can usually be made on the basis of ornament and figure style, each region having its own manner of expressing the exuberant feeling of Romanesque, as for example, by the contorted drawing of Anglo-Saxon and its luxuriant leaf design, or the barbaric intensity of facial expression characteristic of Ottonian work. In the twelfth century we witness a general integration of style in the direction of equilibrium. The ornament tends to emphasize the stems of its foliations, and to organize them into slower and heavier rhythm, giving thus solidity to design; toward the century's close, and even into the thirteenth, initials resolve themselves into coiled spirals resembling often a watch spring in effect. The figures become more static in posture, and acquire a reticent solemnity, excellently expressive of the rationalizing of Christian dogma at the hands of the schoolmen. The outstanding criterion whereby one may differentiate painting of the twelfth century from that of the eleventh, throughout Europe, is the stabilizing of composition. Symmetry and consistency replace the volatile and unanchored arrangements of the earlier Romanesque.

On this proto-Gothic style, seemingly as finished and mature as the ideal of aged dignity that pervades its figures, there are grafted, toward the end of the century, the first shoots of Gothic naturalism (*Fig. 101*). The earliest symptom seems

ENGLISH PSALTER OF THE EARLY FOURTEENTH CENTURY: *Bishop Fox and Choir of Ducks*

[270]

to be the transformation of script, the most peculiar change, perhaps, in the history of writing, whereby the traditional minuscule descending from Alcuin's reform in the ninth century begins to acquire the spiky appearance of the Gothic black letter. The thorny aspect of the text transmits itself to the initials, and both are mutually assimilated, so that the page becomes an integrated work of art, especially where the miniatures that in Romanesque were full or half page affairs are incorporated into the initial, at first within the form of the letter itself, and later as a panel attached above it. But the page thus unified has nevertheless become alive by virtue of the natural growth suggested in the spiky script and the initial's irregular outlines; the new-found equilibrium of the twelfth century is vitalized.

ENGLISH MANUSCRIPT OF THE TWELFTH CENTURY: *The Jesse Tree*

This transformation of the Gothic page was accomplished in England and France in the thirteenth century. In the second half of the thirteenth, the initial extends its stem or "bar" toward the bottom of the page, and leaves of ivy, thorn bush, and oak begin to sprout from the stem. In the fourteenth century this leafy border is carried around the page, and separates the two columns of text as well, with the "bar" becoming more slender in the process, and losing more and more its character of a living trunk. As soon as the "bar" branches across the bottom of the page (and even before) the characteristic "footnotes" of the Gothic illuminator put in their appearance—grotesques of every sort and including all fantastic combinations of man and beast, or beast and plant, together with real and fabled animals drawn from the Bestiaries which contained the lore of mediaeval natural history, scenes of daily life, of games, tourneys, and the chase, with a plentiful sprinkling of genial caricature reminding one of Goliardic poetry, sometimes directed at the church. The border frame of the fourteenth century is filled with a veritable menagerie of such actual and unreal creatures, reproducing in miniature the real and imaginary fauna that ornaments the cornices, corbels, and gargoyles of the cathedrals.

[271]

The illuminators reveal in many more ways than this their dependence on cathedral art. A singular instance is given by an equally singular product of the first half of the thirteenth century, the "moralized" Bibles.[5] The text of the Bible was revised at the University of Paris in the thirteenth century, and the corrected texts distributed all over Europe, often in illuminated copies which had much to do with the dissemination of French Gothic style. The "moralized" Bibles were however not complete texts, but picture books with scenes from the Old or New Testament and accompanying miniatures illustrating a moral application of the episode. Thus the Creation of Light is paralleled by the creation of angels, and the Separation of the Waters by the contrast of a virtuous with a loose-living bishop; the "river of living water" proceeding from the throne of God in the Book of Revelation is explained by the moral benefit of baptism. Two of these huge productions, whose illustration extended to thousands of miniatures, are preserved in approximate completeness. The three volumes of one are located respectively in the Bodleian Library at Oxford, the Bibliothèque Nationale at Paris, and the British Museum; another is in the chapter library of the cathedral of Toledo in Spain, minus its last quire, which was lost before the sixteenth century and passed through various hands to a final resting place in the Morgan Library of New York. The miniatures of these books not only reflect the scholastic mingling of philosophy and theology, of Scripture and ethics, but also the respect of the illuminators for the work of their fellow craftsmen who made the Gothic windows; the miniatures, eight to a page, are arranged in two columns of medallions composed exactly like the windows of the thirteenth century, even to the mosaic design that fills the spaces between the roundels. In the light of such imitation, we can understand the preference of thirteenth-century illumination for deep blue and red, these being the colors of the windows as well. The background of the miniatures of the first half of the thirteenth century is gold, usually applied upon a gesso priming that raises the picture somewhat from the page; in the second half of the century this begins to be tooled with arabesques, and is succeeded in the late thirteenth and fourteenth by a painted diapered field that is probably another borrowing from cathedral decoration, being part of the conventional ornament employed in fresco on what remained of walls in High Gothic architecture.

Brighter and more varied colors in the miniatures follow the transformation of tones in cathedral glass, which took place at the turning of the thirteenth into the fourteenth century, and as illumination develops toward its apogee in the latter century, the influence of the cathedral is even more obvious, in that

[5] A. de Laborde, La Bible moralisée, Paris 1911-27.

the favorite frame for the miniature which now becomes a panel inside or be-
side the initial is a sort of section through a Gothic church, resembling the
architectural canopies employed in fourteenth-century windows. Such framing
is already found in the psalters illuminated for Saint Louis (*d.* 1270) and his
pious sister Isabelle, and in these manuscripts also one may see the growing arti-
ficiality of the figure style, as an esthetic ideal of grace and aristocratic elegance
gradually supplants the religious content. The faces become more infan-
tile, the gestures mannered; the tonsured saints, in fourteenth-century manu-
scripts, suggest bald-headed infants. A certain reaction toward more rigorous
drawing may be seen in the greatest of the Parisian miniaturists of the four-
teenth century, Jean Pucelle, who signed the products of his atelier with a
dragonfly (in French, *demoiselle,* but *pucelle* in the fourteenth century), and
had an assistant Chevrier who probably is meant by the bagpiper (*chevrier,*
from *chevrette*) perched upon the border in some of the miniatures done in the
Pucelle workshop.

English illumination follows the French so closely during the period of
High Gothic that at first sight an English manuscript is hardly distinguisha-
ble from a French. Such difference as there is resides in the livelier invention
which the English craftsmen exhibit in their *drôleries,* their more wayward
ornament, and their fondness for scenes of
Hell and combats. In Germany the imita-
tion of Byzantine painting which controls
twelfth-century style is continued in the
thirteenth, but with exaggeration of the
Byzantine accents into agitated movement,
complicated zigzag drapery, and angular fly-
ing folds. From *c.* 1250, there is a general ca-
pitulation to French taste, and the German
quality finds expression more in iconography
than style in the fourteenth century, when
the Dominican mysticism that flourished in
Rhenish monasteries found vent in the illus-
tration of the *Biblia Pauperum,* and related
texts such as the *Speculum humanae sal-
vationis,* wherein the Lives of Mary and
Christ were prefigured by Old Testament
events and types with the intricate sym-
bolism favored by German piety. French
style made little progress in Italian book

ILLUMINATION BY PUCELLE

decoration in the thirteenth century, save in university centers such as Bologna, and in the fourteenth found a rival in the revival of painting ushered in by Duccio and Giotto, which stamped its character upon the miniatures of manuscripts and was true enough to antique tradition to maintain the acanthus as the main element of ornamental vocabulary. In Italy the Gothic blue and red were also used, but in paler tones, and instead of the flat leaves of French borders the Italian acanthus curls, like Byzantine leaves, upon the page. The tenacity with which Spanish illumination [6] clung to Romanesque may be judged by a manuscript of Beatus's commentary on the Apocalypse in the Morgan Library, dated 1220, which simply adapts in its miniatures the illustrations of a Beatus of the tenth century. The French manner was not domesticated in Spain until the latter part of the thirteenth century when it makes its appearance in the illustrations of the *Cantigas* of Alfonso X the Learned, with diapered backgrounds and architectural frames that vary Gothic with Moorish motifs. In the fourteenth century French influence meets a potent rival in the Florentine and Sienese styles that were then becoming models for Spanish miniaturists as well as easel painters.

By the fourteenth century, however, French illumination was the norm of perfection in the art of the whole of Europe save in Italy, and even there its reputation is revealed by the respect with which Dante speaks of it:

> *Quell' arte*
> *Che alluminar chiamata è in Parisi.*

The example here illustrated of this culmination is a page from a pontifical in the Fitzwilliam Museum at Cambridge, illuminated in the first quarter of the fourteenth century (*Fig. 102*). A pontifical was a text of sacred rites peculiar to the bishop's functions, and the portion on this page contains the beginning of the consecration of a church. The core of the ceremony is the tracing of the Greek and Latin alphabets in ashes spread upon the floor, in diagonal lines across the length of the nave, while the clergy chant appropriate canticles, one of whose phrases *O quam metuendus* is here set to its music (Gen. xxviii:17, "How dreadful is this place! this is none other but the house of God, and this is the gate of heaven"). The Greek alphabet is somewhat inaccurately transcribed by the illuminator to form the lower border of his miniature, in which the act of its tracing is performed by the bishop, followed by the chanting clergy, within the diapered walls and vaulted interior of the church. In the initial a priest reads the service in the pontifical. Round about the picture panel are sprays of leaves, animating a design whose vital eccen-

[6] J. Dominguez Bordona, *Spanish Illumination,* Florence 1929.

tricity is carried out by the slender bar and its thorny extension across the bottom of the page. Perched on this is a typical High Gothic grotesque—a hybrid singer, half fish and half man, accompanied by a hare on a harp. The humor of this duet is consonant with the concrete rendering of the ceremony depicted in the miniature; the consecration of the church is not expressed in Romanesque symbolic language, but in terms of something seen.

Seen, however, within the limitations of High Gothic realism, too much engaged in the symbolic synthesis of scholasticism to pursue its implications to their necessary end. In the miniature the space indispensable to a real portrayal does not exist, and the naturalism one senses in the design is suggested rather than rendered, through the leafy sprays, and the eccentric extension of the ornament as if by actual growth. The imprint of the decadence of High Gothic style is on the figures, in their childish features and drapery drawn in mellifluous curves. When Gothic realism finally achieved its full expression, it was not through French hands nor through the decaying tradition of cathedral art, but in the easel pictures and miniatures of Netherlandish craftsmen, such as those who added a series of illustrations to the decorations of a book belonging to the great bibliophile of the end of the fourteenth century and early fifteenth, the Duc de Berry, uncle of Charles VI of France. Here indeed we see the easel picture taking possession of the page, as it took possession of the window in the glass of the time, inviting us for example into a contemporary interior wherein the birth of the Baptist is enacted with no lack of homely properties (*Fig. 103*). The savor of High Gothic elegance lingers in the earlier ornament of the page, with its leafy frame and its thorny lower corners, but the playful "footnote" of earlier times is enlarged into a real landscape, so inviting in its detail and distance that one all but overlooks the Baptism of Christ for which it makes the setting.

CATHEDRAL SCULPTURE IN FRANCE

The evolution of High Gothic style has in some degree been visible in the development of the illuminated manuscript sketched above; it can be followed in more detail in cathedral sculpture. The Gothic phase of this began, like Gothic windows, with Suger's building of Saint-Denis, and though there is nothing left but fragments of the sculptured decoration on the three portals of his church, the drawings of the portal figures made by Montfaucon in the early eighteenth century have preserved their essential aspect, which is that of the statues on the west front of Chartres. In the figures of its west façade as in its western windows, Chartres continues, a decade later, the style initiated at Saint-Denis, and opens among existing monuments the history of Gothic sculpture.

The change from Romanesque is fundamental, in the organization of iconography, in architectural composition, and in figure style.

The tympana and lateral statues of the three portals, their lintels and capitals, constitute a cycle of the Life of Christ, and somewhat also of the drama of man's redemption. The embrasure figures which flank the doors were probably meant to be the ancestors of the Saviour (*Fig. 106*), his birth and infancy are on the lintels of the south portal, and his Passion is depicted on the capitals of the façade. The Ascension is the subject of the left portal, and Christ in Glory occupies the central tympanum, with the apostles on the lintel below, and angels and the Twenty-four Elders of Revelation in the archivolt marking the scene as the Second Coming and the Day of Judgment (*Fig. 104*). In the archivolt of the Ascension portal are the Signs of the Zodiac and Labors of the Months, typifying the toil that disciplines man to spiritual perfection, while round the Madonna enthroned in the south portal are the Seven Liberal Arts with their famous exponents, symbolic of the wisdom that must be acquired for spiritual understanding, and also reflecting the proficiency in the arts which Gothic faith attributed to the Virgin. These Arts are delightful reminders of the High Gothic mixture of real and ideal: the ancient embodiments of learning, Aristotle for Logic, Cicero for Rhetoric, Priscian for Grammar, Euclid for Geometry, Pythagoras for Music, Boethius for Arithmetic, Ptolemy for

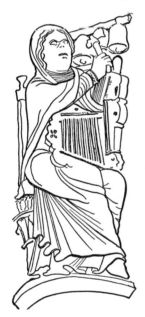

Astronomy, are dignified enough, but the personifications are in active pursuit of their themes, with Music striking bells, Rhetoric declaiming, Astronomy gazing at the sky with globe in hand, and Grammar in stern command of two monastic pupils.

In contrast to the loosely articulated façades of Romanesque, this west front shows an architect's design. An architect's or a sculptor's, for sculpture is here so part of the construction that one feels the directing master must have been adept in both pursuits. For the first time we see employed the High Gothic principle that the figures shall be carved out of the structural member itself and not applied, so that each of the "ancestors" is one with the colonnette behind him. More than one hand was at work on this façade, and in their styles the archaic and "modern" meet: two older masters carved the outside embrasure figures, of whom one was also employed on the façade of Notre-Dame at Étampes, the

[276]

other, according to Vöge,[7] a member of Suger's atelier at Saint-Denis. The head master is of later vintage and far more finished style; to him we can ascribe the rest of the colonnette-figures and the central tympanum and lintel (*Figs. 104, 106*). A fourth hand has been recognized in the archivolt carvings and the lateral tympana. The distilling of Gothic style can be observed in the works of this atelier: the older masters clinging to Romanesque convention in drapery of confusing corrugation that cannot explain its own arrangement nor express the form it clings to; the head master refining his folds and pleats into concentric curves or long vertical accents that make the slim figures as structural as their own colonnettes. He is not above a reminiscence here and there of Romanesque; one of the "ancestors" still crosses his legs in a Languedocian pirouette, but the new style humanizes form and face, modifying the arched eyebrow and bulging eyeball of the earlier masters, and presenting in the Christ of the central tympanum a new Saviour, no longer the threatening avenger of monastic Last Judgments but a mediator between God and man.

The master who carved the enthroned Madonna of the south portal is close in style to the sculptor of the Sainte-Anne portal of Notre-Dame at Paris. This portal belonged to the original church replaced by the cathedral begun in 1163, or else to the early plan of Notre-Dame itself, and in any case betrays its later adjustment to the loftier and more pointed other two portals of the final façade (*Fig. 107*). The additions of the thirteenth century include some voussoirs in the archivolts, the decoration of the area between the old rounded arch of the original tympanum and the new pointed ogive above it, and finally the second lintel added at the base to raise the portal to the height desired. On this lintel, since Christ's Infancy was already illustrated on the older lintel above it, the sculptor of the thirteenth century had recourse to the apocryphal stories of the Virgin and her parents, Joachim and Anna, from which latter character the portal derives its name. Two generations separate these friezes, enough to sharpen the contrast between proto-Gothic and High Gothic style. In the upper lintel the heads are too big and frontal, the faces Teutonic and grim; the movement and gesture are stiff, the drapery clinging. In the frieze below there is natural, though restricted, gesture and gait, three-quarters posture, more fluent drapery, and a new quality of civilized gentleness. The new style lacks however the rude force of proto-Gothic, which is at its best, despite modern reworking, in the Madonna of the tympanum, flanked by angels and the figures of Bishop Maurice de Sully, and the donor King Louis VII of France, whose donation is recorded to the left by a seated scribe. This

[7] W. Vöge, *Die Anfänge des monumentalen Stiles im Mittelalter*, Strassburg 1894, pp. 37 ff.

Madonna continues a type current in Romanesque art from the tenth century—frontal, hieratic, less the mother than the throne of her Child, she nevertheless is not without a touch of Gothic humanism, visible in the more sensitive modeling of her face and hands.

Between the archaic reliefs of the Sainte-Anne portal and its reconstruction, the evolution of Gothic sculpture is carried forward by the first atelier that was organized for the new cathedral of Chartres, begun after the fire of 1194 had destroyed all of the church except the west façade. The best work of this atelier is not all at Chartres; it has left excellent trace of itself in a series of statues on the west front of Reims, relics probably of an abandoned earlier program for the sculpture of that façade (*Fig. 108*). The series begins with a badly mutilated figure of uncertain identity on the face of the buttress of the south portal. Next to him is Abraham, looking up to heaven whence comes the voice bidding him stay his hand, already raised to slay the pinioned Isaac; on the pedestal below is the ram caught in the bushes. Moses follows, holding the tablet of the Law and the column surmounted by the brazen serpent. Isaiah stands above the sleeping Jesse, prophesying the "rod out of the stem of Jesse" that named him as the ancestor of Christ. John the Baptist is next, displaying the Lamb of God upon a disc.

The series ends with Simeon holding in his arms the cross-nimbed Christ child, expressing thus the denouement toward which these symbolic figures tend. Isaac, the innocent sacrifice, foreshadows the crucified Christ; his Cross is typified by Moses's brazen serpent. The stem of Jesse in Isaiah's prophecy is premonitory of the coming of the Saviour, whose arrival is heralded by the Baptist's "behold the Lamb of God" and realized at last in the Presentation of the Child in the Temple where he appears in Simeon's arms. These figures of clinging drapery and timidly projecting arms represent the style of Chartres in the early years of the thirteenth century, not yet liberated from proto-Gothic archaism. The Chartrain stamp upon them is the multiple ridging of the drapery, and especially their long heads with salient cheekbones, and the air of transfigured simplicity which pervades the products of the school.

The same five "types of Christ" are in fact repeated at Chartres itself, in figures on the central portal of the north transept.[8] Here they are joined by five more of similar significance: Melchisedek, Samuel, David, the prophet Jeremiah, and Peter as the beginning of the church. These transept portals of Chartres, with their porches, are among the most elaborate transept façades in Gothic architecture. They owe their magnificence to the survival of the west front in the fire of 1194, for when the new cathedral was planned at the

[8] M. S. and E. Marriage, *The Sculptures of Chartres Cathedral*, Cambridge, England 1909.

beginning of the thirteenth century, the new concepts of iconography and style had perforce to find expression in the transepts and not in their usual location on the west façade. Newest of these concepts was the greater reverence, as Gothic feeling ripened, that was paid to the Virgin, and especially at Chartres where no local saint disputed her pre-eminence. The north transept was devoted to the Old Testament, but this was viewed as ending with Mary and the Incarnation, and her Death, the Assumption of her soul by Christ, and her Coronation were the themes of the central one of the three north transept portals. The pillar that supports the lintel of this portal is the proper place, in High Gothic iconography, for the statue of the Madonna; here however we see her mother St. Anne, holding the infant Virgin in her arms. The head of St. Anne, one of the chief relics of the cathedral, brought to Chartres in 1205, explains the substitution.

This slender figure, a happy compromise between the structural rigidity of the earlier style and a real rendering of motherhood, is thus an unusual though not inconsistent element in the symbolism of the old dispensation, worked out in so great detail in the sculpture of the three north portals. In the orders of the archivolt of the central portal, after the angels who hold their

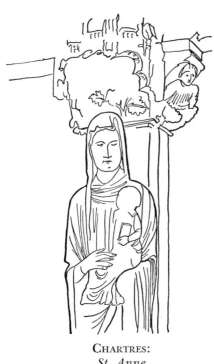

CHARTRES:
St. Anne

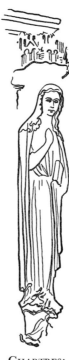

CHARTRES:
St. Modesta

accustomed place in the inner order, we find the prophets who foretold the coming of Christ, and the figures representing his ancestry—a linking of Old and New Testament seen again in the "types of Christ" mentioned above whose statues flank the portal to right and left. In the tympanum of the left portal are the Infancies—the Nativity and the Adoration of the Magi in which the Virgin is protagonist—and in the archivolt are the virtues Gothic piety ascribed to her: the Fruits of the Spirit, "love, joy, peace, longsuffering, gentleness, goodness, faith, meekness, temperance" (St. Paul, Epistle to the Galatians, v:22), and for good measure the three Theological Virtues of Faith, Hope, and Charity, and the four Cardinal Virtues, Justice, Self-control, Wisdom, and Courage. The right portal continues the prefiguring of Christ in similes from the Old Testament: the Lord with two adoring angels presides over the sufferings and temptation of Job, type of the Passion of Christ, and the Judgment of Solomon, symbol of divine justice. The Old Testament imagery continues in the archivolt with the stories of Esther, Samson, Tobias, Judith, and Gideon; and in the statues flanking this portal—Balaam who foretold the Messiah (Numbers xxiv:17); the Queen of Sheba and Solomon; Jesus son of Sirach, author of Ecclesiasticus and homonym of Jesus Christ; Judith, deliverer like Mary of her people; and Joseph, betrayed and sold as was the Saviour. Beside the left door the statues revert to Mary: Isaiah, with his prophecy of the virgin's son, stands next to the Annunciation; on the other side Mary and Elizabeth, pregnant with Jesus and John Baptist, meet in the Visitation, with Daniel beside them, foretelling the Virgin Birth with his vision of the stone cut without hands from the mountain. On the pedestal of Mary's statue is the Bush that burned before Moses and was unconsumed, a further symbol of her purity.

In these figures of the lateral portals a later phase of Chartres style can be seen, in greater detachment from the pillars on which they are carved, a greater freedom of their movement and gesture, and the fluency of their drapery. But the persistence of this manner commenced in the first decades of the thirteenth century is one of the remarkable phenomena of Gothic sculpture. The atelier that carved the "types of Christ" for the central north portal trained the workmen who were authors of the Christ and apostles of the south transept, and these in turn taught the sculptors of the statues of the lateral portals north and south. The style goes on into the second half of the thirteenth century with constantly increasing fluency and power of characterization, but never loses its essential features of finely ridged drapery, reticence of gesture, and simple but deep religious feeling.

Its climax is the Christ on the pillar of the central portal of the south tran-

sept (*Fig. 110*)—the finest embodiment of the Gothic concept of the Saviour, a Christ unmistakably French, solemn and Romanesque in his rigid verticality, but benign withal and intimate, far from the remote Pantocrator of Byzantine mosaics. On the embrasures of the portal are the twelve apostles; in the tympanum the Last Judgment in High Gothic guise, with the Saviour showing his wounds, surrounded by angels holding the cross, lance, and other instruments of his Passion, and the suppliant figures of Mary and the Beloved Disciple, praying for erring humanity. On the lintel below St. Michael separates the Elect and Damned, whose beatitude and torment are spread over the lower voussoirs of the archivolt to left and right. The rest of the arch contains the full assemblage of heavenly hosts, the Nine angelic Choirs—Seraphim, Cherubim, Powers, Dominations, Virtues, Thrones, Principalities, Archangels, and Angels.

Thus was pictured the Second Coming of Christ, considered by the comprehensive scholastic logic as the proper end of history, whose previous course was illustrated, again from the scholastic point of view, on the portals to left and right, as the chronicle of the church and its saints. To the left, on Christ's right, is the portal of the Martyrs; to the right, that of the Confessors, saintly men who nevertheless did not win the crown of martyrdom. Type of the martyrs is the first one, St. Stephen, whose story is told on the lintel of the left portal, with Christ as the martyr *par excellence* in the tympanum above him. In the archivolt the saints who died for the faith are deployed, first the children, the Holy Innocents; then the Elders of the Apocalypse, receiving in their robes the blood from the Lamb on the keystone (Rev. vii:14); lastly a miscellaneous array of sainted kings, priests, and bishops. The embrasure statues continue the catalogue with SS. Theodore, Stephen, Clement, and Lawrence on one side, and Vincent, Denis, Piat, and George on the other. The first-named is an inimitable piece of idealized concreteness; clad in the full dress of a knight of the day, with chain mail, surcoat, pointed shield, sword, and bannered lance, he is the beau ideal of young French manhood, but his bending head links all this realistic detail with the dominant dogmatic theme (*Fig. 113*).

The right portal, devoted to the Confessors, shows Christ again in the tympanum, blessing the two most popular confessor-saints of the Latin Church, Martin and Nicholas, whose stories are told below. St. Martin divides his cloak with a beggar and sees Christ clad with its severed portion in a dream as he sleeps. St. Nicholas drops money through the window of a poor nobleman's house to endow his daughters, and at the saint's tomb the sick are healed by the oil that issues from it. Both saints appear again as statues beside the door,

in company with other famous Confessors—Pope Leo the Great, St. Ambrose, St. Jerome, St. Gregory, and St. Avitus—and the orders of the archivolt are filled with the holy monks, kings, bishops, and warriors who complete the history of the church, and for the purposes of Gothic philosophy, of man.

The drama of Redemption, carried from the beginning to the Incarnation on the north transept, is thus completed up to the Last Day on the south. But the piety of Chartres, famed even in a pious age for the devotion of its people and its clergy to this cathedral, for whose building nobles and peasants alike are said to have harnessed themselves to drag the stones, was not content with the transepts thus completed, and c. 1224 the porches were begun which serve as vestibules for the portals. On the arches and piers of these porches were carved the remaining portions of the Gothic encyclopedia. Appropriate to the moral perfection of the Virgin, mistress of the north transept, were the Beatitudes and the Active and Contemplative Life represented on the left arch of the porch, and to complete the Old Testament the middle arch displays the story of Creation and the Fall of Man, while the labor of mankind thereby imposed is symbolically rendered on the right arch with the Occupations of the Months. On the pillars are a throng of graceful figures of sometimes unknown identity, the final products of the Chartrain school, and last of the 700 carved figures of the north transept, among whom a local martyr, St. Modesta, seems to raise her hand in welcome to the visitor. On the south porch, the symbolism centers on the themes of Judgment and sainthood: we find as types of sin and righteousness the Wise and Foolish Virgins, and the Virtues and Vices; to complete (and even repeat) the list of saints commemorated on the portals, there are the Elders, the virgin martyrs, prophets, a series of scenes of martyrdom, and two dozen additional confessors.

The Virtue of Constancy and its corresponding vice are here reproduced from one of these series (*Fig. 112*). Constancy is portrayed in scholastic abstraction as a seated personification, holding a shield on which is her symbol of a crown ("Be thou faithful unto death, and I will give thee a crown of life," Rev. ii:10). Below, the sin of Inconstancy is given its most flagrant illustration—a monk has cast off his habit and leaves the open door of his cloister. The sudden reduction thus of the abstract ethic embodied in the Virtue enthroned above, to an instance of everyday experience, is essentially Gothic, like the homely setting of the relief (*Fig. 109*) from the old choir screen of the cathedral (now in the crypt), wherein the Magi, warned by an angel to flee the wrath of Herod, are awakened as they lie in bed, while a groom tends their three horses outside a carefully rendered door.

Chartres was a country cathedral, just beyond the active commercial and in-

tellectual life that was in full flow in more northern France. The air of rustic simplicity which gives its sculptures their reticent charm is lost as we move to the cathedral schools of Paris and Amiens. The west front of Notre-Dame at Paris was completed as to its portals (incorporating and remodeling the Sainte-Anne portal) about 1220, and the sculpture of its façade is thus contemporary with the second phase of the school of Chartres. Only the reliefs are original, however, the statues dating all from the nineteenth-century restorations of Viollet-le-Duc, who also left hardly a section of the relief work entirely untouched. The central door has its proper subject of the Last Judgment, portrayed as at Chartres, except for the Resurrection of the Dead added on the lintel (and entirely restored); the most striking feature of this composition is a detail of Hell—Death on the "pale horse" (Rev. vi:8) in the form of a naked female, with the "hell" that "followed with him" falling from the horse with bursting bowels.

The finest of the Paris portals is the north door, dedicated to the Virgin (*Fig. 105*). The story of her death, with the apostles miraculously transported to her bedside from the ends of the earth, is taken from the *Golden Legend*, the thirteenth-century encyclopedia of saintly lives and legends, and also the second scene in which her body was lifted by angels at Christ's command, and carried up to Heaven. But the culmination of Gothic iconography, the Coronation of the Virgin by her Son, is only implied by the legend; it was the ardent Mariolatry of the thirteenth century that made it the central theme of Virgin portals. The story at Paris is developed in characteristically scholastic fashion, reflecting the pondered religious thinking of the university town. In the center of the lintel is the Ark of the Covenant, symbol of the Incarnation, with three royal ancestors of the Virgin to the right, and three prophets on the left. With that finesse which makes the sculpture of Paris more sophisticate than other schools, the sculptor has solidified the lintel composition by spreading an open scroll across the knees of the six personages, thus affording a sort of plinth for the composition above. The drapery of these figures, with its flattened pleats, is better observed than the ridged surfaces of the drapery at Chartres, and the prophets, apostles, and kings wear an air of intellectual piety quite different from the naïve devotion of the other school.

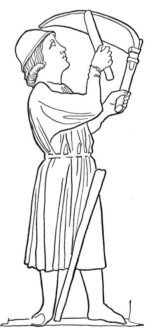

PARIS, VIRGIN PORTAL:
The Mower (June)

[283]

Most noteworthy in this portal is the new natural ornament; the trees beside the seated apostles are but part of a rich growth, including some ten varieties of the flora of France, which encloses the archivolt, entwines the panels beside the portal, and invades the calendar of the month occupations on the jambs.

If Chartres be called the cathedral of the mystic, and Paris that of the schoolmen, Amiens may without too much forcing of metaphor be termed the cathedral of the bourgeoisie. It is also the most consistently High Gothic of the French cathedrals, built and decorated within the thirteenth century, with its west front begun in 1220 and finished in 1236. The normal iconography of a Gothic façade could here be carried out without adjustment to earlier work, and so we have the Last Judgment in the central portal, the Virgin's door to the right, and the portal of the local saint, in this case St. Firmin, to the left. Here too are preserved all three of the *trumeau*-statues on the piers supporting the lintels of these portals, the famous Christ, the *Beau-Dieu d'Amiens;* the figure of St. Firmin; and the Virgin, in her High Gothic role as a standing Madonna, no longer the seated throne of her Son as in proto-Gothic renderings, but a womanly figure, tempering a regal dignity with youth and motherhood. The *Beau-Dieu* stands on a pedestal carved with beasts of the ninety-first Psalm: "thou shalt tread upon the lion and adder, the young lion and the dragon shalt thou trample under feet." The adder lays one ear to the ground and covers the other with his tail; this was interpreted by Gothic symbolic zoology as the sinner "who stops his ears to the Word of Life." The Christ is a sterner figure than the one at Chartres, more mundane, and much more freely constructed; the right arm projects in a blessing (that has in it also something of a warning), the drapery has acquired full folds and undercut shadows, and the mantle is pulled up diagonally across the waist to mask the *bête noire* of Gothic sculptors—the articulation of hips and torso.

The essence of Amiens style is contained in the figure of St. Firmin, embodiment of undoubted, but somewhat official piety (*Fig. 111*). The statue embodies also the virtues and faults of the school: its dexterous technique, visible in the fine detail of the episcopal attributes and costume, and its trend toward a smooth superficiality. Responsible for this was the encyclopedic synthesis which the cathedral represents—with thousands of statues and reliefs to be produced, to illustrate the innumerable details that made up the cathedral's symbolism, the instinct of realism was overborne by the scholastic ensemble, and individuality sacrificed to type. Resulting also was a tendency to model the features superficially upon the face, and seek artificial rather than natural means of expression, of which one instance is the lifting of the lower

eyelid to a horizontal line, giving the curious almond-eyed effect that will cling to Gothic art until the Renaissance.

The apostles who with the four major prophets line the embrasures of the central doorway are a debonair assemblage, cheerfully parading their symbols of martyrdom. The superficial technique of the school is most evident in the overloaded detail of the Last Judgment, Mary's Death and Assumption, and the Finding and Translation of St. Firmin's relics, which are the subjects of the tympana of the portals; the same is even more true of the archivolt reliefs, and to a lesser degree of the statues flanking the lateral portals. The finest reliefs on the façade are in the quatrefoils of the *soubassement*, representing prophecies, the Virtues and Vices, Old and New Testament scenes, and the Labors of the Months. Our illustration of one of these "labors" (*Fig. 114*) selects the month of leisure rather than of work; it is May, with a man rest-

ing under a flowering tree, and the zodiac sign of the Twins, above, turned into a pair of lovers.

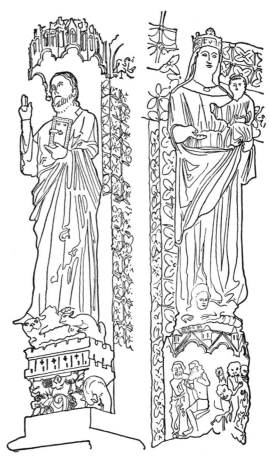

The style of Amiens, reflective of the atmosphere of a prosperous commercial town, seems to be a continuation of that of Paris, with a developed technique that masks the lack of invention one feels in the Amiens work outside of the three fine *trumeau*-statues. Another atelier was active at this time at Reims, which seems to have been inspired by Chartres. The statues of the "types of Christ" on the front of Reims cathedral are sufficient evidence of the domestication there of Chartrain style, and this series may well have been part of a Virgin portal of an original design for the west façade. If this be so, the central Judgment portal of this abandoned design is the one now relegated to a lateral position on the north transept of Reims, and the portal of the local saint the one which is now the

AMIENS: *Christ and the Virgin*

central door of this transept. The third portal seems to be made up of the sculptures of a sepulcher taken from the interior of the old cathedral (burned in 1210); of this portal the most interesting details are the crisp early Gothic foliate ornament decorating the round arch of the tympanum, and the figure of the Madonna in the tympanum itself—a figure of transition, seated like her sisters of Chartres and the Sainte-Anne portal of Paris, but with the Child shifted from his hieratic frontal pose to a more filial position on her left arm.

The Judgment portal of this north transept was restored in 1830, and the Christ on its *trumeau* is of later Gothic vintage; Panofsky [9] has identified the original occupant of this *trumeau* as the statue of Christ now walled into a buttress of the choir, similar in style to the apostle figures on the jambs. Certain features reflect the reconstruction of the portal: its embrasures are not splayed in Gothic fashion; the Resurrection of the Dead which should occupy the lowest lintel has been moved up to a higher register; the apostles that flank the door are six only, instead of twelve. In the groups of Elect and Damned, a portion of the latter has been chiseled out because the cathedral clergy of the eighteenth century were shocked by the too literal rendering of the Vices as there portrayed. Noteworthy is the Resurrection of the Dead, composed of two rows of little nudes getting out of coffins with Gothic ornament, or huge jars, and reminding us with their summary modeling that Gothic style, based on a tradition of a human figure draped with Christian modesty, never had the training in nude anatomy that is the foundation of Greek sculpture.

The central portal, known as the Sixtus portal, was more probably dedicated to the local St. Remi, since scenes of his life are included in the reliefs of the tympanum. The saints and angels on its embrasures are the figures that show the school's relation to Chartres; modeled with more ample volume, and more detachment from their colonnettes, they nevertheless are dressed in the finely ridged drapery of the earlier school. The peculiar features of this Reims atelier of the first half of the thirteenth century are a tendency to put the knee too low, with that innocence of bodily structure exhibited by the nudes of the Resurrection, and to render the hair as a wiglike curly mass. The most characteristic and most attractive product of the school is the group, in the Judgment tympanum, of Abraham receiving in his bosom the harvest of little naked souls borne to him on the draped hands of a bevy of angels; the patriarch has the protuberant cheekbones and facial type of the Chartres "types of Christ" and apostles, while the angels are Chartrain in their drapery, but wholly local in their curly wigs and squat proportions. Reims seems to have been the center

[9] E. Panofsky, "Ueber die Reihenfolge der vier Meister von Reims," *Jahrbuch der Kunstwissenschaft* 1927, p. 68, fig. 4.

of a more original iconography (witness the variety of detail in the Judgment) and a more creative style than Amiens; we shall meet its peculiar heads, drapery, and low-placed knees again when we come to examine the sculptures of Bamberg in Germany.

❖ ❖ ❖ ❖ ❖

The trend of French Gothic sculpture from the middle of the thirteenth century was not determined by the mysticism of Chartres, the thoughtful style of Paris, nor the robust naturalism of the early atelier at Reims. Direction was given rather by the more superficial technique of Amiens, which afforded easier entrance to the new esthetic rather than religious ideal that was to govern French sculpture for a century. The landmark of this change is the completion of the transept portals of Notre-Dame at Paris about 1255. On the south portal is the story of St. Stephen, and a number of reliefs by some interpreted as scenes from student life at the University. In these attractive panels the reduction of reality in the interest of graceful line and unruffled area is far advanced; the heads are scarcely modeled, and the drapery is all smooth surfaces and curves. In the Stephen stories there is more attention to detail, but the anatomical weakness of the style comes out when unusual action must be rendered, as in the stoning of the saint, in which the awkward movement of the executioners' arms seems about to tear their sleeves, and Stephen's crouching body is swathed in a dalmatic that is a mere unfunctional bag.

These transept portals (*Fig. 115*) are probably the most beautiful and certainly the most consistent creation of French Gothic. Conscious now of esthetic intent, the gables rise sharply with an extreme of aspiring points, and no limiting line or surface is allowed to stand without crockets or perforations to dissolve it. The aim of Gothic toward solution of form *in* space, contrasting with the ancient insistence on the definition of solids, is expressed here as in the thorny Gothic lettering by tapering pinnacles and points, whose manifold variety is organized with just proportion and scale into an ensemble of singular loveliness. The north portal being the Virgin's, the Infancies are carved on the lintel (Nativity, Presentation, Massacre of the Innocents), and her most popular miracle, the rescue of the erring Theophilus from his compact with the devil, occupies the tympanum. The focus of the portal is the Madonna on the *trumeau,* the only statue still surviving of the lower story of the cathedral, and not without some damage of its own, since the Child has been broken away from the Virgin's arm (*Fig. 116*).

She is a new type of Madonna, a French aristocrat, on whose face the eyes, nose, and mouth are diminished to ultrarefinement. Standing with weight on

[287]

one foot, her body sways from the line of the lintel pillar, and breaks the hitherto normal conformation of the statue to its architectural member. The mantle is drawn across the body in a beautifully fluent sweep which introduces the Gothic "cascade" on her right thigh, and another feature of late High Gothic drapery is seen here first in the increasing heaviness of the dress toward the feet, and its relative thinness about the breast and shoulders, resulting in a tapering columnar effect. The statue marks the break in High Gothic sculpture, the loosening of its structural integration with the cathedral, and the divorcing of its content from the *credo* the cathedral represents. The popular undertone of Gothic is coming to the surface, but inheriting no technique or tradition of style wherewith to express its realism, it strives to bend thereto the ideal vocabulary of cathedral art, with increasing artificiality and mannerism as the result.

The result in fact is manifest in the Madonna placed upon the *trumeau* of the south transept of Amiens a decade later (*Fig. 117*), the "Golden Virgin" of local nomenclature, made famous by Ruskin's epithet, "soubrette of Picardy." The traits incipient in the Paris statue are here accentuated: tilt of the head, slit eyes, heavy drapery tapering toward the breast and head, and the hipshot pose. No pains are spared to turn the Mother of God into a lovely lady; the youthfulness of the head is underlined by the playful glance exchanged with the Babe, the heavy crown on the girlish brow, and the eagerness of the scrambling angels who support her nimbus. Round about the *trumeau* runs a border of hawthorn, continuing along the stringcourse of the lintel on which the twelve apostles stand in genteel conversation. St. James is arrayed as a pilgrim with his staff and hat, and all the Twelve are well shod, against the austere tradition of mediaeval iconography that apostles' feet should be bare of aught but sandals.

The *fin de siècle* phase of the High Gothic trend is illustrated by most of the sculpture on the west front of Reims.[10] This was among the longest of the great French cathedrals in building; after the old church was burned in 1210, the present one was immediately begun, and finished only at the century's end. We know the names of the architects from an inscription which once was in the pavement of the nave, telling us that Jean le Loup began the portals, Jean d'Orbais began the "coiffe" (meaning either chevet or vaulting), Gaucher of Reims worked on the vaults and portals, and Bernard of Soissons completed five vaults and the western rose window. The façade itself is evidence of late date; there is in Gothic architecture no more complete solution of form in space. The west front of Paris had still the square outline of

[10] P. Deschamps, *La cathédrale de Reims*, Paris 1937.

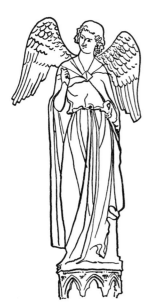

REIMS, WEST FRONT:
An Angel

proto-Gothic, with buttresses well marked and separating the portals; Amiens impaired the clear division of portals and stories by advancing the statuary row around the buttresses, and the gables into the second story. But at Reims the buttresses are masked by the union of all three portals in a continuous screen; for more light (and less mass) the tympana have disappeared, making way for windows, and their compositions have been moved up into the gables; the gables themselves have climbed higher in the effort to mask and break up the horizontal accent of the stringcourses, and the solidity of the towers has disappeared in open galleries. Iconography has followed the suit of architecture, relaxing dogmatic tradition for sentimental appeal: the Last Judgment, rightfully the subject for the central portal, is relegated to the right gable; in the left is a much-restored Crucifixion; the place of honor is accorded to the Coronation of the Virgin, sculptured at the apex of the central door. On the *trumeau* of this door stands a simpering Madonna, a weak creation weakened more by modern "restoration."

The bombardment of Reims during the first World War ruined many of the portal statues across the front of the cathedral; the special victims were the groups in the left bay where the burning of a scaffolding, lighted by a shell, broke and calcined the figures. One of these was an angel, the right of two attending St. Nicaise on the left embrasure of the bay, whose enigmatic smile has become famous as the "sourire de Reims." In other angelic faces of the façade however the smile becomes a grimace, as on the countenances of the angels in the Coronation group of the central gable, and throughout this extraordinary series of statues the eye ranges from puzzlement at the triviality of one piece to admiration of the dignified beauty of another. The reason for such unevenness of inspiration would seem to lie in the composite character of this *fin de siècle* atelier, recruited from the schools of Chartres, Paris, Amiens, and possibly even Germany, where the great cathedral workshops were finishing their work.

In the Annunciation and Visitation of the central bay (the Virgin portal), the gathering of styles can be seen at first glance (*Fig. 119*). The Virgin Annunciate is typically of Amiens, with the stolid expression of the statues on the embrasures of the Golden Virgin's portal, while Gabriel is an epicene cousin of the Golden Virgin herself, with all the details of fastidious daintiness

[289]

enhanced. On the other hand the Mary and Elizabeth of the Visitation exhibit a style difficult to parallel in Gothic art at all, conditioned apparently by the same imitation of some surviving Roman statues as that which produced so antique an apparition in the so-called Samuel on the left central buttress beside Gabriel. Yet one can recognize in the broken ridges of the drapery, the low-sunk knee, and robust amplitude of physique, an affinity with the Chartres-derived style of the earlier school of Reims, whose influence we shall find later at Bamberg. The Teutonic features of Mary, and the resemblance of Elizabeth to the corresponding statue at Bamberg (*Fig. 120*), raise the question whether this eclectic workshop of Reims may not have included a German sculptor, trained in the early Reims style, active at Bamberg, and returning to Reims to join the atelier recruited for the final sculpture of the façade. Unfortunately this must be left to conjecture because of the lack of agreement on the relative dating of the Reims statues and the sculptures at Bamberg.

On the other side of the Virgin portal, St. Joseph, the Virgin, the high priest Simeon, and the prophetess Anna enact the Presentation of the Child in the Temple. The figure of Joseph is the Reims exaggeration of late Amiens style; his hair and beard are bushier than at Amiens and the downward curve of his nose with his retroussé mustache give his head a somewhat feline and wholly artificial effect. The lack of essential form in this decadent style is evident here; as soon as the sculptor begins to elaborate detail upon his mass, the volume disappears—one feels a lack of bulk in Joseph's mouth and chin. The dainty prophetess shows to perfection the consummate grace of the autumnal phase of cathedral art; indeed the suavity of Anna and Joseph is unapproachable. The polite air which they give to the scene, as if it were the baptism of some wellborn infant of Reims, grows gently serious on the faces of the Virgin and Simeon in the center. Mary is of the Amiens type she represents in the Annunciation; Simeon's protuberant cheekbones, oblong face, and knitted brow relate him to the "types of Christ" and apostles of Chartres.

The development of the Gothic west front reached its greatest expansion in the façade of Bourges, exhibiting five portals instead of the usual three. Their history however is typical of the mutilation accomplished by the iconoclasm of the religious wars and the antireligious vandalism of the French Revolution. The two portals to the right, dedicated to SS. Ursinus and Stephen, belong to the early years of the second half of the thirteenth century, and the central Judgment portal to its last quarter. But its neighbor on the left, the Virgin portal, has lost all of its Gothic sculpture save two registers of the tympanum; the reliefs of the archivolt and *soubassement* are of the sixteenth century, to which the portal of St. Guillaume, at the extreme left, entirely

belongs. A thorough restoration in the middle of the nineteenth century has left little untouched in the two right portals; in the Judgment portal the Christ of the *trumeau* is modern and all but one of the heads in the Resurrection of the Dead have been restored; as also the two outer orders of the archivolt.

The Last Judgment of the tympanum thus remains as almost the only work by which to estimate the Gothic style at Bourges (*Fig. 118*). The central group of the Christ, Mary and John, and the angels with the instruments of the Passion, is of the usual High Gothic type. Below, St. Michael weighs the souls and protects one of them from a devil, while others less fortunate are prodded toward a huge caldron rising out of a dragon's jaws, which represents here, as in the Romanesque tympanum of Autun, the mouth of Hell. As at Autun, also, Heaven is a city, within which Abraham sits holding the souls of the Blest in a napkin, while angels on the battlements hold forth crowns. The Elect are a happy throng, headed by a Franciscan and a king, moving toward St. Peter who ushers them into Paradise. The late thirteenth-century style is evident throughout these figures: small heads with tiny features, broad sweeps of drapery that becomes baggy on kneeling figures, the mannered tilting of the head. There is how-ever something more vital than decadent in the style at Bourges, allied to the popular taste that could substitute current melodies for plain song, and give Judas a comedy role in Passion plays. The tragicomedy of the Damned shows a positive delight in the bestial presentment of the demons. The smile on the faces of the Blest is not so *précieux* as that of the Golden Virgin; beatitude is expressed by a broad grin.

A sort of apotheosis of the High Gothic decadence we have been following, elevating its artificiality into a norm of fastidious elegance, is reached in the early decades of the fourteenth century, and best illustrated by the Virgin

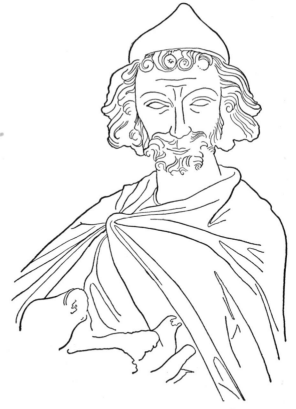

REIMS, WEST FRONT: *St. Joseph*

statue in the choir of Notre-Dame at Paris (*Fig. 121*). There is some analogy between this pert Virgin and the Athena Parthenos of Athens; each was symbol at once of the Lady's protection of the city, and of the city itself. The popular devotion to this Madonna as *genius loci* is probably the reason it survived the pseudoclassic reaction against Gothic in the seventeenth and eighteenth centuries, and the fury of revolutionary mobs. The sculptor has certainly made a virtue of the weakness of his style. All the symptoms of artificial sentiment that the Golden Virgin displayed are here frankly developed. The brows are over-arched and plucked, the almond eyes more Mongolian than ever, the hip thrown further out; the girlish thin mouth is smaller, and the crown makes even heavier contrast with the immaturity of the head that bears it. The drapery which cascaded down the thigh in the earlier style is now brought round in front and complicated by ornate borders and tubular folds; within it, the body has entirely disappeared. Last of all, we are now introduced to the free-standing statue, independent of any architectural *fond* for its effect. It is a just perception that sometimes gives this figure, as it stands in the choir, a background of soft drapery and an entourage of lilies, since such delicate and aristocratic femininity demands the intimate setting of the boudoir.

Nowhere is the taste of France more impeccably exhibited than in this style of High Gothic decadence. Its products were in demand and copied all over Europe. When imitated in Germany, they are often absurd; in England a lean vigor sometimes imparts to them a youthful and attractive *gaucherie;* from the fervor of the Spanish temperament they gain a strange austerity; in Italy they become lyric. In France such works have less religious content than anywhere else, but the elegance of their French treatment made them the norm of taste in the rest of fourteenth-century Europe, and induced a general adoption of French mannerism from sheer worship of its distinction. The carriers of the style were largely the illuminated manuscripts exported from France or done abroad by French illuminators and their imitators, and to a hardly less degree the ivories produced by the ateliers of Paris in the late thirteenth and the fourteenth century. These ivories are not only our best example of the Gothic decadence in quantity production (though sometimes rising to exquisite creations such as the statuette from Villeneuve-lès-Avignon, *Fig. 122*) but having often retained their color, they recall to us the somewhat startling fact that Gothic sculpture in its original state was polychrome. It was, to judge from the ivories, a discreet polychromy like Greek *ganosis,* masking direct comparison with human flesh and clothing, but not approaching real coloring sufficiently to impose the parallel. The ivories were largely devotional pieces, diptychs, triptychs, and polyptychs carved with the Life of Christ and employed for

private devotion, crozier heads, reliquaries, and book covers, but also sometimes objects of profane use such as toilet boxes and mirror cases, on which romantic subjects were the vogue, introducing, significantly, the element of intrigue into mediaeval romance.

HIGH GOTHIC SCULPTURE IN GERMANY, ENGLAND, AND SPAIN

The sculpture made for German cathedrals during the High Gothic period has three outstanding qualities: a technical dexterity considerably above the average in France; a curious subservience nevertheless to French models in iconography and style; and a naturalism of high order, capable of superb expression and characterization, but likely at times to descend to bathos under pressure of emotional content. We have already seen in the Crucifix of Werden the expressive power of German Romanesque; we meet it still in works of the early thirteenth century, such as the Mary of a Calvary group surmounting the choir screen of Halberstadt cathedral—a striking rendering of controlled but bewildered grief. It is more fully realized in the reliefs of the choir screen of Bamberg—an Annunciation, a St. Michael slaying his dragon, and twelve pairs of prophets and apostles engaged in serious and sometimes violent discussion, whose intensity is underlined by Romanesque contortions and swirling drapery.

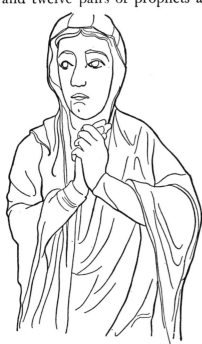

The cathedral of SS. Peter and George at Bamberg [11] is in its present state a construction dedicated in 1237, replacing a Romanesque church founded in 1007 by Henry II and his queen Kunigunde. The founding is commemorated in the tympanum of the Gnadentür, the north door of the eastern end, in a relief showing the Madonna enthroned, adored by Peter, George, and Bishop Thiemo to her right, with the king and queen, and an attendant monk, to her left. In these figures one can see the lively Romanesque of the choir screen sobering down, as it were, into a proto-Gothic style not unlike that of the early transept statues at Chartres, and a further stage is reached in the twelve prophets, each with an apostle standing on

HALBERSTADT: *The Virgin*

11 A. Weese, *Die Bamberger Domskulpturen*, Strassburg 1914.

his shoulders, who line the embrasures of the Princes' portal, on the north side of the cathedral. This naïve symbol of the relation of Old and New Testaments is an idea borrowed from France; it is for instance the subject of the windows in the south transept of Chartres where the apostles are carried pickaback.

In the tympanum of this portal we see the Bamberg manner in still further development; its subject is a Last Judgment that condenses the Resurrection, Separation of the Elect and Damned, and Christ in Judgment—the three separate scenes of French Last Judgments—into the tympanum's restricted space. The Byzantine influence always present in German mediaeval art betrays itself by introducing the Baptist instead of John the Evangelist as Mary's partner in their intercession for humanity. The grins of the Blest and the grimaces of the Damned are so exaggerated in this syncopated rendering of the Last Day that they eventuate in very similar effect, and the devil who leads his victims (including a king) to perdition is frankly comic. But one can sense the attempt to reproduce a French pattern, and the head of the unfortunate king follows the French Gothic formula of flaring curls beside the head—though here emotion makes them flare out unduly in angular fashion on either side.

The French influence on Bamberg sculpture is not difficult to explain. The west towers of the cathedral imitate those of Laon, so much admired in the early thirteenth century (p. 307), and the bishop who built the cathedral, Ekbert, count of Andech and Meran, was connected, by the marriage of his sister to Philip Augustus and of his nephew to Blanche of Champagne, to France and specifically to the province whose artistic center was Reims. It is in fact the early school of Reims that seems the source for the robust figures of the Church and Synagogue which flank this portal. Replicas of these are to be found at Reims, standing beside the rose window of the south transept, but the German sculptor produced a far more powerful though less graceful work, with forms of solid reality that French sculpture of the period never attained.

Our illustration (*Fig. 123*) reproduces the "Adam door," the south portal at the east end of the cathedral, exhibiting the figures of St. Stephen, Henry II and Kunigunde, St. Peter, and Adam and Eve. The filiation from the style of the Reims north transept is not difficult to detect as one notes the wiglike hair of Stephen and Peter, and also the telltale low position of the knee. If further evidence of French derivation were needed, one could find it in the French Gothic chevet of the model of the cathedral held in Kunigunde's hand, closely resembling the east end of Reims. Kunigunde herself is very like the "Queen of Sheba" who is the central figure on the face of the pier left of the central portal of the west front of Reims, and the "King Solomon" who is Sheba's

pendant on the right-hand pier is similar to Henry II. The possible dating of the Bamberg portal as early as *c.* 1235 compromises the usual derivation of the Bamberg style from the later Reims school; it is not impossible that a German sculptor, schooled in the early atelier of Reims, returned to work at Bamberg, and later joined the eclectic group which finished the façade of Reims cathedral. This would explain the Teutonic Mary and Elizabeth of the Visitation at Reims, and the general identity of style of the Elizabeth in this group with the Elizabeth of another Visitation in the ambulatory of Bamberg (*Fig. 120*). The German characterization in this case is far the stronger, even though the drapery suffers from the excessive complication to be noted in German miniature painting of the time. At any rate the French inspiration is obvious in the figures of the Adam portal, and seems here more exotic than elsewhere by reason of its contrast to the Romanesque ornament of the door, its round archaic arch, and the suspended effect of the statues.

The enterprise of German naturalism is to the fore in the frankness of the nude figures of Adam and Eve—something no French Gothic sculptor would have chosen for portal statues. It is even more visible in the royal horseman on a pillar of the eastern choir of Bamberg (*Fig. 124*). His spreading locks, so like those of the king in the procession of the Damned in the Princes' portal, and the indented drapery resembling that of the figures on the Adam door, who are sheltered by the same sort of canopy as appears above this rider's head, enable us to date this equestrian statue in the same middle period of the thirteenth century which produced the sculptures of the Adam portal. The ornament of the console that supports the horse is French and specifically of the east of France, and the usual parallel at Reims is not wanting—a beardless king among those who decorate the buttresses of the north transept. But again we may question whether this royal type was originally German or French. The features of the king at Reims, like those of the Elizabeth of the Reims façade, show in comparison with their replicas at Bamberg a simplification and conventional tightness that smacks more of imitation (if imitation there be) than original. The Bamberg "Reiter" is in any case a fine ideal of German youth, a knightly figure with broad Teutonic features that nevertheless bespeak a gentle birth; enthroned in his saddle, he views the world with cheerful confidence.

This statue (variously identified as a Magus, Constantine, St. Stephen of Hungary, or the Emperor Conrad III) conceived though it be in the formulae of relief, nevertheless marks an incipient revival of sculpture in the round for the equestrian figure, a type preserved in the Middle Ages mainly in the mounted "Constantines" that figure in reliefs on Romanesque façades, especially

in the southwest of France. The type appears in Italy about this time in a group on the front of Lucca cathedral, representing the mounted St. Martin dividing his cloak with the beggar. Somewhat later a sculptor of developed Bamberg style produced the equestrian free-standing statue of Emperor Otto in the market place of Magdeburg. Two allegorical females escort the emperor in the Magdeburg monument, and also in the equestrian portrait of Bernabò Visconti, of the end of the fourteenth century, in the Castello Sforzesco at Milan; these figures, free standing in the German group, serve as props in the Italian work to insure the solidity of the horse, reflecting the caution with which the first attempts were made in this, the most difficult problem of sculptural technique.

The cathedral of Naumburg [12] is closely dependent on Bamberg in plan and superstructure, including the western towers which imitate those of Bamberg as Bamberg in turn borrowed them from Laon. The bishopric, like that of Bamberg, was a creation of the eleventh century, and like Bamberg again rebuilt its cathedral in the thirteenth. It was finished by Bishop Dietrich of the house of Wettin, who installed in the western choir the remarkable series of portraits of the benefactors of the see in the early days of its foundation. Two of these, the statues of the Margrave Ekkehard and his consort Uta, are here reproduced (*Fig. 129*).

Dietrich, by virtue of his lofty birth, could regard most of these noble personages as relatives, and the collection was thus in a sense his own ancestral portrait gallery. But the subjects of the portraits lived two centuries before, so that the "likenesses" are pure evocations, and their strong individuality is therefore even more surprising evidence of German Gothic ability to find its ideal in the concrete. There are twelve of the statues, four of them female, and all but two are carved in French fashion out of the piers they adorn. All are painted, and thus preserve, as does German sculpture in general far more than French, a visual impression of Gothic polychromy. The last renewal of the painting occurred in the sixteenth century. Of the two "founders" here illustrated, Ekkehard has the heavy solidity of the German physical ideal; his squared shoulders and poise of head betoken a somewhat too conscious aristocracy, and his double chin, baggy eyes, and coarse nose and mouth mark him as of fiber far less fine than the margravine beside him. Uta's expression and posture mingle engagingly an unconscious hauteur and femininity; the detached interest that fixes her gaze belongs to the one, and the wholly womanly gesture that raises her mantle to shield her face is part of the other.

The evolution of German Gothic into its own style out of Romanesque and

[12] H. Beenken, *Der Meister von Naumburg*, Berlin 1939.

under French leadership is thus well illustrated at Bamberg and Naumburg. The sculptors of these wholly German towns were remote enough to turn French teaching to those ends of expression and naturalism for which their genius was particularly adapted. In Alsace, at Strassburg, their contemporaries were too near France to be so independent. The Gothic sculpture of Strassburg cathedral [13] is mingled with a large amount of modern restoration, but there are still outstanding examples of it left, notably the beautiful "angel pillar" in the interior, the statues of the two lateral portals of the main façade, and the two portals of the south transept. The lingering aftermath of Strassburg style is seen in the prophet statues of the central western door, of the early fourteenth century. When, in 1793, the commissaries of the French revolutionary Convention (Saint-Just and Lebas) ordered the destruction of the cathedral's statues by way of preparing its transformation into a "Temple of Reason," an indignant naturalist named Hermann removed the statues of Church and Synagogue which flank the transept portals to his botanical garden, and saved the tympanum reliefs by boarding them up and lettering the boarding with the slogan *Liberté, Égalité, Fraternité.* The two lateral statues have given their names to the unknown "Master of the Church and Synagogue," one of the most gifted sculptors of the thirteenth century, who with his school completed the decoration of the south transept, and the "angel pillar" that bears its interior vaulting, with its Christ in Judgment, angels with the instruments of the Passion and blowing trumpets, and the four Evangelists, ranging from floor to ceiling in a wholly original and singularly moving vision of the Last Day. Of the rest of the master's work, the reliefs of the Burial of the Virgin and her Assumption on the lintels of the two doors of the south transept fell victim to the revolutionary votaries of "Reason" and were replaced by copies done in the nineteenth century; the Twelve Apostles of the embrasures are now a collection of fragments.

The "Master of the Church and Synagogue," as one may see from our illustration of the *Death of the Virgin* in the left lunette (*Fig. 127*), is close to the style of Chartres. His German quality comes forth however in the emphatic emotion expressed in these reliefs. He must have been trained at Chartres, deriving thence his fine-ridged drapery and long narrow heads with high cheekbones, deep eye sockets and cheeks, and French water cress provides the foliate border of his scene. But the strong and obvious feeling that sways the figures out of balance is quite out of keeping with the mystic reticence of Chartres, and equally consistent with German naturalism. When this naturalism was

[13] O. Schmitt, *Gotische Skulpturen des Strassburger Münsters,* Frankfurt am Main 1924; H. Weigert, *Das Strassburger Münster und seine Bildwerke,* Berlin 1935.

given architectonic restraint, as in the figures of the Church, crowned and triumphant, and the Synagogue, with broken standard, bowed head, and bandaged eyes (*Fig. 125*), the style is capable of exquisite creation, clothing the thin figure inherited from Romanesque with fluent drapery, and profiting by the unarticulated waist to give an individual accent to these allegorical maidens.

One of the lost apostles carried a scroll with an inscription in the rhymed Leonine verse popular from the twelfth century:

Gratia divinae pietatis adesto Savinae
De petra dura per quam sum facta figura,

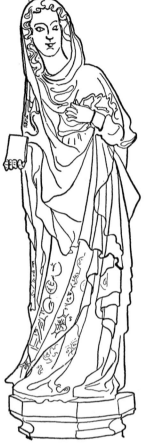

"Let the grace of divine compassion be with Savina of Steinbach (*petra dura*), by whom this figure was made." "Savina" was long considered to be of the family of Erwin of Steinbach who continued the west façade of Strassburg begun in 1277. However this may be, the sculpture that is still original on the western front is of a later vintage than the work of the "Ecclesia" master and runs the gamut of such finely considered works as the Foolish Virgin (*Fig. 126*) to another of the Five, a buxom German *Fräulein* completely and comically fascinated by the "Prince of the World" (a favorite motif in German Gothic iconography), who holds out to her enraptured view the apple of temptation.

COLOGNE CATHEDRAL:
The Virgin

These figures of the Wise and Foolish Virgins, with Christ at the head of the Five Wise and the Tempter in the midst of the Foolish, decorate the jambs of the south portal; on the north lateral door are the Virtues, trampling the Vices underfoot as in Romanesque iconography. These swaying figures are clad in drapery more fluent than functional, with sweeping sharp folds often dominated by one that falls diagonally between the knees from waist to feet, and sometimes showing the "cascade" in front which indicates their date toward the end of the thirteenth century. Such features reflect the influence of decadent French style on the German Gothic, an influence more obvious on what is the most notable German Gothic work of the early fourteenth century, the fourteen statues on the piers of the choir of Cologne cathedral, representing Christ, the Virgin, and the Twelve Apostles.[14]

[14] B. Hertel, *Die Bildwerke des Kölner Domes*, Berlin 1923.

The cathedral of Cologne, begun in 1248, dated from a time when French taste was established in Germany as well as the rest of Europe north of the Alps and Pyrenees, and adhered throughout its long progress toward a completion not accomplished until the nineteenth century, to French style. There can be no doubt also of the stylistic dependence of these figures in its choir upon French fashion of the first half of the fourteenth century—nearly all follow the pattern exemplified by the Madonna in the choir of Notre-Dame at Paris, with the same absence of form beneath the complicated drapery, the same mannered curve of the silhouette. Nevertheless, the figures are as German as can be in the quick and obvious emergence of emotional content, at once more natural and less elegantly controlled than is the case with the French models followed. Moreover the series as a whole shows merely variation of a single theme, taking their cue and curvature from the vaulted space of the choirs. "Like a garland," says Pinder, "their rhythm sways from pier to pier . . . the individual forms are *bent,* and do not bend themselves." [15] There is in such undulating conformity to the curvilinear space in which these figures are set a continuation of the Gothic submission of sculpture to architectural control, but revealing in the search for movement the decay of High Gothic stability.

The perforated stone screen which masks the solid façade of Strassburg cathedral is evidence of similar discontent with the traditional values of Gothic art, expressed in figure sculpture by the veiling of religious content in superficial grace or a naïve naturalism. The change in tracery from the bar tracery of the thirteenth century, confined by its technique in clear geometric patterns, to the involved curvilinear flowing tracery of the fourteenth is evidence of the same trend. In Germany the superior skill of the stonecutters carried the trend to an extreme, reducing Christian history to the tone of a fairy tale, and evolving patterns in stone that are veritable *tours de force.* We reproduce an example of the fourteenth century in a portal of the Sebaldus-church at Nürnberg, whose pendant tracery is a fair example of German virtuosity, and whose statues remind one of the toys for which the city is famous (*Fig. 128*). The Madonna, and the St. Sebaldus holding the model of his church, are no more than admirable examples of technique, and charming but unimpressive in their realism; the Wise and Foolish Virgins below are dolls in stone.

15 W. Pinder, *Die deutsche Plastik des vierzehnten Jahrhunderts,* Munich 1925, p. 23.

❖ ❖ ❖ ❖ ❖

On English Gothic sculpture [16] the French influence is as undeniable as is the case with German, but the native strain is much more to the fore. The early Gothic style of Saint-Denis and Chartres was not without an echo in England, in sculpture as in the making of colored windows. The pillar statues of Solomon and the Queen of Sheba which flank the Romanesque portal of Rochester cathedral (*Fig. 91*) are structural additions, and doubtless inserted on the jambs to follow the fashion set by Suger and the sculptors of the Chartres façade. The style of the quaint reliefs on the Sainte-Anne portal of Notre-Dame at Paris is faintly felt in the friezes that decorate the west front of Lincoln. But the typical French treatment of a portal with pillar-statues and a full composition in the tympanum was rarely followed in England, where one finds rather a tendency to mingle the figured decoration with architectural ornament, and a greater interest in decorative unity than edifying iconography. The Judgment Porch of Lincoln is the only English portal that resembles French models in devoting the tympanum to a developed composition, in this case the Last Judgment.

An English specialty was the sculpture of the spandrels of Gothic arcades, in which the craftsmen sometimes indulged themselves with a wide diversity of subject matter, as in the medley of monsters, foliate ornament, Biblical subjects, and the scenes of the Last Day that ornament the choir and transepts of Worcester. The favorite motif was however a series of angels. Of this decorative solution the best-known example is the "angel choir" of Lincoln. The finest and most typically English application was the angel that fills a half spandrel, as in the ends of the transept of Westminster Abbey (*Fig. 131*), where one wing is deployed to fill the upper corner of the area while the body and the folded wing make a fine stabilizing accent for the vertical termination of the arcade, satisfying thus the artist's native craving for an architectural motivation of his relief. These fine angels that terminate the transepts at Westminster represent the best of English carving in their period of the mid-thirteenth century; the flat pleating of their drapery gives a lovely movement across the surface, releasing a buoyant vigor that is lacking, for all their grace, to the angels of the well-known choir of Lincoln. The slim and angular immaturity which is the Gothic ideal in England is disciplined here to the needs of monumental propriety, without losing entirely its delicate *gaucherie*.

The angels of Lincoln carry the theme of an iconographic scheme designed to relate the Fall of Man, the Incarnation, and the Judgment—obscurely, as is so often the case in English Gothic where dogma is commonly submerged

[16] E. S. Prior and A. Gardner, *An Account of Mediaeval Figure-Sculpture in England,* Cambridge, England 1912.

in ornamental pattern. The decoration of the choir is in fact an obvious mason's work; though carved before placing, the sculptured spandrels are of the stone used in the building's construction—Lincoln stone, with shafts and capitals in Purbeck marble—and made of three slabs with vertical joints that occasionally control the design. On the first bays of the north side (counting west to east), we see the Fall of Man and Christ in Judgment, with one angel bearing the Lance of the Crucifixion and another impersonating St. Michael with his scales. Opposite on the south side is a Madonna and further *membra disjecta* of a Last Judgment—an angel bearing a soul in a napkin and another holding the Book of Conscience. Such examples show the disintegration of the highly organized cathedral iconography when it passed the frontiers of France.

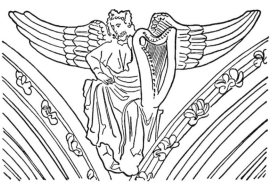

LINCOLN, ANGEL CHOIR: *David*

With the second bay on the south and the third on the north the dogmatic burden of the angels is obviously more lightly felt; they include a crowned and bearded figure holding a harp (evidently David despite his wings), an angel bearing the sun and moon, another with a falcon on his wrist, while the remainder wield their musical instruments, palms, crowns, books, and scrolls with a joyful insouciance that grows more marked as we progress toward the eastern end of the choir. Another swarm of angels surrounds the quatrefoil enclosing the Christ in Judgment of the south portal of the choir, where the turning of the Saviour's glory into the Gothic quatrefoil is an excellent illustration of the predominance of pattern over meaning. Nevertheless the scholastic scheme is more consistent in this portal: the inner order of the archivolt contains a series of kings and queens that were probably meant for the ancestors of Christ, like the "kings' galleries" on French façades, and the other orders exhibit prophets (or apostles) and the Wise and Foolish Virgins who are the proper symbolic adjuncts to a Last Judgment.

The most complete illustration of English Gothic sculpture is afforded by the façade of Wells Cathedral, the great screen built by Bishop Jocelyn between 1220 and 1242, the towers being added from 1390 to 1420. The sculpture of this west front is the most extensive to be found in England, the total number of figures in the round and in relief reaching six hundred, which is about the number on the west front of Reims, the richest in this respect in

France. The statues and reliefs at Wells are arranged in registers which culminate in the attic marking the position of the nave. The first zone has lost its sculpture save for a few statues at either extremity, and the two rows of reliefs in quatrefoils above this register, with half figures of angels and themes from the Old and New Testaments are only partially preserved. The two tiers of statues set in niches on the front and returns of the buttresses, and in the panels between them, continuing around the north tower to and including its eastern front, may be considered to represent the companies of prophets, martyrs, confessors, virgins, etc. that constitute the host attendant on Christ in the Last Day. For the Last Judgment is obviously the underlying motif of the ensemble, though handled in the loose manner usual in English Gothic. The reliefs in the arcade surmounting the arch heads of the windows and the buttresses represent the Resurrection of the Dead, and the row of nine statues in the arcade above them stand for the Nine angelic Choirs; above these again are the Twelve Apostles. The whole is crowned by the mutilated figure of the Christ-Judge, to whom without doubt once knelt John and Mary, in the now empty niches that flank the seated Saviour.

Such an arrangement of sculpture on the façade is unique in English cathedrals, and of course bears no relation to contemporary west fronts in France. Given the slowness with which English Romanesque developed into Gothic, the source of the idea is rather to be sought in the twelfth century, and Prior and Gardner have suggested that Bishop Jocelyn had in mind the aspect of west French Romanesque façades such as those of Poitiers and Angoulême, where the sculpture is spread over an arcaded screen instead of being concentrated in the doorways. The portals of the west of France had commonly no tympanum and were therefore small in span, and this may account for the insignificant scale of the doors of Wells. The tympanum of the main portal contains only a seated Madonna in a quatrefoil flanked by censing angels. Above the door is a panel dividing the series of Old and New Testament reliefs, and containing a mutilated Coronation of the Virgin. The figures in the niches immediately over this panel have been identified as Solomon and the Queen of Sheba. The statues of the façade at present number 127 out of an original 180, and date for the most part within the years of Jocelyn's building of the screen, 1220–1242, but the Nine Choirs and the Apostles are of the fourteenth or early fifteenth century when the towers were added, and pieces here and there in the rest of the ensemble postdate the time of Jocelyn. The two statues of our illustration (*Fig. 130*) are within his period and illustrate the developing Wells style—long slender figures with corrugated drapery, and immobile faces.

The English Gothic tomb was at first an imitation of continental models, es-

pecially the sepulchers at Tournai whence in the twelfth century England had imported some of her baptismal fonts. In the thirteenth century, until near its end, the more luxurious tombs were almost a monopoly of the London workers in Purbeck marble, who are true to English style in the picturesque accent added to their effigies of the deceased—the hands of husband and wife clasped in affection, a warrior drawing his sword, and a constant use of the mediaeval symbol of high social station, the crossed legs. Bronze and wood began to be used in English statuary only at the end of the thirteenth century; the first royal figures in bronze were the statues in Westminster Abbey of Henry III and Queen Eleanor cast by a goldsmith named Torel in 1291. These are hollow cast by the *cire-perdu* method, but overthick, showing inexperience in the craft.

The most attractive aspect of English Gothic is found not so much in monumental work as in incidental sculpture, the heads and figures ornamenting corbels, capitals, and especially the details of ecclesiastical furniture. In this category English craft grew wonderfully proficient in the fourteenth century, and produced little masterpieces in the carving of wooden choir stalls and misericords, whose imaginative vagaries remind one of the contemporary *drôleries* on the pages of English manuscripts.

The decadence of continental Gothic style had its repercussion in England, the influence coming not only from France but apparently from Germany as well, since in the north around York and Durham the end of the thirteenth and the fourteenth century witnessed a vogue for heavy complication of drapery and swaying poses that seem more Teutonic than French. The Peterborough "school" on the other hand clings in style to straighter figures and simpler drapery design conforming to the norms of the earlier Gothic work exemplified by the Wells statues of Jocelyn's time. In the south and west of England the characteristic features of the French decadence appear in childish forms and faces and cascading folds in the front of the statue—a type used in some of the figures of Queen Eleanor carved upon the crosses which her husband Edward I set up, along the road of her funeral procession from Lincolnshire to London (*c.* 1292).

The trend in general of the fourteenth century was away from mason's work done in the *chantier* of the building itself, toward shop productions which consequently lack the earlier architectonic quality. This is true for the statues; in relief one finds a greater elaboration of detail and still further submergence of the figures in the ornamental pattern, as for example in the spandrel carvings of the Lady Chapel at Ely (*c.* 1340). Tombs become more elaborate as the monument rises from the floor and acquires a canopy, and the

ENGLISH ALABASTER:
The Resurrection

coffin begins to be arcaded with figures of "mourners" set in its niches. The first developed example of this type is the sepulcher of Countess Aveline of Lancaster in Westminster Abbey (*c.* 1275); the motif is French in origin, being used on the tombs of a son and brother of Saint Louis in Saint-Denis about 1260, and even as early as the twelfth century on sepulchers in the southwest of France. The Black Death of 1348–1349 seems to have punctuated the development of style in England more than anywhere else. Scarcity of labor resulting from the large mortality it caused led to a standardizing both of architectural and sculptural work, a process aided in no small measure by the appearance at this time of the masons' guilds, and vividly reflected in the wording of contracts that provide for the copying of existing works. Sculpture was no longer considered a necessary adjunct to architecture; if niches were provided for statues, they were at least not always nor immediately filled, or filled eventually with a statue done in a shop without relation to the architectural *parti*.

The effect of the plague can be gauged by comparing works of the first decades of the fourteenth century, such as the charming doorway of the chapter-house of Rochester (*c.* 1340), the lovely lean figures on the Percy tomb at Beverley (*c.* 1320), or the lower figures on the Exeter façade (*c.* 1345), full of vigor and expression, with sculpture of the century's latter half, as for instance the statues on the upper part of Exeter itself, executed in the last quarter of the century in a wooden style, with no differentiation save by gesture or attribute. The "kings of England" on the west front of Lincoln (*c.* 1380) are similarly monotonous, adhering to the single royal type established in English iconography by Edward III. The most important contribution which England made to the closing years of the High Gothic period was the work of the "alablaster men," [17] as they are called in documents of the fifteenth century,

BEVERLY: *Percy Tomb*

[17] Society of Antiquaries of London, *Illustrated Catalogue of the Exhibition of English Mediaeval Alabaster Work,* London 1913.

craftsmen who in the second half of the fourteenth began to exploit the alabaster quarries of Derby and Staffordshire in the making of slab reliefs with scenes of the Life and Passion of Christ and compositions in honor of Mary. The earliest of these pieces are units in themselves with their own borders; later on they appear in sets of three, with the central panel having a battlemented entablature projecting forward, as in a fine example in the Metropolitan Museum of New York exhibiting Christ's Entombment, Crucifixion, and Ascension (*c.* 1430). The final phase of the craft, in the fifteenth century, produced large ensembles made into altarpieces by framing the panels in wood, with whole cycles of the Passion or Virgin scenes thus portrayed. These were articles of export; no complete examples of them exist in England, but they are to be found in churches and museums of France, Spain, Denmark, Germany, Switzerland, Italy, and even Iceland. The English alabasters are no more than routine creations of craftsmen, uniform and uninventive in style and iconography, but it may be questioned if the Gothic period in England has left us anything more essentially insular and innocent of continental refinement; their meager modeling and sharp-featured Norman heads, reminding one of miniatures of the twelfth century, are very English in economy of form and expression, and closer to popular taste than anything that English Gothic produced.

❖ ❖ ❖ ❖ ❖

The story of Gothic style in Spanish sculpture is a strange contrast between a highly individual initiative at the end of the twelfth century and an almost complete capitulation to French fashion in the middle of the thirteenth. The Romanesque of Spain was integrated in such works as the cloister reliefs of S. Domingo de Silos and those of the Puerta de las Platerias at Compostela, and developed no further along a native line in the middle quarters of the twelfth century. Sculpture in this epoch was dominated by foreign influences; we have seen at Sangüesa in Navarre (p. 241) that the façade was composed in west French fashion and pillar figures introduced upon the jambs after the proto-Gothic manner of Saint-Denis and Chartres (*Fig. 90*). The great porch of the church of Ripoll in Catalonia,[18] with its multitude of figures enacting the stories of Peter and Paul, of Jonah, Daniel, Cain and Abel, with groups of David and his musicians, Christ before Pilate, the martyrdom of a saint, and Christ among the Four-and-Twenty Elders, evinces in style so much of Lombard character that it must have been executed by itinerant *Comacini*. They have left their signature, as it were, in the heavily modeled beasts that

[18] A. K. Porter, *Romanesque Sculpture of the Pilgrimage Roads*, Boston 1923, p. 255, pls. 560, 580–582.

form a frieze at the base of the façade, and also by introducing, in a series of the Labors of the Months, the figure of the cooper making barrels for the autumn vintage, which is the characteristic symbol of August in Italian calendars. The western Romanesque of France again is imitated on the portal of S. Tomé de Soria in Castile while the Burgundian style of Autun and Vézelay seems to have inspired the sculptures of S. Vicente at Avila.

The influence of trans-Pyrenean style is evident also in the greatest work of twelfth-century sculpture in Spain, the Pórtico de la Gloria of Santiago de Compostela,[19] but any foreign impulse that can be detected here is far transcended by the poetic genius of the sculptor. He has left his name in an inscription on the lintel of the portal of the porch, *Matheus,* and the date of the lintel's installation, 1183. The focus of the iconography is a double one: above the colonnette engaged to the *trumeau* of the portal sits St. James, the patron of the church, and above him in the tympanum is Christ enthroned in Judgment, with the four Evangelists seated beside him, accompanied by their symbols, and also a row of angels with the instruments of the Passion. On the archivolt the Four-and-Twenty Elders of the Apocalypse make music on a variety of instruments; they are seated as radiating figures after the manner of the decoration of voussoirs in the arches of portals in Saintonge and Poitou. But the theme of the tympanum is not so much Romanesque as developed Gothic; to the old subject of the Apocalyptic Christ and Elders and the evangelistic symbols, there are added the Evangelists themselves and the motif of the Passion angels which is part of the High Gothic concept of the Last Day.

This iconography, advanced for its date, is carried out in the proto-Gothic pillar statues which adorn the embrasures of the three doors—to Christ's right, the prophets; to his left, the apostles—and by the additional prophets, together with a crowned female who may be Judith, and a Sibyl, who figure on the exterior piers of the porch. At the springing of the vaulting ribs are angels trumpeting the summons for the Resurrection of the Dead, and collecting their souls, while the separation of Elect and Damned is illustrated on the archivolt of the portal to the right. The symbolic proportion inherited from Romanesque is powerfully employed in the central tympanum, where the figure of Christ is over sixteen feet in height, and dominates the whole ensemble of the porch. The arresting accent thus introduced has repercussions throughout the throng of statues and reliefs, especially in the figures of the prophets and apostles, who have none of the proto-Gothic reserve, exhibiting still the unstable stance and nervous movement of the old Hispano-Languedocian school. Among them

[19] A. K. Porter, *Spanish Romanesque Sculpture,* Florence 1928, II, pls. 156–160.

one especially is famous in the annals of mediaeval art—the Daniel whose laughing face is a vivid survival of Romanesque expression.

The precocious eloquence of this sculpture is doubtless part and parcel of the brilliant culture that expanded in this corner of Spain in the second half of the twelfth century, absorbing and developing the nascent vernacular poetry of the French Midi, as Matheus combined and extended the French Romanesque and proto-Gothic elements in his porch. But his originality is evident not only in the vitality of his art, but in the absence of any continuation of it save by uninventive imitation, in Spanish sculpture of the end of the twelfth and the early thirteenth century. His style is repeated by a later generation of sculptors who decorated the great hall of the episcopal palace adjoining the church, and his porch was copied at the cathedral of Orense in the first third of the thirteenth century. But at this time the new cathedral style of northern France was entering Spain, and Matheus's brilliant Romanesque was forgotten in the Gothic art that followed the union of the kingdoms of Castile and León in 1230. Its souvenir lived on in remote Galicia, where architecture clung to Romanesque style even into the fourteenth century, and an imitation of Matheus's central portal can still be seen at S. Martin de Noja, dated by an inscription on its lintel in 1434.

At Túy in Galicia, however, French Gothic style makes its appearance c. 1225, in a tympanum obviously taken from the left portal of the façade at Laon, but executed in a manner still local, and archaic as compared with its Gothic model.[20] A real domestication of French Gothic ensued in the two capitals of the newly united Spanish kingdom, when the cathedral of Burgos was commenced in 1221, and that of León in the middle of the century.[21] The sculpture of the west front of Burgos has vanished, and the earliest part of its sculptural program which now survives is the Puerta del Sarmental (c. 1230) of the south transept, a free transcription so far as iconography is concerned of the central doorway on the west front of Chartres. Christ is crowned in southern fashion, but as at Chartres he sits enthroned amid the four evangelistic beasts, above a row of apostles on the lintel, and surrounded by angels and the Elders in the archivolt. Local usage has added the four Evangelists themselves, as at Santiago, writing busily at their desks. The statues of

20 It is curious evidence of the far-reaching influence of Laon that it was also imitated at about this time at the cathedral of Freiberg in Saxony, whose "golden door" contracts the three portals of its French model into one. To the Adoration of the Magi in the lunette is added a Christ at its summit officiating both in the Coronation of the Virgin who emerges in half figure from the arch to his right, and in a Last Judgment, spreading over the other orders of the archivolt.

21 F. B. Deknatel, "The Thirteenth Century Gothic Sculpture of the Cathedrals of Burgos and León," *Art Bulletin*, XVII (1935), pp. 243 ff.

the jambs are of much later date, but the bishop on the *trumeau* may be Maurice, the builder of the cathedral who died in 1238.

The sculptures of this portal have been ascribed by Deknatel to two artists from the atelier of Amiens cathedral, one of whom did the tympanum, the other the apostles, some of the voussoirs of the archivolt, and probably the bishop. The specific French source thus indicated is strongly supported by the close relation of the Burgos Christ to the *Beau-Dieu*. A sculptor trained by these French immigrants was responsible for the Last Judgment of the north transept (*c.* 1240), again copied from a Chartrain model, in this case the central portal of the south transept (*Fig. 132*). The discrepancy between Amiens style and Chartrain iconography in these two portals may be explained on the assumption of a sketchbook of Chartres in the Burgos atelier, which was also employed at León, where the rose window of the north transept repeats the rose in the same location at Chartres. The translation of the Chartres portal is free: Spanish taste for inserting living persons into compositions prompted the introduction of King Ferdinand and Queen Beatrice among the Elect; the archivolt is more sparsely carved with figures than at Chartres, and the apostles that flank the portal are placed not on colonnettes but in niches.

The decoration of the cathedral was carried on for another generation by an eclectic *chantier* which executed the four hundred heads on the arches of the triforium, and the sculptures of the upper cloister, dating in the last third of the thirteenth century. These are headed by the beautiful portal of the cloister, with its tympanum filled by a Baptism of Christ, executed with a freedom and a sense of the effect of tempered light that justifies Bertaux's epithet of "sculpture d'intérieur." On the jambs are an Annunciation and David and Isaiah as prophets of the Incarnation. The Annunciate and Gabriel are ample figures, retaining in pose and gesture much of the expressive quality of Matheus's prophets and apostles at Santiago, and achieving in spite of their Gallic refinement a Spanish accent of significant reality, as opposed to the mere naturalism of German Gothic translations from the French. The rest of the decoration of the cloister consists of a series of wall statues on corbels, and groups on the piers of the porticos. Some of these are contemporary portraits, such as the four princes on one of the piers, sons of Alfonso the Learned and Queen Violante, who are themselves portrayed in statues on the wall. The *Adoration of the Magi* here reproduced (*Fig. 133*) represents the average of the cloister sculpture. The group is close to that of the Annunciation on the portal in its ample forms, clothed in garments with a characteristic Spanish accent, more dry and sharp than the graceful fluency of the parent French style.

The cathedral of León repeats the arrangement of Reims in plan, ambu-

latory, and radiating chapels, though the porch of its west façade and the rose of its north transept are derived from Chartres. The same filiation, due possibly to a Chartres sketchbook as mentioned above, is obvious in the Last Judgment of the central portal on the west façade which adapts the Burgos version of the south transept of the French cathedral. But Spanish realism is carried here to a delightful extreme in the pleasant social gathering into which the assembly of the Blest is converted. A portly king chats with a Franciscan monk; an angel wraps a newly resurrected soul in his mantle; another enlivens the scene with the music of an organ which is pumped by one of his fellows while another beats the time. Hell is rendered circumstantially as well, with two caldrons over fires which devils keep alive with bellows, while demons plunge Avarice and Luxury into one of them. The archivolt is filled

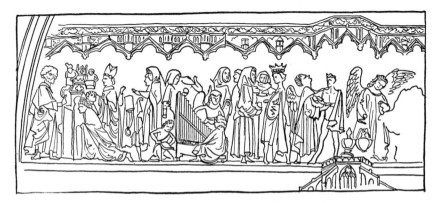

LEÓN CATHEDRAL: *The Blest in Paradise*

with the Resurrection of the Dead (assisted from their tombs by angels), the Elect and the Damned, and martyrdoms of saints, while the apostles (eleven surviving) line the embrasures. On the *trumeau*, however, the Virgin has displaced the figure of the Saviour; *Nuestra Señora la Blanca* is her popular appellation, owing to her polychromed figure in white, detailed with black and red. Her presence here, as in the same location at Reims, is testimony to the disintegration of scholastic iconography in the direction of more sentiment and less dogma.

The lateral portals were done with an eye to the north transept of Chartres, or sketches thereof. The left door has in its tympanum the Infancies (Annunciation, Nativity, the Shepherds, Adoration of the Magi, Flight into Egypt, Massacre of the Innocents), corresponding in a general way to the subject of the left portal of the Chartres transept, but expanding the theme with the Flight into Egypt and the Slaughter of the Innocents. This scene occupies the

top of the tympanum, with a soldier impaling a baby on a spear as the crowning motif. The archivolt has a subject proper to the theme of the Incarnation in its first order, where a Tree of Jesse is portrayed, but the ancestors of Christ are misunderstood as the Elders, and given the musical instruments of the Four-and-Twenty. The rest of the archivolt wanders from the subject with the Lives of the Baptist and Paul, and an interesting but nonpertinent rendering of the priestly orders from subdeacon to pope. The original embrasure statues seem to have been meant as Types of Christ, terminating in the figures of the Baptist and St. Peter as pope, as on the central portal of the north transept of Chartres. This portal at Chartres furnished the inspiration for the right door of the west façade of León, where we have also the Death and Coronation of the Virgin, though the sculptor of León has combined in one scene, not too successfully, the Death and Burial of Mary. At Chartres an iconographic slip occurred when the Wise and Foolish Virgins were inserted in the archivolt of the Infancy portal (left of the Coronation) since these maidens belong properly to a Last Judgment; the error is duly followed at León where the Virgins occupy the outside order of the archivolt.

The central portal of the south transept of León is little more than a replica of the Puerta del Sarmental at Burgos, having the same elements of the apocalyptic Christ, the Four Beasts and the Evangelists, the apostles (standing here) on the lintel, and a bishop on the *trumeau*. The statues of the embrasures, most French of all the León sculptures, are not in their original position, and may once have constituted an Annunciation, with a prophet added, and an Adoration of the Magi—repeating in such case the arrangement on the right portal of the west front of Amiens. The tympanum over the walled-up door to the right of the central portal is decorated with the story of S. Froilán. The archaistic imitation of Burgos manifest in the main south transept portal is increased in the door of the north transept, which reverts, in spite of a date late in the thirteenth century, to a Romanesque composition not unlike that of the Pórtico de la Gloria, with Christ standing in a mandorla upheld by angels, and the evangelists in the corners of the tympanum, writing in the presence of their symbols. This primitive iconography makes strange contrast with the fully developed Gothic drapery of the angels, and of the virgin martyrs and confessors in the archivolt, or the statues on the embrasures of the portal (SS. James, Peter, and Paul, and the Annunciation with a prophet). The Madonna on the *trumeau*, known as Nuestra Señora del Dado, owes her picturesque name to the die (*dado*) thrown by a disgruntled gambler at her figure, which shed blood at the blow.

The style of the León sculptures is French one stage removed; even where

most close to French models as in the Last Judgment of the west front and the jamb statues of the south transept, the local accent is sufficiently pronounced to indicate a native sculptor. The French influence came partly no doubt through the sculptors who worked in Amiens style at Burgos, but also, at León, from the later school of Reims. But even though, to use the phrase of Deknatel, the two cathedrals can be called "outposts of French art in the thirteenth century," their sculpture has in general the graver quality constant in the mediaeval art of Spain, to which the incipient decadence of French art of the second half of the thirteenth century could transmit its artificial forms but not its artificial content. Even in the fourteenth century, when the French decadence, in more accentuated form, was still providing models for the sculptors of the Peninsula, there is usually to be found along with exotic iconography and formulae a certain tough rigor in the Spanish imitation. The incidental sculpture of Spanish cloisters in the fourteenth century abounds in the *dròleries* of the French miniaturists, and the portal of the chapterhouse of Pamplona as well as the charming group of the Adoration of the Magi in its cloister were done by a sculptor Jacques Pérut who signed the latter of these works in French. Yet the *Last Days of the Virgin,* recounted in the tympanum of the portal, and the Epiphany group, are executed with a reticent immobility and brusqueness of accent quite distinct from French design. The same combination of Spanish gravity and French formulae continues in the great sculptural ensembles of choir screens and retables which began to appear in Spain toward 1350; in these there is still the souvenir of Romanesque rigidity, despite the fact that many of them seem to be, in subject matter and arrangement, only enlargements of French ivory polyptychs.

A similar impression is given by Spanish High Gothic painting of the fourteenth century where a more trivial effect might be expected from the influence on it of the mannered style of the French minor art of manuscript illumination. As it was, the austere spirit of Romanesque exhibited in Spanish frescoes of the twelfth and thirteenth centuries is not entirely lost by the panel paintings of the late thirteenth and fourteenth, and endows their quaintness with a *gauche* sincerity. Panels became the principal vehicle for painting partly because of the introduction of Gothic style in architecture, whose broadly windowed walls left little room for frescoes, and while in Spain the Gothic windows were often walled up against the heat, the resulting darkness of the interiors discouraged mural decoration. The painted panels were mostly antependia or altar frontals. They are not limited to the Gothic period, many of them dating in the twelfth century, and constitute in fact the best illustration available for the development of Spanish style from *c.* 1150 to

1350.[22] A fair illustration of the final phase is the altar frontal of St. Clement in the Plandiura Collection at Barcelona (*Fig. 134*).

This piece, dating early in the fourteenth century, is of Catalan origin, and shows its dependence on French illumination by the diapered gold background employed throughout the scenes, which are incidents in the life of Clement, pope and martyr. The obscure episode at the upper left seems to be the conversion of St. Theodora. To the right above is Clement's miracle of the spring: the Lamb of God reveals the spot where the saint could cause water to flow, to slake the thirst of his fellow prisoners, condemned like him to labor in the stone quarries. The trial of Clement is depicted below to the left, and to the right the casting of his body into the sea, with the famous sequel thereof. According to legend a church miraculously appeared to cover the body of the saint, and on the anniversary of his death was revealed by the receding of the waters. A careless mother on one of these anniversaries, joining the procession to and from the shrine, left her child behind when the celebration was over and the waters had closed above the holy place, only to have the infant restored to her (as we see in the final group to the right) by the intervention of the saint. Despite the mannerisms of French miniature painting here adopted— the artificial cascading of drapery, the elimination of space by the decorated background, the curious flatness of the frontal faces—the action is rendered still with Romanesque stiffness, and the narrative conceived with that undertone of serious piety which is seldom lacking to the religious art of Spain. This quality in Spanish art was to find more congenial expression in the second half of the fourteenth century through the introduction of the Sienese style of Italian Gothic painting by Ferrer Bassa and his school, and the substitution, in place of the restricted possibilities of the altar frontal, of the monumental Spanish retable, more often painted than carved, a huge affair which in its final development covered the whole east wall, and rivaled the cathedral itself in the comprehensiveness of its iconography.

ITALIAN GOTHIC SCULPTURE

Gothic style, as we have seen, changed its character as it crossed the Pyrenees, the Channel, and the Rhine, and began to speak other tongues than French, but nowhere is it so transformed as in Italy. In its other colonizations French formulae and iconography were at least the starting point of local modification; in Italy they were opposed by a vigorous tradition of wholly separate

[22] The Romanesque and Gothic panel painting of Spain can be best studied in the well-illustrated articles of W. W. S. Cook, *Art Bulletin*, vols. V, VI, VIII, X, under the title, "The Earliest Painted Panels of Catalonia," and in Volumes I and II of C. R. Post, *A History of Spanish Painting*, Cambridge, Mass. 1930–41.

origin. This origin is familiar to us from what has been said in the chapter on the Romanesque, concerning the persistence of Byzantine iconography in Italy, and the constant tendency in the peninsula to react to stylistic change in the direction of the antique. Even the powerful impulse of Ottonian style from Germany, emerging in the strongly Teutonic Lombard sculpture, was unable to counteract the native predilection for antique forms in the center and south of Italy. Tuscany in the twelfth and early thirteenth centuries produced a Romanesque sculpture that revived Roman ornament and often resembled the reliefs of early Christian sarcophagi, and South Italy and Sicily witnessed a veritable renaissance of classic style under the patronage of Frederick II. In painting, as we have seen, the penetration of the northern Romanesque was negligible compared with the influence of Byzantine style, and in iconography it is only here and there that the traditional Greek types are changed in deference to transalpine notions.

Thus when Gothic style began in Italy in the second half of the thirteenth century, tardily, and at a time when French Gothic was the norm for England, Spain, and Germany, the iconography of Italy was Byzantine and its forward experiments in style were mostly revivals of the antique. The dissociation from the scholastic Gothic of the North can be seen in the decoration of Italian cathedrals. The elaborate and symbolic program of statuary which was the Gothic phenomenon *par excellence* in the cathedral art across the Alps was carried out in only one of Italy's churches, the cathedral of Milan, and was due in this case to an actual importation of German art and artists. Sculptors in Gothic Italy worked less upon the façades of churches than in their interiors, making pulpits, altarpieces, reliquaries, fonts, and tombs. Only at Orvieto can one detect the directing mind of the ecclesiastic which is so obvious in the complicated symbolism of French cathedral sculpture; the smaller and simpler *parti* presented by church furniture left a wider latitude to invention and to the exercise of the lay imagination.

From this arises another characteristic of Italian Gothic art—the emergence of the artist's personality. The sculpture and painting done in transalpine lands in the thirteenth and fourteenth centuries was not so humbly anonymous as is usually assumed, but it is nevertheless true that while the master masons who acted as the architects of Gothic cathedrals in the North have left their names behind them and stamped some individuality upon their architectural design, the sculptors and the painters of the miniatures of manuscripts, even in the cases where their names are known, are indistinct as individuals and seldom emerge enough from general tradition to be credited with a personal style. In Italy on the contrary the Gothic artists made stylistic

history: one need merely think of Nicola and Giovanni Pisano, Giotto, Duccio, and Simone Martini, to realize the outstanding role of sculptor or painter in Italian religious art, in contrast to his submergence in the co-operative work-shops of the North.

The first work of Gothic sculpture in Italy represents at once a complete revolution of style. Nicola Pisano [23] signed the pulpit in the Baptistery of Pisa in 1260, ten years after Guido da Como finished his pulpit in S. Barto-lommeo at Pistoja (*Fig. 80*). The latter is the sophistication of the trend toward insignificance in Tuscan Romanesque. Its doll-like figures tell the Christian story with no more impressiveness than the characters of a fairy tale. The Lombard impulse with which the Tuscan school commenced has left only a lingering reminiscence in the lion pedestals of the colonnettes. The design of the pulpit is rectangular; the capitals and ornament antique; no Gothic accent disturbs this completely Romanesque creation. In Nicola's pulpit the plan is hexagonal, the lions alternate with plinths as bases for the columns, and the Corinthian capitals, though their leaves are cut in the saw-toothed Byzantine mode, are modified with Gothic crockets. Forms strange to Tuscan art appear: the corners of the hexagonal balustrade are marked by clusters of colonnettes; the arches of the colonnade are cusped into the trefoil favored by Arab decorators. In the reliefs we find a powerful resurrection of antique figure style, transcending even those evocations accomplished by the artists of Frederick II's "renaissance."

Of the six sides of the parapet, one is open to the stairway; the other five contain the *Nativity*, the *Adoration of the Magi*, the *Presentation in the Temple*, the *Crucifixion*, and the *Last Judgment*. The first of these panels includes the *Annunciation*, and develops the Birth itself into the panorama employed in Byzantine art, with an angel making the Annunciation to the Shepherds, Mary reclining, Joseph seated, and the two midwives bathing the Child. The *Adoration of the Magi* however is given a separate panel, which is perhaps the one best illustrating Nicola's pursuit of antique effect; the Wise Men are bearded with the curly beard of a Jupiter, and the Madonna wears the coronet and veil of Juno, to whose type her face is conformed. Even the horses of the Magi, protruding into the left side of the scene, are evidently modeled on a Roman pattern. The source of the sculptor's classic vocabulary becomes apparent in the next relief of the *Presentation in the Temple* (*Fig. 135*), for here he has inserted an extra priest behind Simeon, and copied in this figure the drunken Bacchus supported by a small satyr as he enters the house of a poet,

[23] G. H. and E. R. Crichton, *Nicola Pisano and the Revival of Sculpture in Italy*, Cambridge, England 1938.

as the god appears on an antique vase in the Campo Santo, the public ceme-tery, of Pisa. The composition on the vase is a well-known Neo-Attic subject (*Fig. 6*), repeated in reliefs preserved in several European museums; another example was recently unearthed during the German excavations at Ephesus.

From such study of existing Hellenistic marbles came Nicola's composition —a crowded arrangement like that of Roman sarcophagi, with a secondary row of heads and inserted bits of architecture to provide depth to the render-ing, as was done in the late Latin version of Alexandrian style. The classic effect is enhanced by the new respect paid to the human figure, which is now enlarged in scale, and fills the forward plane with dignified and solid volume. It is only in the Crucifixion and Last Judgment that this recaptured style col-lapses, and Nicola shows himself after all of the thirteenth century, and purveyor of a Christian con-tent too fraught with feeling to stay within the bounds of classic calm. Already in the Presentation one is aware of Gothic sweeping folds and the Gothic "cascade" on the Roman garments, and in the Crucifixion, the Virgin's form is completely broken into a right angle as she faints in the arms of the other holy women. The scene becomes even more Gothic by the little figures of the Church and Synagogue introduced in its up-per corners. The Last Judgment, a confusion of forms and heads with some well-muscled nudes in the rendering of Hell, compromised with Byzantine iconography by including the apostles as Christ's assessors in what would other-wise be a Gothic separation of the Elect and Damned. The out-standing impression which these reliefs convey, is however their revival of Greco-Roman forms.

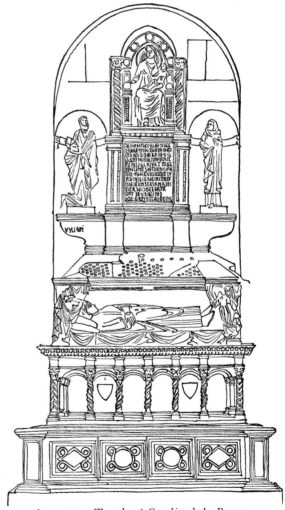

ARNOLFO: *Tomb of Cardinal de Braye*

[315]

The sudden flowering of this "renaissance" in Tuscany can only be explained by Nicola's parentage and early bringing-up in Southern Italy. A Sienese document of 1266 names him son of "Peter of Apulia." From the architecture and sculpture which he saw in the making during his youth came the crocketed capitals like those of Frederick II's French architects in the south, the clustered colonnettes repeating a motif used in Frederick's Apulian Castel del Monte, the hexagonal plan of the pulpit conforming to Apulian practice. In South Italy can be found the parallels for the accessory sculptures of the pulpit—the prophets, Evangelists, and Sibyls carved in relief in the spandrels or as statuettes above the capitals.

The Sienese document mentioned is the record of a threatened fine if Nicola "did not make his pupil Arnolfo come to Siena at once" to work on the pulpit in the cathedral, already commissioned in the same year 1266. He was assisted also in this work by another pupil Lapo and his own son Giovanni, soon to become more famous than his father. The Sienese pulpit (*Fig. 136*) is a larger affair, an octagon instead of hexagon, but employs the same subjects as its predecessor in Pisa, adding the Massacre of the Innocents, and dividing the Last Judgment into two panels. The differences do not end with this extension of the subjects. A narrative interest complicates the Infancy scenes, inserting the Visitation and the Journey of the Magi into the Adoration, and Herod's Council with his Wise Men and the Flight into Egypt into the Presentation.

The compositions with large-scale figures with which at Pisa Nicola so closely approached the classic are replaced by a vertical "ladder" arrangement of row on row of figures and heads. A decided increase in dramatic action unbalances both human forms and the compositions, reaching an extreme in the stirring scene of the Massacre of the Innocents, whose effect is entirely tragic. The classic faces of Nicola's Pisan repertory are here for the most part distorted with emotion; only in the panel of Paradise in the Last Judgment does the quest of classic effect appear again, in two half-draped women seated with backs to the spectator—the first recognition of the decorative nude which Italy had seen since the collapse of antique style. But the influence of ultramontane art is more evident than that of antiquity in this pulpit of Siena. The Seven Liberal Arts of scholastic learning are seated on the pedestal of the central supporting column, with Philosophy at their head; the Virtues appear as statuettes above the capitals; statues have replaced the clustered colonnettes to mark the juncture of the panels. Among these statues is a figure hitherto unknown to Italian iconography—the standing crowned Madonna of the French cathedral portals.

Of the pupils who worked with Nicola on the pulpit at Siena two attained

[316]

a lasting fame—Arnolfo and Nicola's son Giovanni. Arnolfo, whose presence was so earnestly desired by the document of 1266, worked with Nicola and Giovanni on the fountain, the Fonte Maggiore, which was finished in 1278 at Perugia. After that he went to Rome, where he was appointed to erect the sepulcher of the French cardinal de Braye who died at Orvieto in 1282, and established in this monument the "Pisan" type of tomb—a sarcophagus on a dais, with the figure of the deceased recumbent on its lid, and angels drawing curtains to disclose the effigy; above, the cardinal kneels, under the protection of two saints, to an enthroned Madonna whose statue surmounts the whole. At Rome Arnolfo learned the Cosmatesque technique of inlay with which this tomb is richly ornamented, and in return introduced Gothic figure sculpture into the decorative ateliers of the Roman marbleworkers, who imitated, in works of the end of the century, both Arnolfo's tomb of the cardinal and the beautiful canopy he designed for the altar of S. Maria in Trastevere. Another pupil of Nicola's whose hand can be traced in the duller statues of the Siena pulpit was a Dominican monk named Guglielmo, famous less for a pedestrian imitation of his master's style than for his connection with the *arca* or reliquary of S. Domenico at Bologna, begun by him, but finished in the Renaissance, when the young Michelangelo carved for it a candle-bearing angel.

These pupils spread abroad through Italy the new classicism of Nicola, soon however to be made *vieux jeu* by Giovanni's powerful style.[24] The younger man's independent work begins with his pulpit in S. Andrea at Pistoja, in 1301 (*Fig. 137*). This might be almost a monument to his father, so closely has he followed the design of Nicola's Pisa pulpit, in subjects as well as hexagonal plan and alternating supports. But it is characteristic that instead of the Presentation in the Temple, where Nicola's classicizing found its best opportunity, Giovanni has substituted the Massacre of the Innocents, and exploited to the full the tragic content of the theme. His dramatic genius is not confined to the reliefs; the architecture itself of the pulpit develops a staccato accent in its abruptly pointed arches, and one of Nicola's lion pedestals is replaced by a bearded figure bearing with obviously painful effort a colonnette upon his back. The statues of the Siena pulpit are integrated with its structure; at Pistoja they are sprung from the angles with positive and individual action. In Nicola's Nativity at Pisa, Mary reclines with all the calm dignity of an antique matron on an Etruscan sarcophagus; in Giovanni's scene she is a nervous and solicitous mother covering her Child from the cold. The deacon-saint at the left corner of this panel, here illustrated, is a fair sample of Giovanni's

24 A. Venturi, *Giovanni Pisano, his Life and Work,* New York 1928.

modeling, keeping broad lighted surfaces the better to accent sharp-cut folds in drapery and dramatic shadows in the deep triangles of the eyes. No Italian until Bernini will make so free with marble; it is gouged to the verge of form destruction, with every surface and silhouette made alive and intense. The Sibyls, vague symbols of old-world prophecy of Redemption, have become startled maidens, aghast at the import of the message the angels bring them (*Fig. 138*).

Giovanni's adoption of French formulae is far more complete and understood than Nicola's. In the Epiphany the second Magus turns to the last of the Kings as he points to the Star, after the manner of French ivories; on one of the corners of the pulpit Christ stands upon the lion, dragon, asp, and basilisk, as on the *trumeau* of Amiens. French fashion is most evident in Giovanni's drapery, made up of sweeping folds that taper to tightness upon the breast and increase in weight as they descend. He adopts as well the French Gothic "cascade," already shifted to the front of some of his figures as French taste in the fourteenth century preferred. But the Italian sculptor applies these formulae of the French decadence to far different ends. The significance of the great ensemble of sculpture and glass in the French cathedral was concentrated in Italian Gothic in the individual statue or relief; the artist must himself conceive the content

GIOVANNI PI-SANO: *Prophet from Cathedral Pulpit, Pisa*

and create his own expression. If one compares the Virgin of the choir of Notre-Dame with one of Giovanni's Madonnas (*Fig. 139*), this contrast is clear; the French Mary, a charming *article de Paris,* has no significance beyond her dainty elegance; Giovanni's Mother looks with tragic intensity at the Child, who peers into her eyes as if to discover the secret of his impending Passion.

These standing statues of the Madonna, an innovation in Italian sculpture, nevertheless adopt the forms of the French fourteenth century—"cascade" opposed to a sweeping fold in the skirt, the crown, the hipshot pose. French iconography, curiously mingled with classic evocations, intrudes itself into the great ensemble which Giovanni created in the pulpit for the cathedral of his native city, finished in 1310. Broken up in the sixteenth century, it has now been reconstructed—a platform rather than a pulpit, with ten sides instead of the earlier hexagons and octagons. To fill the extra panels, Giovanni introduced the Birth of the Baptist and a series of episodes of the Passion. The central support is composed of the three Theological Virtues—Faith, Hope, and

[318]

Charity—standing on a polygonal pedestal carved with reliefs of the Liberal Arts. One of the supporting colonnettes has a pair of statues engaged to it representing apparently the Virtue of Fortitude: the divine quality in the person of St. Michael, with Roman armor and sword; the human virtue as Hercules, with club and lion's skin. Two other of these supports present an enigmatic parallel; one is a crowned female with two infants at her breasts, variously interpreted as the City of Pisa, the Earth, or the Church, with the four Cardinal Virtues grouped about her pedestal, among whom is a female nude imitating an antique Aphrodite of the type of the Venus de' Medici. The other is a statue of Christ, supported in like manner by the four Evangelists. If the crowned personification be given her probable meaning of Pisa, the allegory equates the state with deity itself, and the fierce loyalty of the Italian to his city is idealized along with piety.

Giovanni Pisano's style, in the hands of pupils and their schools, was dominant in Italy during the first half of the fourteenth century and continued to influence Italian Gothic art to its end. Tino di Camaino, pupil of Giovanni at Siena, worked first at Pisa where he made the tomb of the emperor Henry VII, of which the seated portrait statue and other pieces still exist in the Campo Santo. At Florence he executed the sepulcher of the bishop Orso in 1321, substituting again the image of the defunct for the Madonna that crowned the earlier Pisan tomb type of Arnolfo. Thereafter he lived and worked at Naples, constructing the tombs of the Angevine dynasty, in which Arnolfo's design of Cardinal de Braye's tomb was enlivened by Giovanni's staccato accents in the architectural forms, and by ingenious use of the Pisan statues as caryatids. The style was continued at Naples by the Florentine masters Giovanni and Pace, authors of the elaborate mausoleum of Robert of Anjou at S. Chiara, which borrowed much from Pisan prototypes—the seated portrait of the king (done from a death mask), the sharp architectural accents, and the angels withdrawing curtains from the recumbent effigy on the sarcophagus. Another sculptor of Giovanni's school, Giovanni di Bal-

VERONA: *Can Grande della Scala*

[319]

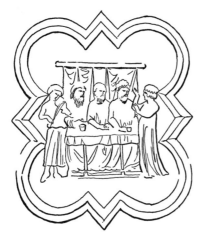

ANDREA PISANO: *Panel of the Baptistery Doors, Herod's Feast*

duccio, carried the Pisan style to Milan, where he was commissioned to make the tomb of Duke Azzo Visconti, now in fragments, and left his masterpiece in the shrine for the relics of St. Peter Martyr in the church of S. Eustorgio. This monument sums up the whole of Pisan style, using Tino's caryatids as eight figures of Virtues supporting the sarcophagus, on which are reliefs recounting the life of the Dominican martyr. The caryatids and the other statues revert to Nicola's quiet classicism; they are engaged to the architecture in the earlier Pisan manner or free standing, and represent Doctors of the Church, the prophets, and celestial powers. An aedicula terminates the top, sheltering the Madonna seated between SS. Peter and Dominic, and surmounted by figures of Christ and two angels.

The art of Balduccio was at least the starting point for the very original style of the Campionesi, a family of marbleworkers from Lake Lugano, who were certainly responsible for one, and possibly for all, of the remarkable monuments commemorating the Scala family, tyrants of Verona. The first of these tombs attached or near to the church of S. Maria Antica at Verona introduces the characteristic motif of the school, an equestrian statue of the deceased as the finial of the monument. This feature is most effectively displayed in the second tomb of the series, placed above the portal of the church, on which, astride a horse with trappings waving in the wind, sits Can Grande della Scala, embodiment of confident and ruthless despotism, his feet thrust truculently outward in the stirrups, his broad face greeting the spectator with a grin. The later tombs of the Scaligers were free standing in the churchyard, the last one, of Can Signorio, signed by Bonino di Campione in 1374. Contemporary with this lingering offshoot of Pisan style are the sculptures adorning the palace of the Doges at Venice, a miscellaneous encyclopedia of Gothic imagery, without the systematic organization of such ensembles in France, but mingling sacred characters and events with ancient emperors, kings, and sages, and the Labors of the Months with renderings of local trades. This popular revision of the scholastic synthesis probably owed much of its naturalism and homely detail to the intervention of German artists. The same influence qualifies the style of the last sculptors who may be counted as of the Pisan tradition, the brothers Jacobello and Pier Paolo delle Massegne, who after executing the high altar

of S. Francesco at Bologna, signed in 1394 the marble apostle statues that stand on the choir screen of St. Mark's at Venice (*Fig. 140*).

❖ ❖ ❖ ❖ ❖

A singular contrast to the staccato Pisan style is presented by the Gothic sculpture of Florence. Dominated by the powerful influence of Giotto, it nevertheless succeeded in tempering his terse design with grace—a grace borrowed from the same decadent French sophistication which Giovanni Pisano turned to such dramatic ends. In contrast to the Pisan crowded compositions the Florentine carvers used fewer figures in a scene, and plentiful empty space; their statues and reliefs exhibit none of the gouged hollows, tortured poses, and shadowed features of Giovanni's fiery style, but follow instead the full

FLORENCE, CAMPANILE: *Jabal, "Father of Flocks"*

[321]

forms of Giotto, on which the details are superposed with no subtraction of bulk and weight. Instead of the deep-cut Pisan drapery, the folds in Florentine hands become a superficial pattern on the figure's mass, following the graceful curves of the French fourteenth century, but reduced to the slower and more reticent rhythm of Giotto's drawing.

The first of the school was a Pisan, Andrea di Ugolino, native of Pontedera, and known as Andrea Pisano in his adopted city of Florence, where he initiated Gothic bronze sculpture with his doors for the Baptistery of S. Giovanni, in 1330. On these, in twenty panels, is related the life of the Baptist, with eight Virtues occupying the lower compartments of the doors, seated in abstract dignity like their prototypes in French reliefs, but nimbed with the hexagonal haloes peculiar to Italian iconography. The panels are surrounded by quatrefoil frames that repeat the borders enclosing stories of Old Testament worthies and saints on the portal *de la Calende* of Rouen cathedral. The scenes of the life of John Baptist are set in backgrounds wholly neutral, or reduced to the barest indication of landscape or interiors of buildings. The Giottesque economy of setting is matched with an equal restriction of action; the figures do not move enough to disturb the cascades and curves of their Gothic drapery even in the tragic episodes of Salome's dance and the decapitation of the Baptist.

Vasari ascribed the design of the Baptistery doors to Giotto, and their simplicity of style would be at least some evidence for the claim, but even if this were the case, the more decisive drawing of Giotto is absorbed in these reliefs by Andrea's linear grace. The influence of the painter is far more evident in the panels Andrea carved for the campanile of the cathedral. The campanile was in fact designed by Giotto, who can also without much doubt be credited with the iconographic scheme of the fifty-four reliefs that occupy the hexagonal panels of the lower story, and the lozenge-shaped panels of the next zone above. The lovely tower was begun in 1334; Giotto died in 1337, and Andrea and his assistants must therefore be credited with the execution of the reliefs, whether on the basis of specific cartoons from Giotto's hand, or general instructions. The subjects, confusing at first in their variety and often difficult of explanation, resolve themselves into an ultimate coherence as an exposition of the High Gothic Mirror of Morals—the origin of sin, its atonement by labor, the Seven Virtues (nimbed with

[322]

hexagons as on the Baptistery doors), the Seven Sacraments that convey the grace for the practice of the Virtues, the Seven Arts whose knowledge clothes labor, virtue, and grace alike with understanding and perfection. Scenes of Genesis, the Creation of Man, of Woman (*Fig. 142*), and the Curse of Adam and Eve, open the Labors as the primal cause of man's inheritance of toil, and are followed by the founders of industry and husbandry—Jabal the first herdsman, a pristine figure seated cross-legged within a tent, with his flock reduced in Giottesque abbreviation to three sheep and a dog; Tubal Cain fashioning the first works in metal; Jubal inventing the instruments of music; Noah initiating the culture of the vine.

These Old Testament types fit well into the scholastic symbolism of man's redemption by toil, but mingled with them appear vignettes of contemporary life, conceptions of work unknown to the vocabulary of the schoolmen, and significant of the expansion of commerce and industry that accompanied the rise (and fall) of High Gothic style. Agriculture is a plowman with two oxen whose vigorous pull on the plow reveals in this case at least the specific drawing of Giotto rather than Andrea's Gothic lines. The local interests of Florentine industry intrude themselves. The Arte della Calimala, the woolen guild of the city, is represented not only by its coat of arms over the east door of the campanile, but by an actual representation of a woman at the loom, superintended by a female mentor of classic aspect and ample figure, on which the Florentine shallow drapery makes a decorative pattern, half Gothic and half antique. *Sculpture* and *Painting* have each its panel, occupied not by a personification but by the artist himself at work, with the sculptor engaged in antique fashion upon the figure of a nude youth. An actual building operation stands for Architecture. The new preoccupations of Gothic realism, escaping from scholastic leading strings, inspired the reliefs of the dispensary scene that seems to represent Medicine, and the carter who seems to stand for Transportation or Commerce. Through all the hexagonal panels of the lowest story can be traced the substantial forms and concentrated accents of Giotto, seen here in our illustration of the *Creation of Eve,* but the painter's epic vision is given a lyric grace by Andrea's larger absorption in the fluent patterns of transalpine style.

The upper row of reliefs in their diamond-shaped frames show a falling off of style, due to Andrea's dismissal from the work toward the middle of the century, when the original design was modified into the windowed superstructure completed in the second half of the Trecento by Francesco Talenti. But Andrea's manner lived on in the charming reliefs and statues of his son Nino, who carried the Florentine style back to his native city of Pisa and

finished in 1341 the lunette over the door of S. Martino, showing St. Martin on horseback dividing his cloak with the beggar. The flat face and shallow features of the beggar are an unmistakable signature of Andrea's school, and Nino carried the Florentine manner farther away from his father's Giottesque leanings, shaping the French formulae to ends of more delicate sentiment.

The issue of Giotto's style in sculpture reached its limit of pictorial effect in the Tabernacle of Or San Michele in Florence, finished in 1359. Its sculptor Andrea di Cione, called Orcagna, was himself a painter, and so signed the work. It was done to enshrine a holy icon of the Madonna which had adorned for more than half a century one of the pillars of a market—the *Horreum Sancti Michaelis,* corrupted by local speech into Or San Michele— after the image was credited with stopping the plague of 1348. The panel actually enclosed by Orcagna's shrine is a replacement of the original—a Giottesque Madonna probably by Bernardo Daddi. The goldsmith's training so common in the apprenticeship of Florentine artists emerges in the manifold detail and colored inlay of the architecture that frames the reliefs, and these in turn are conceived in terms of painting. They relate the history of the Virgin from her birth to the "second annunciation," a rare scene in which an angel brings her a palm branch from Paradise and announces her approaching death (*Fig. 141*), with a final large panel at the back of the shrine depicting the Death and Assumption of Mary. Through all these scenes the retreating foreground, developed setting, and superposition of planes betray the hand of the painter, and more than one profile or entire figure is borrowed directly from Giotto's repertory. The graceful French design of Andrea is less in evidence and the compositions more detailed, the whole resembling an elaborate product of the goldsmith's art rather than a plastic ensemble.

Such an effect was again achieved in one of the most beautiful examples of Gothic art in Italy—the façade of the cathedral at Orvieto, where an ingenious mixture of mosaic, colored marble, bronzework, and relief is manipulated into a jeweled expanse of exquisite design. This west front (*Fig. 143*) is wholly Italian in its screenlike masking of the cathedral's structure, with which it has no functional relation, but it is unique in the peninsula for the systematic iconographic program which is carried out in the reliefs of its four piers. In accordance with scholastic comprehensiveness, these carry the panorama of history from Genesis to the Last Judgment. The scenes of Genesis (*Fig. 144*) and of the Last Day are placed on the outer piers, and arranged in friezes divided by the horizontal branches of a vine. Of the inner piers, the one to the left of the main portal presents a profoundly conceived summary of Old Testament prophecy; that to the right exhibits the Life of Christ. In these two

[324]

the figures and groups are enclosed in roundels and ellipses provided by rinceaux of acanthus, in a composition like that of French windows. The Prophecy pillar is carved with a Tree of Jesse, but instead of the French conventional rendering of Christ's ancestry and the figures of the prophets that foretold the Incarnation, the sculptor of Orvieto has elaborated a symbolic complex to express the Messianic hope, drawing his theme from the eleventh chapter of Isaiah; developing it with Old Testament prototypes of Christ and his ministry, and the visions of Daniel and Ezekiel that foresaw the coming of the Kingdom; and ending it with the Annunciation and the *Traditio Legis* to Peter.[25]

The façade of Orvieto was designed by the Sienese Lorenzo Maitani, and the mastermasons of the cathedral were all Sienese until 1347, when Andrea Pisano, leaving his task at the Campanile of Florence, was named *capomaestro*. He served till 1349, and was succeeded by his son Nino, who was followed in 1353 by two more Sienese masters. These continued until 1358, when Orcagna was given charge. Since the sculpture of the façade was done between Maitani's appointment in 1310 and Orcagna's arrival, it is not surprising that the mingling of Sienese and Florentines in the supervision of the work resulted in a mixture as well of the manners of these two leading schools of Tuscan art in the fourteenth century. To the one belong the reminiscences of Andrea's style pervading the reliefs—the flattened profiles and folds of drapery reduced to ridges on the body's mass; the delicate and poignant sentiment of the scenes might point to Nino. But the outstanding quality of these reliefs is shared by the Madonna and angels above the central portal, which seem to be documented as the work of Maitani. In this group—a sculptural Sienese *Maestà* (p. 330)—as well as in the reliefs, especially those of the Creation, Prophecy, and Judgment pillars, there is an evasive treatment of the forms which makes them melt into their surroundings, with a corresponding increase in ethereal effect. This, and the rather long faces and transparent drapery, belong apparently to the Sienese contribution. Certainly the sustained spirituality of these reliefs can nowhere else be matched in Gothic sculpture, and finds its counterpart only in the delicate abstraction of the most exquisite of Sienese painters, Simone Martini.

[25] Elizabeth A. Rose, "The Meaning of the Reliefs on the Second Pier of the Orvieto Façade," *Art Bulletin*, XIV (1932), pp. 258 ff.

VI

Late Gothic

THE REALISTIC MOVEMENT

GOTHIC AND EARLY RENAISSANCE IN ITALY

THE RISE OF Gothic painting in Italy [1] was conditioned by the earlier modes of Italy's mediaeval art, established in the twelfth and thirteenth centuries. We have already made their acquaintance in considering the Byzantine element in Italian painting (p. 153) and the classical trend of the south Italian Romanesque (p. 225). There was the Italo-Byzantine style represented by the mosaics of St. Mark's and those of the Norman churches in Sicily: a style based on actual Greek schooling and always Byzantine in its limitations, which confine the Latin proclivities of its Italian practitioners within the general eastern formulae of composition, figure style, setting, and design of ornament and drapery. There was the *maniera greca,* of Latin inspiration and tradition, but worshipful of Byzantine distinction and elegance, with which it strove with varying success to clothe a native Italian version of Romanesque; signal examples of such style are furnished by the frescoes of S. Angelo in Formis for a case of more Latin aspect, and for a closer approximation of Byzantine effect, the stories of St. Clement in the lower church of his basilica in Rome.[2] The

[1] F. J. Mather, *A History of Italian Painting*, New York 1923.
[2] J. Wilpert, *Die römischen Mosaiken und Malereien der kirchlichen Bauten vom IV. bis XIII. Jahrhundert*, Freiburg i/B 1916, IV, pls. 239–240.

third element, the nostalgia of Italian art for its classic origins, lurks in all the Romanesque phenomena of Italy, but is most obvious in the sculpture produced in the second half of the twelfth century and the first half of the thirteenth, in Sicily and South Italy, within the realm and under the stimulus of the Hohenstaufen Emperor Frederick II. The flowering of this "renaissance" in such Roman survivals as the arch of Capua with its "antique" heads and figures is even more apparent in the classic terms with which Nicola Pisano, himself a son of South Italy, relates the Gospel story on the pulpit of the Baptistery at Pisa. Without too much danger of simplification, these three trends may be personified in the three painters who dominate the beginning of Gothic painting in Italy shortly before and after the year 1300: Duccio, Cimabue, and Cavallini.

Duccio may in fact be called the most gifted manipulator of the Italo-Byzantine style of his time—the Italian version of Neo-Hellenism, which was producing its masterpiece in the mosaics of Kahrie-Djami about the date of the Sienese painter's greatest work, the Maestà altarpiece in the cathedral of his city. He shares with "Macedonian" painting the taste for discursive narrative and uses its time-honored landscape formula of peak and sloping hill, with the characteristic Byzantine fissures and high lights on the flat surfaces of the rocks. The webbing of gold lines on drapery which is so confusing in the late mosaics of St. Mark's appears on Christ's mantle in the scenes following the Resurrection which occupied the predella of the back of the altarpiece. The iconographic formulae of the Twelve Feasts are faithfully preserved, save in the Harrowing of Hell where Latin tradition has imposed the cavern mouth from which Christ summons Adam, Eve, and the patriarchs, and the Entry into Jerusalem and Crucifixion, wherein the Sienese taste for panoramic detail has enlarged the compositions to twice the size of the other pictures of the Passion. Gothic iconography invades the Crucifixion; the Crucified is fastened to the cross with one nail, instead of the Byzantine two, through the feet. The Incredulity of Thomas follows the Greek norm, and the Holy Women at the Sepulcher, despite its Latin motifs of three instead of two women and the western sarcophagus instead of the Greek cavern-tomb, is completely Byzantine in the attitude and gesture of the angel.

This great assemblage of painting,[3] fourteen by seven feet in size, was carried from Duccio's workshop to the high altar of the cathedral in 1311 in a solemn procession of ecclesiastics, magistrates, and the people, amid the pealing of all the bells in the city. The "Maestà," the Virgin enthroned in Sienese fashion amid an adoring throng of saints and angels, filling the front of the altarpiece,

[3] *Masters in Art: Duccio*, Boston 1908, pls. II, VI–X.

and the Lives of Christ and the Virgin on its predellas, pinnacles, and back, were determinants of Gothic painting at Siena, and of the two directions which it subsequently took. One was the development of panoramic narrative which the brothers Lorenzetti in the next generation were to fill with realistic detail, but merely enlarging thereby the discursiveness of Duccio's *Entry into Jerusalem* and *Crucifixion,* which begin and end the twenty-six Passion scenes on the back of the Maestà. The other trend was the Gothic quest of spiritual sweetness, disciplined by decorative pattern, which even the Byzantine Duccio could infuse into his forms and formulae, smoothing drapery and figures into more fluent lines and silhouettes, lowering the sky line and contracting architectural settings for a more intimate effect, and superinducing in the observer a quiet ecstasy of contemplation with his subdued color harmony of gold, green, rose or violet, brown or red, and blue. This is the course followed by Duccio's successor in the leadership of Sienese painting, Simone Martini, who carried to an extreme the decorative rhythm Duccio absorbed from the Byzantine, and softened it still more with Gothic curves.[4] His *Annunciation* (1333) divests the archangel and the Virgin both of bodily existence, and weaves their ethereal forms into a lovely ornamental pattern (*Fig. 145*). Such indifference to material reality is implicit in Duccio's pictures; he could paint a body as well or better than any artist of the fourteenth century, but could also distort it, or deprive it of spatial location if so his composition might be served. Pilate in the *Flagellation* panel of the Maestà extends a commanding arm outside the colonnade enclosing the loggia within which he is supposed to stand, and the apostles who surround the tomb of the Virgin seem to grow out of the tomb itself.

The Gothic curves and cascades that soften Duccio's Byzantine lines are emphasized in Simone's Maestà in fresco on a wall of the Palazzo Pubblico in Siena, where the Virgin sits amid her saints and angels beneath a canopy such

DUCCIO: *Entombment of the Virgin*

4 R. van Marle, *Simone Martini et les peintres de son école,* Strasbourg 1920.

as that the city magistrates carried to protect her image when it was paraded on feast days in her honor. Her throne has become Gothic as well with its sharp Italian gables. The new accents from beyond the Alps are not confined to ornamental forms and fluent line; in Simone's great frescoed portrait (1328) of Guidoriccio, Siena's condottiere, on the wall opposite the Virgin, the Byzantine landscape takes on a touch of Gothic realism with the representation, on its traditional peak and slope, of the strongholds of Montemassi and Sassoforte which Guidoriccio conquered for the city. This panoramic topography expanded in Ambrogio Lorenzetti's art into the real Tuscan countryside of his allegory of Good and Bad Government on other walls

SIMONE MARTINI: *Guidoriccio*

of the Palazzo Pubblico. Here the old Alexandrian formula is given up for good and the background becomes an actual picture of the hilly country around Siena, interspersed with plowed fields, vineyards, groves, villages, and winding roads on which, to illustrate the effect of Good Government, the travelers are voyaging in peace and safety. To the left is a slightly bird's-eye view of Siena itself, with a bevy of maidens dancing in Gothic grace in the foreground, craftsmen and merchants in their shops, and people walking or riding through the streets. Contrasting with these peaceful scenes is the ruined fresco opposite, showing the misery resulting from misrule.

On the terminal wall of this room, the *Sala della Pace,* is the allegory of Good Government. An enthroned bearded monarch impersonates Siena, with the four cardinal Virtues seated beside him, to whom are added Magnanimity and the half-reclining beautiful figure of Peace which has given its name to the hall. Faith, Hope, and Charity soar in the air above. To the left, beneath Wisdom in the sky, is Justice seated on her throne, her functions depicted by two ingenious little symbolic genre groups beside her. At her feet sits Concord holding a cord which binds together a stately procession of Sienese bourgeois, proceeding toward the throne of Siena. The picture is excellent illustration of a late Gothic phenomenon, matching a similar tendency in late antiquity: the

[332]

domestication, so to speak, of symbolism, whereby the aspects of human life and human values of every kind were reduced to type, catalogued, and turned into personifications and allegories. This device was the traditional means with which scholasticism made experience and nature into an illustration of Christian dogma; the repertory thus developed is now used by art to typify experience itself. The prevalent allegorizing of late Gothic is thus a mode of realism, but a superficial one, like the mannered style of French sculpture and miniatures of the late thirteenth and early fourteenth centuries, resulting from the same misfit of mundane content and the ideal High Gothic vocabulary. It was the removal of this screen of symbolism from the rendering of human life that is the peculiar contribution of Giotto.

Giotto's art [5] is the real beginning of the realistic movement in Italy, and the evolution of his own style illustrates the course this evolution was to trace. Humanity is realized in physical and moral being in the attributed frescoes of the Life of St. Francis in S. Francesco of Assisi, but this youthful art has young realism's concrete and eccentric quality. The composition is loose, the accents unrhythmic, the backgrounds unarticulated with the scene. But when he reaches the fullness of his powers in the frescoes of the Lives of Christ and the Virgin in the Arena Chapel at Padua, the composition has been integrated into a solid monumentality, a unity established between the action portrayed and its setting, and the action itself ennobled by a slower rhythm and a deeper significance of pose and gesture. In short the realistic vision has become ideal, and such will be the case with each fresh unveiling of nature to Italian eyes, prone like the Greek to translate concrete experience into type, and to invest the type with beauty.

So far as Giotto's style betrays its education, this would seem to have come from the painting of Cimabue and Cavallini. The story Ghiberti tells of Cimabue's noticing the boy

AMBROGIO LORENZETTI: *Peace*

[5] O. Sirén, *Giotto and some of his Followers*, Cambridge, Mass. 1917.

when he was trying to draw a sheep upon a stone, and taking him into his studio in recognition of his talent, is not incredible. We have but little of Cimabue's work: [6] a St. John in the apsidal mosaic of the Deesis in the cathedral of Pisa, some blackened frescoes assigned to him in the choir and transept of the upper church of St. Francis at Assisi, and the Madonna in the Academy at Florence (c. 1285). This last can furnish an instructive comparison with Duccio's serene Virgin of the Maestà in Siena (*Fig. 147*). Where Duccio's Mary invites contemplation, Cimabue's appeals; the Florentine can copy the enthroned Hodegetria, and cover her mantle with Byzantine gold lines and high lights, but cannot achieve the Greek *ethos* which Duccio marvelously understood and absorbed. Cimabue's style is *maniera greca*, and the restlessness of his Madonna and her attendant angels when compared with Duccio's is part of the native Tuscan taste for drama which a little later will find expression in Giovanni Pisano's vigorous relief, and the Cimabuesque frescoes at Assisi. Among these the best work is the Crucifixion, a tumultuous scene dominated by the symbolically huge Christ, whose form exaggerates into a convulsion the S-shaped silhouette which the Greek Palaeologan painters gave the Crucified. Certainly if Giotto grew up in Cimabue's workshop, he had no lack of stimulus toward the study and rendering of human feeling.

As a grown man in his thirties, he was at Rome for the Jubilee of Boniface VIII in the years around 1300, and there must have seen the mosaics which Cavallini had made for S. Maria in Trastevere, depicting the Life and Dormition of the Virgin, and also the Roman master's great fresco of the Last Judgment in S. Cecilia. Mosaics and fresco are impeccably Byzantine in compositional types: Cavallini includes the apostles as Christ's assessors in the Last Judgment, and Mary and the Baptist as the Intercessors—he even retains the characteristic Byzantine lateral pavilions in his mosaics of the *Presentation* and *Dormition*. The Deesis and apostles of the Last Judgment are not without a touch of transalpine Gothic grace, and their draperies sometimes fall in French "cascades," but the outstanding effect of all this work of Cavallini's is the impersonal Roman dignity and classic bulk which he can give his forms. From Cavallini, and perhaps also from the Pisan sculptors, Giotto must have learned the powerful relief he imparts to his figures and their projection in space.

From his frescoes at Padua of the Lives of the Virgin and Christ, we have for illustration (*Fig. 146*) the meeting of Joachim and Anna, parents of the Virgin, who greet each other in the knowledge separately received of the divine blessing of the coming birth of Mary. The picture is the epitome of Giotto's

[6] A. Nicholson, *Cimabue*, Princeton 1932.

154. FLORENCE, UFFIZI: *The Adoration of the Magi* by Gentile da Fabriano

155. PADUA: Head of Donatello's equestrian statue of Gattamelata

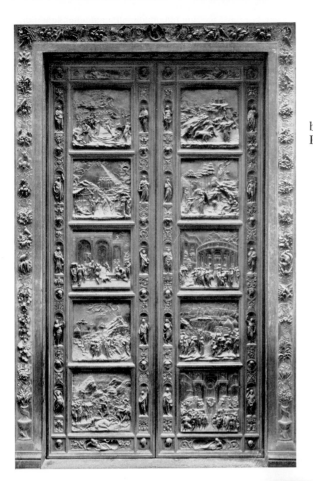

156. FLORENCE, BAPTISTERY: Ghiberti's bronze doors, the "Gates of Paradise"

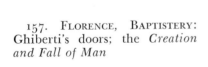

157. FLORENCE, BAPTISTERY: Ghiberti's doors; the *Creation and Fall of Man*

158. PARIS, LOUVRE: The *Parement of Narbonne;* the Crucifixion, Church and Synagogue, Charles V and Jeanne de Bourbon

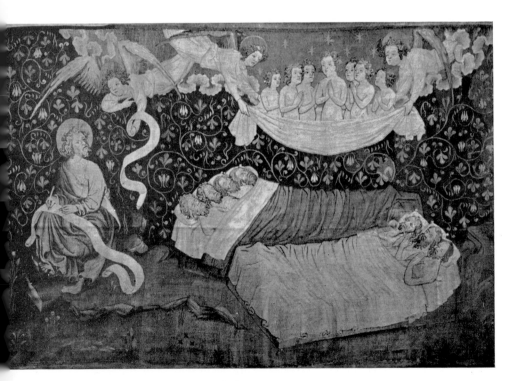

159. ANGERS, CATHEDRAL: Detail of the Tapestries of the Apocalypse; John's vision of the "blessed who die in the Lord"

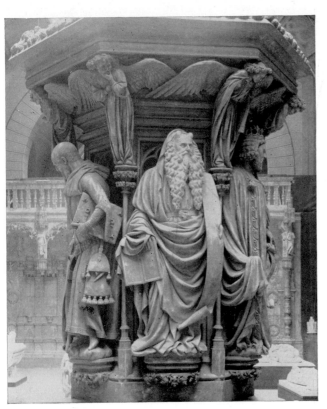

160. Dijon, the Chartreuse of Champmol: The
Puits de Moïse; Isaiah, Moses, David

161. Amiens, Cathedral:
Statue of Charles V

162. Dijon, Museum: Tomb of Duke John the Fearless

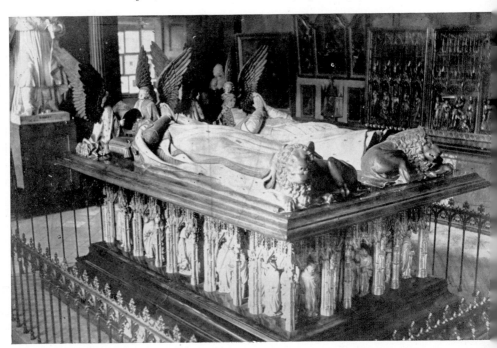

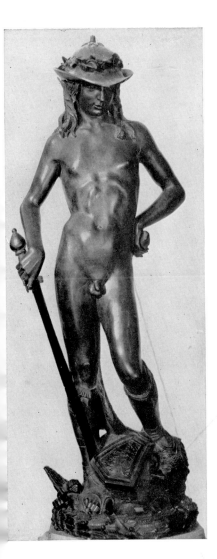

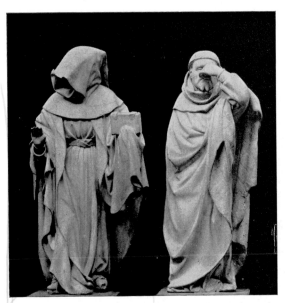

164. DIJON, MUSEUM: Mourners from the
Tomb of John the Fearless

163. FLORENCE, BARGELLO: The Bronze
David of Donatello

165. BERLIN, DEUTSCHES MUSEUM: Triptych; the Trinity, Angels
with the instruments of the Passion, and the Four Evangelists

166. PARIS, LOUVRE: The *Martyrdom of S. Denis,* by Jean Malouel and Henri Bellechose

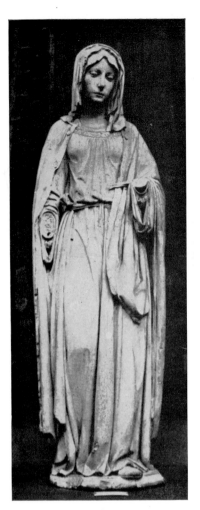

175. COLOGNE, ARCHIEPISCOPAL MUSEUM:
Madonna of the Violet by Lochner

176. PRINCETON, MUSEUM OF HISTORIC ART:
Saint, from an Entombment Group

177. GENEVA, MUSEUM: The *Miraculous Draught of Fishes* by Conrad Witz

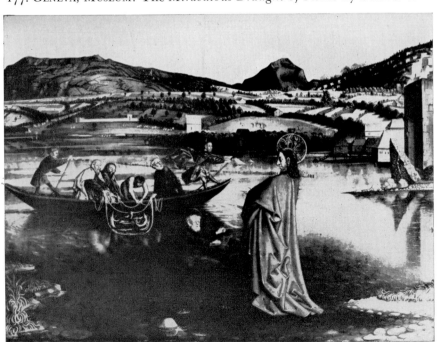

178. Antwerp, Museum: *Madonna*
by Jean Fouquet

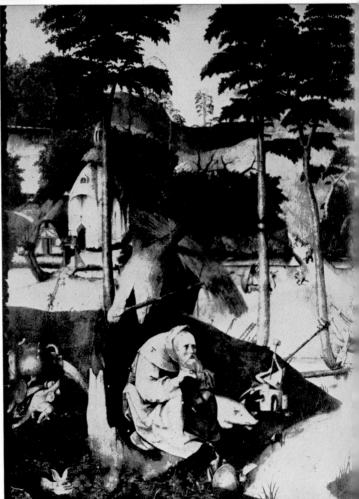

179. Madrid, Prado: *Temptation of Saint
Anthony* by Hieronymus Bosch

developed style, and a clear revelation of the basic realism of his approach. The Golden Gate where the aged Joachim meets his wife is real enough to provide a natural setting, ideal enough to make the setting significant. The mixture of tenderness and realized destiny which animates the embrace of the pair is relieved against the whispered gossip of the women in the gateway. The slow arrival of Joachim's servant on one side and the group of three women on the other weight the composition at either end and dignify the episode. From the economy of movement and gesture, the momentum given by the bulky figures, the simplicity of their silhouettes, comes the ideal epic tone which pervades the whole series of Arena frescoes despite their innumerable and forcible accents of reality. Sienese abstraction, descriptive narrative, and allegory become suddenly archaic when confronted with this Florentine humanism.

Giotto was honored, after his death in 1337, with an imitation of his style more persistent than that given to any other Italian master. We have already seen how the painter's reduction of Gothic drapery folds to mere ridges on his bulky forms was repeated in the reliefs of Andrea Pisano and his school. As for the painters, beginning with his faithful disciple and godchild Taddeo Gaddi, the line of Giotto's followers, the "Giotteschi," can be traced even into the fifteenth century with the three generations of the Bicci family. The imitation was superficial for the most part, and emphasized his obvious aspects: Taddeo Gaddi inflates his massive forms, enlarges his brief architectural settings, and narrows still more the narrow eye which Giotto borrowed from French Gothic mannerism; Taddeo's son Agnolo and Giottino enliven and variegate the high-keyed palette of blue, green, rose, and white with which Giotto enhanced the plastic relief of his figures. All of them increase and complicate the master's simple iconography—in Taddeo's frescoes in S. Croce the Christ child is inserted in the Star of Bethlehem when it appears to the Magi, Elizabeth kneels to the Virgin in the Visitation, the Last Supper takes place at a Florentine refectory table, with Judas sitting, back to the spectator, on the nearer side. From Siena the Giotteschi adopt the ornamental tooling of Simone and especially the Sienese taste for panorama. But they could not, for the most part, preserve the master's power "to give significant emotion convincing mass" (Mather). The monument of this aftermath of Giotto, of which Taddeo Gaddi said that it had "fallen low and was falling lower each day," is the great frescoed cycle (c. 1365) in the Spanish Chapel at the Dominicans' church of S. Maria Novella, where Bonaiuti (called Andrea da Firenze) covered the walls with discursive allegory.

Chief in the series is the *Triumph of the Church,* better named the Tri-

umph of the Dominican order. In front of the cathedral of Florence and its campanile, the pope and emperor are enthroned beside their princes and cardinals, with black and white dogs (the *Domini canes*) guarding the lambs at their feet. St. Dominic is prominent on the right, confuting heretics below, striving above to turn the thoughts of a worldly group toward heaven, while they enjoy themselves in a landscape crowned with a horizon bordered by the villas of Florence. Heaven itself is full of saints, with St. Peter at its doorway welcoming the blest, and the lunette ends at the top with a Sienese Maestà, a Christ seated in a glory on the arc of Heaven surrounded by a choir of chanting saints and angels. The ease and grace with which this transparent propaganda is executed contrasts with the dour pessimism of the famous fresco of the *Triumph of Death* in the Campo Santo at Pisa, finished *c.* 1375 by some half-Florentine follower of the Lorenzetti. The sinister note is struck at the beginning of the panorama with a variant of the French legend of the Three Living and the Three Dead—a noble group on horseback appalled by the sudden vision of three rotting bodies in their coffins. St. Macarius points the moral with a scroll inscribed with warning of the imminence of death, and Death itself is seen to the right, a Fury with streaming hair, bat winged and wielding a scythe. The sick and crippled make a miserable group, imploring Death to deliver them, but the fierce figure sweeps away to the right, toward a party of pleasure-seekers that might illustrate Boccaccio's *Decameron*, seated in carefree joyousness within a grove, playing or harkening to music while two Cupids aim their darts above them. The air is full of demons and angels, disputing the souls which the devils thrust into the pit of Hell and the angels carry off to Heaven. The Black Death of 1348 was a vivid memory still when this scene, half real, half allegory, was painted.

CAMPO SANTO, PISA: *Death*

In Santa Croce at Florence a fragment of a fresco remains, of four cripples imploring the liberation of death, which must have been known to the painter of the gruesome group at Pisa. The fragment is from the brush of Orcagna, sculptor of the Tabernacle of Or San Michele (p. 324). He alone of Giotto's followers retained the epic significance and simplicity of the master's art, but combined it with the best of Sienese ethereality and Gothic grace. His unconscious cult of beauty rather than of

[336]

Giotto's dramatic force is good illustration of the constant ideal trend of the Florentine genius. A goldsmith's son, architect of Orvieto, and sculptor, he was most of all a painter, and one whose purview as a craftsman was broader than Giotto's, seeking large ensembles and ample scale. We know him best from the gentle Christ he painted above the window of the Strozzi chapel in S. Maria Novella, crowning the Last Judgment whose Heaven and Hell descend on either side. The Judge is no longer in a glory, but emerges from the clouds of heaven, like the angels about him who trumpet the blasts of the Last Day and carry the symbols of the Passion. Byzantine tradition lingers in the first pair of witnesses of the Judgment, the Baptist and Mary, the latter being the purest idealization of the Virgin to be found in Italian art (*Fig. 148*). The Heaven and Hell which complete the panorama below were done by Orcagna's brother Nardo di Cione—the Heaven famous for the portrait of Dante included among the Elect, the other fresco a topographical map of the poet's Inferno.

❖ ❖ ❖ ❖ ❖

The fresh infusion of realism that introduces the Early Renaissance of the first half of the fifteenth century was like Giotto's a product of Florence. The movement did not lack reactionaries and traditionalists on the one hand; and on the other its scientific experiments toward the better rendering of light and air, of perspective and foreshortening, of individuality and spatial location were converted in the second half of the fifteenth century, following the usual pattern of Italian art, into a new cult of beauty. The lyric and subjective form this took in the later Quattrocento, ranging from the mere pursuit of sweetness, grace, or picturesqueness by most of the painters and sculptors of the second half of the century to the neo-Platonic mysticism of Botticelli, rose to the "grand style" of the High Renaissance in the early sixteenth, culminating in the lofty themes of Leonardo, Raphael, and Michelangelo. But the latter built, and ideal style from their time onward has rested, upon the analysis of human action and of the mental and moral structure of mankind which was carried out and completed by the fifteenth century in Italy. Modern art until the advent of impressionism made little improvement on Masaccio's construction by contrasting light and shade, and modern sculpture can still go to school to Donatello for individual character in a statue, and to Ghiberti for pictorial relief.

Masaccio's greatest work [7] was the fresco cycle of the Life of St. Peter and the Fall of Man in the Brancacci Chapel of the Carmine-church at Florence

[7] *Masters in Art: Masaccio,* Boston 1907, pls. II–VIII.

on which he worked with some interruption from 1425 to 1427. That chapel and Masaccio's frescoes became for the young painters of succeeding decades a veritable school, where the art of the greatest geniuses of the Renaissance was trained. The technical innovation which Masaccio could communicate to them was the substitution of chiaroscuro for line in the rendering of forms and the introduction of atmosphere and aerial perspective (*Fig. 151*). He is the natural heir of Giotto in simplicity, economy of gesture and detail, and in the momentum which he gives to whatever he wants to express by the solid bulk and monumentality of his figures. But form in Giotto's painting is a matter of darkening the contours of drawing, while Masaccio's frescoes make it as in nature a construction of light and shade. Atmosphere is felt, and dims objects in the distance; the figures move or stand within a space that surrounds them and not merely in the foreground of a Sienese panorama. As in Giotto's art, the motion is restrained and posture statuesque, no whit beyond or below the accent needed to express the ideal content of these happenings in Peter's career, which rise by Masaccio's hand from literary insignificance to events of cosmic import.

Masaccio was a young genius, dying at the age of twenty-six. The men that followed him as pioneers in painting, Andrea del Castagno and Paolo Uccello, had not his epic quality, and were more scientists than artists. They excelled in portraiture, and introduce us to the apotheosis of the individual which marks the Renaissance, and its cult of personal glory. Andrea del Castagno's portrait of Pippo Spano, Italian captain in the service of the king of Hungary (now in S. Apollonia, Florence; *c.* 1435) betrays a too conscious claim to fame and a truculence that lacks the saving humor of Can Grande's figure in his equestrian tomb monument at Verona (p. 320). Pippo's posture (*Fig. 150*) with feet wide apart is still a Gothic formula, however endowed by Castagno with truly Renaissance assurance; it continues the diagram for the standing figure which was used by Villard de Honnecourt, French architect of the thirteenth century, who has left us his formulae in the drawings of a sketchbook preserved in the Bibliothèque Nationale. Villard caused the lines determining the position of the legs to radiate from the groin; the classic notion, recorded by Vitruvius, made the navel the center of the body and of its design. Villard's pattern, made real in Pippo Spano's swaggering figure, was used as late as *c.* 1490 by Botticelli for the warrior statue adorning one of the niches of his *Calumny,* and was a norm for aggressive masculinity throughout the Quattrocento. Only with the assimilation of classic rules were the legs brought closer together, the weight shifted to one side, and the unquiet pose replaced with equilibrium.

Castagno's portrait of the condottiere, however bumptious, is an unforget-
table recording of personality, and a characteristic product of this curious
group of experimental painters. Uccello has left a striking portrait in the mys-
terious praying figure who stands beside the ark in the confusing fresco of the
Deluge, which this eccentric artist painted in the Green Cloister of S. Maria
Novella (*Fig. 149*). This figure has been identified by some as the architect and
sculptor Brunelleschi. The sharp foreshortening of Noah's ark, and the con-
tradictory perspective of the portrait, seen as if from below, are evidence both
of Uccello's passion for perspective, a major preoccupation of the "scientific"
group, and the damage he did to the order and clarity of his pictures by in-
dulging it. In spite of keeping his wife awake because he would not leave his
nightly study of the "sweet perspective," he did not employ this discovery of
the fifteenth century for architectural settings or his landscape, which is only
a variant of the Lorenzettian panorama. He limited his research to foreshort-
ening of living or dead forms—the slain horses and men for example in his
pictures of the battle of S. Romano, placed and drawn as deliberate problems
of foreshortening, and colored arbitrarily with the bright new palette which
Domenico Veneziano, another of these Quattrocento innovators, had brought
from Venice along with his revolutionary technique of an oil glaze wherewith
to varnish and tone the traditional panels of tempera technique.

Among the painters of the early fifteenth century, these inventive pioneers
found a foil in men who clung to habits and attitudes of the fourteenth, or
turned the new techniques toward the native Italian quest of formal beauty
and grace. An artist that may be said to unite both trends in his work is Fra
Angelico,[8] but whatever his style absorbs from the enterprising art world
around him, the cloistered spirit of this Dominican is more at home in the
fourteenth century than in the Renaissance. Few painters have left so much
behind them, or so clearly reveal the slow evolution of a style. In his early
works, such as the reliquaries he painted for a fellow Dominican of S. Maria
Novella, he is a Gothic miniaturist, clinging to the spaceless backgrounds of
the manuscript page, on which the figures enact their naïve scenes as decora-
tive properties. The style broadens with experience in fresco, as style is wont
to do, and during the period when Fra Giovanni lived with his Dominican
community in the monastery of S. Marco in Florence from 1436 to 1445, and
painted its halls and cells with the frescoes that are his principal monument,
the monk absorbed enough of the new Florentine realism to give his ethereal
visions flesh and blood. The frescoes of S. Marco are many and meant for the
cultivated piety of the Dominicans, so that subjects appear that are novel in

[8] W. Hausenstein, *Fra Angelico,* trans. by A. Blake, London 1928.

Italian iconography: a Crucifixion, for example, with St. Dominic embracing the Cross, and the Crucified depicted in Donatello's new fashion with frontal torso and legs and a dignified nudity instead of the twisted body with legs in profile of fourteenth-century art. Christ appears in other pieces as the Man of Sorrows, showing his wounds as he stands in the tomb, or as a pilgrim greeting two Dominicans. In one fresco he has mounted a ladder to be nailed to the Cross by the executioners—a motif employed at Mistra in the Peribleptos (p. 171). The grandest of these murals is the *Crucifixion* of the chapterhouse, silhouetted against an angry sky, and attended not only by the traditional group of the fainting Virgin with the holy women and St. John, but also a symbolic throng of Doctors of the Church, saints (headed by the kneeling Dominic), and founders of monastic orders.

In this *Crucifixion,* the *Virgin and Saints* and the lovely *Annunciation* in the corridor, the extraordinary *Adoration of the Magi* (set in a mountain landscape) painted in the cell the monks reserved for Cosimo de' Medici's sojourns in the convent, and especially in the great *Descent from the Cross* (c. 1445) once in the sacristy of the Trinità at Florence and now in the Academy, the influence of Masaccio is plain, in ampler forms and space which in the last-named picture develops into a distance with something of Masaccio's atmosphere. The same discreet absorption of the new technique is in the friar's last works, the frescoes of the chapel of Nicholas V in the Vatican, where, like every Florentine artist who ever worked in Rome, he was impelled toward greater monumentality by the vaster outlook of the papal city. But these frescoes of the ministry and martyrdom of SS. Lawrence and Stephen, competently and richly painted, have lost something that clung to the pious creations of S. Marco. Their quality is rather found in Fra Angelico's famous *Last Judgments* or his *Coronation of the Virgin (Fig. 152).* The celestial vision that haunted his brush is more evident in these: in the "Dance of the Angels" that welcomes the blest in the *Last Judgment* of the Academy, and the resplendent throne with its angelic entourage where the Virgin kneels to be crowned in the *Coronation* of the Louvre. The motif of the kneeling Mary is here first used in Quattrocento Coronations. With this and other intimate accents the scene is suffused with individual piety, a heaven dreamed in terms ecstatic but personal none the less. Fra Angelico, despite his Gothic archaism, is still a product of the realistic movement and the early Renaissance, worthy of the sainthood the church conferred upon him, but human withal, a Dominican who could put Franciscans into one of his pictures of Hell.

About twenty years after the Blessed Angelico painted his *Coronation,* another monk, quite unblessed, painted another Coronation of the Virgin, des-

[340]

tined for the altar of Sant' Ambrogio at Florence (*Fig. 153*). The Carmelite who painted this picture, Fra Filippo Lippi, was a loose liver, notorious even in the loose life of Medicean Florence. Convicted of forgery, and the seducer of a nun, he lavished what integrity he had upon his art, which holds consistently to an irreligious ideal of sensuous beauty that perfectly expresses himself and the popular taste of his time. He may be said to have set the pace of most of Florentine painting for the rest of his century. The Florence of Fra Filippo was the gay and luxury-loving city that brought upon itself the denunciations of Savonarola and the loss of its liberty; the insatiate love of beauty that was the overtone of the city's *joie de vivre* and moral holiday is the full content of all of Fra Filippo's pictures, leaving little room for piety. He studied and absorbed Masaccio's innovations, and added to them an innovation of his own, being in fact the first to make a real pictorial element out of the sunlight his scapegrace spirit loved. But Filippo's volatile art put the sober figures of Masaccio into movement—actual movement, or the disembodied movement of Gothic line to which he continually reverts despite the teaching of Masaccio's chiaroscuro, and which he passed on to his apprentice Botticelli.

The compositional scheme of his *Coronation* is the same as Fra Angelico's save for the reality of space and figures provided by Filippo's more educated art, but what a difference in the atmosphere of the two assemblages! In the one a concentration of prayerful emotion, in the other a public *festa,* with everyone, even the Virgin, so obviously in party dress that St. John the Baptist in the right-hand corner seems to apologize for his shirt of skins. The kneeling saints in the foreground, all ignoring the Coronation to catch the observer's eye, include Filippo's favorite type of Florentine girl, recurrent in his Madonnas, but here impersonating the wife of St. Eustace and mother of his two chubby children at her feet. Eustace is obviously a portrait, and the husband, wife, and babies make a charming family group, properly posed for their picture. It is the young matron, not the Lord and the Virgin, that engages the eye of the painter in the portrait of himself he has inserted beside the Baptist —a figure kneeling with hands joined in conventional piety. The angel who faces him has no devotional function; he is there to call attention to the artist with a scroll inscribed *is perfecit opus.* The art of Filippo will develop more solid and sophisticated composition than here is shown, in the frescoes of the lives of the Baptist and St. Stephen in the Pieve at Prato which he finished a year or two before his death in 1469. In the Funeral of St. Stephen at Prato, he established a norm for those compositions of the later fifteenth century which one associates with Ghirlandaio—a long architectural perspective with plentiful classic detail, the religious subject occupying a small space "down

stage" in the center, and the rest of the foreground occupied by symmetrical throngs of donors and the donors' friends. But in this and the fresco of the dinner party he painted as the setting for Salome's dance, he is still as in the *Coronation* the sympathetic mirror of the color and pageantry of Florentine life.

❖　　　❖　　　❖　　　❖　　　❖

The realistic movement in Italy and the propensity toward the ideal that converted it into the early Renaissance are well summed up by three sculptors of the first half of the fifteenth century: Donatello, Jacopo della Quercia, and Ghiberti. The first probed personality more than any other Italian artist, and strove to glorify it with the habiliments of classical antiquity. The second so assimilated the nobility and power of antique figures that in this respect his style must be grouped with Donatello's as the prelude to Michelangelo. The third, a passionate admirer of classic sculpture, and an enthusiastic member of the innovating "scientific" group, was yet the one who most turned all he knew

THE "ZUCCONE"

and learned into decorative rather than realistic beauty, and so conserved the tradition of the fourteenth century that he may be called the last of the Italian Gothic sculptors.

Donatello's early manner can be seen in the St. George which once occupied a niche in the exterior of Or San Michele but is now removed to the Bargello.[9] In this he still employs the Gothic stance of widely spaced feet, expressive of the positive and youthful vitality of the figure, emerging also from the fixed gaze, clenched fist, and knitted brow. The statue was done *c.* 1416, and was closely followed by the sculptor's collaboration with Rosso and Ciuffagni on the extraordinary octet of prophets that fill the niches of the east and west faces of the Campanile. The unadulterated style of Donatello is evident in the Baptist, the enigmatic bald-headed figure known since the Renaissance as the "big pumpkin," *Zuccone,* and the Jeremiah. In all of these the study of Roman portrait busts is clear, as Nicholson[10] has shown, and a progression from the Gothic oval of St. George's head to a square-jawed type with deep-cut expressive lines about the nose and mouth. Throughout the series one can see the sculptor's effort to release the drapery from Gothic formu-

[9] *Donatello* (Phaidon edition), New York 1941.
[10] A. Nicholson, "Donatello: Six Portrait Statues," *Art in America,* XXX (1942), pp. 77 ff.

lae and make it real, an effort which never attains the semi-ideal classic type that reveals while it covers the form; the Zuccone's mantle hangs upon him like a bag, and compromises between the Gothic "cascade" and the folds of a Roman toga.

The same conflict between realist and classicist gives a poignant charm to Donatello's children. He was the first of Italian masters really to domesticate the Greco-Roman putti; they first appear in 1432 as groups of whispering urchins creeping cautiously toward the door of a sacrament tabernacle in St. Peter's at Rome, but on the pulpit at Prato and in the singing gallery that once stood in the cathedral at Florence (now in the cathedral museum), they have become the irrepressible romping youngsters that will be imitated by sculpture and painting throughout the rest of the century. It is in their bodies that the classic nude becomes a part of Donatello's art. The progress he made from the real to his own approximation of the ideal in this respect can be measured by comparing the wooden crucifix of S. Croce (*c.* 1420) with the bronze which is the culminating motif on his high altar for S. Antonio at Padua (*c.* 1445). In the wooden crucifix he revolutionized the type of the Crucified, bringing the legs around to a frontal view from the Gothic contorted profile, but the muscular body, the coarse accents on the bony structure, and the undistinguished head deserve the reproach of Brunelleschi that "he had put a peasant upon the Cross." The most charming work of Donatello is the intermediate nude between this and the Paduan crucifix, the bronze *David* of the Bargello. This (*Fig. 163*) is perhaps the first nude statue in the round that had been done in Italy for about a thousand years, and reveals its pioneering quality, in its not too delicate casting (Donatello was not so finished a technician as Ghiberti), and the angular simplification imposed by difficult technique. But its angularity adds to the fascination of this study of adolescent *gaucherie*. The David here portrayed has little to do with Goliath's head on which he stands; the boyish reverie of dreamy eyes and half-smiling lips dwells on quite other subjects than the Philistines. Characteristic of the early Quattrocento's use of antique motifs for their picturesque interest alone is the wreathed shovel hat that David wears, borrowed from some statue or relief of Mercury. But in the crucifix of S. Antonio at Padua the sculptor has assimilated all he could absorb from ancient art, in more compact composition, more decorative silhouette, and the idealized suffering of the Saviour. In his Paduan period also, Donatello achieved his finest synthesis of Florentine realism with the Roman antique, in the monument to the condottiere Gattamelata (1453). This, the first great equestrian statue of modern times, was obviously suggested by the mounted Marcus Aurelius of the Capitol at Rome, but the emperor's

conventional portrait is transformed by the Italian sculptor into a vivid personality (*Fig. 155*).

Jacopo della Quercia was a Sienese, a lonely figure in the early Renaissance, apart from the fever of invention and experiment which was accelerating the art of Florence, but engaged nevertheless with the same problems. Like Donatello in his early work, Jacopo was concerned with making drapery real, and like the Florentine sculptor could seldom make it functional or beautiful; an exception is the lovely figure of Ilaria del Carretto on her tomb at Lucca, if the tomb be indeed from Jacopo's hand. The student of his style comes to feel that the sculptor is not fully himself until he rids himself of drapery altogether and finds expression in the nude alone, as in the reliefs of Creation that are part of the Old Testament series flanking the portal of S. Petronio at Bologna (1425). In these panels Jacopo harks back to authentic principles of classic art, suppressing background and telling his stories solely with space-filling figures. The heroic nudes of the Creation of Adam and Eve, the Fall, and the Expulsion from Eden, carved in broad planes and epic simplicity, are prototypes of those of Michelangelo, not merely in a general sense but as actual models, since there can be no doubt that the later artist, who saw Jacopo's portal when working at Bologna in 1495, used the design of the Creation of Eve in his fresco of the Sistine Chapel.

Jacopo entered a model in the competition for new bronze doors of the Baptistery at Florence, for which Andrea Pisano had in 1330 made the pair that are now in the north portal (p. 322). The competition was opened in 1401 by the Signoria, in co-operation with the Merchants' Guild. Jacopo's competitors included the formidable names of Lorenzo Ghiberti and Brunelleschi, and his style was too broad for the jury; "not having fine detail," says Vasari. The trial panels submitted by Brunelleschi and Ghiberti are still preserved in the Bargello, and support the judgment which commissioned the work to Ghiberti. The subject is the Sacrifice of Abraham, conceived by Brunelleschi still in mediaeval two dimensions, with all accessory detail brought "down stage" and a consequent weakening of the otherwise dramatic intensity of the central episode. Ghiberti's solution is more beautiful than real, but he unifies the composition with an inward axis, foreshortening the angel who flies to stay Abraham's hand, and bending back the frontal torso of the kneeling Isaac on the altar—a classic nude. Thus was perspective, invention of the new artistic science of the Quattrocento, brought into the vocabulary of relief.

Ghiberti spent twenty-one years (1403–1424) on his first pair of doors for the Baptistery, employed as he was on many other works during the period. He kept himself to Andrea Pisano's design, using the same quatrefoils for

frames and the same twenty-eight panels, here divided into twenty for the Life of Christ to match Andrea's Life of the Baptist, and the four Evangelists and four Doctors of the Church to fill the lower eight panels in which Andrea placed the Virtues. Classic heads replace the lion-headed rivets of Andrea's doors. Ghiberti's classicism however is of the Quattrocento selective sort; he employs antique motifs to enliven his decorative repertory, but in the figured reliefs he is sometimes almost as Gothic as Andrea himself. His faces have a classic modeling and the eyes have lost the slit effect borrowed from the French decadence and popularized in Italy by Giotto, but the artist is still too much of a Gothic goldsmith to escape the fascination of linear movement, which he pursues not only in the fluent drapery but in his attitudinizing figures. Like all the artists of the early Renaissance he cannot achieve the classic synthesis of body and drapery; he unites them indeed, but the body disappears in the process.

When the Merchants' Guild allotted a second pair of bronze doors to Ghiberti, he was given as guide an elaborate iconographic scheme worked out by the Florentine historian Leonardo Bruni, retailing the Old Testament narrative in a numerous series of symbolic scenes. There is nothing more modern in the fifteenth century than Ghiberti's refusal to subordinate his art to a layman's dictation, and his success in making the Guild accept his own *parti*. This was a division of the doors (*Fig. 156*) into ten large panels, each devoted to a character or pair of characters: Adam and Eve; Cain and Abel; Noah; Abraham; Jacob and Esau; Joseph; Moses; Joshua; David; Solomon and the Queen of Sheba. He produced in these gates, now the main portal of the Baptistery, a masterpiece so highly considered by the Renaissance that Michelangelo could call them "worthy to be the gates of Paradise," and a technical *tour de force* that was the most audacious sculpture in relief since the Arch of Titus.

We select for illustration the first of the panels, on which is the story of Adam and Eve. Nowhere can a better union be found of lingering mediaevalism and the rising Renaissance. Continuous narration is still with the artist, separately rendering all four episodes of the Creation and Fall of Man, and drapery has never so completely satisfied the Gothic desire for fluent line. The portal of Paradise is an isolated symbol introduced like a property piece in a mystery play. But the nudes are classic—Adam reclines like an antique mountain god, and Eve rises from his side like Aphrodite Anadyomene. In the Expulsion, the gesture of Eve is pure rhetoric (*Fig. 157*); the artist's interest is centered in the decorative accent of her figure, too long and too high waisted as the female will be throughout the fifteenth century, but with

the feet brought together to make a lovely tapering silhouette. What gives the relief its epic air of pristine antiquity is the perspective depth of setting —a depth enhanced by the rendering in the round of the projecting figures of the forward plane. The spatial effect is grander in other panels than in this, and especially in the last when Solomon receives the Queen of Sheba before an imposing structure of retreating arcades and vaults. The mixture of antique revival and surviving mediaevalism which the "Gates of Paradise" reveal is present also in the elaborate borders of the doors, where the classic heads projecting from the roundels and the niches containing figures of prophets and Sibyls are paired with an outer border of fruits and flowers alternating with some of the most attractive studies of animals and birds to be found in sculpture. These last are a legacy from Gothic book illumination, and this natural ornament on Ghiberti's doors is the last example of such Gothic decoration before the capitulation of Italian art to the antique ornamental repertory of the Renaissance.

DONATELLO: *St. George and the Dragon*

EARLY NORTHERN REALISM: BURGUNDY AND THE NETHERLANDS

On the base of the niche which housed his *St. George* on Or San Michele, Donatello carved a relief of the saint slaying the dragon and freeing the hapless princess of Trebizond. A century later, the French sculptor Michel Colombe executed a relief of the same subject for Cardinal Georges d'Amboise, as an altarpiece for the chapel of his château of Gaillon. In the comparison of these two works and in their difference of date one can read the entire distinction between the patterns of late Gothic art in Italy, and in the lands north of the Alps. The Italian work absorbs the detail in dramatic action and movement; specific accents are neutralized to the end of making princess, saint, and horse ideal and decorative. The northern sculptor portrays a Wagnerian dragon and a horse heavily built up from all the equine characteristics; his

[346]

princess is anchored by too detailed drapery, and the knight with too much armor. The realistic movement in Italy moved steadily through the discursive naturalism of the fifteenth century toward the ideal synthesis of the High Renaissance in the sixteenth; in the North the trend was rather toward the multiplication of concrete details which only a consummate master such as Dürer could gather into significant unity. Individual character, in men and things, was broadened into type in Italy, becoming drama in the rendering of action, and beauty in the rendering of forms. In the North, the definition of the individual is sharpened by insistence on physical peculiarity or even deformity, and especially by elaboration of material surroundings and attributes. The northern composition is thus diffused over a multitude of accents and points of interest and made static, however dramatic the scene depicted, by sheer weight of detail. The movement that unifies Italian pictures and reliefs is seldom seen in the North. The late Gothic reliance on allegory and symbolism wherewith to embody its concepts of experience is still the mode of northern art in the fifteenth century although distinctly *vieux jeu* in Italy. Gothic art in the North was ultimately forced, when finally it turned from its discursive realism to a direct rendering of ideal themes, to import for the purpose the facile rhetoric of the Italian Renaissance.

The disintegrating factors in the political, social, and economic make-up of Europe in the fourteenth and early fifteenth centuries made for more confusion in northern thought and expression than in Italy. France suffered from a succession of inept kings of the house of Valois, only one of whom, Charles V, was a man of character. Italy suffered the fearful effects of the Black Death of 1348–1349, but was spared the devastation of the Hundred Years War that racked France from 1339 to 1453. Italy profited as well by the disintegration of the Holy Roman Empire, with the imperial power a pawn in the hands of the archbishop-electors of Cologne, Trier, and Mainz, or identified by the rising rulers of Bohemia, Saxony, and Austria with their own dynastic ambitions. The dukedom of Burgundy, seized in default of heirs in 1363 by King John

MICHEL COLOMBE: *St. George and the Dragon*

[347]

of France, was given by that unfortunate monarch to his youngest son Philip, and added to itself through marriage and otherwise the Low Country counties of Flanders and Holland, becoming thus one of the most powerful states in Europe, and a constant threat to the integrity of France. The decline of royal power aided the rise of the democratic idea, the political expression of the realistic movement, which makes its appearance in the *États généraux* and provincial assemblies, counterparts of the same symptom visible in Spain, Bohemia, and Germany, where also we see the convening of Cortes, Diets, and Landtage. It was in the reign of Edward III (1327–1377) that the English House of Commons crystallized into the legislature we know today, and Parliament finally gained control of revenue and taxes. The Swiss experiment in federated democracy came into being with the Perpetual Pact of the three forest cantons in 1291, developing into the union at the end of the fourteenth century of five peasant cantons with the three cities of Lucerne, Zürich, and Berne. Throughout the cities of Europe the period of the later fourteenth and the fifteenth centuries is one of constant effort on the part of the craftsmen's guilds to make headway or rather to hold their own against the centralizing wealth and commercial power of growing capitalism, represented by the merchant patricians, great banking houses, and even the mediaeval precursors of modern stock companies.

These incipient modern stresses are in fact the final phenomena of late Gothic times, reflected in the greater abyss, economic and social, that separated the rich bourgeoisie and the poor, and the sumptuary laws that cities passed against at least the outward evidence of luxury and extravagance. Charity became so huge a burden that it could no longer be handled by the church and was passed on to the city as a municipal responsibility. The popular risings that began with the peasant revolt of 1251 in northern France were more frequent in the fourteenth century. The peasants made common cause with the rebellious guildsmen in Zannequin's rebellion in Flanders (1323), attacking the houses of the nobility and the merchants' monopoly of political power in the towns. The same union was accomplished for a moment in France when the Jacquerie of 1358 broke out, a rising of the *petite bourgeoisie* of Paris led by Étienne Marcel, and a peasantry maddened by the depredations of the English and the mercenary companies. A lingering serfdom and feudal oppression of the poor in England brought on the revolt of John Ball and Wat Tyler in 1381.

But feudalism was declining; the English archers at Crécy and Poitiers and the utter defeat of the French knights by the Flemish town militia at Courtrai in 1302 destroyed the prestige of the noble cavalry. Chivalry was crystallizing

[348]

into an artificial system, marked by the founding of knightly orders such as the Garter in England (*c.* 1350) and the Golden Fleece in Burgundy (1430), which petrified the forms of chivalric virtue while its substance was violated in as consistent a record of ruthless warfare, treachery, and assassination as European history could exhibit until recent times. The seamy side of politics was screened in contemporary narrative, as for example in the chronicles of Froissart, by the usual disguise of allegory, converting squabbles for power into crusades against injustice. The dilution of morale can be marked in literature: in the addition of intrigue and the "triangle" to mediaeval romance, and in the recession from ideal love to physical passion in the sequence of Italian heroines of the Trecento—Dante's Beatrice, Petrarch's Laura, Boccaccio's Fiammetta.

The church in the fourteenth century no longer served as a field of reference or guardian of Gothic morality. When Sciarra Colonna slapped the face of Pope Boniface VIII at Anagni in 1303, in company with the gangsters of the French king Philip the Fair, the act was symbolic of the collapse of ecclesiastical leadership. The "Babylonian Captivity" which followed kept the popes at Avignon as creatures of the French monarchy from 1305 to 1378, and was followed by the papal schism until the re-establishment of Rome's authority, at least as the titular head of the church, in 1417. The scholastic synthesis of High Gothic was shattered by speculation which probed at the foundations of Aquinas's *Summa*. Experimental science was foreshadowed already in the thirteenth century by the writings of Albertus Magnus and Roger Bacon, and the beginnings of modern physics, analytical geometry, and geography can be traced to thinkers both lay and clerical of the fourteenth and early fifteenth centuries. "Realism," the scholastic principle of the reality of universals on which the reconciliation of faith with experience was based, was gradually in late Gothic thinking replaced by nominalism, insisting on the reality of particulars alone. This prepared the way on the one hand for scientific inquiry, and on the other led religious minds into a mystic rather than theological avenue to God. The fertile field of mysticism in the fourteenth and fifteenth centuries was the Rhineland and the Low Countries, where the Dominican monasteries produced a line of ecstatic seers of visions, from Master Eckhart (d. 1327) to his disciples Tauler and Suso—men who could physically realize a union with the Divine. In the Netherlands the movement was extended by Ruysbroeck, and became a more practical quietism in his successors the "Brethren of the Common Life" at Deventer and Zwolle in Holland, whose schools, where Christian and antique learning were equally prized, were the prelude in the North to both Renaissance and Reformation. From this

[349]

milieu came in the later fifteenth century the *Imitation of Christ* ascribed to
Thomas à Kempis and the radical theology of Wessel Gansfort which formed
the basis and even most of the body of Martin Luther's doctrine.

Piety in the fourteenth century was thus seeking comfort elsewhere than in
the church. The individual soul, in default of constituted guidance, must
needs make its own way to spiritual peace and communion with God. Such
was the theme of Wyclif of Oxford, who rejected all the sacraments save mar-
riage, attacked the doctrine of transubstantiation, was responsible for the trans-
lation of Scripture into English, and pictured the Saviour insistently in his
human guise. This too was the vision of Christ that haunted the Dominican
mystics, who wept at the actual sight of the tortured form on the Cross, and
felt with the Virgin the blood that spurted from the side of her Son. The
German ivories of the fourteenth century which popularized this mystic sen-
timent actually show the jet of blood reaching from the side of the Crucified
to the breast of the Virgin, or a sword in the same position. The physical
Jesus, intimate and comprehensible, was drawn closer to the pious heart by
new iconographic types that dwelt upon his humanity, and especially on the
physical agony of the Passion as guarantee thereof. It is at the end of the
fourteenth century that Christian art turns by preference to themes such as
the *Pietà*, the Virgin mourning the dead Christ lying on her lap, and the *En-
tombment*, with its funereal group of Joseph of Arimathea, Nicodemus, Mary,
St. John, the Magdalen, and the Holy Women.[11]

We have already seen the impact of the realistic movement on High Gothic
style in France, as it tried to force its expression through the untoward forms
of scholastic symbolism. We know the decadence that resulted, the substitu-
tion of a superficial grace and prettiness for meaning. The "Golden Virgin" of
Amiens and her sister of the fourteenth century in the choir of Notre-Dame
at Paris (*Figs. 117, 121*) are sufficient witness to the dissolution of religious
content, blocked from any but artificial expression by an outdated style. The
elegance of this decadent French manner imposed its decorative forms on the
rest of Europe; its triviality lost France the leadership of mediaeval art. The
art of Italy and the Netherlands provided satisfaction for the troubled con-
science of the decades of the Hundred Years War and Babylonian Captiv-
ity which the graceful style of Paris could not give. Italy idealized the French
formulae in the art of Giovanni Pisano and Simone Martini; the Low Coun-
tries transformed them into an argot of earthy realism. By the end of the four-
teenth century these three modes—the lingering Parisian Gothic, Flemish
realism, and Italian idealism in its Sienese version, began to coalesce into a

11 E. Mâle, *L'art religieux de la fin du moyen-âge en France*, Paris 1908.

manner that penetrated into all the national arts of Europe and is known in consequence as the "international style." An example of this "international-ism" may be seen in Gentile da Fabriano's famous *Adoration of the Magi* (1423) in the Uffizi at Florence, with its dominant French Gothic tones of red, blue, and gold, the trend toward curvilinear pattern of figures and landscapes, its Sienese sweetness of spiritual sentiment and panoramic landscape, and the new northern realism of its endless detail (*Fig. 154*).

The Italian influence on French Gothic was promoted (along with other causes) by the sojourn of the popes at Avignon, where they employed a se-ries of Italian painters beginning with Simone Martini who went to Avignon in 1340 and there obtained a favorable notice in one of Petrarch's sonnets by reason of a portrait of Laura. Italian ateliers were established in Paris, like that of Pietro Sacchi of Verona, recorded from 1397 to 1421. The Flem-ish element was of slower arrival, appearing in the reign of Charles V whose most favored craftsmen were Jean of Bruges and André Beauneveu of Valenciennes, sculptor, painter, and miniaturist, celebrated by Froissart, and artist *en titre* of the king's brother the Duc de Berry. The effect of the Flemish transfusion can be seen by comparing two Parisian works done for the king and his brother Louis of Anjou—the *Parement of Narbonne* in the Louvre and the seven tapestries of the *Apocalypse* that hang in the nave of the cathedral of Angers. The "Parement" (*Fig. 158*) is a *chapelle,* or special altar cloth of silk used during Lent, adorned in this case with Passion scenes drawn in ink by a French artist, possibly the king's painter Jean of Orléans. On either side of its central composition of the Crucifixion kneel the figures of Charles V and his queen Jeanne de Bourbon, whereby the piece is dated between 1364, the year of Charles's accession, and 1377, when Jeanne de Bourbon died. The Crucifixion is somewhat "international" in style: a Jew with turbaned head and pigtail in the throng to the right of the Cross is a motif employed in Italy in Giottesque painting, while the realistic animation of the crowded scene, and the careful royal portraits, contribute an accent of Flemish matter-of-factness. But the arcade that forms the upper border of the scenes is still reminiscent of cathedral style; the curvilinear drapery, and movement and gesture that is decorative rather than dramatic, reveal an art that is not yet released from the esthetic preoccupation of the French decadence. The tap-estries of Angers on the other hand (*c.* 1380), whose cartoons were drawn by the Fleming Jean de Bruges, present a singular contrast in the effect of land-scape and of space (despite the "mille-fleurs" background whereby the weaver Nicholas Bataille conformed to contemporary taste), and in the naïve real-ity which invests these apocalyptic visions (*Fig. 159*). Our illustration shows

the "blessed who die in the Lord" (Rev. xiv:13), tucked in their deathbeds with hands clasped in prayer, while angels lift their naked souls to Heaven in a sheet. At the left John Evangelist writes down the vision at the direction of an angel; he is a thoroughly Flemish figure with flaring hair, squat proportions, and drapery which breaks the French "cascades" into a multiplicity of folds. The extent of the artistic *parti* which these tapestries represent is impressive: the overall length of the seven pieces in original state was about 144 meters; the cost of each of the seven hangings (with fifteen scenes in each of them except the second and third) ran as high, allowance made for change in money value, as about $4,000 in terms of today.

The progress of realism can always be traced by the transformation of the portrait. In France this symptom can be followed in the royal tombs at Saint-Denis, the Westminster Abbey of Paris. When Saint Louis (1226–1270) commissioned the sepulchral monuments of his Merovingian predecessors, their effigies were executed in the conventional type of royalty that one finds in the "kings' galleries" of the cathedrals—a noncommittal ideal face with hair falling in a double curve beside the head and none of the realistic evocation accomplished by Bishop Dietrich in the famous statues of the western choir of Naumburg (p. 296). A son of Saint Louis lies upon his tomb in monastic garb, hands clasped in prayer, and eyes opened to the joys of Paradise;

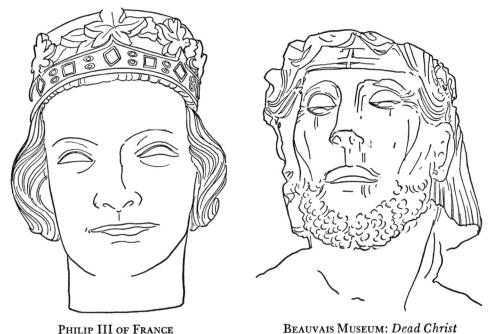

PHILIP III OF FRANCE BEAUVAIS MUSEUM: *Dead Christ*

the face is a characterless type. But in the tomb portrait of Philip III, done about 1300 by Pierre de Chelles, native of Île-de-France, and the Fleming Jean of Arras, the traditional royal head has acquired a wry twist of the mouth that marks a personality. The pious clasped hands continue in effigies of the first half of the fourteenth century, but with increasing attention to physiognomy and material details of dress and indications of worldly station, until in the second half of the century the tombs of Charles V and Philip VI (in Saint-Denis and the Louvre) confront us with André Beauneveu's frank portraiture, emphasizing crown and scepter and attempting no disguise of the less than comely Valois features. A potent stimulus to exact portraiture was the custom of making death masks which arose in the late fourteenth century. But the realistic portrait did not depend on this; an extreme example is the statue of Charles V (*Fig. 161*) on the south buttress of Amiens, which has been sometimes attributed to Beauneveu. This illustrates as well the characteristic tendency of early realism, in its search for individuality, to fall into caricature; the head has a peering suspicious glance and a crown too heavy for it, and the king grasps his scepter with both hands as if in fear of losing it.

The portrait is the natural vehicle of realism; we shall be better able to assess the disintegration of the High Gothic ideal in a theme of loftier content. Such is the Mother of God, in whose gradual transformation from the twelfth century to the end of the fourteenth the rise of realism can be precisely followed. We have seen her on the west fronts of Chartres and Paris (*Fig. 107*) at the very beginning of Gothic style, still hieratically conceived, holding the rigid Child as the focus for his worshipers' adoration, frontally enthroned upon her lap. Nothing but the softer modeling of her face and hands betrays the sentiment with which the later Gothic art will treat her; she is still the *sedes sapientiae*, the throne of the God child. On a lateral portal of the north transept of Reims, a generation later, she is still seated and still frontal, but the Child is shifted to a more maternal position to the side, and mother and infant consequently acquire a more intimate and human aspect. Then she changes to the cathedral Madonna, the standing figure which dominates the Virgin portal of Amiens, a queenly figure, but more approachable since her status is now more royal than divine. Her career in Gothic sculpture thereafter is one of lessening dignity and greater appeal; the lovely Madonna of the north transept of Notre-Dame (*Fig. 116*) is a marquise, and has acquired in her delicacy of features and grace of pose the artificial distinction with which the Gothic sculptor of the later thirteenth century clothed his ideal of aristocracy. She becomes more understandably feminine and more mannered in the *Vierge dorée* of Amiens, and reaches an effect of saucy coquetry in her

statue of the choir of Notre-Dame (*Fig. 121*), beyond which Christian art never went in its familiarity with Mary. When Italian art took on this type, the Virgin became a tragic Mother in the statues of Giovanni Pisano; when Flemish realism has intervened, the tragedy becomes personal and poignant, enhanced by the oppressive accent of the heavy complicated Flemish drapery.

❖ ❖ ❖ ❖ ❖

Such is the Madonna who stands on the portal of the church of the Carthusian monastery at Champmol, two miles outside of the Burgundian capital of Dijon. This is a figure which may well be called a landmark in the history of sculpture, since its filiation from the Madonnas of the decaying cathedral style is evident, and yet it is the initial work of the Burgundian school which was to dominate both sculpture and painting in the north of Europe for the first half of the fifteenth century. To the older tradition belongs the hipshot pose and cascading drapery; new and Burgundian is the deep undercutting of this drapery, its weight, and its complicated subdivision. Most "Burgundian" of all is the strong concrete accent of the Virgin's earnest face, far from the dainty femininity of the Madonna in the choir of Notre-Dame, and reflective of the uneasy piety of the age. The figure was probably the last work of Jean de Marville, "Ymagier et varlet de chambre" of Philip the Bold, duke of Burgundy. This sculptor died in 1389, and was succeeded by a greater artist who determined the future trend of Burgundian sculpture—Claus Sluter of Holland.[12] To him are due the other statues of the portal of which the finest is the figure of the duke, whose face is a wonderful rendering of shrewd devotion as he kneels in decorous reverence to the Virgin. Opposite him is his duchess Margaret of Flanders, who brought Philip the rich province that laid the foundation of Burgundy's later status as a major power in Europe. Behind the duchess stands her patron saint Catherine of Egypt, while St. John the Baptist on the other side is sponsor for the duke.

This last-named statue shows the development of the style from Jean de Marville's compromise with decadent Gothic tradition; it ushers in the characteristic Burgundian stooping posture, accentuated here by the bent knee of the Baptist, and especially by the all-enveloping mantle, the *houppelande* which became the fashion in the late fourteenth century, and was used by these Low Country artists to provide the weight and bulk of reality. It covers the head, masks anatomy, and falls about the feet in spreading broken folds which constitute a sort of base for the figure. The body, whose mechanics and construction were at this time the absorbing study of Donatello and his

[12] A. Liebreich, *Claus Sluter*, Brussels 1936.

fellow naturalists of Florence, was still ignored by these northern artists, who make their figures out of a mass of drapery, topped with a head on which is concentrated an extraordinary power of characterization.

During the work on the portal statues, other sculpture was planned and executed for the interior of the Chartreuse of Champmol. In 1390, a Pietà by the hand of Sluter was placed in the chapel; a Virgin with the dead Christ on her lap, accompanied by two angels. The group, which has disappeared, is almost the first recorded instance in France of this addition to the growing repertory of pathos which late Gothic piety demanded. The type seems first to have been visualized by the Dominican mystics of the Rhine. We can gauge the poignant effect of this lost Pietà by Sluter's greatest remaining work, the *Puits de Moïse* (*Fig. 160*). The "puits" was a pool in the courtyard of the cloister of the Chartreuse, in whose center was placed a Crucifixion on a pedestal adorned with six figures of prophets, from one of whom it took its name of "Moses fountain." Of the Crucifixion only the upper part of the Christ remains—a Christ whose face is marked by lines of agony, but expressing an

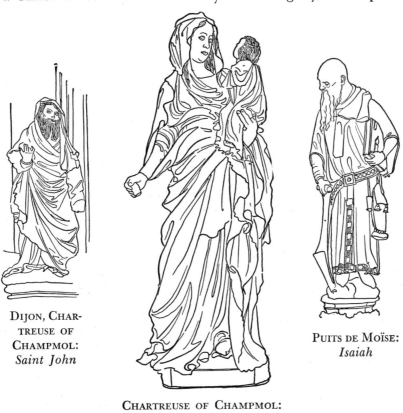

Dijon, Chartreuse of Champmol:
Saint John

Puits de Moïse:
Isaiah

Chartreuse of Champmol:
The Madonna

epic sadness rather than the physical suffering which was more and more the theme of later renderings of the Passion, well illustrated by the painful head of the dead Saviour in the museum of Beauvais (p. 352). The cornice of the pedestal rests on the outspread wings of weeping angels whose slender forms, obscured by the enveloping Burgundian drapery and made still slighter by the contrast of their vigorous wings, are noteworthy examples of the dynamic principle of Gothic art. They lack the robust physical competence of classic caryatids such as those which support so easily the porch of the Erechtheum, but lack as well the painful effect of crushing weight which the Romanesque gave such figures; the Gothic artist sees them as young enough and strong enough of wing to carry by sheer vitality their heavy burden.

The six prophets hold scrolls on which were painted inscriptions foretelling in allegory the coming Crucifixion: Moses, "the whole assembly of the congregation of Israel shall kill it [the Paschal lamb] in the evening" (Exod. xii:6); David, "they pierced my hands and my feet" (Psalms xxii:16); Jeremiah, "All ye that pass by, behold, and see if there be any sorrow like unto my sorrow" (Lam. i:12); Zechariah, "So they weighed for my price thirty pieces of silver" (Zech. xi:12); Daniel, "And after threescore and two weeks shall Messiah be cut off" (Dan. ix:26); Isaiah, "he is brought as a lamb to the slaughter, and as a sheep before her shearers is dumb, so he openeth not his mouth" (Is. liii:7). This developed form of *dittochaeum* was not original with Sluter; it had already been exploited in the illustrations of the German *Biblia Pauperum* (p. 273), and latterly by the mysteries of the Passion, the popular religious plays which in the fourteenth century, in response to the craving for more intimate religious experience, had grown out of the old liturgical dramas of the church. One of these plays might have provided the motivation for Sluter's work; it is a "Judgment of Christ," retailed with copious allegory, which is developed into a veritable court scene, with Christ as defendant, and the Virgin as his counsel, pleading before a tribunal composed of prophets. The issue is foreordained; *secundum legem debet mori;* the Son must die that the Redemption willed by the Father be accomplished.

This is the sentence delivered by the prophets of the pedestal, and justified by the inscriptions on their scrolls; it was carried out by the Calvary above, lamented by the caryatid angels, and reflected in the varied reactions of the striking personalities Sluter has embodied in the six statues. David is the least impressive; he is an obvious compliment to Duke Philip, whose visage is idealized in the royal figure. Jeremiah turns from his open book to ponder the mystery with half-closed eyes and pursed lips; Zechariah is lost in melancholy reverie, accented by his heavy mantle and the ponderous hat under

which his head is bowed. Daniel is a fierce Semitic type, pointing with finality to the prophecy on his scroll whose fulfillment he sees with eyes uplifted to the Calvary above. Isaiah is some old Jew of the ghetto of Dijon, infirm and tottering with the weight of his thick robe, big book, and exaggerated girdle. Moses, the most idealized of the six, is so only superficially, by virtue of his elongated beard, his less specific drapery, and the traditional "horns" on his forehead by which the Middle Ages recognized the patriarch. But the wrinkles of the aged face confront one with reality, extending even to the symbolic horns, and out of this poignant portrait of extreme old age the sculptor has evoked the seer, contemplating with unseeing eyes the cosmic tragedy his prophecy foretells.

In the *Moses* and his companions on the pedestal, Burgundian sculpture shows a degree of lofty inspiration it never reached again; the ability to seize such universal notes amid the confusion of multiplied detail was lost in the pervasive naturalism of the century that succeeded Sluter's death in 1405. His atelier continued under the direction of his nephew Claus de Werwe, and had for its chief occupation the construction of the tomb of Philip the Bold. The duke died in 1404, but the tomb was not finished until 1410. It had existed as a design since the time of Jean de Marville, and to him must therefore be credited this Burgundian version of the old free-standing sepulcher type, with its remarkable development of the traditional funeral procession about its base (p. 304) into the elaborate Gothic arcade that shelters the "pleurants." The Burgundian type thus established became the mode thereafter most employed in northern Europe until the Renaissance, and is illustrated here (*Fig. 162*) by the replica of Duke Philip's tomb which was designed by Sluter's nephew Claus de Werwe for Philip's son and successor John the Fearless and his duchess Margaret of Bavaria. The monument exhibits the pictorial rather than plastic conception of sculpture which is characteristic of the Netherlandish taste inherent in the school. The dissolution of the old relation of sculpture to its architectural setting was already evident in the statues of the *Puits de Moïse*, whose pedestal seems merely a point of departure for the free-standing figures. The same indifference to sculptural mass continues in the ducal tombs, on whose upper slab of marble rest the effigies, hands clasped in prayer, with small kneeling angels holding the casque of Burgundy or a coat of arms above the head. The wings of these angels, spread wide and high, are conceived in the terms of painting, and so also is the alabaster arcade below, of intricate Gothic tracery, within which stand the little "mourners" of the funeral procession (*Fig. 164*).

To understand these *pleurants* one must picture the funerals of the Burgundian dukes. When Philip the Bold died suddenly at his castle of Hall near

Brussels in 1404, the body was embalmed, and 2000 yards of black cloth were provided for the costume of the courtiers who were to accompany the dead duke to his last resting place at Champmol. The procession started from Brussels on the first of May; it reached Dijon on the evening of June 15th. The cortege consisted of about sixty persons, each enveloped and hooded in a black *houppelande,* and the throng was joined at the boundary of each of the ducal provinces by representatives of vassal houses—a funeral whose magnificence impressed the whole of Europe. This is what Sluter and his nephew represented in their alabaster mourners, immobile figurines that yet are very realistic in their attitudes of grief, even to blowing the nose! But their mourning is more often rendered in singular fashion by the drapery alone; shrouding both face and figure, its weight is translated into the oppression of sorrow, and adds a curious dignity to the quaintness of these little men.

❖ ❖ ❖ ❖ ❖

Quaint they are, nevertheless, and quaintness is a quality that clings unceasingly to late Gothic sculpture outside of Italy. The Italian sculptors as well as painters emerged from the realistic movement into the broad idealism of the Renaissance, made broader and more ideal by its expression in the exotic vocabulary of classical antiquity. To realize the gulf between northern realism and Italian abstraction one need only compare Michelangelo's Jovelike Moses and the wrinkled squat old man of Sluter's *Puits de Moïse.* The northern sculptor, even with Sluter's loftier vision, was too absorbed in specific detail to realize the intimations of realism—the sense of infinitude, of eternal values, of unlimited extent of time and space suggested by the particular aspects of experience he loved to elaborate with affectionate detail. As long as Gothic sculpture clung to the cathedral, the latter's grand ensemble and imaginative space endowed its statues and reliefs, however homely in themselves, with the ultimate significance of the scholastic synthesis. But sculpture had now "come down from the cathedral," and no matter how acutely it might observe and copy life about it, it lacked the universal note the cathedral gave it. This is the second factor that makes the full measure of realism, the consciousness of the infinitudes of time, space, and human experience that lurk about the concrete and magnify its significance. Late Gothic sculpture had no means of rendering it; late Gothic painting recovered the sense of it in the unlimited space of landscape.

The northern painter, in the matter of landscape, started as it were from scratch. He did not inherit the Byzantine "Alexandrian" background from which Sienese artists developed their topographical panoramas, and the Flor-

entines their distant views of river valley and mountain range. Beyond the Alps, cathedral style had imposed on miniatures, glass, and such wall painting as the diminished Gothic wall area allowed, the neutral decorative ground of tooled gold or diapered color. The northern landscape was thereby the more committed to fresh observation and invention, and in comparison with the Italian provides invariably a more realistic prospect. The relatively idealized figures and episodes which occupy the foreground of Italian vistas impart their own abstraction to the landscape, which thus becomes a lyric adjunct to the picture, but not a habitat. The *mise en scène* in even the earliest Netherlandish landscapes is on the other hand convincing as the place where the figures live. As northern style developed, the implication of such concrete location was gradually realized, and the unlimited space which specific site involves began to lend its atmosphere of infinitude to the otherwise quaint renderings of Gothic themes.

The discovery of landscape in the North was the work of the miniaturists and painters employed at the courts of France and Burgundy. It was a rapid process like the unfolding of Greek classic style in the fifth century B. C., a quick opening of artists' eyes to a world about them that had hitherto been obscured by the screen of symbolism, and to the highly interesting human being *per se*, no longer considered as a theological term. When Charles VI of France began his reign in 1380, French and Flemish painting was still using the decorative background, and personality was only beginning to emerge in figures; when he died in 1422, landscape and interiors were the vogue, with very specific men and women in them. Painting at Paris *c.* 1390 is well represented by our *Figure 165,* a triptych once in the Chartreuse of Champmol of Dijon, now in the Deutsches Museum at Berlin. Cathedral style is still with this artist, even to the perforation of his panels to make them conform to quatrefoil frames like those which surround reliefs on the façades of Rouen and Auxerre. The gold of his backgrounds is tooled as in the Gothic miniatures, in this case with delicate flowering rinceaux. But Flemish genre has arrived in the comfortable Evangelists, whose symbolic beasts attend them like household pets. The Trinity in the center, surrounded by angels who hold the instruments of the Passion—Cross, Crown of Thorns, the Column of the Flagellation and the Lance—has only an emaciated Crucified to mark the mounting pathos in late Gothic visions of the suffering Saviour. God the Father has still the childish features of the High Gothic decadence, and Christ on the Cross resembles the same figure in the Crucifixion of the *Parement of Narbonne* (*Fig. 158*).

The *Martyrdom of S. Denis* in the Louvre (*Fig. 166*), is only a decade

later in date, but far advanced in realism despite its still archaic background. The saint receives communion at the left, administered through the barred window of his prison by Christ himself, while angels act as acolytes. The prison is of an architecture much less French than Lombard. To the right Denis is beheaded, together with Rusticus and Eleutherius, his companions in martyrdom. Symbolism still intrudes: the narrative is interrupted in the middle by a Trinity, impersonated by God the Father with outstretched arms, an almost effaced Dove above the head of the Crucified, and the tortured body of Christ upon the Cross. But God the Father is now an old man, and Christ a very human sufferer; the executioner who wields the ax above St. Denis's head is a well-studied piece of muscular action, while every face in the picture except the angels and the cherubs who dot the sky around the Cross bears the imprint of distinctive personality. The painter of the panel, now removed from its wood to canvas, was probably Jean Malouel, court painter of Dukes Philip the Bold and John the Fearless; the picture was commissioned for the Chartreuse of Champmol, but left unfinished at Malouel's death in 1415, and completed by his successor as ducal painter, Henri Bellechose.

Malouel was a Hollander, from Gelderland, who entered the Burgundian service at Dijon in 1397, where he is recorded as having painted Sluter's statues on the *Puits de Moïse*. With him to France came his nephews Pol, Hennequin, and Hermann, known from their Dutch origin as the brothers "de Limbourg." From their workshop came the beautiful miniatures of the *Très Riches Heures* of the Duc de Berry, brother of Philip the Bold, now in the Musée Condé at Chantilly.[13] These tiny pictures are a perfect illustration of the elements that went to form the "international style." The *Presentation in the Temple*, for example, is an imitation of Taddeo Gaddi, with Giottesque inflated forms, long necks, and angular postures, while the Temple is a northern copy of his Tuscan architecture. The *Arrest of Christ* shows us a Sienese procession like Duccio's *Entry into Jerusalem*, or Simone Martini's *Via Crucis* in the Louvre, but moving to the praetorium of Pilate through a French street, and composed of a mixture of Flemish men-at-arms and Jews in the oriental dress which so fascinated the late Gothic painters of Italy. In the *Coronation of the Virgin* we have an almost purely Parisian picture, French Gothic even to its trefoil frame and the reduction of all its drawing to flowing pattern; but the initial is bordered with a spray of Italian acanthus. The landscapes of some of the scenes of Christ's life are a variety of Italo-Byzantine, with the characteristic sloping hill or peak, but in the calendar we have the most delightful series of the Labors of the Months that mediaeval art contains, real

13 B. Burroughs, "The Discoverer of Landscape," *The Arts*, Sept., 1927.

winter and summer countrysides on whose horizons rise the detailed render-ings of the duke's châteaux. The first of the series, January, month of feasting, is enlarged from the solitary old man at table which sufficed for High Gothic symbolism, into a magnificent scene with the duke presiding over a banquet, surrounded by his court and servitors, in a hall of one of his castles on whose wall a tapestry is suspended, which can be recognized as a hanging woven at Arras and mentioned in his inventories.

The miniatures of the *Très Riches Heures* were probably done just before the death of the duke in 1417; the book was his favorite in the extraordinary library of illuminated manuscripts which belonged to him. The painters of its miniatures were natives of Holland, as was Claus Sluter, and throughout the rise of the new landscape style and its attendant homely humanity one finds the Dutch genius as its evolutionary leaven—a genius that even in the seven-teenth century, in the art of Ter Borch and Vermeer, was still trying to inter-pret man in terms of his surroundings after the manner introduced by these innovators of the early fifteenth century. Of such pioneers, the ones most definitely impersonating the realistic movement were the brothers Van Eyck from the vicinity of Maastricht on the Meuse, and of the monuments that mark its progress from the archaic phase of the miniatures of the Duc de Berry's *Hours,* the outstanding example is the polyptych of the *Adoration of the Lamb* in the church of S. Bavon at Ghent (*Fig. 169*).

The inscription on this picture tells us that it was begun by Hubert "than whom no greater painter has been found," and finished by Jan "second to him in art," in 1432.[14] The original unity of the present altarpiece is questioned, especially since Panofsky's suggestion that it was made up of three works be-gun by Hubert of which the lower panels would be one, the God the Father with the Virgin and Baptist another, and the angel musicians and singers a third. These according to his analysis were put together and completed by the younger brother, who added the Adam and Eve and the paintings of the outside of the shutters representing two prophets and sibyls, the Annunciation, the portraits of the donors Judocus Vyt and his wife, and the figures of the two Saints John. The "Deesis" of the upper central portion can plausibly be con-sidered as originally meant to be a separate altarpiece. According to this ex-planation of the undeniable oddities in the make-up of the *Adoration,* the lower part was originally a triptych with a central panel extending higher than the lateral wings to contain the figure of God from whom the Dove of the Holy Ghost descends to the Lamb on the altar; in the reconstruction the

[14] W. H. James Weale and M. W. Brockwell, *The Van Eycks and their Art,* New York 1912; E. Panof-sky, *Art Bulletin,* XVII (1935), pp. 453 ff.

central panel was amputated at the top and sides (accounting for the break in the sky line) and the wings subdivided to make a polyptych. To match this polyptych, the Adam and Eve and the angel panels (perhaps originally meant for organ shutters) were added to the triptych which surmounts the central lower panel, and the whole was worked over to an approximate uniformity in style by Jan.

However assembled, the *Adoration of the Lamb* in its interior panels, always excepting the startling nudes of Adam and Eve, bears the imprint of an artist who was at once a respecter of tradition, somewhat of an "internationalist," and somewhat of a mystic as well. These are characters not revealed in what we know elsewhere of the work of Jan van Eyck, who was a pungent naturalist and a wielder of powerful prose, but untouched by aught beyond what his amazingly competent eye could see. The plan of the *Adoration* came from the mind of his brother many years older than he, and belonging to a generation still familiar with the "international style," not yet forgetful of cathedral symbolism, and sensitive to its content. Even if the "Deesis" be an added piece, it still serves the purpose of crowning the central panel with the figure of God the Father, with his assessors the Virgin and the Baptist (original patron of the church of S. Bavon), and completing the symbolic panorama laid out in the central lower panel and its wings. Here we have the vision of Revelation: "the great multitude which no man can number" that "stood before the Lamb," and the "holy city, new Jerusalem," represented by the towers and spires rising above the high horizon, where Weale has thought to recognize the tower of St. Martin's at Utrecht and the city of Cologne. A passage in the *Golden Legend* undoubtedly defined the details: it relates a vision of the sexton of St. Peter's at Rome in which he saw the King of Kings and the Virgin enthroned amid angels, and multitudes of anchorites, bishops, and knights who came "all to fore the throne of the King, and adored him upon their knees." If indeed Jan finished his brother's work with the upper terminal panels, it was a just perception of the symbolic complex that prompted him to insert the figures of Original Sin in the persons of Adam and Eve, with the little vignettes of the *Offerings of Cain and Abel* and the *Murder of Abel* above them. The content is the old cathedral theme of Redemption, commencing with the Fall of Man and continuing on the exterior of the shutters with the promise of Atonement uttered by prophets and sibyls, fulfilled by the Incarnation embodied in the Annunciation, and consummated by the blood of the Lamb, the death of the Martyrs, and the lives of the Saints. It is in fact the scholastic synthesis, "come down from the cathedral," and attuned to the individual piety of Judocus Vyt

and his spouse, whose incisive portraits on the exterior seduce the eye from the Annunciation and the two Saints John.

The landscape of the *Adoration* envelops the figures; they belong to it, despite their symbolic grouping and distribution, and the setting thereby imparts to the spiritual allegory a sense of physical experience. It is still reminiscent with its climbing ground and high horizon, its stratified rocks and semitropical vegetation, of the Italian backgrounds favored by the "international style," but what Hubert owed to this is overborne by the Netherlandish tone pervading all the details. The angels who kneel around the altar of the Lamb, swinging censers or holding the symbols of the Passion, are replicas of those attending the dead dukes of Burgundy on their tombs; the draperies vary from the fluent French lines to the heavy broken folds of Sluter's school. What amazes the close observer of this work is the interminable exact detail and range of characterization. As always in Netherlandish art, the women are less differentiated than the men, but character and mood shift from face to face in all the groups of prophets, Doctors of the Church, philosophers, princes, apostles, martyrs, confessors, and virgins, whom "the Lamb shall feed . . . and lead them unto living fountains of waters." Each flower upon the grass, the grass itself, and every tree and bush is an intimate study. The gems on ecclesiastical vestments, croziers, crosses, tiaras, and miters are meticulously recorded. The splendor of this jeweled color increases on the left wings of the altarpiece, where ride the "Knights of Christ" led by St. Martin, and the "Just Judges" among whom an elderly and a younger rider have been by tradition identified as portraits of Hubert and Jan. More soberly clad, the hermits and pilgrims advance on the right wings, the latter preceded by a gigantic St. Christopher. The detail of the upper portion, again more colorful on the left side, is particularly intriguing in the panel of the singing angels, one of whose brocaded copes is clasped by a morse carved with a figure of Moses holding the Tables of the Law. The lectern which holds their music is elaborately sculptured, the principal relief being a St. Michael slaying the dragon. All through the upper zone the symbolic chain is continued with inscriptions reciting the attributes and titles of God, the Virgin, and the Baptist, extending even to the designs of the tiles in the pavement with their crosses, lambs, monograms of Christ and Mary, and the potent Hebrew acrostic AGLA, denoting the power of the Lord.

We know almost nothing of the life of Hubert van Eyck until his last two years. In 1425 he was at Ghent, where he made two sketches for the magistrates of the city, and we hear also of a visit paid by these worthies to his studio. In 1426 he died and was buried in the crypt under the chapel for which the

Adoration was painted. Whatever fame he enjoyed in his lifetime has been obscured by the prominence of his younger brother, whose career was very different from the mediaeval craftsman's role of Hubert. We first hear of him as painter to John "the Pitiless," prince-bishop of Liége and usurping Count of Holland, whose palace at the Hague was decorated by Jan van Eyck in 1422. By 1425 the painter was "varlet de chambre" (a well-paid and honorable post) to Philip the Good of Burgundy, whose accounts show that Jan enjoyed the confidence of his prince to a remarkable degree. Philip was godfather to Jan's son, and sent him on various diplomatic missions, of which the most important was an embassy to the King of Portugal to ask the hand of his daughter Isabella for the duke, a journey lasting fourteen months from 1428 to 1429 and including a pilgrimage to Santiago de Compostela. His later life was passed at Bruges, where he died in 1441. Jan was thus a citizen of the great world, an honored member of the most splendid court in Europe, and his painting reveals an eye that missed no single item of its splendor, or of the varied and colorful experience which this well-paid and well-connected artist led.

To him we may ascribe the penetrating observation of the very naked Adam and Eve on the altarpiece of Ghent, and no doubt the rich detail of jewels and costumes; these were the things that entranced the younger Van Eyck, who seems when compared with his mediaeval brother to be of a wholly different epoch, a painter who speaks the modern language of materialism. We have selected out of the *oeuvre* of the Van Eycks an illustration which may serve to clarify this contrast, since it is a picture occasionally ascribed to Hubert (with the figures by Jan), but more often to Jan while still young enough to feel the older artist's influence. It is an altarpiece (now in the Louvre) presented to Notre-Dame at Autun by Nicholas Rolin, chancellor of Burgundy (*Fig. 168*). The chancellor, who in the painting kneels at a prie-dieu before the Madonna, was born in 1376 at Autun, and since he looks about fifty, the painting might have been done in Hubert's lifetime. It is quite obviously as much a portrait of the chancellor as an icon of the Virgin, and the accurate rendering of his head, unrelenting even to the somewhat ragged coiffure, is a signature of Jan, as well as the brocaded robe so like those of the angels in the *Adoration of the Lamb*. Characteristic of Jan, too, is the use of Romanesque in the architecture; a "modernist," he found something pristine and pleasantly archaic in the round arches of this loggia, despite the up-to-date bull's-eye windows inserted at the sides. The lighting is diffused and uncentered, employed as always in Jan's work to bring out detail. The principal colors are blue, violet, crimson, and gold, enhanced to translucent brilliance by the enamellike medium which Jan

[364]

used, causing him to be credited with the invention of oil painting though actually the oil medium had been known from mediaeval times.

The Virgin and Child are wooden conceptions, from which the eye quickly strays to the gold-embroidered text from Ecclesiasticus that decorates the edge of her mantle, broken in Burgundian folds upon the pavement, or to the blue and gold brocaded cushion on which she sits, or the lovely Hubertian angel who holds the intricate crown above her head. Detail increases rather than diminishes as the eye is led into the picture; the capitals of the piers that flank the arches of the loggia have reliefs of the *Expulsion from Paradise,* the *Offering of Cain and Abel, Noah leaving the Ark,* and *Cursing Ham.* A flower garden occupies the terrace beyond the loggia where two peacocks strut in the sun, and two men in red and blue enjoy the view over the river and the town. The town is Maastricht and the river the Meuse; it is a feast day, and files of people (tiny figures carefully delineated) are issuing from the streets and crossing the bridge to the cathedral on the right-hand side. The perspective is empirical; true in the atmospheric sense, it lacks the scientific focus which Italian painting and sculpture were achieving at this time. In the distance a range of blue mountains with snow-clad summits carries the setting into unlimited space. But the protagonists of the picture, the chancellor and his Madonna, are not part of this infinitude as were the adoring throngs of the *Adoration of the Lamb;* Jan van Eyck was untouched by such implications, and kept his figures immobilized in the foreground, lest any minutiae of feature, dress, or jewelry be overlooked. His most complete assemblage of photographic detail is the Madonna painted for Canon van der Paele at Bruges. Here the material record is overpowering, and enhanced by an extreme of descriptive lighting, even to the reflections from the flames of the candles held by St. Donatian who occupies the left of the picture. Balancing him on the right is St. George, who steps in as if in tardy and apologetic arrival, tipping his helmet like a hat. The demure Madonna magnificently enthroned in the center is quite ignored by the saint, and especially by the kneeling donor (*Fig. 170*), whose figure is emphasized by a white surplice, and whose portrait is the most powerful physical likeness that art had known since the portraits of republican Rome.

The final step in the emancipation of landscape, where it becomes an artistic concept in its own right, to which figures or actions are subordinated— "une vision de l'univers," to quote Tolnay, "exempte de conventions"—is well illustrated in our *Figure 167.* We have seen this river-scape before, as the lower frieze of the miniature of the *Birth of the Baptist* (*Fig. 103*) and an

example of the fifteenth-century phase of Gothic illumination. It belongs to a series of leaves once in the Trivulzio Library at Milan but now in the Palazzo Madama in Turin, where they have replaced another set of miniatures from the same book, destroyed in a fire of 1903. The whole series illustrated a manuscript once in the collection of the Duc de Berry, which however left his possession in unfinished condition, and the date when these miniatures were added to the book is doubtful, recent opinion inclining to the thirties of the fifteenth century. They have been attributed to the Van Eycks themselves, and show many affinities with the *Adoration of the Lamb,* notably a group of virgins adoring the Lamb upon an altar, which is almost a replica of the corresponding motif in the Ghent altarpiece. But later criticism is inclined to ascribe them to a Dutch follower of Hubert, a gifted painter who in his tiny pictures can capture sunlight and evoke a mood in almost the same degree as his compatriots Cuyp and Van Goyen in the seventeenth century.

Nor is he much more archaic in his painting of an interior, as in the *Birth of the Baptist,* where in sheer rendering of space he outdoes Jan van Eyck's masterpiece of the sort—the portrait of Arnolfini and his wife. The lighting is Eyckian and diffused, an internal twilight punctuated by the white spots so favored in the "international style" and here furnished by the kerchiefs and apron of Elizabeth's maids. It is a silver glow in the window at the back and comes in the side window of the anteroom to pick up the reading figure of Zacharias. The space is not rendered so much by the rising floor as by the curtains of the bed, and the play of light itself is largely due to the distributed reflections, on furniture and metal vases, draperies, and floor. Detail is meticulous and accurate, even to the cat's bowl which the little beast neglects for a moment as if to face the intruding spectator. But such detail, insistent in this homely interior, is tempered with air and distance in the landscape below. The Baptism is quaintly pictured in the foreground, and the Dove of the Holy Ghost descends unobtrusively from God the Father in the initial, but these pious reminders give only a gentle spiritual focus to the mood of this landscape, which in a space of four inches by an inch and a half invites the eye into the vastness of miles of river valley, mountains, and sky. Another of the miniatures in the Turin-Milan series depicts SS. Martha and Julian crossing the choppy water of a harbor in a boat, and still another shows a courtly assemblage on a seashore on which the waves roll convincingly; the variation and change of nature absorb this "plein-air" painter as much as its immobile detail delighted Jan.

❖ ❖ ❖ ❖ ❖

Canon van der Paele, in Jan van Eyck's altarpiece, is already the man of our times: an image of self-assurance that has nothing in common with classic serenity, and blandly ignores the need of any transcendental support in the person of the Virgin. The art of Jan unfolds the full measure of material reality, and to that extent is modern; the modification of it in other Netherlandish painting could only introduce the movement of drama and narrative into its static compositions, adjust the figures to the newly found space, and instill into Jan's mundane visions the wistful spiritual content of the time. These changes were wrought by the contemporary school of Tournai and the later ones of Louvain and Jan's own town of Bruges, of which the representatives are Robert Campin (the "Maître de Flémalle") and Roger van der Weyden of Tournai, Dirk Bouts of Louvain, and Hans Memling of Bruges.

Robert Campin [15] worked mostly in the second quarter of the fifteenth century, in a style that is broader than Jan's, alive with movement and a pervasive naïve drama to which he sometimes makes his symbolism contribute, as when the Christ child, carrying the Cross, flies down the ray of the Holy Spirit toward the Virgin in the *Annunciation* of the Mérode collection at Westerloo in Belgium. The casualness of the episode is unimpaired by this bit of supernaturalism; through an open door in the left wing of the triptych the kneeling donors look with interest on the scene, and in his adjoining workshop on the other shutter, St. Joseph the Carpenter is engaged in the manufacture of a mousetrap. In his *Nativity* at Dijon, Campin enlarges the tale with details from the *Golden Legend:* two midwives are introduced carrying scrolls inscribed with their respective judgments on the miracle of the Birth: "A virgin has borne a son" says one, kneeling in reverence; *Credam quam probavero* is the inscription on the scroll of her skeptical companion. Her hand has withered in consequence; an angel flies down with a phylactery containing the injunction "touch the Child and thou shalt be healed." Campin's settings absorb the figures better than Jan's and make them seem much more *chez eux;* his detail is varied and circumstantial, but less microscopically observed. Characteristic is the long oval given the female face, and the breaking of the drapery into a quantity of sharp edges and flat folds. The "Master of Flémalle" marks a turning point in northern painting—its emergence from the scale and limitations of the manuscript miniature. Cast shadows separate his figures from their background, their gestures and movement have real rather than decorative motivation; the style broadens, and the illustration of a book is made into an easel picture. The Tournai manner, looser and more easily imitated and adapted than the meticulous detail and immobile tightness of Jan van Eyck, was far

15 K. de Tolnay, *Le Maître de Flémalle et les Frères Van Eyck,* Brussels 1939.

more influential in the spread of Flemish style. When this invaded Germany and Spain, the models followed were mostly the Master of Flémalle and Roger van der Weyden.

The homely drama of Campin was handled with more formality and distinction by his pupil Roger van der Weyden (1400–1464), a versatile painter whose style could range from genre to passages of almost classic breadth, and appealed for that reason to every variety of fifteenth-century taste.[16] No artist was more widely imitated in the century. The movement he learned from Campin gave him a realization of bodily structure and functional drapery that is absent from Eyckian painting, resulting in figures more slender and lithe. Whether or not he visited Italy is still a question, but his work at times takes on a plasticity that seems more Italian than Flemish, as in the *Descent from the Cross* of the Escorial. His finest work achieves a dramatic intensity so surprising that some critics, comparing such masterpieces with the subdued tone of some of his last paintings, have tried to explain the diversity by the hypothesis of two Rogers instead of one. He is well represented in the United States by portraits and by such large compositions as the *St. Luke painting the portrait of the Virgin* in the Museum of Fine Arts at Boston, and the *Crucifixion* of the Johnson Collection in Philadelphia. The first of these two has an obvious affinity with the Van Eyck Rolin Madonna (*Fig. 168*), with a simplifying of Jan's detail that still leaves so much to be looked at as to renew one's wonder at Eyckian endlessness in this respect. As Mather points out, the picture is an interesting document of fifteenth-century technique in portrait painting, since St. Luke is using a silverpoint to draw the likeness, after the manner of the time, leaving the color and setting to be imaginatively supplied in the leisure of the studio. The change that Roger has made in Jan's composition is the idealizing of the Madonna type in consequence perhaps of contacts which the painter had with Italian iconography, and the reverent genuflection of the kneeling Luke, which generates a movement consummated in the Madonna's shrinking figure. The *Crucifixion* in Philadelphia (*Fig. 171*) has been called an early work, by reason of its gold background, and the "international" propensity for white, here indulged in the robes of John and the fainting Virgin of the one wing of the triptych remaining, and the loincloth of the Crucified in the central panel. But the expression seems too mature and powerful for early dating. The Corpus of the crucifix is eloquent of late Gothic pathos in its emaciation, and the painter's power of drama is never equaled elsewhere in his work, nor so galvanized by color; Mary faints and John supports her

[16] F. J. Mather, *Western European Painting of the Renaissance*, New York 1939, pp. 70 ff.; J. Destrée, *Rogier de la Pasture*, Paris 1930.

[368]

in a group made poignant by the sharp whiteness of the garments, and the suffering Christ becomes at once more tragic and more significant by virtue of the scarlet hanging against which the body is relieved.

Dirk Bouts (c. 1395–1475), official painter to the city of Louvain, was a Dutchman, born at Haarlem, and possibly a pupil of the Albert Ouwater to whom some have ascribed the landscape miniatures of the Turin-Milan *Hours*.[17] He thus represents another injection of Dutch naturalism into Netherlandish painting, not so much as an innovator as one who follows and expands the implications of Eyckian art. Without much change in the formula of land-scape, he nevertheless reduces it to order and scale, and adjusts the figures within it—figures of an unbelievable impassivity, gaunt and vertical, painted with cautious precision. In his most famous picture (*Fig. 173*), the *Last Supper* at St. Peter's in Louvain, he has employed the traditional motifs of an interior lighted from windows at the side and with a landscape prospect through the portal, but not as a back-drop; Christ and his curiously stolid apostles are set around the square supper table of an inn, well centered in the space por-trayed. This composition changed the conception of the Last Supper there-after in northern iconography, and marks the final phase in the evolution of the type from its original Hellenistic form of the semicircular couch. Despite the centering of the Saviour's figure, and the small attempt at isolating it by relief against the *cheminée* in the background, the sacramental theme of the Supper is petrified by the immobility of its participants. The features and dra-pery are drawn and lightly shadowed with expert touch, but the figures are posed and subject to the same dispassionate observation that drew the dishes on the table and the designs of the tiled pavement. The lighting is still de-scriptive, but as in Bouts's landscapes, it is a lighting of high noon; shadows are absent or brief, and this with the accurate delineation of objects in distance eliminates the atmosphere and gives sometimes to this artist's paintings the effect of a vacuum. Nevertheless, Dirk Bouts carried Netherlandish painting definitely beyond the mediaeval tradition that separated figure plane from background; thereafter both are commonly included in a unified spatial composition.

The stilted vertical forms of Bouts take on a spiritual content in Memling's work.[18] Hans Memling was born about 1433, in Seligenstadt not far from Mömlingen (near Mainz) from which his family derived its name, and brought with him from the Rhineland the mystic quietism that had spread in that re-gion from the Dominican monasteries. At Bruges, where he worked from

17 W. Schoene, *Dirck Bouts und seine Schule*, Berlin 1938.
18 E. Fromentin, *The Masters of Past Time*, London 1913.

before 1466 to his death in 1494, and where the Hospital of St. John contains a veritable gallery of his paintings, he was much called upon for portraits, but his habitual subject is the Madonna, in half figure or enthroned with saints and donors, and pictured always in the half reverie of introvert *recueillement* that Memling imparts to all his figures, but to the Virgin in especial degree. He is probably mentioned in a document of 1454 as assistant to Roger van der Weyden ("jone pointre Hayne"), and shows the influence of that master as well as of Bouts. German enough to cling to mediaeval tradition despite his date, we have from his hand one of the most elaborate Passion cycles in mediaeval art, a single panel at Turin in which the last days of Christ are narrated *ad infinitum* within the streets and around the walls of Jerusalem, with conscientious insertion of all the incidents that legend had added to the story. Memling is the same quaint narrator and miniature painter in the panels of the reliquary of St. Ursula at the Hospital of St. John wherein the pilgrimage of the saint and her eleven thousand virgins is narrated to Rome and back again over the Alps up to the denouement at Cologne where the maidens accept their martyrdom with decorum at the hands of knightly executioners. He is still in all of his paintings well within the Eyckian tradition, which he manipulates however to his own mildly mystical purpose: the lighted vistas through doors and colonnades are contrasted with the dark accents of the low-ceilinged interiors where he likes to set his figures, enhancing the serene twilight in which they stand or sit in contemplative reverie and spiritual isolation. We illustrate him here (*Fig. 172*) with one wing of a votive diptych at St. John's Hospital, a Madonna to whom on the other wing young Martin van Nieuwenhove pays his vows. No painting better illustrates the transcendental atmosphere which landscape gave to northern painting; if one shuts out the vista seen through the window, the Virgin loses half her spell.

This picture dates in 1487, beyond the limit of the mid-fifteenth century which is for the most part respected in this book, but the quality of Memling's painting, owing to his respect for Eyckian tradition, and a certain German archaism of concept which contrasts with a perfected technique, belongs still to the earlier years of the Quattrocento. The real sophistication of this Flemish school came only with Gerard David whose career takes us well into the sixteenth century. He painted at Bruges like Memling for most of his life, removing to Antwerp only in 1515, when the silting up of Bruges's waterways to the sea had choked the town's commerce and ruined its prosperity. In Antwerp he died in 1523, leaving behind him an *oeuvre* which sums up the Eyckian manner, and takes it finally out of its miniature tradition into a more monumental style, without however changing its essential immobility. The land-

scape which Bouts had organized is enriched with a middle distance in which
David places accessory scenes or figures in his characteristic groves. Interiors,
whether of rooms or streets, become more spacious and pass without change
of atmosphere from within to without. David still uses Memling's Madonna
compositions, and the female idealization Memling borrowed from the Tour-
nai school, but the mysticism of Memling is replaced by a very sincere but
bourgeois piety, communicated by beings more intimately real. The sharp
contrasts of the earlier masters are broadened into a chiaroscuro doubtless
learned from Italy, which also contributed the occasional putti, garlands, and
classical reliefs wherewith David sophisticates his settings. With him and with
the transfer to Antwerp of the center of Flemish painting, began the importa-
tion of Italianate style and the consequent decay of the native northern manner.

THE REALISTIC MOVEMENT IN GERMANY, ENGLAND, SPAIN, AND FRANCE

The history of late Gothic painting in Germany [19] must be reviewed in the
categories of North and South. In the South, German style was dominated from
the latter half of the fourteenth century by Prague, where an Italo-Bohemian
painting developed under the cosmopolitan patronage of the Bohemian kings
Charles IV and Wenzel. In the North the artists of Westphalia and Cologne
followed fashions imported from France and Flanders, producing at the end
of the fourteenth century and the early years of the fifteenth a Teutonic ver-
sion of "international style" as practiced in the ateliers of Paris, by the illu-
minators of the Duc de Berry, and by the early easel painters of Burgundy.
The *Crucifixion* (*Fig. 174*) which the Westphalian Conrad of Soest painted
in his altarpiece for Nieder-Wildungen in 1404 is itself an excellent exam-
ple of "international style," in its combination of narrow foreground with
gold "sky," the insignificance of its figure of Christ, and its mixture of realis-
tic accents with graceful lines and flowing drapery, tempering the tragedy with
idyllic poetry and decorative pattern. But Conrad is German enough in the sub-
ordinate panels of the altarpiece, revealing a native taste in such emphatic
passages of genre as the crouching St. Joseph who busily blows the fire of a
brazier in the Nativity. Cologne's style in its infancy can be seen in the un-
derpainting of an altarpiece made for the nunnery of the Poor Claires which
is now in the choir of the cathedral. Its twenty-four panels, dating from the
middle of the fourteenth century, were successively repainted until *c.* 1400,
but still retain in spite of the more naturalistic touches due to restoration, the

[19] K. Glaser, *Die altdeutsche Malerei,* Munich 1924.

charming decorative insignificance of French ivories and miniatures of the High Gothic decadence.

Cologne was a scene of Master Eckhart's preaching, and it was there that Suso wrote his *Little Book of Wisdom*. The piety of these Rhenish mystics, diluted and sentimentalized in popular translation, furnished the content of the city's art until the second half of the fifteenth century, and even outlived to some extent the invasion of Flemish and Dutch realism which took place at that time. The miniaturist manner was gently naturalized and broadened, without any real deviation from the manuscript tradition, in the works of the "Veronica master," so called from the St. Veronica he painted in a picture of the Pinakothek at Munich, in which the holy woman holds the kerchief imprinted with the Saviour's portrait. To the "Veronica master" is also attributed the Madonna which defines as it were the style of the school in the early fifteenth century, the well-known "Virgin of the Pea-flower" of the Wallraf-Richartz Museum in Cologne (*c.* 1420). On the wings of this triptych are the two favorite female saints of northern Gothic—St. Catherine holding the sword and wheel of her martyrdom and St. Barbara with her tower; on their exterior comes the customary note of pathos in a *Christ crowned with Thorns*. The female type is still the French young lady of the fourteenth century: high childish forehead, small mouth and narrow eyes, sloping shoulders thinly clad, in robes which cascade into heavier folds below. The gold background and nimbi are tooled as in Sienese Gothic painting, but with patterns and inscriptions that derive rather from the technique of manuscript miniatures. The tone of the "Veronica master" is sweetly serious, an implementing of the devotional image with a physical ideal concrete enough to stir emotion, abstract enough to spiritualize whatever feeling is evoked.

The delicate sentiment of Cologne style was given substance and the authority of broader composition and scale by the leading painter of the school, Stephan Lochner. His work is evidence of the power of the city to mold such immigrant masters to its native manner, for Lochner was a Swabian, from Meersburg on Lake Constance. Of his dated paintings we know only two, done in 1445 and 1447, and little is recorded of his life save that his most productive years were spent at Cologne, where he seems to have died of the plague, a man in his forties, in 1451. Late Gothic taste considered his masterpiece to be the *Dombild*, the great altarpiece which Dürer saw and noted in the diary of his journey to the Netherlands, noting also, thriftily, that it cost him "two white pennies" to have it opened. When Dürer saw the picture it was still in the Ratskapelle for which it was commissioned (it was brought to the cathedral in 1809), and there it had a particular *raison d'être* as portraying all of the

city's saintly protectors: the Three Kings whose relics were Cologne's most precious possession, and who are honored by the central composition of the *Adoration of the Magi,* and on the wings St. Ursula with her virgins and St. Gereon with his comrades of the martyred Theban Legion. The Annunciation on the shutters of the triptych is an epitome of Lochner's style. The new realizations of his age with which he surely was not unacquainted—space, material detail, personality, and habitat—are employed only far enough to give conviction to what is otherwise a spiritual vision. Converging beams on the ceiling and foreshortened furniture and pavement establish an interior, but the beautifully detailed tapestry on the rear wall acts as much as a limiting foil as the diapered backgrounds of the miniatures. Lochner works from the ensemble in, and his lovely detail and color (his favorite palette is wine-red, ultramarine, a bright transparent green, and gold) are subordinated to a composition ideally and symmetrically conceived, and ingeniously articulated and organized more by color than by form and line. It is in fact the symmetry of his compositions, and the equilibrium of his groups, as for instance in the *Adoration of the Kings,* that satisfies while limiting the imagination. His Gothic frames, in German fashion, intrude their traceries along the upper edge of the panels, preserving thus the architectural accent of the manuscript miniatures.

The picture of Lochner's here selected (*Fig. 175*) is a Madonna in the archiepiscopal museum at Cologne, known as the Madonna of the Violet. It belongs to his middle period, since the kneeling donor (in miniature scale as is usual in Cologne painting) is the Elisabeth von Reichenstein who became abbess of the nunnery of St. Cecilia in 1443, and is here not yet so distinguished by her costume. The same brocaded hanging and neutral background eliminate space as in the *Annunciation* of the Dombild and several other pictures by Lochner. The small size of the donor is in some sort a key to his conception of the Virgin, as an image transcending human measurement, full-bodied and convincing as a beautiful woman, but yet a symbol by every detail of her abstract environment and the ease with which her figure is converted into symmetrical and monumental design. The painting might well be termed a belated specimen of High Gothic art, so close is its content to the Madonnas of the cathedrals, yet in plastic realization it comes nearest, in Lochner's *oeuvre,* to Netherlandish naturalism. Like Fra Angelico, Lochner felt the impulse of his time toward cubic form in three-dimensional space, but controlled it to the service of a spiritual content.

The Bohemian style of the mid-fourteenth century drew a Sienese strain from contacts with Avignon and with Italy itself, and spread its version of "internationalism," with the strong Tuscan imprint thus acquired, far and wide

in south and eastern Germany, to the Middle Rhine, and perhaps even to Hamburg, where Master Bertram in his Peter altar of 1379 (Hamburg, Kunsthalle) seems to give his quaintly prosaic figures a relief that Bohemian style learned from Italy, while struggling to put them in a space he cannot represent. It was only with Master Francke that the Burgundian version of realism reached Hamburg, probably from Westphalian antecedents. His style, varied, vigorous, and inventive beyond his technical equipment, is characteristically German in its genre excursions; on the altarpiece which Francke painted for the English Company in Hamburg, in 1424 (Hamburg, Kunsthalle), Christ in the *Resurrection* uses his bannered cross as a walking stick to help himself out of the Tomb, and Joseph in the *Epiphany* thriftily stows away the gifts of the Magi in a chest. In Middle Rhenish painting during the first third of the fifteenth century, Bohemian plasticity assumes almost the aspect of enamel, especially in the Ortenberg altar at Darmstadt (1420–1430) whose Madonna and her entourage of saints are done in metallic tones of silver, rose, yellow, and white. Nürnberg's painting in the early years of the century is even closer to Bohemian style and to its Italian antecedents, preserving in its most finished work of the time, the Imhof altar in the Lawrence-church, a Sienese suavity unparalleled elsewhere in Germany.

But landscape was undiscovered in the South until the advent of Lucas Moser, and Moser's signature on the altarpiece he painted for the country church at Tiefenbronn in the neighborhood of Lake Constance sounds indeed like the plaint of an unappreciated innovator: "Wail and weep, O Art, for no one cares about you any more! Alas! 1431." The central shrine of Lucas's altarpiece contains a carved *Assumption of the Magdalen* of later date; on the exterior face and the shutters of its door is portrayed the story of Mary Magdalen, with a realization of space and of the figure's existence in it that makes the work as much of a landmark in German painting as were the Duc de Berry's miniatures and the *Adoration of the Lamb* in the art of Flanders. The setting of the scenes is curiously contrived to shift from episode to episode without losing continuity despite the framing of the panels; we see Mary, Lazarus, Martha, and their two priestly companions coming to the shores of France on a choppy sea like that of a miniature in the Turin-Milan *Hours* (p. 366); the next panel shows the group asleep in the porch of the temple at Marseilles which becomes a Gothic church in the right-hand picture to provide the *mise en scène* of the Magdalen's last communion. No German painting at this date had reached so full a realization of landscape, interiors, and the location of groups, and no German until Conrad Witz was able to develop the implications of Moser's isolated achievement in spatial composition.

[374]

The combination, in Moser's Magdalen altar, of a sculptured central shrine with painted wings became characteristic of south German altarpieces from the thirties and forties of the fifteenth century, reinforcing the lingering Bohemian tradition of form with the mutual assimilation of plastic and pictorial effect. The inner faces of the wings, to match the gilded large-size reliefs of the shrine, were commonly painted with space-filling three-dimensional figures against a gold background. Only on the outer faces of the shutters could painters indulge the possibilities of their proper medium with interior perspectives or landscape settings. Some of them indeed were both sculptors and painters like Hans Multscher of Ulm, who crowds his space with figures plastically conceived, and reduces the Gospel scenes to the vocabulary of a peasant. His squat proportions and guttural accents were continued in milder form by the unknown master who painted the Tucher altarpiece in the Liebfrauenkirche at Nürnberg, and shares with Multscher also an affinity with Robert Campin. This Fleming's influence is more plainly evident in the work of Conrad Witz, who developed the spatial suggestion of Tournai style into a peculiarly mathematical extension, measuring his landscape for example, in his picture of *St. Christopher carrying the Christ Child* (Heilspiegel altar, Basel Gallery) by an alternation of jutting headlands. His *St. Catherine and the Magdalen* (Strassburg Museum) sit in a cloister gallery whose ample perspective is defined by a diagonal succession of bays, and the dwarflike figures of Joachim and Anna (Heilspiegel altar) greet each other at a Golden Gate whose bar is deliberately projected toward the observer to insure and determine the dimension of depth. Mentioned in a tax return at Constance in 1418, Witz was one of the numerous artists attracted to Basel during the great council held there from 1431 to 1443. When the bottom dropped out of the Basel art market with the decline of the Council's importance and its termination, the artist removed to Geneva where he painted, in a panel commissioned by Cardinal Mies, a masterpiece that ranks as one of the most finished landscapes of the fifteenth century (Geneva Museum; *Fig. 177*). The picture, signed and dated 1444, represents the *Miraculous Draught of Fishes*, with a very immobile Christ, St. Peter half submerged, and a group of apostles getting their boat in motion and hauling the net. But the human episode is forgotten in the remarkable view the painter gives of Lake Geneva, with Mont Blanc in the distance and to the right the tower and piers that marked the entrance to Geneva's port. The view is exact, but devoid of aerial perspective; distance is accurately and prosaically measured by a receding series of horizontals and diagonals in the landscape.

After the middle of the fifteenth century, German painting in general capit-

ulated to the superior technique of the Netherlands. South Germany had already gone to school to the Master of Flémalle; after 1450 all Germany bowed to Van der Weyden and Bouts. The squat figures became slender, the earlier inhibited efforts at naturalism were replaced by free and confident drawing after Flemish archetypes. The awkward movement of primitive painting recovered the ease that was lost with High Gothic fluency, but an ease that was now functional and natural, no longer decorative, and a motion inward and outward as well as parallel to the picture plane. The Italianism that had entered German art through the Franco-Burgundian "international style" and the Bohemian school was cut off, not to resume its flow until Dürer's Italian journey. At Cologne we find a succession of anonymous masters—the "Master of the Life of Mary," "of the Lyversberg Passion," "of the Triumph of the Virgin," "of St. George"—who introduce the Flemish manner with a varying degree of assimilation, mainly of the manner of Roger van der Weyden. Hinrik Funhof of Hamburg followed so closely the style of Dirk Bouts that he has been suggested as the disciple of the Louvain master who finished his "Justice" series for the Hôtel de Ville at Louvain (Brussels Gallery). Hans Multscher's assistant, the Master of the Sterzing Altar (Rathaus, Sterzing) deserted his mentor's crowded and rustic style for Van der Weyden's looser composition, idealized faces, and easier lines. The *Nativity* of Friedrich Herlin of Nördlingen, in his altarpiece for St. Blasius at Bopfingen, is a modification of Roger's rendering in the Middelburg triptych at Berlin, and Hans Pleydenwurff brought the Flemish style to Nürnberg in the same Rogerian vein. The Flemish fashion, toward 1475, began to ebb, and the uniformity it had brought to German painting was gradually replaced by more local manners, reflecting German disunity in the fifteenth century. Princely centers like those of France, Italy, and Spain which might have fostered an aristocratic art, were lacking to this Germany; the art markets were the cities and German late Gothic style is bourgeois in consequence, seldom lacking even in its most ideal conceptions a homely atmosphere or some pungent note of genre. The end of the century witnessed a sublimation of this bourgeois taste in the heavy estaffage and complication of what German writers call the late Gothic "baroque." The importation of the more accomplished technique of Flanders had led to a sacrificing of pious content to mechanics of composition, feats of drawing, and rich combinations of color; into the vacuum thus provided the "baroque" poured a fulsome tide of Teutonic feeling. The loose Rogerian composition loosened restraint, and figures tended toward unreasonable and exaggerated movement or gesture, and the compositions toward confused arrangement. The "baroque's" most prevalent symptom is the artificial complication of drapery; the heavy tubular folds

[376]

of the earlier painting are tortured into meaningless complication and divorced from bodily form or action. The style is best exemplified by *fin de siècle* work at Cologne such as that of the Master of the Bartholomew Altar (e. g., his Thomas altar in the Wallraf-Richartz Museum at Cologne) and some of the output of the atelier of Michael Wolgemut at Nürnberg. The two outstanding masters of the end of the century, Martin Schongauer of Colmar (d. 1491) and Michael Pacher of Tyrol, were not entirely free from its artificiality. Schongauer reveals its influence in the "wood-sculpture" folds with which he enlivens the edges of his drapery, and his obvious seeking after unusual arrangements in depth. But he never fails to subordinate such detail and devices to an ultimately clear and monumental presentation. Pacher (d. 1498) achieves dignity even when most "baroque" less by the individual genius which guided Schongauer as engraver and painter than by virtue of the schooling which he or at least his atelier had derived from neighboring North Italy and especially from Padua and Mantegna.

❖ ❖ ❖ ❖ ❖

The Puritan iconoclasts of England [20] did their work so well that little remains whereby to judge the insular contribution to late Gothic art. What does remain, however, indicates that English painting felt only remotely the stirring of the realistic movement, and retained far into the fifteenth century the decorative and mannered style of the Gothic decadence derived from France. English style of the first half of the fourteenth century might better be studied, so far as panel painting is concerned, in the museums of Bergen and Copenhagen, since Norway's art was dominated at this time by English influence, and has survived in a few altar frontals and altarpieces which are better preserved and more interesting than anything of the sort or date in England itself. They show the characteristics of contemporary English sculpture: staccato accents that break the even flow of the parent French decadence, a lean and adolescent

JOHN II OF FRANCE

20 T. Borenius and E. W. Tristram, *English Mediaeval Painting*, Florence 1927.

gaucherie of physique and movement, and the usual subordination of the subject to decorative pattern. On a panel of an altar frontal from Nes in Norway, now in the Bergen Museum, the witnesses of the Crucifixion, Mary and John, are ensconced in the lateral lobes of its quatrefoil frame, and the Cross itself elongated to reach the tips of the other lobes. The most important wall paintings of the period are those of Croughton church in Northamptonshire, which are of interest also as an index to Gothic Mariolatry: the whole south wall is devoted to twenty-four scenes of the Virgin's life (including the Infancy of Jesus), paralleling a less extensive cycle of Christ's Passion on the opposite wall. Such frescoes follow closely the norms of miniature painting, and this is still the case in murals of the middle and later years of the fourteenth century, as for example those of St. Stephen's Chapel at Westminster (now in the British Museum), where the backgrounds are patterns in gilded gesso after the manner of the illustrations in the manuscripts.

French art was not only imitated but domesticated, in this land where French was still the language of court and aristocracy far into the fourteenth century. King John of France, who made himself so much at home in England while he dwelt there as a captive from the field of Poitiers (1356–1360), had with him during his exile his favorite painter Girard of Orléans. Girard may be the author of the well-known profile of the king in the Bibliothèque Nationale at Paris, painted probably during the royal captivity, and a landmark of incipient realism; the character of the most foolish and the most romantic of the Valois kings could hardly be better recorded. A painter of the Franco-Flemish Parisian school of the later fourteenth century, Jacquemart de Hesdin, has been cited as the author of the panel portrait of Richard II (1377–1399) at Westminster Abbey, and also of the famous diptych at Wilton House owned by the Earl of Pembroke, in which the young king kneels in adoration of a Madonna surrounded by angels, with SS. John Baptist, Edward the Confessor, and Edmund standing beside him as his sponsors. Others have suggested an English hand for both pictures, and still others have assigned the diptych at least to the schools respectively of Bohemia, Cologne, and North Italy. The diversity of opinion reflects the "international style" of the work, and the domestication of this exotic manner at the end of the fourteenth century can be seen in an English sketchbook at Magdalene College, Cambridge, whose human figures, birds, and animals are reminiscent of north Italian drawing such as that of Pisanello. A weaker version of "internationalism" is represented by the four scenes of the *Life of St. Etheldreda* (c. 1425) on the wings of an altar once in Ely cathedral, now at the Society of Antiquaries in London, with tooled gold backgrounds like those of Cologne, a stiff translation of French Gothic dra-

pery, and homely details suggestive of Flemish genre. The Flemish style arrives in force in the second half of the fifteenth century, especially in portraits, and one of Memling's most appealing pictures is the triptych he painted for Sir John Donne of Kidwelly in 1468 when he was in attendance on Margaret of York at Bruges at the occasion of her marriage to the Duke of Burgundy. In the most important monument of English painting of the end of the century, the frescoes in the chapel of Eton College, executed between 1479 and 1488 by William Baker and his assistants, the style is a very competent adaptation of the manner of Louvain, disciplined and restrained by the traditional English economy of form and expression.

In Spain [21] as well the Netherlandish realism took no root before the middle of the fifteenth century, and then mainly in the western kingdom of Castile. Aragon, Catalonia, and Valencia clung until the arrival of the Italian style of the High Renaissance to what might be called the Mediterranean coastal manner—basically Sienese, but modified progressively with accessions of the "international" mode, and sporadic imitations of the Van Eycks. Ferrer Bassa's frescoes in the cloister of the Franciscan convent of Pedralbes at Barcelona (1346) are entirely in the spirit and conception of Simone Martini; the Madonna is envisaged as a Sienese Maestà, surrounded by her throng of angels. The Spanish accent is unobtrusive, but visible in details of brutality in the scenes of the Passion, such as the emphasis on the process, in the *Deposition from the Cross,* of extracting the nail from the Saviour's foot. Italian influence was not confined to painting: shortly before the date of Bassa's frescoes, a pupil of Giovanni Pisano sculptured the sarcophagus which was to contain the relics of St. Eulalia, patroness of the city, for the new cathedral of Barcelona. The Sienese style broadens into a more "international" manner in the painting of the Serra brothers, who also introduce us to the huge Spanish retables, such as that of a chapel in S. María at Manresa (c. 1394) with fifteen main panels, beginning with the Logos setting the globe of the world in motion and ending with the *Coronation of the Virgin.* The Catalan style passed westward to meet there the *mudéjar* element from southern Moslem Spain—a combination well represented by the reliquary triptych of the monastery of Piedra in Aragon now in the Historical Academy of Madrid (1390), on which Moorish wood carving enframes an Italo-Hispanic series of panels painted with the life of the Virgin and music-making angels. Catalan Sienesque painting is continued in the early fifteenth century by the work of Luis Borassá, after whom there is progress only in the elaboration of decorative features, and an essential

21 C. R. Post, *A History of Spanish Painting,* Cambridge, Mass. 1930–, vols. I–VI; E. Harris, *Spanish Painting,* Paris 1937.

stagnation reflected in the contracts which emphasize rich colors and precious materials, but frequently also specify the copying of existing works.

The first Catalan artist to reveal acquaintance with Flemish painting is the "Master of St. George," so called from a panel of *St. George slaying the Dragon* in the Chicago Art Institute, the four wings of which, depicting the martyrdom of the saint, are in the Louvre. The kneeling princess in the panel at Chicago, and especially her elaborate crown, remind one of the altarpiece of Ghent, and a novelty for Catalonia is also the substitution of blue sky for the "international" gold background in the landscape, together with the Eyckian oil medium applied over the tempera painting. On the other hand a beginning is here made of the embossing of details in relief whereby the painting of Catalonia comes to resemble Greek and Russian icons in the imprisonment of its color in gilded stucco, an effect extended by the elaborate brocading of drapery. At Valencia a more painterlike mode was followed, avoiding the overloaded ornament, and keeping more loyally to the initial Sienese inspiration, until the conquest of Naples by Alfonso of Aragon in 1442, when Jacomart Baço was summoned by the king to paint ex-votos of his victory, and derived from that Italian focus of the northern manner a certain amount of rich Eyckian detail wherewith to leaven his "international" idealism. The real entry of Flemish style into Valencian painting comes with Luis Dalmáu, whose career can be followed only to 1460 when he disappears from view, and whose authentic surviving work is limited to the retable of the "Councillors" painted for the Council House of Barcelona in 1445 (now in the municipal museum). Dalmáu was actually sent to Flanders in 1431, and arrived there a few months before the completion of the *Adoration of the Lamb*. The impression this masterpiece made upon him was profound; he does not try to imitate its oil technique, but the singing angels beside the Madonna enthroned in her Gothic niche are close replicas of those at Ghent and the kneeling councillors are equally imitative of the portraits of Jan van Eyck.

In Castile Spanish painting was apparently fertilized with the Giottesque tradition by the Florentine Starnina who seems to have been employed by John I from 1379 to 1391. The Florentine manner is visible in the frescoes of the chapel of S. Blas in Toledo cathedral at the end of the fourteenth century, and shortly afterward makes a surprising appearance in Moorish Spain, in the scenes of courtly life and war that are painted on the leather ceilings of three alcoves in the Court of Lions at the Alhambra. In the first half of the fifteenth century the Italian style continues in the work of the Florentine Dello Delli, curiously "internationalized" with the perspective architectures and loggias popular both with Venetian and Burgundian painters. To him may be as-

cribed the apsidal fresco of the Last
Judgment in the old cathedral at Sala-
manca and probably also the huge re-
table of fifty-five panels recounting the
history of Christ and the Virgin. The
contract for this immense and charac-
teristically Spanish structure is dated in
1445. In the later fifteenth century Cas-
tilian taste capitulated to Flemish style,
the more so after the union of the west-
ern kingdom with Aragon by the mar-
riage of Ferdinand (1479–1516) with
Isabella, heiress of Castile, and the alli-
ance with the imperial house of Austria,
Burgundy, and Flanders by the mar-
riage of their daughter and son to Philip
the Fair of Burgundy and Margaret of
Austria. Queen Isabella's own picture
gallery contained a number of Flemish
works, notably a triptych by Roger van
der Weyden, of which the right wing

GALLEGO: *Head of St. John from Cruci-
fixion*

representing Christ's appearance to his Mother is in the Metropolitan Museum
at New York. The influence of the Netherlands came in Spain as elsewhere
mainly through the Tournai master and Dirk Bouts, both of whom can be de-
tected in the style of the most characteristic Castilian painter of the later fifteenth
century, Fernando Gallego, who is however very Spanish in the expression he
seeks to evoke from his Flemish types, a tendency developing into near-caricature
at the hands of his imitator and relative Francisco. The mixture of native con-
tent and Flemish style reaches its finest achievement in the *fin de siècle* work of
Bartolomeo Bermejo, a highly individual genius, indulging his own esthetic
preferences in design at the expense of the religious subjects demanded of him,
and in his last work, probably after a visit to Italy, assimilating the breadth and
idealism of the Florentine late Quattrocento. With him begins in some degree
the turning to Italian fashion that was to end the reign of Flemish style and
shape the Renaissance in Spain.

❖ ❖ ❖ ❖ ❖

The evolutionary pattern of the realistic movement in transalpine Europe
is by now made clear. Its first stage of the end of the fourteenth century and

the early fifteenth is the "international style," combining the delicate sentiment of Siena with bits of Flemish genre and retaining the decorative distinction and fluency of the French High Gothic decadence. The creative phase that followed issued from the workshops of Dutch masters such as Claus Sluter and the Van Eycks or the painters of Tournai, who unveiled the material world obscured by scholastic symbolism, and established the two poles of realism, in their specific portraiture of men and things on the one hand, and on the other by their grasp of the universal through the medium of landscape and its unlimited space. The third period is of the later fifteenth century, when the Flemish school developed the implications of its early painting, and the new style spread and was domesticated in Germany, England, and Spain. The movement was checked, in the sixteenth, by the divorce of art from its previous popular inspiration, and the growth of an artificial and aristocratic content which invited for its expression the grand style of the High Renaissance in Italy.

If France [22] is treated last and apart, in this brief survey of the Flemish dissemination, it is because France was really three countries instead of one in the fifteenth century, pending its gradual recovery from the Hundred Years War and its unification under Louis XI. Northern France for most of the first half of the century was in the hands of the English or of the Burgundians, who in fact were in possession of Amiens from 1435 to 1472. This section was allied to Flanders on every social and economic count; the south belonged culturally to the "riviera" that included the coast of Italy and of Spain as well as that of Provence and Languedoc. The most French portion of the country was its center from Touraine to Champagne, and this section produced the most Gallic reaction to the realistic movement.

In north French painting of the fifteenth century, after the decline of the Parisian schools which had fostered the "international style" (p. 351), a strong influence from Flanders was to be expected. Valenciennes was the home of Simon Marmion, to whom have been attributed a number of pictures illustrating this *mélange*, notably the *History of S. Bertin,* an altarpiece once in the abbey dedicated to that saint at Saint-Omer, but now divided between the National Gallery in London and the Kaiser Friedrich Museum in Berlin. An undoubted Flemish strain pervades its charming panels, in vistas through doors and loggias, and twilighted interiors reminding one of Memling, to whom in fact the altarpiece once was ascribed. The French quality is nevertheless obvious, in the firmer line, reticent expression, and simple clarity of composition.

[22] Ch. Sterling, *Les primitifs français,* Paris 1939; O. E. Lemoisne, *Gothic Painting in France,* Florence 1931; *Catalogue de l'exposition des primitifs français,* Paris 1904.

If the author be Marmion, he can be credited as well with the *Miracle of the Cross* in the Louvre as a later work, and the miniatures of numerous manuscripts. In the United States he is best represented by a *Crucifixion* in the Johnson Collection at Philadelphia, whose style is reminiscent of Bouts.

The school of Touraine owed its rise to the sojourn of the royal court in the Loire Valley, while Charles VII, "roi de Bourges," was exiled from Paris by the English occupation. One of its first essays was the decoration of the chapel in the house of Jacques Coeur at Bourges, done shortly before the disgrace of that prototype of modern capitalist and banker in 1453. The angels who deploy their inscribed scrolls on the ceiling of the chapel are a revision of the Burgundian type established in sculpture by Sluter, but with the full modeling of the central school, and a French avoidance of Flemish genre. The outstanding figure of this phase is Jean Fouquet of Tours, the most characteristic French painter of the fifteenth century; miniaturist, portraitist, and artist *en titre* to the court of Charles VII and Louis XI. His principal work as a miniaturist was the illumination of the *Antiquités Judaïques* of Josephus in the Bibliothèque Nationale, and the *Hours* of Étienne Chevalier (*c.* 1455) in the Musée Condé at Chantilly. He first appears as a portrait painter with the panel depicting the sour, suspicious visage of Charles VII, ironically inscribed "the very victorious King of France" (Louvre), but reaches his full power after a trip to Italy about 1445–1447. Shortly thereafter he painted the diptych which Étienne Chevalier, minister of the king, ordered for his chapel in Notre-Dame at Melun; it is now divided between the Kaiser Friedrich Museum and that of Antwerp. One panel (Berlin) is devoted to the remarkable portrait of Chevalier with his patron St. Stephen; the other, according to credible tradition, is a presentation of the king's mistress Agnes Sorel thinly disguised as the Madonna (*Fig. 178*). The donor's panel is the better one, showing Fouquet's sharp characterization, his skillful handling of figures in space, and the plastic isolation he contrives by means of his simple backgrounds and interiors, which transport one to the cool halls of Italian palaces, decorated with Roman pilasters and marble inlays. In the "Madonna," whose crown and ermine robe are as much the perquisites of the royal favorite as of the Queen of Heaven, the full rotundity of woman, child, and cherubs enhances the materialism of Fouquet's style.

In Burgundy, which lost its ducal patronage after the murder of John the Fearless on the bridge of Montereau in 1419, and the removal of the court to Flanders under his successor Philip the Good, art seems to have reverted to the tradition of Sluter. At least this would explain the beautiful *Annunciation* in the Magdalen-church at Aix-en-Provence, whose Gabriel and Mary are

heads surmounting voluminous Burgundian draperies, brocaded with a detail worthy of Jan van Eyck. On the shutters, in the Brussels Museum and the Cook Collection at Richmond (England), are the prophets Jeremiah (Brussels) and Isaiah (Richmond). These have the sophistication of their date, *c.* 1440, and much of Flemish naturalism in the paraphernalia that clutter the lunettes of their niches, but are French in the clarity with which the figures are relieved against the background, and Sluterian in their serious significance. The painter of this picture was probably an artist of Dijon, and possibly employed by René of Anjou, count of Provence and king of Naples until ousted by Alfonso of Aragon in 1442. This prince, whose court in Provence was a hive of south French art and of a literature to which he himself was no mean contributor, had a favorite residence at Avignon. The city, after the departure of the popes and their Sienese proclivity in artistic matters, became in the fifteenth century the center of an international "school" of painting, attracting masters of such varied origin as the painter of the Aix *Annunciation,* Enguerrand Charonton from Laon, Nicholas Froment of Avignon itself, and the unknown genius who created the great *Pietà* of Villeneuve (*frontispiece*).

Charonton's best-known and best-documented work is the *Coronation of the Virgin* commissioned in 1453 for the Carthusian monastery at Villeneuve-lès-Avignon. The coronation is performed by Father and Son, and surrounded by the angelic hosts and throngs of saints, all floating in the air above a circumstantial landscape of Villeneuve, which is dominated by the Crucifixion, and bordered below by representations of Hell and Purgatory. It is interesting to see how heavily these figures weigh upon their supporting clouds, by virtue of their ponderous detail, in contrast to the lightness of similar Italian compositions, as for example the *Disputa* of Raphael. Charonton's younger contemporary Froment is best known for a curious picture of the *Burning Bush* (Aix), painted for King René about 1475 and presenting on its shutters our best portraits of the literary king and his wife Jeanne de Laval. The Burning Bush which warned Moses of the divine presence was a mediaeval symbol of Mary's virginity; hence we find the Madonna enthroned in its foliage, looking down at the angel who admonishes Moses, and the patriarch seated to the right, taking off his shoe that it might not desecrate the "holy ground" (Exod. iii:5). The picture discreetly mingles borrowings both Flemish and Italian: the angel's broken drapery and the very real old shepherd who impersonates Moses are of the North; the Madonna type and landscape remind one of Italy.

The greatest French work of the fifteenth century is also the most mysterious as to authorship and date, the latter ranging in critical opinion from the first half of the fifteenth century to its end. This is the *Pietà* from Villeneuve-

lès-Avignon in the Louvre, the finest rendering of the theme in art, not even excepting Michelangelo's great group in St. Peter's at Rome. The beautifully chiseled face of the donor kneeling at the left gives us no clue to the picture's origin; he is not a high ecclesiastic, wearing only the white surplice of a priest. The white of this surplice and of the loincloth of the Crucified and the Virgin's wimple are used in the scene as by Roger van der Weyden to intensify its poignancy, and this together with the gold background and its tooling would indicate a date as early as the middle of the century. Some exotic experience must have suggested the Moslem domes and minarets that contribute, on the horizon, the slight suggestion of a landscape. Some north Italian element in the faces and the picture's silver tone, a symptom of Spain in the incisive thrust of painful accents, the conservative clinging to the neutral field—these mark the work as part of the international "coastal" style that reached from Valencia and Barcelona to Naples. Despite its realism, the theme is pitched in a lofty key: death and sorrow are ennobled, the shocking corpse is transfigured as a symbol, and the final effect is one of serenity and grandeur.

Gothic painting here attains a universal note without the aid of landscape, without resort to abstraction as in Italy, and with no relaxation of its hold on concrete and poignant reality. The picture is in fact an early example of what French writers call the *Détente*—the "relaxation" of the Gothic tight and too promiscuous detail, seeking a broader and more simple style to express a content of more profound significance. It is a peculiarly French phenomenon, the resurgence of the *rationale* that organized the variety of High Gothic into the artistic counterpart of St. Thomas's *Summa*. An achievement of idealism through the realistic process alone, and independent of landscape and setting, it could find expression in sculpture as well as in painting, and is in fact best illustrated by sculpture produced in Touraine and Champagne at the close of the fifteenth century and during the early decades of the sixteenth.[23] The best-known monument of the school of Touraine is the *Sepulcher* of Solesmes, the work of Michel Colombe or at least of his school, and finished in the last decade of the fifteenth century. At this time the influence of Italy's renaissance was much to the fore in France, and aided by the actual importation of Italian marble carvers, who are probably to be credited with the classic Quattrocento ornament of the pilasters framing the Entombment. The main group enacting the burial of Christ is a masterpiece of the Touraine school completely in contrast to the sculptural style that prevailed in the north of France. The Franco-Flemish manner native to this locality is abundantly illustrated by the choir stalls and carved altars of churches in the Flemish

[23] P. Vitry, *Michel Colombe et la sculpture française de son temps*, Paris 1901.

ENTOMBMENT OF SOLESMES,
NICODEMUS

provinces of France and in Flanders itself, such as the altarpiece of Abbeville, and the stalls of Amiens cathedral; it is an extension of the Burgundian style toward a close approximation of the effects of painting, pursuing architectural and landscape perspective *à l'outrance,* and destroying with free-standing figures and objects the solidity of relief.

Michel Colombe and his school in contrast seek a plastic mass; the angels fold their wings; the folds of drapery diminish in number and increase in weight; expression is controlled and idealized by the plastic imperative of reticence and equilibrium. The Entombment is of course a traditional mediaeval subject, given form by mid-Byzantine art, whose type controlled the Latin rendering until the latter half of the fourteenth century. At this time the late Gothic quest of pathos began to transform the type into a replica of the scene in the Passion plays, finally taking it out of relief into free-standing sculpture, the first example of which is the Burgundian *Sepulcher* of Tonnerre of 1453. Seven persons are usually represented: two old men at the head and foot of the tomb, holding the shroud; the Virgin in the middle behind the sarcophagus, faint-

ing and sustained by John; the Magdalen and two other Holy Women. Mention in contracts of the "Mary of the head" and "Mary near the Magdalen" shows how fixed the arrangement had become. The monument of Solesmes displays a variant that is borrowed from Flemish and German Sepulchers, i. e., the placing of the Magdalen in front of the tomb, in accordance with the words of Matthew (xxvii:61): "and there was Mary Magdalene . . . sitting over against the sepulcher." The figure of Nicodemus is a *tour de force* of pungent naturalism, a truly Renaissance figure in its exaggerated personality, and truly Gothic in its homeliness. The seated Magdalen is a complete expression of the *Détente:* her hands are clasped in convulsive strain and her body suggests a recurrence of weeping, but under a fine control that is sculpturally rendered

[386]

by closed contours and solid mass. The same restraint and breadth of style pervades the beautiful sculpture produced early in the sixteenth century by an atelier of unknown artists working in and around the city of Troyes in Champagne, though here the plastic serenity of Touraine is tempered with more evident emotion. The great works of the school are few in number, the *Pietà* of Bayel near Troyes, the *Entombment* of Chaource (dated in 1515), the *Saint Martha* in the Madeleine at Troyes, and a female saint at Princeton which once belonged to a *Sepulcher (Fig. 176)*. The statue of St. Martha the Housekeeper at Troyes is said to have been dedicated by a group of maidservants. She once delivered Tarascon in Provence from a dragon by sprinkling holy water around the city; in the statue she is represented in performance of her pious mission, staff in one hand and a holy-water bucket in the other. Characteristic of the school is the sharp and simplified cutting of nose, eyes, and mouth, enhancing the shadows cast upon the face by the projecting veil. The drapery, very real, has yet a subtle composition reminiscent of High Gothic figures, of heavy breadth below which tapers to a fine complication on the breast. The same is true of the Princeton *Saint*, which can be said like the Magdalen of Solesmes to epitomize the French *Détente;* its winsome homeliness is still in Gothic style and in the realistic movement, but has reached ideal expression under its own power, so to speak, and without the classic vocabulary which the High Renaissance in Italy was forced to borrow, to achieve the same effect.

Prevalent throughout these monuments of the *Détente,* from the *Pietà* of Villeneuve to the Princeton *Saint,* is the note of tragedy. "The fifteenth century," says Mâle, "had been invested with the gift of tears." In a transformation of mediaeval iconography that began in the second half of the fourteenth century, the focus of religious art moved toward the Passion of Christ, which itself was rendered in its most poignant aspects.

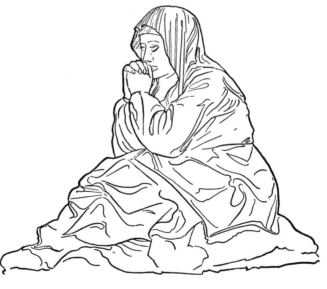

ENTOMBMENT OF SOLESMES, THE MAGDALEN

[387]

In the Crucifixion the Corpus is racked upon the Cross, stained with blood from the crown of thorns, and hangs painfully from its nails. The Pietà displays a corpse in rigid ugliness, and the Entombment becomes a ritual of sorrow. New types arose to give further vent to pathos, such as Christ awaiting torture or dead and supported by angels. Even old dogmatic concepts such as the Trinity and the Fountain of Life were cast in the current tragic molds; in the Trinity the Father holds the Cross with the dead Crucified upon it, and the Fountain becomes the mystic wine press whose wine is the blood of Jesus. Fraternities sprang up that took their names from the moving aspects of the Passion—societies of the "Holy Blood," of the "Five Wounds," of the "Seven Sorrows of Mary." This last, like the Seven Deadly Sins, is curious evidence of the tendency of the realistic movement to catalogue and classify its emotional content; the Seven Sorrows are listed as the Prophecy of Simeon at the Presentation of the Christ Child in the Temple (Luke ii:35, "a sword shall pierce through thy own soul also"), the Flight into Egypt, the Search for the Child among the doctors in the Temple, the Flagellation, the Crucifixion, the Pietà, the Entombment. Details of the Passion were elaborated into remarkable bits of narration; the mystics of the fifteenth century discovered that there were seventy-seven thorns in the Crown of Thorns and that each had three points. This minute enhancement of Christ's suffering fills the Passion picture of Memling at Turin with details such as the carpenters making the Cross, and the stretching of the Saviour's body upon it.

All the elaboration of realism was not invented by the painters and sculptors of the fifteenth century, who in most cases were only reproducing the images provided by contemporary religious drama—the Passion plays and mysteries of the time. These performances took on their popular form in the fourteenth century, growing out of earlier liturgical dramas of the church whose didactic character was suited to the collective faith of the High Gothic synthesis, but quite inadequate for the troubled piety of the realistic movement. The new mysteries were real plays seeking dramatic content not only in the canonical Gospels but the apocryphal as well, and staging the stories of the saints on the basis of the store of Christian legend that Jacobus de Voragine had gathered in his *Golden Legend* of the thirteenth century. The chief source for the Passion dramas was a book which began its popular circulation about 1400, the *Meditations of St. Bonaventura,* dating from the thirteenth century and ascribed to the well-known disciple of St. Francis. Though this attribution was false, the book is genuinely Franciscan, naïve and specific in its treatment of the Christian theme which it embroiders with every possible stimulus to emotion.

The *Meditations* begin with a colloquy sustained by God on the one hand

[388]

and Pity and Peace on the other, supplicating the Deity for the salvation of mankind. Truth and Justice, opposing, point out that man is doomed to die, by the irrevocable decree of God Himself. The contradiction is solved by the sentence that men still shall die, but death shall lose its terror by the sacrifice of the Son. The Annunciation follows, and the Life of Christ is deployed with every sort of anecdotal enrichment, providing for example a favorite theme for fifteenth-century painters in the meeting of the Holy Family, in its return from Egypt, with the young Baptist in the wilderness. Another detail underlined in the *Meditations* was the laying of the newborn Child upon a bit of hay while His mother and Joseph knelt before Him and angels descended to make obeisance to their Lord. This motif appears in the stage directions of a mystery played at Arras about 1415 and in art in the same period; it is present in the frescoes of Masolino at Castiglione d'Olona and is found simultaneously in Flemish altarpieces. The climax of the book is of course the Passion whose pathos is personified in the Virgin, idealized as a foil of maternal tenderness and suffering against the ferocity of persecution. A long account is given of her parting with Jesus on the eve of the Passion; she passes in prayer the night before the Crucifixion; on the Way of the Cross she meets the procession at a crossroad, and covers the body of her Son with her veil. When the body is taken from the Cross, she receives it on her knees. This vision, popularized by the mysteries, became the Pietà of the fifteenth century.

The *Meditations*, the mysteries, and the iconography of pathos current in the religious art of the realistic movement owned a common origin in the individual's quest of spiritual satisfaction. The book purports to be written for a nun of the Poor Claires, the plays and the pictures made the Saviour human and accessible. The altarpiece itself is a symptom of the time. If the stained-glass window and cathedral sculpture are the characteristic media of High Gothic art, the Book of Hours and the easel picture are no less proper to late Gothic. Windows and statues are expressive like the cathedral they adorn of the confident collective piety of the scholastic synthesis, which insured salvation through one's membership in a universal church, headed by the deputies of Christ and guiding mortals through the pitfalls of this world by a trustworthy routine of sacraments. The collapse of this leadership and of confidence in its guidance in the fourteenth century made spiritual peace a personal problem, an individual understanding with God. Hence the rise of the easel picture, conceived and dedicated as one's own propitiatory offering, with its included Donor increasingly important as the altarpiece developed through the fifteenth century. Hence also the popularity of the Book of Hours, written and illuminated for private devotion.

[389]

The uneasiness of fifteenth-century piety, deprived of its quondam reliance on the church, can be seen in another outstanding phenomenon of the realistic movement—the preoccupation with Death. The motif is an old one, appearing already in thirteenth-century French literature, in the *Dit des Trois Vifs et des Trois Morts,* relating the meeting of a count, a duke, and the son of a king with the corpses of a pope, a cardinal, and a papal notary, with an ensuing edifying dialogue. The Black Death of the middle of the fourteenth century gave new impetus to the theme, inspiring such expressions as the Triumph of Death in the Campo Santo at Pisa (p. 336) where the *Dit* reappears as the vision of a hermit. But in the fifteenth century the imminence of death became a major motif of religious plays, taking a new aspect in which ecclesiastics and civilians alternate in a long procession—pope, emperor, cardinal, king, etc., down to the simple parish priest and laborer. Each character in turn is led off to death by his double in the form of a grinning skeleton. From the stage this *Danse Macabre* passed into art, appearing first in a fresco, now destroyed, which once adorned the walls of the Cemetery of the Innocents in Paris (1424). Guyot Marchant popularized the motif in a series of woodcuts published in 1485, and it was varied in compositions such as the *Danse Macabre des Femmes,* the *Danse aux Aveugles,* and the *Mors de la Pomme,* in which Death is represented as striking down men and women in the enjoyment of pleasure and especially in the act of daily occupations. This last was the inspiration of such works as Dürer's *Knight, Death, and the Devil* and Holbein's famous woodcuts of the Dance of Death which were published at Lyon in 1538.

Like all the phenomena peculiar to the realistic movement the grisly notion first appears in art with characteristic individual application, at the end of the fourteenth century. Guillaume de Harcigny, physician to Charles VI of France, had himself represented on his tomb in the episcopal chapel at Laon as a cadaver half mummy and half corpse. He died in 1393; a decade later at Avignon Cardinal Lagrange (d. 1402) commissioned a tomb in Burgundian style with a mummified *gisant* whose moral significance is made plain to the observer by the epitaph: "Wretch, why art thou proud? Thou art naught but ashes and soon will be like me a food for worms." The concept develops through the fifteenth century with ingenious variations, and passes on into the sixteenth; René de Chalons, killed in 1547 at the siege of Saint-Dizier, had requested that he be represented on his tomb as his body would look "three years after death." The request was duly carried out, and Ligier Richier carved upon his sepulcher a skeleton to which the flesh still clings, and which offers with macabre gesture the heart of the deceased to God. The underlying pessi-

mism of such manifestations was depicted with cool irony in the extraordinary works of Hieronymus Bosch (d. 1516), anticipating Dali and surrealism with nightmarish visions and devilish distortions of familiar forms. A *Temptation of St. Anthony* (*Fig. 179*) disarms the observer with its smiling landscape, only to make him aware on a second look that everything about it is wrong; tiny demonic creatures creep across the bridge and infest the ground, or emerge as small monstrosities from the placid surface of the pool. The saint, a very average being, sits crouched in terror amid a diabolic world, "tempted" to despair by this foul infiltration of evil into the homely and dependable environment of every day.

The diabolism of Bosch, the atrocious cruelty in the Passion altarpieces, the cadavers on the tombs reveal a taste that found the evil aspect of experience convincing. The preference for the macabre is only one quality of the end of late Gothic art, but perhaps it is the most significant. It expresses a "sense of pain" comparable to that of the Hellenistic period which found issue in the agony of the *Laocoön* and the *Flaying of Marsyas* (p. 25). The cause in both cases was much the same—the collapse of a code of reference; the classic morale was dying in the Hellenistic world and Europe of the fifteenth century was feeling the disintegration of High Gothic faith. The art whose outline is the termination of this book expressed an age which generated the revolt of the Reformation and was the prelude to the religious wars of the sixteenth century. The Reformation and the ferment that preceded it were mainly northern phenomena; the role of Italy in the crisis was conservative and reactionary, a difference of religious attitude amply expressed by the gulf between the art of High Renaissance in the peninsula and its counterpart in the North. While Michelangelo was painting the Christian epos on the ceiling of the Sistine Chapel with antique giants and heroes, Gruenewald was devising for his Isenheim altar the ugliest, most poignant, and greatest of Crucifixions, and Dürer was wielding his inquisitive and sparkling line in eloquent detail that was still Gothic, implementing a romantic idealism with concrete and earthy accents. The cult of the individual with which the Middle Ages ended was turned by the Renaissance in Italy into an apotheosis of man for which it borrowed the vocabulary of classical antiquity; the North, immersed in reality, clung to native idiom. The "grand style" achieved in its final form a divorce of beauty from truth, establishing an academic point of view [24] whose *a priori* norms and exotic loveliness had no necessary root in experience. It supplanted the Gothic tradition in the rest of Europe during the course of the sixteenth century, in the wake of the political and religious ideals

[24] C. R. Morey, "The Academic Point-of-View," *The Arts*, June and July, 1927.

that were its academic counterparts—absolutism in government and the intolerance in faith evinced by Protestant and Catholic alike. In one country only was the tide of Italianism entirely stemmed. In the Low Countries, where late Gothic style was born and bred, Flanders succumbed to Spanish domination and surrendered at the same time its old artistic tradition to Italian fashion. But Holland maintained its liberty both in politics and art, and preserved a national integrity while it continued the honest and penetrating portraiture of men and things its own sons had initiated at the beginning of the fifteenth century. The seventeenth century saw the culmination of this divergence in two masters who worked in neighboring cities a stone's throw so to speak from one another, but were utterly distinguished in style and outlook. The movement and brio which Rubens could impart to his robust Flemish forms is part and parcel of Italian rhetoric; Rembrandt's indispensable detail and uncanny analysis are inherited from the Van Eycks. From this Dutch oasis of Gothic tradition, from Rembrandt and the contemporary Dutchmen who so faithfully painted Holland's likeness in the seventeenth century, the strain of authentic realism has continued into our own time, still evident in the two contributions late Gothic passed on to modern art—the candid portrait of person and thing, and landscape in its own right, reflective of mood, wherein the modern soul still seeks to recover that communion with the infinite which was the initial and essential content of mediaeval art.

BRINAY: *Romanesque Fresco; Christ*

Reading List

(The titles are selected with reference to availability, quality and quantity of illustrations, and authority. Works on architecture are not included.)

HISTORICAL BACKGROUND

W. J. DURANT, *The Life of Greece,* New York, 1939

C. H. HASKINS, *The Renaissance of the Twelfth Century,* Cambridge (Mass.), 1933

J. HUIZINGA, *The Waning of the Middle Ages,* London, 1924

H. St.L. B. MOSS, *The Birth of the Middle Ages,* Oxford, 1935

J. W. THOMPSON and E. N. JOHNSON, *An Introduction to Mediaeval Europe, 300–1500,* New York, 1937

A. A. VASILIEFF, *History of the Byzantine Empire,* Madison (Wis.), 1928–29

EARLY CHRISTIAN ART

M. LAURENT, *L'art chrétien primitif,* Brussels, 1911

C. R. MOREY, *Early Christian Art,* Princeton, 1942

W. NEUSS, *Die Kunst der alten Christen,* Augsburg, 1926

BYZANTINE ART

H. BUCHTHAL, *The Miniatures of the Paris Psalter,* London, 1938

O. M. DALTON, *Byzantine Art and Archaeology,* Oxford, 1911

O. DEMUS, *Die Mosaiken von S. Marco in Venedig,* Vienna, 1935

CH. DIEHL, *La peinture byzantine,* Paris, 1933

E. DIEZ and O. DEMUS, *Byzantine Mosaics in Greece,* Cambridge (Mass.), 1931

J. EBERSOLT, *La miniature byzantine,* Paris, 1926

A. GOLDSCHMIDT and K. WEITZMANN, *Die byzantinischen Elfenbeinskulpturen des X–XIII Jahrhunderts,* Berlin, 1930–34

A. GRABAR, *L'art byzantin,* Paris, 1938

G. MILLET, *Recherches sur l'iconographie de l'Évangile,* Paris, 1916

P. SCHWEINFURTH, *Geschichte der russischen Malerei im Mittelalter,* The Hague, 1930

K. WEITZMANN, *Die byzantinische Buchmalerei des 9. und 10. Jahrhunderts,* Berlin, 1925

ROMANESQUE ART

A. BOINET, *La miniature carolingienne* (plates only), Paris, 1913

P. DESCHAMPS, *French Sculpture of the Romanesque Period,* Florence, 1930

E. T. DEWALD, *The Illustrations of the Utrecht Psalter,* Princeton, 1932

H. FOCILLON, *Peintures romanes des églises de France,* Paris, 1938

A. GOLDSCHMIDT, *Die Elfenbeinskulpturen aus der Zeit der karolingischen und sächsischen Kaiser; aus der romanischen Zeit,* Berlin, 1914–26

A. GOLDSCHMIDT, *German Illumination,* New York, 1928

F. HENRY, *Irish Art of the Early Christian Period,* London, 1940

C. L. KUHN, *Romanesque Mural Painting of Catalonia,* Cambridge (Mass.), 1930

É MÂLE, *L'art religieux du XIIᵉ siècle en France,* Paris, 1924

A. K. PORTER, *Spanish Romanesque Sculpture,* Florence, 1928

A. K. PORTER, *Romanesque Sculpture of the Pilgrimage Roads* (1 vol. of text; 9 vols. of plates), Boston, 1923

SIR E. SULLIVAN, *The Book of Kells* (24 plates in color), London, 1927

READING LIST

ROMANESQUE AND HIGH GOTHIC

J. Domínguez Bordona, *Spanish Illumination*, Florence, 1929

A. Gardner, *A Handbook of English Mediaeval Sculpture*, Cambridge (England), 1935

A. Gardner, *Mediaeval Sculpture in France*, Cambridge (England), 1931

R. van Marle, *The Development of the Italian Schools of Painting*, Vol. I, The Hague, 1923

E. Panofsky, *Die deutsche Plastik des XI. bis XIII. Jahrhunderts*, Munich, 1924

O. E. Saunders, *English Illumination*, Florence, 1928

O. E. Saunders, *A History of English Art in the Middle Ages*, Oxford, 1932

HIGH GOTHIC

M. Aubert, *French Cathedral Windows of the XII and XIII Centuries*, New York, 1939

M. Aubert, *La sculpture française au début de l'époque gothique*, Florence, 1929

G. H. and E. R. Crichton, *Nicola Pisano and the Revival of Sculpture in Italy*, Cambridge (England), 1938

E. Mâle, *Religious Art in France: XIII Century*, London, 1913. (A later edition is the 5th French edition, *L'art religieux du XIIIᵉ siècle en France*, Paris, 1923)

M. S. and E. Marriage, *The Sculptures of Chartres Cathedral*, Cambridge (England), 1909

A. Nicholson, *Cimabue*, Princeton, 1932

W. Pinder, *Die deutsche Plastik des XIV. Jahrhunderts*, Munich, 1925

A. Venturi, *Giovanni Pisano, his Life and Work*, New York, 1928

G. Graf Vitzthum, *Die Pariser Miniaturmalerei*, Leipzig, 1907

HIGH AND LATE GOTHIC

H. Arnold and L. B. Saint, *Stained Glass of the Middle Ages in England and France*, London, 1913

T. Borenius and E. W. Tristram, *English Mediaeval Painting*, Florence, 1927

L. F. Day, *Windows*, New York, 1909

R. van Marle, *Simone Martini et les peintres de son école*, Strasbourg, 1920

H. Martin, *Les peintres des manuscrits et la miniature en France*, Paris, 1909

F. J. Mather, *A History of Italian Painting*, New York, 1923

C. R. Post, *A History of Spanish Painting*, Cambridge (Mass.), 1930–

O. Sirén, *Giotto and some of his Followers*, Cambridge (Mass.), 1917

LATE GOTHIC

C. Glaser, *Die altdeutsche Malerei*, Munich, 1924

E. Harris, *Spanish Painting*, New York, 1937

O. E. Lesmoisne, *Gothic Painting in France*, Florence, 1931

É. Mâle, *L'art religieux de la fin du moyen-âge en France*, 3d ed., Paris, 1925

H. Martin, *Les miniaturistes français*, Paris, 1906

F. J. Mather, *Western European Painting of the Renaissance*, New York, 1939

Ch. Sterling, *Les primitifs français*, Paris, 1939

Ch. de Tolnay, *Le Maître de Flémalle et les frères Van Eyck*, Brussels, 1939

W. H. J. Weale, *Hubert and John Van Eyck, their Life and Work*, New York, 1908

Index

INDEX

INDEX

INDEX

INDEX

INDEX

INDEX

INDEX

INDEX

INDEX

INDEX

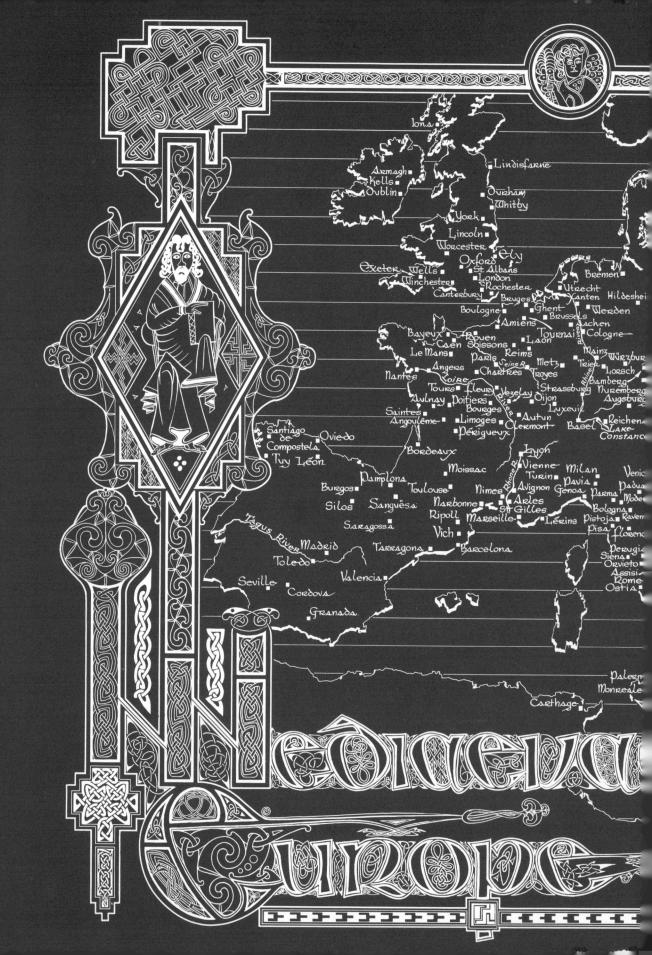

Iona

Armagh
Kells
Dublin

Lindisfarne
Durham
Whitby
York
Lincoln
Worcester
Exeter Wells Oxford Ely
St. Albans
Winchester London
Canterbury Rochester
Boulogne Bruges
Amiens
Bayeux Rouen
Le Mans Caen Soissons Laon
Angers Paris Chartres
Nantes Loire Troyes
Tours Fleury
Aulnay Poitiers Vezelay Dijon
Bourges
Saintes Limoges Autun
Angoulême Clermont
Périgueux

Bremen
Utrecht Xanten Hildeshei
Ghent Werden
Brussels Aachen
Tournai Cologne
Metz
Seine R. Trier Würzbur
Reims Mainz Lorsch
Strassburg Bamberg
Rhine R. Nuremberg
Luxeuil Augsburg
Basel Reichen
Lake
Constanc

Santiago
de
Compostela Oviedo
Tuy León
Burgos Pamplona
Silos Sanguëssa
Saragossa
Tagus River Madrid
Toledo
Seville Cordova
Granada

Bordeaux
Moissac
Toulouse Nimes
Narbonne St Gilles Arles
Ripoll Marseille
Vich
Tarragona Barcelona
Valencia

Lyon
Vienne Milan
Turin
Avignon Pavia
Rhone R. Genoa Parma
Bologna
Lérins Pistoja
Pisa
Florence
Perugia
Siena
Orvieto
Assisi
Rome
Ostia

Venic
Padua
Mode
Raven

Palerm
Monreale
Carthage

Medieval
Europe